Roman Art from the Louvre

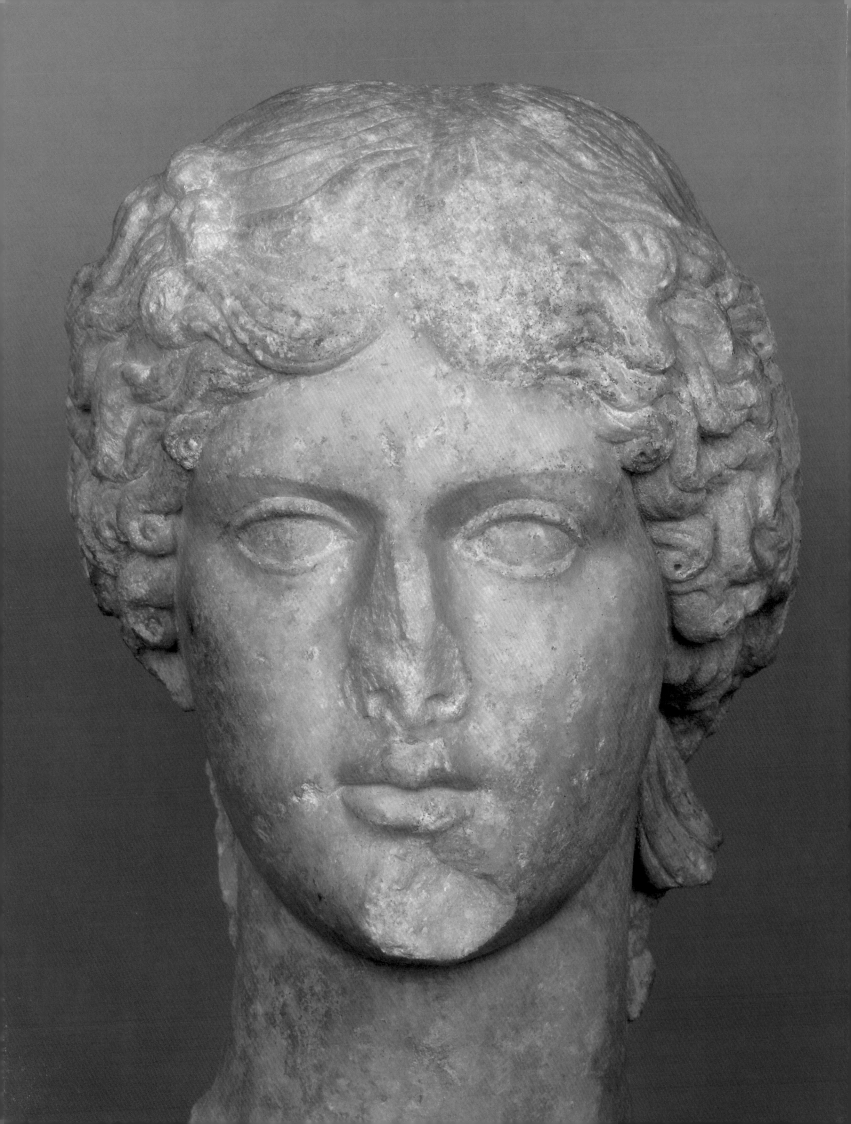

Roman Art from the Louvre

By Cécile Giroire and Daniel Roger

Foreword by Henri Loyrette
Preface by Alain Pasquier
Introduction by Jean-Charles Balty

Essays by Cécile Giroire, Ludovic Laugier,
Néguine Mathieux, Daniel Roger

Catalogue entries by Michel Amandry,
Véronique Arveiller, Catherine Bastien,
Pascale Carpentier, Sophie Cluzan,
Roberta Cortopassi, Sophie Descamps,
Jannic Durand, Elisabeth Fontan,
Cécile Giroire, Marianne Hamiaux,
Ludovic Laugier, Jean-Luc Martinez,
Néguine Mathieux, Caroline Papin,
Christophe Piccinelli, Daniel Roger,
Agnès Scherer

American Federation of Arts in association
with Hudson Hills Press

This catalogue is published in conjunction with **Roman Art from the Louvre**
an exhibition organized by the American Federation of Arts and the Musée du Louvre.
The exhibition is supported by an indemnity from the Federal Council on the Arts and
the Humanities.

The American Federation of Arts is a nonprofit institution that organizes art exhibitions
for presentation in museums around the world, publishes exhibition catalogues, and
develops education programs.

Guest Curators: Cécile Giroire and Daniel Roger

For the American Federation of Arts:
Publications Manager: Michaelyn Mitchell
Designer: Eileen Boxer
Editor: Jana Martin
Indexer: Laura Ogar
Translations from the French are by Alison Dundy, Nicholas Elliott, Elizabeth G. Heard,
Marguerite Shore, and Molly Stevens. Translation coordinator, Molly Stevens, The Art of
Translation.

Frontispiece: Portrait of Agrippana Major (cat. no. 18)

10 9 8 7 6 5 4 3 2 1

 American Federation of Arts
305 East 47th Street, Tenth Floor
New York, NY 10017
www.afaweb.org

 Hudson Hills Press
3556 Main Streeet
Manchester, Vermont 05254
www.hudsonhills.com

Library of Congress Cataloging-in-Publication Data

Giroire, Cécile.
Roman art from the Louvre / by Cécile Giroire and Daniel Roger ; foreword by Henri
Loyrette ; preface by Alain Pasquier ; introduction by Jean-Charles Balty ; essays by
Cécile Giroire ...[et al.].
 p. cm.
Published in conjunction with an exhibition organized by the American Federation of
Arts and the Musée du Louvre.
Includes bibliographical references and index.
ISBN 978-1-885444-35-6 (pbk. : alk. paper) / ISBN 1-55595-283-6 (hardcover : alk. paper)
1. Art, Roman--Exhibitions. 2. Art--France--Paris--Exhibitions. 3 Musée du Louvre--
Exhibitions. I. Roger, Daniel. II. American Federation of Arts. III. Musée du Louvre. IV.
Title.
N5760.G52 2007
709.37'07444361--dc22
 2007009056

Exhibition Itinerary
Indianapolis Museum of Art
September 23, 2007–January 6, 2008

Seattle Art Museum
February 21–May 18, 2008

Oklahoma City Museum of Art
June 26–October 12, 2008

Printed in China

Contents

To Alain Pasquier, with gratitude.

Directors' Acknowledgments The Louvre's Roman holdings, which date from the second century B.C. through the sixth century A.D., include a dazzling array of monumental sculptures, sarcophagi, marble busts and reliefs, bronze and terracotta statuettes and implements, jewelry, a cache of over one hundred major silver pieces from Pompeii, glass and metal cups and vessels, mosaics, frescoes, and furniture. From this renowned collection Guest Curators Cécile Giroire and Daniel Roger have selected 184 objects—masterworks that have been on view in the Roman galleries of the Louvre, some exceptional treasures that were not available to the general public, and magnificent works that have not been on view in recent decades. The largest number of objects from one department of the Louvre ever to be on loan in the United States, this selection presents a captivating in-depth picture of the ancient Roman world and the diverse artistic influences that shaped its art. The majority of the works in the exhibition will be reinstalled at the Louvre after the closing of this exhibition, so this will be a rare occasion to see these works outside of Paris for the foreseeable future.

The staffs of the American Federation of Arts and the Musée du Louvre deserve recognition for their exceptional work on behalf of the exhibition and publication. At the AFA, we wish to first recognize Judy Kim, former Curator of Exhibitions, for her key role in the organization of all aspects of this complex and ambitious project. Ms. Kim had the invaluable help of Curatorial Assistants Kristin Stein and Deirdre Conneely. Michaelyn Mitchell, Director of Publications and Design, meticulously coordinated all aspects of the production of this handsome and important catalogue, an invaluable contribution to the scholarship on Roman art. Very ably assisting Ms. Mitchell were Sarah Ingber, Editorial Assistant, and former Editorial Assistant Alec Spangler. Kathleen Flynn, Director of Exhibitions Administration, skillfully oversaw myriad complex administrative and organizational issues. Eliza Frecon, former Registrar, Jennifer Hefner, Registrar, and Anna Hayes, Head Registrar, expertly handled the challenges of preparing and touring the exhibition. We also want to acknowledge Janet Landay, former Director of Exhibitions and Programs, Suzanne Burke, Director of Education, and Madeleine Cygan, Assistant Educator. Thomas Padon, former Deputy Director for Exhibitions and Programs, conceived of the exhibition and initiated the discussions that led to the development of *Roman Art from the Louvre*. We would like to thank Patrick Mauger and his staff at Architecture Patrick Mauger who worked closely with the Guest Curators and AFA staff as Design Consultant for this project.

Cécile Giroire and Daniel Roger have been the leading forces in the French part of this project. Though in charge of this collection a relatively short time, they have accomplished a truly remarkable feat in preparing *Roman Art from the Louvre*. We would like to pay tribute to their achievement and thank them for their relentless efforts. In fact, they have changed the way we look at roman artworks, allowing new discoveries to surface. They have breathed a new spirit into the presentation in comparison with the present display in the Parisian galleries. This was not only an intellectual effort but required a tremendous amount of coordination. They had to collect ideas and opinions from their American partners, communicate and share their goals with the presenting museums, respect their points of view, and meet deadlines.

In the vast administration of the Musée du Louvre, we wish to single out Didier Selles, Chief Executive Director; Aline Sylla-Walbaum, Director of Cultural Development and Assistant General Administrator; Christophe Monin, Deputy Director of Cultural Development; Sophie Kammerer, International Development Manager; Xavier Près, Legal Department; Alain Pasquier, Chief Curator and Head of the Greek, Etruscan, and Roman Art Department, and all the members of the department who played a part in this project; Alain Boissonnet, Head of the Architecture, Museography, and Servicing Department; and those who worked for this exhibition within the Marble, Mount, Woodwork, Paintwork and Metal Workshops, as well as within the Graphic Design Department.

Roman Art from the Louvre benefited greatly from an indemnity from the Federal Council on the Arts and Humanities. For all her help and support, we are grateful to Alice Whelihan, Indemnity Administrator, Museum Program, National Endowment for the Arts. We also wish to recognize the talents of Eileen Boxer, who designed this beautiful book.

Finally, we recognize the museums participating in the tour of this definitive exhibition—the Indianapolis Museum of Art, the Seattle Art Museum, and the Oklahoma City Museum of Art. It has been a great pleasure to work with them, and we thank them for being such professional and enthusiastic partners.

Julia Brown, DIRECTOR, AMERICAN FEDERATION OF ARTS
Henri Loyrette, PRESIDENT AND DIRECTOR, MUSÉE DU LOUVRE

Curators' Acknowledgments Our thanks go first and foremost to Alain Pasquier, Chief Curator and Head of the Greek, Etruscan, and Roman Art Department, who entrusted us with this ambitious project, which the Louvre's administrative staff undertook with such enthusiasm. Henri Loyrette, President and Director of the Musée du Louvre, continually followed and supported our work—amid all the other projects he has initiated—along with the administrative staff, in particular, Didier Selles, Chief Executive Director, and Aline Sylla-Walbaum, Director of Cultural Development and Assistant General Administrator. Sophie Kammerer, International Development Manager, was also an invaluable daily contact.

The idea of showing the Louvre's Roman art collection in the United States was conceived in 2003 by the American Federation of Arts, and the exhibition would not have been realized without the work of the good-natured and untiring Judy Kim, former Curator of Exhibitions at the AFA, and her assistants. Kathleen Flynn, Director of Exhibitions Administration, was actively involved in every step of the process, and Michaelyn Mitchell, Director of Publications and Design, supervised the production of the catalogue, often working under numerous constraints. Eliza Frecon and then Anna Hayes were efficient and energetic registrars.

At the heart of the Greek, Etruscan, and Roman Art Department is a group of people who spare no effort in the accomplishment of their work. Among them are Néguine Mathieux and Ludovic Laugier, to whom very special thanks go for their experience, accessibility, and energy. Giovanna Léo and Christelle Brillault efficiently coordinated multiple duties, and we also received timely and indispensable help from Pascale Carpentier and Brigitte Tailliez, as well as Caroline Papin, Véfa Le Bris du Rest, and Manuella Lambert.

Other departments of the Louvre contributed to this exhibition by way of making important loans: the Eastern Art Department, the Egyptian Art Department, and the Decorative Arts Department. Similarly, the Bibliothèque Nationale de France allowed us to draw from works of theirs that are being housed at the Louvre.

This catalogue is comprised of numerous contributions. Our gratitude goes to Jean-Charles Balty, a member of the Institut de France, for his kind participation. A score of authors have enriched our knowledge, helping us to understand so many objects—from the virtually unknown to the world famous. Our warm thanks go to Catherine Bastien, Ludovic Laugier, Jean-Luc Martinez, Christophe Piccinelli-Dassaud, Néguine Mathieux, Agnès Scherer, Véronique Arveiller, Marianne Hamiaux, Pascale Carpentier, Caroline Papin, Marc Etienne, Sophie Cluzan, Sophie Descamps, Michel Amandry, Elisabeth Fontan, Jannic Durand, and Roberta Cortopassi.

A large part of the Roman collection will from now on benefit from the beautiful photographic documentation of Anne Chauvet, Daniel Lebée, and Carine De Ambrosis. At the venues, the exhibition is illustrated by the works of Jean-Claude Golvin, who kindly responded to our requests, and by the meticulous work of Claire Raveau.

Patrick Mauger and Judith Bonnet worked closely with us and the curators at the venues to create a stunning design concept and display furniture for the exhibition.

In preparation for this exhibition, the objects have received the expert care of more than thirty restorers who worked diligently and sometimes in difficult conditions. The professionalism and knowledge demonstrated by the workshops of the Louvre must be saluted, as well as the proficiency of Emmanuel Bougenaux, who, along with his team, manufactured many mounts for the artworks.

Cécile Giroire and Daniel Roger

Foreword Very few museums aside from those in Italy keep collections of antiquities that can offer a broad view of the art of imperial Rome. When the Louvre museum was founded in 1793, both antiquities—mostly Roman—and paintings formed the core of the most prestigious French collections. Thanks are therefore due the American Federation of Arts for inviting a look back at a major part of this museum's original purview by launching this project, which involves sending some two hundred works across the ocean. And yet, because the Louvre's collection is so rich, formed by generations of curators, the Department of Greek, Etruscan and Roman Antiquities still remains barely touched.

It was Alain Pasquier, Head Curator of the Department of Greek, Etruscan and Roman Antiquities, who called upon Cécile Giroire and Daniel Roger, whom he had put in charge of the Roman Collection, to make a choice among so many artworks. They have been very keen to assemble a coherent group of works designed to illustrate the diversity of ancient Roman culture. The selection includes masterpieces, like the impressive historical reliefs, as well as lesser-known yet still significant pieces, like the small group of bronze statuettes and everyday objects. While making important choices from the department's collection, they sought to enhance the compilation with objects from the Department of Near Eastern Antiquities, the Department of Egyptian Antiquities, and the Department of Decorative Arts. I am thrilled that this exhibition has furnished an occasion to bring together pieces separated by the history of the collections. It has also provided an opportunity to take advantage of the talents of the Louvre's scientists.

This event is intended for the largest audience possible—an occasion to take the Louvre's Roman Art collection beyond the European frontier. It is one of many international exchanges that the Louvre wishes to develop with other cultural institutions. And developments in France—the establishment of a Louvre annex in the city of Lens, and the partnership with the Musée de l'Arles et de la Provence Antiques—should not outshine projects the Louvre has undertaken outside of France, especially in the United States, where the American Friends of the Louvre are our valued partners.

This exhibition represents a new era for the Roman collection at the Louvre. In preparation, the museum conducted a thorough study of the works. Most pieces underwent fundamental restoration. This handsome catalogue attests to the work of a team to which we must pay homage. It is my hope that this volume will lead to more restoration projects and other publications, as the collection, including certain lesser-known pieces, is brought to light.

These highlights from the Roman collection will go to museums in Indianapolis, Seattle, and Oklahoma City before returning to Paris. In these great American institutions, the public will have a taste of the Roman galleries as they will soon exist at the Louvre, for the new space there will accommodate more works and offer a more accurate and fair picture of the sheer variety of Roman art. Its statues and marble reliefs, inscriptions, terracotta pieces, bronzes, silver and jewelry, mosaics, and paintings will truly reflect the genius of Rome.

Henri Loyrette

Preface The Roman art collection at the Louvre is rich and varied, filled with acquisitions dating back to the time of King Francis I. Although the statues, portraits, and marbles are clearly essential—not to mention spectacular—there are many other objects in the collection, of every size and function and from every corner and era of the empire, whose history they have punctuated for a long time. It is precisely this diversity that my colleagues Cécile Giroire and Daniel Roger have sought to represent in preparing *Roman Art from the Louvre*, for which I am very pleased to be writing the catalogue preface. They have brilliantly selected works that illustrate every aspect of an art that, as everyone knows, tells us not only about power, influence, war, and conquest, but also about public and private life, social organization, religion, work, and leisure. Jean-Charles Balty's fine introduction provides excellent commentary on these complexities. The works bring to life a world that is long gone yet ever-present, shedding light on our own time as well.

Some of the selected artworks are among the most famous in Roman art. Many of them have not left the Louvre since their acquisition, where they have played important roles in successive displays in the galleries, but they have come to join the lesser-known works, some rarely or never exhibited because of their condition. This show provides an occasion to bring them back to life. Filled with unknown messages that feed both our mind and senses, they are captivating.

In many ways, this exhibition marks a renaissance for the Louvre's Roman art collection. Thanks to the help provided by the American Federation of Arts, and through the considerable task of restoration (Ludovic Laugier's essay explains the basic and often difficult decisions made during the process) great works once dulled by dust have been reborn. Through cleaning and careful repairs they have regained their health, beauty, and strength of expression. The exhibition not only offers a sense of rebirth, but also a glimpse of the future, in the form of the new Roman art galleries at the Louvre—entirely renovated according to innovative principles, the most recent studies and findings, and also the expectations and interests of today's world and visitors.

Let us hope that when the work sent to the United States is returned, it is quickly followed by the new incarnation of the Roman art galleries. There, every day, art lovers and students of all ages—in search of images from a world they may have learned about at school—can come to admire the incomparable genius with which the Romans were able to represent the human face.

Alain Pasquier

Contributors

Michel Amandry Curator, Bibliothèque nationale de France

Véronique Arveiller Researcher, Department of Greek, Etruscan, and Roman Antiquities, Musée du Louvre

Jean-Charles Balty Member of the Institut de France and Professor Emeritus, University of Paris-Sorbonne

Catherine Bastien Documentation Assistant, Department of Greek, Etruscan, and Roman Antiquities, Musée du Louvre

Pascale Carpentier Documentation Assistant, Department of Greek, Etruscan, and Roman Antiquities, Musée du Louvre

Sophie Cluzan Curator, Department of Eastern Antiquities, Musée du Louvre

Roberta Cortopassi Researcher, Department of Egyptian Antiquities, Musée du Louvre

Sophie Descamps Curator, Department of Greek, Etruscan, and Roman Antiquities, Musée du Louvre

Jannic Durand Curator, Department of Decorative Arts, Musée du Louvre

Elisabeth Fontan Curator, Department of Eastern Antiquities, Musée du Louvre

Cécile Giroire Curator, Department of Greek, Etruscan, and Roman Antiquities, Musée du Louvre

Marianne Hamiaux Researcher, Department of Greek, Etruscan, and Roman Antiquities, Musée du Louvre

Ludovic Laugier Researcher, Department of Greek, Etruscan, and Roman Antiquities, Musée du Louvre

Jean-Luc Martinez Curator, Department of Greek, Etruscan, and Roman Antiquities, Musée du Louvre

Néguine Mathieux Documentalist, Department of Greek, Etruscan, and Roman Antiquities, Musée du Louvre

Caroline Papin Documentalist in Training, Department of Greek, Etruscan, and Roman Antiquities, Musée du Louvre

Alain Pasquier Head Curator, Department of Greek, Etruscan, and Roman Antiquities, Musée du Louvre

Christophe Piccinelli-Dassaud Documentalist, Department of Greek, Etruscan, and Roman Antiquities, Musée du Louvre

Daniel Roger Curator, Department of Greek, Etruscan, and Roman Antiquities, Musée du Louvre

Agnès Scherer Documentalist, Department of Greek, Etruscan, and Roman Antiquities, Musée du Louvre

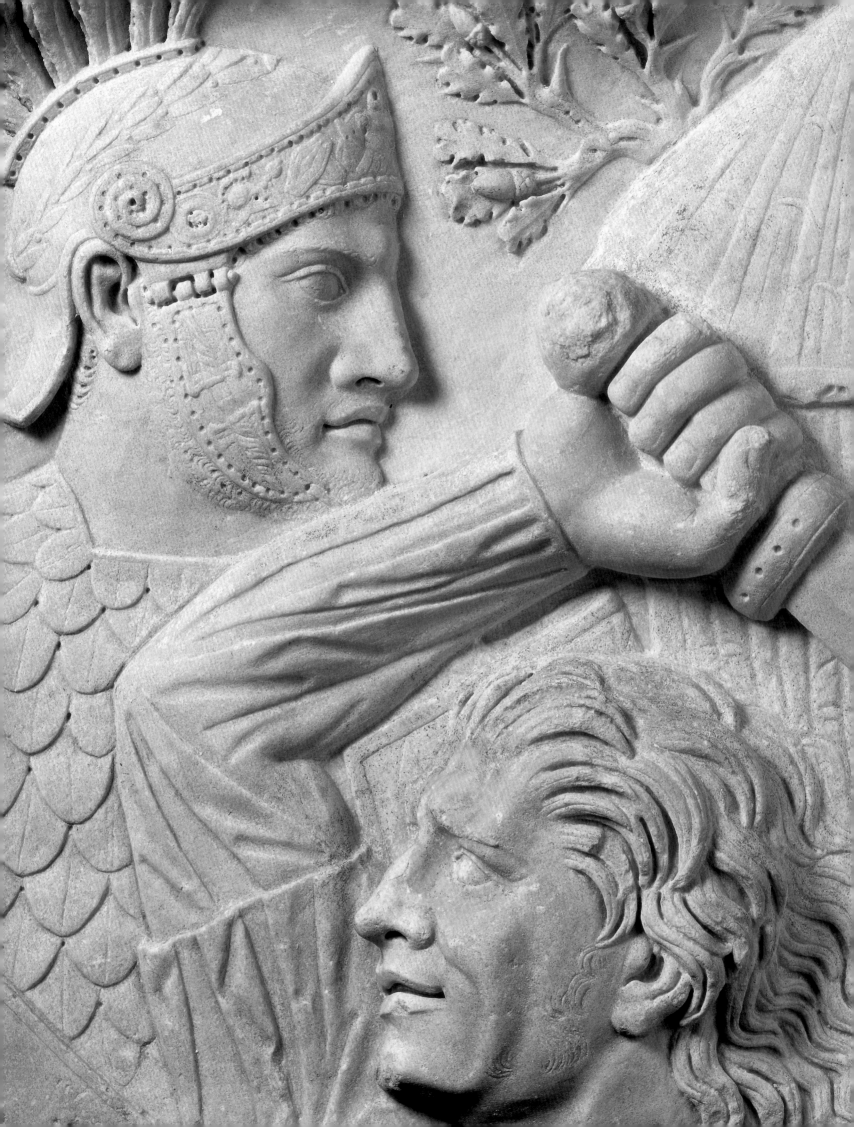

Introduction—Roman Art and the Collections of the Louvre **Jean-Charles Balty** Any attempt to define the art of a period through the collections of a single museum should certainly be considered foolhardy—unless the collections in question are those of the Louvre. Originally assembled from the French royal collections and those of cardinals Richelieu and Mazarin, the Louvre's holdings grew through the purchase of prestigious collections (such as those of Cardinal Albani, the Borghese, and the Marquis Campana); the findings of French archeological expeditions to the Near East (mosaics from Antioch and Kabr-Hiram) and North Africa (mosaics from Sousse, Utica, Carthage, and Constantine; reliefs from Carthage; statues from Cyrene); and many judicious acquisitions that expanded the collection's reach to other provinces of the empire (Asia Minor, Greece, and Thrace). Moreover, the Louvre's Roman art collection includes artifacts representing every art form practiced under the republic and the empire, from nearly every area then under Roman rule. Its sheer breadth and diversity would more than justify such an endeavor.

It is however the very nature of Roman art to elude any attempt at definition or synthesis. It is indeed a deeply polymorphic art whose essence cannot be captured in just a few words. Surprised by its heterogeneity or "lack of stylistic unity,"[1] scholars have declared it be "dual"[2] or even "plural."[3] The latter opinion may well be the best way to account for some of the encountered ambiguities.

From its very beginning, Roman art was torn between its enthusiastic reception of Greek art and indisputable Italic traditions. On the one hand, Greek art was no longer a mere influence that arrived through Etruria, Campania, and Sicily—as it had been in the previous centuries. Rather it was the real shock that followed the conquest of Greece in the second century B.C. and put Rome in contact with archaic, classical, and Hellenistic works of art, all of which enthralled the Roman elites. On the other hand, Italic traditions were often more spontaneous and provided Roman art with a sense of narrative and less rigid perspectives: typical of many popular traditions, these expressed more familiar scenes than those on official monuments.

Roman art is too multifaceted to be described from a linear and simplistic viewpoint; yet long regarded as entirely dependent and slavishly imitative of the best Athenian artistic achievements, it was granted a mere handful of pages in our handbooks, crammed in at the end of histories of the art of antiquity that were otherwise nearly exclusively devoted to Greek masterpieces. Just fifty years ago, the idea of organizing an exhibition of Roman art would have seemed outlandish; yet in September 1963,[4] on the occasion of the Eighth International Congress of Classical

Archeology and the initiative of Jean Charbonneaux, the Louvre presented an exhibition titled *L'art dans l'Occident romain*, which evidently signified a major change in viewpoint during the first few years following World War II.

The 1927 edition of the *Propyläen Kunstgeschichte* devoted only one volume—though written by the famous scholar Georg Rodenwaldt—to *Hellas und Rom*, but by 1967 its coverage had expanded to two volumes, including a full book—under the direction of Theodor Kraus—dedicated to *Das römische Weltreich*. Otto J. Brendel (1953), Heinz Kähler (1958 and 1962), Antonio Frova (1961), Guido Kaschnitz-Weinberg (written shortly before the war but not published until 1961), Giovanni Becatti (1962), Gilbert-Charles Picard (1962), George M. A. Hanfmann (1964),

and Sir Mortimer Wheeler (1964) had all paved the way. Ranuccio Bianchi Bandinelli went further with his two masterly volumes for *L'Univers des Formes*: *Rome. Le centre du pouvoir* (1969) efficiently defined the model of the Urbs; *Rome. La fin de l'art antique* (1970) gave an essential place to provincial substrata and artistic events and led the reader all the way to the beginnings of Romanesque art. Bianchi Bandinelli, who has shown, better than anyone, this "transformation of an art that from Hellenistic becomes Medieval and from Mediterranean European,"[5] has also pointed out, better than others, the misconceptions—and even the total lack of understanding—caused by considering Greek art the "absolute *art*."[6] He disputed again, as Rodenwaldt had, the concept of decadence all too frequently associated with any appreciation of Roman art. As he wrote, a profound mutation was going on—

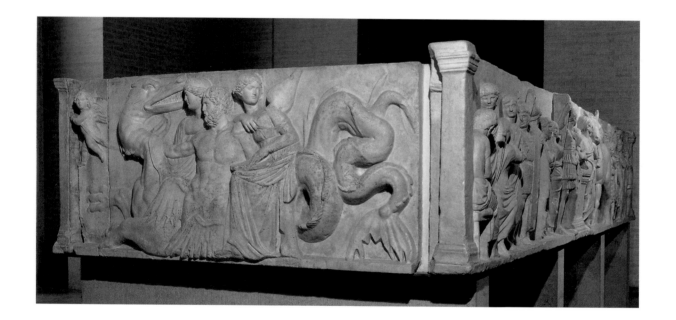

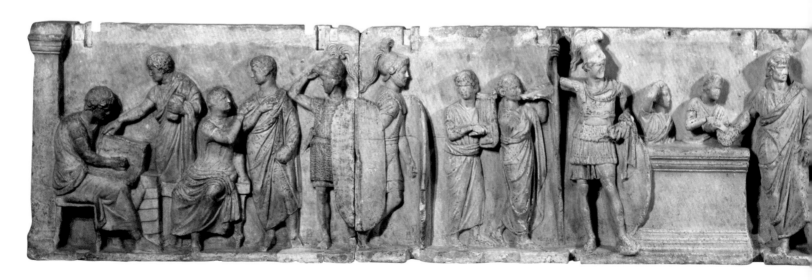

Rodenwaldt's "Stilwandel"—which "our period allows us to follow and easily understand": it is, altogether "the deterioration of a culture that, at a certain moment, loses its usefulness, and the muddled emergence of a new culture that appears cruder but has a more profound human content."[7] He added, "This is not a catastrophe, but a historical process."[8] Is this not similar to statements Pierre Francastel made, at around the same time—in *Peinture et société* of 1965—in regard to trying to understand the conditions and circumstances that preside over the birth and destruction of a "plastic" space, from the Renaissance to Cubism? It is in fact the subtitle of his book: *De la Renaissance au Cubisme.*

O. J. Brendel showed that the off-kilter, practically aerial view, of a cavalry parade *(decursio)* circling around the standards on the two lateral scenes at the base of the Antonine column in Rome seems astonishing when compared to the "classical" composition and perspective used to depict the imperial couple on the monument's principal face. The same could be said (and Brendel noted as much) when comparing the Munich marine *thiasos* (fig. 1) to the Louvre's famous relief of the census (fig. 2), regardless of what position one adopts regarding the monument's uniqueness, date, or sponsor (who may not have been Domitius Ahenobarbus, despite previous assumptions).[9]

The juxtaposition of different compositional principles in a single work indicates that the artist based his choices on a desire to render each situation as effectively as possible. Brendel identified this approach as an "autonomy of the representational form"[10]—Peter H. von Blanckenhagen later

FIG. 1 *"ALTAR" OF DOMITIUS AHENOBARBUS*
End of 2nd century–beginning of 1st
century B.C.
Marble
Staatliche Antikensammlungen und
Glyptothek, Munich

FIG. 2 *"ALTAR" OF DOMITIUS AHENOBARBUS*
End of 2nd century–beginning of 1st
century B.C.
Marble
Musée du Louvre, Paris (Ma 975)
Photo: Réunion des Musées Nationaux /
Art Resource, NY—Chuzeville

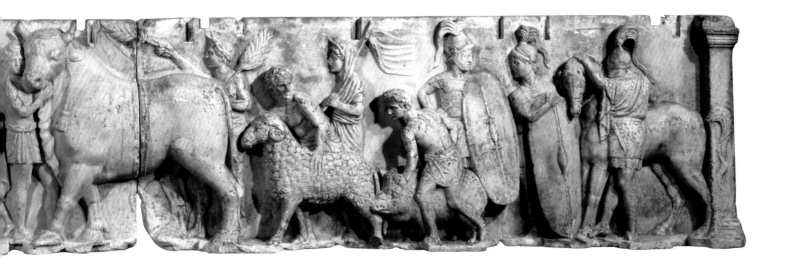

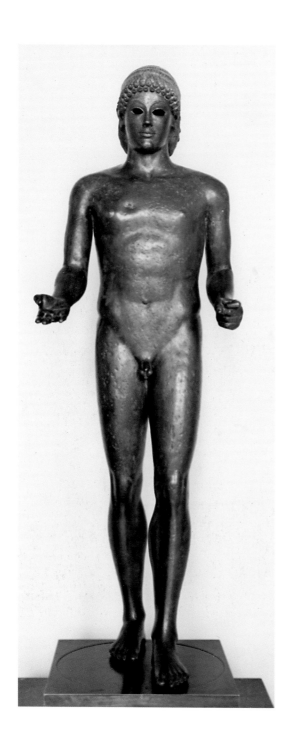

referred to it as Gattungstil (generic style[11])—unrelated to chronology or the sponsor's degree of artistic culture (as shown by the examples of the Antonine column and the Louvre's relief of the census, both belonging to official art). Some of these compositional principles, more and less recurrent, suited specific types of representations: as part of the artistic repertoire they were used emulously, without being subject to much change. Entirely different was the case of new scenes without preexisting models, which thus required the creation of new schemes. Hence, the surprisingly contradictory juxtapositions mentioned above often hinged on whether the artist could call on a specific iconography (in the sense of artistic habits or methods, but not necessarily of pattern books, as has sometimes been imagined). Following Peter G. Hamberg, Brendel has well understood that these schemes, these "independent *nuclei* of composition or autonomous pictures," could be found throughout the history of Roman art.[12] The choice of a model determined the singularity of the piece of art. But was this aesthetic choice made to suit the sponsor's taste, or in order to achieve the effect or objective he was after? After the formative centuries (the end of the republic and the Julio-Claudian era), the latter answer frequently proved to be more accurate.

Ideal sculpture ("Idealplastik")—cult statues and precious bronzes—was inevitably more reliant on Greek statuary than any other artistic realm. Greek statuary served as the primary source for Roman eclecticism, just as it would inspire our own European neoclassicism after Johann Joachim Winckelmann's *Geschichte der Kunst des Alterthums* of 1764 proclaimed it the epitome of Beauty. Since their very first contacts with Greece—whether with Sicily (the capture of Syracuse by M. Claudius Marcellus in 211 B.C.), the rest of Magna Graecia (the capture of Taranto by Q. Fabius Maximus in 209 B.C.), or with Greece itself (the capture of Eretria by L. Quinctius Flamininus in 198 B.C. and his brother Titus's victory in 194 B.C.) or Asia Minor (the capture of Magnesia by L. Cornelius Scipio Asiagenus in 190 B.C.)—and throughout the second century and the early first century B.C., the *imperatores* (victorious generals) did not fail to display, during their triumphal processions, in the temples and all around the great porticoed squares erected on the Campus Martius, those masterworks of the great classical artists (Calamis, Phidias, Sthennis, Lysippos) that were part of their war booty[13] and offered there to

the Roman people as both *monumenta imperatoris*[14] and *ornamenta Urbis*[15] ("monuments of their power" and "city adornments"). The fruits of this enormous pillage were exhibited within monuments that quickly developed into veritable museums, inspiring both widespread enthusiasm—despite the frequently violent objections of Cato and a few other senators that this art was a perverse luxury—and the development of an extraordinary culture of the copy, spurred by the legal impossibility of owning the originals themselves. In Rome, Greek art served not only as the starting point of an artistic evolution that would not occur again until the modern era, but of an increasingly well-defined artistic taste that is discernible in various passages of Latin authors. *Interpretatio, imitatio,* and *æmulatio* are the terms of the ancient rhetoric that sufficiently define, as Raimund Wünsche pointed out, an entire field of artistic production long identified as nothing more than a servile imitation of Greek sculpture, without any recognition of Roman artists' intent to rival the works of the famed Greek masters of the past.[16] Yet didn't they manage to fool us all? The Piombino Apollo (fig. 3), the Idolino, the Benevento Youth (fig. 4), and perhaps even the Centocelle Eros are not creations of the fifth or fourth Greek centuries B.C., but of the Roman era.[17]

In 1951, when few historians of the art of antiquity had grasped the significance of this tremendous creative awakening, Marguerite Yourcenar understood and expressed it remarkably in the words of Emperor Hadrian. Though this beautiful page from her *Memoirs of Hadrian* deserves to be cited in its entirety, the essence of her insight lies in the following sentences:

> Our art is perfect, that is to say, accomplished, but its perfection is susceptible to modulations as varied as those of a pure voice: it is left to us to play the clever game of perpetually drawing closer or further away from a definitive solution, of attaining the extremes of rigor or excess.... There is an advantage to having one thousand points of comparison in the past, to being free to intelligently take up where Scopas left off, or to voluptuously contradict Praxiteles.[18]

Would it require Yourcenar's own artistic sensibility to finally comprehend what was truly at stake? "It is left to us to play the clever game...," Hadrian declares, miles away from Virgil's famous statement so often taken to "justify" a Roman

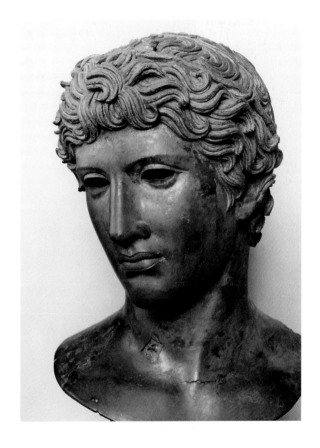

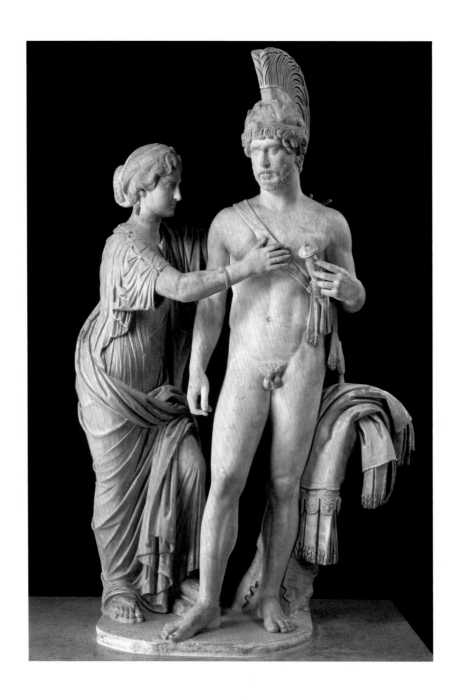

FIG. 5 *PRIVATE COUPLE: MARS AND VENUS*
2nd–3rd quarter of 2nd century A.D.
Marble
Musée du Louvre, Paris (Ma 1009)
Photo: Réunion des Musées Nationaux /
Art Resource, NY— R.G. Ojeda

lack of interest in art: "Exudent alii spirantia mollius aera / (credo equidem), uitos ducent de marmore uultus / ... Tu regere imperio populos, Romane, memento" (Roman, forget not thou to sway the world; These be thy arts; —bring in the reign of peace; Spare subject nation; put the haughty down) (Virgil, *Aen.* VI, 847–853).

Yourcenar's words could serve as an epigraph to Christa Landwehr's innovative and deeply convincing 1998 article on the subject of "Konzeptfiguren" (concept figures),[19] in which she establishes the relative originality of these creations within a formal system strongly dependent on these Greek prototypes. Hence these infinite variations on a classical theme, similar to the variations that great seventeenth-, eighteenth-, nineteenth-, and even twentieth-century composers wrote on a few measures of the famous *Follie di Spagna* without ever dulling their creative imagination. Witness the various Roman renditions—some of them of an undeniable inventiveness—of Apollo, Bacchus (cat. nos. 82 and 155), Jupiter (cat. no. 148), Minerva, Venus (cat. nos. 86 and 153), and Hercules—not to mention those sculptural groupings, the semantic system of which Tonio Hölscher's probing analysis has so brilliantly deciphered.[20] The Louvre statuary group representing an Antonine couple as Mars and Venus (fig. 5) presents one of the best examples of this process, which suffices to prove the success it encountered: two classical originals, the Alcamenes Ares and the Brescia Venus, created independently of each other in different styles and at different times, used here as models for a Roman cult statue in the Temple of Mars Ultor on the Forum Augustum. The model then recurred around 147–149 A.D. as the basis for a statue of Emperor Marcus Aurelius and his wife Faustina as Augusta, before entering the private sphere through numerous statues, many of them funerary, extolling until the third century a couple's *concordia*. The way could not be clearer: every stage is attested to. A similar process was adopted by the school of Pasiteles as early as the end of the Republican era, albeit with radically differing levels of success.[21] Though Pasiteles's five books of *Opera nobilia* have regrettably been lost, his pupils' craft lives on through the famous Menelaos group,[22] highly lauded by Winckelmann and Johann-Gottfried Herder, or the San Ildefonso group now in the Prado.[23] But notable examples, such as the Orestes and Pylades group in the Louvre (fig. 6) or, worse yet, the Orestes and Electra one in Naples, are sufficient testimony to the limits of these methods.

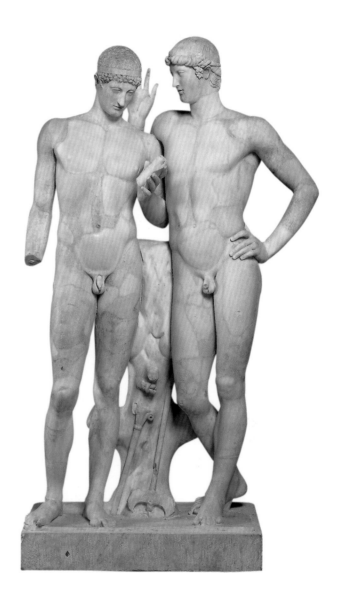

FIG. 6 *ORESTES AND PYLADES*
Middle of 1st century B.C.
Marble
Musée du Louvre, Paris (Ma 81)
Photo: Musée du Louvre—Daniel Lebée and Carine De Ambrosis

For artists, these works of classical Greek art were indispensable components of a true, formal repertory. For the public, they were crucial features of the urban landscape. For art lovers and a certain elite, they were the cornerstones of aesthetic taste. As such, they set the standard in the Roman world for several centuries, regardless of whether their iconographic schemes were followed to the letter or adapted, imbued with an aesthetic or moral connotation or simply discussed among connoisseurs.

It is hardly surprising, then, that Greek art—even through these Roman copies and adaptations—continued to have a major influence on Western art with the coming of the Renaissance and through the finds at Herculaneum and Pompeii, until excavations in Greece and Asia Minor finally gave us direct access to the first but extremely rare originals. Greek art's prolonged significance, which even Karl Marx commented upon,[24] can be explained by its status as a reference as long as this Hellenistic-Roman *koine* had not been dissolved. Spanning several centuries, this *koine* of artistic types and forms constituted one of the most extraordinary formal repertories in the history of art. It cannot, of course, be limited to sculpture: painting, book illumination, metal arts, and decoration of ceramics all drew inspiration from Greek art. Thanks to their small size and moderate weight, these types of objects disseminated the Greek influence throughout the ancient world, ensuring its extension to other periods and its spread to other geographic areas.

Consequently, as early as in 1953, Bianchi Bandinelli recognized the "Pompeian," i.e., the Hellenistic character, of certain scenes on the frescoes of Santa Maria di Castel Seprio.[25] Others have detected these traces of Greek art in the classicism of numerous figures, poses, and compositions in Byzantine miniatures extending to the tenth-century Paris Psalter and the illuminated manuscripts of the "aristocratic" tradition—art historians have even spoken of a "Macedonian renaissance." [26] And in the early seventh century the silver plates of the Lambousa treasure (Cyprus) still tell the biblical story of David using illusionist layouts that go back to classical imagery—allowing L. D. Matzulevitch to refer to them and to several other Byzantine works as works of a "Byzantinische Antike." [27]

Among the other realms of Roman art, the portrait has always been considered one of the most original. In fact, it was so highly praised that in recent decades a thoroughly comprehensible swing of the pendulum has now tended

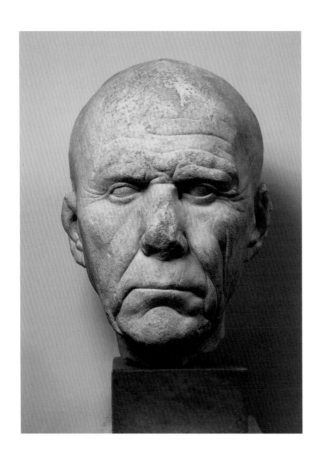

FIG. 7 *HEAD OF AN OLD MAN*
Middle of 1st century B.C.
Marble
Museo nazionale, Chieti, Italy
Photo: Scala / Art Resource, NY

to exaggerate its debt to Greek precedents. There can be no denying that Greek portraits, particularly the Hellenistic individual portrait,[28] influenced the private portraits of Roman society, which was in the process of opening itself to the Mediterranean, and becoming the principal economic and political power in the Hellenistic world. It is also true that the *viri triumphales* of the last two centuries of the republic were seduced by representations of the rulers of Pergamon, Antioch, or Alexandria. Yet this cannot eclipse what was intrinsically Roman in the Roman portrait; what was intrinsic to its landed aristocracy, to its *mos maiorum*-abiding elites and to the very tradition of gentilician wax masks that surprised Polybius and certainly constitutes one of the indigenous features of the Roman portrait.[29]

Given its concurrent use of widely different modes of representation by individuals belonging to the same social classes, or by members of the poorer classes seeking to imitate their more fortunate contemporaries' aesthetic choices, the Roman portrait must also be described as a polymorphic or pluralistic art form. The style of representation could be governed by a desire to assert a genuine "Italic" identity made of *gravitas*, *dignitas*, *auctoritas* (fig. 7); or by a pathos, a fire and ardor evoking the image of Alexander—who served as a model for certain *imperatores* of the period following his exploits in the East (fig. 8); or, to the contrary, by a somewhat melancholy *humanitas* supported by the stoicism of a society now more easily accessible to *homines novi* (fig. 9).[30] Hence, at the same time, portraits are notable for their idealism or their realism. Indeed, contrary to a long-held belief, Greek portraiture was not more idealized than Roman portraiture was necessarily realistic. Thankfully, we have now abandoned this simplistic dichotomy; for far too long, it had altered and even falsified the entire history of the portrait in antiquity.

One should also take heed of Franz Wickhoff's judicious but rarely acknowledged observation that the most accomplished portraits were private portraits,[31] the "first individual accents of European art," according to the remarkable phrase that Charbonneaux borrowed from Bianchi Bandinelli.[32] Circulated throughout the provinces of the empire to assert the omnipresence of the emperor and the *domus Augusta*, the official portrait was merely a copy of an "Urbild" created in Rome in, as Bianchi Bandinelli said, the "center of power," and which is as difficult for us to assess as the originals of classical Greek statuary are, even through the best replicas. Following

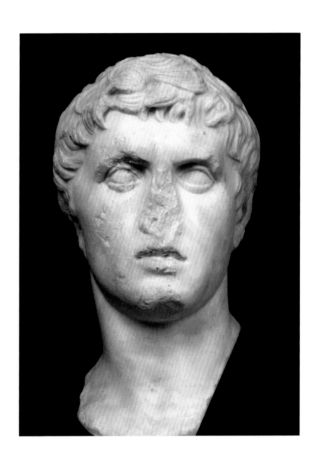

FIG. 8 *HEAD OF A MAN, FROM ROME (LARGO S. SUSANNA)*
2nd quarter of 1st century B.C.
Marble
Museo Nazionale Romano, Rome
(inv. 38997)

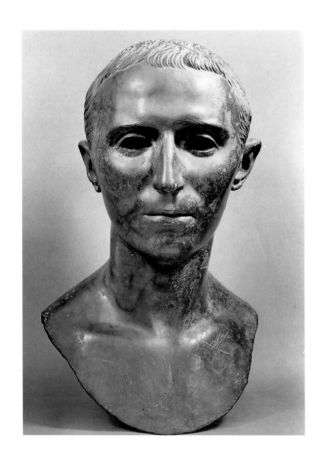

FIG. 9 *HEAD OF A MAN, FROM CAPELLA
DI PICENARDI*
Last quarter of 1st century B.C.
Bronze
Musée du Louvre, Paris (Br 18)
Photo: Musée du Louvre–Chuzeville

rigid formal schemes to express a political message, it is both conventional and often academic; it is an art of the court, well represented here by the Augustus portrait in the so-called "Prima Porta type" (cat. no. 14), unaltered for forty years, by a crowned Tiberius dating from the retirement years in Capri (cat. no. 19); the Trajan (cat. no. 34); the Plotina (cat. no. 48); the Marcus Aurelius (cat. no. 7); and the Septimius Severus (cat. no. 9). By comparison, the spontaneity found in numerous portraits of children, both boys (cat. nos. 17, 23, 78, and 172, but especially fig. 10) and girls (cat. no. 79), is tremendously moving; the elegance of some young women and the self-satisfied look of parvenus are finely observed; the weathered faces of old men are so captivating that they claim an essential place in any world history of the portrait, despite their subjects' eternal anonymity. Yet cannot the same be said of Van Eyck's *Man with a Red Turban*, of Antonello da Messina's *Il Condottiere*, of a Dutch master's *Girl with a Dead Bird*, of Titian's *Young Man with a Torn Glove,* and of countless other masterpieces of this artistic genre?

The official portrait sets the fashion for the general appearance of contemporaries, from hairstyle fashions (cat. nos. 50–57) to facial expressions and bearing; it provides us with a certain "Zeitgesicht" so useful in dating a work.[33] Yet one cannot ignore the liveliness and intelligence in certain subjects' eyes or the mischievousness about their mouths. This is the touch of a few marvelous sculptors who ensured this type of work an entirely different place in the history of art, one too frequently overlooked in favor of political or sociological considerations that contribute to a piece's historical interest but are not alone in securing its place in history. For the Roman portrait must be analyzed and understood on many levels. Outside the formal constraints of the "Zeitgesicht," many pieces are brilliantly alive thanks to a glance or expression masterfully captured by the sculptor.[34] As early as 1814, Aloys Hirt, who was Hegel's colleague in Berlin, eloquently expressed this in his book *Über das Bildnis der Alten*. Partially correcting—albeit only for a single, short period that is the second half of the first century B.C.—what his previous article on the "Zeitgesicht" had too rigidly set forth, Paul Zanker insisted on the same point as Hirt in a more recent contribution titled *Individuum und Typus;*[35] in my opinion, this text still does not go quite far enough.

Under these different aspects—Archaic (cat. nos. 154 and 157), Classical (cat. nos. 25, 26, and 184), or Baroque (cat. nos. 82, 86, and 146)—Roman art was open to all social classes and to the empire's local and various religions and cultures, which accentuated its diversity. Roman art represented everything, with consistent attention to every detail of official or private life and of its actors. Witness the range expressed from the great official historical reliefs (cat. nos. 31, 38, 39, 115, 116, and 159a–b) to the scenes from the life of a magistrate found on the sarcophagus of Q. Petronius Melior (cat. no. 42); from a sacrificial scene to the gods of Rome (cat. nos. 38 and 39) to one to Mithra (cat. no. 171); from cult statues to *lararium* effigies (cat. nos. 152, 153, and 156); from intellectual work (cat. no. 127) to agricultural labor (cat. no. 142). It depicted the entertainments of the theater (cat. no. 128a–b), of the amphitheater (cat. nos. 134–36), of the circus (cat. nos. 138–40), of the hunt (cat. no. 141), as well as the pleasures of the banquet (cat. no. 145), of the baths (cat. no. 146), of the toilet (cat. nos. 58 and 59), and of love.

Illusionistic in its representations of a sacrifice (cat. no. 31), of a group of senators and priests standing before a portico (cat. no. 159), or in the way it transposed pictorial space into a mosaic (cat. no. 8), Roman art could be paratactical in its side-by-side arrangement of scenes whose chronological order required particular clarity (cat. no. 76). It employed head-on views in the sacrifice of Mithra (cat. no. 171), a real cult image made to be worshiped by the faithful, in the principal scene of a stele to Saturn (Louvre, MA 1963) and in the representation of a family of dedicants on a stele from Thrace (Louvre, MA 4138). Nor did it shy away from the antithetical positioning of a few symbolic, nearly heraldic figures (cat. no. 40) or the abstraction of busts and signs appearing against a flat, neutral background (cat. nos. 160 and 171).

While the Julio-Claudian relief of a sacrifice (cat. no. 31)—with its spacing and nearly isocephalic alignment of the protagonists of the ceremony—betrays true Hellenized classical formulas and a spatial conception comparable to that of the Ara Pacis, the Mattei relief (cat. no. 38), those of the two-victims sacrifice (cat. no. 39), and the extispicium (cat. no. 159) exhibit their Roman identity through an attention to narrative detail, which characterizes the scenes' various protagonists and the topographic background that immediately places these events in the Urbs itself and identifies the slabs as fragments of large official reliefs ("Staatsreliefs" rather than "historical reliefs"[35]) created for a public edifice.

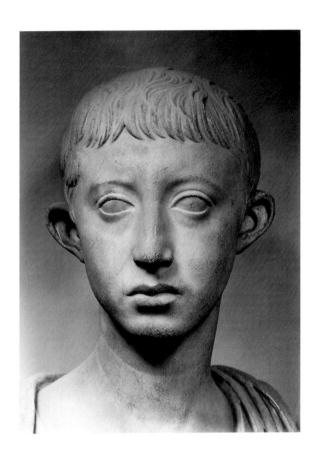

FIG. 10 *HEAD OF A YOUNG BOY*
1st quarter of 1st century A.D.
Marble
Musée du Louvre, Paris (Ma 1140)
Photo: Musée du Louvre–Chuzeville

Transposing these iconographic formulas to the private sphere, a fragment from the lid of the sarcophagus of Q. Petronius Melior (who acceded to the rank of prefect of the Annona in Ostia and was consul suffect toward 245 A.D.) features, with the same principles (topographic background and procession of magistrates and lictors), the key moments of a public career on a private monument. This single example—and there are many others—shows that, in the arts, these two poles of Roman life so frequently held as opposites by law *(res publicae, res privatae)* were not as rigidly separated and impermeable as one might have thought, and that influences are not always one way, proving yet again the plurality of their origins.

Though candelabra, vases, and fountains (cat. nos. 85 and 87–89) are eloquent testimonies to the splendors of the houses and gardens belonging to an elite infatuated with art and culture, every city in the empire provided more modest examples. Objects as simple and popular as oil lamps echo Virgil's *Bucolics* (cat. no. 93), a work children studied with their pedagogues (cat. no. 76), as well as the spectacles of the amphitheater (cat. no. 136). They may also reveal their owner's attraction to certain cults (cat. no. 166). Such situations could be echoed at every level of society.

Roman art is certainly "plural" by its origins and changing patterns of representation; through its variety of styles, many of which are independent of any linear development; and through the very multiplicity of the local artistic substrata upon which it was grafted. From the Iberian peninsula, Gaul, and North Africa to the Near East, around the entire Mediterranean, it imposed the image of the gods, emperors, laws of Rome, and of its army and its lifestyle, while perfectly integrating outside artistic input, along with the people (cat. nos. 49, 146, 147, and 172–74) and cults (cat. nos. 10 and 170) with which it came in contact.

Roman art is also multifaceted in that it touched and profoundly affected every social "class" long before the Edict of Caracalla (212 A.D.) granted citizenship—once exclusively reserved for the free men of the Urbs—to all the inhabitants of this vast empire. Portraits revealed this "access to the person," which Philippe Bruneau used Jean Gagnepain's mediationist theories to describe.[36] Some figures ostensibly asserted their citizenship by wearing a toga (cat. nos. 41–43, 76, and 122) or, for children, a *bulla* (cat.

no. 78); peregrines were draped in their himation; actors in a long tunic with sleeves (cat. no. 128); rhetors and philosophers in a *pallium* (cat. nos. 125–27), while peasants (cat. no. 142), craftsmen (cat. no. 143), and servants (cat. no. 145) wore a short tunic, often rolled up and knotted at the waist for ease of movement as they worked. Yet every one of them was entitled to a portrait.

The Louvre's collections provide the most varied and accurate picture of this universality of Roman art. Without a doubt, *Roman Art from the Louvre* is its faithful reflection.

NOTES

1 Brendel 1953, p. 73; Brendel 1979, p. 136 ("the lack of stylistic unity in Roman art").

2 Rodenwaldt 1940, pp. 12–73 and n. 1; von Blanckenhagen 1942, pp. 310–41 ("Bipolarität"); Bianchi Bandinelli 1960, pp. 276–77; Bianchi Bandinelli 1961, pp. 241–42 ("due strati diversi": "l'uno ufficiale e l'altro popolare"); Kaschnitz-Weinberg 1961, pp. 42–43 ("Die zweifache Wurzel des römischen Kunst"); Kraus 1967, pp. 16 ("zwei Polen": "Klassizismus" and "das Unklassische oder Antiklassische"), 43 and passim.

3 Brendel 1936, pp. 127–44; Brendel 1953, pp. 68–73; Brendel 1979, pp. 122–37; Settis 1982, pp. 159–200. See also Jucker 1968, p. 752: "Für die Kunst des römischen Weltreichs [...] ist die Mehrschichtigkeit charakteristisch."

4 Paris 1963.

5 Bianchi Bandinelli 1970, p. IX.

6 Ibid., p. 377.

7 Ibid., p. IX.

8 Ibid., p. X.

9 For an overview of the various critical positions, see Stilp 2001.

10 Brendel 1936, p. 129; Brendel 1953, p. 72–73; Brendel 1979, p. 133.

11 Von Blanckenhagen 1942, p. 317.

12 Brendel 1953, p. 73; Id. 1979, p. 136.

13 For a discussion of this subject, see Pape 1975.

14 Cicero, Verr., I, 14; Har. resp. 33.

15 Cicero, Verr., II, 1, 55; de lege agr., II, 61.

16 Wünsche 1972, pp. 45–80.

17 Zanker 1974, n. 28–29, pp. 30–33, pl. 33.2-3, 34.1-4 and 36.1, 4, 7 (Idolino and Benevento Youth); Fuchs 1999, pp. 23–28, pl. 24–25 (Piombino Apollo); Balty 2000, pp. 69–71 (Centocelle Eros).

18 Yourcenar 1951, p. 137.

19 Landwehr 1998, pp. 139–94.

20 Hölscher 1987, pp. 38–41, pl. 13–14; Hölscher 2004, pp. 59–65, pl. 34–38.

21 See Borda 1953.

22 Most recently, Fuchs 1999, pp. 59–64, pl. 46.2-47.

23 Zanker 1974, no. 26 pp. 28–30, pl. 30-31.1 and 3; Schröder 2004, no. 181 pp. 371–79 and fig.

24 Marx 1968, p. 42: "The difficulty does not lie in understanding that Greek art and the epic are connected to certain forms of social development, but that they still provide us with an aesthetic pleasure and that, in many regards, they represent in our eyes a norm, or even an inaccessible model." Previously cited in Bianchi Bandinelli 1961, p. 18 and n. 14.

25 Bianchi Bandinelli 1953, pp. 132–33; Id. 1961, p. 424.

26 Weitzmann 1971, pp. 126–223 (particularly, pp. 176–223).

27 Matzulewitsch 1929.

28 See Zanker 1976.

29 Polybus, VI, 53 and 54, 1–4.

30 For a discussion of these different aspects of the portrait during the Republican era, see Balty 1982; Balty 1993, pp. 7–11, pl. 1–7.

31 Wickhoff 1900, pp. 59–60.

32 Charbonneaux 1961, p. 34; Bianchi Bandinelli 1973, p. 244.

33 For this concept, see Zanker 1982.

34 Zanker 1997.

35 The term "historical relief" was long used because the relief was seen as a faithful, practically photographic representation of actual events, in their precise topographic context. I prefer the term "official relief" (in German "Staatsrelief," see Oppermann 1985, p. 7), given that many scenes are, in fact, entirely symbolic. See also Torelli 1982, pp. 1–2.

36 Bruneau 1982, pp. 77–78.

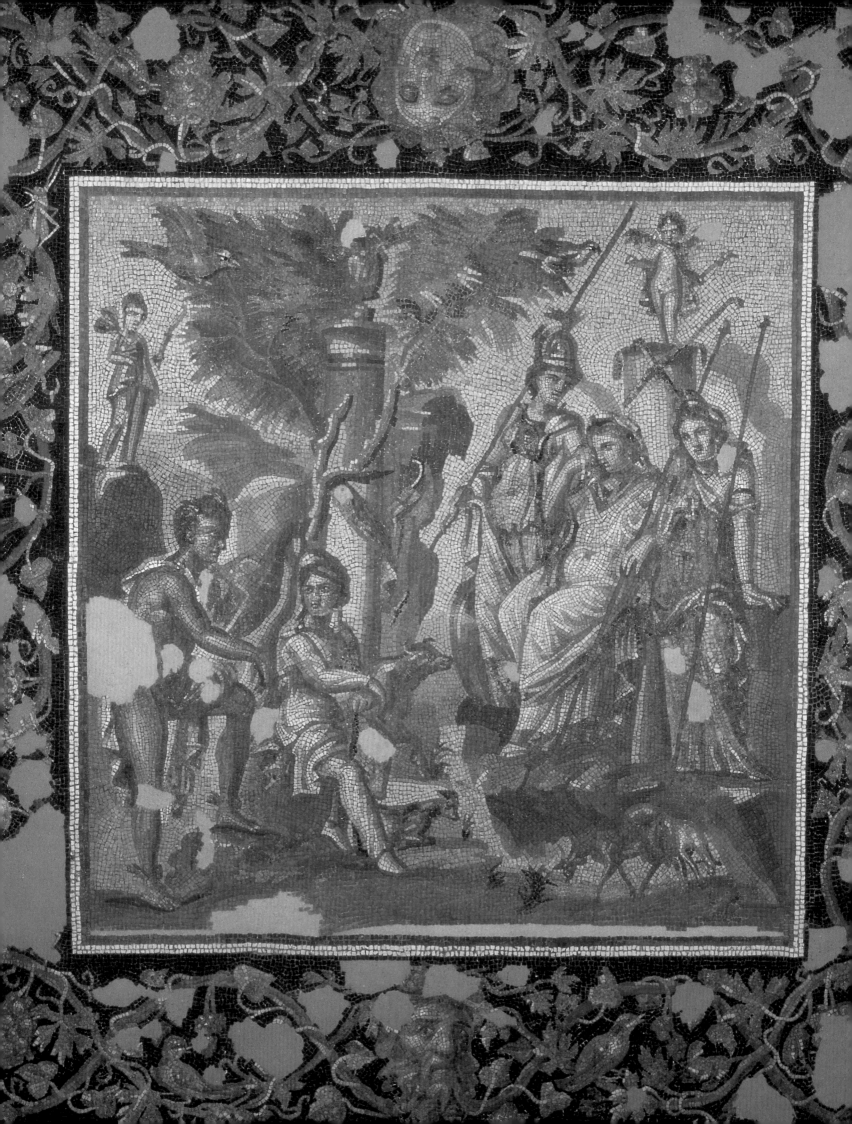

Building the Roman Art Collection at the Louvre **Cécile Giroire and Daniel Roger** More than two hundred years old and originally composed of collections that largely came before it, the Louvre Museum is home to works that each have their own history. In this regard, there may never be an exhaustive chronicle of the museum's collection, so great is the variety of works acquired by the museum. Having arrived at the Louvre with extensive provenances, the works continued to have their destinies shaped by political regimes, museum reforms, and the creation and dissolution of museum departments.

The works' complex histories are reflected in the range of identifying numbers they have received throughout the centuries, as generations of curators sought to catalogue, classify, and find them. The Department of Greek, Etruscan, and Roman Antiquities uses eight different registration books, spanning from the era of Louis XVIII to the present Fifth Republic, with their own codes. Furthermore, each major collection that entered the Louvre was then assigned a separate code, sometimes considered the registration code. Soon, the size of the collection and the swings of history made open inventories necessary, with new numbers for every object. Since 1896, a continuing number system and code assigned to the type of object—for example, MA for marbles and BJ for jewels *(bijoux)*—has given way to more coherent and regular cataloguing.

The Royal Collections During the Italian Renaissance of the fourteenth and fifteenth centuries, work from antiquity began to be perceived as art, capable of evoking emotion and admiration. Objects connoting prestige, power, and even political commitment—such as statues, reliefs, cameos, and other precious items—were sought after and copied. The Italian princes established the first private collections, reflecting their tastes and ambitions. The passion for ancient Roman artifacts soon spread to France, where the first collections were formed in the south.

By the early sixteenth century, the business of antiquities involved all of Europe, and the French aristocracy and wealthy bourgeoisie were able to take advantage of France's proximity to Italy and existing excavation sites. As feudalism weakened and the central State strengthened, the French kings, hoping to be the first collectors of their time, sought antique marbles, jewels, semiprecious stones—probably like the Jupiter cameo (cat. no. 151)—and finely worked silver. King Francis I sent the artist Francesco Primaticcio (known in France as Le Primatice) to Rome in 1540 and 1545 to find works for his residence in Fontainebleau. The artist returned with statues and casts from which to make bronze replicas.

French kings acquired objects from various sources: in 1556, Pope Paul IV, seeking reconciliation with King Henri II, gave him the Diana (fig. 1), which then decorated the queen's garden in Fontainebleau. In 1684, thirty years after the Venus of Arles (fig. 2) was discovered in the Roman theater, the city council of Arles gave it to Louis XIV. In 1685, Louis XIV purchased the Germanicus (fig. 3) from Prince Savello; it had been standing in Rome's Villa Montalto since at least 1649. French kings also bought large portions or all of certain collections: in 1665, that included part of the collection of Cardinal Mazarin, who had died four years earlier.

Acquiring antiquities was a complex and costly process. Ministers in Italy involved a large and expensive network of intermediaries, dealers, agents, name-lenders, and diplomats. In Rome, one had to pay heavy taxes and receive permission from the pope to organize the convoys. Objects were shipped slowly, by sea, river, and ground. Those damaged or not previously restored by Italian sculptors were repaired upon arrival, sometimes worked on by great artists like François Girardon.

Among the many works amassed by Louis XIV was a shipment, in 1679, of 303 crates sent from Rome to Versailles. In 1684, another 48 statues, 36 busts, and 13 vases arrived. Among these works, many were copies or imitations (and sometimes reinterpretations) of works from antiquity. Several casts were made in Rome and then imported to inspire French artists. It was Louis XIV's goal to decorate the new palace at Versailles and its gardens. This would be the destiny of the Togatus, discovered in Langres in 1660 or 1668 and offered by the city in 1684 (cat. no. 11).

The Revolution and the Napoleonic Era From Louis XV onward, the monarchy had little interest in acquiring antiquities, preferring contemporary work instead. Then, the revolutionaries expanded public collections. On November 2, 1789, the Constituent Assembly returned all the ecclesiastic possessions to the nation of France, including the treasure-house of the Royal Basilica of Saint-Denis, with its objects from antiquity (fig. 4). The Constitution of 1791, which forbade the king to make use of the possessions of the monarchy, transformed them into a national collection. The decree of April 8, 1792, confiscated the property of noble families who escaped the Revolution by fleeing abroad. All this led to the idea of a public collection displayed for the people.

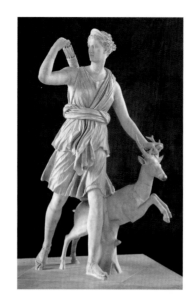

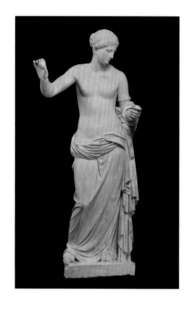

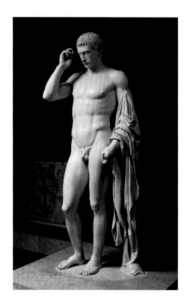

FIG. 1 *DIANA OF VERSAILLES*
2nd century
Marble
Musée du Louvre, Paris (Ma 589)
Photo: Erich Lessing / Art Resource, NY

FIG. 2 *VENUS OF ARLES*
End of 1st century
Marble
Musée du Louvre, Paris (Ma 439)
Photo: Musée du Louvre–Daniel Lebée
and Carine De Ambrosis

FIG. 3 *MARCELLUS AS HERMES PSYCHOPOMPOS*
Ca. 20 B.C.
Marble
Musée du Louvre, Paris (Ma 1207)
Photo: Réunion des Musées Nationaux / Art Resource, NY— Hervé Lewandowski

FIG. 4 *BATHTUB*
2nd century
Porphyry
Musée du Louvre, Paris (Ma 3388)
Photo: Réunion des Musées Nationaux / Art Resource, NY— Hervé Lewandowski

On September 16, 1792, the legislative Assembly decided to house the nation's treasures of art under one roof. On August 10, 1793, the Central Museum of Art opened within the Louvre palace. Starting in 1794, collections were seized from conquered countries through revolutionary wars and brought to France (such as cat. no. 143). In 1796, during Napoleon Bonaparte's Italy campaign, he seized work from every city, despite protests from many French artists and scholars, who argued that art should not be treated as the spoils of war or commercialized. With the 1797 Treaty of Tolentino, the pope had to officially acknowledge the seizure of his works of art.

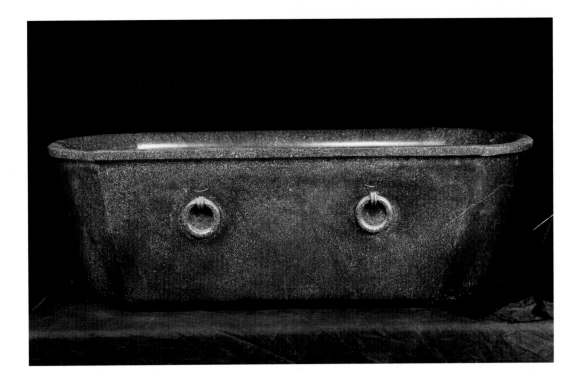

The most famous objects of the collection (fig. 5) entered the Louvre during a victory parade in July 1798. In 1798, Bonaparte seized the collections of the Braschis and Albanis (cat. nos. 24, 27, 28, 29, and 157). Lengthy negotiations preceded the departure of the crates, in 1802, to Marseille. A sizable trove began to enter the Louvre in 1808, when Napoleon—exploiting the financial difficulties of the Borghese family—paid thirteen million francs to his brother-in-law Camillo Borghese (fig. 6) for hundreds of works. Included in the purchase were the busts from the site of Acqua Traversa (cat. no. 7), monuments discovered on the site of ancient Gabii (cat. nos. 19, 34, 37, and 124), architectural reliefs (cat. nos. 31, 39, 40, and 159), and funerary objects (cat. nos. 127, 140, and 181). All in all, three hundred and fifty crates arrived at the Louvre from 1808 to 1811.

When the empire fell in 1815, restitutions were made through specific negotiations with the countries that had been affected by the seizures; however, France did not relinquish all works. Particular negotiations, like the sale to Louis XVIII of a portion of the Albani collection, or the exchange of antiquities for modern works, explain why. Thus, Antonio Canova, appointed by the Pope to recover work taken from the Vatican, allowed the portrait of *Augustus Wearing a Toga* discovered in Velletri (cat. no. 14) to be traded for the *Colossal Portrait of Napoleon*, which Canova himself had sculpted between 1802 and 1811.

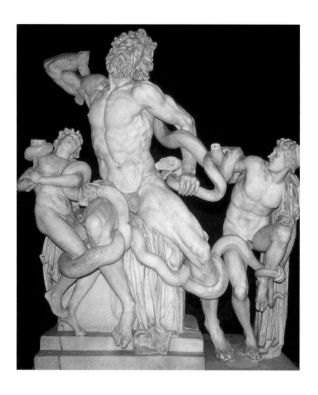

The Durand Collection Among the most notable major French private collections of the early nineteenth century is that of the Chevalier Durand. Edme-Antoine Durand (1768–1835) was the son of a wealthy businessman from Burgundy. A businessman himself and a great art enthusiast, he established several collections of paintings, engravings and prints, coins, gems, and antiquities The latter in particular were acquired during several trips, notably to southern Italy—where he found objects from necropolises and shrines. He also visited the auction houses in France. After the death of Empress Josephine in 1814, he was able to acquire the collection of antiquities she had amassed at Malmaison.

In 1824, Durand offered his collection to King Charles X, and the sale was finalized the following year. Several thousand objects thus arrived at the Louvre, including many bronzes (fig. 7), vases, lamps, and jewels. The Durand

FIG. 5 *LAOCOON*
1st century B.C.
Vatican Museums, Vatican State
Photo: Scala / Art Resource, NY

FIG. 6 *BORGHESE GLADIATOR*
Ca. 100 B.C.
Marble
Musée du Louvre, Paris (Ma 527)
Photo: Musée du Louvre–P. Lebaube

FIG. 7 *HERAKLES OF HERCULANEUM*
1st half of 1st century
Bronze
Musée du Louvre, Paris (Br 32)
Photo: Musée du Louvre–Chuzeville

pieces greatly bolstered what had been small collections. The bronzes and Etruscan vases were exhibited for public viewing as early as 1827 in the southern galleries of the Cour Carrée, which formed the new "Musée Charles X."

There are fifteen works from the Durand collection in this exhibition, including two masterpieces, the Diptych of Muses in ivory (cat. no. 126) and the Bronze Lamp from Herculaneum (cat. no. 90). The remaining objects include jewels (cat. nos. 60, 66, and 70), as well as statuettes (cat. nos. 32, 118, 134, 156, and 161), common pieces (cat. nos. 97, 110, and 177), and decorative pieces (cat. nos. 132 and 138), the majority of which are bronzes.

The Campana Collection In 1861, the French government acquired a portion of the famed collection of Marquis Campana. In 1863, some of its antiquities were installed in the galleries on the second floor of the south wing of the Cour Carrée—similar to the galleries of the Musée Charles X inaugurated some three years before. The acquisition profoundly altered the configuration of what was then the Louvre's Department of Antiques and Modern Sculpture. It also greatly enriched the Louvre's Roman collections, especially those of jewels, figurines (cat. no. 131), lamps (cat. nos. 92–94 and 136), and terracotta architectural reliefs. This famous Italian collection begun by the direct ascendants of the nobleman Giovanni Pietro Campana (1808–1880) initially consisted exclusively of objects from antiquity. Later, the collection was expanded to include modern Italian painting (now the Collection of the Primitives at the Musée du Petit Palais in Avignon), becoming one of

Europe's largest and most renowned and varied collections of nineteenth-century art.

The antiquities collection is distinguished by its impressive size (its pieces number in the thousands) and provenance (fig. 8). Campana was a passionate collector and antiquarian, as well as the director of the Rome's Monte di Pietà, which operated as a loan and savings bank; in the tradition of his family, he also distinguished himself as an archeologist. Beginning in 1831, he carried out his own excavations in Rome and Etruria, and it is these excavations that yielded much of the core of the collection. Campana was also very active in the Italian art market—specifically in connection with traders in Chiusi, Viterbe, Rome, and Naples—and through his purchases, together with his excavations, he managed to build a remarkable, though heterogeneous, collection.

Among the antiquities, the more prestigious works were set off to be displayed, while the humbler pieces were devoted to trade, the museological consequence of this being that they fell prey to the age-old tradition of interfering with antique works. To exalt the grandeur of Rome and make the artworks as impressive as possible, Campana took it upon himself to commission very extensive "restorations," reworkings composed of elements of ancient and modern origins (cat. nos. 22, 41, 48, 149, and 150 for the best examples). At times, these were identical to genuine pastiches. Eventually housed among several Roman properties—including Villa Campana in Laterano, which was transformed in 1846 to accommodate the sculpture collection—Campana's collection was no "ordinary" private collection. Campana was preoccupied with creating a "model museum" devoted to Italian art; he approached it as one would a veritable multi-faceted enterprise, and the commercial results eventually overshadowed his philanthropic aspirations.

Archeological Missions Before legislation was created to protect objects excavated in the Mediterranean region, archeological activity was a key facet in how the Louvre enhanced its Roman collection. For example, in the mid–late nineteenth century, from the reign of Louis-Philippe, as France began settling North Africa—then a little-known part of the Greco-Roman world—scientists, soldiers, diplomats, and scholars conducted explorations and excavations. The objects unearthed were sent to France free of charge (cat. no. 1) or sold to the French government (fig. 10). One piece, a mosaic depicting servants at a banquet (cat. no. 145), was discovered during work carried out by military engineers in

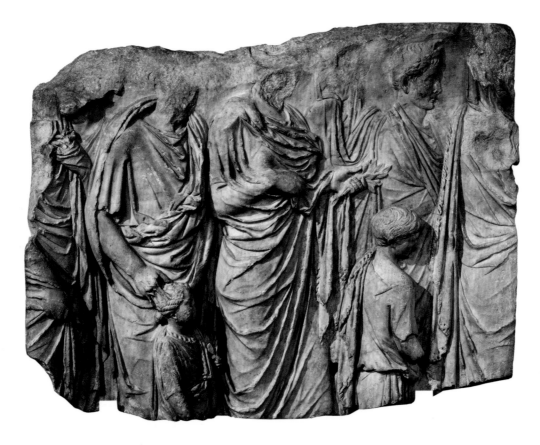

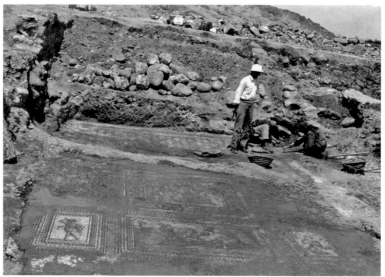

FIG. 8 *FRAGMENT OF THE ARA PACIS*
9 B.C.
Marble
Musée du Louvre, Paris (Ma 1088)
Photo: Musée du Louvre–Chuzeville

FIG. 9 *THE ATRIUM HOUSE TRICLINIUM*
(in situ), 1932
Photo: Department of Art and
Archaeology, Princeton University

FIG. 10 *DIOSCURUS FROM CARTHAGE*
1st quarter of 2nd century
Marble
Musée du Louvre, Paris (Ma 1822)

1875 in the region of Carthage, in Sidi Bou Said, near the home of General Baccouch. First shipped to one of the general's properties in Tunis, the piece was sent to Europe to be exhibited in the Tunisian section of the 1883 World's Fair. It was later purchased by the Louvre, in 1891.

As a result of the French influence in the region (under French mandate since the end of World War I and the dismantling of the Ottoman Empire), France is associated with the archeological excavations of Antioch (fig. 9). In the 1930s, France participated in excavations of Antioch (Antakya, in present-day Turkey) under the direction of the Committee for the Excavation of Antioch and Its Vicinity. The excavating team included representatives from Princeton University, the Musée Nationaux Français, the Baltimore Museum of Art, and the Worcester Museum of Art. In 1936, members of Harvard University's Fogg Art Museum and the Dumbarton Oaks Foundation joined as well. The aim of these excavations was to further understand the topography of a city that had enjoyed such great prestige at the end of antiquity. Among the major discoveries were mosaic ornamental pavements from the second century A.D. to the fall of the city in the early sixth century. As stipulated in negotiations with local authorities, the objects from the excavations were shared with Turkey and the excavating groups. The Louvre's Roman collections were then enriched by a group of ten panels that are essential milestones in the history of the mosaic (cat. no. 8).

The Roman art collection at the Louvre continues to grow. Gifts (cat. no. 35) and purchases (cat. nos. 20, 83, and 146) are considered with regard to the preservation of the heritage of the country of origin. To guarantee against fictitious provenances, the museum only accepts works that are already known.

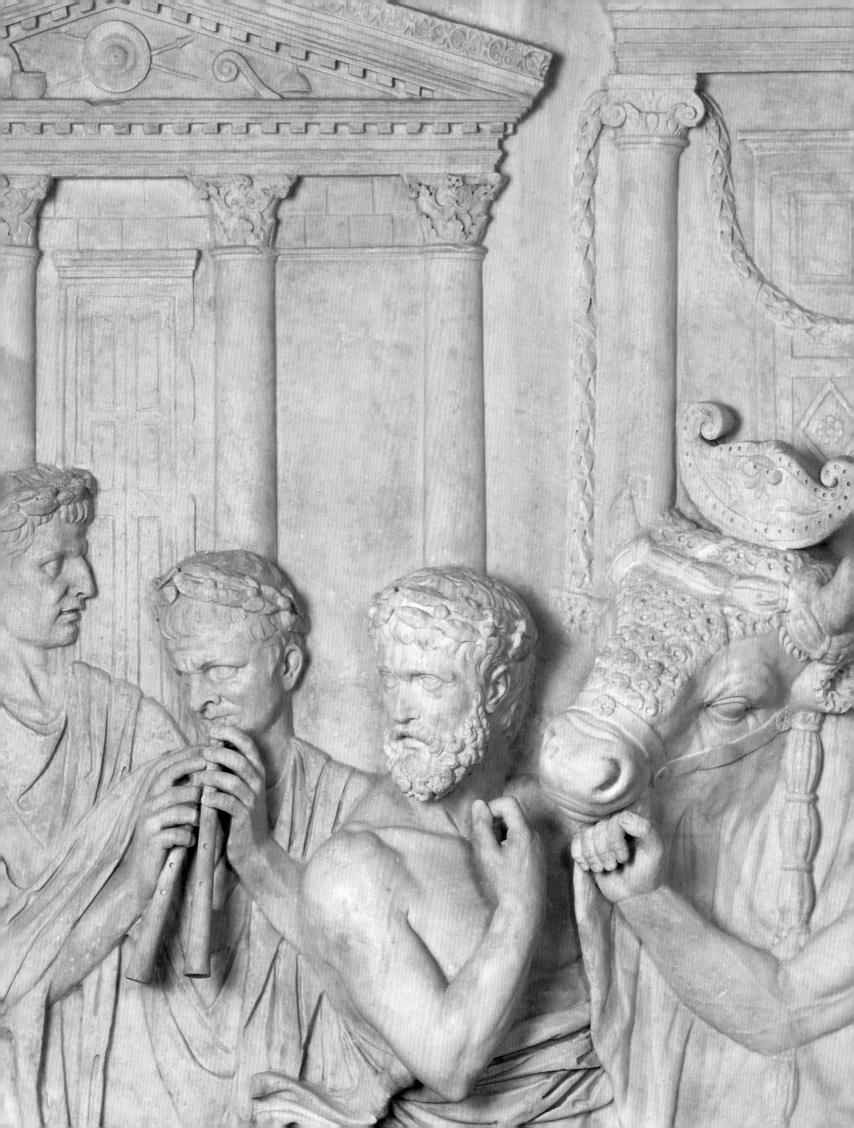

The Restoration Program of the Louvre's Roman Art Collection—The Present and the Past

Ludovic Laugier *Roman Art from the Louvre* has created the opportunity for an exceptionally far-reaching restoration program. In 2004 and 2005 more than 120 pieces of art in a variety of materials were restored, most not for the first time.

The Louvre itself is more than two hundred years old, with collections made up, in part, of objects recovered by archeological missions and, in large measure, of objects acquired through the purchase of prior French and Italian collections. In many cases, a work's modern life in a collection may therefore be nearly as long as its ancient life, and the second stage of its existence may have included several restorations. But from the Renaissance to the present day and from one century to the next, restoration has been shaped by different aspirations, tastes, and methods.

The history of antiquity restoration in the modern era directly concerns many of the pieces in this exhibition and has determined the methods selected by the scientific personnel and restorers at work on this project. In fact, the latest restorations have considerably enriched our knowledge of antiquities, including the Roman historical reliefs, the Campana collection statues, and the Herculaneum paintings. While restoring a work that was previously subjected to successive modern additions, restorers were able to uncover its original surface. At the same time, they assessed the extent of earlier restorations, the condition of the original piece, and the techniques used to make it. In turn, these findings allowed for a better evaluation of the object's style and date.

Beginning in Italy in the fifteenth century, the restoration of antiquities has reflected the Moderns' shifting relationship with testimony left by the Ancients. Changing attitudes have been expressed by changes in how works are handled. Modern additions have ranged over many techniques and styles, or have even been categorically rejected.[1]

During the early Renaissance, when the first great collections of classical antiquities were being assembled in Florence, Rome, and Northern Italy, collectors and artists found themselves faced with a crucial question: What should we do with the fragmentary relics of Greco-Roman civilization? At the time, antiquities were seen as precious vestiges and material illustrations of a glorious history and culture that was largely grasped through the assiduously read Greek and Roman literature. Many of these messengers from the past were anthropomorphic statues—naked, mutilated bodies that viewers empathized with the way they might with grievously wounded war veterans.

These pieces also served as models. Artists could imitate—or even attempt to compete with—antiquities in order to create new, idealized forms, such as those advocated by artists like Alberti or Vasari. Therefore, Renaissance artists and collectors felt it necessary to repair the damage of time.

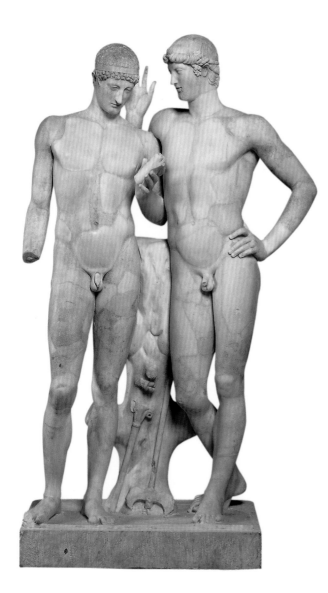

They restored statues to their physical and narrative integrity (after often being neglected during the early Middle Ages) by putting loose elements back in place and, especially, by fashioning modern additions. Thus restored, the deities and great men of antiquity reclaimed their symbolic power, and their restoration gave Renaissance artists the opportunity to compete on an equal footing with the masters of the past.

With a touch of patriotism, Florentine artist and chronicler Vasari claimed that the first restorations took place in his great city in the fifteenth century, when Donatello restored a Flayed Marsyas for Cosimo the Elder (Cosimo de Medici) and Verrochio restored one for Lorenzo de Medici. Many Italian sculptors soon followed suit, from modest *scarpellini* (stone carvers) to more renowned artists such as Venice's T. Lombardo or Rome's Guglielmo Della Porta, who started a dynasty of sculptor-restorers that remained highly active throughout the sixteenth century. Giovanni Della Porta was celebrated for his restoration of the Farnese Hercules's legs: the legs he sculpted were so widely appreciated that they were kept in place even after the statue's original legs were discovered. The Della Porta studio reached impressive heights of technical mastery and audacity with the *tasseli* technique (small modern marble pieces) used to replace the numerous lacunae of the Orestes and Pylades group (fig. 1), as well as with the reassembly of the statuette of Bacchus and Silenus (cat. no. 82). Around the same period, B. Cellini boasted that he could challenge the masters of antiquity by completing damaged statues. In his autobiography, he claimed that a torso of Apollo, in tears, had begged him, the Master, to turn his attention to it, and that he had responded by making it into a Ganymede.[2] The torso's alleged aspirations aside, restoring antiquities by adding marble components always led to the loss of some original elements: breaks in the stone needed to be smoothed for modern complements to be attached, and ancient components that could no longer be completed were simply eliminated (cat. no. 31). Though rarely mentioned, less destructive methods—such as making complements out of stucco or clay—were already in use at this time. The Laocoon in the Belvedere, for instance, was briefly outfitted with a right arm made of clay by G. Montorsoli.[3] Michelangelo Buonarroti, who did occasionally restore works of art, proved something of an exception to the prevailing trend when he refused to restore the Belvedere Torso. Indeed, he was so fascinated with

FIG. 1 *ORESTES AND PYLADES*
1st half of 1st century
Marble
Musée du Louvre, Paris (Ma 81)
Photo: Musée du Louvre—Daniel Lebée
and Carine De Ambrosis

the perfection of this fragment of ancient sculpture that it largely inspired his own use of the *non finito*.

In the seventeenth century, the Borghese, Ludovisi, and Barberini families still hired the greatest baroque sculptors of the day to restore the marble statues accumulating in their Roman villas and palaces.[4] Baroque artists such as Bernini, Cordier, Algardi, and Dusquenoy approached this restoration work with an unquestionable reverence for the ancient model and an irrepressible desire to compete with the masters. They could adapt their styles to the lacunar statue, as can be seen in the arm of the Borghese Gladiator attributed to Cordier,[5] or make strikingly modern contributions. In the case of the Borghese Moor, for instance, the same Cordier turned an ancient alabaster torso into a fashionably picturesque piece by adorning it with many colored stones (fig. 2). Bernini installed the same collection's Hermaphrodite, now owned by the Louvre, on a cushion that bore no relation to antiquity at all.

Professional art restorers such as L. Agostini, B. Mari, and H. and O. Boselli became increasingly more numerous, particularly in Rome, and more discreet in their methods than the baroque masters (cat. nos. 23 and 159).[6] Orfeo Boselli's treatise on antiquities, *Osservazioni della Scoltura Antica* (Observations on Ancient Sculpture), written around 1664–67, came bound with a restoration manual and set forth the techniques of a profession rich with promise. It described how to attach modern additions with dowels or metal clasps, to fill in the joints between modern additions and original components, and to prepare a patina that could be applied to the entire statue in order to match up its various types of marble.[7]

The coming of the Age of Enlightenment and neoclassicism found restorers of antiquities attempting to meet new demands. Restorers were now expected to consult with specialists studying the history of the art of antiquity. In Rome, patronage from the Princes of the Church encouraged restorers to mix with art historians. From the 1750s to the 1770s, the era's most eminent collector, Cardinal Alessandro Albani, surrounded himself with a circle combining artists and the erudite. Most prominent in this circle were the painter R. A. Mengs, the sculptor B. Cavaceppi, and the German scholar J.-J. Winckelmann, who jointly espoused a new approach to restoration set forth in the introduction to Cavaceppi's *Raccolta d'antiche Statue*, published between 1768 and 1772.[8]

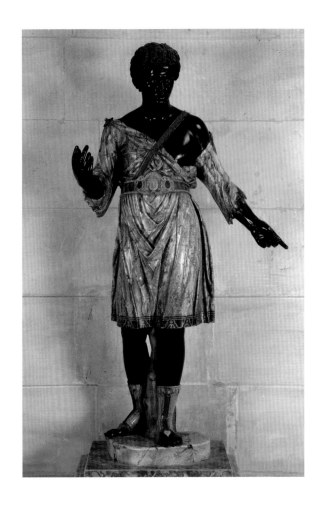

FIG. 2 *BORGHESE MOOR* (antique torso restored by Nicolas Cordier at the beginning of the 17th century)
Châteaux de Versailles et de Trianon, Versailles (MV 8411)
Photo: Réunion des Musées Nationaux / Art Resource, NY—Daniel Arnaudet and Gérard Blot

Cavaceppi and his colleagues held that the most beautiful fragmentary antiquities should not be restored, that modern additions to a restored statue should not exceed a third of the entire piece, and that restorers were to conform to the subject originally represented, working in consultation with scholars if necessary. When identifying a statue's exact subject proved impossible, the restorer was to perform an easily modifiable generic restoration while waiting for new archeological finds to allow for the restitution of appropriate attributes. The style of modern additions was to match that of the original fragment, in keeping with the spirit of emulation inherent in the emerging neoclassicism.

Yet the period's mercantilist, commercial ethos encouraged Cavaceppi and the many assistants employed in his workshop (fig. 3) to stray from the same principles he espoused in his writing. In actuality, no statuary fragment left the workshop untouched; marble pieces were given extensive additions (cat. no. 25); statues were frequently reconstructed from a variety of antique models; and the sales catalogue indiscriminately mixed pastiches and fakes with originals. When the finds at Herculaneum prompted a new interest in Roman frescoes, Mengs and his followers observed the same principles, and often accepted the same compromises when they restored such works (cat. nos. 80 and 158).[9]

By the end of the century, Cavaceppi and an entire school of sculptor-restorers were accepting countless commissions both from individuals and pontifical museums. Between 1770 and 1790, V. Pacetti, C. Albacini, A. Penna, and G. Pierantoni worked under the direction of antiquarian G. B. Visconti at the Vatican's new museum, the Pio Clementino. From 1780 to 1784, the same group worked with Visconti's son, E. Q. Visconti, to prepare the new display of the Borghese collection.[10] Certain antiquities, such as the Borghese Praying Woman,[11] were re-restored in order to correct initial sixteenth- and seventeenth-century restoration efforts, while new acquisitions were restored according to neoclassical principles (cat. nos. 15, 19, and 34). The Statue of Polymnia restored by A. Penna (cat. no. 184) is representative of the late-eighteenth-century method in that it combined the original ancient legs with a modern torso and head; both modern additions closely followed the initial style and iconography associated with the muses found on Roman sarcophaguses.

Penna's work on the statue elicited much enthusiasm from his contemporaries. Yet while these restorations—

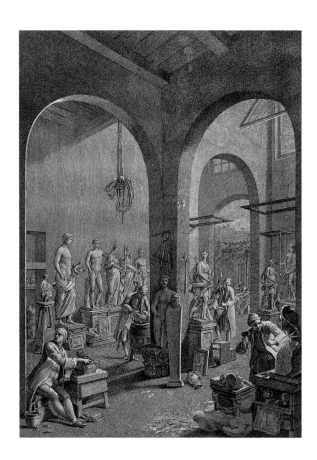

FIG. 3 *BARTOLOMEO CAVACEPPI*
Frontispiece for *Raccolta d'antiche
statue, busti, bassirilievi ed altre sculture*,
1768–72, vol. 1
Research Library, The Getty Research
Institute, Los Angeles

carried out under the supervision of knowledgeable scholars—appeared to be far less fanciful than earlier efforts, interventionism remained the order of the day. The scholars' science of restoration was still in its infancy.

The nineteenth century was undoubtedly a turning point in the history of antiquities restoration. But while it may be tempting to view the era's developments as a linear evolution, in reality the most diverse (even opposing) practices openly coexisted throughout the century.

At the Chiaramonte Museum established at the Vatican by Pope Pius VII between 1802 and 1808, the curator A. d'Este exhibited several marble statues restored by either Cavaceppi or his apprentice, Pierantoni. In other pieces in the exhibition, restorers G. Paccini and G. P. Fraccini used plaster or stucco to avoid re-cutting the originals in order to attach modern components (a method still used into the early twentieth century). Other pieces in the Chiaramonte's collection were presented in their fragmentary state.

In 1803, the famous sculptor Antonio Canova was appointed Inspector General of Antiquities by Pope Pius VII. He was charged with overseeing the many pontifical acquisitions intended to make up for French seizures of art following the Treaty of Tolentino in 1797 (cat. no. 14). Though he accepted previous restoration principles, Canova was probably instrumental in the changes that began to be felt at the Chiaramonti Museum. He was also at the heart of a heated debate over Lord Elgin's acquisition—and the restoration—of the Parthenon marbles.[12]

When invited, in 1803, to restore the Parthenon marbles, Canova categorically refused, declaring that no one should lay a hand on masterpieces dating back to Phidias and Pericles, masterpieces whose very shortcomings were preferable to any type of addition. The episode took place against a background of pre-romantic enthusiasm for the evocative charm of ruins and fragments. William Hazlitt, a romantic writer of the time, was among the many insisting that these Greek marbles were superior pieces precisely because they were in a fragmentary state. Thus considered, these marble statues supplanted countless restored works, drawing the viewer back to the true antiquity of the Acropolis and ancient Greece.[13] J. Flaxman and H. Fuseli also held the Parthenon marbles to be far superior to the Belvedere Apollo, which was one of the most famous antiquities since its discovery in 1502.[14] Just a half century earlier, the statue, restored by G. Montorsoli, had embodied Winckelmann's ideal of beauty. Hegel, whose writings were redefining the

relationship to the past and history, saw in the Parthenon marbles of the so-called Theseus and Ilissos "a completeness, a more vital autonomy than if the statues had had their faces restored."[15]

Ultimately the statues' pediments, friezes, and metopes were displayed at the British Museum unrestored. As the modern concept of a museum developed, this more archeological approach began to take precedence over the science of decorum that had developed out of the tradition of princely collections, and the cult of authentic vestiges replaced the taste for modern copies. Both trends progressively marginalized the practice of additive restoration. Greek and Roman marbles collected by archeological missions working for museums in London, Berlin, Vienna, and Paris were rarely or only partially added to, most frequently in plaster. Similarly, antiquities appearing on the late-nineteenth-century art market were no longer systematically completed in marble to increase their value (cat. no. 45).

But this new trend did not abolish older practices. Shortly after its arrival in London in 1821, the Venus de Milo was given a few plaster supplements and a marble foot. In fact, the curators probably only stopped at that because the statue's pose was so difficult to reconstruct. King Ludwig of Bavaria hired the Danish sculptor B. Thorvaldsen to restore the pediments from the Temple of Athena Aphaia on Aegina, which he had acquired for the Munich Glyptothek. From 1816 to 1818, J. M. Wagner devised a nearly complete reconstruction of the figures—many of which were extremely damaged. Thorvaldsen prepared clay models, and Finelli made the marble prostheses used to add numerous human figures to the tympanum.[16] The Glyptothek restoration was deemed so successful that even artists who had lobbied for the Parthenon marbles to be left untouched, including Canova, had to applaud the results.

One example where particularly interventionist tactics where employed is the Campana collection, an impressive collection of Greek, Etruscan, and Roman terracottas, vases, and jewelry gathered between 1829 and 1857 by the Marquis Campana, whose goal was to create the greatest and most innovative European private museum of his era.[17] Campana's approach to marble statues combined the old tradition of the seventeenth- and eighteenth-century Roman patrician collections with the pedagogical aspirations of his time, in particular the presentation of works using iconographic criteria. Campana therefore aimed to acquire a collection of twelve Caesars or a series of nine Muses such as those visible in any Roman palace. In

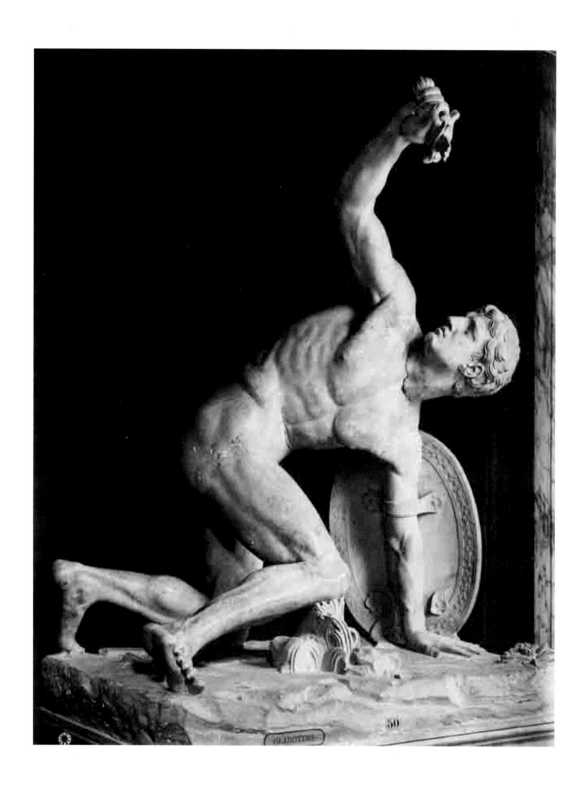

FIG. 4 *WOUNDED GLADIATOR*
Musei Capitolini, Rome
Photo: Alinari / Art Resource, NY

assembling these groupings, Campana sometimes managed to find intact pieces (cat. no. 54), but he did not hesitate to have marble fragments extensively restored (cat. nos. 22 and 30).[18] One of his restorers, the sculptor F. Gnaccarini, invented "*pappa* Gnaccarini," a type of white paste used to cover up the cracks on statues.[19] Along with other nineteenth-century sculptor-restorers such as Tenerani, Rauch, and Tieck, Gnaccarini combined archeological knowledge with an increasing virtuosity to execute astonishingly convincing restorations.

Marble antiquities in princely collections and the first public museums were significantly altered over the course of three centuries. An extreme example is the Belvedere Laocoon, subjected to so many interventions that the exact extent and authors of its multiple restorations are still debated to this day. Bandinelli, Montorsoli, Cornacchini, and Girardon were certainly among those who took part before the original left arm of the priest of Apollo was rediscovered in 1905 and finally reattached in 1959.[20]

At the turn of the twentieth century, the great western museums and most private collections definitively opted for antiquities without modern additions, showing a taste for fragmented pieces and placing emphasis on an artwork's authenticity and aesthetic and historical significance. In parallel, restoration moved toward methods that were increasingly respectful of an antiquity's integrity. In Rome, Cesare Brandi from the Istituto Centrale del Restauro was one of the first to set forth the principles of stability, reversibility, and legibility intended to serve as guidelines for any restoration work.[21]

From the 1920s until the late 1970s, the cult of the original fragment even provoked an unusual reversal. The desire to study and exhibit genuine, unaltered antiquities led curators to adopt a radical new approach of de-restoration. According to the tenets of de-restoration, classical antiquities needed to be stripped of modern prostheses in order to regain their original purity. Indeed many baroque and neoclassical restorations modified the meaning of certain antique statues: for example, P. E. Monnot's restoration of a Discobolos torso from the Capitol turned it into a wounded gladiator collapsing to the ground (fig. 4), which completely altered its initial meaning. In 1924, Guido Galli removed Montorsoli's additions to the Belvedere Apollo. Beginning in the 1930s, vast de-restoration campaigns were organized at the Louvre (cat. nos. 2, 11, 20, 31,

76, and 159) and in Munich, where Thorvaldsen's restorations were removed from the Aegina pediments between 1962 and 1965. More recently, museums in Copenhagen, New York, and Malibu have followed the same trend, to the point that most western museums' storage spaces are now veritable graveyards for the additions once made to Roman and Greek antiquities. But, while de-restoration does occasionally provide a better appreciation of works distorted by their initial restorations, it remains largely illusory: the very nature of the initial restorations frequently makes it impossible to return to its original fragmentary state. Though removing plaster additions can uncover a piece's original break lines, removing marble complements only reveals flattened surfaces frequently dotted with the holes made to attach additions. Some pieces have been returned to their original appearance, while others have been left with mangled faces reminiscent of a World War I field hospital. Today, de-restoration methods are viewed as just as drastic as the restoration methods of the sixteenth to nineteenth centuries, and are no longer tolerated. Still, many are thankful that our predecessors rid us of the most ill-advised additions.

As the era of de-restoration waned, the debate was opened on the best policy for dealing with prior restorations. The question seemed to defy any systematic approach.[22] Meanwhile, the development of the history of taste and of collections as fields of study revived an interest in restored works. As a result, antiquities' modern histories are now more fully taken into account and, since the 1980s, de-restored works have been re-restored at the Louvre, in Copenhagen, and at the Getty Museum in Malibu.[23] The Louvre's Old Fisherman is a Dying Seneca once again. Montorsoli's arms have been restored to the Belvedere Apollo, thus recovering the slender silhouette for which it was famous throughout Europe.[24] The history of antiquities restoration marches on.

For this exhibition, the pieces restored were frequently ones whose modern history needed to be taken into account. With more than one hundred and twenty works of terracotta, bronze, ivory, and marble, as well as paintings, to restore, the Louvre had to assemble a team of more than thirty restorers with specializations covering the range of materials. Each restorer is identified in the catalogue's descriptive notes. The museum also called on the expertise of the mosaic restoration workshops in Saint Romain-en-Gal (cat. no. 145) and Arles (cat. nos. 8 and 81).

The work carried out varied widely in scale. It depended not only on whether a piece was a colossal statue or a small terracotta lamp, but also on whether it had been displayed in the museum's galleries or kept in its storerooms for extended periods. Some works required a simple cleaning; others needed a thorough restoration (cat. nos. 23, 38, 39, 40, 148, 150, and 159). Now recognized as part of a piece's history, modern additions were never removed, with the exception of a few late plaster complements that had replaced missing marble additions and were later badly damaged either through public display or casting work (cat. nos. 40 and 89). On the other hand, the statue of Nero as a child (cat. no. 23) was reunited with the right arm sculpted for its presentation at the Villa Borghese in the first third of the seventeenth century. This modern addition, which had long been kept in the Louvre's storerooms, was reattached with a fiberglass, teflon-insulated dowel fastened with epoxy resin. The modern arm in no way interferes with our understanding of the original work but restores it to the appearance it had in the seventeenth-century prints such as a 1638 print by François Perrier that were responsible for its brief fame.

Modern additions no longer in the correct position or in danger of breaking were taken off and reattached using more stable materials. For instance, the legs added to the statue of Dioscure when it entered the Campana collection were off kilter, and the statue's head, antique but not original, was of defective construction. The statue was dismantled and the head and legs correctly repositioned using epoxy resin bases glued on with the same material. The original iron pins, now far too rusty, were replaced with teflon-insulated brass dowels.

Many processes were employed, depending on the material: mosaics, for instance, were laid out and reassembled on honeycomb panels, and the adhesive of the most fragile tessera was reinforced. Restoration considered the piece's display as well: a fresco with two painted Dionysiac scenes from Herculaneum (cat. no. 158) retains a 1760 display stand composed of wood cases, a slate panel, and plaster. Because it is in such good condition, this stand constitutes an essential example of how Roman frescoes were restored when they were brought from Campana in the eighteenth century. Though the fresco's slate support representing an architectural decoration (cat. no. 80) has also been conserved, that piece's original wood case was replaced in the nineteenth century by a frame that is now in poor condition; the frame has been removed and replaced by a honeycomb panel. Set on mortar, the panel can easily be removed if additional restoration is needed.

The issue of cleaning was tackled case by case. For works that were only lightly soiled, cleaning methods were first tested, and then wax was sometimes removed from the surfaces of these works. Keeping a close eye with an OptiVISOR, the surfaces were then treated with water.[25] Some historical reliefs, sarcophagi, vases, and certain marble statues were particularly dirty, due to the aging of various layers of solutions applied over the centuries and to former casting projects. After a variety of tests, these were cleaned by applying cellulose and water compresses,[26] with the exception of the Mattei sacrifice scene (cat. no. 38) and the Borghese Jupiter (cat. no. 148), which were treated using a microsanding technique.[27]

The Jupiter statue (cat. no. 148), the Bust of Marcus Aurelius (cat. no. 7), and the Bust of a Young Priest (cat. no. 172) were analyzed with binocular magnifiers to identify areas bearing traces of antique polychromy. Areas featuring these precious vestiges of the past were cleaned using a dry process rather than water, then protected for the ages with Paraloid. Joints used to reassemble statues in prior restorations were opened, cleaned (they had often blackened with time), and sampled for analysis,[28] while their surfaces were finished with durable, reversible materials.[29] Finally, they were retouched with watercolor or dry pastel to match the surrounding materials.

Every one of these distinguishable, reversible, and durable restoration procedures was preceded by an exhaustive archival investigation of the work's history, particularly through the study of drawings and photographs that might reveal the work in successive states of restoration. This research allowed restorers to pinpoint questions to be answered during restoration: Do the circumstances of the work's discovery explain its condition? When were additions made? Were there several restorations? Does the list of modern additions to the piece, which informs the study of any antiquity, need to be revised? The systematic documentation by restorers, the cleaning of soiled surfaces to uncover distinctions between ancient and modern marble, the opening of reassembly joints that frequently jutted out, and the observation of ancient and modern surfaces greatly enhanced our knowledge of certain objects. Each restoration was an opportunity to update the map of modern additions to these antiquities, and to make numerous observations regarding what construction and restoration techniques were used.

The study of the Louvre's Roman historical reliefs, nearly all of which are included in the exhibition (cat. nos. 31, 38, 39, 40, 115, 116, and 159), was considerably enriched by the restoration process. The list of restorations carried out on the Haruspicy Relief (cat. no. 159), initially restored on the Capitol in the sixteenth century, then for the eastern facade of the Borghese Villa at the beginning of the seventeenth century, was updated. Surfaces conserving their original outer layer were differentiated from those worked on with a chisel in order to counter marble erosion, a phenomenon that had not previously been noted in the case of the Haruspicy Relief (fig. 5). The sacrifice scene from the Mattei Palace (cat. no. 38) was analyzed in a similar manner. Egidio Moretti's restorations of 1635 were distinguished from a later restoration probably carried out in the late eighteenth or early nineteenth century. It was established that the beard of one of the only two figures to have retained their original heads was a modern addition. The panel therefore no longer features a bearded figure, and the revision of this stylistic clue has modified our understanding of the relief in the context of Roman production. It was also noted that the lower left border of the panel was re-cut out of the material of a figure. Originally astride the figure farthest to the left in the current composition—which bears traces of retouching—this figure was later erased (fig. 6). We have therefore learned that the relief, which is missing its bottom half, used to extend farther to the left and featured an additional figure.

As for "The Praetorians Relief" (fig. 7), there were some doubts regarding the authenticity of the plaque's upper third and of its bas-relief heads, which were thought to be the fruit of a seventeenth-century restoration executed for the Mattei collection. The actual nature of the marble was no longer visible; excessive filling made it impossible to distinguish cracks from modern reassembly joints. But restoration revealed that the upper part of the relief is indeed sculpted from the same material as the rest of the antique panel, whose veining continues on both sides of the crack. This latest discovery greatly boosted the significance of this important piece of military iconography from the imperial period.

By restoring the Campana collection marbles, the Louvre team was able to shed some light on the methods of addition used to restore that famous collection's antiquities. Detailed studies had established that vases and terracotta considered too lacunal were given extensive additions, while jewelry pieces were reassembled in

FIG. 5 *HARUSPICY RELIEF*
(detail of cat. no. 159)

FIG. 6 *HISTORICAL RELIEF, SACRIFICAL SCENE*
(detail of cat. no. 38)

occasionally fanciful ways.[30] But what of the collection's Roman statues? Though Gnaccarini remains the only one of the Marquis Campana's restorers identified as having worked on the collection's statues, our latest restoration project has revealed a great deal about the methods employed. The busts of Augustus (cat. no. 30), Caligula (cat. no. 22), and Plotinus (cat. no. 48) display a renewed mastery of the *tasseli*. Indeed, these little pieces of marble are as numerous and as precisely placed here as they are on the Orestes and Pylades group restored in the sixteenth century (fig. 8). The *tasseli* were pocked with a fine point or a granulating roller to imitate the wear to the antique marble that surrounded them. The statues' modern additions were also decorated with *tasseli*, or with etched lines imitating them, for the sole purpose of making the additions look like partially restored antiquities. The deceptively convincing effect of Gnaccarini's restorations had, of course, been hinted at by his use of "pappa" to mask cracks and reassembly joints, but the methods employed by the team of Campana collection restorers he probably worked with reach a level of subtlety in details that had never previously been achieved.

The Louvre restorers were pleasantly surprised by what the Herculaneum paintings (cat. nos. 80 and 158) held in store. Having been taken down in the eighteenth century, the paintings were likely to be covered with touch-ups. Yet careful examination and a light cleaning using compresses revealed that touch-ups had, in fact, been kept to an absolute minimum. The two Bacchanal scenes (cat. no. 158) boast a remarkably well-conserved antique pictorial layer.

Undertaken with the AFA's support for the present exhibition, this vast restoration program has provided an opportunity to improve the presentation of the Louvre's Roman collections, both for an American audience and its future display in the museum's galleries. It has also helped to increase our knowledge of these Roman antiquities and their modern restoration.

FIG. 7 *"THE PRAETORIANS RELIEF"*
(detail of cat. no. 115)

FIG. 8 *ORESTES AND PYLADES*
(*tasselli* detail)
1st half of 1st century
Marble
Musée du Louvre, Paris (Ma 81)
Photo: Musée du Louvre—Daniel Lebée
and Carine De Ambrosis

NOTES

1 On the history of antiquities restoration, see, most recently, the studies by S. Howard and O. Rossi Pinelli, with a bibliography of earlier sources, in Grossman, Podany, and True 2003, pp. 61–74.

2 Hope and Nova 1983 (first pubished in the mid-16th century), pp. 170–71, no. 368.

3 Laschke 1993.

4 Regarding Bernini and Algardi's restorations for Cardinal Ludovisi, see Rome 1992. Most recently, M. Marvin in Grossman. Podany, and True 2003, pp. 225–38.

5 B. Bourgeois in Grossman, Podany, and True 2003, pp. 149–62.

6 Sparti 1998.

7 Most recently, B. Bourgeois in Grossman, Podany, and True 2003, pp. 149–62.

8 Cavaceppi 1768–72; L. Laugier in Martinez 2004a, pp. 167–73.

9 Burlot 2005.

10 L. Laugier in Martinez 2004a, pp. 119–29.

11 Musée du Louvre, Ma 2228.

12 O. Rossi Pinelli in Grossman, Podany, and True 2003, pp. 123–29.

13 Quoted by Potts 1998, p. 114.

14 Fuseli 1830, pp. 75–79.

15 Quoted by Potts 1998, p. 118.

16 O. Rossi Pinelli in Grossman, Podany, and True 2003, pp. 123–29.

17 Nadalini 1992.

18 The fragmentary torso known as the Actaeon Torso (Louvre Ma 2) was an exception in the galleries of Campana's Lateran villa. See Paris 2005–06, fig. 2.7.

19 Michaelis 1908.

20 Rebaudo 1999.

21 Brandi 1963; the *Bolletino del Istituto central del restauro*, (1950–) deals with these issues.

22 A. Pasquier in Paris 2000b, pp. 57–59.

23 See M. Moltensen in Grossman, Podany, and True 2003, pp. 207–24.

24 Liverani 2003.

25 Providing 10x magnification, or, if necessary, through a binocular magnifier, 30x magnification.

26 Occasionally supplemented with ammonium bicarbonate, pH control during rinsing.

27 In certain cases, microsanding is the only efficient technique, particularly when water treatments are out of the question. One need not disparage this process, so long as granulometry and pressure are carefully selected.

28 Samples of all wax, rosin, or pine resin adhesives from past restorations were sampled for analysis by Nathalie Balcar, a research engineer with the *Centre de Recherche et de Restauration des Musées de France*, in order to provide material for a study on restoration materials of the past.

29 Resins and various extenders, depending on the appearance of the surrounding marble.

30 P. Nadalini, op. cit., on restorations by the brothers P. and E. Pennelli. For jewelry, see F. Gaultier in Paris 2005–06, pp. 39–53.

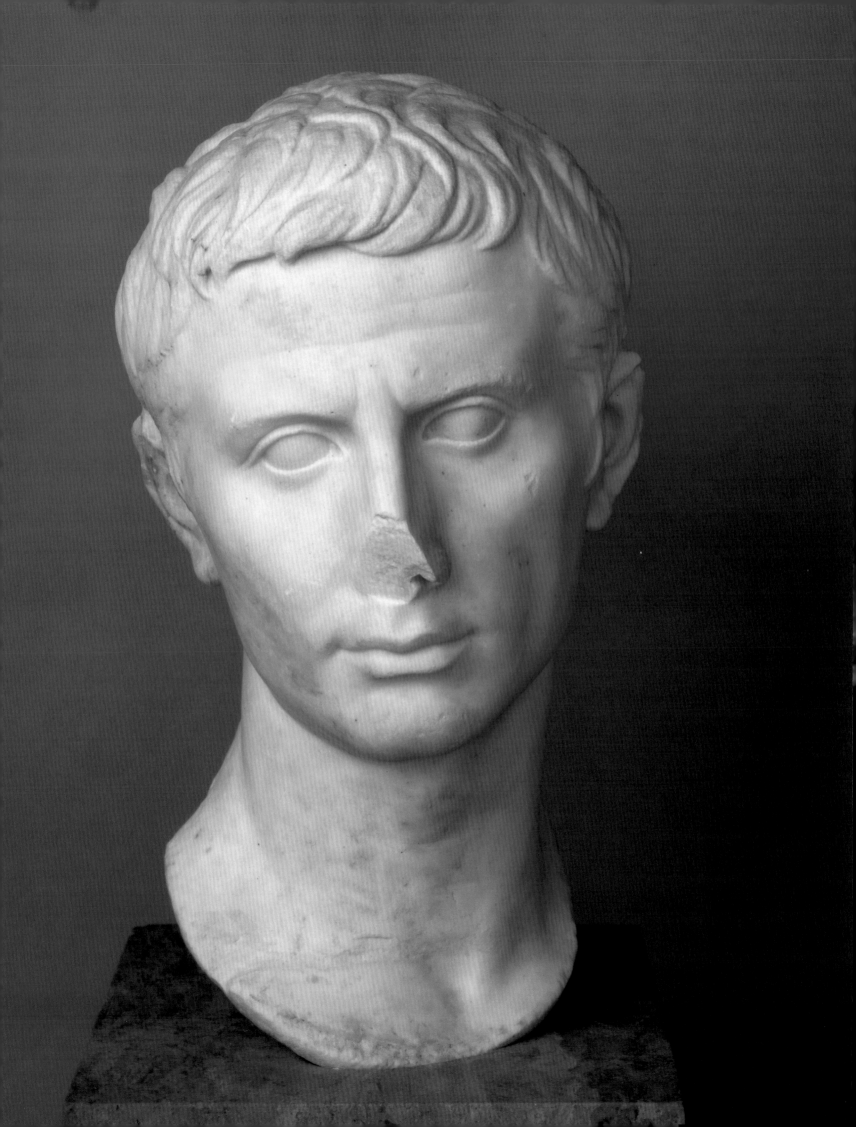

The Emperor Daniel Roger Neither god nor king nor dictator, the man in charge of the empire was not called the emperor in Rome. The title that Augustus (born Caius Octavius) claimed was simply "first senator" *(princeps senatus)*. What we call "empire" was known as *res publica*.

The imperial regime was established gradually. In 27 B.C., Octavius received the title of Augustus, which he would pass on to his successors. The senators granted him the civic crown, which many emperors would wear after him (cat. no. 19), and decided that the curia would be embellished with a gold shield that listed his merits: Virtus, Clementia, Justitia, and Pietas (courage, clemency, justice, and piety). Augustus obtained supreme command *(imperium)* over the provinces of Spain, Gaul, and Syria, where there were the largest legions. He made himself consul, renewing that every year until 23 B.C., at which time he obtained *imperium* over all the provinces and was granted *tribunicia potestas* (powers of the tribunes of the plebs) for life: he was awarded sacrosanctity, the right to call for a vote from the people to subvert laws proposed by the senate, the right to veto decisions made by the Senate, and the right to act directly with regard to any citizen who called upon him. In 12 B.C. he was honored with the title *pontifex maximus*, which was bestowed on him by the senate and which he claimed not to desire. In 28, B.C., and again in 14 A.D., he was invested with the authority of censor, which allowed him to revise the list of the senators. In 2 B.C., he was proclaimed *pater patriae* (father of the fatherland). By the time he died in 14 A.D., the imperial regime had been established.

With the exception of *tribunicia potestas*, which he boldly derived from the office of the tribunes of the plebs, Augustus did not, for the most part, make great institutional innovations. He only retained the option of filling public offices and positions according to his will, assumed various functions, took on all titles inherited from the Republic (especially those from the turbulent civil war period) and associated them closely with himself. While there was not a governing constitution in the modern sense, there was a group of practices accepted by all—especially the idea that a man has preeminence over the State. More than new honors, Augustus claimed *auctoritas*, authority based on merit, victories in battle, genealogy (human and divine), and all the virtues he was acknowledged to have. Throughout the *Res Gestae*, the political autobiography he wrote at the age of seventy-six, he claims his legitimacy, listing his achievements as a citizen and a senator among senators.

In reality, senator and emperor were not equal. As censor, the emperor was able to purge the senate. Furthermore, it was often through imperial favor that a citizen could go from being an equestrian to a senator *(adlectio in amplissimum ordinem)*. In an administration where the

highest positions were difficult to fill, the emperor appointed *homines novi*, new senators, who were both devoted and competent, like Quintus Petronius Melior (cat. no. 42). Finally, the concentration of power given to the *princeps* deflated the *cursus honorum*, a political ladder of sorts, and many sought to take commanding positions in the military or provincial governments, or, by default, modest but substantial positions at the municipal level. Starting in the fourth century A.D., imperial power over the Senate tightened. A hierarchy formed among senators (along the ranks of *clarissimi, clarissimi et spectabiles, clarissimi et illustres, comites*). The administrative missions alternated with court positions and representative functions, the latter of which were often prestigious (cat. no. 13).

Although he refused the crown offered by Antony, Julius Caesar "could never fend off the infamy of aspiring to bear the title of king," according to Suetonius (*Vita Caesaris*, LXXIX, 3). This led to his execution by Brutus and Cassius in March, 44 B.C. For Caesar, there was but one model for the monarchy: that of the Hellenistic βασιλεῖς (kings) who reigned over the Orient after Alexander the Great with great pomp and circumstance. Aware that the Romans hated the monarchy, Augustus would not assume its trappings. Instead he focused on philosophical notions, especially those promoted by Cicero and Sallust, who, in the Platonic tradition, favored a regime that combined democracy, aristocratic oligarchy, and monarchy. Thus, Augustus rejected regal luxury in the Hellenistic style. He did not surround himself with courtiers but instead had friends like Mecenus, Agrippa, and Athenodorus. While his enemies Mark Antony and Sextus Pompeius dared to disguise themselves as Neptune and Dionysus, Augustus refused to receive divine honors in his lifetime. In the domain of the arts, he adopted an Athenian model, defined by measure and restraint, rather than a Hellenistic one, characterized by fieriness and dynamism.

In Egypt, Augustus had Alexander's tomb opened, drawing inspiration from it for his own mausoleum, and founded the city of Nicopolis near Actium, in the manner of the Greek leader. Augustus also followed in the republican tradition in establishing cities in the provinces—no less than ten capitals carried the name of Augustus in Gaul—embellishing these cities, constructing monuments in them, and effectuating major construction was particular to the Hellenistic monarchs. Augustus boasted of building a marble city when he had received only bricks (Suetonius, *Vita Augusti*, XXVIII). He wanted to promote an image of

himself as an invincible general (fig. 1). He presented himself as the savior of Rome and its institutions. The epithet Σωτήρ (savior), used to depict the Ptolemies (or Lagids), would suit him perfectly. He began to forge an ideology of "good" government in the eastern way—with the good emperor defending the fatherland, embellishing it, watching over its citizens, and endowed with virtues that benefit the entire empire (*Felicitas, Hilaritas, Laetitia Temporum, Victoria Aeterna*, as later appeared on coins).

Augustus also benefited from special divine favor—later expressed by the epithet *Felix* (blessed) on the diploma awarded by Elagabalus (cat. no. 117). He was protected by tutelary divinities, likening himself to Apollo and declaring Venus Genitrix the founder of his family, who protected him like the Τύχη (good fortune) of the Hellenistic kings.

The emperors followed in the tradition of Greek rulers by establishing veritable cultural policies: by embellishing public buildings with works of art from the whole empire, by opening libraries next to temples as Augustus did, in the *fora* (public squares) as Trajan did (cat. no. 34), or in the thermal baths as Caracalla did. All culture was Greek: Marcus Aurelius (cat. no. 7) wrote his *Meditations* in Greek. Portraits from the Antonine dynasty, after Hadrian, resemble those of the Greek poets and philosophers and betray an eastern notion of power. Although they didn't behave like tyrants, the emperors built huge palaces, very different from Augustus's home on Palatine hill, luxuriously decorated with copies of Greek and Hellenistic masterpieces (cat. nos. 26–29). A circular floor plan that was symbolically centered on the emperor was already being used for Augustus's mausoleum, and Hadrian borrowed it for his. It was also employed for Nero's Domus aurea (cat. no. 23), for the maritime theater in Tivoli (cat. no. 24), and for the Pantheon. Public architecture escalated toward the colossal, from Caesar's forum to the Basilica of Maxentius, from the baths of Agrippa to those of Diocletian. In the provinces, the eastern model was adopted: in its proportions and oversized decor (cat. no. 1), the basilica in Carthage is reminiscent of the one in Ephesus. In Lepcis Magna, Septimius Severus built a colonnade comparable to the one in Palmyrus in order to connect Hadrian's baths to the port.

Clearly, these major construction plans affected the economy. The emperor influenced the empire's economic prosperity in many ways, both through the spoils of his conquests (by conquering Dacia, Trajan was able to build the largest forum in Rome), and through his control of coin minting (cat. no. 36) and the supply of foodstuffs. Thus,

when Rome was threatened with a food shortage, Augustus organized the *praefectura annonae*, the Roman welfare system responsible for food supply, and Claudius built the port of Ostia, which Trajan then expanded. Using their personal fortune, the emperors distributed additional foodstuffs and money and organized games. Imperial control of the economy reached a peak with Diocletian's Edict on Maximum Prices (301 A.D.), aimed at curbing inflation by fixing the prices of more than a thousand food and industrial products, capping salaries and setting a limit on the cost of

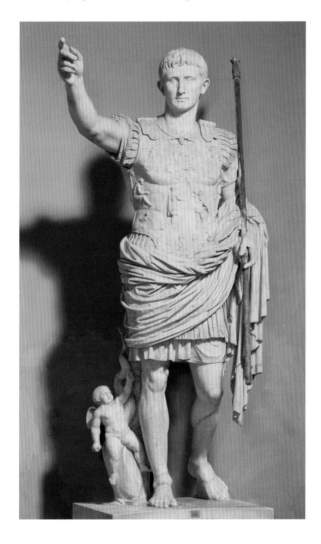

FIG. 1 *AUGUSTUS PRIMA PORTA*
Ca. 20 B.C.
Marble
Braccio Nuovo. Vatican Museums,
Vatican State (inv. 2290)
Photo: Scala / Art Resource, NY

transportation and on honoraria for liberal professions. Similarly, the depreciation that was constant in late antiquity brought about many reforms, such as that instituted by Constantine when he introduced the *solidus* (cat. no. 12).

This management of the empire necessitated the formation of an imperial government, through the development of a court, a council *(consilium principis)*, a chancellery, and offices around the emperor. And with these changes, interventionism grew stronger. The emperor gradually became the unique source of law. He developed imperial legislation, established jurisprudence when writing about legal affairs, and asked the lawyers to codify the laws.

In the end, the institutions of Rome, a city-state turned empire, would model themselves after the great establishments of the Hellenistic kingdoms. The evolution was logical but unwanted by Augustus. What was the bond that united the population of Rome around a leader it could not elect if not a patriarchal and paternalistic link, as illustrated in Augustus's Ara Pacis? In the provinces, how could the missions and methods of Augustus's legates differ from the ones of the Στρατηγοί of the king (military and civil governors in the provinces of Hellenistic kingdoms)? Certainly Rome retained strict control over administrative and judicial offices, as well as a very organized, sizable, and powerful army. But very quickly, emperors had to develop a genuine bureaucracy that would act in their name (cat. no. 117) and resort to official letters (cat. no. 35) and written orders, like the Hellenistic kings. Beyond the mode of government, Romans adapted to the world they conquered. The creation of publican companies and joint-stock businesses allowed Roman *negociatores* to copy, compete with, and replace eastern associations in commercial areas like Delos.

The emperor also controlled religious institutions. He was seen leading processions (cat. no. 31) with his head covered *(capite velato)* as *pontifex maximus* (cat. no. 30). The pontificate was a form of priesthood inherited from the oldest republic: the position of *pontifex maximus* was a lifetime appointment to head a college of fourteen ordinary pontiffs, flamine priests (cat. no. 159), and vestal virgins. As such, he had to settle all disputes and avoid any errors when performing rites. After Augustus, all the emperors exercised these priestly functions, an indication of the importance it held for them. But whereas Augustus based his religious policies on traditional religion and ritual formalism, the "bad" emperors committed the error of likening themselves to a god while alive (Caligula to Jupiter, Nero to Apollo, Commodus to Hercules). The "good" emperor, on the

other hand, only governed because he was the greatest and the best of citizens. Although only a simple mortal, he was nevertheless tied to divine powers (separated from all mysticism), and every Roman was to pay homage to him. Each family was associated with the *genius* of the *pater familias* (father of the family), the individual divinity who protected every birth and life. And even before receiving the title *pater patriae*, Augustus established an official cult to his *genius* (cat. no. 32) and the *lares* of his ancestors, celebrated at family altars.

et Augusti flamine priest. In Lyon, the Federal Sanctuary of the Three Gauls received an altar to the goddess Rome and to the *numen* of Augustus. Often, these official devotions to the first emperor stemmed from spontaneous popular acts (cat. no. 33).

In fact, it was through popular will—and the inspiration drawn from the legendary ascension of Romulus—that a Senate law granted Caesar, and later emperors, the rank of demi-god (apotheosis, *consecratio*). Held at the close of a ceremony around a funeral pyre, funerary honors paid to

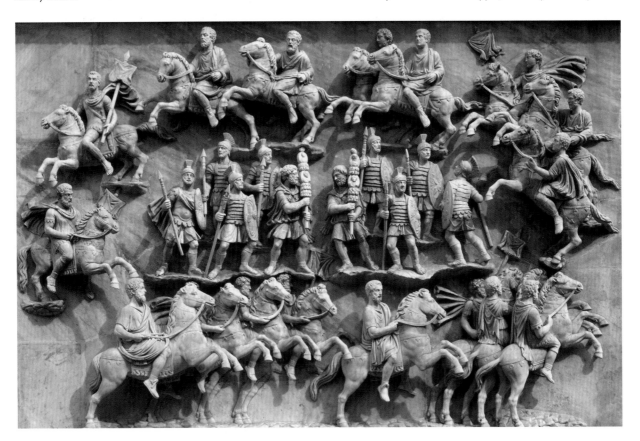

Rituals of social equality, the *compitalia* were occasions for slaves to be the equals of their masters, assuming a disguise for one day. In Rome, these celebrations took place along the border between neighborhoods. But in 67, 66, and 65 B.C., they gave rise to popular unrest and consequently were banned. As *pontifex maximus*, Augustus reinstalled them but had them guarded by *vicomagistri* and associated them with a public cult of his *genius* and *lares Augusti* (cat. no. 161), to which priests of modest social origin throughout the empire were devoted (they were known as the *augustales*). Altars situated at crossroads were built in front of a chapel or niche containing representations of the divinities. Furthermore, Augustus shared a "superhuman power" (*numen*) with the gods. In the provinces a cult was devoted to it, associated with the *genius* of Rome and led by a Romae

FIG. 2 *DETAIL OF RELIEF FROM BASE OF COLUMN OF ANTONINUS PIUS: PARADE OF SOLDIERS (DECURSIO)*
160–161 A.D.
Marble
Cortile delle Corazze, Vatican Museums, Vatican State
Photo: Scala / Art Resource, NY

the dead inspired a religious cult. Thus when Augustus died, Tiberius formed the *sodales Augustales* (cat. no. 42), men in charge of an imperial cult in Rome, as well as the other municipal cities. In Rome, the emperor-god received a temple and its own flamine priest. The imperial figures who had the right to apotheosis could be represented with the attributes of gods or goddesses (cat. no. 15): in 14 A.D., games were offered in honor of the god Augustus *(ludi augustales).*

But the *Apocolocyntosis of the Divine Claudius* (cat. no 21), a satirical pamphlet attributed to Seneca on the occasion of Claudius's death in 54 A.D., shows that the apotheosis of the emperor was soon emptied of all religious content. The book refers to the transformation of Claudius into a pumpkin, and certain emperors, disavowed by the Senate and the people after their death, did not obtain the right to apotheosis, including Tiberius (cat. no. 19), Caligula (cat. no. 22), and Nero (cat. no. 23). In a decision made by the Senate, Nero even had to submit to the *damnatio memoriae* (damnation of memory), as did Domitian, Commodus, Geta, and others after him: their names were hammered off inscriptions and their portraits destroyed or reworked into the image of their successor or a member of their family.

The problem of succession was indeed complex, as evidenced by the difficulties Augustus had finding a future emperor in his immediate or extended family. In 25 B.C., he organized a marriage between Julia—his only child with Scribonia—and his nephew Marcellus (son of his sister Octavia), thus making Marcellus a closer relation, but Marcellus died in 23 B.C., at a time when Augustus himself was seriously ill. Augustus therefore turned to Agrippa (cat. no. 16)—who, while not related through blood, had the necessary qualifications to succeed him—and again offered Julia as a wife.

Augustus's recovery, the birth of his grandsons Caius and Lucius Cesar and then Agrippa Postumus (cat. no. 17), and finally the death of Agrippa in 12 B.C., made it certain that the empire would go to one of Julia's sons. Julia then had to marry Tiberius, the child of Livia's previous marriage, which brought the Julio-Claudian branches closer together. Tiberius became a guardian for the three princes, even though Augustus sent him to the Orient as early as 6 B.C. In Nimes, a temple was built to Caius and Lucius, appointed the Princes of Youth.

But Lucius died in the year 2 A.D., and Caius in 4 A.D.; Augustus therefore had to adopt Tiberius (cat. no. 19) and the young Agrippa Postumus, his last hope to see a direct descendant succeed him. At the same time, Tiberius had to

adopt Germanicus (cat. no. 20), Augustus's great-nephew, Livia's grandson, and the spouse of Aprippina the Elder (cat. no. 18), daughter of Julia and Agrippa. Unfortunately, Agrippa Postumus proved to be dimwitted and was exiled. So as of 14 A.D., only Tiberius was in a position to succeed Augustus. But with the deaths of Germanicus (19 A.D.) and Drusus the Younger (23 A.D.), the child from his marriage with Vipsania, his first wife, Tiberius was left without an heir. It was therefore Caligula (cat. no. 22), the son of the prestigious Germanicus and Agrippina, whom succeeded him in 37 A.D., and after Caligula was assassinated in 41 A.D., it was Claudius (cat. no. 21), the brother of Germanicus and grandson of Tiberius, who the praetorians made emperor. Claudius had a son, Britannicus, from a first marriage to Messalina; when Messalina was killed, Claudius married Agrippina the Younger, who already had a son, Nero (cat. no. 23), from a first marriage. When Britannicus died, the door to the empire was opened to Nero, who became emperor in 54 A.D. The complex relations that united different members of the Julio-Claudian family—by blood, marriage, or adoption—showed that the principate did not depend on clear rules of succession. For a successor to be appointed, it was necessary to tighten the relationship to the reigning emperor as much as possible. Augustus's family nevertheless established the idea that succession was dynastic in nature. Thus, Vespasian would have two consecutive sons, Titus and Domitian as successors. The conspirators who assassinated Domitian had beforehand chosen Nerva, old and reputed for his restraint. From Nerva to Marcus Aurelius (cat. no. 7), the emperors appointed men they believed were qualified to succeed them. However, Marcus Aurelius bequeathed the empire to his son, Commodus. After the civil war of 192 A.D., Septimius Severus (cat. no. 9) revived the idea of a dynasty and left the empire to Geta and Caracalla. From that point on, soldiers would make and defeat emperors and no dynasty would form, even though Constantine, after his victory over Maxence (cat. no. 11) left the empire to his three sons.

The emperors therefore quickly became concerned with associating possible successors with the imperial government. With Marcus Aurelius and Lucius Verus, this notion of involvement evolved into the idea of sharing power. The idea reached its peak under Diocletian, who organized the Tetrarchy: he divided the empire into east and west, giving an Augustus and a Caesar control of each part.

But from the start, the emperor exercised his authority as commander-in-chief (cat. no. 34). Originally awarded

to a commander on the occasion of a Triumph, the title Imperator was soon reserved for emperors alone; and, in their names, epithets for the Imperator (Britannicus, Dacicus, Parthicus, Sarmaticus, Germanicus, Dalmaticus, etc.) are reminders of the populations they conquered. Aside from adoption—which the emperor exercised when he deemed a man worthy of his succession—and blood, the military seemed to be a natural source, not only when an enemy in a civil war was crushed, but in the camps, when the army would agree on appointing a new emperor.

The nature of imperial power was constantly being declared in the headings of official texts. The military diploma of a marine from Misena (cat. no. 117) is written in the name of Emperor Elagabalus:

> Imp(erator) Caes(ar) divi Antonini Magni Pii Aug(usti) fil(ius) divi Severi Pii nepos M. Aurellius Antoninus Pius Felix Aug(ustus) sacerdos amplissimus dei invicti Solis Elagabali, pontif(ex) max(imus) trib(unicia) pot(estate) IIII co(n)s(ul) III design(atus) IIII p(ater) p(atriae) et M. Aurel(lius) Alexander nobilissim(us) Caesar imperi et sacerdo(tis) co(n)s(ul) desig(natus). (Emperor Cesar, son of the Deified and Great Antony Augustus, grandson of the Deified and Dutiful Severus, Marcus Aurelius Antonius Augustus, Dutiful Fortunate, very magnificent priest of the unvanquished Sun god Elagabalus, chief priest of the State, holder of the tribunician power four times, thrice consul, consul appointed for the fourth time, Father of the Fatherland, and Marcus Aurelius Alexander, very noble Cesar of the Empire and of the priest [of the Sun god], appointed consul.)

This imperial title shows that in 221 A.D., the titles, responsibilities, functions, and merits held by Augustus were still the foundation of imperial power. The same was true in the Greek part of the empire, where, in 138 A.D., Hadrian sent an official letter to the inhabitants of the city of Naryka (cat. no. 35):

> Αὐτοκράτωρ Καῖσαρ, θεοῦ Τραϊανοῦ, παρθικοῦ υἱός, θεοῦ Νέρουα υἱωνός, Τραϊανὸς Ἀδριανὸς Σεβαστὸς ἀρχιερεὺς μέγιστος, Δημαρχικῆς ἐξουσίας τὸ κβ΄, αὐτοκράτωρ τὸ β΄, ὕπατος τὸ γ΄, πατὴρ πατρίδος (Emperor Cesar, son of the deified Trajan, victor over the Parthians, grandson of the deified Nerva, Trajan Hadrian Augustus, chief priest of the State, holder of the tribunician power twenty-eight times, twice imperator, thrice consul, Father of the Fatherland.)

1 Portrait of Lucilla

2nd half of 2nd century A.D. ▪ Discovered in
Carthage (Tunisia), on the hill of Byrsa, 1845 ▪
Grey veined marble ▪ H. 63 in. (160 cm) ▪
Delaporte gift, 1853 (MA 1171—INV. N 1482) ▪
Restorer: C. Knecht, 2006

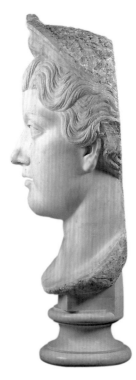

This colossal marble head is not complete. At some point, as early
as when it was fabricated, a vertical cut stripped away the back of
the head and the nape of the neck. The resulting flat surface on the
back consists of two slightly staggered planes, such as those that
might have been roughly cut with a saw in the quarry. Judging from
the coarse markings of the coiffure behind the diadem, that part of
the head was not meant to be seen.

Turned slightly toward the right, the figure has a coiffure known
as "melon slice" waves, which was typical in the Antonine era. The
style was characteristic of Faustina the Younger, wife of Marcus
Aurelius, and Annia Lucilla, her daughter, who was the wife of
Lucius Verus; but given the natural resemblance between mother
and daughter, the idealization of the features, and the desire to
indicate dynastic continuity at this point, it is not possible to distin-
guish one woman from the other. Nonetheless, the shape of the
mouth and the rounded curves of the cheeks encourage one to see
this as a portrait of Lucilla, who could be depicted here as Venus
or, more likely, as Juno, two established divine forms for both
Faustina and Lucilla.[1]

This marble was discovered on the hill of Byrsa during excava-
tion of the foundations of the Saint-Louis chapel. The hill was likely
the center of the Punic city, and under Augustus was banked up
into a plateau to make way for a monumental center. Under
Antonine rule, the monumental trappings of the site were com-
pletely restored. One of the largest basilicas in the Roman world
stood along the southeast side of the plateau, which was probably
also the site of a library, two temples, and porticos. On the site of
the basilica, the 1845 excavations brought this monumental head
to light. The basilica of Ephesus, which housed imperial statues, is
an example of this type of structure: Augustus and Livia were
depicted seated in a room at its end.[2] Thus one can deduce that
this statue was not displayed alone but accompanied by either
Marcus Aurelius or Lucius Verus, depending on whether it depicts
Faustina or Lucilla.

Other works discovered at Byrsa would lead one to surmise that
there was a consistent building program, with two monuments to
the glory of Lucius Verus delimiting the esplanade to the east (the
basilica where Lucius Verus would be accompanied by Lucilla) and
to the west (a triumphal arch on the *cardo*, the main street, extend-
ing from north to south).

If standing upright, the statue bearing this head would have
measured more than 26 feet high. If seated, it would have mea-
sured between 19½ and 23 feet high, but the basilica foundations
would not have been able to support such a weight, which means
the work could not have been made entirely of marble. Researchers
have therefore speculated that this was an acrolithic statue, with
only the head, hands, and feet made of marble, and the rest made
from carved wood covered in fabric. Such statues were well known
in Greece, described in particular by Pausanias, but only Vitruvius
and Trebellius Pollio[3] apply this word to work in the rest of the
empire, the former simply using it in the sense of "colossal," the
latter with a pejorative slant.

However, there is no evidence, no mortise or surfaces, that
points to this head having been affixed to a wood core. There are
traces of lime mortar on the hair behind the diadem and on the
tenon under the neck, which indicate that the head was set in
masonry. Imagine, then, the piece atop a pier, perhaps some 26
feet above the ground. Though the non-marble portions could
have been made of wood in accordance with ancient technique,
more likely they were made of light masonry and stucco. Indeed,
traces of stucco remain on the eyelids and on the right ear.

In 146 B.C., Scipio Aemilianus's definitive victory over Carthage
ended the third Punic war. The Roman Senate ordered the total
destruction of the city and sent ten magistrates to utter the reli-
gious expression of *devotio*, which prohibited all new building on
the site of the city. According to Sallust,[4] who expressed an idea
that was then rather widespread, it was with the disappearance of
its enemy that Rome's decline began.

While Caesar established the Colonia Concordia Iulia Karthago
in the immediate proximity of Byrsa, it was Octavian, in 29 B.C.,
who expanded the colony and built it up on the site of the Punic
city, after his legate, Sentius Saturninus, had carried out the rites
that brought an end to the *devotio*. The large projects he completed
on Byrsa, the leveling of the hill, and the burying of any Punic ves-
tiges allowed him to circumvent the prohibition of 146 B.C. He
went on to inspire the poet Virgil.[5] For everyone, Virgil's descrip-
tion of Aeneas, ancestor of the Roman people and co-founder of
Punic Carthage, evoked Augustus who claimed to be of his lineage.
By founding Carthage once again, Octavian showed his desire to
usher in a new era in the history of Rome, before laying the founda-
tions for the future empire. (D.R.)

NOTES
1 Mikocki 1995, pp. 63-68.
2 Price 1984, pp. 140 and 255; Inan and E. Alfoldi-Rosenbaum 1979, p. 57; 61, Taf. 4.
3 Vitruvius, II, 8, 11; Trebellius Pollio, in *Historia Augusta*, XXXII, 5: "*statuam ... acro-
litham sed auratam.*"
4 *Conspiracy of Catiline*, 10.
5 *Aeneid*, I, 421–25.

BIBLIOGRAPHY
Kersauzon (de) 1996, pp. 280–81.
Gros 1995.
Mikocki 1995, pp. 63–68.

2 Portrait of Augustus

Ca. 27 B.C. ▪ Provenance unknown ▪ Fine-grained white marble (Carrara?) ▪ H. 14¾ in. (37.5 cm) ▪ Purchased in 1807, formerly in the Borghese collection (MA 1280–INV. MR 427; N 1595) ▪ Restorer: H. Bluzat, 2006

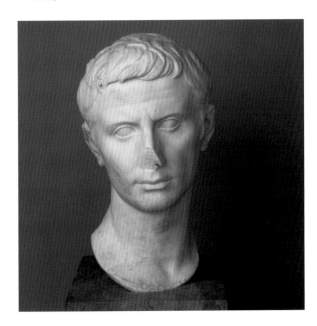

This portrait has fundamental importance in the study of Augustan iconography. Both it and a very similar portrait in the Forbes collection[1] are considered excellent examples of the Louvre type of Augustan portrait, the others being Alcudia, Lucus-Feroniae, Béziers, and Prima Porta.

Analyzing official Roman portraits based on hairstyles rather than tradition or numismatic depictions can be traced to J. J. Bernouilli's work published in 1882. In discussing Augustus, Bernouilli focused primarily on the Prima Porta type. In 1931, O. Brendel made further distinctions regarding the concepts of "type," "copy," and "replica" and defined four additional Augustan portrait types. It was then established that, at some time during the reign, artists were commissioned to carve the portrait in front of the emperor, in the style and with the features chosen by him, and that this model from life, the prototype, would be copied all over the empire, on coins, statues, and busts. Later research focused on determining which portrait adhered most closely to the prototype, and in 1954 G. Hafner demonstrated that the Forbes head is the closest to one of the five known prototypes.[2]

This portrait type is distinguished by a hairstyle with a distinctive "fork" in the locks of hair over the left eye and a "pincer" on the far right over the right eye, with four waving locks in between, combed to the right. The wave over the nose is particularly prominent. In contrast to the other portrait types, where Augustus is depicted as eternally youthful, the Louvre type is striking in its depiction of advanced age. The head is also slightly downcast to the right, and the almost imperceptibly downward curve of the lips suggests a sense of disillusionment.

From coins, replicas, and documentations of features in literature, we know that the Lucus-Feroniae (ca. 40 B.C.) and Alcudia (slightly later) portrait types were the oldest. The Béziers type

appeared between 40 and 30 B.C. Then, when August became sole ruler of the state, he needed a representational version of himself that would distinguish him from when he was a factional leader. The resulting Prima Porta type, with its well-received classicizing style, can therefore be dated to about 27 B.C.

But dating this portrait is far more challenging. Assuming certain features of the hairstyle would change consistently, K. Fittschen and P. Zanker[3] have attempted to demonstrate that the Louvre type came later than the Prima Porta type; however, they recognized a close relationship to the Alcudia type and therefore dated it to no later than 17 B.C., when Augustus revived the public civil and religious three-day celebration known as the *ludi saeculares* (secular games).

Basing his analysis on the facial features and apparent age of the sitter, K. de Kersauson followed J. Charbonneaux[4] in dating this portrait to the beginning of Augustus's old age, after the tragic loss of his grandsons Lucius in 2 A.D. and Caius in 4 A.D. In this case, the portrait would correspond to the publication of the *Res Gestae*, the seventy-six-year-old emperor's memoir and political testament. But D. Boschung believes that the portrait has so many similarities with the Alcudia type that it is unlikely that the development and spread of a type as prized as the Prima Porta could have come between them.[5] He thinks, instead, that the two prototypes underwent parallel developments and that the man in this portrait was less than forty years old.

The creation of models approved by the head of state, the politically motivated dissemination of prototypes, and the large-scale production of copies to use are distinctly Roman phenomena. As with the likenesses shown on coins, the goal was to create a personal tie with inhabitants throughout the empire. As power was highly personalized, everyone had to know exactly what the emperor looked like. Augustus was an innovator in this area, using his portraits to define the nature of the tie he wished to establish with the societies of both Rome and the provinces. Should he appear with the idealized and godlike features of the Prima Porta type? Or should he show emotion, associating himself with the Hellenistic tradition of portraiture, in the style of the portrait shown here?

It may well be that Augustus quite pragmatically chose to disseminate two different portrait types at the same time. That way, his subjects could choose the version most appropriate for their individual purposes. This policy would have resulted in the Prima Porta type becoming the dominant form for official representations, while many representations for private use bear the sensitive, rather melancholic aspect (but not the type of hairstyle) of this head. Other examples of this include the Neuilly-le-Réal bust (cat. no. 33), the small glass head in Cologne's Römisch-Germanisches Museum, the faience head in the Metropolitan Museum of Art, and the Meroë portrait in London's British Museum. (D.R.)

NOTES
1 Museum of Fine Arts, Boston, 06.1873.
2 Bernouilli 1882; Brendel 1931; Hafner 1954.
3 Fittschen and Zanker 1985, p. 9.
4 Charbonneaux 1963, p. 151.
5 Boschung 1993b, pp. 63–65.

BIBLIOGRAPHY
Kersauson (de) 1986, pp. 90–91.
Boschung 1993b, p. 129.

3 Mirror

Late 1st century B.C.–1st half of 1st century A.D. ▪ Discovered at Boscoreal (Italy), 1895 ▪ Silver, traces of gilding ▪ H. 11⅜ in. (28.9 cm); Diam. 6½ in. (16.6 cm) ▪ Gift 1895, formerly in the E. de Rothschild collection (BJ 2159–INV. MNC 1979) ▪ Restorer: O. Tavoso, 2006

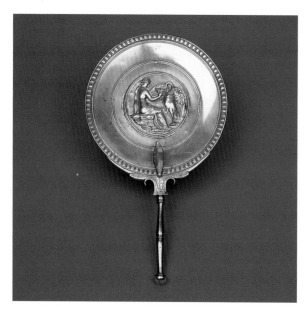

This round mirror has a baluster-shaped handle that ends on both sides in a pointed leaf shape, with two slender birds' heads with long beaks embracing the curve of the disc. One side of the disc is polished for reflection. The other side has a row of oval shapes forming a border and a central medallion, worked in repoussé, illustrating the mythological episode of Leda and the swan. The young Leda is seated in three-quarter view on a rock, her body half-nude, a *himation* (greek mantle) covering her legs. Large bracelets adorn each of her wrists. Her hair is combed into a chignon, from which some locks fall stylishly on the nape of her neck. With her right arm she offers a *phialos* (saucer) to the swan, which faces her, standing, its neck bent and its wings outspread. The bird rests its right foot on her knees.

This scene illustrates the episode where Zeus changes himself into a swan in order to lure Leda, the wife of Tyndareus, the king of Sparta. According to some versions of this legend, Leda's union with Zeus resulted in the births of the Dioscuri, Castor and Pollux, Clytemnestra (wife of Agamemnon, king of Mycenae), and Helen, renowned for her beauty, whose abduction by Paris caused the Trojan War. The iconography of Leda and the swan, already popular in Greece, was disseminated throughout the Roman world in numerous variations and materials, particularly in the painted decor of houses in Herculaneum and Pompeii, which were quite close to Boscoreal.[1]

Most frequently depicted with great sensuality, here the scene seems particularly well adapted to the mirror, an object associated with the toilette and female private life. Two other mirrors with handles belong to the treasure of Boscoreal.[2] It was common for collections of precious silver (including table services) to include luxurious accessories for the toilette that reflected to the owner's wealth and social standing. Thus the treasure from the house of

Menander in Pompeii also includes two mirrors, one of which has a handle.[3] This type of metal mirror, which appeared on the Italian peninsula beginning in the late sixth century B.C.,[4] consisted of a bronze disc to which a handle, initially made from another material such as wood or ivory, was attached. Its use spread through the fifth and fourth centuries B.C. with the emergence of manufacturing centers such as Praeneste (Palestrina). Etruscan mirrors and those used by the Greeks in southern Italy inspired luxury items produced by the Romans beginning in the first century A.D.[5] (C.G.)

NOTES
1 For a general survey of this rich iconography, see L. Kahil and P. Linant de Belle-fonds, "Leda," LIMC, VI, 1992, pp. 236–46, pl. 114–25.
2 Louvre, Paris, Department of Greek, Etruscan, and Roman Antiquities, Bj 2158 and Bj 2160; see Baratte 1986, p. 94, ill. p. 47.
3 Maiuri 1933, nos.15 and 16, pp. 350–54, pl. XLVII, XLVIII, and LVIII; and Painter 2001, fig. 8, p. 52, and M15 and M16, p. 64.
4 F. Gaultier, "Les Miroirs étrusques et prénestins" (Rouen 2000), pp. 52–53.
5 G. Sennequier, "Miroirs métalliques et miroirs en verre" (Rouen 2000), pp. 54–55.

BIBLIOGRAPHY
Héron de Villefosse 1899, pp. 90–92 and pl. XX.
Baratte 1986, pp. 45 and 94, ill. p. 44.
Pirzio Biroli Stefanelli 1991, no. 62, p. 265, figs. 115–16, p. 146.
Berlin 2002, no. 516, p. 653.

4 Skyphos

Late 1st century B.C.–1st half of 1st century A.D. ▪ Discovered at Boscoreal (Italy), 1895 ▪ Silver, traces of gilding ▪ H. 2⅜ in. (6.2 cm); Diam. 5⅞ in. (14.9 cm) ▪ Gift 1895, formerly in the E. de Rothschild collection (BJ 1914–INV. MNC 1962) ▪ Restorer: O. Tavoso, 2006

This *skyphos* is made of an inner bowl and an outer bowl where the foot and handles were attached. The handles are embellished with a decoration of volutes and rosettes ending in two swans' heads. One side of the outer bowl serves as a setting for a still life that develops over two panels, depicting food and objects connected to the theme of the banquet. On one side, a bunch of celery rests on the ground, next to a piglet with tied hooves. A tortoise precedes it. On the upper portion, a large footed bowl contains fruits and vegetables including a pomegranate, a pine cone, and an *askos*, a small drinking vessel in the shape of a wineskin. A plant garland falls elegantly from the bowl. A large knife case, a cauldron that bears the signature in Greek of the silversmith (CABEINOC), and an *oenochoe* (wine pitcher) complete the composition. The decoration on the other side consists of a woven basket resting on the ground, a hare crowned by some mushrooms, a pomegranate bough laden with three ripe fruit upon which two thrushes perch, and an overturned basket with spilling pomegranates. The number *VII* is engraved under one handle, on the belly of the vessel.

This drinking bowl has an identically shaped and decorated counterpart by the same silversmith[1]—who signed this bowl in Latin.[2] Only the components of the still life are different. Of the 110 items in the Boscoreal treasure, these are the only two characterized by this iconography. The quite comparable treasure from the house of Menander in Pompeii includes no example of this iconography.[3] All the same, this theme, which combined food and objects related to the banquet, seems particularly appropriate to a ceremonial vessel. In fact the most frequent occurrence of comparable elements is found in the decoration of country villas.[4]

Initially executed in mosaic in Pompeii, the still life truly blossomed within the realm of painting, beginning in the first century B.C. with the emergence of the second style in painting. It consisted of foodstuffs depicted alone or with other objects, as in the two Boscoreal cups. The constituent elements of both creative domains draw from the same formal repertoire: animals (living or dead), vegetables, trays of fruit, overturned baskets, vases, and cooking utensils enliven these scenes without there being any connection among them. Thus a question arises about the overall meaning one should give this decorative genre. Vitruvius provides a hint in Book VI of his treatise on architecture, in which he notes the custom of sending gifts of unprepared foods—*xenia*—to guests so they could prepare them as they wished. If this secular source is accepted for isolated depictions of foods, it perhaps can be replaced by a religious interpretation when these appear side by side with objects. Thus the scene of the pig with fettered hooves might suggest preparations for a sacrifice.[5] (C.G.)

NOTES
1 Louvre, Paris, Department of Green, Etruscan, and Roman Antiquities, Bj 1913; see Baratte 1986, p. 91, ill. pp. 23 and 60.
2 Only two names of artisans appear on the pieces from Boscoreal: Sabinus, on the two cups with still-life decoration, and Marcus Domitus Polygnos, on one of the mirrors; see Baratte 1986, pp. 83–84.
3 Maiuri 1932.
4 Croisille 1965 and De Caro 2001.
5 Baratte 1986, p. 61.

BIBLIOGRAPHY
Héron de Villefosse 1899, pp. 81–82 and pl. XVI.
Baratte 1986, pp. 56, 58, and 91, ill. p. 60.
Pirzion Biroli Stefanelli 1991, fig. 32, p. 48, figs. 103 and 104, p. 138 and no. 42, p. 261.

5 Oenochoe

Late 1st century B.C.–1st half of 1st century A.D. ▪ Discovered at Boscoreal (Italy), 1895 ▪ H. 3½ in. (8.8 cm); Diam. 2½ in. (6.5 cm) ▪ Gift 1895, formerly in the E.P. Warren collection (BJ 1902–INV. MNC 2056) ▪ Restorer: O. Tavoso, 2006

Like the *skyphos* and the *patera*, this *oenochoe* (wine pitcher) was used for pouring drinks. Modest in size, it has a round belly and wide, pointed spout. A fine geometric frieze chiselled at the junction of the belly and the neck interrupts the polished surface of the vase. The decoration is focused on the handles. Symmetrically arranged flowers and volutes ornament the lower joint of the handle, while a leaf enhances its curvature. Two birds' heads with long beaks, with a volute in front, embrace the curvature of the neck of the vase, forming the upper junction of the handle. This decorative motif is often seen at the juncture points of silver pieces (handles) and is used in the four Boscoreal pieces shown here (cat. nos. 3–6). Like the *skyphos* and *patera*, this *oenochoe* has an exact companion piece in the treasure,[1] which shows indications of a weight on its base, relating it to the pair of vases.[2] Similar to these two small specimens, the Boscoreal treasure includes four other wine pitchers, one pair of which has figurative decoration.[3]

This piece is distinguished from the rest of the treasure by its atypical itinerary. Most of the treasure, which was discovered in June 1895 hidden at the bottom of a cistern on a vineyard,[4] was acquired by Baron Edmond de Rothschild with the intention of donating it to the Louvre, but this pitcher was dispersed on the art market first, and was purchased—along with a handled cup[5]—by E. P. Warren, a member of the Board of Trustees of the Museum of Fine Arts, Boston.[6] However, inspired by the act of generosity of the Baron de Rothschild, Warren allowed these pieces to join the others in the Louvre's collection. (C.G.)

NOTES
1 Louvre, Paris, Department of Greek, Etruscan, and Roman Antiquities, Bj 1901; see Héron de Villefosse 1899, pp. 93–94 and pl. XXI, 1 and 2; and Baratte 1986, p. 90.
2 *P(ondo) I, uncias III, semunciam, scripula II*, or 425 g according to Héron de Villefosse 1899, p. 94, the two vases weigh respectively 200 g (Bj 1901) and 194 g (Bj 1902).
3 Pirzio Biroli Stefanelli 1991, figs. 101 and 102, pp. 136 and 137, nos. 39-40, pp. 260-61.
4 Regarding the circumstances of the discovery, see Van der Poel 2001.
5 Louvre, Paris, Department of Greek, Etruscan, and Roman Antiquities, Bj 1919; see Héron de Villefosse 1899, no. 97, pp. 127–28.
6 Archives des musées nationaux and Paris 1989a, p. 342.

BIBLIOGRAPHY
Héron de Villefosse 1899, p. 127.
Baratte 1986, p. 91.

6 Patera

Late 1st century B.C.–1st half of 1st century A.D. ▪ Discovered at Boscoreal (Italy), 1895 ▪ Silver, traces of gilding ▪ L. 9¾ in. (24.6 cm); Diam. 4¾ in. (12 cm) ▪ Gift 1895, formerly in the E. de Rothschild collection (BJ 1987–inv. MNC 1985) ▪ Restorer: O. Tavoso, 2006

This *patera*, or saucepan, has a concave basin and flat horizontal handle ending in a soldered joint. The basin is ornamented with a double row of long leaves, side by side, with a central rib and rounded tip. They are separated by a smooth bandeau and a narrow row of fish and shells, which stand out against a background of a light guilloche motif. A double thyrsus decorated with ribbons extends to the handle, while two delicate birds' heads embrace the curvature of the basin at the point where it meets the handle.

This *patera* fits with an identical but slightly larger piece that is 5 inches in diameter (12.8 cm).[1] An abbreviated name, *Maxima*, is inscribed on the bottom. Interestingly, the site of Herculaneum yielded a pair of cups with exactly the same shape and decoration as the basin of these, except they were slightly smaller in diameter.[2]

This type of metal vessel appeared in the first century B.C. and in all likelihood was part of a wine service.[3] It is well represented in the Boscoreal treasure, which includes six *paterae*,[4] two of which are pairs. Such pieces were likewise fabricated in glass, as seen in two pieces in the Louvre, thought to be from the first or second century A.D.,[5] and another, excavated from a tomb in Losone (canton of Ticino, Switzerland), dated 80–130 A.D.[6] (C.G.)

NOTES
1 Louvre, Paris, Department of Greek, Etruscan, and Roman Antiquities, Bj 1986; see Baratte 1986, pp. 31 and 92.
2 Naples, Museo Nazionale, inv. 25290 and 25291; see Pirzio Biroli Stefanelli 1991, fig. 53, p. 73, and fig. 91, p. 128, and no. 24, p. 256.
3 Baratte 1986, p. 30.
4 Louvre, Paris, Department of Greek, Etruscan, and Roman Antiquities, Bj 1986 and Bj 1987, Bj 1988 and Bj 1989, Bj 1990, Bj 1991; see ibid., p. 92.
5 Louvre, Paris, Department of Greek, Etruscan, and Roman Antiquities, MNE 130 and N 5196 – LP 2180; see Arveiller-Dulong and Nenna 2006, nos. 547 and 36.
6 Bellinzona, Museo Civico, inv. 139.72.078; see Locarno 1988, no. 127, p. 107.

BIBLIOGRAPHY
Héron de Villefosse 1899, pp. 105–06, pl. XXIV.
Baratte 1986, p. 92.

7 Bust of Marcus Aurelius

Ca. 170 A.D. ▪ Discovered at Acqua Traversa (near Rome), 1674 ▪ Fine-grained marble ▪ H. 33 in. (86 cm) ▪ Purchased in 1807, formerly in the Borghese collection (MA 1166–INV. MR 561; N 1416) ▪ Restorer: C. Devos, 2006

This bust, in nearly perfect condition, is characterized by the contrast between the light and brilliant skin of the face and the dark mass of hair, covered with concretions. Numerous grooves and stains on the left side of the face show that concretions were also scratched into the flesh. The sculptor clearly appreciated the play of light and shadow and enhanced it by skillfully carving (with a drill) the hair and the fringe of the *paludamentum* (military cloak) that covers the cuirass. Such an approach was common in the Antonine era, when a search for visual effects distinguished it from the prevailing classicism of the eras of Hadrian and Antoninus Pius. One finds it in historical reliefs—where the depiction of movement was elevated to such an extent that art from this era has been described as having baroque tendencies,[1] and in portraits—where an emotional vein inherited from Hellenism surfaces once again.[2] Likewise the composition of the face is original, with highly raised eyebrows and rather lowered eyelids conveying both a lively expression and a distant and dreamy air.

The Louvre has eight marbles that were discovered at Acqua Traversa: an Aphrodite of the Capitoline type, four portraits of Lucius Verus, and three portraits of Marcus Aurelius.[3] They are from a group of some thirteen effigies of these sovereigns excavated from the site between the seventeenth and nineteenth centuries. Acqua Traversa extends approximately ten kilometers north of Rome, along the Via Cassia (or, in this section, the Via Claudia), which begins at the Milvius Bridge. While impressive traces are still visible (despite the construction of the Villa Manzoni in 1924), nothing is known about the overall layout of the site.

In 1609, the area passed into the hands of the Borghese family. Until his death in 1621, Camillo Borghese—who became Pope Paul V—exploited it as an archeological trove. The first discovery of a portrait of Lucius Verus (now lost) made it possible to connect the site's remains with the villa belonging to this ruler, described in the *Historia Augusta*.[4]

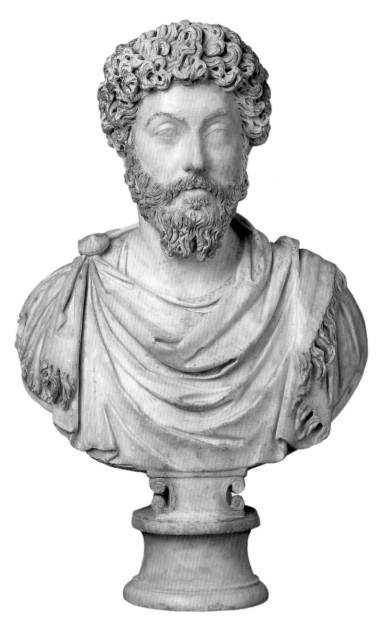

In 1650, maintenance work unearthed an Aphrodite, probably the one now in the Louvre. The other finds were more modest, but in 1674, nine portraits of Lucius Verus and Marcus Aurelius were brought to light.[5]

The two colossal portraits of the co-emperors, now in the Louvre, came from excavations of 1720 conducted on the same spot.[6] One portrait of Lucius Verus, others of Plotina and Faustina the Younger, and five idealized statues, now in the Torlonia collection, were excavated in the early nineteenth century.

The only remains that exist from the excavations of 1674 are the five portraits in the Louvre. Four others were lost—probably after their discovery, as Carlo Fea has indicated. What is striking about the Acqua Traversa group is the profound similarity connecting the three portraits of Lucius Verus. Besides the size, garments and physiognomy and the treatment of the beards, the treatment of the hair is identical, lock for lock. These portraits, and those of Marcus Aurelius, may have been kept in an ancient storehouse—either for protection or storage resulting from renovation of the villa furnishings, thus explaining the discovery in 1674 and 1720, on the same site, of busts that are so similar and so well preserved. The exploration of a cistern near the discovery site may indicate that these busts had been stored underground in a channel, cellar or cryptoporticus.

The text of the *Historia Augusta* attributes the building of the villa at Acqua Traversa to Lucius Verus, at a time when, having returned from a victorious campaign against the Parthians in 166 A.D., his political influence gradually waned. The text describes the leader's decline into debauchery, despite the exhortations of Marcus Aurelius, but with the discovery of part of the villa's sculptural decoration, a different version of the facts emerges. The great number of portraits of the co-emperors, the unity of style that links them, and the serial production of effigies of Lucius Verus show that this ornamental and political program was inspired by the continuing idea of shared imperial power.[7]

The portrait of Marcus Aurelius shown here belongs to type III,[8] or "Type Term 726,"[9] the creation of which dates to the accession of the new emperor in 161 A.D. This type was reproduced throughout his reign, but 166 A.D., when Marcus Aurelius asserted his authority, marks the beginning of type IV, or "Museo Capitolino Imperatori 38." So it is interesting to note that it is type III, a style that prevailed at the time of power-sharing, which is best represented at Acqua Traversa. (D.R.)

NOTES
1 Rodenwaldt 1935.
2 Bergmann 1978, pp. 32–33.
3 As well as Ma 1166, Ma 1159, Ma 1179 (Marcus Aurelius), Ma 1101, Ma 1131, Ma 1094, Ma 1170 (Lucius Verus), Ma 335 (Aphrodite).
4 *Historia Augusta*, VIII, 8–9.
5 Fea 1790, p. CCLXIII.
6 Ma 1179 and Ma 1170; Winckelmann 1784, t. II, p. 305.
7 Albertson 2004.
8 Bergmann 1978, p. 25.
9 Wegner 1939, p. 33.

BIBLIOGRAPHY
Fittschen and Zanker 1985, p. 74, n. 10d.
Kersauson (de) 1996, pp. 520–21.
Mastrodonato 2000, pp. 203–04.
Rome 2000b, pp. 618–19, no. 13.

8 Mosaic Panel

2nd half of 1st–early years of 2nd century A.D. ▪ Discovered at Daphne, near Antioch on the Orontes (Turkey), House of the Atrium, 1932 ▪ Marble, limestone, molten glass ▪ H. 73¼ in. (186 cm); W. 73¼ in. (186 cm) ▪ Transferred 1936, excavation of 1932 under the direction of Princeton University, with the support of the National Museums of France, the Baltimore Museum of Art, and the Worcester Art Museum (MA 3443–INV. MND 1945) ▪ Restorer: Atelier de conservation et de restauration du musée de l'Arles et de la Provence antiques, under the direction of P. Blanc, 2005–06

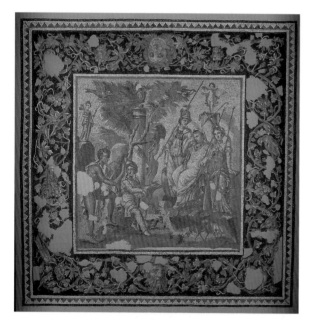

This mosaic presents a mythical scene. In a mountainous landscape that recalls Mount Ida, the young Paris—dressed in oriental costume and seated on a rock—listens to the god Hermes, sent by Zeus to entrust him with a mission: to present the golden apple of discord to the goddess judged most beautiful. Standing to the left with lance in hand, Athena wears a helmet and breastplate decorated with a Gorgon's head. Seated next to her, Hera, head veiled, holds a long golden scepter. Aphrodite also holds a scepter and rests, somewhat nonchalantly, against a rock. Aphrodite will be chosen, out of the three, after promising Paris the love of Helen—a love that will result in the Trojan War.

Interlaced vines and ivy issue forth from two male faces, one youthful, the other mature; the vines, inhabited by insects, lizards and birds, wind around the central panel, against a black background.[1] Both the iconography and the style of this mosaic panel link it to the Hellenistic tradition,[2] then well established in the Roman east, particularly in the capital, the third largest city in the empire after Rome and Alexandria. In fact, this mosaic was the central element of a floor decoration from the *triclinium* (dining room) of a sumptuous house with an *atrium* (an inner courtyard) in Antioch.[3] Five *emblemata* (central panels with the most important decoration in a mosaic floor), inlaid figures arranged in a

T-formation, adorned the entrance and the central area of this dinning room, while the other part of the floor where the beds were placed along the sides was decorated with a single diamond pattern. Thus guests appeared to be greeted by Dionysius and Heracles,[4] engaged in a drinking contest and framed by a satyr and a maenad.[5] The Judgment of Paris and then Aphrodite and Adonis have an inverted orientation.[6]

Then, the Louvre's panel occupied a central position. In terms of both the scene's construction and the landscape's idyllic evocation, this panel has the most accomplished composition. Its choice of subject, common in Campanian painting but rarely represented in mosaic, may be explained by the tradition in which the Judgment of Paris took place at Daphne on the outskirts of Antioch.[7] More generally, the subject corresponds to the rebirth of sophist philosophy in the Greek portion of the empire in the second century A.D.; this intellectual movement focused on the teaching and use of rhetoric according to classical models from the fifth and sixth centuries B.C. The school of thought is represented by, among others, Plutarch or Athenaeus, who in Book 12 of his *Banquet of the Learned*, states: "I for one affirm also that the Judgment of Paris, as told in the poetry by writers of an older time, is really a trial of pleasure against virtue."[8]

With its emphasis on pleasures, this is the oldest floor panel in the copious body of mosaics from Antioch unearthed during the 1932 excavations,[9] yet its date cannot be precisely established. Decorating the floor of a house that was altered many times but whose foundation dates to the Augustan era, it can at least be placed between the earthquakes during the reign of Caligula (37–41 A.D.) and the one that took place during Trajan's reign, in 115 A.D.[10] (C.G.)

NOTES
1 The birds have been identified; see Becker and Kondoleon 2005, pp. 75–79.
2 Ibid, p. 26.
3 Ibid., pp. 19–48.
4 Panel in the Worcester Art Museum (acc. no. 1933.36); see Worcester 2001, no. 55, p. 170, and ill. p. 176, and Becker and Kondoleon 2005, pp. 178–81.
5 Panels in the Baltimore Museum of Art (in. 33.52.1 and 33.52.2); see Worcester 2001, nos. 56 and 57, pp. 171 and 172.
6 Panel in two parts, at Princeton University, The Art Museum (40.156) and at Wellesley College Museum (1933.10); see Worcester 2001, nos. 59 and 60, pp. 174–75. These five *emblemata* were grouped together for the first time after their excavation in 1932, on the occasion of a traveling exhibition held in 2001 in Worcester, Baltimore, and Cleveland; see Worcester 2001.
7 Tradition repeated by Libanios, the original rhetorician of Antioch, in the fourth century (*Orationes*, II.241)
8 See Worcester 2001, pp. 69–70, and Becker and Kondoleon 2005, pp. 28–29.
9 Regarding the excavations, see Elderkin 1932; regarding the mosaics, see Levi 1947, Campbell 1988, and Cimok 2000.
10 Levi 1947, p. 16; Baratte 1978, p. 92; Balty 1981, p. 361; and Becker and Kondoleon 2005, p. 20.

BIBLIOGRAPHY
Elderkin 1934, pp. 42–48.
Levi 1947, vol. I, pp. 15–21, and vol. II. Pl. Ib.
Baratte 1978, pp. 87–92.
Campbell 1988, no. 7i, pp. 19–20, pl. 70.
Worcester 2001, no. 58, pp. 172–73.
Becker and Kondoleon 2005.

9 Portrait of Septimius Severus

Ca. 205 A.D. ▪ Discovered in Gabii, near Rome, 1792 ▪ White, very fine-grained marble ▪ H. 29⅛ in. (74 cm) ▪ Purchased in 1807, formerly in the Borghese collection (MA 1118–INV. MR 647) ▪ Restorer: Ch. Devos, 2006

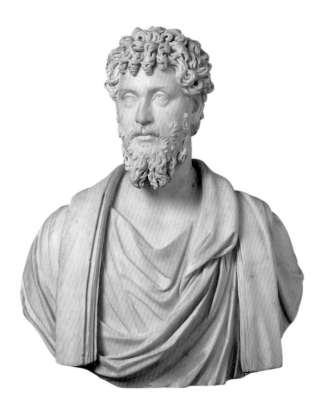

In 1791 and 1792 the Scottish painter Gavin Hamilton carried out the first "archeological" excavations on the site of Gabii, a Borghese family estate, 12½ miles (20 km) east of Rome on the Via Prenestina (the ancient Via Gabina), along the banks of Lake Castiglione. Gabii played an important role in the legend of how Rome was founded, and archeology has revealed that the site was inhabited from the ninth to sixth centuries B.C. An important city in Latium and an ally of Rome, it experienced a decline beginning in the third century B.C. While its fortunes were restored in the late first and early second centuries A.D., particularly during Hadrian's rule, the heart of the city seems to have been abandoned by the beginning of the third century A.D.

In the late eighteenth century, the ruins of the *cella* (sacred room) of a temple and a *cavea* (curved series of tiers, like those in theaters) built on the slope in front of this edifice were still visible. Hamilton cleared the sacred area bordered by a portico and shops, but above all he explored the forum in Gabii along the Via Prenestina. There he discovered nearly two hundred pieces of sculpture, some fifty of which are now in the Louvre. These pieces, among others, embellished ten or so niches beneath the portico and three bases along the central esplanade. Some sat on inscribed bases (cat. no. 124). Many related to figures that were significant in municipal life.

At the northeast corner of the portico was a door leading to a square room measuring approximately 484½ square feet (45 sq. m), which was surmounted by a large inscription dedicated to Domitia (cat. no. 37). The large number of imperial portraits discovered here led E. Q. Visconti[1] to identify this room as a temple devoted to imperial worship (Augusteum), initially dedicated to Domitia and then to her family. The portraits were created between the Julio-Claudian era and the reign of Gordian III (238–244 A.D.). According to Visconti, "the remarkable busts of Septimius Severus and Geta, as well as one of Corbulo, and others, now headless depictions— some male, of imperial rank and wearing breastplates, some female—were discovered inside a small temple adjacent to the forum portico." Thus this portrait came from the Augusteum, where Visconti also mentioned a bust of Julia Domna, the Syrian wife of Septimius Severus.

One can see that portraits of Septimius Severus were inspired by those of Marcus Aurelius, in terms of both their expressiveness and the chiaroscuro effects produced in the hair with the extensive use of a drill (a tool for cutting shallow holes). In this manner, the founder of the Severan dynasty, who attained his heights of power following a civil war, emphasized his desire for continuity with and fidelity to the Antonine legacy. A. M. McCann has distinguished ten types of portraits of the ruler, while D. Soechting confines himself to four types. This portrait falls within the "Sarapis" type (McCann type 9, variant B, with an "elongated face" and "classicizing style"; Soechting type 3, workshop B), because of the four locks of hair that fall vertically over the forehead. This hairstyle was adopted by the emperor, who was from Africa, after a voyage to Alexandria

(199–200 A.D.), where it seems that he became involved with the worship of the Egyptian god Sarapis (cat. nos. 167–69). The type first appeared on the arch of the Argentarii in Rome, dedicated in 204 A.D., and perhaps earlier on certain coins.

The form of the toga and excellent condition of the bust have led to doubts regarding its authenticity, however. Beginning in the Antonine era, male fashions tended to tighten, flatten, and stretch out the *umbo*, a mass of folds across the chest portion of the toga. Under Septimius Severus, the *contabulatio* toga type was introduced: the toga was arranged in such a way that the *balteus*, the folds running on the hip, tended to be hidden and the chest was covered by a flat, thick, and broad rectangle of cloth, more or less horizontal, that passed over the left shoulder and below the right armpit.

In this portrait, the *contabulatio* has not reached this stage. The *umbo* is folded and flattened over the shoulder, but the *balteus* is still visible. On the other hand, a thick reverse side of vertical cloth passes over the left shoulder and seems to fall over the right shoulder, an arrangement that long seemed completely atypical and not very comprehensible to art historians. But in fact, it seems that during and after the Severan era, innumerable variations were introduced for arranging the different parts of the toga, in order to obtain broad, even bands of fabric in the style of the *contabulatio*. Some other busts (in the Uffizi Gallery in Florence, at the Musei Capitolini in Rome, and at Chatsworth House in Derbyshire, England have a similar toga arrangement. The so-called sarcophagus of the Twin Brothers at the Museo Nazionale in Naples makes it clear that it is the *sinus* of the toga, the rounded border, that is folded over many times in order to form this broad edge.[2] (D.R.)

NOTES
1 Visconti 1797, pp. 19 and 26.
2 Goette 1989, pp. 68, 152, pl. 56-3.

BIBLIOGRAPHY
McCann 1968, p. 192, pl. XLVII.
Soechting 1972, pp. 196–97.
Kersauson (de) 1996, pp. 354–55.
Rome 2003, pp. 321–22.

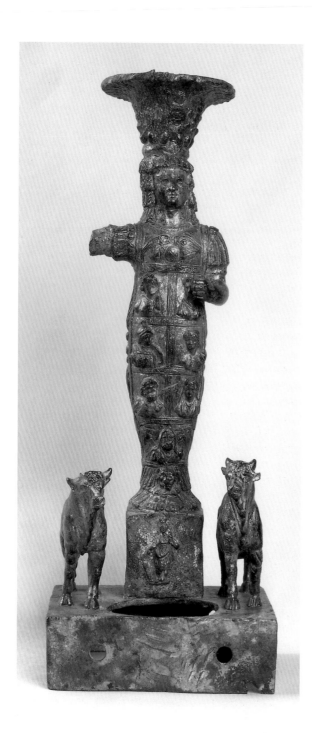

10 Statue of Heliopolitan Jupiter

2nd century A.D. · Discovered in Baalbek (Lebanon) · Copper alloy, gold · H. 15⅛ in. (38.4 cm); L. 5¾ in. (14.7 cm); W. 5 in. (12.7 cm) · Formerly in the Sursock collection (DEPARTMENT OF EASTERN ANTQUITIES, INV. AO 19534) · Restorer: C. Pariselle

Jupiter is represented standing, crowned with a basket or Greek *kalathos*, a symbol of abundance and fertility. The god holds his left arm forward with a closed fist. His right arm, once raised in a display of power, is broken at the elbow. The god's body is draped in a double garment composed of a long pleated *chiton* hanging to the feet and a wrap whose broad bands intersect to create panels. Two long vertical bands along the figure's sides are decorated with lightning bolts.

The panels on the front of the statue display busts of deities placed under the winged disc of the sun. From top to bottom we recognize Helios, easily identified by his sunbeams; Selene, with a crescent moon over her shoulder; a helmeted Athena and a Hermes with a winged head; Zeus holding his scepter and Hera surrounded by rosaces. Beneath these panels are representations of Cronus and a lion.

The panels on the back of the statue feature, from top to bottom: the winged disc, the eagle (Heliopolitan Jupiter's animal), a flower, a rosace, ram heads—which may represent Jupiter–Ammon; and more rosaces, likely to have solar or astral symbolic significance.

Here Jupiter stands on a small plinth decorated with the image of a Tyche, whose head resembles a tower and whose hand holds a horn of plenty. The entire structure rests on a large rectangular plinth that is hollow without a bottom, and outfitted with a circular hole. On the plinth, standing on either side of the deity, are two young bulls with relatively undeveloped horns.

The statue of Jupiter was cast in a single piece, except for the two bulls, which were attached by rods beneath their feet. The decorations were all made at the casting stage aside from a few details, such as the animals' coats, which were subsequently engraved with a very fine point. The entire piece, including the animals, was originally gilded.

The statue was discovered in Baalbek. It had been broken into several pieces from violent blows, most likely inflicted by Christian opponents of the pagan cult that had remained particularly active in the city of Heliopolis. Heliopolis, a city devoted to the sun, was one of the major sites of the cult of the ancient oriental divinity Ba'al, which developed into the cult of Zeus in the Hellenistic era, then of Jupiter in the Roman era. Here, the representation of Jupiter draws on the iconography of various forms taken by the god of storms throughout the Mediterranean Basin, all the way back to ancient times.

The statue illustrates the religious syncretism characteristic of oriental religions in areas occupied by the Greek and Roman empires. The position of the deity's arms is reminiscent of the gestures of countless metal figurines representing the god Ba'al standing and walking, holding up an armed hand to set off thunder while brandishing lightning with his other arm. Wrapped in strips of cloth, Jupiter's body exhibits similarities with that of the Egyptian god Osiris, who was also sometimes represented wearing a *kalathos* on his head, and whose life, like Ba'al's, was cyclical. The

young bulls are symbols of power and fecundity likened to the powerful god of Storms in ancient oriental texts and pictures. In the Roman era, Ba'al and his bull were honored under the names of Jupiter of Heliopolis or Jupiter of Doliche, after two of the great urban centers where the cult of Jupiter flourished, notably through the influence of Roman soldiers.

This statue recreates the image of Jupiter as worshipped in the temple of Baalbek. The orifice in the plinth may have served to receive offerings. Certain sources refer to the offering of jewels to contribute to the construction of sculpted figures. It is equally possible that written questions were left at the feet of the Heliopolitan god who, according to other sources, pronounced oracles. Emperor Trajan consulted him in 113 A.D. before battling the Parthes. (S.C.)

BIBLIOGRAPHY
Dussaud 1920.
Paris 1998, p. 190.
Weber 1999, fig. 7a, p. 10.
Paris 2000a, no. 73, p. 91.

11 Portrait of Maxentius

Early 4th century A.D. ▪ Provenance unknown ▪ Grey, large-crystalled marble ▪ H. 18½ in. (47 cm) ▪ Formerly in the royal collection (MA 3522 bis) ▪ Restorer: C. Devos, 2005

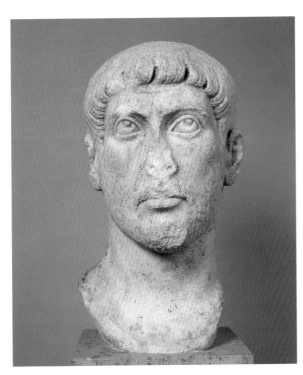

This head was fitted onto a statue that wore a toga or breastplate. The shape of the tenon below the neck and the twist of the neck show that the man looked toward the right. The head suffered a crack at some point along the entire length of its right side, extending along the neck and to the back; these parts were reassembled, as were the top of the breast and the lower part of the neck. The break damaged the right ear but only chipped the left ear. The nose is completely gone except for the bottom hollows of the nostrils.

According to contemporary manuscripts (now in Langres, France) by the Jesuit priest Jacques Vignier, as well as Théodecte

Tabourot, the body for a statue was found in Langres in 1660 or 1668. A 1677 engraving by Etienne Baudet shows this head surmounting it,[1] and in 1701 Jean-Aymar Piganiol de la Force wrote that the statue was located in the gardens of Versailles.[2] Edme Baugier writes that the same year the body was discovered, a head was also taken out of the ground,[3] but it is not clear that this is the same head that was later mounted on the statue and separated from it around 1975, when the local museum in Langres was able to secure the return of the body to the city where it was discovered.

While drawings of the statue from the time of its discovery are still extant,[4] there are no known reproductions of the Langres head. E. Baugier describes the statue and head found in Langres as being cut "from a similar marble," but the present head is much grayer than the body, its stone containing larger crystals. Baugier writes that the head was sent to Louis Phélypeaux, Marquis de la Vrillière, the secretary of state to Louis XIV. According to J.-A. Piganiol de la Force, the head could also have come from the Phélypeaux collection, but we do not know enough about the contents of that collection to venture more than a hypothesis on provenance.

K. de Kersauson has suggested identifying this portrait with the effigy of Maxentius (306–312 A.D.), but the absence of a confirmed portrait rules out any certainty about the true physiognomy of this emperor. Coins show a bearded figure with a round face and powerful, short neck. His hairstyle has stiff, curved locks fanning out over the forehead and revealing a straight fringe. Based on this, two types of faces were subsequently attributed to Maxentius. R. Calza relied on a commentator from Antioch, Jean Malalas (491–578 A.D.), who in his *Chronographia* describes Maxentius as having curly hair.[5] Thus the round face and hairstyle of the Ostia statue in a toga, found in the College of the *Augustales*, can perhaps be identified as Maxentius, but the Dresden and Stockholm portraits that H.-P. L'Orange recognizes as Maxentius are quite different: they share a clear resemblance, with the hair of the bangs fanned out over the forehead.[6]

With its eccentric features—evidence of artistic tendencies from the second half of the third century—the Louvre portrait deviates from those two examples. The asymmetry of the face, wrinkled forehead, and the expression of the fleshy-lipped mouth lend the countenance an expressiveness that suggests depictions from the time of the emperor Gallienus. With locks of hair shaped into rolls and separated by the deep slashes made with a drill, the hairstyle is unusual: its closest parallel is the portrait in the Musei Capitolini (inv. no. 1580), where a similar treatment is attributed to changes made during the period of the Tetrarchy, when the short beard was commonly worn.[7] Finally, the elongation of the face, the geometric features, the emphasis on the eyes and the intensity of the glance anticipate Constantinian portraiture. In any case, about 300 A.D. should stand as a chronological background for the work. (D.R.)

NOTES
1 Chalcography collection, Louvre, no. 1338.
2 Piganiol de la Force 1742, p. 210.
3 Baugier 1721, p. 352.
4 Vignier manuscript (Ca. 1670), Bibliothèque Royer no. 147, Musée du Breuil Saint Germain, Langres, 123 pages ill.
5 Calza 1972, pp. 188–96, pl. LXV.
6 L'Orange 1933, pp. 52, 105.
7 Rome 2000a, p. 544.

BIBLIOGRAPHY
Fittschen and Zanker 1985, p. 159, n. 10.
Kersauson (de) 1996, pp. 520–21.
Rimini 2005, p. 233.

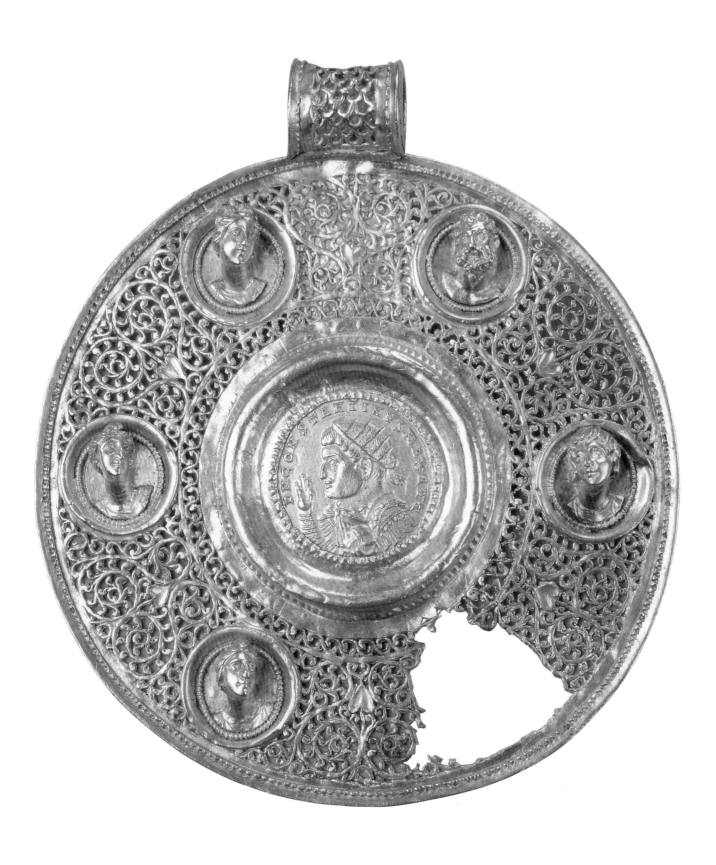

12 Medallion Coin

Ca. 324–26 A.D. ▪ Provenance unknown ▪ Gold ▪ Diam. 3⅝ in. (9.2 cm) ▪ Purchased in 1973 (BJ 2280–INV. MNE 684) ▪ Restorer: D. Robcis, Centre de recherche et de restauration des musées de France, 2005

In this medallion, a gold coin is set within the center of a gold disc. A ring for hanging it projects from the top. The coin is a double *solidus* with an imperial effigy on the front, identified by the inscription D(OMINUS) N(OSTER) CONSTANTINUS MAX(IMUS) AUG(USTUS). In bust view, the emperor is seen in left profile, in military dress (here a cuirass and *paludamentum* or mantle), wearing a ring-shaped crown, his right hand raised in salutation and his left hand holding a globe, symbol of the universal empire.

The other side of the coin depicts Constantine's two sons, Crispus and Constantine II, dressed in—and holding—the insignia of their consular status (the *trabea*, the consul's clothes, the crown and a scepter surmounted by an eagle). They are accompanied by their names and office: CRISPUS ET CONSTANTINUS NOB(ILISIMI) CAEAS(ARE)S CONS(ULE)S II (though this is obscured by the coin's mounting). Under the busts is an indication of the workshop that issued the coin: SIRM(IUM), present-day Sremska Mitrovica, near Belgrade in Serbia. Thus this is a coin minted in Sirmium on the occasion of the second consulship of Constantine's sons, which began on January 1, 321 A.D.

The gold disc in which the *solidus* is mounted has openwork decoration done in a technique known as *opus interrasile*.[1] The decoration is punctuated at regular intervals by gold medallions out from which busts in high relief project. Between each of these busts, two leafy vines scroll symmetrically from either side of a heart-shaped leaf. Of the original six busts depicted, five remain: three female on the left and two male on the right—all turned in three-quarter view toward the center of the jewel. The formal homogeneity of their standardized faces is broken by the varied treatment of their hair. Just who these busts represent is still in question, since they lack the attributions that would enable identification.[2]

This medallion was part of a series of five known circular or octagonal pieces.[3] Four appeared on the art market in 1970 and were disbursed between the Dumbarton Oaks Collection in Washington, the British Museum in London, and the Louvre. A fifth was acquired in 1994 by the Cleveland Museum of Art. All are thought to have belonged to a single necklace and to have been separated by many pairs of Corinthian colonnettes in *opus interrasile*; the necklace was joined by a clasp decorated with precious stones. The clasp and colonettes are owned by the Cleveland Museum.

Together they make for an exceptional group, consistent with the type of coin-jewels used in third-century Rome and the empire. Other complete or nearly complete examples of these exist,[4] but the homogeneity of the five Constantinian coins of this necklace is a distinguishing feature: the coins, struck in 321 and 324 A.D. on the occasion of the second and third consulships of Crispus and Constantine II, were not meant for circulation. With the exception of one, earlier examples of this kind of necklace consist of coins of different emperors that may be more than a century apart,[5] suggesting that they are the result of deliberate hoarding. This necklace, however, was most likely made between 324—the date the most recent coins were issued, and 326 A.D.—the year Crispus was executed after having been severely sanctioned with a *damnatio memoriae*.[6] It can be considered as a memorial work produced within the imperial entourage and offered to a court dignitary, such as a consular diptych (cat. no. 13). (C.G.)

NOTES
1 According to the expression used by Pliny the Elder in his *Natural History*, Book XII, 94: "Coronas ex cinnamo interrasili auro inclusas"; see Yeroulanou 1999, pp. 15–26; and Deppert-Lippitz 1993.
2 Deppert-Lippitz 1996b, pp. 55 and 58.
3 All were published on the occasion of the publication of the medallion acquired by the Cleveland Museum of Art; see Deppert-Lippitz 1996b and Yeroulanou 1999, pp. 224–25.
4 Ibid., pp. 201–01.
5 Ibid., pp. 58–59.
6 Deppert-Lippitz 1996b, p. 43.

BIBLIOGRAPHY
Duval 1973, pp. 367–74.
Deppert-Lippitz 1996b, pp. 30–71.
Baldini Lippolis 1999, no. 3, p. 144.
Yeroulanou 1999, no. 117, p. 224.

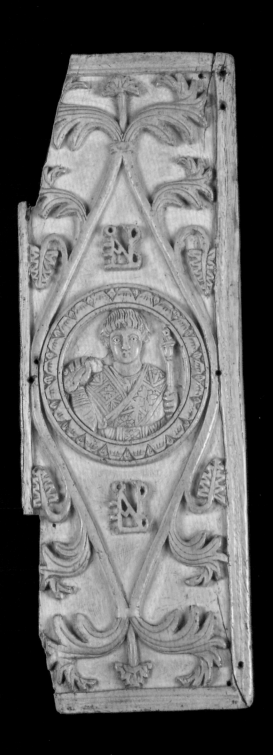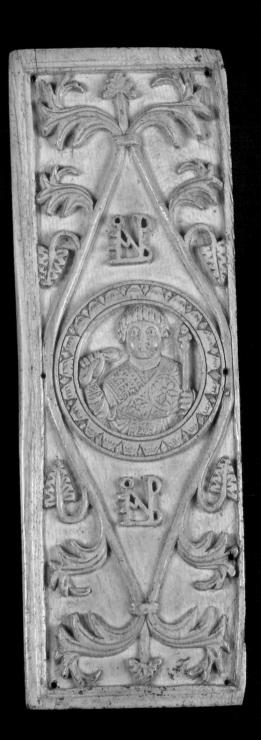

13 Diptych Leaf of Consul Areobindus

506 A.D. ▪ Constantinople (Turkey) ▪ Elephant ivory ▪ H. 13⅜ in. (34 cm); W. 4⅝ in. (11.9 cm); D. 3½ in. (9 cm) ▪ Gift 1951, formerly in the Settala collection in Milan (1759), the Trivulzio collection (1773), the Possenti collection in Fabriano, the Lord Crawford collection in Rome (1892), the Trivulzio collection in Milan (1929), the Montesquiou-Fezensac collection (1934) (DEPARTMENT OF DECORATIVE ARTS, INV. OA 9525)

Dating from late antiquity, "consular diptychs" originated in a Roman custom of gratitude. Individuals elected to the highest civil offices would thank high ranking citizens who had supported their candidacy by sending them a diptych of two ivory writing tablets hinged together and lavishly carved. On a recess carved into the back of these tablets was a thin coating of wax where a message could be inscribed.

In 384 A.D., the use of this type of diptych was restricted to those who had achieved the office of consul, the highest honor of a civil service career. That office was conferred only once a year. Consisting of two panels that featured the same decor, the diptychs were used until the end of the consulate under Justinian in 541 A.D. Since they usually feature the name or monogram of the consul (as does the Louvre piece), the year a consul achieved office precisely dated the monuments. Among the diptychs that have been preserved, the oldest were produced in fifth-century Rome, while sixth-century models were carved in Constantinople. This is probably due to the fact that, after the fall of the Western Roman Empire in 476 A.D., imperial power and its institutions were transferred to Constantinople.

The Louvre diptych was produced in 506 A.D., on the occasion of the consulate of Areobindus. The grandson of consuls, Areobindus was a hero of the war against the Persians and had married Princess Anicia Juliana, daughter of Olybrius, one of the last western Roman emperors. When he died in 512 A.D., Areobindus was in competition with Anastasius to accede to the imperial throne. An exceptionally high number of diptychs and panels in his name remain: two complete diptychs and five individual panels. These are also the oldest of the Constantinople series.

The Areobindus panels correspond to three iconographic types. The first depicts the consul presiding over circus games. The second, which includes the Louvre diptych, features a bust of the Consul within a medallion. The third features two horns of plenty crossed over a basket spilling over with fruit and is represented by a single panel in the Lucca cathedral.

Most of the other diptychs dating from the sixth century are of the first two iconographic types, which have the most symbols of the consular office. Those diptychs that represent the consul always portray him—as is the case here—wearing the *trabea picta*. In one hand he holds the two essential signs of his office, the scepter and the *mappa*, a piece of cloth consuls waved to signal the beginning of the circus games—by the sixth century, the last vestige of the consulate's otherwise long-lost political power. On the Louvre diptych, the medallion featuring the consul's bust sits in the center of a large lozenge formed by branches with stylized leaves that evoke, in particular, the same ornaments used in early sixth-century sculpture in Constantinople. Above and below the medallion, the consul's monogram, in Greek lettering, is carved in high relief.

Consular diptychs were clearly not aimed primarily at acquainting those they were offered to with the specific features of a consul, but rather to propagate an idealized and solemn image of the new honorific office the consul had acceded to through imperial grace. Any attempt at portraiture was superceded by expressive stylizations that served to accentuate the hieratic quality of the central figure, heavily garbed in the conventional symbols of his office, his round, impassive, smooth and stereotypical face enlivened with large eyes. Like other official portraits produced in Constantinople during this era, the diptych of Areobindus provides a perfect early sixth-century example of the application of the neo-Platonic aesthetic inherited from the philosopher Plotinus's meditations: that the material reality of an individual's features be transcended in order to better express the symbolic essence of the honorific office that distinguished him. (J.D.)

BIBLIOGRAPHY
Gori 1759, pp. 105–10.
Volbach 1976, no. 13, pl. 6.
Paris 1992, no. 14, pp. 52–53.
Gaborit-Chopin 2003, no. 7, pp. 45–47.

14 Portrait of Augustus Wearing a Toga

Ca. 10 A.D. (head), ca. 120 A.D. (toga) ▪ Head discovered at Velletri (Italy) in 1777; provenance of toga unknown ▪ Marble ▪ H. 85 in. (216 cm) ▪ Received in exchange in 1815 following the Napoleonic seizure of 1798, formerly in the Vatican collection and the Giustiniani collection (Venice) (MA 1212—INV. MR 100; N 1577) ▪ Restorer: D. Ibled, 2006

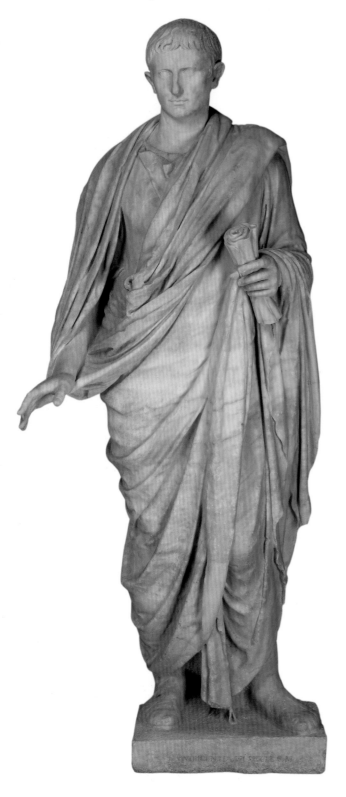

Within the boundaries of the Volscian territories, the town of Velletri is located some 50 kilometers (31 miles) southeast of Rome, on the Via Appia. Between this highway and the village itself, at the place known as San Cesareo, the Gens Octavia (the paternal family of the future Augustus) had a villa. The family was originally from Velletri, where Octavian would spend the early months of his life (Suetonius, *Vita Augusti*, I, 1) before dividing his adolescence between Rome, where his father, Caius Octavius, settled the family near the Palatine, and Velletri, to which he continued to be connected (CIL X 6618; 6630).

It was at another country residence, Montesecco, between Velletri and Lake Nemi, that the head shown here was discovered in 1777.[1] The head was then added to the Giustiniani collection, which by then was already being dispersed; after passing through the hands of a British intermediary, Lyde Brown, and perhaps C. Albacini, it entered the Vatican collections in 1783.[2] It was published in 1784 by E.Q. Visconti, who gave the dimensions of a complete statue at the time of its acquisition ("[Augusto] alto palmi nove e once cinque"), which proves that the mounting of the head upon the toga-clad body took place before it entered the Vatican (in the Pio-Clementino Museum).

This particular type of toga lacks a *sinus* (cat. no. 41) and has some characteristics typical of Hadrian's time: the hem of the toga does not cover the left knee and the cloth is not fitted against the right knee, which does not protrude out of the fabric. The hem is pulled up nearly vertically under the *umbo*, where it disappears; in this particular case, the *umbo* is nonexistent. On the other hand, the rendering of the toga avoids a schematic arrangement, with the parallel folds typical of that era. Instead of heavy and furrowed with grooves, the fabric conveys the anatomy, particularly over the right hip, and volumes of the body. In fact, this Augustus wears his toga like a Greek garment, a simple drape thrown over the shoulders, which closely corresponds to the Hellenistic style in fashion under Hadrian. The arrangement of the few curving folds lends the statue a certain dynamism, but actually that would have displeased Augustus. According to Suetonius (*Vita Augusti*, XL, 8), the emperor was indignant that togas were being replaced by Greek-style mantles in the forum.

Here, the treatment of the hair is very close to the Prima Porta type: a large forelock above the nose forms a pincer with two smaller but clearly delineated locks above the right eye. But the facial features are less timeless and idealized than the Prima Porta type. Strongly ridged eyebrows arch heavily over the eyes; small depressions on either side of the nose accentuate the cheeks and give the mouth a bitter expression. These details, which seem to be a result of the model's age, suggest that this statue should be dated near the end of Augustus's reign. (D.R.)

NOTES
1 Piazza 1797; Bonadonna Russo 1983.
2 Lanciani 2000, pp. 215–16.

BIBLIOGRAPHY
Boschung 1993b, p. 170.
Kersauson (de) 1986, pp. 146–47.
Visconti 1784, II, p. 92, pl. XLV.

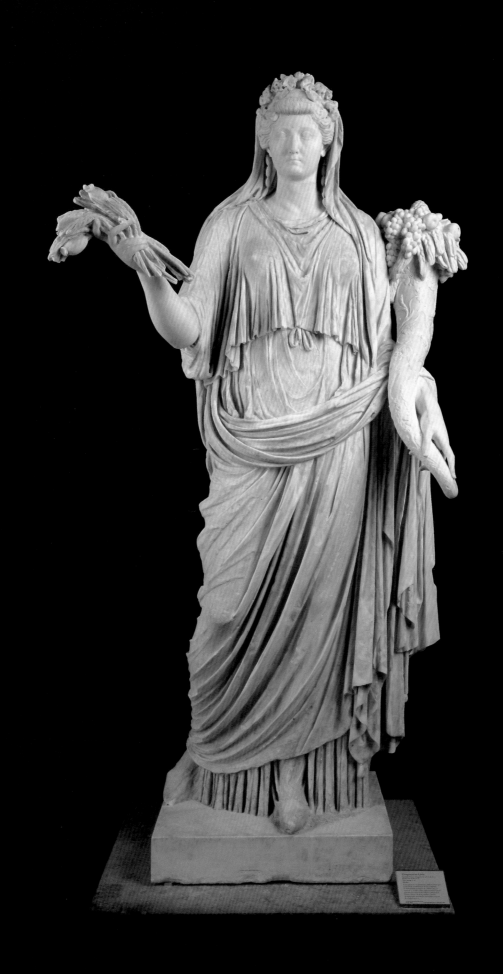

15 Portrait of Livia as Ceres

Ca. 20 A.D. ▪ Discovered in Rome (?) ▪ White marble ▪ H. 86⅝ in. (220 cm) ▪ Purchased in 1807, formerly in the Borghese collection (MA 1242–INV. MR 259; N 80) ▪ Restorers: B. Cavaceppi, ca. 1780, and D. Ibled, 2006

First published in 1796 in *Sculture del Palazzo de la Villa Borghese detta Pinciana*, edited by E. Q. Visconti, this statue of Livia, wife of Augustus, underwent not only many modern restorations but also additions such as the arms, the cornucopia, part of the crown of flowers, and large pieces of veil around the neck. Given these circumstances, it is legitimate to wonder about the sculpture's original appearance.

Its restorers, including B. Cavaceppi, wanted to complete the statue with attributes of the goddess Ceres, or Fortuna, with poppies, ears of wheat, and a cornucopia, but we do not know whether this was a case of restoring lost symbols of divinity or rather a justification for adapting a head of Livia, wearing a crown of flowers, to this statue. What makes a conclusion even more elusive is that whether or not the head belongs to the statue, the restoration is cohesive.

Livia is represented here in a *stola*—a long, full-length pleated robe worn by married women and Roman matrons, and the female equivalent to the toga. She is draped in a *palla*—a simple square mantle wrapped around the body, which here also serves to cover the hair—with long folds falling over the arms in a cold and severe classical style. Worn with or without sleeves, the *stola* looked like a sewn-up sheath. In this case, sleeves were hooked on. It is cinched at the waist by a belt that may be hidden by a hanging fold. Like the toga, it had symbolic value in Roman society, embodying the dignity of a married woman, particularly during official ceremonies. It was emblematic of the restoration of traditional morals that Augustus supported, particularly conjugal fidelity: married to Livia for fifty-two years, Augustus died telling her, "Livia, nostri conjugi memor vive" (Livia, remember our marriage) (Suetonius, *Vita Augusti*, XCIX). Thus it is not surprising for Livia to be depicted in this costume. Suetonius also mentions that Livia's great-grandson Caligula called her "Ulixes stolatus" (Ulysses in a *stola*) (*Vita Gai*, XXIII).

A headless and armless statue discovered in Falerone in the Marches, and now in the Glyptothek in Munich (inv. 367), has some similarities to the statue shown here, including body position (standing with the weight on one hip, the right knee flexed), *palla* draping, sleeves hooked on the *stola*, and veil covering the head.[1] On its base is an inscription (CIL VI 882a) that reads AVGVSTAE IVLIAE DRVSI F—Livia's imperial title as of 14 A.D., the result of an adoption provision in her husband's will. So we know that at this time there was an official type of portrait presenting Livia as a matron, wearing a mantle that, in its drape over the abdomen, suggests representations of Juno, goddess of Roman matrons. The Louvre portrait in fact corresponds to a date after the death of Augustus and accentuates, with its wide face and large eyes, the resemblance between Livia and Tiberius. It also presents the then-seventy-two-year-old Livia with younger-looking features and the hairstyle she wore in her youth, including a *nodus* (a roll of hair over the forehead), three coils of hair edging the temples, small locks escaping over the temples and forehead, and a chignon. Among

the five types of Livia portraits recognized by R. Winkes or the four types defined by E. Bartman, this falls into the Fayoum type.

This Livia wears a crown of flowers and an *infula*, a ritual headband, beneath her veil. The ends of the headband are decorated with pearls and hang down over her neck. The presence of the *infula* may be related to various important priesthoods: it is the insignia of certain priests such as the Vestal Virgins, the Fratres Arvales, and those devoted to Ceres. After the death of Augustus, Livia atained an official rank for the first time and thus became a priestess of the deified Augustus, giving her status equivalent to that of the Vestals. A cameo in the Kunsthistorisches Museum (inv. IX A 95) shows her in that guise—wearing a *stola*, veil, crown, and carrying poppies and ears of wheat—opposite a bust of the deified Augustus.

But the *infula* is also connected to the worship of Ceres. On the Louvre statue, the larger-than-life size of the body and head supports the suggestion that this piece represents a deity. There are other known examples of Livia as Ceres/Fortuna: the seated statue from Iponuba now in the Museo Arquelógico Nacional in Madrid, and a statue from Puteoli now in the Ny Carlsberg Glyptothek in Copenhagen. Thus it is quite possible that the head of the statue shown here belonged to a Livia depicted as the goddess Ceres or Fortuna. If indeed the Louvre statue of Livia depicts a deity, that means it was created after the empress's deification in 42 A.D., under the reign of Claudius, when she became known as Diva Julia.

Clearly, the question of what the sculptor truly wished to depict—was it a matron, a priestess, or a deity?—is complex. The question touches on one aspect of Roman eclecticism. In fact, the sculptor drew upon the whole repertoire of attributes, ornaments, and symbols that were attached to Livia at different times. Each element spoke to the various points of view of the Romans who contemplated the statue. Precluding any conclusion that the statue had one specific function, status, or model, the profusion of meanings here corresponds to one of the features of Roman art: the individualization of representations. The only thing that the artist has allowed us to perceive with certainty here is that this is indeed a portrait of Livia. (D.R.)

NOTE
1 Winkes 1995, p. 193.

BIBLIOGRAPHY
Kersauson (de) 1986, pp. 102–03.
Winkes 1995, p. 148.
Bartman 1999, pp. 146–47.

16 Portrait of Agrippa

Claudian era ▪ Discovered in Philippeville
(present-day Skikda, Algeria) ▪ Paros marble
▪ H. 17⅜ in. (44 cm) ▪ Delamare mission,
1848 (MA 3554–INV. LP 3029; MND 2139) ▪
Restorer: C. Devos, 2005

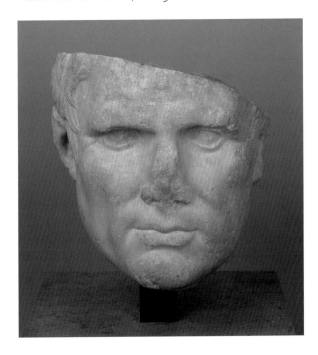

Discovered on the site of the ancient city of Rusicada, this frag-
ment is badly damaged but still has its original surface. Most likely
the head was created out of two pieces of marble: at the back of
the skull, a piece of marble was added and attached with a tenon
to the smooth surface straight above the nape of the neck. The left
rear portion of the head was damaged at some point and then
restored (the plane of the break has been flattened); the tenon
created another break that resulted in the loss of the entire top of
the skull as well as all the patches. Thus for this portrait, one can
observe, as with the head of Germanicus (cat. no. 20), that it was
initially composite and painted, then damaged, restored, and
finally un-restored.

Agrippa seems elderly here, his features gaunt, his forehead
wrinkled. The lower portion of his face is strengthened by a power-
ful lower jaw. The flesh is very finely modeled. Of the twelve or so
portraits of Agrippa discovered to date, there seem to be two origi-
nal types: a portrait bust from Gabii[1] after a bronze original
executed by a Greek artist but now lost, and a statue in Venice, for-
merly in the Grimini Palace but which came from Rome, with
fleshier and more slumped features that give the face a sense of
heaviness and lack of energy. It seems that artists and perhaps
their patrons hesitated to settle upon a definitive style. Thus the
heroic Grimini statue fits within a veristic vein, while the Gabii por-
trait is closer to the classical and timeless ideal seen in portraits of
Augustus. The portrait shown here relates to the emotional realism
inherited from Hellenism.

The hesitation to settle on a definitive style probably reflects
the difficulties that Augustus encountered trying to establish his
regime and defining the laws of succession. By the time Agrippa
died, artists were still unable to settle on one or more set types
located precisely in time.

Agrippa was born in 64 B.C., a few months before Octavian,
with whom he became friends during their studies of rhetoric. He
was constantly at Octavian's side during the civil wars. After the
Brindisi pact, Octavian was left in command of the western por-
tion of the empire (40 B.C.), and he sent Agrippa to Gaul to
reinforce Caesar's conquests. As master of the fleet, Agrippa con-
structed a port and established a navy. Using his wealth, he built
new aqueducts for Rome, restored monuments and put on games.
It was because of him that the future Augustus was victorious in
the naval battle at Actium (31 B.C.), where Marc Antony was elimi-
nated. Triumphant, Octavian became head of state, restoring the
republic, with power shared by two consuls.

In 28 or 27 B.C., Agrippa and Octavian instituted reforms meant
to restore political stability. Agrippa, relying on his immense for-
tune, initiated a policy of public works. At his behest the Campus
Martis was designed and the Pantheon built, along with baths,
porticoes, and warehouse centers. Throughout this period, the
nature of the new regime was becoming defined. In 24 B.C., in the
absence of Augustus, Agrippa organized the marriage between
Marcellus, nephew of Augustus, and Julia, Augustus's daughter.
And in 23 B.C., Augustus, then extremely ill, named Agrippa his
political heir. At that time, he seemed to favor a mode of succes-
sion based on merit, and Agrippa was well known throughout the
empire for the seriousness, determination, and energy that are
reflected in his best portraits. These qualities justified his position
in the state, which is why his portraits have such political
significance.

Leaving on a mission to the East in 23 B.C., Agrippa returned to
Rome in 21 A.D. to marry Julia—Marcellus had died two years ear-
lier and Augustus wished to endow his choice of successor with a
dynastic foundation. More than ever, Agrippa seemed to be
Augustus's heir at that point—first by the nature of his service, and
then by family connection. He and Julia had three sons and two
daughters. But he was often absent from Rome, re-establishing
order and founding colonies in the east and Judea, just as he had in
Gaul and Spain. He died suddenly in 12 B.C., in Pannonia. (D.R.)

NOTE
1 Louvre, Ma 1208 – inv. MR 402.

BIBLIOGRAPHY
Fabbrini 1980.
Johansen 1971, pp. 27–28.
Roddaz 1984, pp. 615–28.
Kersauson (de) 1986, pp. 56–57.

17 Portrait of Agrippa Postumus

Ca. 4 A.D. ▪ Discovered in Alexandria (Egypt) (?) ▪ Basanite ▪ H. 12¼ in. (31 cm) ▪ Seymour de Ricci bequest, 1944 (MA 3498–INV. MND 1961) ▪ Restorer: B. Dubarry-Jallet, 2006

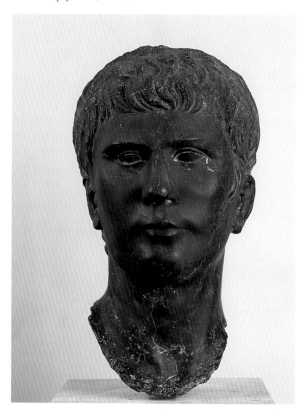

Agrippa Postumus owed his name to being born a few months after the death of his father, Agrippa, in 12 B.C. His mother, Julia, was Augustus's daughter from the emperor's first marriage to Scribonia. Agrippa's two older brothers, Caius and Lucius, bore the name Caesar after their adoption by Augustus, who wanted to reserve imperial succession for them, but their premature deaths in 2 and 4 A.D. thwarted these plans. Henceforth, Augustus resolved to adopt his last blood descendent, as well as Tiberius, Livia's son from her first marriage.

But Agrippa Postumus fell into disgrace, for reasons never made clear by Latin historians. Tacitus (*Annales*, I, III, 3) blames Livia for persuading Augustus to exile him, in 7 A.D., due to his boorish character and an arrogance derived from his physical strength. However, Suetonius (*Vita Augusti*, LXV, 9) writes that Augustus had the senate pass a formal resolution to convert this punishment to a life sentence, which would suggest more serious issues. At any rate, according to Tacitus, after stopping in Sorrento (*Vita Augusti*, LXV, 3), where his family had a villa at Boscotrecase that is famous for its Third Style paintings, Agrippa Postumus was exiled to the island of Planasia, present-day Pianosa (Tacitus, *Annals* I, III, 3).

Tacitus (*Annals*, I, V, 5-VI, 7) also noted that a few months before Augustus's death, he is thought to have visited Agrippa Postumus, and a reconciliation was in progress, but the first act of the new emperor, Tiberius, was to send a centurion to assassinate Agrippa Postumus. The last surviving grandson of August was unarmed and taken by surprise— he fought bravely, but his life was cut short before the age of twenty-six.

The head shown here was initially fitted with a tenon so it could be mounted on a statue. It is sculpted from basanite, a hard stone used in Egypt. The portrait, long confused with portraits of Lucius or Caius Caesar, and even Caligula, was first attributed to Agrippa Postumus in 1958 by F. Chamoux.

For some time now, knowledge of this prince's physiognomy has allowed us to recognize his portraits within the Julio-Claudian family.[1] The modeling of the mouth, where the sculptor has taken advantage of the color of the basanite in a very expressive play of chiaroscuro, the elongated eyes beneath the straight, seemingly knitted brows, and the intensity of the gaze are all indicative that this is Augustus's third grandson. This is particularly well illustrated in the Louvre portrait. Like the face of his father, Agrippa, that of Agrippa Postumus is powerfully structured. His low forehead and strong eyebrows give him an impenetrable air, at once stubborn and determined.

While effigies of Agrippa Postumus are not rare, identifying them is made somewhat more difficult due to the resemblance among the three grandsons, the resemblance between him and his father Agrippa, and the very short period during which their portraits were produced—essentially, from 4 to 7 A.D. Two hair types for Agrippa Postumus have been identified, however.[2] Type 16 Capitoline Gladiatori,[3] like the portrait shown here, has heavy, long locks drawn toward the center of the forehead and arranged in two forks toward the temples.

The age of the young man carved from basanite and the quality of the workmanship have led Type 16 to be identified as an adoption-type portrait, inaugurated in 4 A.D. The other type identified for Agrippa Postumus, Newby Hall, is dated to the period before his adoption, and is so similar to portraits of Caius and Lucius that the body of works constituting this group is far from being clearly identified. (D.R.)

NOTES
1 Kiss 1975, pp. 65–70.
2 Boschung 1993a, pp. 55–56.
3 Identified by Fittschen and Zanker 1983, no. 21.

BIBLIOGRAPHY
Chamoux 1958.
Kersauson (de) 1986, pp. 146–47.
Belli Pasqua 1995, p. 131.

18 Portrait of Agrippina Major

5–44 A.D. • Discovered in Athens •
Marble • H. 15¾ in. (40 cm) • Purchased
in 1909 (MA 3133–INV. MND 848) • Restorer: B.
Dubarry-Jallet, 2006

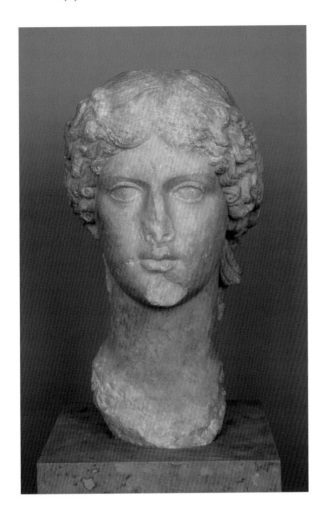

Agrippina Major (or Agrippina the Elder) was born in 14 B.C. to Julia, daughter of Augustus, and Agrippa. In 5 A.D. she married Germanicus, grandson of Livia. They had nine children, including the future emperor Caligula and Agrippina Minor, mother of the emperor Nero and future wife of the emperor Claudius.

Agrippina Major accompanied Germanicus on his campaigns in the Rhineland and the east. After Germanicus died in Antioch in 19 A.D., Agrippina returned to Rome with his ashes. Under the reign of Tiberius, she found herself subject to the manipulations of Sejanus, prefect of the Praetorian Guard, who sought to eliminate potential successors to Tiberius. He convinced the emperor to exile her and her son Drusus to the island of Pandataria (present-day Ventotene, off the coast of Campania), where she died of starvation, as did her son Drusus, in 33 A.D. Her son Nero the Elder was assassinated in 37 A.D.

Portraits of Agrippina were created during three different periods of the first century A.D: at the time of her marriage—which made her the mother of a potential emperor; when her son, Caligula, came to power in 37 A.D.—and collected his mother's remains from Pandataria to place in the mausoleum of Augustus; and at the time of the marriage of Claudius to Agrippina Minor—

who was anxious to insist on their connections to the lineage of Augustus. On the basis of coins and inscriptions, three types of portraits can be identified—since Agrippina's hairstyle, which remains unchanged in the various representations, cannot act as an index for locating the portraits in time: the hair is parted in the center, with two flat, rather loose waves descending low on the forehead, more disheveled locks over the temples that have small curls at the ends and hide the ears. The hair is drawn back and gathered into a bow at the nape of the neck. Two long locks descend from the neck and rest on the shoulders.

The portraits that are easiest to identify are those dating to the time of Caligula, when relatively large numbers of coins were issued. A portrait discovered among the set from the basilica at Valleia and now in Parma (1952.829) is from this period. It is a posthumous portrait, where Agrippina appears strongly idealized. It is on the basis of physiognomic parallels, shared attributes in hairstyles, and comparisons with coins that other portraits, such as Capitoline 421, are dated.

The Claudian phase is characterized by harsher, more schematic features. By that time, it is no longer a question of idealizing Agrippina Major, but of indicating the connection with her daughter Agrippina Minor. Thus, Agrippina Major's hairstyle, like that of her daughter, is more orderly: the curls over the temples and ears are divided into two or three rows, the locks on the shoulders are now helix-shaped, hanging down the neck. In the Louvre portrait, these specific traits are not present, even if the hairstyle is already simplified, compared to portraits that date with certainty to the era of Caligula.[1]

As for portraits dating to the era of Tiberius, prior to Agrippina's exile, they are reputed to be more veristic, but given the dominant tendency toward idealization in portraits of the imperial family during this period, and the so-called "provincial" deviations from official portraits, as seen in certain portraits executed far from Rome, it is difficult to attribute one effigy or another to this period. In any case, the portrait shown here bears no trace of provincialism. On the contrary, the turn of the neck and the sensitivity of the modeling, along with the great regularity of the features, imbue the work with an expressiveness that occasionally precludes an idealized style, and in this case reveals a Hellenic influence. However, this does not facilitate dating the work—all the more so because another portrait from Cyrene,[2] in an entirely different context, shows the same sensibility and can definitively be dated to the Claudian era. (D.R.)

NOTES
1 Wood 1988, pp. 412–13 and no. 15.
2 Anti 1928.

BIBLIOGRAPHY
Kersauson (de) 1986, pp. 132–33.
Tansini 1995, p. 66, fig. 17–18.

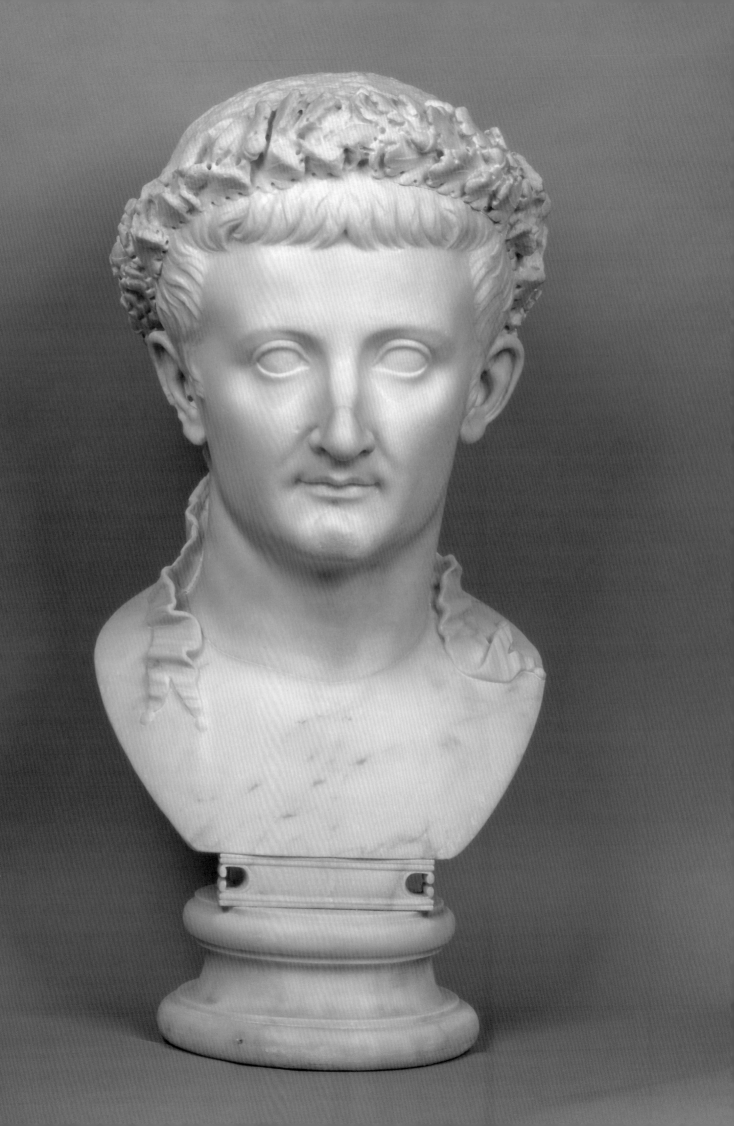

19 Portrait of Tiberius

Ca. 37 A.D. • Discovered in Gabii, near Rome, 1792 • White marble • H. 22½ in. (57 cm) • Purchased in 1807, formerly in the Borghese collection (MA 1239–INV. MR 663) • Restorers: G. Pierantoni, 1792, and G.-L. Barthe, 2003

Found under the same circumstances as those surrounding the discovery of the bust of Septimius Severus (cat. no. 9), this portrait probably came from the forum's Augusteum (a shrine dedicated to the imperial family).

In his analysis of Julio-Claudian portraits, D. Boschung categorizes six distinct prototypes for portraying Tiberius.[1] In this portrait, the hair is combed forward, with short bangs over the forehead, formed by straight and regularly laid locks that open in the center in a little fork. At the right and left edges of the bangs, the strands overlap like pincers. This type of hairstyle puts the portrait in the "Chiaramonti" category, a type that seems already to have existed in the time of Augustus but which endured through the reign of Tiberius and continued to be used after his death in posthumous portraits. The head's massive scale, idealized and abstract features, and inexpressive eyes all suggest that this portrait was made after Tiberius's death.

The characteristics of this head closely resemble those of the head of Tiberius found in the theatre in Cerveteri (the Roman Caere). That head has the same triangular-shaped face, widely spaced round eyes, aquiline nose (despite severe damage), small, carefully modeled mouth with a slightly protruding upper lip, and prominent chin. It was set in a colossal seated statue, recalling representations of Jupiter Verospi; other imperial portraits, including a representation of Claudius in the same pose, also decorated the theatre.[2] Phidias first developed this statuary prototype for his depiction of Zeus in Olympia (437–432 or 432–428 B.C.); it was widely used as a model for representations of Roman emperors, such as Augustus on the Gemma Augusta in Vienna, and another statue of Claudius discovered in Leptis Magna.

Whether or not the head shown here was used in Gabii in a representation of the Jupiter Verospi type is still subject to speculation. Pierantoni's restoration eliminated any remaining trace of the base for mounting the head, although the shape of the *leminisci* (ribbons attached to the crown), which may have flowed over the shoulders before they were gathered on the torso in a modern restoration, leaves this possibility open.

The oak leaf crown seen here was usually bestowed *ob cives servatos*—to those who had saved the lives of Roman citizens. Augustus, who had put an end to civil war, was a deserving recipient. Tiberius, who was frequently a victor on the battlefield in his youth, also earned this honor. But the oak leaf crown in gold was also a funerary offering, as was the one in the Antiquarium of Munich's Residenz.

Various medallions of Domitian, Hadrian, and Antoninus Pius bear the image of Jupiter Victor or Capitoline, based on the inspiration of Phidias's statue in Olympia wore a laurel crown. On the other hand, coins from Elis dating from about 430 B.C. show that Phidias's statue in Olympia wore a laurel crown. However, an inscription (CIL VIII 6982, in the Louvre's collection) originally from Constantine (known as Cirta by the Romans) describes a statue of Jupiter Victor that stood in the city's capitol, wearing a crown of twenty-five oak leaves and fifteen acorns. The reutilization of the Verospi model, then, is an excellent example of Roman eclecticism.

The oak-leaf diadem—a mark of honor, a funerary present, or an attribute of the god of victory—never appeared in portrait sculptures or coins depicting the living Tiberius. When Augustus died, Tiberius requested that the Senate elevate his predecessor to the position of a god; by right of adoption, Tiberius would then be in a position to claim the title of *divi filius* (son of a god), although he was never actually deified himself. Nevertheless, upon his death, Tiberius received divine honors within the general framework of the cult of the imperial family, as encouraged during the reigns of Caligula and Claudius. The growth of this cult was aided by the ambiguous significance of motifs such as the oak leaf crown, as well as the Roman artistic convention of depicting rulers with god-like attributes without actually laying claim to their divine status. Instead, such depictions were justified by a pretext of reverence for Hellenistic artistic models.

Tiberius Claudius Nero, son of Tiberius Claudius Nero and Livia Drusilla, was born in 42 B.C. Shortly after his birth, his mother divorced her first husband in order to marry Octavian. Tiberius was first married to Vipsania Agrippina, the daughter of Agrippa, in 16 B.C., but after Agrippa's death in 11 B.C., Augustus compelled him to marry his daughter Julia, who was Agrippa's widow. Although Tiberius was an excellent general who achieved considerable diplomatic and military success, he did not win Augustus's favor. Angered by the emperor's attitude, he retired to Rhodes, where he lived from 6 B.C. until 4 A.D. when Augustus, who had adopted grandsons Caius and Lucius Caesar as his successors, was compelled to adopt Tiberius after their deaths in 2 and 4 A.D. Tiberius then succeeded as emperor in an orderly transition in 14 A.D.

During the early years of his reign, Tiberius demonstrated scrupulous respect for republican principles. But he spent his last years in Capri, far from Rome, surrounded by his court. He remained in power until his death in Misenum (Capo di Miseno) in 37 A.D. (D.R.)

NOTES
1 Boschung 1993a, pp. 56–58.
2 Giuliano 1957.

BIBLIOGRAPHY
Kersauson (de) 1986, pp. 162–63.
Rome 2003, pp. 316–17.

20 Portrait of Germanicus

Ca. 4–14 A.D. ▪ Discovered in Rome (?) ▪
White marble ▪ H. 11⅞ in. (30 cm) ▪
Purchased in 1988 (MA 4712–INV. MNE 937) ▪
Restorer: B. Dubarry-Jallet, 2006

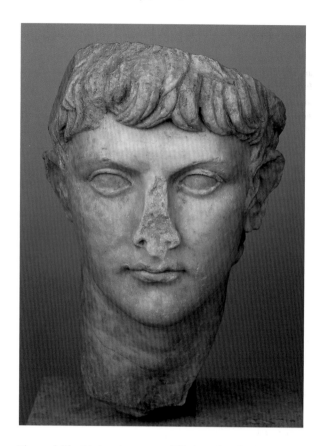

The model for this bust has proven difficult to identify. The hairstyle does not match those of Augustus, whose drooping eyebrows more closely framed the eyes. Nor does the portrait resemble those of any of Augustus's grandchildren: Caius, Lucius Caesar, and Agrippa Postumus. Clearly executed after Caius's death in 4 A.D., the face represented can therefore only be that of Germanicus, Livia's grandson, who married Agrippina the Elder, Augustus's granddaughter, in 5 A.D.

Between his adoption by his uncle Tiberius in 4 A.D. and the death of Augustus ten years later, Germanicus frequently accompanied Augustus on military campaigns. During this period, portraits like this one proliferated. The piece can be dated to this time, between 8 and 10 A.D. (as can the heads in the British Museum 1883 and 1884, the Munich Residenz, and the Louvre Ma 3135). Cast aside by Tiberius after 14 A.D., Germanicus would only begin to be represented again, posthumously, as of 19 A.D.

Three hairstyle types are granted to Germanicus; the "Béziers," "Gabii," and "Corinto-Stoccarda" types. K. Fittschen has pointed out the similarities between the "Corinto-Stoccarda" capillary features and certain hairstyles worn by Tiberius, Caligula, and

Claudius, which would make the "Corinto-Stoccarda" a posthumous type just like the "Gabii" type.[1] But this concurrence seems unlikely, since another type, the "Béziers" type, is still evident in 23 A.D. Therefore Fittschen determined that portraits of the "Corinto-Stoccarda" type are not in fact of Germanicus. The Louvre's new acquisition thus reinforces a type that poses a fundamental problem in the chronology of portraits of Germanicus.

In its current state, this male head appears as a mask consisting simply of the face and the front of the neck. The back of the sculpture was cut away on three planes: a vertical or occipital plane, a nearly horizontal or summit plane, and an oblique or right temporal plane. Beneath the Adam's apple, the neck has been broken along three lines. Traces of polychromy have survived in the hair, particularly in the hollows of the locks on the right side of the head and above the left eye. The polychromy consists of a calcium carbonate mixed with red ochre, typical of mineral pigments. Traces of paint on the eyes were observed during the restoration.

Roman-era heads originally constructed out of several pieces are quite an enigma. The hair, lips, eyes, and clothing were most often given a coat of paint to conceal joints and fillings, offsetting any aesthetic drawback of making the heads out of several pieces. The technique was the result of economic, social, and technical factors: sculptors, mostly Greek artisans both poorly paid and ill-considered in Rome, found the cost of raw materials too high to be able to abandon large pieces of marble. It is also likely that in an attempt to divide labor, actual portraits were sculpted by a specialist, while the hair was made by a younger or less talented workman from one or two pieces already added to the head. An unsuccessful portrait was therefore not of any great consequence.

It has been suggested that this portrait could be of the *velato capite* type known to include two portraits of Germanicus. Yet here the bond lines are not symmetrical: the line above the left temple does not correspond to the one on the right. Joined surfaces were crafted in a different manner. Originally, the top of the skull was set on a join bed studded with small recesses. Following an accident, the back of the head had to be planed down to attach a piece with a mortise; the top of the skull, now loose, was reattached with the same system. A shock to the right temple probably required the attachment of a third element, which was simply glued, possibly in the modern era. This second accident probably caused the irregular break around the neck. A third mishap may have led to the head being abandoned and, later, to all the additions being removed. (D.R.)

NOTE
1 Fittschen 1987.

BIBLIOGRAPHY
Kersauson (de) 1990.

21 Portrait of Claudius

Ca. 50 A.D. (head), ca. 120 A.D. (toga) ▪
Provenance unknown ▪ Marble ▪ H. 52⅜ in.
(133 cm) ▪ Purchased in 1807, formerly in the
Borghese collection (MA 1211–INV. MR 3387) ▪
Restorer: N. Imbert, 2005

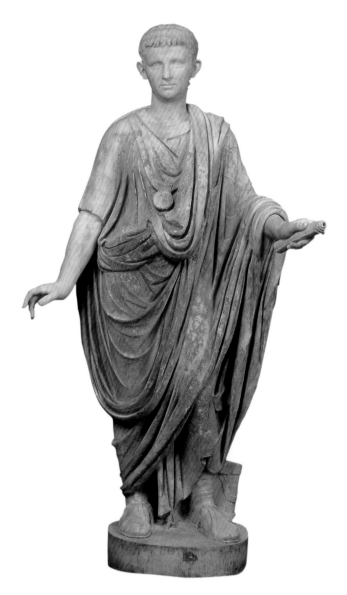

Claudius—Tiberius Claudius Nero Drusus—was Livia's grandson.
Livia had a son from her first marriage, Drusus Decimus Nero,
known as Drusus the Elder, who married Antonia the Younger
(daughter of Mark Antony and Octavia the Younger, the sister of
Augustus). They had two sons: Germanicus and, in about 10 B.C.,
Claudius.

Claudius was a clumsy, stuttering child, sickly by nature and
generally disregarded even by his own family. Instead of being
given any significant official duties, he was relegated to studies.
Finally, when he was more than forty-five years old, Caligula offered
him the responsibilities of consulship. According to Suetonius,
when Caligula was put to death by the Praetorian Guard in 41 A.D.,
Claudius cowered behind a tapestry (*Vita Claudi*, X, 1), fearing that
he would share the same fate. Instead the guards proclaimed him
emperor when they discovered him. He was then forty-nine.

A good ruler who knew history and philology, Claudius is cred-
ited with writings on the ancient Etruscan language, which was
then almost extinct. Reorganizing the administration of the empire,
he delegated important responsibilities to highly competent freed-
men. He constructed aqueducts and expanded the port of Ostia.
Born in Lugdunum (now Lyon), he maintained a liberal policy
toward the inhabitants of the provinces and offered many of them
Roman citizenship. Many towns were given the status of munici-
palities *(municipia)* and colonies. In 43 A.D., he brought Brittany
(now Great Britain) into the empire through conquest and rein-
forced the frontier along the Rhine, but surrounded by intrigues in
his court, he could not arrange a peaceful transition to the throne
upon his death.

This head of Claudius was mounted much later on the body of
a boy wearing a *bulla* (a boy's neck ornament). The head portrays a
man long past the age when he would have worn a *toga praetexta*
(the purple-bordered garment worn by children on formal occa-
sions). It should not be considered a portrait of Claudius as a
youth; at that age, living in obscurity, he had few ambitions and
was likely never represented.[1]

Though of fundamental importance in the evolution of imperial
portraiture, portrait types of Claudius have not benefited from the
kind of exhaustive study applied to representations of many other
emperors. The existence of the Cassel type, where Claudius has
smooth, idealistic, youthful features, has caused some to believe
that there were in fact portraits of him in his youth. But studies
carried out on coins reveal that this type actually dates from the
first months of Claudius's reign and was soon superceded by the
so-called Haupttypus model, which featured realistic details, in
contrast with the Julio-Claudian tradition.[2]

The Cassel type seems to have been developed in haste, consis-
tent with the principles inaugurated by Augustus; the limited
distribution of the prototype (the original model from life) pre-
vented the propagation of a uniform Claudian model. It reflects the
waning of the classicizing approach to representation, developing
a new formula that is well illustrated by the portrait shown here.

The bone structure is prominent, the cheeks hollow; deep creases
run from the eyes to the cheeks and from the nose to the corners
of the mouth. The eyes appear small and sunken. The head has a
characteristic triangular form with a narrow lower face, prominent
ears, and a wide forehead accentuated by the linearity of the bangs.
While it may be risky to attribute psychological content to a Roman
portrait, it is nonetheless striking that an emperor so mocked for
his ugliness chose to be depicted in the unprepossessing reality of
his actual appearance. As mentioned in the entry on Augustus
(cat. no. 2), emperors strove to establish close ties with their sub-
jects. This tendency encouraged a revival of traditional, more
veristic portraits based on republican models, a trend that reflected
a predominantly aristocratic approach to portraiture.

Here, the toga leaves the left knee uncovered, showing the
folds of a *lacinia* (lower border) that does not touch the ground.
The *sinus* (large overfold in front of the body) is rather narrow and
stiffly rendered, suggesting a date at the beginning of the second
century, during the reign of Trajan or Hadrian (cat. no. 14). (D.R.)

NOTES
1 Balty 1963; Stuart 1938.
2 Massner 1994.

BIBLIOGRAPHY
Kersauson (de) 1986, pp. 186–87.

22 Portrait of Caligula

Ca. 40 A.D. ▪ Discovered in Rome on the
Aventine Hill ▪ Marble ▪ H. 71⅝ in. (182 cm)
▪ Purchased in 1861, formerly in the Campana
collection (MA 1267–INV. MR CP 6406; MNE 837) ▪
Restorer: Ch. Devos, 2005

Born in 12 A.D. in Antium (now Anzio), Caius Julius Caesar
Germanicus, better known as Caligula, was the youngest of nine
children, the son of Agrippina the Elder (Augustus's granddaugh-
ter) and Germanicus (the grandson of Livia and brother of
Claudius). At the age of twenty-five he became emperor. The popu-
larity of his father, who had died in 19 A.D., earned him considerable
adulation from the Roman people, who placed their hopes in him
following the reign of Tiberius, but they were soon disappointed.
Caligula's health was poor; he was incapable of enforcing a coher-
ent political strategy and soon showed obvious signs of mental
instability. He was put to death by soldiers of the Praetorian Guard
in 41 A.D.

This portrait shows why representations of Caligula have long
raised issues regarding identification. Compared to the portrait of
Tiberius (cat. no. 19), it is evident that Caligula copied his uncle's
hairstyle, known as the Chiaramonti Type. This hairstyle continued
throughout Tiberius's reign and even after his death, and was the
style most often used in representations of Caligula. Interestingly,
this close imitation of Tiberius accurately reflected the docility
demonstrated by a young Caligula when summoned, as a youth, to
Tiberius's court in Capri: "Sit dictum nec servum meliorem ullum
nec deteriorem dominum fuisse" (They say there is no better slave
nor worse master) (Suetonius, *Vita Gai*, X, 4).

In this portrait, Caligula is shown seated. The body does not
correspond to the head, which was subjected to numerous repairs
over the course of the nineteenth century, when it was part of
the Campana collection, but this pose was commonly used in
imperial statues and is seen in depictions of emperors when they
are shown in divine form, such as the Verospi Jupiter model (cat.
no. 19). Augustus is also shown in this fashion on the occasion of
his apotheosis in the Gemma Augusta, a cameo in Vienna's
Kunsthistorisches Museum.

In the case of the Louvre statue, the absence of divine attributes
suggests that the emperor is being shown in his political role.
Seated as if ready to grant an audience to standing supplicants, his
pose demonstrates his power. Similarly, Augustus is shown on a
skyphos from the Boscoreale Treasure (Bj 2366) sitting on a curule
chair (a folding seat reserved for the most important dignitaries) to
accept the barbarians' surrender.

As on that vase, the left leg of the seated statue is bent and a
wide fold of the toga is draped over the knee. The statue's toga's
style can be dated to the first century A.D.[1] It is striking how quickly
the new regime had developed an iconography of power using a

limited number of representational types. Filled with symbolic
imagery, these were repeated over and over. This prototype allowed
the emperor to be consistently shown in a form that emphasized
the powers invested in his office.

A description of the Emperor Caligula reads as follows:
"Gracilitate maxima cervicis et crurum, oculis et temporibus con-
cavis, fronte lata et torva... quacumque de causa capram nominare,
criminosum" (His neck and legs were spindly, his eyes and temples
sunken, and his brow was wide and threatening...it was considered
a criminal offense to mention the word *goat*...) (Suetonius, *Vita
Gai*, L, 1). The portrait shown here does indeed have some of those
characteristics: a wide forehead, sunken temples and jutting jaw,
the back of the head rising vertically from the nape of the neck, the
hair falling down behind, giving the impression of an extremely long
neck. These features give the emperor the look of a goat, a resem-
blance that is particularly striking in the cameo in the Metropolitan
Museum of Art (11.195.7) and fragment 128 in Aquileia's Museo
Archeologico Nazionale. In this last work, Caligula is immediately
recognizable from just the mouth, the chin, and the right cheek,
which are all that remain of the original portrait.

Caligula's reign was too short for his portrait type to undergo
significant change. Two cameos, in the Bibliothèque Nationale
in Paris and in the Louvre (Bj 1845), show Caligula as a child. It is
possible that his resemblance to his father Germanicus was then
deliberately emphasized by his hairstyle.[2] On the other hand, two
other portraits—one in the Antiquario Flegreo in Pouzzole from the
forum in Cumae, and the other in the museum in Fossombrone—
show Caligula with a new hairstyle and the features of an older man.
Thus it is clear that during his brief reign, Caligula made no effort to
embellish his image or conceal the features of his far from comely
face. Considered in this light, his portraits mark a timid change in
the development of idealized portraiture as inaugurated by Augustus
and continued by Tiberius, and anticipate further changes in portrai-
ture that would take place during the reign of Claudius. (D.R.)

NOTES
1 Goette 1990, p. 154, no. 16.
2 Boschung 1989, pp. 58–60, pp. 100–01.

BIBLIOGRAPHY
Kersauson (de) 1986, pp. 178–79.
Boschung 1989, p. 107, pl. 2.

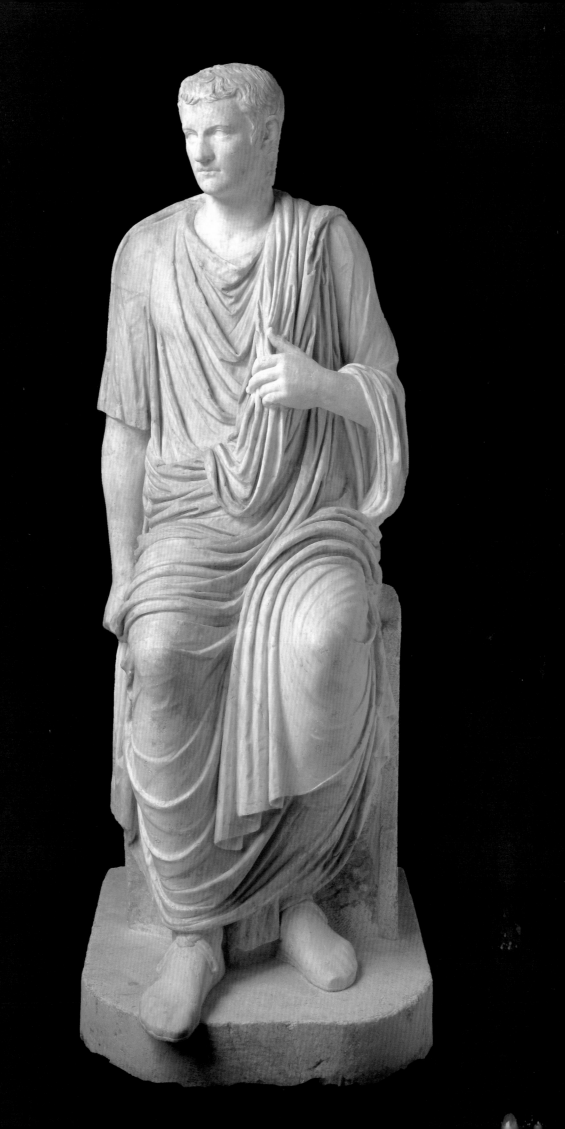

23 Portrait of Nero as a child

Ca. 50 A.D. ▪ Provenance unknown ▪ Fine-grained marble ▪ H. 54⅜ in. (138 cm) ▪ Purchased in 1807, formerly in the Borghese collection (MA 1210—INV. MR 337; N 1580) ▪ Restorer: D. Ibled, 2005

When Claudius came to the throne, he was the last of the Julio-Claudians of his generation to take control of the empire. Only his legal heirs could legitimately succeed him. Claudius and Messalina's one child, Britannicus, was seven years old when his mother was murdered in 48 A.D. as part of a scheme plotted by Agrippina the Younger. Agrippina, the granddaughter of Julia and Agrippa and great granddaughter of Augustus, planned to make Nero, her son from her first marriage, Claudius's successor. She married Claudius in 48 A.D. and managed to convince him to adopt Nero two years later. Following the death of Claudius in 54 A.D., Nero became the emperor Tiberius Claudius Nero. Just a year later, Agrippina had Britannicus poisoned. Nero was then eighteen years old.

Claudius's adoption of Nero occurred one year before Nero reached his legal majority at the age of fourteen and donned the *toga virilis* (adult man's toga). The adoption made Nero his presumptive heir, and Nero's image had to be promptly disseminated throughout the empire. The Louvre and the Museo Archeologico Nazionale di Parma have almost identical portraits of a young boy wearing a *toga praetexta* (a purple-bordered toga) and *bulla* (ornament worn around a child's neck). The statue in Parma comes from the basilica in Velleia, where it was found with other Julio-Claudian portraits, including a depiction of Claudius.

Comparisons with coins bearing the image of Britannicus exclude the possibility that this is a portrait of Claudius's natural-born son. The hairstyle is very similar to what is seen in the last Claudian portrait images, known as the Turin type, which feature hair combed very straight over the forehead and parted in a little "fork" over the nose or over the inside corner of the right eye. This hairstyle was worn by Claudius in the Sebasteion (a temple dedicated to the cult of the emperors) in Aphrodisias. The similarity of hairstyles emphasized the close affiliation of Claudius and Nero, though they had no actual blood tie.

Although here Nero's mouth is already rather small and fleshy and his eyes appear sunken under low-arched brows, his face still has childlike appeal. However, the trend toward greater realism in imperial portraiture inaugurated under Claudius continued during Nero's fourteen-year reign; thus the facial model in the four portrait types changed considerably as the young man matured physically: the hairstyle gained more volume, becoming more elaborate and even extravagant—probably with the aid of curling irons. The facial features became coarser, and the expression turned grim and hostile.[1]

These changes represent more than just a quest for accurate depictions. The late portraits of Nero are striking because they demonstrate an approach to art that is aimed at producing a specific effect. These portraits reflect Nero's aesthetic preoccupations and his determination to provocatively confront the veristic pattern of the time of the Republic, as well as the Augustan imperial ideology, which was based on balance, moderation, and a respect for traditional forms. In 69 A.D., Nero would pay for this attitude with his life. (D.R.)

NOTE
1 Hiesinger 1975.

BIBLIOGRAPHY
Kersauson (de) 1986, pp. 210–11.

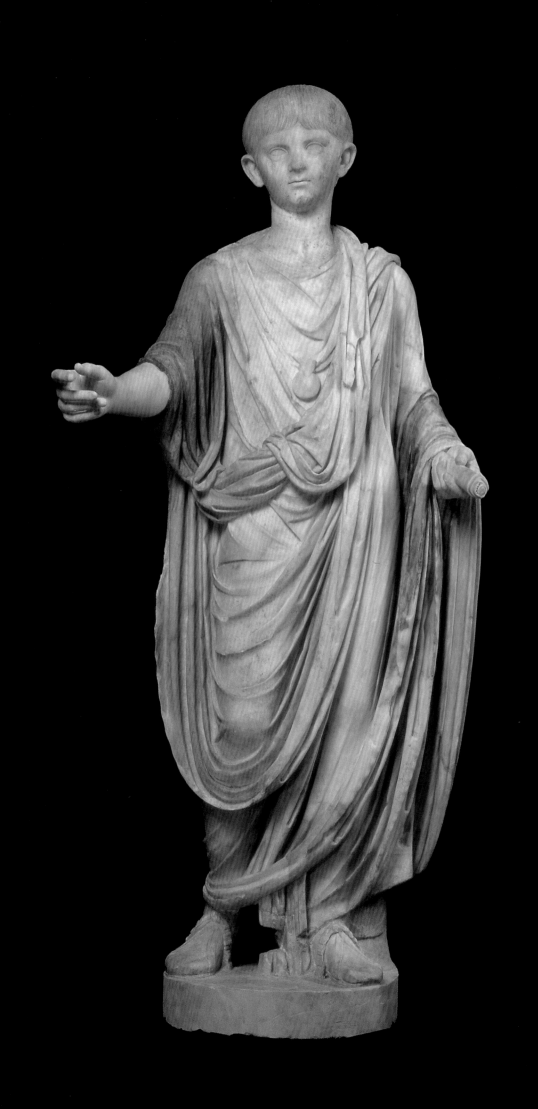

24 Maritime Theater Reliefs

Ca. 125–130 A.D. • Discovered in Tivoli (Italy), Villa Hadriana • Marble • H. 9½ in. (24 cm); L. 19½ in. (49.5 cm) • H. 9½ in. (24 cm); L. 21¼ in. (54 cm) • H. 9½ in. (24 cm); L. 19½ in. (49.5 cm) • Revolutionary seizure in 1798, formerly in the Albani collection (MA 151–INV. MR 746; MA 1575–INV. MR 744; MA 152–INV. MR 745) • Restorer: V. Picur, 2000

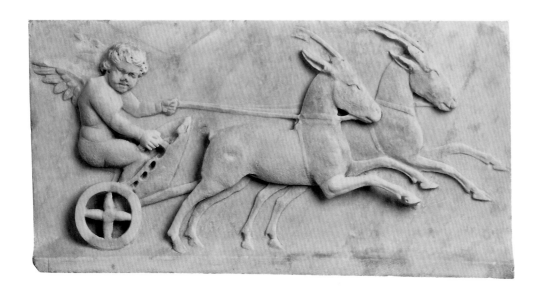

The frieze's three slightly concave panels are decorated with cupids driving chariots drawn by two antelopes, two dromedaries, and two boars. As attested to by several drawings and a description by Pirro Ligorio,[1] the panels were found in the sixteenth century in the Villa Hadriana in Tivoli, specifically in the ruins of the "maritime theater"—a miniature circular *domus* that was a favorite retreat of the emperor Hadrian (117–138 A.D.). A few panels from friezes that originally decorated the building have been returned to the villa, while others have been dispersed between collections in London, Rome, Berlin,[2] and Paris. In some cases, the original emplacements of these representations of marine processions and chariot races remain uncertain.[3] For instance, the cupid driving a two-wheeled chariot drawn by gazelles appears against a flat background, on a panel that has a slightly different curvature than the other two examples in the Louvre collection, which are more concave and joined together. Moreover, the teams in these last two panels appear against a background evoking a hippodrome, or, more specifically, a *spina* adorned with Corinthian columns, with dolphins to count the number of laps, and an obelisk decorated with fanciful hieroglyphics. This suggests that the panels might belong to two different friezes among the several decorating the theater's circular or semi-circular porticoes. Representations of actual chariot races with cupids as charioteers were particularly popular in Rome and were mainly found on a style of sarcophagus produced as of 125–130 A.D. (cat. no. 140), as well as on the mosaics of Volubilis, Carthage, or Piazza Armerina.

The Louvre panels are stylistically similar to panels on other friezes from Villa Hadriana, including those on the central nymphaeum of the Piazza d'Oro, which was probably produced by the same workshops. (L.L.)

NOTES
1 Vermeule 1960, no. 137, p. 121; n. 511, p. 33, fig. 100. Piro Ligorio, *Trattato di Tivoli o della Villa Hadriana*, manuscript Vat. Lat. 5295, f° 11v-12v.
2 British Museum, GR, 1805.è-3.133; Vatican, Amelung 1908, no. 158, pl. 38, Berlin, Staatlische Museen, SK 904.
3 The chariot race traditionally took place in the large annular portico that ran around the outside of the canal surrounding the circular island, but the curvature of the Louvre panels do not correspond.

BIBLIOGRAPHY
Vogel 1969, p. 158.
Caprino and Üblacker 1985, p. 81.
Toulouse 1990, pp. 133–34, no. 94.
Martinez 2004a, pp. 424–25, nos. 857–59.

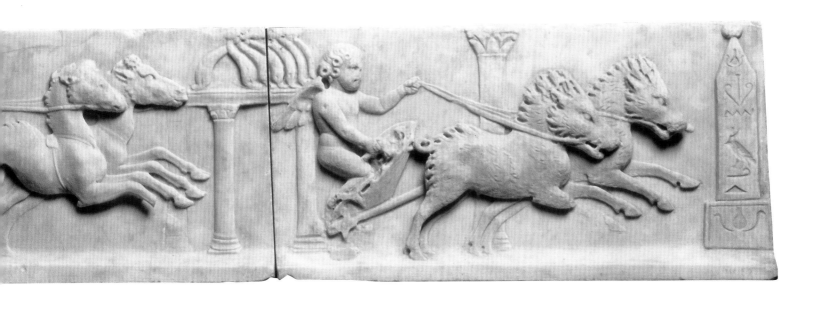

25 The Lansdowne Paris

Early 2nd century A.D. • Discovered in Tivoli (Italy), Villa Hadriana, by Gavin Hamilton in 1769 • Marble • H. 65 in. (165 cm) • Purchased in 1988, formerly in the Roger Peyrefitte collection and the Lansdowne collection (sold March 5, 1930) (MA 4708–INV. MNE 946) • Restorer: V. Picur, 2001

The right forearm, left arm, legs, torso, and plinth of this statue are modern; the head has been completed and reworked. Correspondence between the Scottish artist Gavin Hamilton and Lord Townley indicates that fragments of this statue were discovered in Tivoli in 1769, in the Pantanello, which, as the lowest area on the site of Hadrian's former imperial villa, had turned into a marshy lake. The excavation uncovered about forty mutilated marble pieces left in disorder at the end of antiquity. Once restored, the reassembled statues were put on the booming market for Roman antiquities sustained by the demand from English aristocrats returning from their "Grand Tours" with collections of souvenirs. In 1772, Hamilton sold this statue to William Fitzmaurice, second count of Shelburn, following his passage through Rome in 1771. The future prime minister (from 1782 to 1783) was made Marquis of Lansdowne in 1784.

Lacking any specific attributes, the identification of the Lansdowne statue long remained uncertain. A single clue, the Phrygian cap, tended to indicate an Oriental model. Comparing it to a famous statue in Kassel, experts theorized that it represented Attis, or Atys, lover of Cybele, Mother of the Gods, but the subject of the Kassel statue is equally doubtful. Others drew on several statues (in the Vatican, villa Torlonia, Musei Capitolini, and the Farnese Collection in Naples) representing Ganymede turning toward an eagle hovering above him, advancing the theory that the Lansdowne statue might be a decorative variant depicting the cupbearer captured by Zeus.

Yet the attribution of the prototype for a figure leaning on its right arm led to identification. Indeed, it had long been noted that this type of statue was known through numerous replicas (in the Vatican's Gallery of the Candelabra, Kassel, Copenhagen, and a statuette in the Villa Borghese), so it was assumed that it reproduced a famous original. The crossed legs, the support's integration in the composition, the male nude's youthfulness, and the languor of the facial expression evoke the influence of a fourth-century B.C. statue. This has led experts to attempt to establish a connection between these statues and a literary description of a Paris-Alexander by Euphranor, an Athenian sculptor of the fourth century B.C.

Pliny the Elder (*Natural History* XXXIV, 77–78) vaunts a Paris Alexander: "both judge of the goddesses and lover of Helen, yet also murderer of Achilles." This identification is by far the most likely for this statue: the Phrygian cap characterized Paris both on Greek vases of the middle of the fourth century B.C., and, reaching back to about 500 B.C., on the west pediment of the Temple of Athena Aphaia on Aegina.

On the other hand, the Lansdowne statue's nudity is highly unusual, as Paris is generally shown in oriental garb, and nearly all other replicas depict him with a mantle thrown over his shoulders. Should we accept the attribution to Euphranor? Our understanding of this painter and sculptor's style has been considerably expanded and updated by the discovery of several of his originals. Unfortunately, none of these clothed pieces, among which the Apollo Patroos in the Athenian Agora and the Piraean Athena are most prominent, allow a close comparison with the Lansdowne Paris's statuary type.

Still, the Lansdowne statue serves as a good example of a category of works selected to decorate the Tivoli villa, despite the fact that we do not know their initial location. Several modestly sized male nudes, all replicas and pastiches of the second classicism, were found in the Villa Hadriana. The Capitoline Faun attributed to Praxiteles, for instance, was assumed to be one of the works chosen to decorate the villa. A replica of the Cincinnattus attributed to Lysippus, which later entered the Lansdowne collection and is now in Copenhagen, and the replica of the Eros of Centocelle, now in Saint Petersburg, were also discovered in the same area. The Fould Satyr (cat. no. 26) and the Lansdowne Paris both belong to the repertoire from which sculptors working for Hadrian drew the models for certain effigies of Antinous, notably for the so-called Antinous Albani in the Musei Capitolini. (J.-L.M.)

BIBLIOGRAPHY
Michaelis 1889, p. 22, no. 39.
Dacos 1961, pp. 371–79, no. 2, fig. 4.
Palagia 1980, pp. 32–34, no. 3.
Raeder 1983, pp. 42–43, no. I, 16.

26 The Fould Satyr

2nd quarter of 2nd century A.D. • Discovered in Tivoli (Italy), Villa Hadriana, in 1782 • Marble • H. 52 in. (132 cm) • Purchased in 1860, formerly in the Fould collection (MA 318–INV. NIII 1034) • Restorer: V. Picur, 2005

Based on an account by P. E. Visconti, A. Chabouillet has suggested that this statuary is that of two satyrs—an older boy and a young child—discovered in Emperor Hadrian's villa in Tivoli during the excavation carried out on the estate of Count G. B. Centini in 1782.

The boy satyr stands with one leg crossed nonchalantly as he leans his head to the right. A faun skin around his shoulders also wraps around his left arm, and he holds a large *pedum* (crook) at his side. The two little horns at the top of his forehead, peeking through hair wreathed in bulrush, indicate that he is a faun as well as a satyr. At his side leans the figure of a child, sculpted against the tree trunk that supports the duo. The child rests his right hand on the back of the older satyr's thigh while taking a step to his right. He is holding what was generally assumed to be a small *pedum* tipped upside down.

The older satyr's head, once broken at the neck, has been returned to its place. The only modern additions to the piece are the older satyr's right arm and penis, the tip of the child's nose, and the base's plinth. The satyr's tail has also been erased from his lower back.

The 2005 restoration revealed more re-carving against the supporting trunk and all around the child's back: indeed, the bunch of grapes does not appear to be original. The grape's singular shape and traces of planed areas indicate the child was once winged. It has also become clear that he is not holding a *pedum* upside down, but a torch; he could therefore be a cupid instead of a satyr, or a funerary spirit whose association with the older satyr has yet to be explained.

Considered in the context of Tivoli, the deceased personage that leaps to mind is Antinous, the lover of Hadrian who died in 130 A.D. But since the statue's funerary aspect remains unconfirmed, its association with the young Bithynian—sometimes represented in Dionysian form—can only be taken as conjecture. Clearer knowledge of the context in which the statue was discovered would allow us to assess the decorative cycle it belonged to, and its significance. The Fould satyr does fit comfortably with Dionysian pieces, such as the Capitol's satyr in red marble and the Museo nazionali Romano's satyr at rest and Dionysius, all of which were found in the Villa Hadriana built and decorated between 118 and 138 A.D.[1] Like the latter statue, the Fould satyr is one of those eclectic works derived from fourth-century B.C. Greek pieces, including those of Praxiteles, which were highly regarded during Hadrian's reign. (L.L.)

NOTE
1 Rome, Musei Capitolini, inv. 657, 739. MNR, Helbig no. 2217

BIBLIOGRAPHY
Chabouillet 1861, pp. 28–31, no. 869, pl. 4, 5.
Bienkowski 1895, p. 284.
Raeder 1983, p. 155, no. III, 37.

27 Antinous as Osiris

Ca. 130 A.D. ▪ Discovered in Tivoli (Italy), Villa Hadriana, in 1769 ▪ Marble ▪ H. 29⅞ in. (76 cm) ▪ Revolutionary seizure in 1798, formerly in the Albani collection (MA 433—INV. MR 16) ▪ Restorer: H. Bluzat, 2006

Contrary to long-held belief, these fragments of a statue of Antinous as Osiris, made into an independent bust in the eighteenth century, did belong to the collection of Cardinal Albani, as indicated as early as the 1810 Louvre inventory. Only the head and a fragment of the shoulder and left breast seen here date back to antiquity.

The piece is probably the "head of Antinous in the guise of an Egyptian idol," as mentioned in a letter the Scottish artist and excavator Gavin Hamilton wrote to Charles Townley in 1772. The letter reveals that excavations carried out in 1769 in the "little lake of Pantano" uncovered several fragments that later entered the Albani collection: an Egyptian-style Antinous, a sphinx in green basalt, two portraits of Caracalla, and a portrait of Lucius Verus.

This bust was seized by the French army following the signing of the treaty of Tolentino on February 19, 1797, and transferred to the Louvre, along with fragments from the same location taken from Pontifical collections, (for example, the famous colossal statue of Antinous exhibited in the Capitol in the eighteenth century). By confusion between the Pontifical and Albani provenances, it was left in 1815, unclaimed, in Paris.

Several statues portraying Antinous as Osiris share the same features. They represent the young Bithynian, who drowned in the Nile in 130 A.D., wearing a *nemes*, an Egyptian headdress made of starched cloth, decorated in front with an *ureus*, or rearing cobra, a symbol of royal power. Antinous stands with his left leg forward and his arms resting along the sides of his body, wearing the royal *shendjyt*, a pleated skirt. In the case of the Vatican and Munich statues, as with a head in Dresden, his hair is entirely hidden by the *nemes*.

The Louvre head differs in that it includes curls, which hide the ears, and a fringe along the forehead with a forked strand of divergent locks in the center, a capillary feature found in other effigies of a bareheaded Antinous. The Vatican, Dresden, and Munich statues belong to two well-defined series that once decorated the Villa Hadriana's Canopus—so named for a city east of Alexandria, as described in ancient sources, that was famous for its temple devoted to Sarapis and the canal that linked it to the capital of Greek Egypt. Hadrian hoped to evoke this site by creating a decorative complex southwest of his villa in Tivoli.

Hadrian's Canopus, an elongated ornamental lake, opened on an exedra some 50 feet in diameter, decorated with a fountain and niches containing sculptures. Twelve niches sheltered 5¼-foot-high colored stone representations of Egyptian gods, as well as busts of Antinous as Osiris of the same dimension. Eight larger niches housed bigger statues of Antinous as Osiris (the Vatican's model is 7¼ feet high), which are classified in two series, those in white marble and those in red marble. J. C. Grenier has suggested the series may have a symbolic significance evoking the heraldic colors of High and Low Egypt: white marble statues in the hallway leading to the exedra would therefore represent the Valley of the Nile, red marble statues would represent the delta of the river, and the fountain at the end would be an allusion to the first Cataract from which the Nile's waters were alleged to have sprung.[1]

Mostly likely, the Canopus and its decorations referred not only to the geography of Egypt, but also, quite precisely, to the itinerary of Hadrian's journey of 130–131 A.D. It was on this journey that Antinous drowned. Though both the Louvre bust's exact provenance and its origins in this decorative program are uncertain, they certainly make use of the same symbolism associating the young man with the pharaoh deified as Osiris. (J.-L.M.)

NOTE
1 Grenier 1999, pp. 74–77.

BIBLIOGRAPHY
Raeder 1983, p. 133, no. II, 15 and pp. 155–56, no. III, 38.
Meyer 1991, p. 120, no. IV, 2, pl. 106a-d.
Martinez 2004a, no. 1505, p. 723 (references to the Louvre catalogues and other fragments in the Vatican and in Munich).
Frankfurt 2005, no. 348, p. 734 (K. Parlaska).

28 Cynocephalic Ape

Egyptian later period or Roman era · Discovered in Italy, possibly in Rome or Tivoli · Diorite · H. 17⅞ in. (45.5 cm) · Purchased in 1815, formerly in the Albani collection (INV. N 4128)

This statuette represents a particular species of ape with a dog-like muzzle, known as a cynocephalic baboon. With thick fur covering its shoulders, this creature is clearly male. Although there is no inscription, the sculpture may depict the moon god Thot, who assumed the appearance of an ibis or a seated baboon, crowned with the lunar disk. This god reigned over the world of the intellect and was particularly venerated by scribes, and believed to have invented written and spoken language, numerical figures, and the calendar.

Thot became identified with Hermes Trismegistus in Roman times and was considered to be the repository of Egyptian wisdom. This may be why his images have been found in many of Rome's shrines dedicated to Isis. The provenance of this example is unknown: it may come from a sanctuary or a patrician dwelling, where it would have been part of an Egyptian-inspired decorative scheme.

In the eighteenth century, the statue was in the collection of Cardinal Alessandro Albani. As a pendant to the statue of a falcon (cat. no. 29), it was part of the decor of the Egyptian-style Canopus antechamber of the prelate's villa on the Via Salaria, built between 1764 and 1765. This example of egyptomania, fashionable in Rome since the seventeenth century, was sufficiently well known to be included in an engraving in J. J. Winckelmann's *Geschichte der Kunst des Alterthums* (History of Ancient Art). It appeared in the French edition published in 1790. At this date, the head was still crowned with a lunar disk. (L.L.)

BIBLIOGRAPHY
Roullet 1972, pp. 125–27.
Paris 1994, p. 48, no. 2.
Martinez 2004b, pp. 166–73.

29 Falcon

Egyptian later period or 2nd century A.D. ▪
Discovered in Italy, in Tivoli (?) ▪ Basanite,
encrusted with yellow marble ▪ H. 15⅜ in.
(39 cm) ▪ Purchased in 1815, formerly in the
Albani collection (INV. N 3654)

This raptor is sculpted in a hieratic pose, emphasized by its eyes, which are inlaid with yellow marble. The front part of the wings, the point of the beak, and part of the tail have all been restored. Beneath the eyes, circular outlines represent the markings that distinguish the peregrine falcon. Master of the Egyptian sky, this bird is often a representation of the god Horus, protector of royalty. Other deities also assume this form, however: Montu, the warrior god of Thebes and its environs, and Sokar, ruler of the necropolis in Memphis. Without more specific indications, inscriptions or attributes, this sculpture cannot be definitely identified.

The falcon once belonged to the collection of Cardinal Alessandro Albani, a pendant to the sculpture of the seated baboon (cat. no. 28) and part of the decor of the Egyptian-style Canopus antechamber in the prelate's residence on the Via Salaria. It appears in a drawing by Charles Percier[1] wearing the double crown of Egypt. This restoration was removed when the statue was acquired by the Louvre.

The statuette fits into a decorative scheme typical of European Egyptomania, but well before that, it played a role in a far more ancient form of egyptomania, which swept through Rome in the imperial era. Among the best-known examples is the Serapium in Hadrian's Villa (117–138 A.D.) in Tivoli, decorated with Egyptian-inspired motifs. Cardinal Albani received articles from the excavations of this imperial residence, and two other falcons may have come from this source.[2] It is possible that this sculpture was found in the same location. However, the Musei Capitolini's falcon has also been associated with the excavations of the Villa Casali on Rome's Caelian Hill.[3] Lacking a specific citation in the Albani inventory, we cannot be certain of the statue's provenance, but we do know that, whether created in the imperial era or in the Egyptian Late Period (664–343 B.C.), and subsequently exported to Italy, this falcon was an element in the exotic decor of a sumptuous patrician residence in Rome or its environs. (L.L.)

NOTES
1 Bibliothèque de l'Institut de France, MS 1008, no. 22.
2 Rome, Museo Nazionale, inv. 22703, Musei Capitolini, inv. 31. See Roullet 1972, p. 128, no. 261–62.
3 Ensoli Vittozzi 1990, p. 39, n. 7.

BIBLIOGRAPHY
Lyon 1978, p. 14.
Ensoli Vittozzi 1990.
Paris 1994, p. 50, no. 3.
Lollio Barberi 1995, pp. 154, 172.
Martinez 2004b, pp. 166–73.

30 Fragment of a Statue of Augustus as Supreme Pontiff

Late 1st century B.C.–early 1st century A.D. ▪ Discovered in Rome (?) ▪ Marble ▪ H. 35⅜ in. (90 cm) ▪ Purchased in 1861, formerly in the Campana collection (MA 1276–INV. CP 6426; MNE 830) ▪ Restorer: C. Devos, 2005

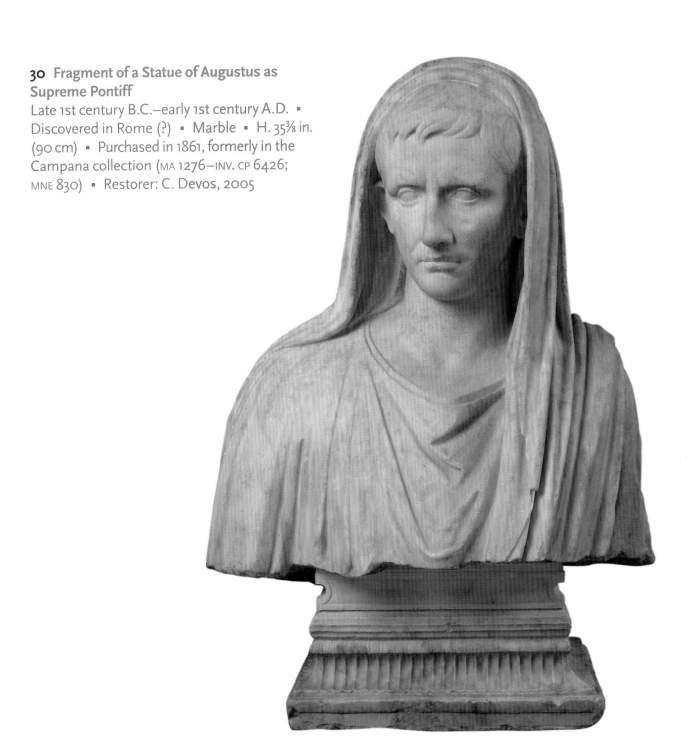

This portrait of Emperor Augustus (27 B.C.–14 A.D.) is a fragment of a full-length statue that was recarved into a bust and then set on an architectural element taken from another source. The chin, nose, and arch of the right eyebrow are mid-nineteenth-century restorations as are the top of the skull and several folds of the toga. The emperor is represented *capite velato*, as a priest, or, more specifically, as *pontifex maximus* (supreme pontiff), a title he took after the death of Lepidus in 12 B.C. The Louvre's fragmentary statue belongs to the same type as the full-length Via Labicana statue sculpted after 12 B.C., probably near the end of the emperor's reign, based on the rendering of the toga with a *sinus* and *umbo*. However, the different hairstyle—a forked strand over the left eye and three large forelocks brushed to the left—distinguishes the Louvre portrait from that type. This capillary indication is comparable to the one found in the Forbes type (cat. no. 2), said to be developed toward the beginning of the Christian era but more likely in 27 B.C., in competition with the Prima Porta type. On the Louvre's bust, marks of old age are obvious. The statue must therefore date toward the very end of the emperor's reign. It expresses one of the cardinal virtues Augustus stressed through imperial propaganda: *pietas augusta*. (L.L.)

BIBLIOGRAPHY
Kersauson (de) 1986, pp. 88–89, and no. 38.
Goette 1990, p. 115, no. BA 33.
Boschung 1993b, p. 133, no. 53, pl. 54, 214, 2.

31 Fragment of a Relief of a Double Suovetaurilia Sacrifice

1st or 2nd quarter of 1st century A.D. ▪ Discovered in Rome at the end of the 15th century ▪ Grey veined marble ▪ H. 70⅞ in. (180 cm); L. 90½ in. (230 cm) ▪ Revolutionary seizure in 1798, exchanged in 1816, formerly in the Grimani collection (MA 1096 –INV. MR 852) ▪ Restorers: N. Imbert and A. Méthivier, 2006

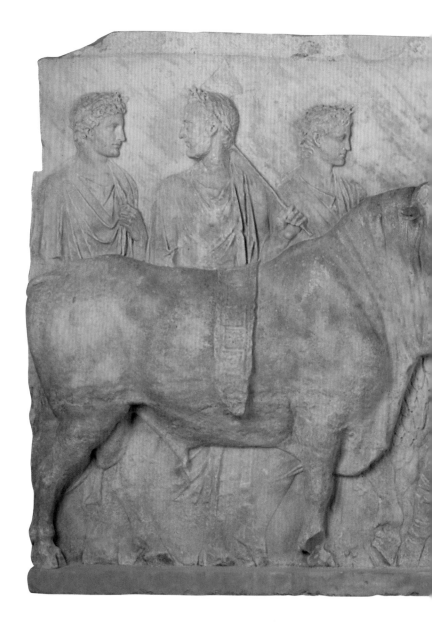

This relief was discovered in Rome during the Renaissance and appears in an anonymous Italian drawing from the beginning of the fifteenth century that is now in the collection of the Louvre.[1] On the right side of the composition, the priest, half life-size, slightly taller than the other figures and with his head veiled, performs the opening rites of a sacrifice. Holding a *rotulus* (long scroll) in his left hand, he burns incense on a rectangular altar covered with fruit and ornamented with garlands of leaves; behind it stands a laurel tree. He is attended by a *camillus* (assistant) holding an open incense coffer; two assistants standing behind him once carried the necessary sacrificial implements, but these have not been preserved.

The procession in the foreground includes three animals—a pig *(sus)*, ram *(ovis)*, and bull *(taurus)*—who lent their names to a particular form of offering, the *suovetaurilia*. The bull wears ceremonial vestments and ornaments on its back and head (known as *dorsuale*, *frontalia*, and *infulae*). The animals are led by three *victimarii* (assistants responsible for carrying out sacrifices), each wearing a toga knotted at the waist rather than the customary *limus* (sacrificial apron). This particular garment, rarely represented, is mentioned by Servius; it reflects the fashion of the city of Gabii.[2] Behind the bull, a *popa* (sacrificial assistant), flanked by two toga-clad men, carries a sacrificial ax over his left shoulder. Following the priest's assistants are a pair of lictors, each holding two fasces and facing each other.

All the figures are crowned with laurel. The priest must therefore be the emperor himself. The lines formed by the heads of the processional figures, as well as by the heads of the animals, emphasize his importance. At the far right of the relief, a second altar and laurel tree are partially preserved. In the branches of this second tree, the flute and fingers of a flutist can still be discerned. Together with the second altar, these imply the former existence of another group of celebrants to the right of the procession in the Grimani collection. There is a relief in the Louvre, of the same height and type of marble, that shows a bull, ram, a *popa* holding an ax, and a sacrificial priest, all moving toward the left. This relief, known since the sixteenth century, belonged to the Della Valle family; it was probably once a fragment of the right part of the original composition, which thus originally depicted a double *suovetaurilia*.[3] A second priest must once have faced the single one that survives in this panel.

Suovetaurilia ceremonies were traditionally dedicated to Mars. They were purification rites, known as *lustra*, held to conclude a census or military campaign. At times, two priests officiated in these circumstances and were invested with censors' powers. Augustus and Tiberius officiated as such priests in 14 A.D., Claudius and Vitellius in 47–48 A.D., and Vespasian and Titus in 72–73 A.D.

Unfortunately, the priest's face here is mostly a restoration, as are those of several of the other figures. The scene can therefore only be dated based on stylistic criteria. The orderly composition of the procession—shown against an almost completely plain background—the clear delineation of the draperies, and the idealized facial features all suggest a classicizing style of art intended to reinterpret a typically Roman ceremony. Based on comparisons with the procession shown in Augustus's Ara Pacis finished in 9 B.C., this relief may commemorate the census organized by Augustus and Tiberius in 14 A.D. If, on the other hand, it relates to the Ara Pietatis built under Claudius (41–54 A.D.), the relief would represent Claudius and Vitellius in 48 A.D.

In addition to the similarities with the Ara Pacis, the scene here is remarkable for the close attention given to rendering the plasticity of forms, the play of light and shadow, and the effects of various textures; these stylistic details were typical of art of Tiberius's era (14–37 A.D.) and came to even fuller fruition during Claudius's reign. In this relief such stylistic effects are still relatively restrained, and the hairstyles of the figures differ from those in reliefs of the Claudian era (cat. no. 115). Therefore the most probable date would be the beginning of Tiberius's reign. The two laurel trees may be references to those planted on the Palatine Hill in

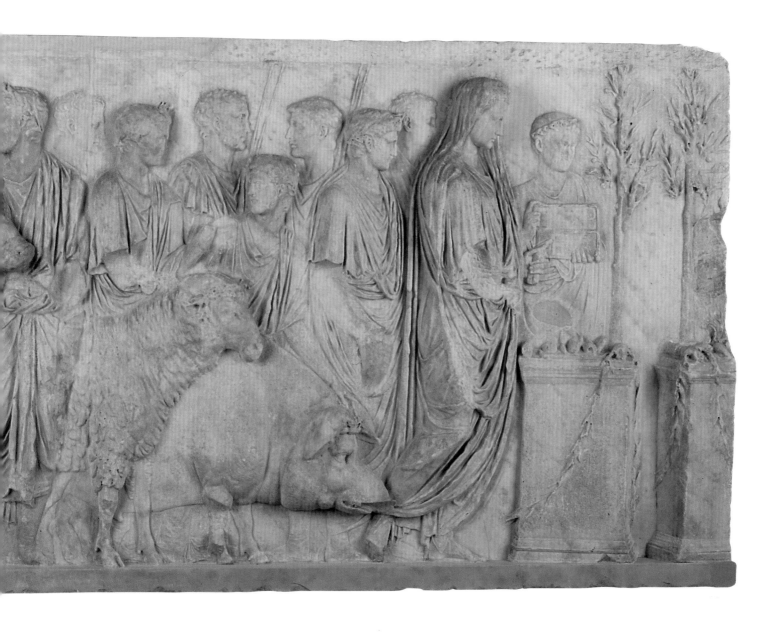

front of the residence of Augustus, an association that suggests dating the relief to the census of 14 A.D. In addition, careful study of the upper left part of the officiating priest's face reveals highly idealized and regular features; these are typical of portraits of the eras of Augustus and Tiberius rather than those in the Claudian style, which are typically rendered with greater realism. (L.L.)

NOTES
1 Louvre, Department of Prints and Drawings, inv. 4316.
2 Museo archeologico of Venice, see Sparti 1998, no. 42; Servius, *Ad Aen*. 5, 755.
3 Ma 1097, formerly in the Borghese collection; the left part of the panel is modern.

BIBLIOGRAPHY
Michon 1909, pp. 190–206.
Scott-Ryberg 1955, pp. 106–09, pl. 35.
Koeppel 1983a, pp. 80–85 and pp. 124–27, fig. 34.
Turcan 1988, p. 35, no. 80, fig. 80.
Tortorella 1992, figs. 1–9.
ThesCRA, I, processions, p. 56, no. 121, pl. 14, sacrifices, pp. 208–09, no. 89, libation, p. 268, no. 58, II, purification, p. 79, no. 65, pl. 12.
Martinez 2004b, pp. 482–83, nos. 973 and 975.

32 Genius

Era of Tiberius ▪ Provenance unknown ▪
Bronze inlaid with silver ▪ H. 4⅞ in. (12.5
cm) ▪ Purchased in 1825, formerly in the
Durand collection (BR 727–inv. ED 4339) ▪
Restorer: A. Conin, 2006

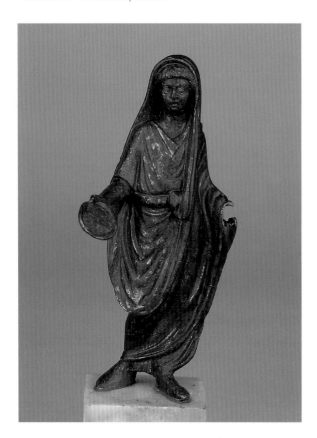

Dressed in a short-sleeved tunic and wrapped in a toga, a section of which covers his head, the young man extends his right hand to offer a *patera* used for libations, decorated with semi-circles and engraved rays. The figure has short hair arranged in bangs over his forehead. His face, with eyes inlaid with silver, is finely modeled; the folds of his garment are carefully rendered. His left hand, now lost, had been attached and undoubtedly held an inscribed scroll called a *volumen*. His feet are clad in the closed ankle boots, *calcei*, customarily worn with the toga.

Given the costume, the figure brings to mind the Emperor Augustus who, in numerous official statues and reliefs, is depicted as a sacrificer, with a section of toga raised over his head. The hairstyle of short locks arranged over the forehead is likewise characteristic of the Julio-Claudian emperors. Undoubtedly meant to embellish a domestic altar *(lararium)*, the small statue probably did not represent an emperor but more unassumingly the *genius*, the guardian spirit of the *pater familias* honored in Roman houses.

Each man possessed a *genius*, a sort of guardian angel charged with ensuring the perpetuation of the race, who accompanied him throughout his life. Offerings were consecrated to him on his birthday. This sort of figure generally had the features of a young man, his head veiled according to Roman ritual, depicted performing libations with a *patera*. The left hand most often held a cornucopia—a symbol of prosperity—an incense case, or, as in this example, a scroll meant to convey the intellectual faculties of the master of the house.[1] In paintings of *lararia* discovered in Pompeii[2] the *genius* appears flanked by the home protector's divinities, called the *lares* (cat. no. 161) dressed in the *toga praetexta*, which was white with a purple border.

Like a temple, each house contained an altar, near which the *pater familias* would carry out the functions of a priest. Following this model and an ancient belief according to which illustrious men were protected by the gods, Augustus established a cult dedicated to his *genius* between 14 and 6 B.C., which consecrated him as father of the Roman people. The emperor's *genius*, associated with the *lares compitales* (the gods that were the guardians of crossroads), were worshiped in the different neighborhoods of Rome and in cities in the provinces. The establishment of this imperial cult gave a place of honor to the cult of the domestic *genius*, depictions of which were inspired by the iconography of the reigning emperors. (C.B.)

NOTES
1 LIMC VIII, suppl., p. 601, nos. 1, 2, 7–9, pl. 372, I. Romeo, "Genius."
2 Lararium of the House of the Vettii: Fröhlich 1991, p. 279, L 70, pl. 7. This work lists numerous examples.

BIBLIOGRAPHY
De Ridder 1913, p. 100, no. 727, pl. 50.
Paris 1959, p. 30, no. 13.
Kunckel 1974, p. 90, no. F I 6.

33 Augustus and Livia

Late 1st century B.C.–early 1st century A.D. ▪
Discovered in Neuilly-le-Réal, near Moulins
(Allier, France), 1816 ▪ Bronze ▪ H. 7¼ in.
(18.5 cm) (Augustus); 7½ in. (19 cm) (Livia);
H. base 1⅛ in. (3 cm) ▪ Purchased in 1868
(BR 29–INV. N. III 3253 and BR 28–INV. N. III 3254)

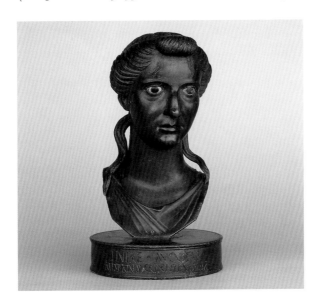

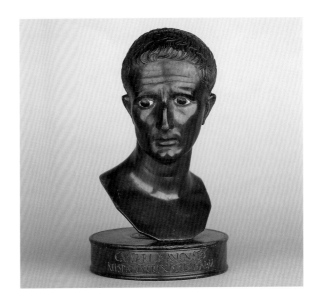

These two busts were discovered on May 7, 1816, under circum-stances carefully recorded by the notary who sold them a few weeks later. Experts are divided on the question of their authentic-ity.[1] According to the notary's document of May 29, 1816,[2] these bronzes were discovered one right after the other by two laborers. Both busts lay just underneath the surface in a narrow area. No further antiquities have been found at this site.

The record of the sale describes what the busts looked like upon excavation: except for the left eyes, the figures showed no significant deterioration. In fact, they were in such remarkable con-dition that some doubted the authenticity of the dark green patina of the outer surfaces. Some people went so far as to say that the busts were modern imitations.

The inscriptions (CIL XII 1366) engraved on the vertical edge of the circular bases are unusual. On the male figure, the inscrip-tion reads: CAESARI AUGUSTO ATESPATUS CRIXI FIL(IUS) V(OTUM) S(OLVIT) L(IBENS) M(ERITO); on the female: LIVIAE AUGUSTAE ATESPATUS CRIXI FIL(IUS) V(OTUM) S(OLVIT) L(IBENS) M(ERITO).

Thus it is clear that these works were dedicated to Augustus and Livia by Atespatus, son of Crixus (which was a known Gallic name), for the purpose of asking that his wish be granted. But the titles of Caesar Augustus and Livia Augusta are chronologically inconsistent and therefore present problems. Livia was not called Augusta until the death of her spouse, who was posthumously named Divus. If the two busts are a pair, then their titles should be Divus and Augusta. Moreover the emperor formally adopted Livia as his daughter in his last will; out of respect for his last wishes, Livia became known as Julia when she was widowed. And even if the title Livia Augusta is not entirely unheard of (notably, it is mentioned by Suetonius), from the year 14 A.D. on, the official title of the mother of the emperor Tiberius was Julia Augusta. That is what Livia's title should have been in the inscription from Neuilly-le-Réal.

Nor are the busts' depictions of Augustus and Livia— cast in the same alloy as their bases—easily placed within the body of por-traiture of the imperial couple. The artist insisted on showing the subject's advanced ages: Augustus's face appears to have thinned; his features are drawn; the softness of his flesh is subtly expressed in the asymmetry of folds between his nose and cheeks, the rings under his eyes, and the slightly swollen areas around his nose. However, his hair—falling from the top of his head to the nape of his neck in even waves and locks, curling first to the right and then to the left— and the styling of the short bangs (two sets of eight locks arranged around the center line of the face) evoke more youthful portraits.

The bust of Livia reveals a similar discrepancy between an aged appearance and a younger, out-of-fashion hairstyle. The empress, wearing a *stola*, is also represented in her old age, with sagging flesh around her cheeks and bags under her eyes. Her mouth is larger than in many other portraits of her.

Livia's hair is depicted in the *nodus* style—pulled forward above the forehead and held in a roll, the hair then descending into a braid and a low chignon—in favor during the last years of the republican era. It is drawn up in headbands against her temples and above her partially covered ears. Two wavy locks of hair fall loosely from the chignon onto her shoulders. Livia coiffed her hair with a *nodus* in her youth.

The earliest evidence of the *nodus* hairstyle was found on a gold coin of Mark Antony from 40–39 B.C. that has an image of his wife Octavia on the reverse side.[3] The statue of Livia erected in Rome in 35 B.C., which belongs to the "Marbury Hall" type, is also coiffed like this.[4] The Hague cameo, undoubtedly the most beautiful example of this type, shows further skill and finesse—the hair is braided not only at the crown of the head but also around the chignon.[5]

Another type of portraiture of Livia, known as "Fayoum,"[6] shows a simplified but equally elegant version of the *nodus* coiffure that probably dates to the early years of the imperial era. The Neuilly-le-Réal bust resembles this second type, which may also be seen in the basalt bust of Livia in the Louvre.[7] The bronze features a lower example of the *nodus*, with small sinuous locks of hair falling over the forehead, but the fashioning of the braid extending from the *nodus*, the size of the headband over the temples, the locks on the shoulders, and the loose chignon all indicate that this was an independent creation.

On this point, x-rays provide additional information that explains the way these two busts were made.[8] While the alloy employed was identical and both busts appear to have been crafted in the same way, each was in fact created using a completely different method. The bust of Augustus, which has thin bronze walls, was cast by the indirect lost-wax process. In contrast, the bust of Livia, with considerably thicker, irregular bronze walls, was made through direct lost-wax casting. The artist then worked directly on the wax model, taking inspiration from a two-dimensional portrait of Livia—perhaps from her image on a coin or jewel, such as the carnelian from the Petescia treasure found on the outskirts of Rome, or a medallion in a glass paste, such as the cameo in Berlin.[9]

Despite these anomalies, many voices have been and continue to be raised in defense of the authenticity of the Neuilly-le-Réal busts. All of their unusual qualities—one might also mention the busts' polygonal shape—can be explained when one considers the provincial context of the artistic commission. Regarding the hairstyle, portraits of Livia with the *nodus* demonstrate the longevity of the Fayoum style, primarily in areas farther away from Rome and the main art studios.

The eyes support the argument that these busts are indeed authentic. The antiquity of the right eyes, which witnesses said were intact in 1816, has recently been confirmed through analysis. The eyeball was made of white glass, commonly used in Roman glassmaking. The iris—a violet glass paste for Augustus—was fused to the eyeball in a mold that gave the eye a slightly convex shape.[10] Thus there is no discontinuity in materials between the hard white eyeball and the dark iris. This technique is exceptional.

The reputation of the Neuilly-le-Réal busts must therefore be restored. Dating them precisely—before or after the death of Augustus—remains an open question due to the discrepancy between the two dedications. One could equally raise questions about where these portraits were meant to be displayed: Were they left in a *lararium*, or consecrated in a temple? The presence of votive inscriptions tends to support the second hypothesis.[11] (S.D.)

NOTES
1 For the latest account with an earlier bibliography, see Bartman 1999, pp. 3, 195–96 (modern); Lahusen and Formigli 2001, pp. 70–73 (antiquities).
2 Bertrand 1868–69, pp. 255–58.
3 Berlin, Münzkabinett, Bartman 1999, p. 59, fig. 47.
4 Marbury Hall type eponymous bust, in the Liverpool museum, inv. 1988.116, Bartman 1999, pp. 64–67, 161–62, figs. 52–54, 143.
5 Bartman 1999, pp. 67, 190, fig. 55.
6 Named after the eponymous bust discovered in Arsinoé, now held at the Ny Carlsberg Glyptotek, Copenhagen, inv. 1444; Bartman 1999, pp. 4–5, 74–77, 174–75.
7 Department of Greek, Etruscan and Roman Antiquities, Ma 1233.
8 X-rays and metallurgic analyses were conducted by the Centre de recherche et de restauration des musées de France (C2RMF), forthcoming.
9 Bartman 1999, pp. 13, 187–88, fig. 2, 11, 181.
10 Study and analysis of the right eyes of Augustus and Livia were conducted by Juliette Dupin and Isabelle Biron, C2RMF, forthcoming.
11 Kaufmann-Heinimann 2004, p. 249.

BIBLIOGRAPHY
De Ridder 1913, nos. 28–29, p. 11, pl. 5.
Kersauson (de) 1986, pp. 94, 96.
Bartman 1999, pp. 3, 195–96.
Lahusen Formigli 2001, pp. 70–73, 360–63, 462, 467, 472, 473.

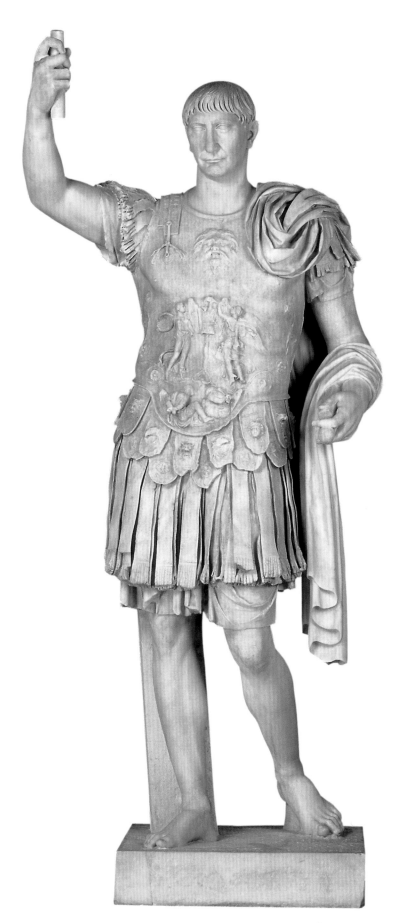

34 Emperor with the Head of Trajan

Early 2nd century A.D. (statue), 108–117 A.D. (head) ▪ Statue discovered in Gabii (Italy) in 1792; head discovered in Italy ▪ Marble ▪ H. 86⅝ in. (220 cm) ▪ Purchased in 1807, formerly in the Borghese collection (MA 1150–INV. MR 360) ▪ Restorer: D. Ibled, 2006

This armored statue was discovered in the ancient city of Gabii, about twenty kilometers east of Rome, on the Via Praenestina. The portrait of Trajan, set on a modern neck, did not belong to the statue; it was furnished in 1793 by Vincenzo Pacetti, who produced this reconstituted piece for the museum of Gabii, which was founded by Prince Marcantonio IV at the Villa Borghese.

The statue is an adaptation of the Doryphoros, a Greek bronze sculpted by Polykleitos, ca. 440 B.C. Its arms and outer garment are also modern. It belongs to a type that includes twenty-three figures, the oldest of which are Julio-Claudian (14–68 A.D.).[1] This type represents an emperor with a mantle draped over his left shoulder, his right arm raised, pronouncing the *adlocutio* to encourage his troops.

The statue's breastplate features a double row of *pteryges* decorated with profiles of eagles and heads of lions, elephants, and gorgons alternating above a double row of lambrequins. The armor is also ornamented with a mascaron representing Oceanus wearing a vegetal beard and two flying Victories adorning a trophy, with shields taken from the enemy. At the base of the trophy, two muscular barbarians with long hair sit face to face, leaning against shields, their hands tied behind their backs. This propaganda scene alludes to a military victory over barbarians, whose universal stir is suggested by the figure of Oceanus. It is surrounded by foliage starting at the base of the trophy and ending in rosettes.

Though the breastplate has often been dated to the Flavian era (69–96 A.D.), both its form and decoration could place it in the late first or early second century under the reign of Trajan (98–117 A.D.). The barbarians are similar to those on Trajan's Column, and the existence in Ostia of a statue of Trajan in armor of the same type reinforce the latter estimate.[2] Therefore, among other restorations, Pacetti's choice of adding the head of Trajan to the Gabii statue was not entirely unjustified.

Trajan was the emperor responsible for the greatest expansion of Roman territory. The portrait belongs to the Decennalia type developed in 108 A.D. to commemorate ten years of Trajan's reign and is recognizable by the locks of hair on the forehead, which curve to the left and are interrupted by two indentations. The partial idealization of the emperor's features, in which he seems to be untouched by the passage of time, and the arrangement of the hairstyle intentionally recall portraits of Augustus. The Decennalia type was produced until the death of the emperor in 117 A.D. The Louvre statue, which is reconstituted but consistent, therefore provides an eloquent picture of Trajan as chief of the armies, the *princeps optimus*, a victorious imperator. (L.L.)

NOTES
1 Stemmer 1978, pp. 7–23.
2 Calza 1964, no. 86, pl. LIX.

BIBLIOGRAPHY
Kersauson (de) 1996, p. 67, pp. 76–79.
Rome 2003, p. 139.
Martinez 2004a, pp. 131–35.
Martinez 2004b; p. 172, no. 296.

35 Stele with Greek Inscription

138 A.D. • Provenance unknown • Bronze • H. 35⅜ in. (90 cm); W. 19¾ in. (50 cm) • Gift of the Société des Amis du Louvre, 2000 (BR 4996—INV. MNE 1179) • Restorer: M.-H. Meyohas, 2002

The stele has molding around the edges and is crowned by a triangular pediment, a piece of which has been broken off. The center of the tympanum has traces of decorative ornamentation (now lost). The lower portion of the stele is worn away, and the inscription is incomplete. The letters had been carved into wax before being cast.

The text of the inscription is a letter addressed from the Emperor Hadrian to the Greek city of Naryka, located in Lokrida, southeast of Thermopylae. It was undoubtedly in response to a request put forth by the inhabitants, who wanted to know the legal status of their town, which had not been registered in the archives of the empire's cities. This omission had probably created a conflict with a neighboring town that attempted to subjugate Naryka. If Naryka had not been recognized as an autonomous town *(polis)*, the inhabitants in effect would have risked becoming dependent upon another city, to which they would have been obliged to pay tribute. Hadrian's letter confirmed that Naryka was, indeed, a town, since it belonged to numerous institutions, including the amphictiony, a religious federation of peoples associated with sanctuaries, and the Boeotian Confederation, to which it supplied a judge, the Beotarch. The city was likewise a member of the Panhellenion, the large association that brought together all the Greeks, founded by Hadrian in 132 A.D., for which Naryka appointed a judge, known as the Panhellen, and a priest. Naryka moreover was organized into an independent town and was mentioned as such by Greek and Latin authors.

Hadrian's tenure makes it possible to date the letter to the last year of his reign. He died on July 10, 138 A.D. The inscription is testimony to the benevolent manner in which the Antonine rulers governed the provinces. Hadrian, in particular, took more interest in the provinces than in Italy and was the only emperor to visit his entire empire. Passionate about Greek culture, he returned to Athens three times and promoted a policy in favor of the cities. This inscription carved in a precious metal was perhaps the official copy of Hadrian's letter, displayed by the people of Naryka in the city agora or in one of its sanctuaries. During the Roman era, legal texts and public documents were written on bronze tablets of similar dimensions. The rarer stelae were driven into stone bases. (C.B.)

BIBLIOGRAPHY
Jones 2006.

36 Monetary Jewel

2nd or 3rd century A.D. ▪ Discovered in Syria (?) ▪ Gold ▪ L. 18½ in. (47 cm); L. of chains 16⅛ in. and 16½ in. (41 and 42 cm); Diam. of coins 1¼ in. (3.2 cm) ▪ Gift in 1967, formerly in the Pérétié collection and the Boisgelin-De Clercq collection (BJ 2234–INV. MNE 77)

This jewel consists of two *aurei*, or gold coins, mounted in gold settings composed of stylized palmettes with a minimum of openwork. The first coin depicts Trajan in right profile, wearing a breastplate and *paludamentum* (a general's cloak), his head crowned with laurels. The inscription reads IMP(ERATORI) CAES(ARI) TRAJAN(O) OPTIM(O) AUG(USTO) GER(MANICO) DAC(ICO) PARTHICO, which dates the coin to 116 A.D., the year he received this title. On the reverse side, two prisoners sit back to back on either side of a trophy, identified by the legend below, PARTHIA CAPTA, which continues around the edge of the coin: P(ONTIFEX) M(AXIMUS) TR(IBUNICIA) P(OTESTATE) CO(N)S(UL) VI P(ATER) P(ATRIAE) S(ENATUS) P(OPULUS) Q(UE) R(OMANUS).

The second coin shows the right profile of a bearded Hadrian, also wearing a laurel wreath. An inscription refers to him as HADRIANUS AUG(USTUS) CO(N)S(UL) III P(ATER) P(ATRIAE), the title used by the emperor beginning in 128 A.D.[1] On the reverse side, a winged victory holds a crown and palm leaf encircled by the legend VICTORIA AUG(USTI).

Four rings have been placed symmetrically on the reverse of these settings' *aurei*. Two rings on either side of their lower portions are attached to two gold chains of slightly different lengths, composed of interconnected flat links in the shape of a figure-eight—the "loop in loop" style.[2] Most likely, the same double chain was once attached to the rings on the upper part of the coins as well.

Monetary jewelry appeared in Rome under the first empire and spread extensively during the third century in different forms, including rings (cat. no. 61), pendants on a chain, bracelets, brooches, and belts.[3] Some of this jewelry, such as the piece shown here, raises some question about the way it would have been worn. The length of the double chain (twice 16 inches, if the missing section was as long) and the presence of two relatively small medallions present a mystery. This type is most often placed in the generic category of necklaces.[4] The same name is applied to the Oplontis jewel—older but very similar in form—though it features two small studded medallions instead of two coins.[5] Some have put forth the hypothesis that the Louvre jewel could have been an element of military finery, like the torques and *phalerae* attached to soldiers' leather harnesses and offered as *dona militaria* (military decorations).[6] But the existing iconography does not support this hypothesis, and unlike the *phalerae*, the monetary medallions seem too small to have been fastened to an element of military dress. Finally, neither chains nor coins show any sign of wear, indicating limited use. Most likely the coins were never put in circulation, their initial purpose forsaken so they could be hoarded and used as finery. (C.G.)

NOTES
1 My warmest thanks go to Daniel Roger, who kindly proofread and corrected the transcriptions provided by de Ridder 1911, p. 188, no. 1161.
2 Type 4, variant b, according to the typology established by Pavesi and Gagetti 2001, IVb fig. 4, p. 37 and pp. 47–72.
3 Metzger 1980 and Bruhn 1993.
4 De Ridder 1911, pp. 188–89; and Metzger 1980, p. 86.
5 Ambrosio (d') 1994, no. 12, p. 42; and Ambrosio (d') and De Carolis 1997, no. 194, pp. 65–66, pl. XIX.
6 Bruhn 1993, p. 23.

BIBLIOGRAPHY
De Ridder 1911, no. 1161, pp. 188–89 and pl. VI.
Metzger 1980, p. 86, and fig. 10, p. 87.
Bruhn 1993, fig. 22, pp. 28 and 29.

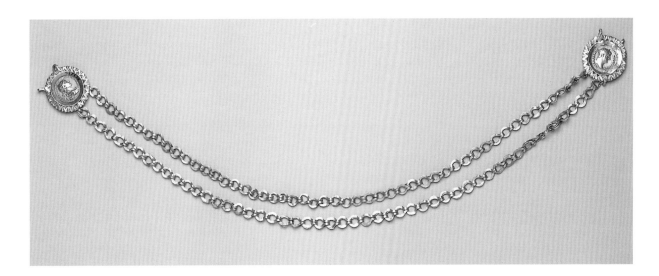

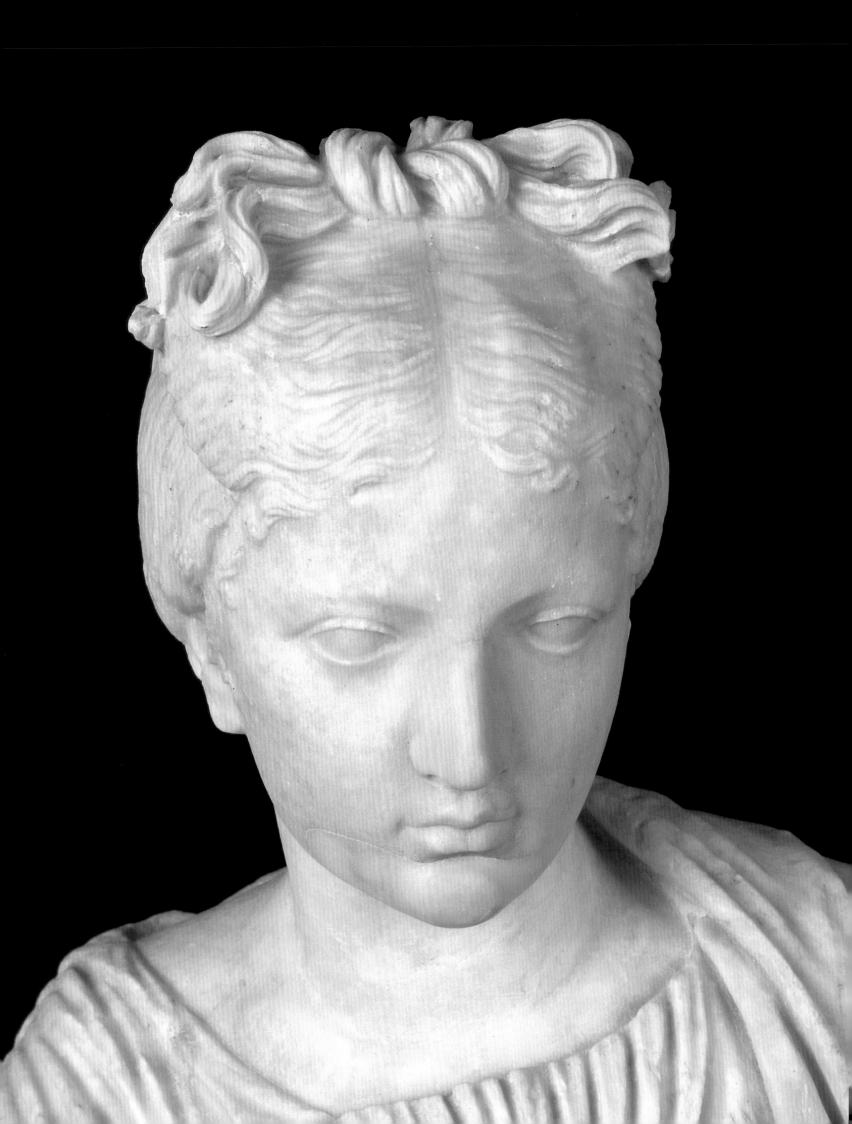

Citizenship **Cécile Giroire** At the very foundation of Roman civilization was the concept of *civitas* (citizenship). *Civitas* shaped the sociopolitical structure of Rome under the republic and, later, the empire. In effect, Roman civilization was structured on the division between citizens and non-citizens—who were recognized only through their relationship to citizens. More than a way of life, citizenship represented a legal status. To be legally classified as a citizen, and thus a member of this privileged social group, with its specific set of rights and duties, a Roman needed to be a member of one of the thirty-five voting tribes of the city of Rome, and registered on the tax rolls used for the compulsory census, which was carried out every five years from the birth of the republic. The citizen wore a toga for his first census, when he would be assigned an official first and last name, tribe, and the century with whom he would be called to go to war (until the reign of Marius) or to vote. The citizen then declared his family, wife, children, and slaves, and the extent of his fortune.

The Roman administration's goal in enforcing the census was not only to count Roman citizens but also to evaluate its military and fiscal potential. The magistrates in charge of the census structured the city as a political and military collective, and the magistrates responsible for it categorized citizens according to a strict hierarchy. At the top were the Roman nobility—the patricians of the senatorial and equestrian orders (men wealthy enough to afford their own horses). Below them were five classes of plebeians—administratively ranked men divided into centuries according to age. Each level of the hierarchy had its own definition of a citizen's exact civic role, including military rank and duties, tax rate, his right to participate in political debates, and his right to attain a public office and honor. In this way, the census structured the civitas as a political and military community.

In addition to his military and civic duties, a citizen had seven fundamental rights: to own property, marry, take legal action, vote, hold office, join the priesthood, and appeal to the people in a criminal case. In 123 B.C. the creation of the *annona,* which provided wheat for the Roman people, also exempted citizens from having to engage in income-producing activities since their food was provided, at least in part, through the distribution *(frumentationes)* of basic foodstuffs at either no or reduced cost. Certain citizens, however, such as women and freedmen, did not enjoy these rights.

As the concept of citizenry evolved from the beginning of the republic to the end of the empire, it was characterized by two tendencies: the extension of citizenship to a greater portion of the population, and the development of civic duties—particularly in regard to participation in the city's political life. Originally extremely restricted and granted to a minority of the population,

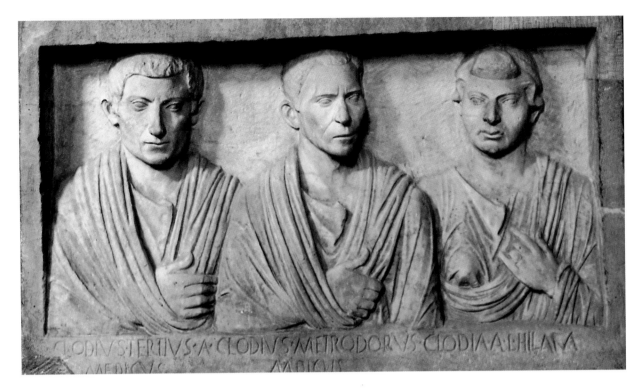

CLODIVS·TERTIVS·A·CLODIVS·METRODORVS·CLODIA·ATHLATA

citizenship was transmitted by birth or acquired (in whole or in part) through individual actions (emancipation, holding office in local magistrates, military service) or through collective and territorial expansion.

Begun under Augustus, the process of expanding access to citizenship culminated with the Antonine Constitution of 212 A.D.—by which time Caracalla conferred citizenship on all of the empire's free population. However, this expansion was accompanied by a concurrent restriction of political rights. While Augustus's vast political and social reforms did not radically alter the organization of society —each individual remained a member of a group within a legal hierarchy, with codified rights and duties—these reforms did change the nature of citizenship, in that political participation was no longer guaranteed. Under the empire, the new monarchic regime banned political participation and debate.

The architectural embodiment of this socio-political organization of society was an emblematic building: the forum. Initially designed to serve as a marketplace, it quickly grew into a public space for both public and private business. Around the forum were erected the city's most important buildings, including basilicas—closed edifices dedicated to the administration of justice and other general affairs; curiae—where the Senate assembled; and temples. Shops and markets were interspersed among these public buildings and places of worship.

Following its erection in the valley between the Capitoline and the Palatine in the seventh century B.C.,

the *forum romanorum* became the model every city in the empire sought to emulate. With the Via Sacra running through its center, it combined the city's oldest monuments with a series of new constructions developed throughout the republic. Later, in order to alleviate traffic in the heart of the city, Caesar initiated the building of the "imperial forums" to the north, a project that would continue under Augustus, Vespasian, Nerva, and Trajan.

Unlike the *forum romanorum*, the imperial forums were designed as enclosed squares placed in relation to a temple. The last and most sumptuous of these was built in 113 A.D. according to plans by Apollodorus of Damascus. The relief showing the reading of auguries and declaration of sacred vows (cat. no. 159 in two fragments) expresses the monumental scale and iconographic ambition of the forum's decorative work and also bears witness to one of the most representative fields of Roman art.

If the forum embodies the architectural, urban expression of citizenship, the portrait could be considered its counterpart in the visual arts. Aside from descriptions left in the ancient texts, our image of the Roman citizen is primarily due to the remarkable development of the private portrait. From the beginning, the portrait is very much a reflection of the legal status of the subject.

In Rome, the portrait went beyond the simple representation of the individual that blossomed in Hellenistic Greece. It became an act of filial piety, with a strictly defined political, legal, and social context. The privilege of being

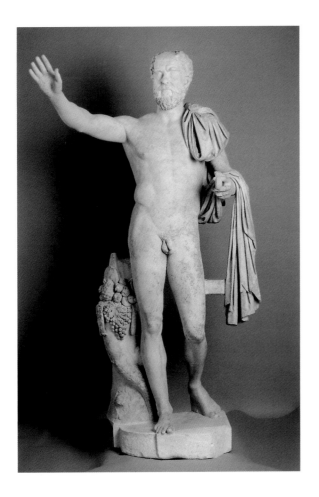

represented *(ius imaginum)* was restricted to the nobility, within the specific framework of the cult of the ancestors. Patricians and, later, plebeians who had reached the higher magistracies were legally permitted to conserve images of their ancestors and place them in cupboards with doors in the atrium of their homes (Pliny, *Natural History*, XXXV, 2, 6). The portraits recalled the existence of previous generations and related the family line.

Initially, portraits consisted of wax masks made at the deceased's funeral (Polybius, *Histories*, IV, 53). They would evolve into reliefs on metal or marble medallions *(imago clipeata)* or into busts. Outside the home, they were placed on funerary monuments as a commemorative image of the deceased, as well as a sign of social standing (fig. 1). Though certainly important, physical resemblance was not the portrait artist's sole concern. He was also charged with expressing moral and family values and the deceased's political loyalties. The subject's connection to a particular lineage was also expressed in heroic nudes (fig. 2) that reflected both the influence of Greek culture and the social assertion dear to the Roman nobility of the republic. These portraits, whether depicting a triumphant general or an anonymous patrician, echoed the use of nudity in Greek representations of heroes, and carried not only a distinct appropriation of Greek culture, but a strong political meaning as well.

But the ultimate representation of the Roman citizen was as a *togatus*—a citizen wearing the attire indicative of his social rank (cat. no. 41). Generally speaking, the head was the only element of Roman statuary that actually reproduced the subject's particular physiognomy: it sat atop a stereotyped body displaying the clothing or attributes appropriate to a certain social status. With the appearance of imperial effigies under Augustus, portrait-making expanded to encompass a variety of materials and techniques throughout the empire's many regions (cat. nos. 45–47).

Representations of women in Rome were rarer and less varied. Women were shown wearing large tunics matched with coats of a different cut, more or less freely inspired by classical Greek models (cat. no. 48). Roman matrons, who were born free and became citizens through marriage and the birth of their children, had their own symbolic garb: the *stola*, a long dress cinched at the waist and worn over a tunic. For modesty's sake, a coat was worn over the *stola* on any public outing.

Surviving portraits, including a majority of marble pieces and a few painted on wood (cat. no. 49), reveal the impressive amount of attention women devoted to their

FIG. 1 *FUNERARY STELE WITH THREE FIGURES*
Last third of 1st century B.C.
Marble
Musée du Louvre, Paris (Ma 3493)
Photo: Musée du Louvre–Chuzeville

FIG. 2 *PUPIENUS*
3rd century
Marble
Musée du Louvre, Paris (Ma 1059)
Photo: Musée du Louvre–Anne Chauvet

clothing. Portraits also relay the importance of the imperial model, which was imitated both by men and women. The extensive visibility of the imperial image—through coins or honorific representations on public edifices and places of worship consecrated to the emperor—inspired formal borrowings, most noticeable in men's and women's hairstyles. Comparing imperial and anonymous portraits illustrates the crucial impact this mimesis had on the art of the portrait, through the imitation of hairstyles, but also a more general formal similarity (cat. nos. 50–57). Jewels put the finishing touches on a woman's refinement: among the many preserved, we find rings, fibulae (brooches), necklaces, bracelets, earrings, and pins (cat. nos. 60–70) made of precious substances (gold, stones, and pearls) or more modest materials (bone, glass, and imitation gemstone) imitating their noble cousins.

That meticulous attention emphasized the status of the female Roman citizen: beyond her roles of wife and mother, she was able to enjoy a genuine autonomy provided by legislation that looked favorably upon emancipation. Unlike the wives of Athenian citizens, Roman matrons were not confined to the *gynaeceum* (a section of the house exclusively reserved for females). Roman matrons could leave the house, have a profession, enjoy leisure activities, and maintain relative financial independence by retaining control of their dowries and inheritances. Toward the end of the republic, women gained the right to divorce. At the beginning of the empire, they became independent once they had three children—and by this stage, Roman girls received the same education as boys.

Citizenship was initially gained at birth. Tradition and Roman law endowed the head of the family with total power over his progeny. This authority was evidenced from birth, when a father chose whether or not to recognize his child. If recognized, the newborn was integrated into the family within a few days. Following a purification sacrifice, the child was given a name, as well as a medallion full of amulets—the *bulla*—made of gold for those who were free and of leather for those who were not.

Like his parents, the young Roman wore a tunic representing his social status: the *toga praetexta* with a purple trim (cat. no. 78). The education of the children was the responsibility of the *pater familias*. Initially, the *pater familias* taught his children to read, write, hunt, and fight and passed on his moral and civic values, but with the beginning of the republican era, in noble households those duties fell to a slave or an emancipated pedagogue. Education remained private and mimetic. During the first century of the empire, public schools—run by teachers (*magister* or *litterator*)—appeared in Rome, created to meet the needs of families that could not hire a pedagogue.

From age twelve to sixteen, young citizens studied Latin, Greek, and the classical authors with a grammarian (*grammaticus*). At sixteen, they began to study rhetoric and Greek or Roman dialectics. Finally, they could choose to specialize and continue their studies in a Greek city (Athens, Rhodes, Alexandria, Pergamon, Antioch, etc.) or, later, with the creation of respected university centers, throughout the empire. At the same time, the young citizen continued his civic education with his father, who could open the way to a political career for his son by bringing him to public assemblies, and familiarizing him with the life of the forum.

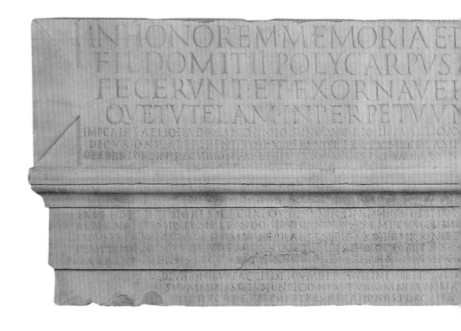

37 Lintel with an Inscription from Gabii

April 23, 140 A.D. • Discovered in Gabii (near Rome) • Marble • H. 30¾ in. (78 cm); L. 11½ ft. (355 cm); D. 13⅜ in. (34 cm) • Purchased in 1807, formerly in the Borghese collection (MA 596—INV. MR 1061) • Restorer: C. Breda, 2005

This exceptional architectural element was a lintel more than 10 feet wide, part of the facade of a temple whose consecration is reported in the engraved text. The first four lines feature the largest letters and are inserted, along with three other lines in smaller letters, in a *tabula ansata* (a dovetailed cartouche) resting on a cornice, beneath which is the remaining text.

The text is a decree to establish a foundation in Gabii to commemorate Domitia (cat. no. 52), wife of the Emperor Domitian (81–96 A.D.) on the occasion of her birthday. The original decree, as mentioned in the final line, was inscribed on bronze tablets conserved in a public edifice (temple or archives).

Two of the empress's freedmen, Domitius Polycarpus and his wife Domitia Europe, started the foundation at their own expense, though it took on an official aspect by being accepted by the *ord(o) decur(ionum)*, Gabii's municipal senate. The reference to the consulates dates the inscription to 140 A.D. and situates the event under the reign of Antoninus Pius, forty-four years after the assassination of Domitian. A decree of *damnatio memoriae* by the Roman senate ordered Domitian's name erased from inscriptions and his portraits destroyed. The Gabii inscription is therefore quite surprising in its description of an official tribute to Domitia and her *domus*, which must be interpreted as her family.

A temple constructed in the family's memory was decorated with statues (mentioned at the beginning of the inscription), probably of the imperial consort and certain members of her family. Additionally, Domitia is referred to as Augusta, a title bequeathed by Augustus to his wife Livia and used exclusively by the wife of the living emperor following the reign of Domitian. Though she outlived her imperial husband by many years, Domitia had most certainly been dead at least ten years by the time the foundation was inaugurated; yet the title cannot be considered an imperial cult in so far as Domitia had not been deified. A recent study explained these tributes through the dynastic complexity of Domitia's family, which included Julio-Claudians, Flavians, and Antonines and combined political power with the prestige of the family name.[1]

The Antonines were in power at the time the foundation was started and maintained a close relationship with the city of Gabii, where they developed part of their activity (repairing, decorating, and building monuments). In particular, the *ordo* of Gabii had already paid tribute to Hadrian with an official dedication (CIL XIV, 2799). This decree evokes the Aelia Augusta *curia*, whose name is related to the Antonines. The commemoration of Domitia in Gabii may have served to reinforce the connection between the city and the imperial family. (C.P.)

NOTE
1 Chausson 2003.

BIBLIOGRAPHY
CIL XIV, 2795 bis.
Dessau 1962, no. 272.
Ducroux 1975, p. 18, no. 81.
Chausson 2003, pp. 102–05.

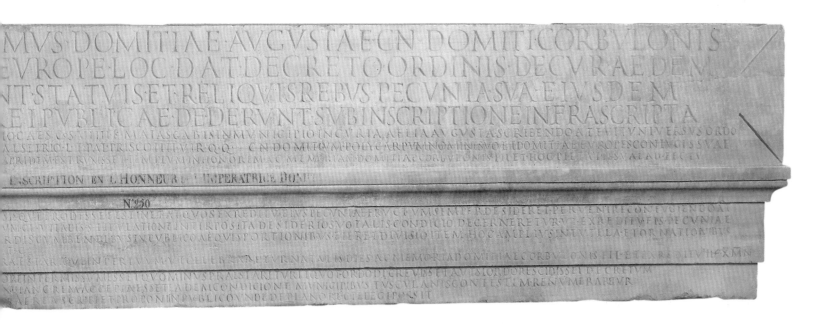

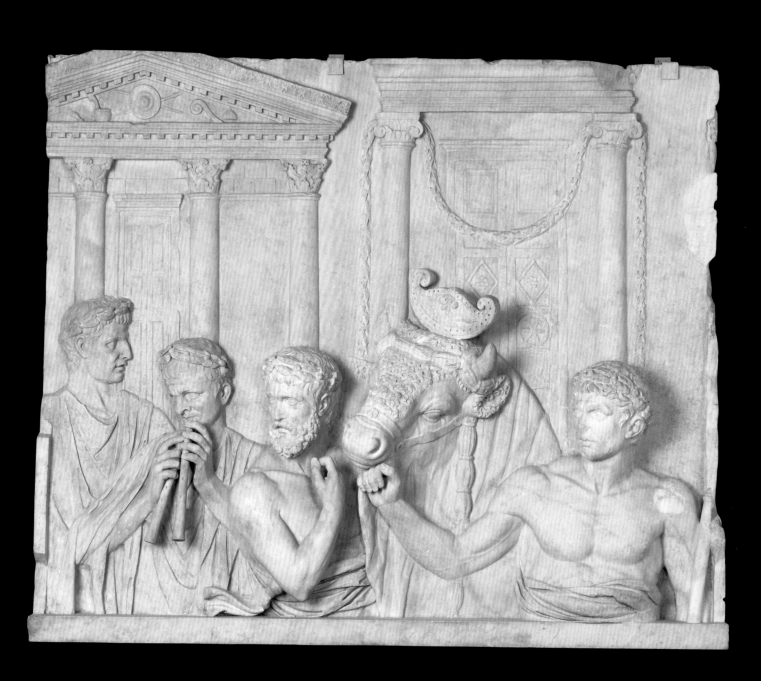

38 Historical Relief, Sacrificial Scene

3rd quarter of 1st or 1st quarter of 2nd century A.D. ▪ Discovered in Rome ▪ Grey veined marble ▪ H. 67¾ in. (172 cm); L. 83⅛ in. (211 cm) ▪ Purchased in 1884, formerly in the Mattei collection, the Fesch collection, and the Aguado collection (MA 992–INV. MNC 1786) ▪ Restorers: N. Imbert and A. Méthivier, 2005

The scene on this relief takes place before two monuments: a tetrastyle temple with Corinthian capitals and a distyle building with Aeolian capitals, also decorated with a garland of laurel. The pediment of the tetrastyle temple is decorated with representations of cult-related objects, including *aspergilium*, *simpulum*, a shield on crossed lances, a *lituus*, and a *flamen's* hat. In the foreground, from left to right, we find a series of slightly larger than life-size figures: a *togatus*, a *tibicen* playing a double flute, and two sacrificial assistants leading a bull dressed for the sacrifice with *infulae* and *pelta*-styled *frontalia* (cat. no. 31). The vertical support of the plaque to the right of the scene is original. The left side was reshaped, erasing a figure, which was undoubtedly lacunar and had been totally removed. It is clear that the plaque originally extended further to the left: the priest, *camillae*, and altar would initially have been to the left of the procession. The crowns of laurels worn by the figures whose ancient heads have been conserved suggest the emperor's departure on a military campaign *(profectio)* or his return to Rome *(adventus)*. In this case, the officiating priest would be the emperor himself.

Before being acquired by the Louvre, this scene was part of the Mattei collection. Though probably discovered in Rome, its exact provenance remains unknown: according to the archives of the patrician Mattei family, Asdrubale Mattei purchased this scene and the Praetorians relief (cat. no. 115) from Pompeo Ferrucci in 1615.[1] The two reliefs were displayed as matching pieces for two centuries, each located over doors between the courtyard and garden of the Mattei palace.[2] A note from the archives, dated December 17, 1635, refers specifically to its restoration, which was entrusted to a certain Egidio *scultore*,[3] most likely Egidio Moretti, an artist known for making statues in the antique style for Lord Arundel. The lower half of the relief is missing and the heads of the two sacrificial priests are modern, as are the musician's hands and double flute, the priest's raised arm at the left of the bull, the bull's muzzle, and the right part of its *frontalia*. The close-cropped beard of the figure wearing a toga, rendered in short, divergent tufts, was carved later—either in late antiquity[4] or in the modern era, to match the bearded heads installed by Egidio Moretti.

A comparison with the Conservators' Palace's relief of Hadrian's *adventus* in the Palazzo dei Conservatori led experts to date the Mattei relief at the beginning of Hadrian's reign. If this is accurate, the plaque would represent a public ceremony on the Roman forum, before the Temple of Vespasian and the front colonnade of the Temple of Concord. This dating rests implicitly on the idea that the relief may have been discovered, like many others, in Trajan's Forum (98–117 A.D.), which was finished under Hadrian (117–138 A.D.).

G. Koeppel has, however, suggested an earlier date. The temple's *sima* with lotus and palmettes is most similar to the decorations on the hexastyle temple visible in the Villa Medici's fragment of a sacrificial scene from the Ara Pietatis.[5] The sharply curved loops on the bull's muzzle, drilled with a single turn of the drill, are comparable to those of a bull on another fragment from the same Ara Pietatis: the Villa Medici's sacrificial scene before an octostyle temple.[6] This Ara Pietatis Augustae dates from the end of the reign of Claudius (41–54 A.D.), but Koeppel also quotes M. Torelli, who suggests that the scene may date from the reign of the following emperor, Nero (54–68 A.D.) The plasticity of the sacrificial assistants' torsos and the volume of the original hair tend to support this hypothesis. To the right of the buildings in the background, Torelli identifies the house of Gnaeus Domitius Ahenobarbus, father of the emperor, and, to the left, the Aedes Penatium on the Velia. The scene would be related to the annals of the Fratres Arvales, which evoked "in sacra(m) via(m) sacrificium ante domum Domitianum" (a sacrifice made on the sacred path in front of the house of Domitius) on the occasion of the eleventh of December, 55, 57, 58, and 59 A.D.[7]

Though the scene can be dated convincingly to the end of Claudius's reign, or, more likely, to the beginning of Nero's, the precise circumstances of the sacrifice, which was probably in honor of the emperor and in the public context of the *urbs*, remains hypothetical. (L.L.)

NOTES
1 Guerrini 1972, p. 15: Archives Mattei, AM 41, IV, fol. 20.
2 Ibid., AM 55, fol 31.
3 Venuti and Amaduzzi 1979, I., p. LI and III, pl. XXXVIII.
4 Koeppel 1983a, p. 84, n. 149.
5 Ibid., cat. no. 13.
6 Ibid., cat. no. 12.
7 Ibid., p. 85.

BIBLIOGRAPHY
Wace 1907, pp. 245–49, fig. 3.
Michon 1909, pp. 223–31, fig. 12.
Scott Ryberg 1955, pp. 130–31, pl. 46.
Guerrini 1972, p. 15.
Koeppel 1983a, p. 84, 140, no. 37, fig. 46.

39 Historical Relief: Sacrifice of Two Bulls

Late 2nd–early 3rd century A.D. • Discovered in Rome, ca. 1570 • Grey marble • H. 70⅞ in. (180 cm); L. 90½ in. (230 cm) • Purchased in 1807, formerly in the Borghese collection (MA 1098–INV. MR 848) • Restorers: N. Imbert and A. Méthivier, 2005

In the foreground, from left to right, are a bull being led to sacrifice by an assistant wearing a *limus*, a small *togatus*, and a *popa* (also wearing a *limus*) preparing to strike down a second bull. Decked with a garland of flowers, the bull's head is held down by a chain of which only a wrenching remains. Near an altar—reconstructed in the modern era—a *tibicen* holds a modern torch substituted for the traditional double flute, and a *camillus* crowned with laurels carries an incense box. In the second plane, the heads and torsos of two sacrificial assistants appear behind the bulls. In the third plane, two bearded *togati* move left, opposite the procession, before an arcature flanked by columns topped with Tuscan capitals.[1] Behind the *tibicen*, a bearded lictor in a *sagum* (cloak) holds an axe tied to a bundle of fasces.

The character's heads are crowned with laurels, allowing us to determine that the scene is a state sacrifice in which the emperor probably participated as a priest, standing to the right of the altar.

Four ancient fragments make up the panel, but several modern additions are evident, principally in the upper left and the lower right corners. These include the altar, the heads in particularly high relief, the upper part of the three characters at the center of the composition, and the lower part of the head of the bull on the left. In certain places, the marble's surface is highly worn and the contours of the relief have been partially retouched. The panel featuring the two *togati* moving to the left was arbitrarily installed in its current emplacement—information well known from a drawing in the *Codex Vaticanus Latinus* 3439 *(Codex Ursinianus)*, folio 88d, executed toward 1570–80. Between 1572 and 1577, Pierre Jacques

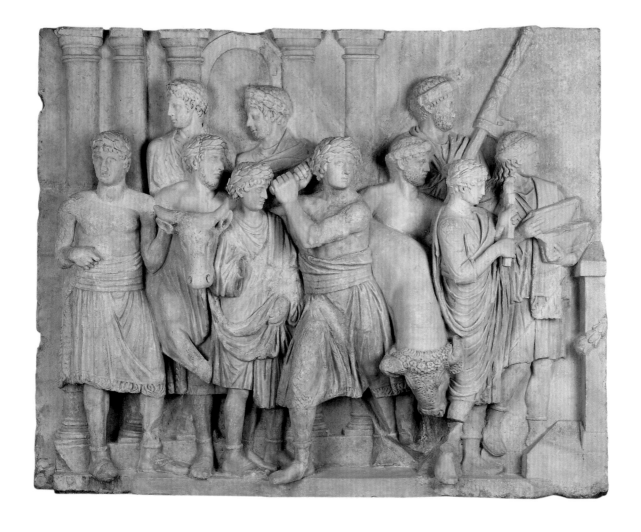

de Reims sketched the right fragment, without restorations, and gave as its location the Capitol hill.

It was thus deduced that the fragments of the sacrifice were the responsibility of Prospero Boccapaduli, head of construction for the Palazzo dei Conservatori, as was the Haruspice scene (cat. no. 159). Since the Haruspice scene originated in Trajan's Forum, this work was assigned the same provenance by association, but no evidence actually supports this hypothesis: the panels' presence on the Capitol hill simply indicates that the fragments were discovered in Rome in the mid-sixteenth century. Following Boccapaduli's death in 1585, they entered the Borghese collection, where, as of 1619, the elements of this particular puzzle were assembled to compose a rectangular panel decorating the eastern facade of the Villa Pinciana.

The three principal fragments of this tour de force of modern reconstitution are in the tradition of the great reliefs on the Arch of Marcus Aurelius (160–180 A.D.) that were carved between 176 and 180 A.D.—more specifically, the sacrificial scene now displayed in the Palazzo dei Conservatori that features *tibicen, camilli,* and sacrificial priests similar to those restored in the Louvre's relief. But certain details, such as the style of the characters' eyes and the only remaining original beard, resemble those found on heads in the dynastic relief on Rome's Sacchetti Palace, suggesting they should be dated later, to the reign of Septimius Severus (193–211 A.D.). The fragment with two *togati* arbitrarily installed on the third plane of the composition is carved in a very similar marble and also dates to the beginning of the third century. But a few stylistic differences in the details of the figures' beards and hair cast some doubt on its belonging to the same monument. (L.L.)

NOTE

1 The columns and arcade, considerably further back than the original relief, are modern re-cuts. This type of restoration was intended to make the fragment appear consistent with the bases of the hexastyle temple's columns, which are visible behind the legs of the participants in the procession.

BIBLIOGRAPHY
Scott-Ryberg 1955, pp. 158–59, pl. 56, fig. 87.
Koeppel 1986, pp. 13–14 , 37–38, 76–80.
ThesCRA 2004, p. 225, no. 220, pl. 54.
Martinez 2004a, p. 481, no. 971.

40 Frieze with Griffons

1st quarter of 2nd century A.D. ▪ Discovered in Rome ▪ Marble ▪ H. 28⅜ in. (72 cm); L. 9⅜ ft. (285 cm) ▪ Purchased in 1824, formerly in the Fesch collection (MA 3127—INV. LL 400) ▪ Restorer: P. Klein, 2005

The surface of this frieze shows numerous signs of wear. Its lacunae have been completed in marble and stucco. Two griffons face one another, each with one paw resting on a *kantharos* holding a tuft of acanthus or on a candelabra decorated with garlands of laurel.

The frieze is one of a series of panels acquired by the Louvre from the Fesch and Borghese collections (Ma 982, Ma 986) and believed to have come from Trajan's Forum (117–138 A.D.), as did plaques showing Victory sacrificing a bull or decorating a candelabra with garlands (Ma 307, Ma 591). By studying the Borghese griffon plaques, we can reconstruct the moldings of alternating heart-shaped leaves and spearheads, as well as a pearl-and-pirouette astragal, to the area beneath the plinth supporting the Fesch plaques. Another series of plaques, in the Vatican Museum, indicates that friezes and architraves decorated with fasces were sculpted together and were, in fact, frieze-architraves.

These classical pieces combining religious allusions and Golden Age symbolism served as ornamentation in the largest imperial forum in Rome, built to celebrate Trajan's numerous victories most notably in the Dacian Wars. The frieze depicting Victories sacrificing bulls topped the columns in the central nave of the Basilica Ulpia. It is more difficult to determine the exact placement of the Louvre's griffon friezes, as the circumstances of their discovery remain unclear. Pieces from this series may also have decorated the basilica, possibly in the apses of the central nave, or in the galleried courtyards around Trajan's Column. The Italian digs led by R. Meneghini from 1998 to 2000 uncovered a similar fragment in the southern part of the forum. This fragment belonged to a frieze decorating a triple portico with Corinthian capitals that led to the monumental entrance to Trajan's Forum and was contiguous with the Augustan Forum. (L.L.)

BIBLIOGRAPHY
Zanker 1970, p. 513.
Meneghini 2001, pp. 262–63.

41 Citizen Wearing a Toga

Late 1st century A.D. • Discovered in Rome, on the Viminal Hill (?) • Marble • H. 88¼ in. (224 cm) • Purchased in 1861, formerly in the Campana collection (MA 987–INV. CP 6378) • Restorer: B. Perdu, 2006

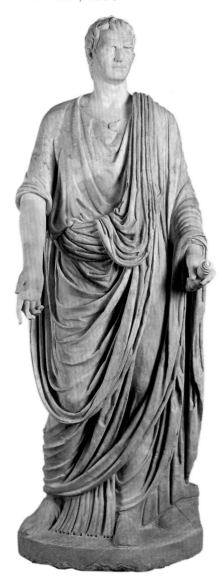

H. d'Escamps first published this work in *Marbres antiques du musée Campana à Rome* in 1855, asserting that this was a statue of the dictator Sylla (138–78 B.C.) and indicating its provenance. Though this has remained the statue's traditional identification, the head is actually a modern re-creation, probably executed by the Marquis Campana's restorers.

The most interesting aspect of this statue is the toga, the official costume of a Roman citizen. This uniquely Roman garment was worn with or without a tunic (a loose shirt-like undergarment), by both men and women in the early part of the republic. Early in Roman history, women replaced it with the *stola*, a garment of Greek origin (cat. no. 15); and in the imperial era, men began to wear the toga mainly for public occasions, replacing it with the Greek *pallium* (cloak) or *lacerna* (cape pined with a fibula on the shoulder) for private use.

The toga consisted of a semi-circular piece of white wool cloth, about 18.4 feet in diameter. For mourning, a darker toga was worn—the *toga pulla*. When consuls opened the portals to the temple of Janus, Salian priests staged their ritual dance with arms, or equestrians performed various ceremonies such as the *transvectio* or *decursio equitum* (equestrian parades), they donned a scarlet toga—the *trabea*. Consuls, praetors, censors, other high-ranking magistrates, and various municipal officials wore the purple-bordered *toga praetexta*.

On the statue of Sylla, the toga covers only the left shoulder. On the chest and right arm one can see the tunic, the sleeves of which, toward the end of the Republic, could be long. A plunging neckline allows the head through. At the beginning of the empire, the tunic becomes full-length. The *lacinia* is the part of the toga that falls in bunched folds between Sylla's legs. It is one of the corners of the semi-circular fabric. The curved edge of the toga becomes the *sinus*, the large fold that hangs down on the right thigh. Half the straight section of the fabric—where we find the purple border characteristic of the *toga praetexta*—forms the *umbo*, a pocket-like fold, and the other half forms the *balteus*, or belt, which is re-covered by the *umbo*.

The wearer of a toga draped the straight part of the cloth over the left shoulder so the curved portion of the fabric covered his left arm and the *lacinia* fell widely to the ground in front of his feet. The fabric hanging down in the back was pulled over the right shoulder and completely covered the back. He placed the straight edge under his right arm—without creasing the fabric—and then threw it over his left shoulder, forming the *balteus* around the abdomen. A considerable amount of fabric then fell over the right leg to the ground, the end of which was then thrown over the left shoulder again to form the *sinus*, which had to be adjusted. Finally, the rectangular portion of fabric hanging down in front was pulled up so that the *lacinia* fell exactly between the two feet. Excess material was folded back on the *balteus* to become the *umbo* across the chest.

The idea of ancient drapery was to allow great freedom of movement with minimal adjustment. The toga took on many forms throughout Roman history. As fashions changed, so did the toga. The *toga exigua*, fashionable at the end of the republic, measured only 11½ feet (3.5 meters) in diameter; it hugged the body and had almost no *sinus*. In the example of Sylla shown here, the edge covering the right shoulder has slid down to leave the shoulder exposed, a style perfectly appropriate for an orator in the heat of his discourse. But in the Augustus from Velletri (cat. no. 14), the toga wraps the whole body. The folds that were thrown behind could serve as a head covering during a religious or official rite (*capite velato*). During the republican era, the *cinctus gabinus* style covered the head, and the toga was used almost as a belt, leaving the arms free. Finally, beginning in the third century A.D., the *umbo* was arranged in the *contabulatio* form, applied long, flat, and broad over the left shoulder (cat. no. 9).

Here, Sylla wears *calcei*, the appropriate footwear for a toga-clad Roman citizen. Senators wore their *calcei* higher up on the leg, decorating them with a ribbon pulled through a loop and four crossed straps. Sylla has the *capsa* or *scrinium* at his feet, a cylindrical wooden case containing his *volumina*, the oratorical texts that symbolized the importance of discourse and debate in Roman intellectual and political life. (D.R.)

BIBLIOGRAPHY
Kersauson (de) 1986, p. 224.

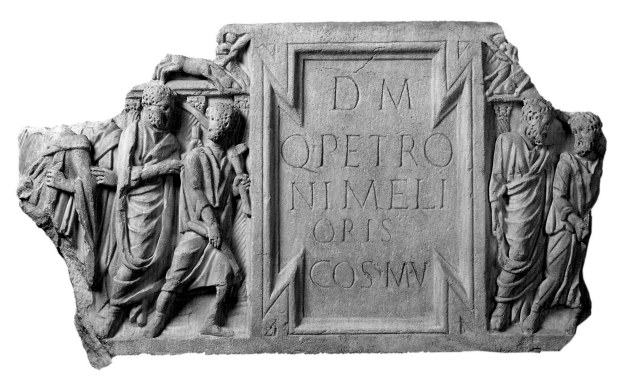

42 Fragment with an Inscription of Petronius Melior

Mid-third century A.D. ▪ Discovered ca. 1520, in the region of Florence ▪ Marble ▪ H. 21¼ in. (54 cm); L. 38¾ in. (98.5 cm) ▪ Purchased in 1861, formerly in the Campana collection (MA 1466) ▪ Restorer: C. Knecht, 2006

The inscription on this fragment was first re-transcribed in 1520, in a manuscript written by numerous hands, an extension of a collection begun by Accursio.[1] It was located in the central part of the front of a sarcophagus lid (now lost). At the time of its discovery, this fragment was more complete than its current form. In 1575, it was hastily drawn by Vincenzio Borghini,[2] then published in 1743 by Antonio Francesco Gori,[3] with certain inaccuracies (figs. 1 and 2).

The inscription reads D(IS) M(ANIBUS) Q(UINTI) PETRONI MELIORIS CO(N)S(ULARIS) M(EMORIAE) V(IRI) (To the divine souls, to the memory of Quintus Petronius Melior, consul) (CIL XI, 1595). Referring to the political activity of the deceased, the inscription sets the sarcophagus among the senatorial sarcophagi type. In fact, the Louvre marble is one of the finest surviving examples showing a *processio consularis* (procession of the consul): either Melior or his descendents chose to illustrate the sarcophagus

with ceremonies showing his rise to the office of consul. On both sides of the inscribed area (here, a *tabula ansata*, a rectangular frame with dovetails on both sides) are depictions of the new consul accompanied by a lictor (public officer who attended the chief magistrates). Carrying a short staff in one hand and, in the other, a bent fasces from which a cutting edge protrudes, the lictor turns his head toward the new magistrate, who carries a scroll in his left hand as a mark of his office.

The consul was accompanied by twelve lictors on his public travels. The day he assumed office, escorted by a varied crowd, he first went from his residence to the Capitoline, where, along with his co-consul for that year, he offered a sacrifice to Jupiter and left his offerings, then continued on to the Curia, where the senate received them both. The drawings show that the left portion of the sarcophagus lid illustrated that session in the presence of the Senate: the consul is seated, surrounded by the other senators wearing the *toga contabulata,* a garment widely worn during the Severan dynasty and likely imported from Egypt. It was made fashionable by the entourage of Septimius Severus, an emperor strongly influenced by eastern forms of worship, particularly involving the god Sarapis.[4] Thus it appears that the sculptor of this sarcophagus wanted to show the senators attired in a uniform that linked them to the emperor.

The columns of a portico that can be seen in the background are a very conventional decorative element on sarcophagi. At most, they can be seen as a reference to the urban context within which the *processio consularis* is taking place.

Fig. 1 Front of Petronius Melior's sarcophagus lid as seen in 1575 in the "opera di Santa Maria del fiore." Drawing by Vincenzio Borghini, 1575.

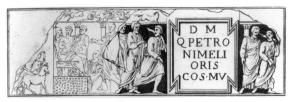

Fig. 2 Front of Petronius Melior's sarcophagus lid. From Antonio Francesco Gori, *Thesaurus veterum diptychorum consularium et ecclesiasticorum* (Florence: J. B. Passeri, 1743).

The upper register of the lid edge is badly damaged. One can make out, on the left, a victory figure carrying a palm and mounted on a two-horse chariot (biga). The companion figure, on the right, holds a cornucopia. Gori's drawing, which does not show these figures, depicts a row of trophies.

In Ostia, a statue base inscribed in 184 A.D. (CIL XIV 172), visible opposite the theater, bears the name of a certain Petronius Melior, an equestrian originally from Fiesole or Florence who held municipal posts in Etruria and rose to the office of procurator of the annona (the free public food supply). He would have been Quintus's father or grandfather. A figure such as Quintus was known as a homo novus, the first in his family to attain membership in the senate. The list of the Sodales Augustales Claudiales (CIL VI 1984) mentions Q. Petronius Melior as a sodalis in the year 230 A.D. Created by Tiberius and overhauled by Claudius, the sodales Augustales Claudiales consisted of a prestigious college of priests devoted to the worship of the emperor.

In the baths of Tarquinia, an inscription (CIL XI 3367) expands upon the career of Q. Petronius Melior, describing fourteen additional functions he took on, from the quaestorship in 231 A.D., to his consulship, which took effect in 244 or 245 A.D., mentioning among other offices his post as legate of Ulpia Vitrix, the thirtieth legion, in lower Germany, and guardian of finances for the Etruscan towns of Tarquinia and Gravisca. His military career took him to Bonn, Strasbourg, and finally Xanten, but he preferred to carry out his civil duties in his native region, which is where he spent his final years. The inscription to him is dedicated by the senate and the inhabitants of Tarquinia, since "he loved the city and restored the baths." At Melior's behest, these inhabitants had an inscription carved in the same stone to Domitia Melpidis, Melior's wife and "their most worthy patron" (CIL XI 3368). (D.R.)

NOTES
1 Milan, Biblioteca Ambrosiana, manuscript D 420 inf. includes a precise reference: "Prope aedem s. liberatae, apud lapicidam quemdam." Thus the inscription was seen, and not discovered, near the Santa Liberata palace, at a stonecutter's.
2 Florence, Biblioteca Nazionale Centrale, manuscript II X 70.
3 Gori 1743, p. LXXV, pl. VII. Gori states that he did not see the object, but he is clear that he was inspired by Borghini and by another source we do not know. Despite Liou 1969, Borghini's drawing and the unknown source, probably closer to Gori, show that the object may well have been found in a more complete state than its current condition.
4 Rupprecht Goette 1990, pp. 71–74.

BIBLIOGRAPHY
Baratte and Metzger 1985, pp. 28–29.
Ciampoltrini 1987.
Reinberg 1995, p. 363.
Turcan 1999, pp. 69–70.
Wrede 2001, pp. 62–63.

43 Three Lictors

Early empire (?) • Provenance unknown • Bronze • H. 4¼ in. (10.9 cm); 4½ in. (11.4 cm); 4½ in. (11.4 cm) • Purchased in 1825, formerly in the Durand collection (BR 729—INV. ED 4384) • Restorer: A. Conin, 2006

When the emperor passed by a crowd, lictors were responsible for holding the onlookers back. The statue here is composed of three lictors standing side by side, their heads turned slightly toward their right. They wear long togas draped over short-sleeved tunics and calcei (ankle boots). In the left hand each holds the fasces, emblem of Roman lictors, one end resting on a shoulder. The fasces consisted of elm or birch rods bundled like a cylinder around an ax, usually tied with a red belt.

Here the first lictor raises his right hand to his shoulder, as if to adjust his tunic; the second holds his arm down the length of his body; the third holds back a fold of his toga. The variations of these poses and the size of the figures break the monotony of the composition. The hairstyle—short locks arranged over the forehead—is characteristic of the Julio-Claudian era. In keeping with the fashion of the early empire, the sinus (toga fold) forming a semi-circle beginning at the waist is not very voluminous.

Lictors appear on numerous official reliefs. They also appear on two silver cups from the Boscoreal treasure depicting the surrender of the barbarians to the Emperor Augustus and the triumph of Tiberius followed by a sacrifice.[1] They had existed earlier under the monarchy, when they served as escorts to the kings. During the time of the republic, lictors accompanied magistrats who had the imperium, or official authority, to raise and command an army and also had certain administrative and judicial rights.

Undoubtedly this group of statuettes was once attached to a more complex scene. That all are glancing toward the right seems to indicate that a scene was unfolding in that direction.

Another figurative appliqué, now in the J. Paul Getty Museum, consists of two magistrates dressed in togas, with a fabrication mark on the back indicating that the piece was part of a larger group.[2] For the most part, these small-scale groups, inspired by ceremonial scenes sculpted on historical reliefs during the imperial era, ornamented pectoralia, the decorated breastplates used to cover the chests of bronze statues of horses. It seems that these adornments were most commonly seen on horses pulling a quadriga (a two-wheeled chariot pulled by four horses, running abreast) rather than on horses with riders.[3] (C.B.)

NOTES
1 Baratte 1986, pp. 69–76.
2 Scott and Podany 1990, p. 47 and p. 52, fig. 12 a-b.
3 Kreilinger 1996, pp. 28, 33.

BIBLIOGRAPHY
De Ridder 1913, p. 101, no. 729.
West 1933, p. 162, n. 36.
Poulsen 1977, p. 37, nos. 8-10.
Ronke 1987, p. 738, no. 209, fig. 218.
Kreilinger 1996, p. 207, no. 253, pl. 49 (with comparisons, pp. 205–07, nos. 241–54, pl. 47–49).

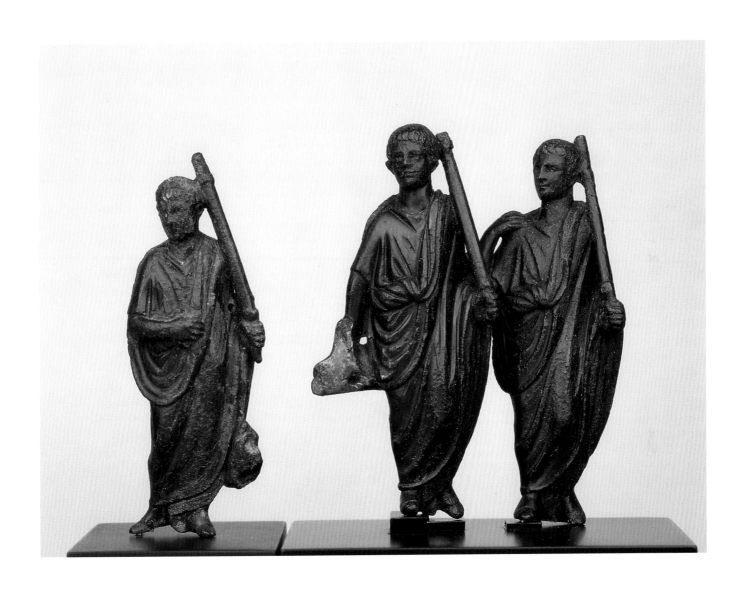

44 Magistrate

1st century A.D. • Discovered in Tralles (present-day Aydin, Turkey) • Light yellow clay • H. 5⅞ in. (15 cm); W. 3½ in. (9 cm) • Purchased in 1887 (inv. CA 97) • Restorer: C. Knecht, 2006

This figure displays the florid, bloated quality of the morbidly obese: puffy face; pendulous jowls; a wide, flat nose; thick, downward curving lips; and deep creases from nose to mouth. Contributing to his massive appearance is his thick, short neck—barely allowing his head to emerge from his heavy-set body. Chest, stomach, and waistline form a single bulging unit, of which the lower part is lost.

The figure has the characteristics of an obese gourmand and bon vivant.[1] The caricature is typical of the grotesque figures made in Smyrna in Asia Minor and Alexandria in Egypt beginning in the third century B.C. Found in Tralles, a wealthy city in the Meander valley that was reconstructed by Augustus following an earthquake, this figurine is associated with Smyrna and probably dates from the first century A.D.[2] Statues made in Smyrna may have been inspired by the studies and precise representations of physical pathologies and deformations being done by the city's school of medicine, but any clinical observations are coupled with outright caricature in this example,[3] which can be identified, by a number of attributes, as a magistrate participating in an official religious ceremony.

The figure wears the magistrate's *toga praetexta* gathered over the left shoulder, which is distinguished by a woven purple border (known as a *clavus*); here it is conveyed by the high technical quality of this polychrome figurine. Head veiled *(capite velato)*, the figure holds a small casket in his left hand, perhaps an *acerra*, a special box used to hold incense during sacrifices.[4] (N.M.)

NOTES
1 Grmek and Gourevitch 1998, pp. 174–76.
2 Two fragments of a similar figure from Smyrna are in the collection of the Louvre (CA 5298, CA 4999) Besques 1972, p. 223, pl. 304, no. E/D 1691–92). Also see Bol and Kotera 1986, p. 178, no. 90; and Schurmann 1989, p. 156, pl. 93, no. 546.
3 Cèbe 1966, p. 355; Uhlenbrock 1991; and Aristide D. Caratzas, pp. 77–78. Summerer 1996, pp. 171–77.
4 Daremberg and Saglio, Ed. 1873–1919, I, p. 22.

BIBLIOGRAPHY
Besques 1972, p. 126, pl. 154i, no. E/D 846.

45 Portrait of an Unknown Man, Once Thought to Have Been Aulus Postumius Albinus

Early 1st century B.C. • Rome • Marble • H. 14⅝ in. (37 cm) • Hoffmann purchase, 1888 (MA 919–INV. MNC 1004) • Restorer: Christine Devos, 2006

Once thought to be a portrait of Aulus Postumius Albinus, a consul in 99 B.C., this head is now considered the portrait of an unknown man, probably of the patrician class. Broken off at the neck, it probably belonged to an honorific statue. The nose is damaged and the surface of the marble is pitted in a number of places. The upper and rear parts of the head are missing. Holes were pierced in its surface to attach marble patches, probably during the Roman era.

The head turns to the right in a lively pose. The hair is wavy and somewhat sparse; rings surround the small eyes; the eyebrows slant upward; the parted lips suggest a toothless mouth; the skin shows the wrinkles of advanced age. The expressiveness of the face and its marks of old age are vividly rendered: the folds in the skin of the neck also reflect the movement of the head, for instance. This portrait is thus a striking demonstration of realism, carried out with truly baroque flair.

This type of representation, which recalls portraits of Hellenistic rulers, was much admired by the upper classes at the end of Rome's republican period, particularly for ceremonial statues. The Louvre's sculpture is foremost among a series of pieces that include portraits in the National Gallery of Oslo, the Braccio Nuovo in the Vatican, and the Museo Torlonia in Rome. Sculpted at the beginning of the first century B.C., this head closely echoes a bronze prototype created around 150–100 B.C., which may have been the work of a Greek artist working for the Romans. W. Megow also noted similarities to a facial profile in terracotta found in the Kerameikos cemetery in Athens; that piece is currently displayed in the Metropolitan Museum of Art. (L.L.)

BIBLIOGRAPHY
Berlin 1980, p. 70, no. 35.
Kersauson (de) 1986, pp. 14–15, and no. 3.
Megow 1999.

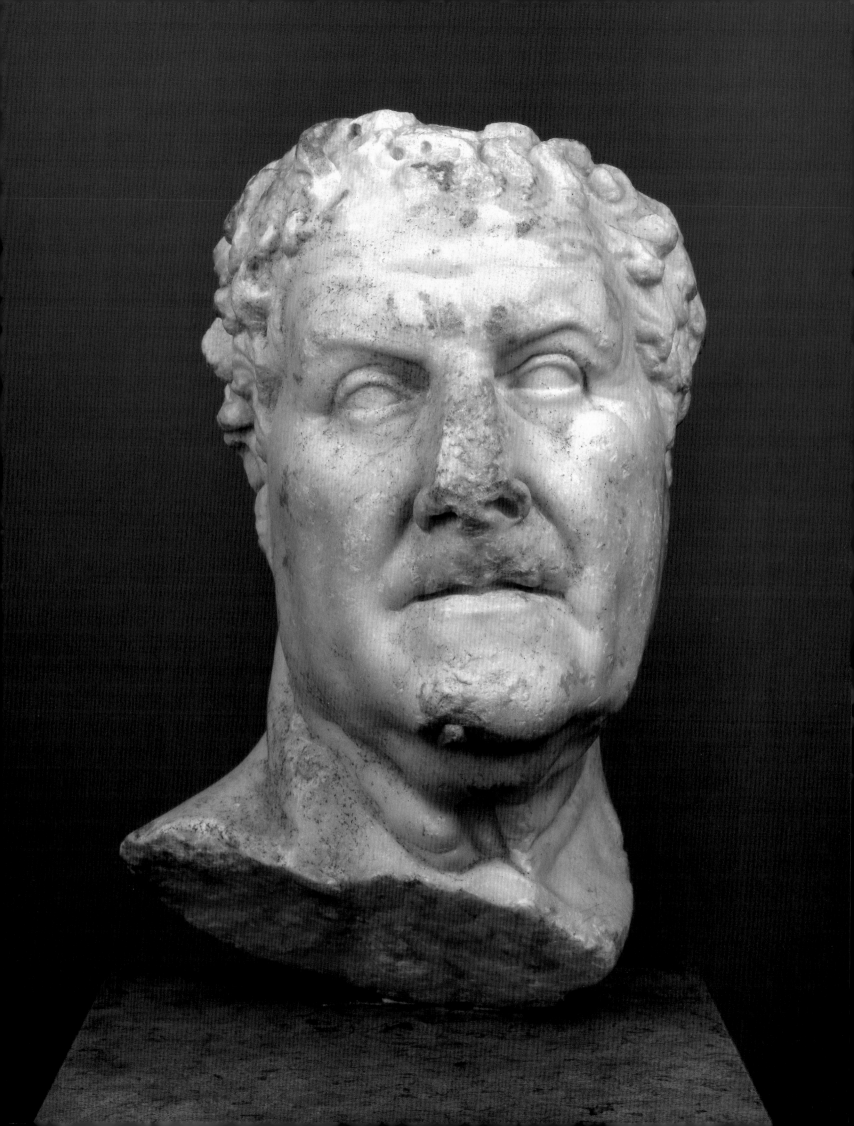

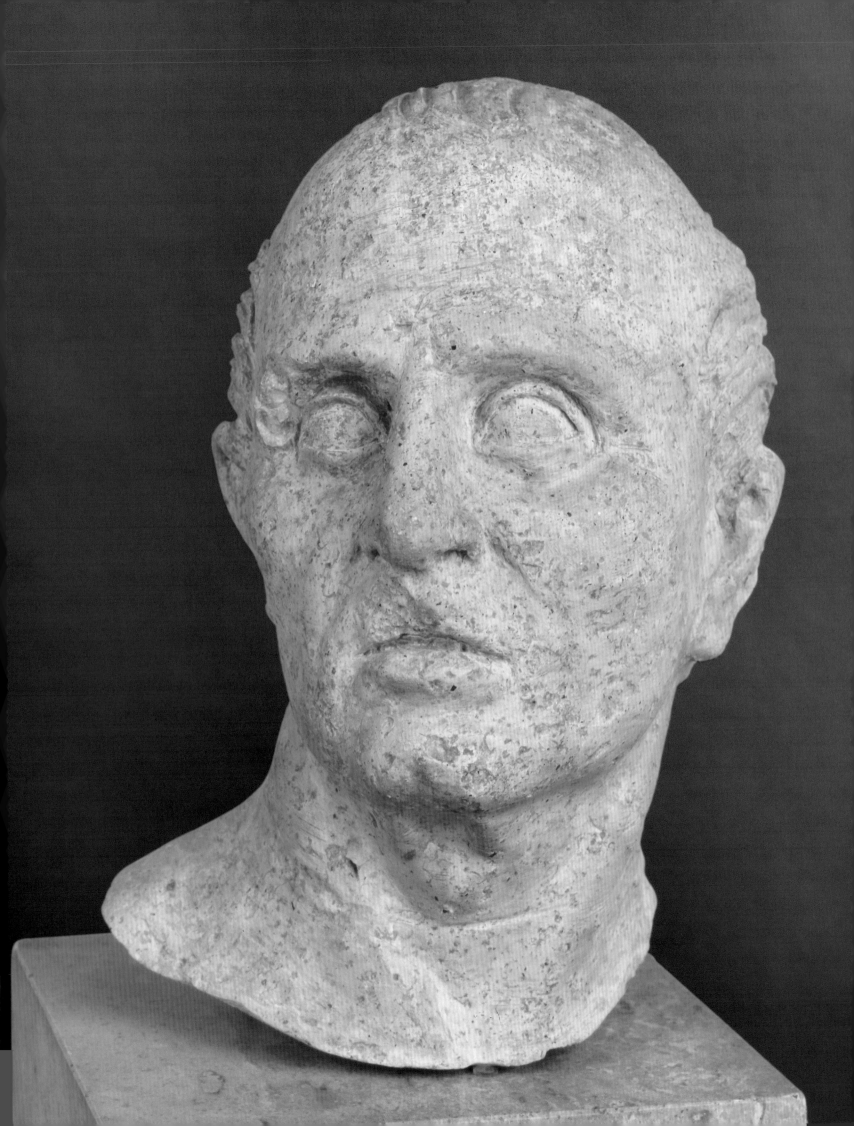

46 Portrait of an Unknown Man

1st century B.C.–1st century A.D. ▪ Provenance unknown ▪ Pale brown clay ▪ H. 9½ in. (24 cm); W. 7⅛ in. (18 cm) ▪ Purchased in 1861, formerly in the Campana collection (INV. CP 4307) ▪ Restorer: C. Knecht, 2006

In the Campana collection, this head of a man was mounted on a small terracotta pedestal that was severely damaged and has been removed. During restoration, a thermoluminescent analysis of the clay confirmed the authenticity of the sculpture. Fashioned from a clay with many additives, the portrait is well preserved, missing only part of the right eyebrow and upper lip. The flesh is treated in a distinctively realistic fashion. The skin of the neck sags slightly and the cheeks are somewhat sunken, showing the marks of advanced age. The eye sockets, emphasized by the slightly protuberant brow, are deeply set. Veins stand out on the temples and crow's feet with three distinct wrinkles are visible. Wrinkles also crease the forehead. Wavy strands of sparse hair are carefully combed back from the receding hairline. But the impression created by these signs of aging contrasts with the symmetry governing the overall representation and the regularity of the features: the straight line of the nose is juxtaposed with the rectilinear lines of the eyebrows.

The expressiveness of the face reflects Hellenistic influences in contrast to typically Roman verism. There is a strong sense of movement in the portrait, created by the twisting of the neck, angle of the head, and liveliness of the upturned gaze. The slightly parted lips add to the poignancy of the expression.

Hellenistic and verist influences are evident in portraits from the end of the republic to the early part of the empire, but the use of clay was unusual. As can be seen from the fingerprints in clay visible on the interior of the neck, this portrait was not modeled but rather created from a mold. This technique, together with the realistic features of the face, has led some to draw a parallel with ancestor portraits, which were produced from wax death masks molded directly from the face of the deceased (Polybius, *Histories*, IV, 53), following the practice invented by Lysistratos. Another portrait of an elderly man in the Museum of Fine Arts, Boston, seems to support this interpretation;[1] however, the smaller size of the Louvre's head and its features, which are more generic than individualized, cast some doubt on this assessment. Such works in clay may have served as models for bronze or marble statues.[2] But that hypothesis is somewhat contradicted by the careful modeling of the surface, showing evidence of the extensive use of tools (in hair, wrinkles, and ears, for example) and brushes (on the level surfaces), as well as the presence of polychrome painting. Remains of red pigment can be detected in the ears, nostrils, eyes, and hair, all of which escaped overzealous cleaning from previous restorations. These flesh tints clearly link this portrait to the Etruscan-Italic tradition, in which terracotta sculpture had the status of an autonomous art form with its own techniques and purposes. The statues found in Lavinium, particularly portraits of children, are early evidence of this tendency toward realism.[3] The portrait found in the Manganello sanctuary in Cerveteri (the Roman Caere), dating from the first quarter of the first century B.C., demonstrates an effort to render the individualism of the features delicately, using red tinted polychromy.[4] (N.M.)

NOTES
1 Inv. no. 01.08008, L. D. Caskey, *Catalogue of Greek and Roman Sculpture* (Boston and Cambridge: Museum of Fine Arts and Harvard University Press, 1925), pp. 189–91, no. 108.
2 D. E. Kleiner, *Roman Sculpture* (New Haven and London: Yale University Press, 1992), pp. 37–38.
3 *Eno nel Lazio: archeologia e mito*, exhib. cat. (Rome, 1981). S. Moscati, *Les Italiques, l'art au temps des Etrusques* (Paris, L'Aventurine, 1995), pp. 130–32, pls. 83–84.
4 Museo de la Villa Giulia, Rome, inv. no. 56513. See *Gli Etruschi*, Venice, Palazzo Grassi, November 26, 2000–June 1, 2001 (Milan: Biompiani 2000), p. 631, no. 304.

BIBLIOGRAPHY
Kersauson (de) 1986, p. 12, no. 2.

47 Portrait of a Man

Ca. 250–60 A.D. ▪ Discovered in Italy[1] ▪ Bronze ▪ H. 10 in. (25.5 cm) ▪ Gift of Napoleon III, 1870, formerly in the Tysckiewicz collection (BR 44–INV. NIII 3534)

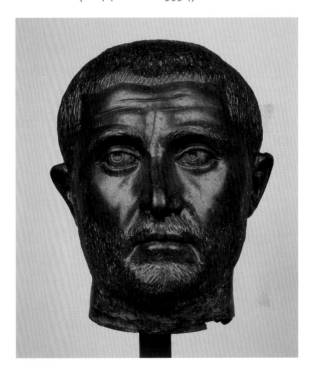

This head, turned very slightly toward the right, follows the direction of the eyes, which are deep-set beneath thick, down-turned eyebrows. The broad forehead, furrowed by two horizontal wrinkles, is framed by a short hairstyle, combed forward. The very short hair, arranged in the *a penna* style, is rendered by deep, dense incisions that curve over the temples. These incisions decrease at the level of the cheeks, where they begin to form the beard and moustache. The ears are schematically modeled. The nose is long and slightly sloping and the mouth is small and fleshy. The back of the head is hollowed out and missing an important piece of metal at the occiput.

The head was once installed on a modern bust and then removed. It is characterized by great technical skill, particularly in the meticulous detailing of the hair, beard, and eyebrows. The expressive rendering of the eyes, ringed by carved shadows, with hollowed out pupils near the upper eyelid and narrow irises, accentuates the gravity of the glance.

This portrait, which may be identified with the figure of Trebonianus Gallus (r. 251– 253 A.D.), is similar to a series of bronze effigies, formerly attributed to the iconography of this emperor.[2] A head now in the Vatican that belongs to this series could represent the sovereign wearing a crown of laurel leaves. Two large statues of nude figures, depicted as gods or heroes, raising their right arms in the traditional orator's gesture, also belong to this series. It is possible that the Louvre head was originally attached to a similar statue.

But the regular and not very individualized features do not allow certain identification: on coins struck with his effigy the emperor's profile is different.[3] The portrait more likely represents an important personage—perhaps someone closely related to the emperor. The transition from the realist style of portraits of the "soldier-emperors" and the return to classicism that would flourish under Gallienus's reign, already seems to have begun in portraits from this era, which was marked by a short period of peace, following a treaty with the Goths.[4] (C.B.)

NOTES
1 It is not certain that the bronze, purchased in Benevento, was discovered at this site, as is often indicated. Count Tyskiewicz, who had acquired it from the antiquarian Jules Sambon, in fact said that he did not know its origin. See Tyskiewicz 1895, p. 277, fig. 2.
2 Lahusen and Formigli 2001, pp. 286–89, no. 180 (head from the Vatican museum); pp. 289–92, no. 181 (head from the Florence museum); p. 294, no. 183 (statue from the Metropolitan Museum of Art); pp. 294–96, no. 184 (statue from the Archaeological Museum of Istanbul).
3 Kent, Overbeck, and Stylow 1973, pl. 109, fig. 478.
4 Balty 1980, p. 55.

BIBLIOGRAPHY
De Ridder 1913, p. 14, no. 44, pl. 8.
Kersauson (de) 1996, pp. 464–65, no. 217.
Lahusen and Formigli 2001, pp. 292–93, no. 182 (with previous bibliography).

48 Statue of a Woman

1st or 2nd century A.D. ▪ Discovered in Cumae (Italy) (?) ▪ Marble ▪ H. 76¾ in. (195 cm) ▪ Purchased in 1861, formerly in the Campana collection (MA 1143) ▪ Restorer: V. Picur, 2005

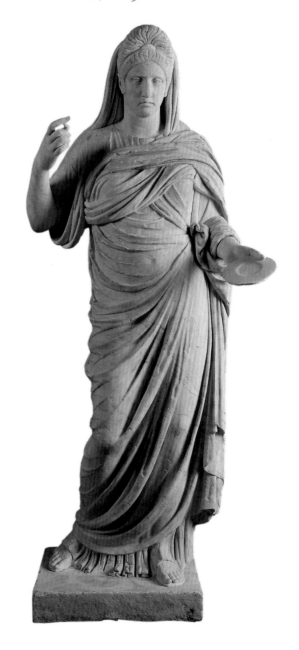

While in the Campana collection, this statue was assumed to have come from Cumae, though its provenance was not confirmed. In the nineteenth century, a skillful restorer in the service of the marquis completed the robed figure by adding a modern imitation of an antique portrait representing the head of Plotina, wife of Emperor Trajan (98–117 A.D.), and both arms. The right arm held a scepter (since disappeared) and the left held a cup in a gesture of libation. The 2005 restoration revealed that this head is entirely modern and that the forger-restorer went so far as to imitate repairs to it. Similar methods were used by the same workshop to create a *Didia Clara* for Campana,[1] taking as a base an antique headless torso featuring a variant of the statue shown here. In depicting this

Plotina, the restorer made use of the complex hairstyle sported by Trajan's wife, seen in several antique portraits on coins struck in 112 A.D., and a famous marble statue in the Vatican Rotunda. A narrow strand of hair frames the face, topped by locks of hair probably held up by a metallic headband to form a sort of diadem. The effigy thus completed was held to be a posthumous portrait of Plotina, who died around 129 A.D. and was deified under Hadrian, her husband's successor, whom she had helped bring to power.

The arrangement of the clothing is familiar from fourth-century B.C. reliefs and several other statues that seem to imitate a famous cult statue. The figure wears a light *chiton* of pleated linen solely visible on the lower part of the body and on the right shoulder. This first tunic is almost entirely covered by a wool mantle, the *himation*, fastened under the left arm. This garment is thrown over the head as a veil and falls in a particularly complex pattern of folds over the chest, its double hem folding back above the bust on the left shoulder and falling between the breasts, forming a sinuous shape. This is exactly the same garment worn by the deity Core-Persephone bearing torches in at least four votive reliefs from the fourth century B.C. that show her holding torches in Eleusis at the side of her mother Demeter.[2] It is also featured in reliefs of Hecate or Artemis-Hecate bearing torches.[3]

Other statues from the Roman era prove that this motif was widely disseminated in female portraits. Several examples were uncovered at the Cyrene site (present-day Libya), for instance.[4] Along with the drape of the clothing of the Dresden Herculanean and of the Pseudo-Artemis from the Mausoleum at Halicarnassus, this was the motif most frequently used for Roman funerary portraits of the second and third centuries A.D. Perhaps because they referred to statues of Core, these portraits assimilated the deceased with the queen of the Underworld.

Due to its resemblance to the muse carrying a double flute represented in one of the Mantinea plaques attributed to Praxiteles's workshop, experts have suggested that the statue is a copy of a Core by the fourth-century B.C. master. In the first century A.D., Pliny mentions a statuary group in Rome representing Flora, Triptolemos, and Ceres attributed to Praxiteles (*Natural History* XXXVI, 23). In the second century A.D., Pausanias (I, 2, 4) refers to the presence of a group of Eleusian divinities by Praxiteles near the Dipylon Gate in Athens. There can be little doubt that Praxiteles was therefore responsible for several representations of Core.

In the modern era, many of these statues were restored as muses with flutes[5] or, most often, as Urania holding a sphere in her left hand.[6] This was such a common occurrence that the type of statue referenced by the Campana copy in the Louvre was named the "Florence Core-Urania." (J.-L.M.)

NOTES

1 Louvre Ma 1081.
2 From Piraeus, National Museum of Athens inv. 1461; from Eleusis, Archaeological Museum, inv. 11; from Eleusis, Louvre, Ma 752, and National Museum of Naples from Mandragon.
3 In the Louvre, for example, see Ma 2723 and Ma 2849.
4 See Traversari 1960, no. 30, pl. XVI; and Alföldi and Rosenbaum 1960, nos. 155–59, pl. 72.
5 Vienna, inv. 157.
6 Uffizi Gallery, Florence, inv. 120, Vatican inv. 293, Louvre Ma 485.

BIBLIOGRAPHY

D'Escamps 1855, no. 86.
Kabus-Jahn 1963, p. 20, no. 80.
Bieber 1977, p. 197, pl. 136, fig. 798.
Kersauson (de) 1996, pp. 90–91, no. 33.

49 Portrait of a Woman

Mid-2nd century A.D. ▪ Discovered in Memphis (Egypt) ▪ Linden wood ▪ H. 18 in. (45.5 cm); W. 7½ in. (18 cm); D. ¾ in. (2 cm) ▪ Gift of King Louis-Philippe in 1834 (P 200—INV. N 2733; LP 412) ▪ Restorer: N. Delsaux, 1997

Here the modern mounting conceals the back and edges of the panel of peeled wood, and the panel's upper right corner has been cut away. A saw has scratched the left corner's surface, and the portrait is generally marred by numerous vertical cracks. A gray solution has been applied to the entire board, followed by a very

light beige layer on the background. Black-painted borders run along the top and bottom of the portrait.

The portrait depicts a young woman looking slightly to the right. Her face is triangular, her chin pointed, her nose long and straight. The eyes have been perfectly delineated with subtle cross-hatching, while a nearly white line defines the thickness of the lower eyelids. The hair is parted in the front, looped back at the sides, and partially covers the ears. A protuberance at the top of the skull probably indicates the presence of a rolled braid. The woman wears earrings consisting of three oblong white pearls on an annular gold wire, one end of which goes behind the ear. The necklace is composed of entwined strands of gold, worn close to the neck.

An ochre yellow tunic falls in deep folds and is gathered at the woman's neck. A grayish cloak is thrown over her left shoulder and pulled across her chest describing the arc of a circle. According to a color photo and description published in 1952, the cloak was originally violet.[1]

This type of tempera portrait depicting the bust of a person painted on small boards of varied thickness was taped with bandage in place on the faces of mummies. They are commonly known as Faiyûm (or Fayoum) portraits, after the Egyptian region where the first examples of this type were found in the late nineteenth century. But they are not exclusive to that area.

Experts commonly agree that some portraits were made from a living model, generally young men or women, but others were mass-produced by specialized painters. Then, in order to adapt the portrait to the shape of the mummy, its upper corners were sometimes cut away.

Deprived of their archaeological context, these works are difficult to date. Experts must observe the style in which they were executed, noting the representations of jewels and clothing, as well as the hairstyles, which, in general, followed the fashions set by the imperial court. The dates for specific works therefore tend to vary from one author to the next.

Klaus Parlasca (1980), for instance, drew on this portrait's similarities with a portrait in the Archaeological Museum in Florence to suggest that it dates from the second quarter of the fourth century. Barbara Borg places it at the beginning of the Antonine period,[2] in the first half of the second century A.D., and compares it to a fragmentary portrait in the British Museum in London. Susan Walker and Morris Bierbrier have also noted the many similarities between these two portraits, both from the stylistic and iconographic points of view, with the only notable difference residing in the hairstyle.[3]

E. Coche de la Ferté has likened the portrait's hairstyle to that worn by Empress Faustina the Elder,[4] who died in 141 A.D., as seen in several marble busts published by Max Wegner.[5] De la Ferté's dating of the piece to the middle of the second century is the dating we have followed. (R.C.)

NOTES
1 Grenier 1952; Coche de la Ferté 1952, p. 18.
2 Borg 1996, p. 51.
3 Walker and Bierbrier 1997, no. 104, p. 110.
4 Coche de la Ferté 1952, p. 18.
5 Wegner 1939, pl. 10–12.

BIBLIOGRAPHY
Parlasca 1980, no. 555 p. 37.
Doxiadis 1995, no. 47 pp. 123 and 187.
Borg 1996, pp. 15, 51, 104, 105, 108, 164, 180.
Parlasca and Frenz 2003, no. 555 p. 175.

50 Portrait of Julia (?)

Ca. 40 A.D. ▪ Provenance unknown ▪ Marble ▪ H. 28 in. (71 cm); W. 19⅝ in. (50 cm) ▪ Purchased in 1861, formerly in the Campana collection (MA 1230—INV. MNE 820) ▪ Restorer: A. Courcelle, 2006

This ancient head has been mounted on a modern bust, the nose redone and the iris retouched. The lines are fine and regular. The figure's thin, narrow lips are closed, the hair parted in the middle. The separated strands, drilled full of waves and tight curls, are drawn across the front and swept back on the sides in two coils from which two locks of hair curl over the neck. In the back, the hair is braided into a *cadogan* (or bow) held in place by a double braid from the center part.

This natural looking, highly elegant type of headdress appeared between the end of the first century B.C. and second decade of the first century A.D., as attested to by the portraits of Livia as a young woman that inspired such Claudian-era effigies as the Louvre's full-length figures.[1] The coiffure testifies to a return of the Greek style fashionable under the republic, before the appearance of the typically Italic hairstyle launched by Octavia, Augustus's sister, and adopted by Livia (cat. no. 33b). This hairstyle with frontal *nodus* was characterized by a flat lock of hair puffed up at the top of the forehead and then braided, with the rest of the hair gathered in a low chignon.

More natural and less elaborate looking, the Hellenizing hairstyle seen here spread through the second decade of the first century A.D.[2] With a few variants, such as a greater numbers of curls framing the face, it was adopted by the Julio-Claudian princesses—as can be seen in the portrait of Agrippina the Elder (cat. no. 18)—and in this portrait, presumed to be of Julia, granddaughter of Tiberius. In the trend's final stage during the Flavian era, the number and volume of curls around the face grew to form a simulated crown atop the head. (C.G.)

NOTES
1 Ma 1245; Kersauson (de) 1986, no. 44, pp. 206–07.
2 Virgili 1989, p. 39.

BIBLIOGRAPHY
Kersauson (de) 1986, no. 97, pp. 206–07.

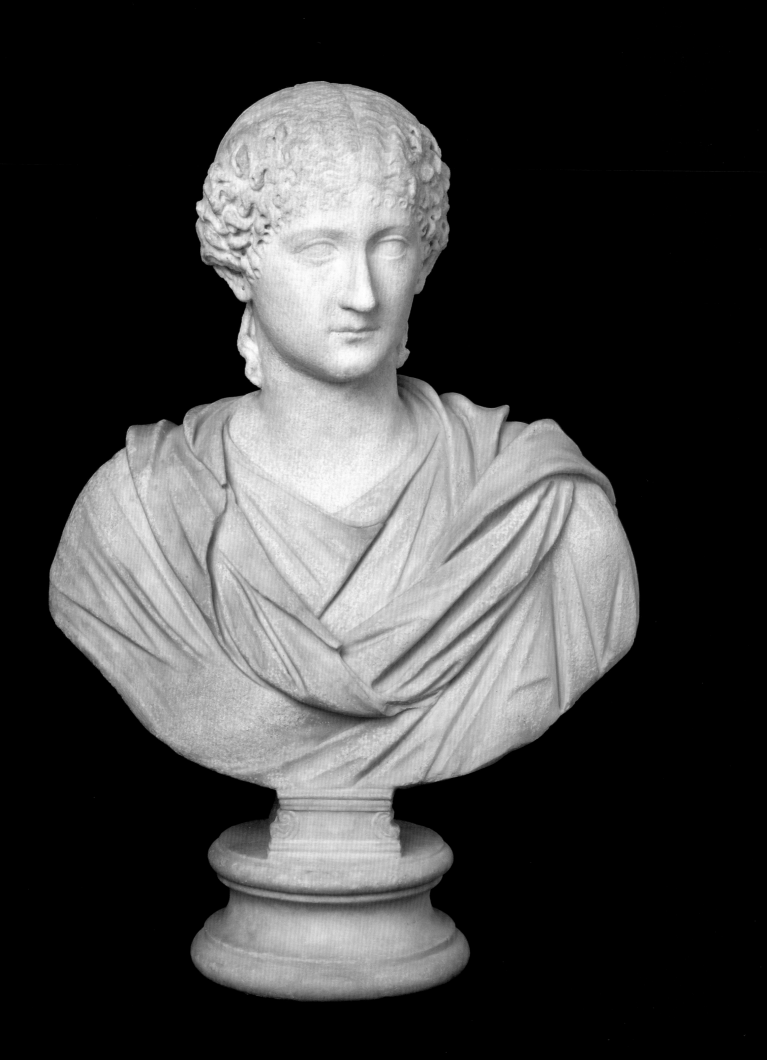

51 Portrait of an Unknown Woman

Ca. 55–65 A.D. ▪ Provenance unknown ▪ Marble ▪ H. 15 in. (38 cm); W. 9⅞ in. (25 cm) ▪ Purchased in 1861, formerly in the Campana collection (MA 1269–INV. MNE 821) ▪ Restorer: A. Courcelle, 2006

As indicated by the cutting of the back lower section, this bust was originally on top of a pedestal to form a herm. The face is large and round, with almond-shaped eyes, wide eyebrow arches, a flattish nose, and a narrow mouth with fleshy lips. There are no lines or wrinkles to convey expression.

The model's hairstyle is a variation on the Hellenizing type popularized by Livia (cat. no. 50); here, the trepan-drilled rows of curls are more numerous and have more volume, replacing the coils of wavy locks. On the back of the head, braids form a low chignon encircled by a fifth braid. Instead of a stray lock sticking out of the carefully arranged hairstyle, groups of two or three ringlets hang down on either side of the ears.

Though largely inspired by imperial fashions, this hairstyle also draws on styles from the Orient: the ringlets echo the styles of Ptolemaic princesses, for instance.[1] Generally dated to the reign of Nero, this portrait remains unidentified. Based on hairstyle, its closest parallel is a bust in Rome's Palazzo Massimo alle Terme, whose identification as Poppaea has not been universally accepted.[2] (C.G.)

NOTES
1 Kersauson (de) 1986, p. 218.
2 Giuliano 1979, no.178, pp. 286–87; and La Regina 1998, p. 27.

BIBLIOGRAPHY
Kersauson (de) 1986, no. 103, pp. 218–29.

52 Portrait of Domitia

Ca. 90 A.D. ▪ Discovered in Rome in the Palace of Tiberius on the Palatine Hill, in 1865 ▪ Marble ▪ H. 11¾ in. (30 cm); W. 9½ in. (24 cm) ▪ Pietro Rosa excavation commissioned by Napoleon III, 1866 (MA 1193–INV. NIII 2662) ▪ Restorer: B. Dubarry-Jallet, 2006

The head of this portrait is broken at the neck, and the nose is a modern plaster restoration. The long face ends with a broad chin. The eyes sit in rounded sockets bordered by thick eyelids. A small wrinkle runs on either side of the nose above thin, sinuous lips. Despite the exuberant coiffure, this impassive face does not reveal the slightest expression. A profusion of tight, little curls, bored with a drill, covers most of the temples and the forehead, reaching up to the diadem on top of the head. Beyond the diadem, the hair is divided into numerous, even braids that are long enough to be elegantly coiled over the back of the head.

The hairstyle is characteristic of portraits of women dating from the Flavian period. The same headdress is worn by the full-length representation of a naked woman—possibly Marcia Furnilla, second wife of Titus[1]—in the Ny Carlsberg Glyptotek collection in Copenhagen. It is more particularly associated with Titus and Marcia Furnilla's daughter, Julia Titi, who is seen sporting this sophisticated hairstyle in many effigies sculpted in marble or hammered on metal.[2] Domitia, the wife of Emperor Domitian, took this fashion to its apogee by wearing a greater number of curls in a sort of crown that occasionally extended upward (as in the portrait in the Museo Nazionale delle Terme in Rome, inv. 4219). As with Julia Titi, the many portraits of Domitia preserved both in stone and in metal allow us to appreciate the many variations of this style: different numbers of curls, hair revealing the forehead along a

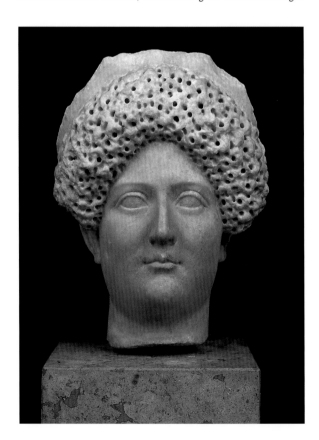

rounded or pointed line, braids gathered in a chignon on the back of the head or simply tied at the nape of the neck.[3]

This imperial portrait, now attributed without reservation, was discovered in the Palace of Tiberius on the Palatine Hill. Excavations requested by Napoleon III and headed by Pietro Rosa, on land the emperor had recently acquired, uncovered two busts now in the collections of the Louvre: this portrait of Domitia and a second very similar but unidentified bust of a woman in Domitia's entourage.[4] (C.G.)

NOTES
1 Kleiner 1992, p. 177, and fig. 146, p. 178.
2 Daltrop, Hausmann, and Wegner 1966, pp. 115–19 and figs. 42–50 g.
3 Ibid., pp. 122–25 and figs. 53–59.
4 Ma 1158. See Tomei 1999, figs. 176 and 177, pp. 257–58 and 467; and Kersauson (de) 1996, no. 9, pp. 38–39, with an error regarding provenance due to its being confused with Ma 1155.

BIBLIOGRAPHY
Daltrop, Hausmann, and Wegner 1966, pp. 122–25 and figs. 54 a, b, and d.
Herrmann 1991, pp. 40–41, and fig. 12a.
Kersauson (de) 1996, no.11, pp. 42–43.
Tomei 1999, figs. 178 and 179, pp. 257–58 and 467.

53 Portrait of an Unknown Woman
Late 1st century A.D. ▪ Provenance unknown ▪ Marble ▪ H. 14⅛ in. (36 cm); W. 8¾ in. (22 cm) ▪ Longstanding part of the collection (MA 581) ▪ Restorer: B. Dubarry-Jallet, 2006

This portrait was restored to fill several lacunae: the lower part of the neck and the nose are also modern restorations. Other parts, including the nose, lips, ears, and hair, remain damaged. The facial features are even and not particularly pronounced. The eyes are set deep in their sockets and accentuated by heavy lids. The nose and mouth are flanked by wrinkles, discreetly animating a face that is otherwise primarily distinguished by a very high coiffure: from the base of the ears and top of the forehead, an impressive series of drilled, regularly-spaced tight curls rise nearly four inches above the head. In the back, the curls change into wavy locks, while the entire back of the head is covered in a large braided chignon.

A simple comparison between this bust and a bust of Domitia (cat. no. 59) suggests the influence the imperial image had on the appearance of female citizens. Here, formal and stylistic similarities reached a level of imitation extending beyond the hairstyle to the slightly cold, restrained treatment of the face. Yet aside from these faithful imitations of the imperial model, one also finds examples of ostentatious one-upmanship where coiffures achieve outlandish heights: a superbly preserved bust in the J. Paul Getty Museum boasts a style as high as the entire height of the figure's face.[1] Mountains of curls could be accomplished with real hair, but more frequently they were achieved with the use of hairpieces. (C.G.)

NOTE
1 Inv. 73 AA 13; see Tulsa 1981, no. 39, pp. 56–57.

BIBLIOGRAPHY
Kersauson (de) 1996, no. 12, pp. 44–45.

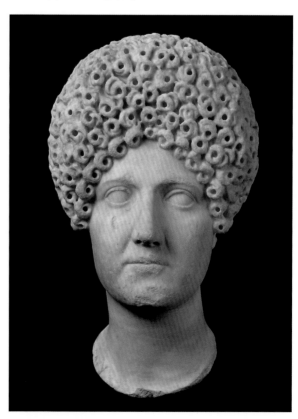

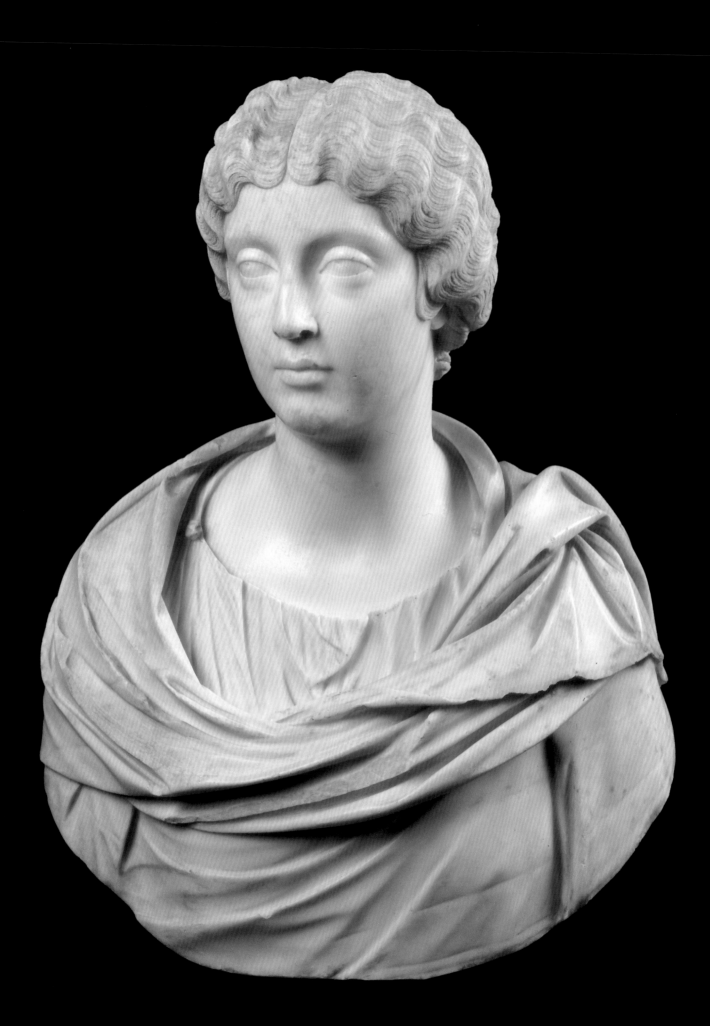

54 Bust of Faustina the Younger

161 A.D. ▪ Discovered near Tivoli (Italy) ▪ Marble ▪ H. 24⅜ in. (62 cm); W. 19⅝ in. (50 cm) ▪ Purchased in 1861, formerly in the Campana collection (MA 1144–INV. CP 6432; N 1376) ▪ Restorers: P. Jallet and A. Liégey, 2006

Cut from a single block of marble, this bust of Faustina the Younger is notable for its excellent state of preservation, despite a few chips on the face, some damage to the drapery, and the modern restoration of part of the chignon. The face has precisely captured fine features and a certain pensiveness; a dreamy air is created by the figure's turning and gazing slightly to the right. Above thin brows, the partially lidded and prominent eyes were hollowed to form irises with delicate incisions; they are partly covered by the upper eyelid. In profile, the figure has a slightly hooked nose, with meticulously rendered, fleshy lips and mouth. The center-parted hair has thick, wavy locks and a pattern of wide flat waves on either side that extends to a thick chignon in the back of the head. Two curly locks fall from the chignon down the neck. The princess wears a tunic under her mantle, one end of which drapes over the left shoulder in deep folds.

This bust is a replica of the widely distributed effigy of the princess,[1] who was the daughter of Antoninus Pius and wife of Marcus Aurelius. Comparing this series to coins bearing her effigy have made it possible to establish both a date and the reason for its distribution: Faustina wears this type of emblematic hairstyle on coins commemorating the births of Commodus and Fulvius on August 31, 161 A.D., which ensured a succession to the Antonine dynasty. As Klaus Fittschen has pointed out, this is an image of a young woman with soft, regular features—the mother of the emperor's children. Nonetheless, though the prototype was elaborated upon in 161 A.D., the stylistic evolution in the treatment of the clothing seems to indicate that certain replicas were made after Faustina's death in 175 A.D.[2] Lucilla (cat. no. 1), wife of Lucius Verus and one of Faustina's daughters, accentuated the family resemblance by adopting the hairstyle made fashionable by her mother. (C.G.)

NOTES
1 Twenty-two replicas recorded to date; see Fittschen 1982, pp. 55–58.
2 Fittschen and Zanker 1983, p. 21.

BIBLIOGRAPHY
Fittschen 1982, no. 11, p. 56, pl. 26, 1–4.
Kersauson (de) 1996, no. 108, pp. 244–45.

55 Portrait of an Unknown Woman

Mid-2nd century A.D. ▪ Provenance unknown ▪ Marble ▪ H. 11¾ in. (30 cm); W. 9½ in. (24 cm) ▪ Longstanding part of the collection (MA 4582) ▪ Restorer: C. Devos, 2006

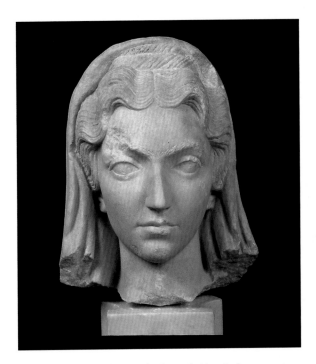

Broken at the base of the neck, this veiled head of a woman was completed in the modern era: the right arch of the eyebrow, the nose, and the chin are plaster restorations. The face is long and thin, with a high forehead and even features. The eyebrows are defined by light incisions; large eyelids border the almond-shaped eyes. The mouth, surrounded by discreet wrinkles, has thin, sharply defined lips. The frontal position, regular features, and lack of expression lend the face a classical allure aimed at idealism. Parted in the center, the hair is styled in relatively prominent waves stretching to the ears. A round chignon of two thick braids twisted together appears beneath a veil covering the entire back of the head.

The high chignon of braids and gently curling hair giving way to wavy locks were styles made fashionable by Faustina the Elder. In the case of this portrait, the hair is treated in a peculiar manner: the wavy locks, while limited in number, are exceptionally expansive. This variation on the imperial model seems to be rare, though it has certain similarities to comparable hairstyles (with more wavy locks and higher chignons) found on other unidentified models from the beginning of the Antonine era.[1] It appears that Roman women took some liberties with the fashions set by the first lady of the empire, most likely in an attempt to be original. (C.G.)

NOTE
1 Including, among others, the portraits at the Uffizi Gallery in Florence (see Mansuelli 1961, no.100, pp. 90–91 and fig. 100) and those in the Musei Capitolini (see Fittschen and Zanker 1983, nos. 102 and 103, pp. 77–79 and pls. 128–30).

BIBLIOGRAPHY
Kersauson (de) 1996, no. 91, p. 212.

56 Bust of Julia Domna

Late 2nd century A.D. • Discovered in Gabii (Italy) • Marble • H. 22 in. (56 cm); W. 11 in. (28 cm) • Purchased in 1807, formerly in the Borghese collection (MA 1107–inv. MR 639; N 1376) • Restorer: C. Devos, 2006

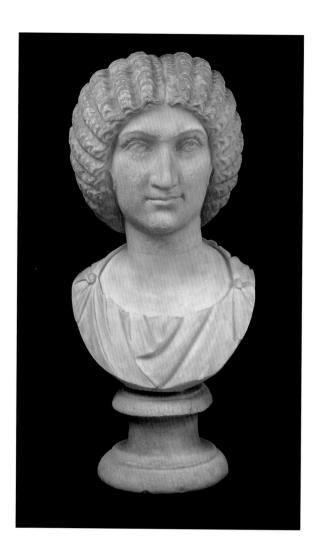

Fixed to a modern bust, this head has been subjected to various restorations aimed at erasing the traces of time. The nose has been redone and the cheeks and mouth lightly retouched to minimize stains and superficial degradations on the stone. The model's features can still be discerned in the rounded shape of the face, the execution of the eyes—featuring pupils defined with a drill, and finely engraved, connecting eyebrows. An imposing hairstyle adds the crowning touch: on either side of a clearly defined center part, a series of precise, wavy locks descends halfway down the neck, coming together on the nape and spreading, intertwined, across the entire back of the head into a high, flat chignon.

The woman represented is Julia Domna, second wife of Emperor Septimius Severus and mother of Geta and Caracalla. This bust, together with a portrait discovered in a temple in Gabii that is also in the Louvre's collections,[1] were the model pieces for the "Gabii type" that now extends to thirty-nine entries in the typology of portraits of this Syrian princess (as established by J. Meischner).[2]

This official portrait represents the first lady of the empire wearing a hairstyle popularized by the princesses of the late Antonine era. The style evolved from a simpler style initiated by Faustina the Younger (cat. no. 54): a relatively wavy mass of hair, divided by a center part and swept up on the back of the head in a large chignon with intertwining locks, inspiring the "turtle" chignon. On either side of the empress's face, two wisps of hair have slipped out of this regimented coiffure, betraying its artificial nature. Indeed, the use of full wigs, which were often substituted for hairpieces, is particularly detectible in the case of marble portraits. In fact, the hair for certain marble pieces was sometimes prepared separately, then added to the head (cat. no. 57).

This type of hairstyle, which may have included variations such as chignons resembling a ball of wool or concentric braids (cat. no. 57), evolved quickly: portraits of the fully mature Julia Domna represent her with looser, wavy locks hanging down her neck. (C.G.)

NOTES
1 Department of Greek, Etruscan and Roman Antiquities, Ma 1109; see Kersauson (de) 1996, no.167, pp. 364–65.
2 Meischner 1964.
3 For example, the portrait in the collections of the Museo della Civilta romana; see Virgili 1989, no. 44, p. 60.

BIBLIOGRAPHY
Fittschen and Zanker 1983, p. 28.
Kersauson (de) 1996, no. 166, pp. 362–63.
Meischner 1964, pp. 30 and 38.

57 Portrait of an Unknown Woman

Early 3rd century A.D. ▪ Provenance unknown
▪ Marble ▪ H. 12 in. (30.5 cm); W. 9½ in.
(24 cm) ▪ Deposit 1959, Musée Guimet
(MA 4523–INV. MND 2163) ▪ Restorer: C. Devos,
2006

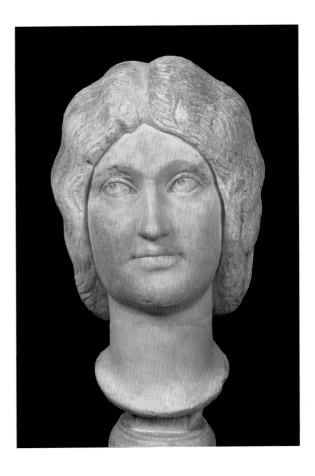

This bust is composed of two pieces carved from two distinct types of marble. One type of marble was used for the head and neck (the latter was broken and later repaired), and another type was used for the hair, which is arranged in two shell-shaped wings covering the head.

The full, broad face has some scratches and surface irregularities, apparently caused by the conditions in which it was buried. It gazes very slightly toward the viewer's left, with finely rendered features, full lips, and large eyes beneath broad eyebrows. The pupils are indicated by double drill incisions at the center of distinctly outlined irises. The nose is a modern reconstruction. The hair, carved from grey veined marble, flows from a center part in large waves that loop back fairly low on the nape of the neck, where they are tied in braids that fall down to the shoulders.

This treatment of the hair recalls the style of wigs fashionable during the era of Julia Domna, and the style echoes the fashion she introduced. One of the reliefs in the Arch of Septimius Severus at Leptis Magna, now in the Tripoli Museum (Libya), shows an example of such a style, which can be dated.[1] The construction of the arch was part of a vast building program, associated with the putative visit of the Emperor Septimius Severus to his native city in 203 A.D.[2] This bust's hairstyle thus represents a variant on a style made fashionable several years earlier, when hair was gathered behind the head in a "turtle" chignon (cat. no. 56). This anonymous portrait, however, renders the imperial hairdressing in a very stylized manner. Comparing it to another portrait in the Louvre reveals this contrast: also anonymous, the other portrait features wavy strands and braids that are depicted in a far more naturalistic way.[3] (C.G.)

NOTES
1 Blas de Roblès 1999, fig. C, p. 36.
2 Ibid., p. 34; and Laronde and Degeorge 2005, pp. 46 and 124–70.
3 Ma 1085; see Kersauson (de) 1996, no. 187, pp. 406–07.

BIBLIOGRAPHY
Kersauson (de) 1996, no. 188, pp. 408–09.

58 Aphrodite Holding a Comb and a Mirror

Early 3rd century A.D. • Discovered in Asia Minor, produced in Balikesir, Hadrianoutherai (Central Mysia) • Micaceous red-brown clay • H. 19⅝ in. (50 cm); W. 7⅛ in. (18 cm) • Purchased in 1983 (INV. CA 6828) • Restorer: C. Knecht, 2006

Here Aphrodite is represented standing, her legs draped in a *himation* decorated with a large band. She holds the garment in place with her right hand in a position loosely inspired by that of the Venus Genitrix. Her bare chest is adorned with rich necklaces; her right arm, ankles, and wrists with bracelets; and cabochon and pendant earrings peek out through strands of her hair. The round mirror in her left hand and the square comb in her right hand clearly refer to her role as the goddess of love and feminine beauty. The imposing hairstyle, parted in the middle with braided locks ending in a flat chignon behind the head, and the facial features—a round chin and small mouth, large eyes, and aquiline nose—are inspired by portraits of Empress Julia Domna.[1] The elongated proportions, exaggeration of certain anatomical elements (large hips, small breasts), and the schematic rendering of the clothing are common features of Severian-era sculpture, and support dating the piece to the first quarter of the third century A.D.

These elements also help us to pinpoint the figurine's origins, given that its exact provenance remains unknown. Statuettes featuring the same iconography and stylistic features were discovered in the necropolises of Balikesir, ancient Hadrianoutherai, in Central Mysia.[2] Founded by Hadrian, this city developed into a significant trading center and became very prosperous under the reign of the Severians.[3] Workshops flourished in Hadrianoutherai, displaying a considerable mastery (essential to creating large clay works without vents), which was heavily influenced by the Greeks, as seen in the local choice of iconographic themes (Aphrodite and Eros).

The figure's hieratic appearances, the opulence of the jewelry, and the variety of clearly visible attributes suggest that the model for it may have been the devotional statue in the Temple of Aphrodite built by Hadrian in Hadrianoutherai. Contemporary finery and ornaments tended to assimilate imperial and divine figures together; the blending was intended to bring these individuals (both divine and imperial) closer to the deceased, next to whom the figurines, may have been placed. (N.M.)

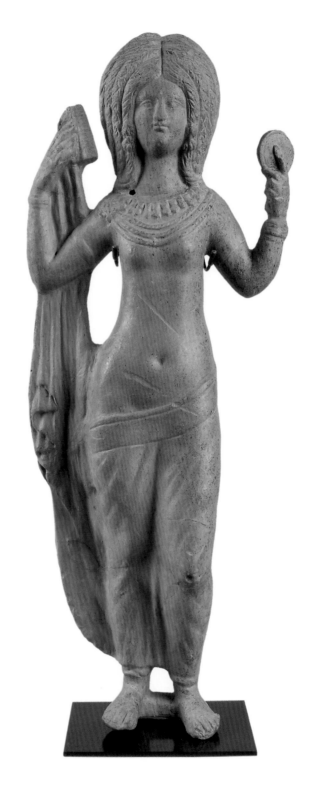

NOTES

1 W. Hornbostel, "Statuette einer Aphrodite," *Stiftung zur Förderungen der Hamburgischen Kunstsammlungen* 1969, pp. 32, 37; and H. Herdejürgen, "Statuette einer Aphrodite mit Modefrisur," *Antiken Kunstwerke aus der Sammlung Ludwig*, 1982, II, p. 194.
2 Besques 1997, pp. 24–25
3 L. Robert, *Villes d'Asie Mineure* (1962), p. 389.

BIBLIOGRAPHY
Bonn 1973, p. 190, no. 294.
Besques 1991, 4, pp. 22–25, figs. 12–14.
Herdejürgen 1997, p. 42, pl. 8, fig. 5.
Frey-Asche 1996, pp. 283–84.
Rouen 2000, p. 91, no. 70.

59 Hairdressing Scene

Ca. 225–250 A.D. ▪ Provenance unknown ▪ Rosy beige clay ▪ H. 5½ in. (13.9 cm); W. 2.95 in. (7.5 cm) ▪ Purchased in 1946 (inv. CA 3262) ▪ Restorer: C. Knecht, 2006

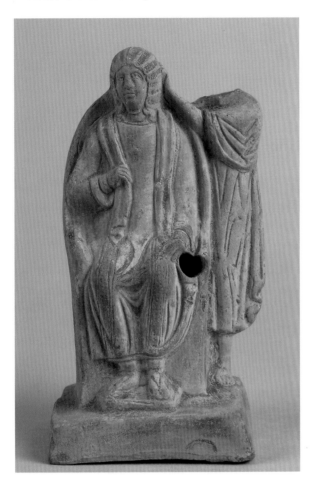

This terracotta group depicts an intimate scene in an opulent interior. A matron sits in a chair with a back and armrests—the *solium* once reserved for deities, then later found in luxurious homes—her sandaled feet resting on a footrest *(scabellum)*. Wearing bracelets on her wrists and ankles, apparently holding a scarf with her right hand, she is clad in a sleeveless under-tunic *(subucula)*, over which she wears an ample long-sleeved tunic *(supparum)* decorated with embroidered bands at the wrists and neck. Such tunics were usually belted at the waist, but here the absence of a belt can be explained by the fact that the woman is not yet fully dressed.

The matron is having her hair done by an *ornatrix*, a servant devoted to dressing, who braids it in a style made fashionable by Empress Julia Domna, with wavy strands along the forehead and temples braided into a large, flat coil at the back of the head (cat. no. 57).

The hairstyle, and the gentle, pensive expression of a face with pronounced pupils, are common to an entire series of figurines discovered in Tunisia. A fragment from an identical sculptural group can be found in the museum in Carthage.[1] Other groups representing Aphrodite surrounded by cupids were discovered in Bir-Bou-Regba[2] and Dougga[3] and appear to feature a head made from the same mold or from a comparable one. A fragment of a similar figurine from Hadrumetum[4] is also in the Louvre. It therefore seems likely that a single workshop was responsible for this type of work. Yet despite the fact that a signature was found on the Dougga group,[5] we have no indication allowing us to situate it precisely in Carthage, Thysdrus, or Hadrumetum. This statuette's technical particularities (surface treatment, precise details, holes) demonstrate a level of craft that would also have been used to make lamps and vases.

In fact, the figurine's exact function remains uncertain. The holes in the right armrest and the servant's head and arms, along with the closed base, have led some experts to believe that it could have been a lamp. Yet the cavity is too shallow for a wick. The object could also have been used as an anthropomorphic vase, though the absence of a genuine lip would have made this function difficult. Finally, additional elements (head with peg, mirror, and comb) may have been part of the composition. Many objects and instruments are generally included in scenes from daily life as represented in North African mosaics dating from the end of antiquity.[6] The dressing scene was a particularly popular subject. Like hunting scenes for men, it emphasized the elevated social rank of the women represented. (N.M.)

NOTES

1 Inv. 47.4, see Besques 1992, p. 157.
2 Bardo Museum. See *Musée Alaoui*, Suppl. I, no. 258, p. 161, pl. LXXXIX.
3 Copenhagen Museum. See N. Breitenstein, *Catalogue of Terracottas* (1941), pp. 100–101, pl. 133, no. 959.
4 CA 2649. Besques 1992, p. 163, pl. 102b, no. E461.
5 J. W. Salomonson, "Römische Tonformen mit Inschriften, ein Beitrag zum Problem der sogenannten Kuchenformen aus Ostia," *BaBesch*, 47 (1972), p. 107, fig. 27.
6 See, for example the mosaics of Sidi Ghrib (Tunisia), fifth century, Musée du Bardo. See A. Ennabi, "Les thermes du thiase marin de Sidi Ghrib," *Monuments Piot*, 68 (1986), pp. 42–44.

BIBLIOGRAPHY

Besques 1947, pp. 3-8.
Paris 1987, p. 77, no. 102.
Besques 1992, pp. 157–58, pl. 96a, no. E442.

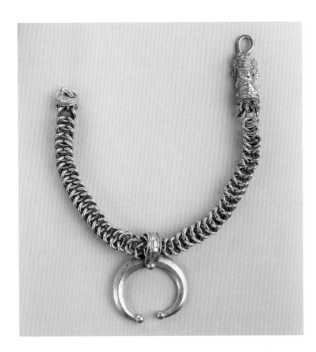

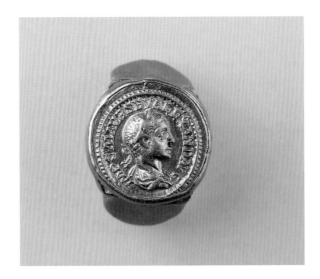

60 Necklace

1st–2nd century A.D. ▪ Provenance unknown
▪ Gold ▪ L. of chain 8½ in. (21.5 cm); H. of
pendant 1½ in. (4 cm) ▪ Longstanding part of
the collection (BJ 505–INV. N 2160)

This necklace consists of a short chain of double links forming a dense braid in a chevron pattern. One of the ends is missing, leaving a disk that was used to support the fastener. At the other end of the chain, an identical disk served as a support for the clasp, which was badly smashed at some point and now has only its fastening ring. The fastener is ornamented with the head of a young man with a large face, his heavy features framed by long, abundant hair arranged in broad locks and held back by a headband.

A fluted ring, set with two small gold spheres, slides along the chain and, at the center, supports a suspended crescent-shaped pendant. The latter's surface is sectioned into triangles, and its ends are closed with small gold spheres that are identical to those adorning the ring.

This type of necklace was very widely disseminated in the first and second centuries A.D. Numerous examples have been discovered, though none are identical to this one. The crescent-shaped pendant was considered a symbol of fertility. The clasp of some necklaces, made up of wheels, could be seen as an allusion to the moon and the sun. Such a jewel is seen adorning the neck of many female portraits of the Fayoum type. Its protective value is made more evident when the ring is embellished with an uraeus[1]—the head of an Egyptian cobra.[2] (A.S.)

NOTES
1 Pirzio Biroli Stefanelli 1992, fig. 173, p. 162.
2 Walker 2000, no. 2-3-4, pp. 39–43.

BIBLIOGRAPHY
De Ridder 1924, p. 42, no. 505.

61 Ring Set with a Coin

Mid-3rd century A.D. ▪ Discovered in Rouen
(France) in 1864 ▪ Gold ▪ Diam. ⅞ in. (2.1 cm)
▪ Purchased in 1865 (BJ 1136–INV. NIII 2500)

This signet ring is characterized by two bands separated by a mounting that is set with a gold coin. The coin is decorated with a head wearing a laurel crown. An inscription reads IMP C M AVR SEV ALEXAND AUG, allowing us to identify this man as Emperor Severus Alexander (222–235 A.D.).

The coin is not the *aureus*, which was in circulation during the early empire[1] but a lower value coin known as a *quinarius*, which was worth 50 *sestertii* (half the amount of an *aureus*). Many of these coins were minted under the Julio-Claudians (particularly Augustus and Tiberius) and then by the Antonines, but became increasingly rare during the third century. Very few have been found: there are only ten examples known from treasures and isolated finds.

The rather low module of the gold piece led to its being adapted to use in jewelry. This one, minted in Rome between 222 and 228 A.D., was mounted in a ring much the same way as the Maximus coin from the Amiens treasury (today in the Bibliothèque Nationale's Cabinet des Médailles in Paris). A third coin, found in Worms, shows Hadrian and was attached to a small finding so it could be used as a pendant.[2]

The Louvre's ring-mounted coin is the only surviving gold piece from the treasure where it was found. This treasure did include other articles of gold jewelry, but, lacking ornamentation, they were melted down to produce 49 ounces (1400 grams) of ore. The collection also included about forty bronze and silver coins, the latest of which can be dated to Trebonianus Gallus, whose administration lasted from 251 to 253 A.D., allowing the entire collection to be dated to the middle of the third century.[3] (C.G.)

NOTES
1 J.-P. Callu and X. Loriot, *L'or monnayé II. La dispersion des aurei en Gaule romaine sous l'Empire*, Cahiers Ernest Babelon, 3, Juan les Pins, A.P.D.C.A. (1990).
2 Dhénin and Loriot 1985, pp. 673–74.
3 Brenot and Metzger 1992, p. 220.

BIBLIOGRAPHY
King 1872, p. 347.
Longpérier (de) 1862.
Dhénin and Loriot 1985, no. 8, p. 674, and fig. 3, p. 675.
Loriot and Schers 1985, no. 63, p. 40.
Brenot and Metzger 1992, p. 220, no. 16, p. 323 and pl. 4.

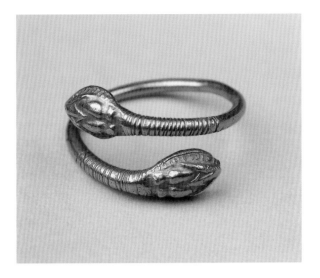

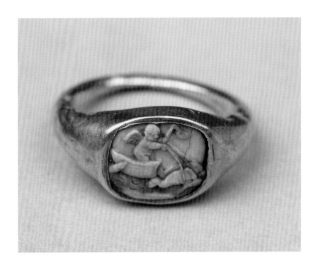

62 Ring in the Shape of a Snake
1st–2nd century A.D. • Provenance unknown • Gold • Diam. ⅞ in. (2.1 cm) • Gift 1890, formerly in the Davillier collection (BJ 1138–INV. MNC 1264)

This ring is shaped from a continuous circular band whose ends overreach each other and end in snake heads. The solid band's smooth surface is striated near the ends, imitating the reptile's skin. The snake heads are open-mouthed, showing teeth.

Rings in the shape of a snake first appeared in the fifth century B.C. and enjoyed tremendous popularity during the Hellenistic period. Originally the most widespread model evoked a coiled snake, ready to bite. The style of the ring was formed from numerous rings placed one next to the other. One end of the band wound over itself, suggesting the reptile's tail, while the other end depicted the head of the watchful animal. Much inspired by this subject, Roman artisans created multiple variations, with different numbers of coils and bands of varying widths. This model was fashionable in the first century A.D.[1] (A.S.)

NOTE
1 Pirzio Biroli Stefanelli 1992, p. 146, fig. 141, p. 244, no. 98.

BIBLIOGRAPHY
De Ridder 1924, p. 102, no. 1138, pl. 18.

63 Ring with Cameo
1st century B.C.–1st century A.D. • Provenance unknown • Gold, agate • H. ⅜ in. (1 cm); Diam. ⅞ in. (2.2 cm) • Longstanding part of the collection (BJ 1301)

This ring is formed from a circular hollow band made from rolled and soldered gold leaf, which flares out near the bezel. The bezel, rectangular in shape but with rounded corners, is set with a blue-tinged agate in two layers against a white background. The carved stone shows an Eros figure standing in a boat, the rudder of which crosses at the back. Brandishing a whip, the figure drives a pair of dolphins.

This type of ring, with a slender band becoming wide and convex around the stone, was in style from the first century B.C. to the first century A.D.[1] Generally, the stones were oval. A rectangular-shaped stone is less common.[2]

The small amount of blank space around the scene, the dolphin's snout, and the end of the cut-off rudder suggest that the edges were chipped when the stone was inserted into the bezel. The chosen subject was very common and appeared in different forms on a variety of supports.[3] Erotes, gods of love, were often seen engaged in dolphin chariot races, as well as in wall paintings in Campania.[4] Later, in the third–fourth centuries A.D., they appeared on mosaic floors in Sicily and Africa, fishing and participating in aquatic races.[5] (A.S.)

NOTES
1 Chadour-Sampson 1997, pp. 114–15, no. 23, same profile.
2 Pirzio Biroli Stefanelli 1992, fig. 108, p.127, another example.
3 LIMC III, pp. 869–70, nos. 186–91; III, 2, p. 619.
4 Tran Tam Tinh 1974, pp. 54–56, no. 30, fig. 35.
5 Dunbabin 1999, fig. 22; Baratte 1978, fig. 77.

BIBLIOGRAPHY
De Ridder 1924, p. 119, no. 1301.

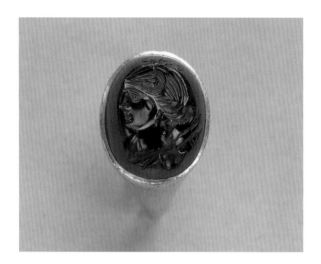

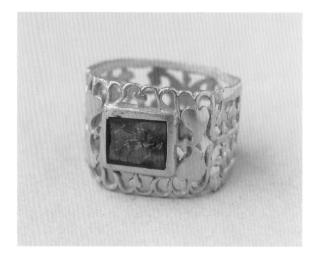

64 Ring with Intaglio
Early 1st century B.C. • Provenance unknown
• Gold, garnet • Diam: ⅝ in. (1.7 cm) •
Purchased in 1882 (BJ 1261–INV. MNC 222)

A rounded garnet crowns this small ring with a partially convex band. The garnet is carved with the head of Artemis, whose bow and quiver emerge behind the nape of her neck. The goddess's hairstyle is extremely complex, forming a twist that frames her face and is knotted in a small chignon behind her head. Long locks descend below her temples, then are lifted and gathered into a tuft atop her head.

From its shape and profile, this ring can be dated to the Hellenistic period.[1] The garnet was rather frequently used in the late republican and early imperial periods. The goddess appears coiffed in this manner on coins dating from 78–77 B.C.[2] A garnet intaglio with an Artemis figure dating from the first half of the first century B.C. (now in the Metropolitan Museum of Art), leads us to date this jewel to the same era.[3] (A.S.)

NOTES
1 Plantzos 1999, p. 37, fig. 2, type V.
2 Vollenweider 1972, p. 14, no. 14, pl. 13, no. 14.
3 Ibid., p. 14, no. 10, pl. 13, no. 10.

BIBLIOGRAPHY
De Ridder 1924, p. 115, no. 1261.

65 Ring with Openwork Ornamentation and Eros Intaglio
Late 3rd–early 4th century A.D. • Discovered in Le Pouzin (Ardèche, France), ca. 1850 • Gold, garnet • Diam. ⅝ in. (1.7 cm); H. of chaton ¼ in. (0.5 cm); L. of chaton ¼ in. (0.6 cm) • Purchased in 1913 (BJ 2374–INV. MND 987) • Restorer: O. Tavoso, 2006

Around 1850, in Ardèche, a farmer found a limestone urn near Le Pouzin (a large village between Valence and Montélimar) along the road leading to Baix. He broke open the cover and discovered this small ring covered in ashes. Fifteen years later, excavations conducted near this location revealed an enclosed burial ground. At that time, a box, a glass bottle, and an onyx bowl (cat. nos. 178–80) were unearthed from a sandstone grave where they lay amid charred bones. These items were rightly acquired by the museum at the same time as the ring.

Opposite the besel, a decorative leafstalk emerges from both sides of two peltae joined back-to-back. Small leaves of ivy are attached by their stems and spread out symmetrically from the leafstalk. The tip of each leaf touches the edge of the ring, forming a continuous ribbon. Near the bezel, two branches of ivy come out from the main leafstalk to fan in two branches on the ring width. They end in two large ivy leaves joined at the base. A new tiny ivy leaf emerges from these—the center of which seems to support the upper and lower parts of the bezel. The large leaves stem from a double stalk that continues an openwork scallop framing the bezel's left and right sides, interrupted in the middle by a small ivy leaf. The bezel is adorned with a garnet engraved with an image of Eros standing with his legs crossed, his head turned to the left, resting his elbow on an undefined object lying on the ground.

It is uncertain whether this should be considered one of the numerous pensive Eros images, in which the god leans on a torch propped on a base or an altar.[1] The pensive Eros holds his head high, stares into the distance, and leans on a stone—an unusual representation of the subject, but one that is, however, illustrated on a cameo in Saint Petersburg[2] from the first century A.D. In style, the representation resembles a second-century A.D. intaglio where Eros is shown facing straight ahead, legs crossed, leaning on a prop and holding a crown,[3] but here the figure is less developed: it is rather squat, its hair represented only by a wavy line, the features of its face barely outlined, its limbs suggested by small sticks. These features place the figure within the body of work defined by M. Guiraud as the "smooth" style.[4] They also suggest the piece is from a later date, as the technique employed to make the ring, known as l'opus interrasile, was developed only after the third century A.D. The method consists of openwork cutouts from gold leaf, where shadow and light play off each other in the spaces and solid areas. Also, the pelta design was a feature of several rings created by the same method.[5] (A.S.)

NOTES
1 Vollenweider 1984, pp. 67–68, no. 97–98, figs. 97–98; LIMC III, p. 931, nos. 984–93, p. 667, A. Hermary, H. Cassimatis, and R. Vollkommer, "Eros."
2 Neverov 1971, fig. 46.
3 LIMC III, p. 997, no. 170, p. 690, F. Blanc, N. Gury, "Eros/Amor, Cupido."
4 Guiraud 1988, p. 54.
5 Yerolanou 1999, p. 255, nos. 303–04.

BIBLIOGRAPHY
Michon 1915, pp. 73–74, fig. 1.
Dupraz and Fraisse 2001, p. 311, fig. 390.

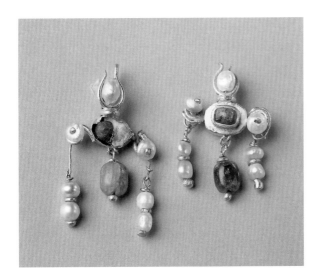

66 Pendant Earrings with Disks

3rd century A.D. (?) ▪ Provenance unknown ▪
Gold, emerald, pearls ▪ H. 1¼ in. (3.3 cm); W.
1½ in. (3.8 cm) ▪ Purchased in 1825, formerly
in the E. Durand collection (BJ 428-429—INV. ED
4763-4764)

These earrings each have an emerald cabochon at their center with
an emerald pendant dangling below. On either side of the cabo-
chon, a volute of gold wire, scrolled in opposite directions, encases
a pearl. An intertwined wire behind it ends in a bead, suspending a
pendant of two pearls that are separated by a ring. Atop the cabo-
chon, a ring designed like a bull's horn encircles a pearl.

The second earring in this pair underwent several alterations.
It lacks the cabochon, the central stone is a different color, the
ear loop was re-soldered, and the lateral pendants are longer, each
supported by simple, straight wire.

Attaching pendants directly to a middle cabochon is unusual;
generally, an intermediate small metal bar supports them.[1] A
somewhat similar setting is found in another pair of earrings in the
collection,[2] where the main cabochon is surmounted by the same
design. This could be a stylized interpretation of the headdress
of the Egyptian goddess Isis—a solar disk surrounded by cattle
horns—and, since the cult of Isis was widespread throughout
the Mediterranean basin, artisans might indeed have chosen this
ornamentation. Could followers have worn this type of earring? Or
was it simply that this attribute of the goddess, who symbolized
the ideal of motherhood and companionship, was used to adorn
a woman's jewel?

The tripartite composition and use of different color stones are
similar to the group of earrings with horizontal small bars more
commonly found in the third century A.D. Some of these, as well,
are decorated with a crescent design recalling Isis's headdress.[3]
(A.S.)

NOTES
1 Pirzio Biroli Stefanelli 1992, p. 195, fig. 234, p. 259, no. 179.
2 Bj 431–Bj 432 Besson 2003, pp. 23–25, pp. 75–82, figs. 82–91.
3 New York 2000, p. 152, fig. 104–08, p. 153, no. 106.

BIBLIOGRAPHY
De Ridder 1924, p. 34, nos. 428–29.
Besson 2003, pp. 20–23, pp. 60–74, figs. 61–81.

67 Earring with Cabochons and Pendants

6th century A.D. ▪ Provenance unknown ▪
Gold, garnet, molten colored glass ▪ H. 2⅛ in.
(5.5 cm); W. ¾ in. (2 cm) ▪ Roudillon gift, 1959
(BJ 2265—INV. MNE 640)

The earring is composed of a rectangular gold plaque supporting
three rows of opaque, green molten-glass square cabochons. The
lower part of the earring is accentuated by a chevron-patterned
plait that is framed on both sides by a thin gold strand. The reverse
side of this plaited strip conceals and serves as the attachment
point for five rings from which small link chains hang, alternately
facing front and sideways. Coiled wires hang from the links with
pearls attached.

Above the plaque sits a garnet set in an oval bezel and flanked
by two flat gold beads. The top right element of the plaque has a
different border.

Incomplete and having undergone several restorations, this
jewel would have been the main decorative element of an earring.
It is quite similar to a pair of rigid pendant earrings, now in the
archeological museum in Istanbul, which date from the late sixth
century A.D.[1] The use of enclosed stones links this piece with artis-
tic design of the early Middle Ages. (A.S.)

NOTE
1 Baldini Lippolis 1999 p. 98, no. 5c 1.

BIBLIOGRAPHY
Coche de La Ferté 1961, no. VII.
Paris 1992, p. 130, no. 82.

68 Hairpin

Roman era ▪ Discovered in Italy (?) ▪ Silver ▪
L. 5¾ in. (14.5 cm) ▪ Purchased in 1861, for-
merly in the Campana collection (BJ 465–INV.
CP 39)

This hairpin consists of a long cylindrical rod that widens near the
top and culminates in a Corinthian capital with two rows of leaves.
The capital supports a round plinth on which a female figure stands
like a statue. Half nude, she is seen in frontal view, the right leg
slightly bent forward. Drapery knotted below her waist completely
covers her lower half. Her right arm is held forward, the palm of her
hand raised. With her left hand, she twists a long lock of stray hair.
The rest of her severe hairstyle—pulled back and gathered into a
chignon at the neck—is held in a tiara atop her head.

Made of gold, silver, and bone, these pins were used to hold
complicated hairstyles and hairpieces (in vogue at the time) in
place. They were topped with diverse ornamentation, including
fruits and flowers. As tools of feminine toiletry, their decoration
was linked to the works and statuettes associated with beauty.
Beginning in the Hellenistic period, the goddess Aphrodite loomed
large among her subjects: she was often depicted nude, leaning
on a column and unfastening her sandal, accompanied by Eros[1] or
shown half nude, holding her hair.[2]

Roman artisans fashioned similar subjects; some, however,
had less verve.[3] In the fourth century A.D., two such pins were
found in the Esquiline treasure: one with a nude Venus unfastening
her sandal and supported by a herm of Priapus, the god of fertility;
the other with a half-nude Venus with her hand in her hair.[4] (A.S.)

NOTES
1 Deppert-Lippitz 1996a, p. 101, fig. 91, p. 142, no. 91.
2 Hoffmann 1961, p. 43, nos. 98A-99, figs. 98A-99.
3 Johns 1966, p. 141, fig. 6.8.
4 Shelton 1981, p. 102, pl. XXII, nos. 1–2.

BIBLIOGRAPHY
Clément 1862, p. 17, no. 39.
De Ridder 1924, p. 38, no. 465.

69 Hairpin

Julio-Claudian era ▪ Discovered in Italy (?) ▪
Bone ▪ L. 4 in. (10.2 cm) ▪ Purchased in 1861,
formerly in the Campana collection (INV. MNE
260) ▪ Restorers: J. Lévy and A. Cascio, 2006

This pin has a stem with a slight bulge near the top. The head of the
pin is shaped like an acorn. Pins were widely used to hold up chi-
gnons and hairpieces, which were popular in the imperial era. There
are examples of very long pins (cat. no. 68), which went through
and held an entire coiffure. Others served a decorative purpose,
which is why the head of this pin is more carefully fashioned than
the stem. The slender end of the pin was probably sharpened by
hand before it was burnished. Only the small ridge near the end of
the pin (just below the acorn) appears to have been worked on a
lathe. The acorn itself was carved from a thicker piece of bone that
was then fit onto the pin.

The acorn motif, although less common than the pinecone,
was used for decoration and as a fertility symbol. It was thus par-
ticularly fitting as a female accoutrement. The Louvre has another
example of a pin (in gold), with a more ornate acorn motif, also
from the former Campana collection (inv. C 33).

Although the pin shown here was crafted from less expen-
sive materials and lacks embellishment, it was a rather elegant
item—plain but very well-turned, and simulating ivory with near
perfection. Hairpins were found in great numbers in female tombs,
as well as in the baths, where women probably lost them regularly.
(P.C.)

BIBLIOGRAPHY
Unpublished

70 Zoomorphic Fibula

2nd–3rd century A.D. ▪ Discovered in Chalon-sur-Saône (Saône-et-Loire, France) ▪ Bronze, champlevé ▪ H. 1 in. (2.4 cm); W. 1¼ in. (3.1 cm) ▪ Purchased in 1825, formerly in the Grivaud de la Vincelle collection and the Durand collection (BR 2025–INV. ED 3430) ▪ Restorer: I. d'Avout-Greck, 1999

This fibula, or brooch, is carved in the shape of a peacock that faces toward the right. On top of the peacock's head is a small egret with three feathers. The empty hollow of its eye must have been inlaid at one time. Its feathers, depicted in champlevé—a decorative technique using colored enamel—have partially disappeared. Red enamel inlays are still visible in the chevron-shaped lines engraved on the tail and in the small geometric cavities carved on the wing. The hinge on the back of the fibula—formed by two bars crossed by an axis known as a *goupille*—is intact, as is the mounting that holds the pin closed. The pin itself is missing.

This fibula was discovered, along with other remains, in the eighteenth century, when the fortress called the "Citadelle," which dominated the city of Chalon from the north, was demolished. The piece is probably from a Gallo-Roman necropolis located on that hilltop. A very similar example in silver-plated bronze was found in the same region, in Autun.[1] Many fibulas carved in the form of real or imaginary animals, such as lions, hares, various birds, sea monsters, chimeras, and winged horses, have been discovered.[2] These representations probably had a symbolic value or protective purpose: the peacock, Juno's favorite animal, was a symbol of resurrection.

Enameled fibulas, which first appeared at the end of the first century, were in fashion throughout the second and early third centuries. Their polychrome decorations were achieved by filling the small cavities carved into the metal's surface with blue, green, yellow, and red enamels. Similar to brooches worn today, the hinged fibulas that appeared in the first century B.C. would replace the spring-back fibulas after the first century A.D. The latter, consisting of only one piece of metal shaped to form the spring and tongue, were fragile and difficult to repair.

Fabricated in bronze, gold, and silver, fibulas were worn by both men and women. A man would use it to fasten his military or civilian coat, either at the shoulder or on the front. A Roman matron would wear hers on one shoulder to fasten her long tunic or *stola*, or on her chest to close her coat. (C.B.)

NOTES
1 Autun 1985, p. 183, no. 340, a.
2 For more about zoomorphic fibulas, see Feugère 1985, pp. 382–94, type 29, fig. 60.

BIBLIOGRAPHY
Grivaud de la Vincelle 1817, pl. XXXV, 6.
De Ridder 1915, p. 74, no. 2025.
Rebourg 1994, p. 157, no. 245.
Fauduet 1999, p. 26, no. 132, p. 60, pl. 17.

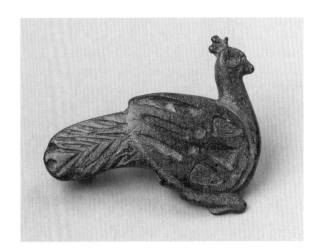

71 Pyxis

1st–2nd century A.D. ▪ Discovered in Egypt (?) ▪ Bone ▪ H. 1⅞ in. (4.7 cm); Diam. 1½ in. (4 cm) ▪ Seguin bequest, 1909 (S 2050–INV. MND 874) ▪ Restorers: J. Lévy and A. Cascio, 2006

The body of this small container, or *pyxis*, is decorated with an image of Eros reclining and propped up on his left arm, his head turned to the left, facing a panther. His right hand is outstretched to his right, as if pointing to the plant garland that separates him from the animal. On the lid, a profile of the goddess Minerva is identifiable by the helmet and the gorgonion mask covering her breast. The base of the *pyxis*, as well as the horizontal rims and the lid, are underscored with carved circular molding.

The body of the container is carved from a cow's femur. A small natural opening (the marrow cavity) emerges in the middle of the garland and was accentuated with a tool, but the particular reason for this is not known. The lid and the bottom of the container were cut from a rib bone. The moldings were turned on a lathe and the figurative motifs were sculpted by hand.

The term *pyxis* comes from the Greek and originally referred to the small wooden boxes used by doctors to hold ointments. This term is commonly used in archeology to refer to all small boxes—whether of terracotta, metal, ivory, bone, or other material—in which women kept cosmetics and articles for their toilette. This

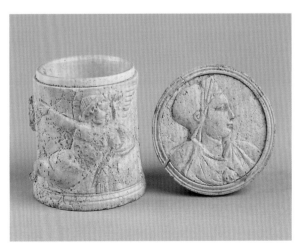

type of *pyxis*, made of bone, was found in many different areas of the empire (Gaul, Italy, and Egypt). It is likely that each region had its own production. Several examples have been found in Pompeii, some of which are displayed in the archeology museum in Naples. This one, although crafted from a more modest material than ivory, would still have been considered an elaborate object with its decorated top, as such tops were usually embellished with simple, concentric circles.

The motif of Eros leaning back, playing a musical instrument, or carrying articles for the toilette, was a very popular decorative element on this type of *pyxis*. This small, chubby, winged child was a frequent character in scenes associated with female finery and cosmetics, as seen in the frescoes of cupids making perfume in the House of the Amorini Dorati in Pompeii. The panther is one of a number of animals depicted in the Procession of Venus.

It is not really surprising that Minerva is depicted on the lid of this *pyxis* rather than Venus. Minerva was one of the goddesses subjected to the Judgment of Paris (along with Venus and Juno) to determine who would receive the golden apple destined "for the fairest" by Discord. Moreover, just as Athena was the titular goddess of the Greek capital, the Romans sometimes used the Latin equivalent, Minerva, to personify the city of Rome. (P.C.)

BIBLIOGRAPHY
Unpublished

72 Mirror Embellished with Relief

Mid-late 2nd century A.D. ▪ Provenance unknown ▪ Gold- and silver-plated bronze ▪ Diam. 3⅞ in. (10 cm) ▪ Purchased in 1990 (BR 4644–INV. MNE 963) ▪ Restorer: F. Dall'Ava, 2006

This mirror is formed by a bronze disk, which is missing a fragment along the edge. Its reflective side is silver-plated. Gilded-bronze leaf, worked in repoussé and plated to the disk, decorates the other side. Though broken in certain places, especially near the crack in the mirror, the ornamentation is well-preserved overall. Within a beaded border, three figures stand in an architectural structure: the goddess Diana is flanked by two smaller, younger people, who face her from their places of honor.

Accompanied by a doe, Diana is clad in hunting attire: a short tunic gathered at the waist that drapes in a long fold, and button-boots known as *embades*. Her left hand holds a bow; her right hand draws an arrow from the quiver. The figure to her right is draped around the hips, the cloth hanging over his arm, wearing button-boots, driving a lance into the ground with his left hand, and leaning against the lance. He has a dog by his side. The figure to Diana's left also wears button-boots, and his left shoulder is covered with drapery that falls behind the whole length of his leg. He holds a lance in his left hand and an unidentified object in his right. These two young figures probably represent hunting heroes, such as Meleager and Hippolytus, or perhaps local deities associated with the world of the hunt, to which the boar—featured on the lower portion of the disk—is also a reference.

The structure in which the three figures stand was likely a temple formed by four columns supporting three pediments. The fluted columns framing each figure rest on bases and have Corinthian

capitals. The base beneath the columns is decorated by an undulating and pointed ribbon motif. Two semi-circular pediments, each adorned with Medusa's head, flank a triangular pediment decorated with a theatrical mask. This type of pediment, known as Syriac, is characterized by the curve of the entablature, which forms an arc and penetrates the interior of the tympanum. Hellenistic in origin, the structure is found on the apse of the Corinthian temple of the Termessos agora, in the Pisidia region of Asia Minor.[1]

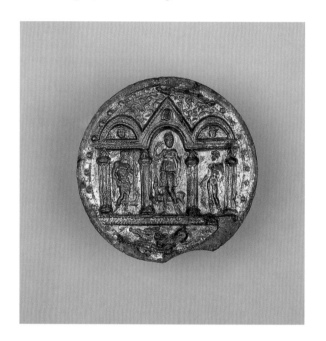

This style of architectural design was particularly acclaimed toward the end of the second century in the eastern part of the empire. It is also seen in a very similar mirror, dating from 160–70 A.D., which is now in the Munich Prähistorische Staatssammlung.[2] For the most part, mirrors with Roman reliefs come from Asia Minor, Syria, and eastern Thrace.[3] (C.B.)

NOTES
1 Crema 1959, p. 389, p. 397, fig. 477; Gros 1996, p. 190.
2 Zahlhaas 1975, pp. 29–32, p. 43, p. 77, no. 31, pl. 29.
3 Treister 1994, pp. 420, 422.

BIBLIOGRAPHY
Metzger 1991, p. 73, fig. 3.

73 Perfume Bottle with Ribbed and Marbled Design

1st century A.D. ▪ Discovered in Cyzica (Turkey) ▪ Glass ▪ H. 3¾ in. (9.5 cm); Diam. of mouth 1 in. (2.5 cm); Diam. of body 3 in. (7.5 cm) ▪ Purchased, 1906 (INV. MND 774) ▪ Restorer: J. Dupin, 2006

74 Amphora

4th century A.D. ▪ Discovered in the Near East ▪ Glass ▪ H. 6 in. (15.5 cm); Diam. of mouth 1⅝ in. (4 cm); Diam. of body 2 in. (5.5 cm) ▪ Gift 1967, formerly in the Péretié collection and the Boisgelin-De Clercq collection (MNE 157) ▪ Restorer: J. Dupin, 2006

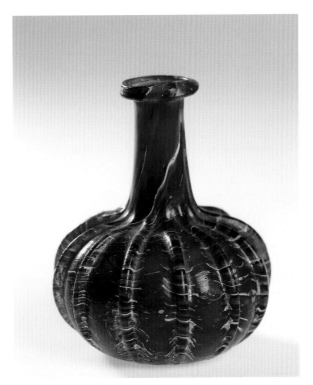

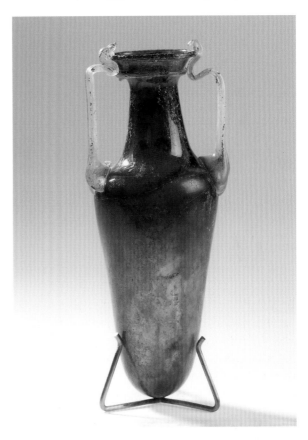

This blown-glass perfume bottle from the eastern Mediterranean has a dark blue and white marbled design. The lip on the mouth of the bottle has a rim that turns out and then in. The neck is cylindrical and the body spherical and smooth, embellished with thirteen vertical ribs pulled from the parison in sharp relief. The bottom is flat.

Perfume containers were highly valued throughout the empire, so it is difficult to determine whether a bottle was of local origin or imported. With the simplest vessels, the contents were valued more than the container. The Aegean world, situated between the two main regions for manufacturing—Italy and the Near East— logically received goods from both sides. Still, we can hypothesize that the first century would have seen glass workshops established much like they had been established in the eastern provinces.[1]

Decorated by a marbling technique used as the glass was being blown, this vase from Cyzica is a rare example of a bottle with decorated sides. Bottles decorated on the sides are far less common than smooth-sided examples.[2] (V.A.)

NOTES
1 De Tommaso 1993, pp. 53–58.
2 Stern 2001, no. 7.

BIBLIOGRAPHY
Arveiller-Dulong and Nenna 2005, no. 826.

This amphora of Syrian-Palestinian manufacture is made of violet-colored blown glass. The mouth flares outward, while the rim folds back inward. The cylindrical neck widens as it nears the body. The shoulder of the vase is oblique, the body conical, and the bottom rounded. Handles consisting of two thin green bands are affixed to the shoulder, pulled toward the top, and folded back below the mouth, where a violet thread is applied. The bottle bears a pontil mark.

These flasks are found in various shapes and designs, at times with contrasting colors, like this one. Given their small size, they were probably used for toiletries. Sometimes these examples also feature a fluted design, with or without an elongated depression in the body. They were very much in fashion in the Near East, Syria, and Palestine.[1] (V.A.)

NOTE
1 Stern 1977, pp. 80–86.

BIBLIOGRAPHY
Arveiller-Dulong and Nenna 2005, no. 1141.

75 Jar with Four Handles

4th century A.D. • Discovered in the Near East • Glass • H. 3⅞ in. (9.75 cm); Diam. of rim 2½ in. (6.8 cm); Diam. of body 3⅛ in. (7.95 cm); Diam. of foot 1¼ in. (3.3 cm) • Gift 1967, formerly in the Pérétié collection and the Boisgelin-de Clercq collection (MNE 171) • Restorer: J. Dupin, 2006

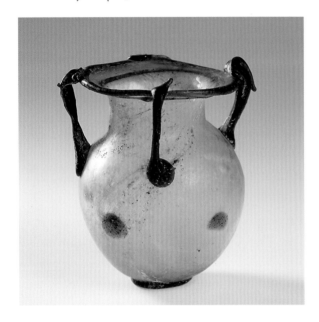

This blown glass jar has a flattened mouth and a rim decorated with a dark green band over a green spiral threads. Its neck is short and cylindrical, its body spherical and embellished with five green dots, its base flat and ringed with a strip of green. Four green vertical handles attach at the shoulder and embouchure. There is a pontil mark on the jar.

The design of five applied dots is rather unusual in the Near East and more common in the western part of the empire, especially on bowls, goblets, lamps, and dishes found in Rhineland, and occasionally on bottles, pitchers, and two-handled goblets.[1] However, the jar's overall shape identifies it as being from the Near East—more precisely, Syria.[2] (V.A.)

NOTES
1 Fremesdorf 1962.
2 Arveiller-Dulong and Nenna 2005, nos. 1181 and 1182.

BIBLIOGRAPHY
Arveiller-Dulong and Nenna 2005, no. 1180.

76 Front of the Sarcophagus of Cornelius Statius

Ca. 150–160 A.D. • Discovered in Ostia (Italy) (?) • Fine-grained white marble (Luna?) • H. 18¾ in. (47.5 cm); W. 58¾ in. (149 cm) • Purchased in 1861, formerly in the Campana collection (MA 659–INV. CP 6547) • Restorer: V. Picur, 2006

Rounded at the head side, as can be seen on the far right, this child's sarcophagus has been reassembled from many fragments. The front panel is, however, in fairly good condition, with a few missing pieces reconstructed from Carrara marble.[1]

Both end panels were decorated with griffons; only the head of the left one remains. The vestiges of the griffon on the right show the head and paw resting on the skull of a ram. The lower plinth bears this epitaph: M(ARCO)-CORNELIO-M(ARCI)-F(ILI)-PAL(ATINA TRIBU)-STATIO-P[ARENTES]-FECER(UNT).

This sarcophagus is among the earliest of the few examples that show various stages in the life of a child. Above the epitaph are four scenes from the young boy's life. First he appears as an infant, wearing a short tunic bound at the waist with several cloth bands and being nursed by his mother. She sits in a large armchair wearing a *stola* and has a waved hairstyle gathered into a chignon. A man with a beard and moustache, dressed in a toga over a long tunic, with *calcei* on his feet, rests his elbow on a pillar and tenderly contemplates this domestic scene, leaning his head on his right hand and holding a scroll in his left.

In the second scene, the same man is shown full face, holding the slightly older baby in his arms: this time the child is wearing a long tunic and playing with an object. Next the child is represented as a little boy, wearing a short toga over his tunic and driving a child-sized chariot drawn by a goat. In the final scene, he stands reciting his lesson in front of his father, who is seated, legs crossed, on a chair with a curved back. Both father and son hold a *volumen*, a papyrus or parchment roll.

It has been suggested that the woman may be a hired nurse and the bearded man a tutor, but the realism of the representations suggests these are actual people rather than standardized prototypes. It is more likely that these are the parents of the young Cornelius Statius and that they wanted the sarcophagus to evoke memories of the daily life they shared with their departed son. (P.C.)

NOTE
1 These pieces include fragments of the background and the upper plinth, the woman's right breast, and her left hand and the right forearm (except for the hand). For the man in the first scene: the nose, the left foot, and the end of the right foot; the nose of the man holding the child; the end of the whip held by the boy on the chariot, as well as the plinth with the hooves of the goat; the right shoulder of the standing child, as well as his feet and a piece of the lower plinth; the end of the seated man's foot.

BIBLIOGRAPHY
Baratte and Metzger 1985, no. 3, pp. 29–31.
Huskinson 1996, nos. 1–23, p. 22, pl. II 1.
Turcan 1999, p. 68, fig. 74.
Bastien 2003, pp. 8–9.

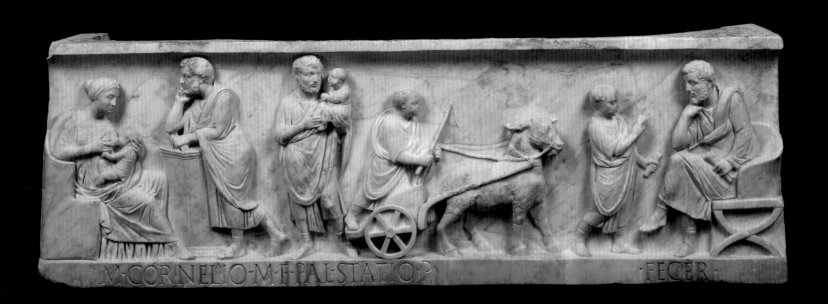

M·CORNELIO·M·F·PAL·STATIO·P· ·FECER·

77 Little Boy as Telesphorus

2nd or 3rd century A.D. (?) ▪ Discovered in Italy (?) ▪ Marble ▪ H. 33½ in. (85 cm) ▪ Purchased in 1807, formerly in the Borghese collection (MA 294–INV. MR 352) ▪ Restorer: V. Picur, 2006

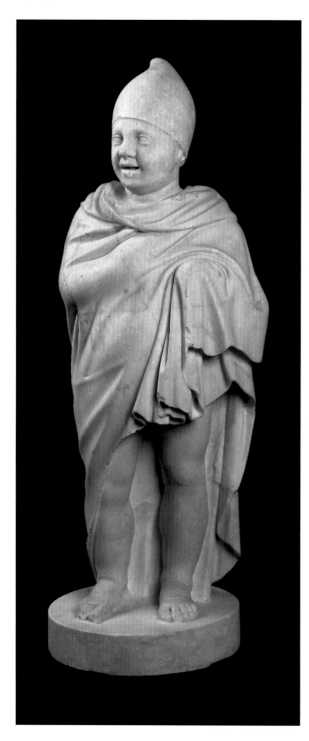

The tip of the hat, part of the back, the toes, and the plinth are eighteenth-century additions. With his right arm, the little boy holds his cloak over his left. His left arm is slightly bent forward. Though the head is clearly an addition, it is made of the same marble as the legs, while the rest of the body is made of another material. This difference in materials might lead us to deduce that the restorer chose to assemble fragments from two similar statuettes rather than sculpt a modern head.

The figure represented here is still identifiable as Telesphorus, a secondary divinity in the Roman pantheon. Associated with Aesculapius—the god of healing who was sometimes thought to be his father—and Hygieia the goddess of health, Telesphorus was some sort of spirit of convalescence, or a divinity who protected children against illness. His name, derived from a Greek word signifying "mystic initiation," is often associated with oracles, as well as the gift of ventriloquism. According to Pausanias (II, 11, 17), the cult of Telesphorus began in Pergamum (present-day Turkey) following an oracle. The cult is confirmed by an inscription dating from Trajan's reign. According to the rhetor Aelius Aristides, Telesphorus would appear to the sick in dreams, along with Aesculapius, to reveal the remedies to their ills. In the second and third centuries A.D., the cult developed further in many centers of healing: in Epidaurus (Greece), in the Severian era and during the same period in Thessaly, and Athens following an epidemic.

Many coins struck in Pergamum under Hadrian's reign, or in Nicea, in Bithynia (present-day Turkey) under Antoninius Pius, show Telesphorus as a small standing figure, wearing an ample cloak or *cucullus* with a hood over his head. The garment, allegedly a convalescence or night cloak, is believed to have originated in Thrace or Gaul. Lamps and terracotta or bronze figurines (Athenian Agora) represent Telesphorus standing or seated with his knees tucked under his chin, the hood hiding all but his face. Several sculpted groups show him with Aesculapius[1] and Hygieia; this is how he appears on several sarcophagi.[2]

The group of small marble pieces in which Telesphorus is represented alone[3] display variations in the way he wears his cloak, which is sometimes stretched forward by his bent forearms. The Louvre statuette belongs to a series likely to represent hero-ized little boys assimilated into Telesphorus, and signal a return of the motif of the dedicator wearing a *himation*, as it had appeared in votive reliefs of the late fourth century B.C. The statuettes were probably placed in the atrium or garden of Roman houses to bring prosperity to the home. Three other replicas still kept at the Villa Borghese[4] serve as reminders that the statuettes were used as garden ornaments in the seventeenth and eighteenth centuries. Occasionally fitted with modern, smiling heads, they prefigured our present-day garden gnomes. (J.-L.M.)

NOTES

1 Louvre Ma 345 with a modern head, London BM 1694, Rome Villa Borghese 776.
2 Budapest, for instance.
3 Rome, Torlonia Museum, Athens, National Museum, Munich, Cyrene.
4 Inv. CVIC, LXV, and LXIX; see Paolo Moreno and Antonietta Viacava, *I Marmi Antichi della Galleria Borghese* (2003), nos. 110, 119 and 125, pp. 145, 152, and 158.

BIBLIOGRAPHY

Lamberti 1796, II, st. VI, no. 2.
Fuchs, p. 175, n. 11, no. 15.
LIMC VII, "Telesphoros," pp. 870-78 s.v. Hilde Rühfel.
Martinez 2004a, no. 290, pp. 168–69.

78 Young Boy Wearing a Toga

Mid-1st century A.D. ▪ Discovered in Rome (?) ▪ Marble ▪ H: 49¼ in (125 cm) ▪ Purchased in 1861, formerly in the Campana collection (MA 1145—INV. MNE 845) ▪ Restorer: E. Paraskewa, 2004

With its somewhat distant-looking quality and distinctive crown of olive leaves, this statue is most likely a memorial portrait. Although the head and body originally came from two separate statues, they are chronologically consistent. The face's triangular shape and expressive features strongly suggest that it was executed during the Claudian era. The toga, with its ample drapery, broad folds, delicate, light pleats, and generously scaled *umbo,* is indeed a work of the second half of the first century A.D.

The child depicted is about seven years old, in Roman times the middle of his *pueritia* (boyhood), which lasted until puberty. A boy was considered an *infans,* incapable of rational speech, until he reached the age of seven, when he would attend school or be tutored, making the transition from maternal influence to paternal education. He could then begin to understand and repeat the ritual formulas of religion and law. A young boy was considered a *pubes* (young adult) at the age of fourteen; for girls, young adulthood came at the age of twelve. Then young men had to serve in the army for ten years before being able to launch a political career at the age of thirty.

Around his neck, this young *togatus* wears a *bulla.* The capsule consisted of two concave pieces, usually rounded and lenticular-shaped, but sometimes heart- or crescent-shaped. The *bulla* hung from a small clapper-ring on a cord or chain. According to a tradition reported by Plutarch, *bullae* were introduced to Rome by Tarquinius the Elder (*Quaestiones Romanae,* 101). Archeological finds have confirmed their existence in the Etruscan era. Fashioned from gold for patricians, leather for plebeians, and reduced to a simple strip of leather for sons of freedmen, they were believed to possess magical qualities that warded off evil.

The toga worn by *pueri,* whether boys or girls, was a child's form of the purple-bordered *toga praetexta.* During the feast of Liberalia on March 16, the *pubes* offered their *bullae* to their *lares familiares* (household deities) and then, dressed in the all-white *toga virilis,* the garment of adult men, flocked to the Forum, where they offered sacrifices to the Capitoline gods.

High priests and magistrates also wore the *toga praetexta* as a sign of distinction rather than a uniform. Among children, the garment served to distinguish free children from others; in the adult world, it signified individuals who had public responsibilities in the city. Roman society was strictly ordered, and there were very clear distinctions among men in social settings, in public venues and at various stages of life. Rome cherished numerous customs and practices, such as wearing the *toga praetexta.* Some of the same observances seem to have been applied to very different circumstances and functions that we would strictly distinguish nowadays.

It may thus seem rather strange that a memorial statue, intended for a small monument in a cemetery, would have a pose so similar to that of a Roman magistrate exercising his prerogatives (cat. no. 41). The *capsa* (storage case for books and papers) at the boy's feet, the *volumen* (or scroll) he holds in his hand, and his

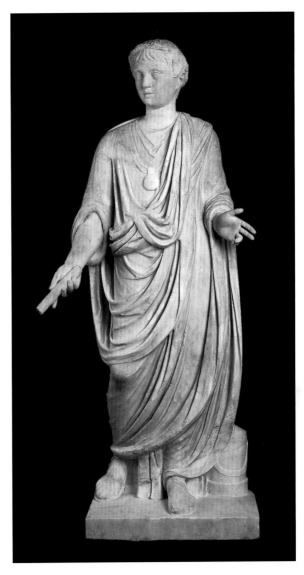

declamatory pose are neither characteristic of the reality of childhood, or evocative of death, but in the case of this statue, the sculptor and patrons had a number of intentions. The sculptor was adhering to established representative formulas: it was not his role to innovate or deviate from the standard for depicting a *togatus* grasping a *volumen* with a *capsa* at his feet. The boy's family would have wished to have the child represented with the dignity due a free Roman citizen, with a statue that conformed to established Roman tradition, showing the boy in an attitude that suggested the man he would have become had he lived. Finally, the boy's orator's pose exalts the life of the mind. The importance of this last theme is quite evident in sarcophagi, which, beginning in the second century A.D., were ornamented with decorative elements referring to the muses, theatre, and poetry. In the Platonistic tradition, intellectual and artistic work in pursuit of the beautiful and the just was a means by which the soul could surmount the weaknesses of the body. Thus depiction of the crown of olive leaves from the tree sacred to Minerva, goddess of wisdom, is very deliberate. (D.R.)

BIBLIOGRAPHY
Kersauson (de) 1986, pp. 196—97.

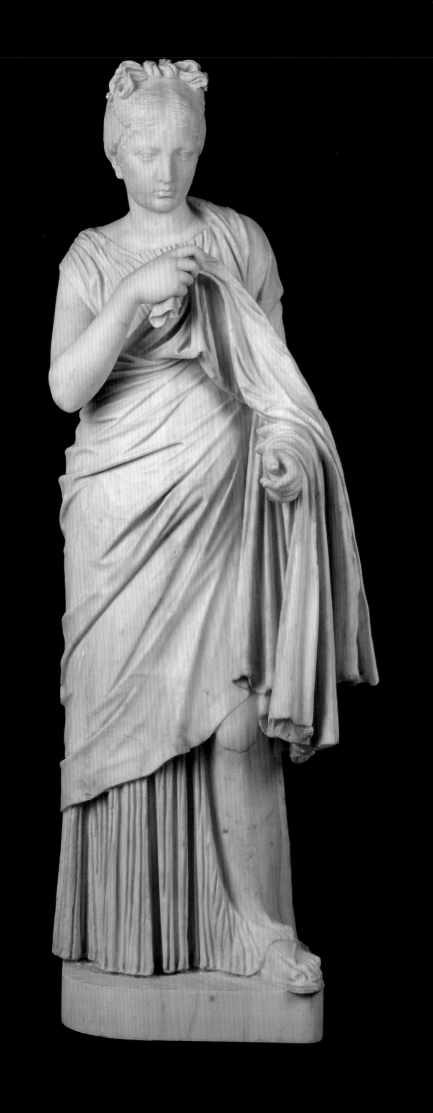

79 Young Girl

Late 1st century B.C. or early 1st century A.D. ▪
Discovered in Rome in the 1790s (?) [1] ▪
Marble (from Mount Pentelikón [?], Athens)
▪ H. 56¾ in. (144 cm) ▪ Documented in the
Louvre's collections in 1806 (MA 682—INV. MR
203) ▪ Restorer: P. Klein, 2005

The nose, chin, and fingers on the right hand and the complete left hand are modern. This exceptionally well-preserved statue is striking for its elegant pose and the complexity of the garment and hairstyle. The very young girl represented (but is it only a portrait?) has styled her hair in a very unusual manner—parted in the middle with small spit curls above the forehead and on the temples, as in certain portraits of Agrippina as Venus; yet in the case of this idealized face, locks of hair are pulled back to the top and back of the head and on the nape of the neck to form three knots. The extravagant hair knots found on the heads of Hellenistic Aphrodites—notably in the so-called Capitoline Venus[2] statuary type—have been imitated but arranged in a more complex manner.

At first glance, the figure's bearing and garments seem simple: leaning on her right leg, with her left foot in a sandal set slightly forward, the young girl wears a thin pleated tunic under a wool cloak, which she is preparing to throw back over her left shoulder with her right hand. The exact arrangement of the clothing is more complex than it appears: the cloak tucked under the left armpit is kept in place by the left arm, which is held forward, and it seems to reappear under her chest ready to be draped over the left shoulder, giving the impression that the young girl is wearing two layers of clothing. The stark contrast between the two fabrics and the regular, nearly straight cut of the cloak reaching to the bottom of the legs evokes Greek works of the fourth century B.C., in particular the muse holding a double flute on one of the Mantinea plaques attributed to Praxiteles's workshop.

But both the young girl's hairstyle and the complexity of the upper folds of her garment are drawn from the repertoire of Hellenistic sculpture. Several muses[3] feature clothing rendered in a similar, if not identical, manner: the right shoulder and arm left free reveal the *chiton*, while the left arm bends to secure the cloak thrown over the left shoulder. Yet in the most common model of the Hellenistic era, the hemline of the coat follows a strong diagonal line parallel to the upper part cutting across the chest. This eclecticism of references could indicate that the sculptor of this statue, in adapting to a more classical style of Hellenistic garments, was part of the classicizing movement in Roman art at the beginning of the empire. The Musei Capitolini's Young Girl with a Dove belongs to the same movement.[4] There again, the model is from the fourth century B.C.—a little girl dedicating a statue in the Artemis sanctuary in Brauron (Attica)—but mixed with references to a Hellenistic group showing children with animals. There, however, the young girl has an idealized face and wears a pleated tunic and *himation* folded back over her left arm in a manner that is entirely different from the Louvre statue's, belonging nevertheless to the same style. (J.-L.M.)

NOTES
1 According to Bins de St. Victor 1821.
2 In Louvre Ma 3133, for instance.
3 Munich Clio, inv. 266, Ephesus inv. 646; see Schneider 1999, pls. 25 and 26 or portrait statues from Asia Minor in Pergamum, for instance; see Linfert, 1976, pl. 66, nos. 363–64.
4 See Jones 1912, p. 349, no. 9, pl. 87.

BIBLIOGRAPHY
Petit-Radel 1806, no. 45 p. 93 with figure.
Notice 1808, no. 104.
Clarac 1851, p. 162, no. 2265.
Kersauson (de) 1986, pp. 38–39, no. 14.

Roman Architecture and Decorative Arts in Civilian and Military Life **Daniel Roger**

In Latin literature, orators, historians, and poets make frequent reference to the distinction between civilian life, in its modern meaning, and military activity, as expressed by the term *domi militiaeque* or *domi bellique*.[1] In Rome, this distinction was older and more fundamental than that between *otium* (cultural activity) and *negotium* (business). The design of the city of Rome itself was based on this dichotomy. When Romulus, from that legendary moment he founded Rome, developed the *pomoerium* (ceremonial boundary around the city), he defined a sacred space from which men bearing arms were banned and wherein the dead could not rest. Thus, a marked division between the time and place of war and the rhythms and spaces of civilian life took root in people's minds.

Aspects of civilian life were reflected in the evolution of architecture and the decorative arts. In provincial towns and small cities such as Pompeii, small houses were sometimes built in standardized, residential "batteries" to shelter a modest urban population. In the third century B.C., apartment buildings began to appear in Rome, and during the reign of Augustus, these would reach seven or eight stories in height. But it was in the large private house—the *domus* or villa—that the vocabulary of civilian decoration, with its varied and intimate themes, truly came into its own.

As of the third century B.C., the Roman house, like its Greek counterpart, had few openings to the exterior. Instead, it drew light and air from its interior courtyard, or atrium. The arrangement of rooms around the atrium (and, in some cases, its lateral extensions, the *alae*) served to emphasize the *tablinum* (reception room) that formed a central axis with the courtyard and entrance. Murals began to evolve as a way of opening up this confined architectural space. The first murals identified in Pompeian houses served to accentuate and enhance the materials used in the construction of the houses: plaster moldings and stuccos, screens, textural effects, and imitations of colored stone and lattice walls simulated architecturally decorative elements such as plinths, orthostats, bands, friezes, and cornices. In 1882, August Mau, who delineated the chronology of the painting style in the city, termed this the First Pompeian Style (second and first centuries B.C.), as expressed, for example, by the Samnite House.

As populations shifted and increased and dwellers adopted a Hellenized lifestyle, masonry and structure evolved along with wall painting styles. The Domus of the Faun in Pompeii is a much-studied example.[2] In the second century B.C., its owner acquired all the buildings around his traditional, atrium-centered house, thereby extending the dwelling to the four surrounding

streets. While retaining the *domus* adjoining his own house, also atrium-centered, to function as lodgings for his servants and a base for service activities, the owner razed everything behind it, constructing in its place a twenty-eight-column peristyle that stretched nearly the entire width of the property. At this stage, the garden, or *hortus*, replaced the original houses that lined the road opposite the main house, which remained centered on the original atrium. The *tablinum*, where the master of the house received his clients (those dependent on him, to whom he is the *patronus*, or protector), opened onto the peristyle, access to which was reserved for *amici* (close friends). At the turn of the first century B.C., a forty-four-column peristyle covering an area nearly 18,300 square feet (and once occupied by the garden) was constructed, increasing the *domus* compound by more than forty percent. This new peristyle became the center of activity, where the master of the house received guests and occasionally organized performances. These profound modifications to the original plan were accompanied by the conversion of many rooms into *triclinia*—richly ornamented dining rooms where one ate lying down, in the Greek style—which signaled a profound change in the way of life. The addition attested to the new focus, among rich citizens and freedmen, like Petronius's Trimalcio, on displaying luxury and wealth; yet despite his ambition to create a truly palatial compound, this owner retained his original First Style paintings. Most likely, their simplicity lent them a certain air of gravitas to which, as a good Roman aristocrat, he would have been attached. As defined by Mau, the Second Style of Pompeian wall painting (ca. 80–15 B.C.) found the *parietarii* attempting to give their walls an added sense of volume through the use of complex trompe l'oeils, such as projecting colonnades and consoles or megalographies. Between these imagined structures, artists painted garlands, figures, tableaux (sometimes inspired by the decorations on white background found on Greek *lecythus*), and windows opening onto sacred landscapes. At times, a painted wall gave way to the illusion of a portico opening onto an urban landscape of overpowering, colossal architecture (nearly always devoid of human figures).

During the Third Style (ca. 15 B.C.–50 A.D.), decoration took precedence over architecture: the column became a frame for decorative foliage, and the cornice evolved into the frieze. By the Fourth Style (the last, as the city's life was cut short by the eruption of Mount Vesuvius in 79 A.D.), ethereal, fantastic structures inspired by theatrical sets were covered with every decorative variation imaginable (cat. nos. 80, 158a-b): small paintings, friezes, megalographies, *aediculae*, niches, still lifes, landscapes, garlands, and flowerbeds—all occasionally enlivened by fantastical or grotesque characters. The resulting decorative heaviness was further amplified by the use of ornate furniture (now mostly lost).

Some small statuary from this era has been preserved (cat. nos. 82 and 83). Frequently installed in wall niches,

such pieces featured an iconography that would vary little between the first and fifth centuries A.D., including deities, mythological characters, and Hellenistic types. These were scale models of prestigious works, often imported in large numbers and produced in the old Hellenistic centers of the Eastern parts of the empire.

Decorative opulence actually appeared on floors before it flourished on walls. As early as the third century B.C., the long Hellenistic tradition of mosaics was established in Greek cities in the south of Italy and Sicily, gradually making its way into the Roman home. While certain *emblemata*, including panels found in Ostia, might have been imported from even more distant regions, one of the oldest mosaics discovered in a Roman environment, the Nilotic landscape in the Sanctuary of Fortuna Primigenia in Preneste (ca. 80 B.C.), was probably made on the premises by Alexandrian artisans. The same was true of the large mosaic of Alexander (8.89 by 16.80 ft.) laid down in the House of the Faun between 150 and 120 B.C., in a large room aligned with the atrium and *triclinium*. Opening onto the first peristyle, this room served as a place to exercise the mind through philosophical, literary, or pedagogical discussions, like an exedra along a palestra. The mosaic depicting Alexander defeating the Persian King Darius III at the Battle of Issos (333 B.C.) was copied from a painting by Philoxenos of Eritrea made for King Cassander of Macedonia at the end of the fourth century B.C. Going beyond a historical account to an emotional realm, it attempts to depict the tragic forces of fear and pity that had been described by Aristotle.

In North Africa, Alexandria soon had to compete with the workshops of Proconsular Africa (Carthage). The principle of registers (arrangements of scenes in superposed rows) began appearing in North Africa only in the late second century A.D., with the figures becoming increasingly frontal. It was probably in Africa that the theme of the four seasons led to the representation of naturalistic scenes that depicted rural labor; hunting or circus scenes were also very popular.

In addition to the African school, another venerable tradition of mosaics was maintained, mostly by the workshops of Antioch. Employing a variety of themes borrowed from every aspect of Hellenistic culture, the Oriental school seemed to aim for the most faithful imitation of painting. Whereas the African school often defined shapes with outlines (cat. no. 145), the Oriental school made use of the entire chromatic range of colors, the contrast between light and shadow, and a complex organization of backgrounds (cat. no. 8). In its search for compositional unity, the Oriental style provided increasingly focused, tight pictures surrounded by a frame of lavish borders (cat. no. 81).

At the beginning of the Christian era, another mosaic style—with no echo either in African or Eastern production— flourished in Italy, where, driven by a certain asceticism, Italian mosaicists abandoned color and relief in favor

of figures composed of black tesserae on a white background. Decorative floor elements receded in favor of wall decorations and architecture. Though figurative themes persisted—including trompe l'oeils such as pictures of dogs beside the inscription *Cave canem* (Beware the Dog) at the entrances to Pompeian houses—here the geometric style came to the fore, with an endless repetition of basic shapes. Their variety, from one mosaic to the next, is truly impressive.

Dinner and serving ware were extremely important indicators of social prestige in the Roman house; and receptions around the *triclinium* provided the master of the house with opportunities to display them. Caius Vestorius Priscus even had the walls of his Pompeian tomb painted with a formal sideboard displaying his nineteen-piece collection of silverware, including different sizes of scyphi, jugs, and long spoons similar to those in the Louvre's collection (cat. no. 114). The treasure of Boscoreale (cat. nos. 3–6), the Hastings *patera* (cat. no. 98), the treasure of Graincourt-lès-Havrincourt (cat. no. 99)—whether it originated in Gaul or, more likely, the Balkans—and the Pitula plate (cat. no. 100) all attest to a fascination with sumptuous dinnerware shared throughout the Empire and even beyond its borders. The range of decorative elements on Roman silverware included bacchanalian themes, botanic decorations (cat. no. 6), reproductions of Hellenistic statuary models, mythological subjects (cat. no. 3), natural scenes (cat. no. 4), and literary allusions. Though not as lavish, bronze dishware (cat. nos. 95–97) was nonetheless an expensive commodity. Levels of decoration spoke to the purpose of a piece: less decorated pieces were purely practical. Other pieces were finished with the same advanced techniques used for silverware: lost-wax casting, light-gauge sheet hammering, soldering, plating, and turning. Though reserved for the wealthier population, these were for utility. Their exact use is not always easily revealed, but some were certainly used for personal hygiene (cat. no. 95), others for cooking, others for domestic use or worship (cat. nos. 96–97). Potters soon set to imitating these metallic objects by giving their works smooth, glossy surfaces. Sigillated (stamp-decorated) dishware (cat. nos. 101–08) was long assumed to be precious since it was commonly traded throughout the Mediterranean Basin. However, as it is so frequently found in archaeological sites, it is now considered a semi-luxury at the most. This type of ceramic was initially produced in the mid-first century B.C. in the workshops of Pozzuoli and Arezzo (cat. no. 101) but has been found as far north as the military camps of the Rhine. The Italian workshops did not survive the development of sigillation in Southern Gaul (La Graufesenque, Montans), which started to supplant their production around 30 A.D., and in 120 A.D., the southern workshops began to collapse due to competition from workshops in central Gaul, near Lezoux, while another competing industry sprang up in northeastern Gaul (Alsace and Palatinate, Argonne) that

would continue to export its goods until the fifth century. Each of these workshops sustained several hundred potters, producing 35,000 to 40,000 vases per batch.

African sigillation (cat. nos. 102–08) first appeared around the same time, reaching its apogee around the third century in central present-day Tunisia. As another example of the desire to emulate the sheen and surface of metal, potters began to produce glazed vases. By the Roman era, this technique, long exploited in the Orient (cat. no. 112) and Egypt, had been known for several millennia. High-quality ceramics with leaded varnish were produced by the workshops in central Gaul in the second half of the first century A.D.

Following the discovery of glass-blowing techniques toward the beginning of the empire, the use of glass utensils (cat. nos. 109–111 and 113), either blown or molded, for dinner services and toilet articles spread quickly. Less expensive than metal, glass had intrinsic advantages (lightness, elegance, transparency, and cleanliness) and rapidly came to be used for everyday objects, though some engraved or even carved pieces are clearly luxury items. Oil lamps were still mostly made of bronze or terracotta. Bronze oil lamps were considered luxury objects and generally placed upon candelabrum. Terracotta oil lamps were extremely common, of little value, and used for domestic or, more rarely, public lighting. They also played an essential symbolic role in religious life and funerary practices. Lamp decorations were drawn from a rich and varied repertoire, including theatrical scenes, deities, street scenes, images from daily life, erotic subjects, pictures of farming or maritime activities, literary themes, and representations of nature. The latter occasionally bordered on the exotic.

Nature was also was incorporated into decor. There were certainly vast public gardens of the day, such as the Horti Lamiani, Horti Maecenatis, and Horti Agrippae, but the gardens surrounding the residences of wealthy landowners more directly reflected an enthusiasm for outdoor decoration. They featured elaborate decors, often with porticos and peristyles that occasionally composed a genuine *scaenae frons*, not unlike scenic facades for a theatrical stage. Conceived as spaces marking the transition between architecture and nature, these structures often featured Corinthian capitals shaped like baskets of acanthus leaves. (However, the use of the Corinthian capital is not a requisite: the first peristyle in the House of the Faun uses Ionic capitals.)

In this context, the *imagines clipeatae*, or tondos, placed between the archivolts of the colonnades could provide a border of foliage scrolls (cat. no. 84), as did the friezes running along the architraves. The trompe l'oeil paintings in Livia's house in Rome or Fannius Synistor's house in Boscoreale show garlands suspended between the columns. The stems of candelabra in rooms adjoining the garden prefigured outdoor vegetation, decorated with

representations of elongated leaves and berries (cat. no. 85). *Oscilla* (small masks and figures) were hung to follow the movement of plants stirred by the wind; like most of the sculpted decor found in gardens, these were frequently decorated with Dionysian motifs. Since a house's water supply was outside, this type of decoration could also be found on springs, fountains, or water basins (cat. nos. 87–89).

When it came to statuary, variety and fantasy were the rule, and groupings were often used to create scenes or landscapes. Inspiration was most frequently drawn from Hellenistic myths such as the Niobids, or Hercules wrestling with the Nemean Lion. Satyrs, fauns, and amazons dominated, along with those deities, demigods, and heroes that evoked wild, untamed nature, fertility, and Bacchanalian rites (fig. 1). These were contrasted with figures that suggested calmness, reflection, and domesticated nature, among which would be the muses Hygieia, Aesculapius, Venus (cat. no. 86), or Apollo.

Military-purposed architecture and decor took on a variety of functions. They marked the transition between peacetime and wartime, celebrated and commemorated battles and victories, and served as vivid illustrations of the soldier's experience. A quote from Horace reflects a soldier torn between home and duty: "Seu te fulgentia signis / Castra tenent seu densa tenebit / Tiburis umbra tui" (Will you stay in camp among resplendent battle standards, or in the deep shade of you beloved Tibur?) (Horace, *Carmina*, I, 7, 19-21). By establishing a "professional army," however, Marius's reforms allowed the civilian population to forget what had once been an annual routine. With the coming of every summer, each citizen of the republic became a soldier on campaign. After Marius, the only citizens who knew both modes of existence were veterans who had returned to civilian life at the end of their military service (cat. nos. 117, 120, 121) and occasionally acquired citizenship (cat. no. 122), or magistrates who had accepted a military command post to advance their careers (cat. no. 42). Under the empire, the old-fashioned religious formalities involved in the passage from one status to the other were commemorated with monuments and buildings. The senate's decision to erect the Ara Fortunae Reduci in 19 B.C., for instance, was in keeping with the Augustan policy of maintaining religious formalism. Domitian's triumph in 93 A.D. was celebrated with a temple to Fortuna Redux, which attested to the continued notion of transition and of the change of status at the end of military operations. The decorations possessed by a soldier in the field were limited to small objects used in daily life—objects used in worship for the private (cat. no. 118) or those related to military honors for the officer (cat. no. 119). However, some military installations, such as the camp at Lambaesis, were decorated with all the resources of architecture. In turn, certain monuments in Rome were inspired by military architecture: Trajan's Forum replicated the layout of the headquarters of a Roman military camp—monumen-

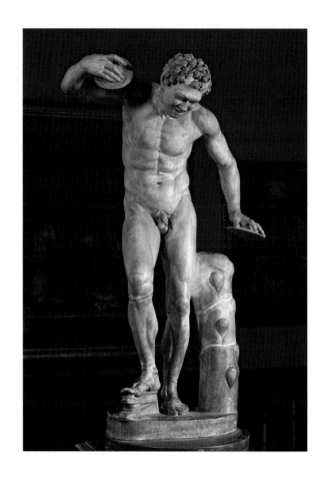

FIG. 1 *DANCING FAUN*
Roman copy of Greek original
Uffizi, Florence
Photo: Scala / Art Resource, NY

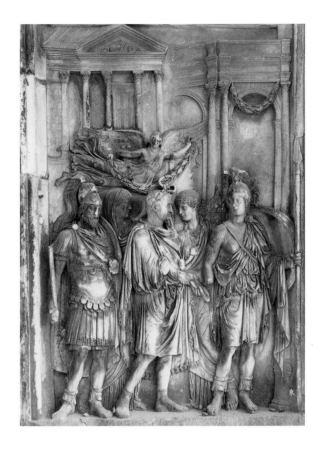

tal entrance, esplanade, a basilica instead of the *principia*—and Trajan's Column at the place where the sanctuary of the legionnaires' banners would stand in camp. This civil monument also featured constant references to the Dacian wars, including statues of Dacians erected in different parts of the edifice (cat. no. 123).

Today, Rome's arches of triumph and the Trajan and Aurelian columns provide the best existing illustrations of war as experienced by soldiers. Stretching nearly 650 feet, the frieze on Trajan's Column provided a vast framework for narration, depicting the various episodes of the two campaigns Trajan led against the Dacians from 101 to 107 A.D. in what is now Romania. With no less than twenty-five hundred characters, the frieze displays an astounding sense of detail, as can be seen in another relief in the Louvre's collection (cat. no. 116). In representing large gatherings of people, particularly in battle or harangue scenes, the sculptor succeeded in capturing the impression of the multitude by placing characters in the background higher than characters in the foreground (fig. 2). One looks at the scenes with a bird's eye view, a technique that allowed the sculptor to avoid the juxtaposition and alignment of figures that had previously characterized sculpted friezes such as the Praetorians relief (cat. no. 115). On public monuments, the subject of which was often war, artists could depict crowds, while in their private works, they could extoll the individual.

NOTES

1 Cicero, *Tusculanes*, V, 19, 55; *De Senectute*, XXIII, 82. Sallust, *De Conj. Cat.*, 6; 9; 29; 53. Starting with the preface to *Libri ab urbe condita*, Livy distinguished military accomplishments from pacific action in relating the causes of Rome's power: *quibusque artibus domi militiaeque et partum et auctum imperium sit*. Aurelius Victor, XVI, 2. Tacitus, *Hist.*, III, 75. Ammianus Marcellinus, XXII, 6, 1. Ovid, *Fasts*, I, 277 sq.

2 Gros 2001.

FIG. 2 *RELIEF: RETURN OF MARCUS AURELIUS VICTORIOUS*
Last quarter of 2nd century
Arch of Constantine, Rome
Photo: Alinari / Art Resource, NY

80 Decorative Architectural Painting

Ca. 60–80 A.D. ▪ Discovered in Herculaneum (Italy), before 1755 ▪ Fresco-type wall painting ▪ H. 47¼ in. (120 cm); W. 24 in. (61 cm) ▪ Gift 1825, formerly in the collection of the Kings of Naples (P 26–INV. CC 68) ▪ Restorer: D. Burlot, 2005

This fragment of a wall painting was among the very first ancient artworks discovered in Herculaneum after the volcanic eruption on August 23 in 79 A.D. In 1684, excavations for a well revealed some ancient ruins about sixty feet below the surface; these finds attracted the attention of antiquities collectors. As it turned out, the well led to the center of Herculaneum's theatre. In 1706, the Prince of Elboeuf had his Palazzo Portici built nearby and expanded the excavation in 1713, seeking statues to decorate his palace. He also sent ancient artworks to France, his native country, and to Vienna, where he served the Hapsburg court as general of the army. However, the king of Naples interrupted his excavations in 1715, and they did not resume until 1736.

Excavations were so deep that they had to be carried out using mining tunnels. The exact locations of the finds are therefore uncertain, and we know nothing of their context. Excavators focused almost exclusively on the discoveries of artifacts, and the *Catalogo* of 1755 and the *Pitture antiche d'Ercolano* (its first volume was published in 1757) give almost no indications of provenance. On the other hand, there is extensive and very erudite commentary on the ornamentation and iconography of the finds.

This panel was executed using a technique similar to fresco painting. The design was painted on a damp lime-based undercoating that contained an additive to delay the drying process. The additive also allowed the applied paint to become thin and take on its characteristic smooth surface. Applied over several base coats, the undercoating consists of two layers: a lower grayish coat (*arriccio*) made of lime blended with volcanic sand, and an upper whitish coat (*intonaco*) in which lime is mixed with calcite.

After the surface was prepared, it was polished and shined to obtain a smooth, satiny finish. The decorative subjects were painted according to a preliminary sketch, always using the "fresco" technique. On the Louvre's painting, restoration has shown that the central panel was originally red but turned black when its cinnabar pigment was affected by the eruption of Vesuvius. It is also possible that a black or deeper red glaze was later applied to this area.

Due to the conditions under which these excavations were carried out, the king's workmen cut the wall paintings into sections as soon as they were discovered, and each segment was removed by sliding a wide, flat tool between the surface of the wall itself and the undercoating. In the case of this painting, the work was cut into five sections, with the largest measuring 1.6 square feet. After being moved, the sections were attached to plaster surfaces applied to custom-cut slate panels; these panels were then reassembled in wooden casings on top of another coat of plaster (cat. no. 158). The edges destroyed during this transfer method were repainted, and a coat of varnish was then applied all over the painting.

Restoration has shown that the varnish used on this panel was a type developed by the Cavaliere Moriconi around 1740; it was no longer used after 1750 because of the damage it caused to picture surfaces over a period of years.[2]

A significant portion of the Louvre's collection of paintings that were formerly in the Bourbon collection were donated by Francisco I, the king of Naples, in 1825. As the museum received them in this condition, modern restoration efforts have been devoted to saving them from the effects of such varnish coatings, still maintaining the layers of plasters and slates, as well as the wooden casing or framing when it is extant.

A nearly identical but larger fresco in the Museo Nazionale in Naples[3] gives us a clearer idea of the original composition to which the Louvre panel once belonged. The twisted column rests on a base whose moldings are richly ornamented with decorative motifs, including egg-and-dart designs, beading, leaves, and feathered effects. On the front of this base, a winged creature soars atop a volute. The base stands next to a recess in the lower part of the wall—to the left in the case of the Louvre panel and to the right in the Naples panel. The recessed area is black, surrounded by a brownish-pink, slightly arched framework. In the Naples painting, we can see the recessed area integrated with its depiction of Venus accompanied by a procession of sea deities and the central panel above in its entire width. Level with the twisted columns' foot is a wall molding; above that is this central panel framed by a band of color with a fillet surrounding a black background, which flanks the column. A winged horse painted in light colors walks on the fillet across the bottom of the panel toward the twisted column. A foliate ornament rises from its head, terminating in a flower, from which springs the support of a console. A candelabrum decorated with foliage stands above the console. Additional foliate decoration on the console incorporates griffons and theatrical masks.

On the right side of the Louvre's panel and on the left side of the Naples panel, a different decorative scheme appears behind the twisted columns, as if they marked the transition to a background extending into a deeper space beyond. This perspective technique using trompe-l'oeil devices is typical of the architectural compositions of the Second Style of Campanian wall painting, as defined by August Mau in 1882. The delicate foliate motifs and the elegant decorative vocabulary recall the Third Style, but ultimately, this eclecticism and willingness to overflow the wall with ornamentation, while leaving extensive areas of the picture field plain, is typical of the Fourth Style.

Based on the perspective effects and the directions in which the shadows are cast, the Louvre panel would have stood to the left of the Naples panel. The twisted columns, which climb toward the outside of the picture plane, would thus be placed symmetrically. An entablature or other architectural device—since disappeared—would have connected the two columns. Perhaps a door was once painted between them, whether closed or opening to an imaginary landscape. Or there may have been a large painting of a scene inspired by literature or mythology. (D.R.)

NOTES
1 Mora and Philippot 1977.
2 D'Alconzo 2002.
3 INV. 8865.

BIBLIOGRAPHY
Tran Tam Tinh 1974, pp. 60–61.

81 Mosaic Panel

Ca. 500 A.D. ▪ Discovered in Daphne near Antioch on the Oronte (Turkey), 1934 ▪ Marble and limestone ▪ L. 53½ in. (136 cm); H. 30¾ in. (78 cm) ▪ Transferred 1936, 1934 excavations under the direction of Princeton University with the support of the National Museums of France, the Baltimore Museum of Art, and the Worcester Art Museum (MA 3442–INV. MND 1948) ▪ Restorer: Atelier de conservation et de restauration du Musée de l'Arles et de la Provence Antiques, under the direction of P. Blanc, 2006

This mosaic fragment features four protomes of rams facing each other in pairs of two. Though depicted in profile, their horns are shown as if facing front. Each ram has a red ribbon tied around its neck, and each pair rests on a pair of wings tied in a green ribbon that unfurls beneath them. Between each ram are stems of flowers.

This fragment is part of the border of a large area of ornamental mosaic tiling that was embellished in the center with a phoenix rising from a carpet of flowers.[1] Both the design of the border—repeated around the entire outer edge of the tiling—and the dominant formal conventions are inspired by the iconography of the Sassanid Empire, where it can be seen on various mediums.[2] However, it is not seen on mosaics, as this technique does not appear to have been practiced much in Persia.

In the Zoroastrian pantheon, rams with ribbons around their necks, which personify wealth and also royal power, represent the warrior god Verethragna.[3] The wings are a reference to that deity and generally indicate a sacred character.[4] It is clear that the imagery inspired Antioch mosaic artists: another ornamental tiling at the same site repeats the same border design with another

typically Hellenistic style of foliage.[5] These floor decorations are therefore a good illustration of Antioch's position as a crossroads for the Greco-Roman and Persian worlds: the iconography and characteristically formal style of Sassanid art is linked with a purely Greco-Roman technique.

Writings on excavations[6] and mosaics[7] indicate that these two ornamental tilings decorated the floors of the villas of Daphne in the nearby residential suburb of Antioch, but the kind of the building with the phoenix mosaic is subject to some debate.[8] The first use of the site dates to the Hellenistic epoch and was probably a private house.[9] Modifications were made over time, the most important dating from the third century A.D., when the entire neighborhood was remodeled. Important fragments of mosaics correspond to that activity. The last significant restructuring of the building occurred in the fifth century, when a large hall was extended over an area previously occupied by eight rooms. The hall was probably bordered on three sides by a portico, and became home to the phoenix tiling. (C.G.)

NOTES

1 The floor mosaic, whose original dimensions were 43 by 33 feet. (13.35 x 10.30 m), was incomplete at the time of its discovery. It has since been moved to the Louvre and reassembled on a smaller scale; see Baratte 1978, pp. 92–98.
2 The closest examples are a gold medallion from a private American collection (see Lozinski 1995, fig. 2, p. 137) and a stucco wall mural in the Field Museum of Natural History in Chicago (see New York 1978, no. 43, p. 110; Brussels 1993, no. 8, p. 149; and Worcester 2001, no. 21, pp. 134–35).
3 New York 1978, no. 43, p. 110; and Brussels 1993, p. 117.
4 New York 1978, no. 39, p. 106.
5 Levi 1947, p. 350 and pl. LXXXII d; Worcester 2001, no. 20, pp. 133–34; and Becker and Kondoleon 2005, pp. 216–21.
6 Stillwell 1938.
7 Levi 1947.
8 Amad 1998 and Lozinski 1995.
9 Lassus 1938, p. 83.

BIBLIOGRAPHY
Lassus 1938, pp. 81–122.
Stillwell 1938, p. 187.
Levi 1947, pp. 351–55, pl. LXXXIII, CXXXIV–CXXXV.
Baratte 1978, pp. 92–97.
Amad 1988, pp. 22–32, and fig. 8a and b.
Lozinski 1995, pp. 136–42.
Rome 2000a, no. 141, pp. 514–15.

82 Bacchus and Silenus

2nd century A.D. ▪ Discovered in Italy (?) ▪
Marble ▪ H. 35 in. (89 cm) ▪ Purchased in
1807, formerly in the Borghese collection and
the Della Porta collection (MA 489–INV. MR 115)
▪ Restorer: P. Klein, 2006

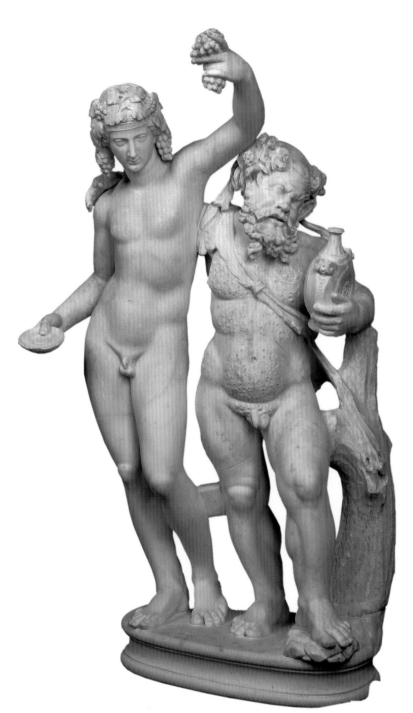

This statue combines two antique fragments: Bacchus's torso and Silenus' torso and head, along with sixteenth-century additions including Bacchus's head, arms, and legs, and Silenus's arms and legs. The restoration is probably the work of the Della Porta family. Pope Paul V purchased part of this collection in 1609, subsequently leaving it to his nephew Scipione Borghese in 1621.

Giovanni Della Porta was the prominent father of a family of sixteenth-century sculptors who made their reputation restoring the famous Farnese Hercules. Here, the restorer transformed the sinuous body of Apollo into Bacchus by adding a head crowned with vines, and two arms—one holding a bowl of grapes and the other raised and holding a bunch of grapes. This figure is a smaller copy of the Apollo Sauroctonus—the lizard slayer, a statue by fourth-century B.C. Greek sculptor Praxiteles, known through many full-scale Roman replicas (in the Vatican and Louvre) but also several statuettes.[1]

Next to Bacchus stands old potbellied Silenus or Papposilenus, an animal hide under his left arm and attached to his right shoulder. In keeping with a tradition well known in Roman art, the thick hair covering Silenus's torso signifies the character's bestiality.

The association of the two figures is far from groundless. The subject of a drunken Bacchus being held up by Silenus existed in Greek and Roman art, and there are at least sixteen known small marble statues,[2] large-scale versions,[3] and appearances of the motif on reliefs.[4] The theme is most frequently found on trapezophores—sculpted table legs[5]—which emphasizes their ornamental function. Indeed, these two lent themselves particularly well to decorating furniture in Roman gardens, which tended to evoke the world of Bacchus. For instance, the decorative repertoire used on marble vases, copings, tripods, and *oscilla* (hanging disks) largely consisted of Bacchus being held up by Ariane or Silenus, along with dancing satyrs and maenads. (J.-L.M.)

NOTES
1 For example, Louvre Ma 4802.
2 For example, Leiden INV. K. 18-88.
3 Venice, Florence INV. 246.
4 Including the Attic sarcophagus in the National Museum in Athens MNA 4008
5 Thasos, Berlin, Athens, Sparta, Volos... See Holtzmann 1993, pp. 247–56.

BIBLIOGRAPHY
Lamberti 1796, vol. II st. IV, no. 8 (fig.).
Pochmarski 1990, pp. 220, 323, no. P 50, pl. 75, 1.
Kalveram 1995, pp. 236–37, no. 140.
Martinez 2004a, no. 54, p. 50.

83 Venus from Montagne

Late 4th–early 5th century A.D. ▪ Discovered in Saint-Georges-de-Montagne, near Bordeaux (France), 1843 ▪ White marble ▪ H. 16 ⅞ in. (43 cm) ▪ Purchased in 1953 (MA 3537–INV. MND 2063) ▪ Restorer: B. Perdu, 2006

In 1843, two statuettes of Diana and Venus were uncovered during the digging of foundations in Saint-Georges-de-Montagne (Gironde). The site, known as Le Petit Corbin, had already yielded many other fragments. Painstakingly buried during the Roman era, probably in a single wood case, the statue of Venus was acquired by the Louvre in 1953, while the statue of Diana was purchased by the Musée d'Aquitaine in 1971. The sculptures had initially decorated the residential section of a large villa.

Studies of sculptures found in the aristocratic villas of southwest France[1] have shown that Diana and Venus can be categorized in a series of large statuettes representing mythological characters set on a rounded and molded plinth. Though Venus's plinth was restored in a different marble very shortly after its discovery, analysis has shown that Diana and Venus were made from a single type of marble originating in the east of the empire, in Paros, Usak, or Marmara. The question remains whether the marble was brought to Aquitania Secunda in its raw state or as the finished sculpture.

Venus's smooth, classical face, which is the focal point of the entire group's movement, displays the distinctive traits of late-fourth-century small decorative sculpture: a round face, structured in superimposed arches (particularly the arch of the eyebrows, with a prominent bridge of the nose), slightly swollen eyelids, and a small, plump mouth with parted lips. Examination of the statuettes, the design that guided their construction, and their finishes, along with comparisons such as E. K. Gazda's to the Carthage statuette,[2] or L. Stirling's to a head of Hecate from the *mithraeum* in Sidon,[3] and the parallels between Diana's doe and the dog in the same *mithraeum* (cat. no. 171), demonstrate that the statuettes are characteristic of the production of sculpture workshops in Asia Minor, such as those in Caria, in present-day Turkey, during the late fourth or early fifth century. The city of Aphrodisias, for instance, became well known for its many highly reputed workshops that used to carve local marble.

Venus is represented rising out of the water in accord with the conventions of the Aphrodite Anadyomene type. The triton and dolphin, which recall the maritime setting, were sometimes depicted alternately with two cupids accompanying the birth of Aphrodite in Hellenistic-era representations. The statuette's straight nose, mouth with deep-set corners, and triangular forehead are also drawn from the Hellenistic period. Though Venus imitates the bearing of Polyclitus's Diadumenus, her body is not as lithe and is conceived according to a shorter model, where the body height equals only six times the head height instead of seven times. The sculptor of the Venus from Montagne is therefore tapping into a long tradition by depicting the goddess at the moment she rises from the waves.

The late-empire sculptor has also retained a certain ambiguity from Aphrodite's Hellenistic past: though the dolphin, triton, and Erotes are here to identify the scene as the birth of Venus, the Eros holding up a mirror belongs to another motif, that of Venus at her toilet. The goddess's hands are positioned to wring the foam from her hair, or arrange her locks in a chignon.

Though conceived to be viewed face-front, the sculpture is covered in scenes, anecdotes, and contrasts. Rather than choosing between the traditional Erotes, dolphin, and triton, the artist chose to represent them all. Three actions are taking place at once: an Eros whips his mount while a triton supports another Eros holding up a mirror to Venus, who is looking elsewhere. No two gazes or faces exist on the same plane. The bottom group, featuring predominantly vertical lines, seems to be drawn upward; heads raised, arms held out, legs extended, vertical flippers, rudder held straight. Surprisingly, the mirror's handle is nearly life-sized and features a slit carved into its end. The artist had clearly planned to fit a regularly sized, real bronze mirror onto the handle in order to magnify the goddess's face. As it is, the mirror provides a transition from the baroque lower plane to the classical upper plane.

The triton, dolphin, and Erotes have been carved without any attention to detail: the Erotes's feet do not have clearly individualized toes, the triton's head is asymmetrical, his nose is extravagantly turned up, and one Eros clearly has one arm shorter than the other. These non-human creatures, which have barely risen from raw matter, are here to exalt the superior goddess, she who is perfectly accomplished and already Olympian. For the statuette's original commissioner, a member of a fourth-century elite that included knowledgeable, selective collectors, the Greco-Roman pantheon served to support a certain reverence for classical culture but had by then lost any religious content.[4] (D.R.)

NOTES
1 Balmelle 2001, pp. 233–37.
2 Gazda 1981.
3 Stirling 1996.
4 Hannerstad 2002.

BIBLIOGRAPHY
Stirling 2005, pp. 29–37.

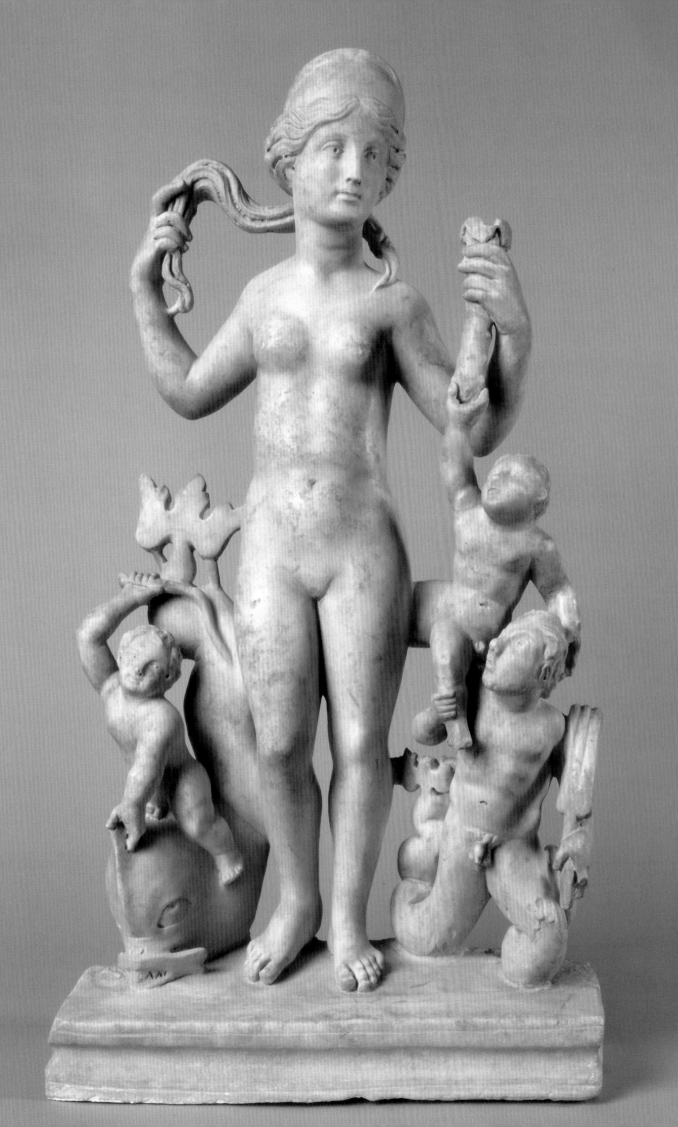

84 Tondo

Early 1st century A.D. ▪ Provenance unknown ▪
Marble ▪ Diam. 22⅞ in. (58 cm) ▪ Long-
standing part of the collection (MA 1657–
INV. MR 1018) ▪ Restorers: A. Liégey and G.
Delalande, 2005

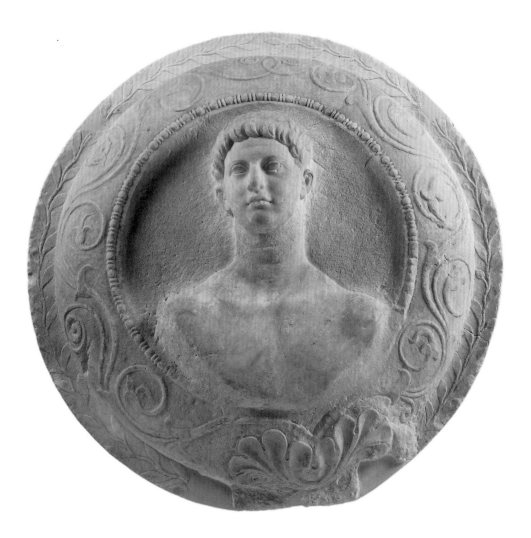

Sculpted in high relief, the bust of a young man, occupies the center of this convex tondo (or *imago clipeata*). The flat outer rim (portions of which are modern reconstructions) is decorated with a double laurel wreath. The broad border is covered with almost symmetrical foliate motifs, springing from a stylized acanthus base, and its inner rim is accented by a slim band of beads and semi-circular motifs. On the slightly concave picture field of the tondo, the bare-chested young man is shown facing the viewer. The nose is a modern reconstruction and the lips and eyes are damaged. Traces of re-working—on the relief field, the decorative designs on the lower part of the tondo, and the neck and bust of the subject—suggest that the bust may have originally been draped and perhaps even surrounded with distinctive attributes.

Tondos framed by foliate decoration are not common, but there are a few examples in the museums in Corinth, Naples, and the Vatican. The young man's face does not have particularly distinctive features; if the work is a portrait, it is too generically rendered for the model to be identified. Formerly suggested likenesses to portraits of Drusus the Elder or the Emperor Claudius (41–54 A.D.) cannot be sustained. The classicism of this representation, as well as the treatment of the tondo's decorative elements, strongly suggests the first half of the first century A.D. as the correct date for this work, which would have been used for exterior decoration. (L.L.)

BIBLIOGRAPHY
Kersauzon (de) 1986, pp. 182–83, no. 85.
Martinez 2004a, p. 423, no. 855.

85 Candelabrum (base)

Early 2nd or 4th century A.D. (?) ▪ Base
discovered in Rome in the Syrian sanctuary
on the Janiculum Hill, 1803 ▪ Marble ▪
H. 90½ in. (230 cm) ▪ Purchased 1816,
formerly in the Fesch collection (MA 2754—INV.
LL 34; N 1357) ▪ Restorer: A. Liegey, 2005

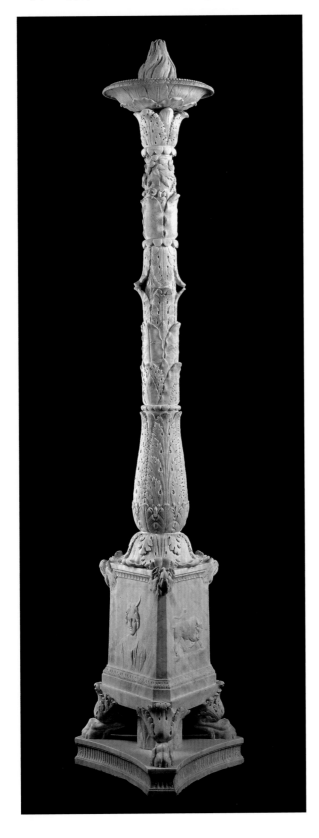

This candelabrum is composed of five marble elements, each
mounted on the other. On a triangular base stand three animal
paws, joined together by a plinth. Above that is a triangular base
with griffon heads decorating its upper corners. Its three faces
depict the god Sol, his bust draped and his hair crowned with seven
sunbeams; the goddess Luna, her head crowned with a crescent
and her tunic crossed with a baldric; and a bull galloping toward
the right above a ground line. A latin inscription, *Doryphorus Pater*,
is carved on the rim beneath the bust of Sol.

The base's upper surface supports a bouquet of acanthus
leaves, which spread out to form the convex base of a long shaft,
composed of elements decorated with alternating ranges of acan-
thus, laurel, and few flowers visible in the upper half. This foliate
ornamentation is in fairly low relief except at the top—where they
spread out to support a dish-shaped form composed of leaves with
a beaded border, from which a low flame rises.

The base of this candelabrum was discovered by the Italian
archeologist Carlo Fea in 1803 while he was excavating a Roman
sanctuary on the southern slope of Janiculum Hill. He entrusted
a sculptor with its restoration. Indeed, in its present form, this
candelabrum was made by assembling ancient fragments from
a number of distinct objects (as evidenced by the variations in
veining and tonality among the cream-colored marbles) and the
addition of those modern components.

The shrine on Janiculum Hill was consecrated to Syrian divini-
ties from the end of the first century B.C. until the end of the fourth
century A.D. The provenance of this triangular base, whose shape
and ornamentation recall the three principal gods worshipped in
Heliopolis, was confirmed in 1909 by the discovery of its original
pediment, which is still in place at the center of the temple's main
chamber on the far west side of the sanctuary. The sanctuary was
restored by a wealthy Syrian merchant who was a contemporary of
Marcus Aurelius and Commodus; this restoration reused a number
of elements from earlier buildings. The ornamentation of the base,
as well as the appearance of the divinities that decorate two of its
faces, suggests a date in the first half of the second century A.D.

But this dating could be altered by the inscription on the
principal face (assuming it does not simply indicate the sacer-
dotal function of the votary), depending on whether it could be
considered contemporary with—or later than—the bas-relief.
The prominence given to the sun divinity Bel-Iaribolos, the god
carrying the spear, may also indicate changes in the hierarchy of
Syrian divinities under the Palmyran influence, which promoted
the spread of Chaldean sects during the fourth century A.D.

Dating the other antique fragments is even more problematic
without any archeological context. Nevertheless, this candela-
brum, reconstructed at the beginning of the nineteenth century,
is quite typical of the objects discovered in a number of fairly sig-
nificant buildings, both civic and religious, public and private. The
translation of the metal forms originally used in lighting fixtures
into marble shows that such objects could have both decorative
and votive functions, depending on the user's requirements.
(C.P.-D.)

BIBLIOGRAPHY
Cumont 1896, p. 225, no. 59, p. 482.
Gauckler 1909, pp. 257–60 and 264.
Michon 1909, pp. 149–50.
Gauckler 1912, pp. 159–62 and 166, pl. 25.
Cain 1985, no. 64, p. 171.

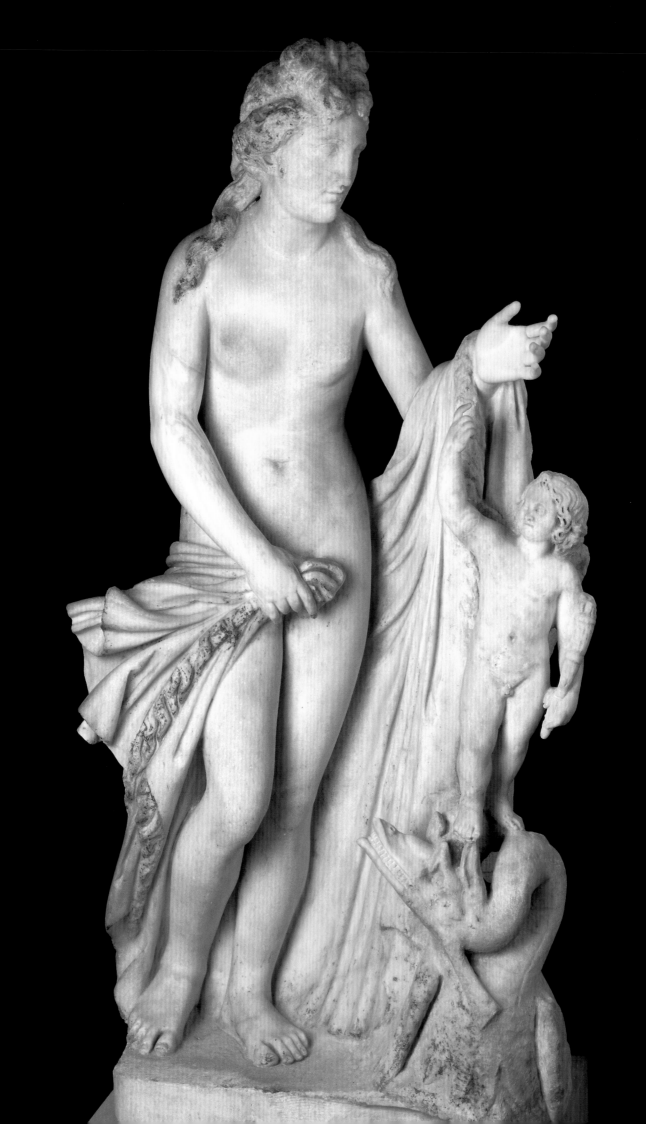

86 Venus and Eros

3rd century A.D. • Discovered in Italy (?) • Marble • H. 53⅞ in. (137 cm) • Purchased in 1807, formerly in the Borghese collection (MA 280–INV. MR 370) • Restorer: V. Picur, 2006

Both Venus and Eros's right arms and left hands are modern, as is the sea monster's head. This small statuary group is a good example of the kind of Roman decorative sculpture found in gardens and thermal baths. Both its modest format and the models it refers to are characteristic of a massive production of varying quality that was intended for Roman patricians. Venus stands naked, holding in place with her right hand and left arm a fringed cloak that enfolds her body at the same time that it reveals her hips and legs. She is turned toward a small naked Eros, who holds a torch from his perch on a sea monster.

This composition is familiar from an analogous but much larger group kept in the Vatican and referred to as the Venus Felix since the sixteenth century.[1] The Vatican group, believed to have come from an imperial residence of the Severian era, is inscribed in the name of Sallustia Barbia Orbiana, wife of Emperor Alexander Severus (222–35 A.D.), but it has been suggested that the face of Venus depicts the features of Faustina the Younger, wife of Emperor Marcus Aurelius (161–180 A.D.). The small Louvre group would therefore testify to the dissemination in the private sphere of a decorative motif that was originally conceived for the emperor.

Nonetheless, the prototype for these works might well be an eclectic Roman piece known through other replicas[2] and issued from the so-called neo-attic workshops that provided classicizing artworks for Roman clientele at the beginning of the empire. The motif has been identified on a fourth-century B.C. anthropomorphic vase[3] and a second-century B.C. terracotta figurine[4] but is not attested to in marble statuary before the imperial era, though its occurrences in marble works clearly draw on fourth- and second-century B.C. repertoires.

This Venus reproduces the pose of the Greek Aphrodite Pudica (modest Aphrodite) archetype. Examples of the so-called Capitoline Venus have consistently referred to Praxiteles's famous Cnidus Venus, while the garment gathered around the legs is drawn from another statuary type, known as the Syracuse type, which represents a Hellenistic Venus rising from the water. The idealized face, general attitude, and presence of the sea monster aim to recall models cited in the third century A.D., as indicated by the figures' somewhat stocky proportions and a variety of technical details: the goddess' right eye has been hollowed out according to the convention inaugurated in the second half of the second century A.D. (the left eye is barely hollowed out); the sculpture's back has been left untouched, and the back of Eros's wings and the cloak's fringes are barely hinted at, probably because the statuary group was intended to be placed in a niche and visible from only one perspective.

The classicizing vocabulary used here endured in "idealized" Roman sculpture until the fall of the Roman Empire, of which the Venus from Montagne (cat. no. 110) is a fine example from the fifth century A.D. (J.-L.M.)

NOTES
1 See Haskell and Penny, 1981, no. 87, pp. 323–24, fig. 172.
2 Doria Pamphilj, Istanbul INV. 498, Baltimore.
3 National Museum of Athens INV. 4127.
4 Karlsruhe INV. B 382.

BIBLIOGRAPHY
Michon 1914, p. 168.
LIMC II 1984, "Aphrodite," p. 79, no. 698, pl. 70, s.v. A. Délivorrias.
Machaira 1993, pp. 72–73, no. 45, pls. 45–46.
Martinez 2004a, no. 301, pp. 174–75.

87 Fountain Basin

1st century A.D. • Discovered in Gortyn (Crete) • Marble • H. 30¼ in. (77 cm); Diam. 51⅛ in. (130 cm) • Purchased in 1890 (MA 2237–INV. MNC 1295) • Restorer: P. Roumegoux, 2005

A lion's head is all that remains of the two ancient gargoyles through which water flowed from the center of this large, shell-shaped and heavily restored basin. Surrounding the central rocky form are six figures in high relief, among them, a naked Hercules, his right hand brandishing a club; a woman holding a basket of fruit; and a figure of Silenus, pressing on a wineskin, holding a vessel, garbed in a faun's skin (customary garb for members of the Dionysian entourage). The other three figures include the bearded, goat-footed Pan, his shoulders covered in similar garment. Pan no doubt originally held a *syrinx*, the multi-piped flute that carries his name, as well as a *pedum*, the long rod with a curved end used in rabbit hunting. He is flanked by two satyrs, their shoulders also clad in faun skins. One carries a struggling goat in his left hand; the other leans his right hand on a tree trunk; both hold the lower half of a shell in their raised hands.

At the summit of the rocky cliff, a crowned figure of Cupid appears sleeping on his cloak, his foot resting on a lizard. In his sleep, Cupid is opening the upper half of a shell pierced with a hole for water to flow from.

This fountain combines a truly baroque composition with an equally naive sculptural technique. It may seem surprising in its

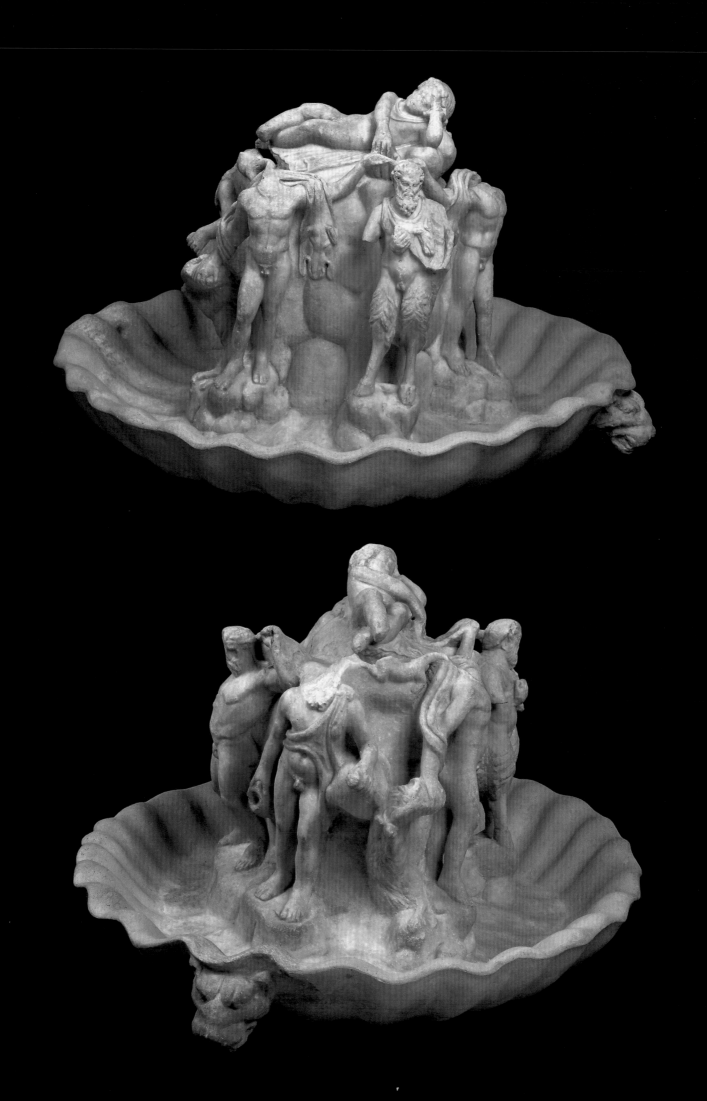

departure from the classical references of Roman art; however, it is important evidence of the persistence of the exuberantly mannerist forms that were the legacy of Hellenistic works. There were undoubtedly additional creative influences that spread from Pergamum—first to the Asian coast of the Mediterranean and throughout its islands—before expanding far beyond the eastern Mediterranean basin.

Although the association of water and the principal figures in the Bacchic cycle is not unusual in this type of object, the use of rustic divinities, instead of the more common representations of rivers and nymphs, may indicate a symbolic and ritual dimension to this sculptural group. The ensemble goes beyond the merely decorative and anecdotal ornamentation. The presence of Cupid, who dominates the other figures, is a clear allusion to his cosmological dimension. His sleeping state and apparent fragility in no way diminish his power over human passions. (C.P.-D.)

BIBLIOGRAPHY
Daremberg and Saglio, vol. 2, p. 1236, fig. 3159.
Reinach 1898, vol. 2, no. 5, p. 492.

88 Well Coping ("Puteal Bevilacqua")

Late 1st century B.C.–early 1st century A.D. • Discovered in Italy (?) • Marble (from Paros?) • H. 20⅝ in. (52.5 cm); Diam. 20 in. (51 cm) • Revolutionary seizure in Verona, 1797, formerly in the Maffei collection (MA 679–INV. MR 1014) • Restorer: V. Picur, 2006

Renowned in the sixteenth century, this unusual monument inspired many artists. It was initially in the Roman collection of cardinals Paolo Emilio (1481–1537) and Federico Cesi (1500–1565), then entered the collection of Mario Bevilacqua (1536–1593) in Verona, was acquired and published by Scipione Maffei around 1732, and then seized by Napoleon's troops on May 20, 1797.

This cylindrical, hollow object is a *puteal* (from the Latin *puteus*, meaning a well), the decorated stone curb around the mouth of a well, often found ornamenting Roman gardens and sanctuaries. Archeologists have borrowed the term from a letter Cicero wrote to his Greek friend Atticus in the first century B.C. (*Atticum*, I, 10, 3), ordering *putealia* to decorate his home. This type of monument was found on site in Pompeii. Possibly indicating a sacred source, the aboveground part of the well frequently took the shape of (and had a type of decoration found on) a round altar. A notch on the edge allowed for the passage of a rope, while three holes probably once served to close a lid.

Placed on a molded base, the body is carved with a Bacchanalian scene representing seven characters: three dancing satyrs and three dancing maenads alternate in a procession led by an Apollo playing the *cithara*. Behind Apollo, the first satyr, practically facing front, wears a faun skin and plays a double flute (or *aulos*). Beside him, a maenad in a *chiton* and *himation*, her hair in a bun, seems to pivot her bust to the right toward the flute-playing satyr, while her body moves to the left. The following satyr, seen from behind, holds his faun skin in place as he walks. Behind him, the maenad walking toward the right turns her head to the left, creating a link with the next satyr, who appears to be dancing with his faun skin thrown over his left arm. Behind him, the last maenad spins around. The eclecticism of the models cited here (a fourth-century B.C. Apollo Kitharodos, the flute-playing satyr of the beginning of the Hellenistic era, the dancing maenads) betrays a neo-attic creation from the late first century B.C. or the beginning of the first century. This repertoire was drawn on for a significant decorative marble production (including tripods, candelabra, vases, and oscilla), which Athens specialized in at the end of the Hellenistic era and beginning of imperial times. (J.-L.M.)

BIBLIOGRAPHY
Lanciani 1992, p. 120, fig. 76.
Golda 1997, pp. 90–91, no. 31, pl. 1.1; 34.1 A4; 35.1 A3; fig. 17.1.
Biscontin 2000, 4, pp. 38–53, figs. 11–17 and 19–21.
Martinez 2004a, no. 1188, p. 593.

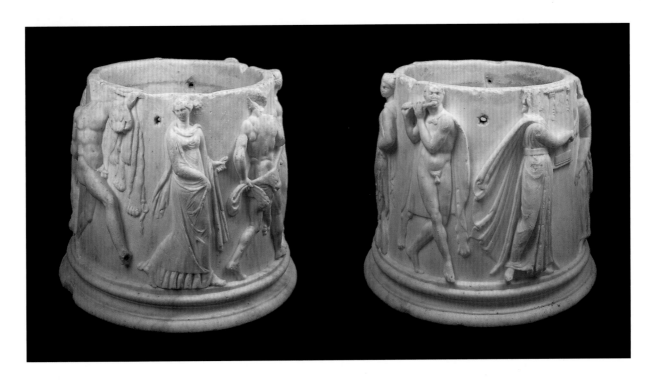

89 Vase with Masks

Ca. 80–100 A.D. • Discovered in Italy (?) •
Marble (from Paros?) • H. 32⅛ in. (81.5 cm);
Diam. 31⅞ in. (81 cm) • Purchased in 1807,
formerly in the Borghese collection (MA 434–
INV. MR 900) • Restorer: P. Klein, 2006

Despite having spent many years outdoors, this large marble decorative vase is well preserved. The base, carved from the same block of marble, is also exceptionally well preserved and dates from antiquity. Only a fragment of the base, the braided molding, and part of the lip of the calyx above the beardless face are modern additions. However, two areas on opposite sides of the lower part of the gadrooned bowl have clearly been recarved, indicating the original emplacement of handles, since removed.

This vase was a calyx krater with low handles: the form first appeared in ceramics produced by Exekias's workshop in the sixth century B.C. Metal, bronze, and silver models went through particularly lavish decorative stages in the fourth century B.C. These pieces, created for banquets at aristocratic courts, were imitated by Roman vases, which took up their form and a decorative vocabulary evoking the Dionysian world.

The vase's decorations are particularly meticulous: two thyrsi (the staffs of the Dionysian revels), ending in pinecones and draped with bands hung with goatskins, emerge from two pairs of masks set back-to-back. Three masks represent elderly, bearded satyrs; a fourth shows a younger, smooth-cheeked satyr. The *pedum*, a weapon used by shepherds to hunt for hare, rests near the younger satyr, evoking a bucolic world.

Once again, a repertoire of *oscilla* and candelabra, which Athens had specialized in producing in the late Hellenistic era and the early imperial era, is cited here. A shipment of this type of vase, intended to decorate Roman gardens, was discovered in Madhia off the coast of Tunisia, in the wreck of a ship that had probably left Athens bound for Rome. In fact, these large decorative Roman vases were tremendously popular in the modern era. The two most famous examples, the Medici vase in Florence and the large Borghese vase, were imitated in Versailles and many European gardens.

In the seventeenth century, the Borghese Krater with Masks sat at the top of the guardrail of the staircase of the Villa Borghese's main facade (a recent copy has since replaced it). The krater was brought inside in the eighteenth century and placed in the villa's third room, on the altar now in the Louvre (Ma 358), where it is shown emerging from an acanthus base, fastened by a hole that was drilled through the base and the lower modern molding. Following the restitutions of 1815, this arrangement was maintained in the Louvre. E.Q. Visconti chose to place the vase in the ground floor rotunda as the focal point leading into the gallery of antiquities. This decorative object impressed artists such as James Tissot, for instance, who made it the subject of one of his views of the Louvre.[1] (J.-L.M.)

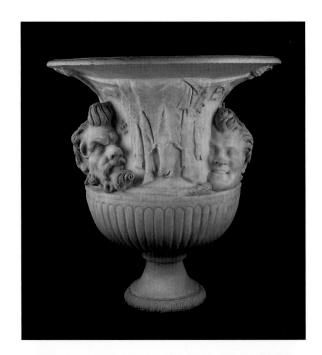

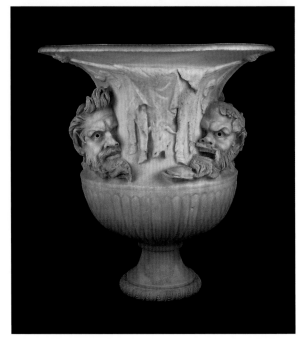

NOTE
1 Museum of Art, Rhode Island School of Design.

BIBLIOGRAPHY
Lamberti 1796, I, st. III, no. 13.
Gassinger 1992, p. 183, no. 24, pls. 228–29.
Martinez 2004a, no. 1166, pp. 580–81.
Martinez 2004b, p. 157, fig. 168.

90a Candelabrum Lamp-Holder

Early 1st century A.D. (before 79) ▪ Discovered in Pompeii, with the lamp BR 3109 (cat. no. 90b) ▪ Bronze ▪ H. 49⅝ in. (126 cm) ▪ Purchased in 1825, formerly in the Durand collection (BR 3164–INV. ED 2779) ▪ Restorer: I. d'Avout-Greck, 1997

With its fluted shaft and slightly flared bottom, the candelabrum rests on a tripod shaped like lion's paws, partially covered by a double plant-motif sheath. Three palmettes, one broken, ornament the space between the lion's paws. Each palmette has nine petals, surmounted with an openwork volute decoration. The tripod ends in a ring in the shape of a plant calyx into which the shaft is fitted. The upper end of the shaft is topped with a small chalice covered with a lantern-holder pan. The flared neck of the chalice is inlaid with tin in the form of heart-shaped ivy foliage and three-seeded berries. The pan, marked with concentric circles, is ornamented with an ovum frieze around the edge.

This composite-style candelabrum, characteristic of the Augustan era, has various elements borrowed from more ancient models.[1] The tripod shape characterized by three distinctive elements—the lion's paws, the palmettes, and the ring in the form of a plant calyx—are found, beginning in the fifth and fourth centuries B.C., on candle holders in Etruria and southern Italy. The shape was modified, little by little, to accommodate oil lamps, which were preferred to smoke-emitting candles. The lamp-holder, crowned with a pan, undoubtedly first appeared between the second and first centuries B.C., replacing the curved points where candles of tallow and wax had once been.

Numerous bronze candelabra were discovered in the houses and villas of Campania, destroyed during the eruption of Vesuvius in 79 A.D.[2] These costly objects, probably fabricated in local workshops, were an important furnishing component. They were placed in reception and dining rooms, next to beds, tables, and trivets used for banquets. Less luxurious lamps were also made out of iron and wood. (C.B.)

NOTES
1 Boube-Piccot 1975, pp. 50–51, type c; Laterre 1986–87, p. 19, nos. 24–25, pl. 13, pp. 39–40, type 3.
2 These candelabra have been studied by Pernice 1925, pp. 43–57.

BIBLIOGRAPHY
De Ridder 1915, p. 153, no. 3164, pl. 113.

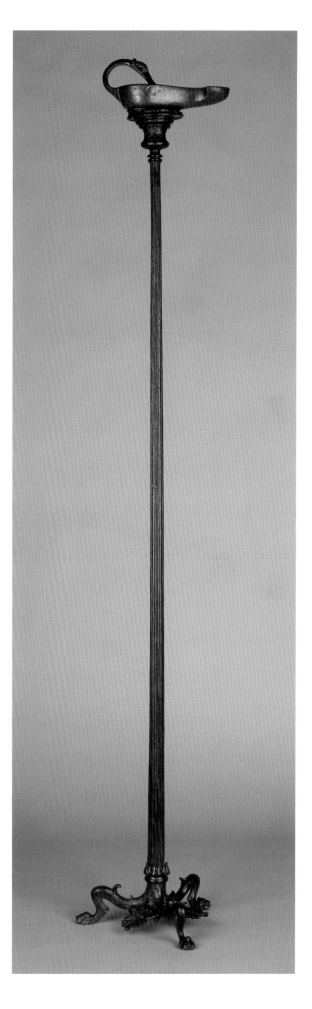

90b Pyriform Lamp

Mid-1st century A.D. ▪ Discovered in Pompeii, with candelabrum BR 3164 (cat. no. 90a) ▪ Bronze ▪ H. 3⅜ in. (8.5 cm); L. 8¼ in. (20.5 cm) ▪ Purchased in 1825, formerly in the Durand collection (BR 3109–INV. ED 2778) ▪ Restorer: A. Conin, 1997

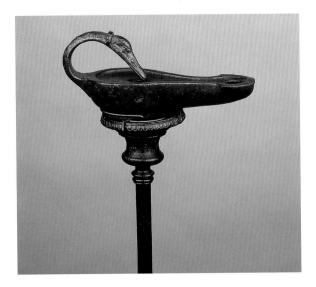

The pyriform tank of this lamp rests on a low foot. The pan, surrounded by a flat border, extends to the half-moon shaped spout. At the center of the disk is an opening in the shape of a water drop, into which oil was poured. The handle, which curves forward, is ornamented with a swan's head emerging from a floral calyx. The bird's eyes and plumage are finely engraved, and its closed beak bends over the opening.

Bronze pyriform lamps are characterized by handles that end in a theater mask or an animal head; swan, horse, or panther. Many lamps of this type were discovered in the wealthiest houses of Pompeii and Herculaneum. Still in use at the time of the eruption of Vesuvius, they frequently bear traces of prolonged use and were clearly fabricated well before the catastrophe.[1] Their typical form, adapted from terracotta models of the Hellenistic era, was definitively established in the second quarter or the middle of the first century A.D. Produced in great quantity during the second half of the first century and in the early second century, these lamps were spread throughout the empire.[2] (C.B.)

NOTES
1 Valenza 1977, p. 160.
2 Conticello De' Spagnolis and De Carolis 1988, pp. 138–39 (with an important bibliography).

BIBLIOGRAPHY
De Ridder 1915, p. 147, no. 3109, pl. 109.
Bailey 1996, p. 42, no. Q 3677 (cited in comparison).

91 Lamp with Two Spouts with Volutes

Late 4th century A.D. ▪ Provenance unknown ▪ Bronze ▪ H. 3⅜ in. (8.5 cm); L. 6⅞ in. (17.5 cm) ▪ Longstanding part of the collection (BR 4549) ▪ Restorer: A. Conin, 2006

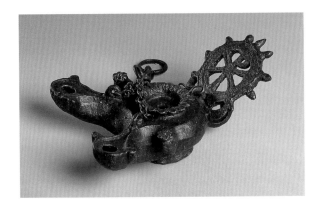

Shaped from a spherical vessel and flattened on top, this lamp rests on a low foot. Two pointed, arch-shaped spouts are framed by two small volutes and attached to the vessel by two larger, protruding volutes that end in a six-petaled rosette with a center bud. A corolla formed from a row of petals encircles the pouring hole that was pierced in the center. Above the ring-shaped handle is an openwork, circular reflector, supported by a striated crescent. Trimmed with nine buttons, the reflector—in the shape of a crown of leaves—is inscribed with the monogram of Christ, the first two Greek letters of his name.

The lamp is equipped with its own suspension system: small chains attach to three rings—one at the base of the reflector, two at the beginning of the spouts—that connect to a larger chain ending in a suspension ring. The bottom of the lamp is concave and pierced in the center of a small, square-sectioned opening. Vestiges of a fastening system on the bottom may indicate that the lamp could have been placed on a candelabra or bronze lamp support.

This type of lamp, of which there are numerous examples, is derived from a model based on Hellenistic forms that date to the early imperial era, between the late first century B.C. and the early first century A.D. It is characterized by two or sometimes three spouts, ornamented with protruding volutes.[1] It is not certain if this form continued beyond the first century or was abandoned and then revived in the fourth century.[2] If it is, indeed, a revival, this could be explained by the return to the classical tradition by the new society in the late empire.

Late-period bronze lamps with volutes are often surmounted by a reflector embellished with *XP,* the monogram for Christ. This type seems to have been widespread in Rome in the fourth century, as evidenced by a group of lamps now in the Vatican Museum, one of which is very close to the Louvre piece.[3] The reflectors on these lamps—originally meant to cast light—are ornamented with openwork motifs and function only as decoration.[4] The monogram is one of symbols most frequently depicted on bronze and terracotta lamps from the early Christian era, symbolizing Christ's martyrdom. (C.B.)

NOTES
1 For more on this type of lamp, see Conticello De' Spagnolis and De Carolis 1988, pp. 41–42.
2 Bailey 1996, pp. 60–61.
3 Conticello De' Spagnolis and De Carolis 1986, pp. 48–49, no. 18; Rimini 2005, p. 247, no. 74.
4 For more on lamp reflectors, see Bénazeth 1992, p. 151.

BIBLIOGRAPHY
Dain 1933, p. 195, no. 231.

92 Lamp

Late 1st century B.C.–early 1st century A.D. ▪ Discovered and produced in Italy ▪ Clay ▪ L. 4¾ in. (12 cm); Diam. 3⅜ in. (8.7 cm) ▪ Purchased in 1861, formerly in the Campana collection (INV. CP 4911) ▪ Restorer: C. Knecht, 2006

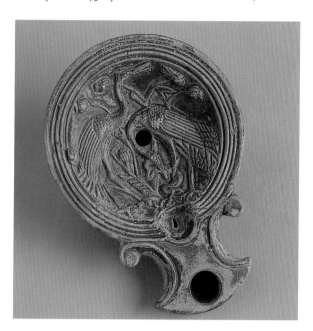

The discus of this lamp has elegantly modeled ornamentation. Two herons with long legs and necks and beautiful plumage grace an aquatic setting suggested by the tall plants. One bird seizes a serpent. Such "Nilotic" settings were very much to the Alexandrian taste; their motifs are found throughout the decorative repertoire of elegant objects (particularly in gold work) and were fashionable beginning at the end of the Hellenistic era. Paccius, the artisan who crafted the lamp, incised his mark on the base: his workshop in the vicinity of Rome was active during the Augustan era. (M.H.)

BIBLIOGRAPHY
CIL XV, 6605.2.3 (b).

93 Lamp

Mid-1st century A.D. ▪ Discovered and produced in Italy ▪ Clay ▪ W. 5¾ in. (14.5 cm); Diam. 4 in. (10.3 cm) ▪ Purchased in 1861, formerly in the Campana collection (INV. CP 4913) ▪ Restorer: C. Knecht, 2006

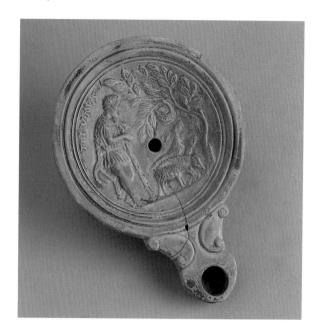

The discus of this lamp is decorated with a rustic scene: a shepherd, wearing a short belted tunic and an animal skin, leans on his staff and watches over his flock of sheep and goats. The animals are grazing on the leaves of shrubs, whose dense foliage shelters a bird perched on a nest and sheltering her young. The shepherd's name, Tityrus, is inscribed behind him, recalling the shepherd described in *Eclogues* (40 B.C.), Virgil's renowned poems extolling the simplicity and wisdom of country life. This is among the best examples known of this ubiquitous scene, which is often found on other decorative objects, particularly intaglios. (M.H.)

BIBLIOGRAPHY
CIL X, 8053.9.
CIL XV, 6240.9.
Daremberg and Saglio, III, 2, p. 1326, fig. 4589.
Bailey 1980, II, p. 45.

94 Lamp

1st half of 3rd century A.D. ▪ Discovered and produced in Italy ▪ Clay ▪ W. 5 in. (12.7 cm); Diam. 3½ in. (8.8 cm) ▪ Purchased in 1861, formerly in the Campana collection (INV. CP 4419) ▪ Restorer: C. Knecht, 2006

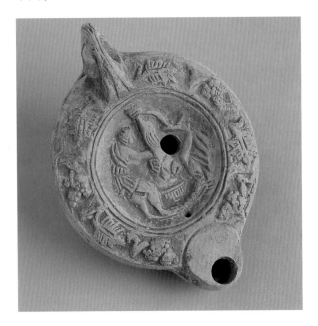

Framed with an alternating motif of grape leaves and grapes, the discus depicts a scene of daily life: a slave dressed in an *exomis* (a short tunic) plunges his hand into the entrails of an animal he is butchering. The animal is suspended by its feet from a branch with a gnarled trunk shown at the right. This scene, rarely depicted on lamps, recalls the statuary group known as L'Ecorcheur rustique (Peasant Disemboweling a Deer) and shows the growing taste for the picturesque in art at the end of the Hellenistic era, which was much admired by the Romans.

The entire decorative scheme of this lamp is carried out with particular care, from the ornamentation of the handle to the decorated double ring around the maker's name, C. Titus Aest(ius) (?), stamped in the hollow on the bottom of the lamp. (M.H.)

BIBLIOGRAPHY
CIL XV, 6718.1.

95 Shell Bowl

1st century A.D. ▪ Provenance unknown ▪ Bronze ▪ H. 2 in. (5 cm); Diam. of opening 6⅛ in. (15.5 cm) ▪ Longstanding part of the collection (BR 2928) ▪ Restorer: F. Dall'Ava, 2002

This bowl in the shape of a shell is extremely naturalistic. The fluted shell has eighteen radiating rounded sections. Fine parallel lines, visible on the surface, seem to indicate a smoothing process used to obtain a polished appearance. Probably cast and then reshaped by hammering, the bowl originally rested on three feet, as can be seen by the pewter solder arranged in a triangle on the underneath. Two added small feet in the shape of spiral shells are still visible on a similar basin that is now in the Naples museum.[1]

Numerous receptacles of this type, in bronze and silver, have been found in cities located around Vesuvius, particularly in Pompeii.[2] Two variations exist, one with a continuous silhouette without visible feet—such as this example—which is quite realistically modeled, and the other with a discontinuous silhouette and a circular base, which is generally more stylized.

Receptacles typically have either a hanging ring attached to the top of the shell or small side handles, as seen in an example discovered at Boscoreal that is now in Berlin.[3] They were made in Campania during the second half of the first century A.D. Only a small number have been found in the Roman provinces, in Gaul, and in free Germany (the section of Germany not occupied by Romans).[4]

The purpose of these bowls is difficult to determine, and numerous interpretations have been advanced. They have been associated with a table service and, because of their shape, possibly identified as baking pans. They were most likely set aside for grooming and undoubtedly used for drawing and pouring water. The shell motif seems to have been used for everything related to the theme of water: fountains and nymphaea placed inside houses were often embellished with shells inserted into a decorative scheme. This motif was likewise associated with the domain of the toilette and often appeared in representations of Aphrodite, who is sometimes shown holding a basin in the shape of a shell. Some groups of bronze statuettes show Eros holding out a small shell-shaped dish to the goddess.[5] (C.B.)

NOTES
1 Daremberg Saglio I, 2, pp. 1431, fig. 1890.
2 Tassinari 1993, t. I, pp. 81–82, type N; vol. II, pp. 169–73. For an example that is very close to Br 2928, discovered in the Villa of Mysteries, see vol. I, p. 190, no. 10 (INV. 4525); vol. II, pl. p. 512. For a pair in silver, found in the House of Menander, see Maiuri 1933, pp. 368–69, nos. 84–85, pl. 63.
3 Berlin, Antikenmuseum: Oettel 1991, pl. 23, no. 27.
4 An example now in Rouen: Tassinari 1995b, p. 60, no. 41. A pair found in Hanover: Eggers 1951, pl. 11, no. 109.
5 A. Hermary and H. Cassimatis, "Eros," LIMC, III, 1986, p. 877, no. 308, pl. 625.

BIBLIOGRAPHY
De Ridder 1915, p. 128, no. 2928.

96 Situla

Early 1st century A.D. ▪ Discovered in
Caporalino (Haute-Corse, France) ▪ Bronze
▪ H. 13 in. (33 cm); Diam. 11 in. (28 cm) ▪
Purchased in 1874 (BR 2828—INV. MNB 655) ▪
Restorer: A. Conin, 2006

The belly section of this *situla* (bucket) ends in a fold at the base.
The cylindrical neck was with engraved ridges and flattened on the
upper border. The middle portion of the handle, fluted and crowned
with a hanging ring, extends at both ends in a stalk shape emerging
from a plant calyx made up of two leaves edged with a beaded ring.
The folded ends of the handle form a hook decorated with a duck's
head. Fasteners for the handle, fitted with a molded ring, are deco-
rated with a youthful head emerging from a palmette alongside
two dog heads. A collar engraved with small circles surrounds the
head of a child, whose two coils of falling hair end in a roll. The
moving handle was cast separately, as were the fasteners, which
were riveted onto the cylinder neck. The body of the vessel was cast
from a single piece and then hammered.

This piece comes from the hamlet of Caporalino, located in the
municipality of Omessa in Haute-Corse (north Corsica). It was dis-
covered in February 1873 at the edge of a stream along with three
bronze vessels—one pitcher and two similar situlae that were also
acquired by the Louvre.[1] Three feet found alongside the vessels
undoubtedly belong to the larger of the *situlae*, which is orna-
mented with a rich silver-inlay decor. According to evidence
collected shortly after the discovery, the objects were found dis-
mantled and stacked inside one another upside down and resting
on a slab.[2]

The three Caporalino *situlae* clearly come from workshops in
Campania, in southern Italy, where bronze vessels were fabricated
in the first century A.D. Similar examples were discovered in
Pompeii, Germany, central Europe, and even Sweden.[3] Another
production center, dating to the middle of the first century, was
located in northern Italy. In provincial centers, the fabrication of
situlae was revived during the second century and lasted until the
third century. But vases coming out of these workshops had more
schematic decorations.

That so many *situlae* were found within the territory of the
Roman Empire and beyond its borders indicate that they were
widely used. They were needed for sacrifices, for holding water
used for purification, and, in domestic life, for banquets and to
serve wine. According to Greek custom, wine was never consumed
undiluted, but was cut with cold or even hot water. One sampled
the beverage with the help of a ladle or a dipper that doubled as a
sieve, and strained out the spices contained in the wine. (C.B.)

NOTES
1 De Ridder 1915, p. 122, no. 2827, pl. 102 (a large situla where the bottom is missing),
 no. 2830 (3 *situla* feet that undoubtedly belong to no. 2827), no. 2829 (bottom of a
 situla), p. 124, no. 2857 (neck and handle of no. 2829). The pitcher may correspond
 to no. 2664.
2 Aubert 1874, pp. 59–60.
3 Ferrare 1996, p. 210, no. 39 (*situla* from the House of the Faun in Pompeii); Szabó
 1995, p. 83, no. 2, fig. 2 (*situla* from Somlójenö, Hungary); Kunow 1983, p. 18, Type E
 24, p. 130, no. K 18 (*situla* from Havor, Sweden).

BIBLIOGRAPHY
De Ridder 1915, p. 122, no. 2828.
Poulsen 1991, p. 228, no. I.3.1.10–11.

97 Patera

1st century A.D. • Provenance unknown •
Bronze • L. 11⅜ in. (28.8 cm); Diam. 7⅛ in.
(18.2 cm) • Purchased in 1825, formerly in the
Durand collection (BR 3031–INV. ED 2814) •
Restorer: A. Conin, 2006

The *patera* consists of a bowl that was cast and then turned on a lathe. The bowl's interior surface is engraved with fine grooves and at the bottom of the interior surface is embellished with concentric circles arranged around a pinpoint hole. Along the flat edge are roughly engraved numbers ranging from I to V. The outside bottom has concentric fluting.

Made separately and then attached with solder and rivets, the smooth handle tapers toward the end. At each tip, it is decorated with two thin shafts that end in a goose head with incised eyes and plumage. Its "pincer" form hugs the curvature of the bowl. Beneath the beginning of the handle is an incised motif of veined leaves and filling the side portion is engraved foliage.

Many bronze *paterae* embellished with goose heads were discovered in houses buried by the eruption of Vesuvius in 79 A.D.[1] They were fabricated either in Pompeii or Capua, where there must have been workshops that specialized in producing them.[2] Four examples, probably imported from Campania, were found in the Roman provinces: one in a villa in the region of Achaea in Greece; one in a tomb in southern Gaul; and two in Thracian graves from the early second century A.D.[3]

Often depicted with pitchers on sacrificial monuments, these bronze vessels were used to pour offerings of libations, liquids, perfumes, or foods onto the flame of the altar. A fresco in Pompeii shows a *patera* and pitcher at the foot of a table that is laid with a luxurious silver beverage service.[4] At home, in reception halls, they were brought to guests before a meal so that guests could wash their hands. Since Romans ate with their fingers, this procedure would be repeated during the meal. (C.B.)

NOTES
1 A *patera* handle, now in Pompeii, comes from the House of the Moralist. See Tassinari 1993, vol. I, p. 59, type H 2313 (INV. 2552), p. 164, pl. 95, fig. 2; vol. II, pl. 138 and 461. Eleven examples are now in the Museo nazionale of Naples. See Sarnataro 1997, pp. 95–105, nos. 63–73, p. 205, pls. 71–73.
2 Tassinari 1995a, p. 89, n. 3.
3 Nuber 1972, pp. 47–48, list p. 193, type E IV, pl. 4, fig. 2. This type of *patera* was most often associated with a pitcher with a trefoil spout, embellished on the handle with a lion's head and paw; see Tassinari 1993, type D 2300.
4 Fresco from the tomb of Vestorius Priscus. See Pirzio Biroli Stefanelli 1991, p. 5, fig. 1.

BIBLIOGRAPHY
De Ridder 1915, p. 139, no. 3031.
Paris 1959, p. 46, no. 70.

98 Pot with Handle

2nd century A.D. • Discovered in Hastings
(Sussex, United Kingdom) • Silver • H. 2⅝
in. (6.7 cm.); Diam. 4⅛ in. (10.4 cm.); W. 7⅜ in.
(18.8 cm.) • Purchased in 1888 (BJ 1984–INV.
MNC 980)

Found on a property known as Caspet near Hastings, this casserole is the only silver object in the Louvre's collection that is from England. Cast and then reworked on a lathe and decorated with a stylet, the vessel consists of a smoothly shaped bowl with sides that curve gently inward. It rests on a flat base, part of which is now missing. This damage prevents us from knowing the complete text of the dedication engraved (very lightly) on its back. The remaining text that is still legible reads: NUM.. AUGUS.. DEO... ROMULUS CAMULO / GENI FIL.. / POSUIT. With only a few letters missing, a reconstruction has been suggested.[1] The dedication would have been to the god Mars—appropriately associated with Camulus by the Gauls. The patronymic of the votary's father is formed from the same root.

The pot has a flat, decorated handle that has been re-soldered. Its slightly tapering sides end in a bearded head of Silenus, flanked by two swans' heads with closed beaks. From the swans emerge two stems that meet in the center to form a luxuriant succession of full-blown, floral calyxes. Three more delicate stems emerge from this central design: the middle one is composed of berries and a pistil; the two side stems follow the curving lines of the handle and are joined at the edge of the pot with a border of circled berries ending in two swan's heads.

Utensils of this kind appeared at the end of the first century B.C., and many bronze[2] (cat. no. 97) and silver[3] examples have been found in Campania. Silver versions are often found in pairs, with one slightly smaller container nested into a larger one.[4] They have been found next to vessels used for table service and were clearly designed to hold and pour liquids. (A.S.)

NOTES
1 Héron de Villefosse 1888, p. 131.
2 Ferrare 1996, p. 243, no. 348; Pirzio Biroli Stefanelli 1990, p. 221, fig. 200, p. 278, no. 92.
3 Naples 2003, p. 277, IV.94–95.
4 Baratte 1986, p. 32, p. 92, Bj 1986, Bj 1987, Bj 1988, Bj 1989; Toledo 1977, p. 141, nos. 93–94.

BIBLIOGRAPHY
Héron de Villefosse 1888, pp. 129–31.
De Ridder 1924, p. 193, no. 1984, pl. XXVII.

99 Plate

3rd century A.D. • Discovered at Graincourt-lès Havrincourt (Pas-de-Calais, France) (?) • Silver • Diam. 13 in. (32.9 cm) • Gift of the Société des Amis du Louvre and Pierre Lévy, 1958 (BJ 2213–INV. MND 2130)

A very worn geometric pattern emphasizes the contours of this large round plate, which rests on a low, round pedestal. The plate's inside edge is decorated with a frieze that rises slightly above the rest of the dish; a narrow, concave molding joins the frieze to the base. A medallion with a mythological scene, bordered by very worn molding, occupies the center. An unadorned area covering a third of the surface serves to magnify the medallion, which is further emphasized by an engraved circle.

The outer edge of the plate is decorated with a series of four scenes, separated by eight bacchanalian heads in profile that are paired back-to-back with a garland, but despite its apparent uniformity, this iconographic schema is not in fact repetitive. Each pair of heads is different, preceded by a goblet of fruit, a *pedum* (shepherds crook), or a staff garnished with a ribbon. Pan is shown in succession with a maenad, with a young satyr and an older satyr, with a maenad and a young satyr, and with a Silenus and a maenad.

The overall schema of each composition is the same: a pair of animals proceed or face each other separated by a third or fourth element, such as a tree or plant. But the animal scenes vary widely: a boar threatened by a dog leaps off a tuft of grass and attacks another dog; a lioness follows a tortoise whose head is lowered for a confrontation with a bear standing on its hind legs; two lions stalk a stag trying to escape death; a lioness devours a horse lying on its back; another lioness pursues an antelope.

In the plate's center medallion is a scene of Leda and the swan: a young woman stands nude at the water's edge, as if expecting a water lily in bloom to float to the surface. In a pose similar to one associated with Venus, she waves a long veil from her outstretched arms, which swells in the wind as she tries to escape the advances of Jupiter, to her right, who has been transformed into a swan.

This plate is part of a trove consisting of a little more than 17½ pounds (8 kg) of silver[1] in nine different pieces, including three large plates, one saucer with a wide inner ridge decorated with a acanthus leaves, a plate with nearly straight sides, two small cups—one engraved with a niello swastika at the bottom and decorated at the top with a beaded rim and pirouettes, and a cup with a flared rim, embellished with foliage and a large shell.

The reason for these pieces having been gathered together in Roman times is unclear. It may have been pillaged. It may have belonged to one family who collected it one piece at a time. It may have been part of a complete table setting that would have included bronze and glass utensils. In fact, only two of the plates seem to have been purchased to complete a set: they share virtually identical diameters and similar decorations (a central medallion and contours adorned by a frieze). The iconography of one features a naturalist theme; the one shown here recounts the mythological episode of Leda seduced by Jupiter[2]—a favorite theme of silversmiths beginning in the first century A.D.

More ostentatious collections of matching plates exist in the Chaourse treasure[3] and in Rethel,[4] discovered in the north of France and dating from the third century A.D. Each set is almost identical in decoration.

The provenance of these items is also in question. They are said to have been discovered by accident during minesweeping operations; the areas they were found in were battlefields in World War II. Apparently, a Yugoslavian member of the minesweeping team took them to France on the sly and pretended to find them there,[5] where, following an inconclusive legal inquiry, the Louvre acquired them, but doubts persist. A development proposed for the site of the alleged find led to a series of archeological surveys of more than 4,000 square meters in 1998. The results were completely negative—no traces of habitation, burial grounds or ditches; not a single shard of pottery or any other archeological material.

As the composition and characteristics of this plate are similar to other discoveries in the north of France, the Graincourt treasure may, in the future, be found to pertain to collections discovered in the Balkans. (A.S.)

NOTES
1 Valenciennes 1997, pp. 28–32.
2 Baratte 1986, p. 44, fig., p. 94.
3 Paris 1989b, pp. 131–32, nos. 78–79, fig.
4 Paris 1989b, p 166, nos. 110–11, fig. 110–11; pp. 168–69, nos. 113–14, figs. 113–14.
5 Delmaire 1993, pp. 417–18.

BIBLIOGRAPHY
Paris 1989b, pp. 141–42, no. 88.

100 Plate with Dionysian Motif

2nd century A.D. • Discovered in Italy (?) • Silver • Diam. 4⅛ in. (10.6 cm); H. ⅜ in. (1.1 cm) • Longstanding part of the collection (BJ 1955) • Restorers: F. Dall'Ava and O. Tavoso, 2006

This small plate rests on a low, round base. A very worn inscription underneath indicates that it belonged to Pitula Proculi.[1] An engraved circle on the otherwise undecorated bottom highlights the slope of the concave sides, which end in a flattened rim ornamented with a frieze bordered by two moldings. Two slightly different, alternating scenes are repeated. Two pieces of fruit—one round (perhaps an apple), the other pear-shaped—sit on a

101 Krater

Ca. 10 B.C.–10 A.D. ▪ Provenance unknown ▪ Clay ▪ H. 8¼ in. (21 cm); Diam. 8⅝ in. (22 cm) ▪ Pennelli purchase, 1869 (H 436–INV. NIII 3445) ▪ Restorer: C. Verwaerde, 2006

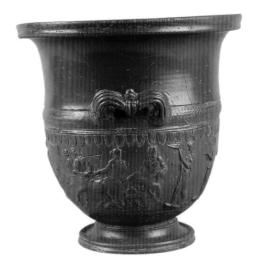

pedestal beside a plinth. A head with beard and mustache—perhaps Silenus—leans against a staff of Dionysus wrapped in a ribbon and resting at an angle. This is preceded by a lion galloping in the direction of another staff of Dionysus, facing the head of a young satyr on the same type of pedestal. In the next scene, framed by two oblong, tree-like shapes (possibly resembling yew or cypress), an animal with short fur and paws with long claws pursues a doe that flees with its head raised toward the sky. The following scene is identical except that a lioness replaces the lion, and the fleeing doe looks straight ahead.

This type of small plate in silver or silver-plated bronze may have served as a base for another receptacle, such as a sauce bowl[2] or drinking glass. Since the discovery of the Vaise treasure in Lyon in 1992, another seventeen items from silver troves have been identified. Many of these were found in Roman Gaul.[3] The ornamental motifs are either of plants[4] or figures (combining scenes of running animals and masks).

Depiction of humans is much more unusual. The plain listel around the outer edge of this plate's rim, as well as the simplicity of the figures and careful placement of the motif, suggests that the plate should be grouped with two others, one of which is in New York at the Metropolitan Museum of Art (18.145.37)[5] and the other in Vienna at the Antikensammlung (INV. VII A8).[6] Both are believed to be of Italian provenance, dating from the second century A.D. (A.S.)

NOTES
1 Reproduction of graffito found in Longpérier 1883, p. 3, notes 2 and 3.
2 Paris 1989b, pp. 214–16, no. 172.
3 Aubin, Baratte, Lascoux, and Metzger 1999, pp. 48–50.
4 Paris 1989b, pp. 144–45, no. 90, p. 205 no. 155.
5 Toledo 1977, pp. 150–51, no. 99, fig. 99.
6 Mutz 1972, pp. 86–87, figs. 202–03.

BIBLIOGRAPHY
Héron de Villefosse 1910, pp. 192–94, p. 193 fig.
De Ridder 1924, p. 190, no. 1955.
Baratte 1991, p. 324, no. 2, p. 325, fig. 5.
Aubin, Baratte, Lascoux, and Metzger 1999, p. 48, fig. 32.

This krater is known as sigillated ceramic. Distinguished by its reddish-orange hue and glossy surface, this type of ceramic was introduced in Arezzo, Italy, in the first century B.C. to compete with metal vessels. In his *Epigrams* XVI, 98, Martial alludes to such tableware: "I entreat you not to scorn these vessels from Arezzo; for such were the sumptuous serving pieces of Porsenna." Porsenna was the highly respected ruler of ancient Etruria.

Although this type of ceramic was created in what was originally Etruscan territory, sigillated ceramic works showed noticeable Hellenistic influences—both in form and decorative scheme—in the later decades of the century. *Canthares* (drinking containers with handles) and kraters (mixing bowls) assumed standard forms, as demonstrated by this wide-mouthed vessel with two handles mounted on the middle of its body. The upper portion of the vessel is left unadorned; on the lower portion, beneath a molded horizontal band surmounting a frieze of ova (egg-shaped decora-

tive elements), is a decoration of two groups of low-relief figures. These, influenced by the neo-Attic style, were inspired by Greek poetry. Below each handle is a symmetrical depiction of two centaur-drawn chariots. In one chariot, a man wielding a whip and dressed in a finely pleated tunic is seated next to a woman. In the other, a nude woman grasping a club, her head covered by a lion skin, sits next to a man. Two archers follow the first chariot, and two women—one holding a parasol and the other a basket—follow the second.

The attributes (club and lion skin) are those of the hero Hercules, and the scenes depicted are from the triumphs of Hercules and Omphale. To achieve expiation for his crimes, the hero was forced to submit to the Queen of Lydia, who imposed various labors and constraints upon him. The exchange of their garments was a demonstration of their submission to each other, one subjected by the imposition of slavery and the other by the passion of love. The bound hands of the centaurs and the reins held by the young man in the short tunic also convey the idea of submission. Such prostration by love is all but indistinguishable from the effects of inebriation,[1] and, like the dissolution of personality caused by drunkenness, belongs to the domain of Bacchus. This association explains the frequent recurrence of this scene on banquet serving vessels,[2] particularly in works produced in the atelier of Marcus Perennus Tigranus.[3]

Applied to both sides of the krater, the two-part maker's mark indicates the owner of the workshop (Perennus) and the name of one of its most renowned craftsmen (Tigranus). Known for the high quality of its production, this distinguished atelier was one of the most successful in Arezzo.[4] This very representative vessel shows a masterly command of form, beautiful color, and a richly complex composition, with each figure relating to the others in gesture and gaze. Their delicate relief, whether posed full-face, profile, or in three-quarter view, and the use of overlapping give the impression of depth. The elegant and varied treatments of draped cloth and musculature are also distinctive. This workshop's production was exported throughout the empire in the later decades of the century, when there was considerable demand for affordably luxurious products following the civil wars. Branches of the atelier were opened in Pisa and Lyon. However, the growth and development of workshops in La Graufesenque and Lezoux in Gaul during the first century A.D. ultimately superseded the production of Arretine ware. (N.M.)

NOTES
1 Drunkenness also caused the tragic outcome of Hercules's adventures with the centaurs.
2 G. H. Chase and C. C. Vermeule, *Greek, Etruscan and Roman Art: The Classical Collections of the Museum of Fine Arts, Boston* (1963), pp. 228–29, 267, no. 255. A. C. Brown, *Catalogue of Italian Terra-Sigillata in the Ashmolean Museum* (1968), pp. 15–16, nos. 37–39.
3 A. Oxé, H. Comfort, and P. Kenrick, *Corpus vasorum Aretinorum* (2000), pp. 317, 323.
4 F. P. Porten Palange, "M. Perennius e M.Perennius Tigranus," *Splendida Civitas Nostra, Studi Archeologici in onore di Antonio Frova* (1994), pp. 331–400.

BIBLIOGRAPHY
Rayet and Colligon 1888, fig. 131.
Pottier 1926, pl. XIV, no. 62.
Dragendorff and Watzinger 1948, p. 82.
Paris 1970, pp. 166–67, no. 209.
LIMC VII, p. 49, no. 36, J. Boardmann, "Omphale."

102 Dish

Late 5th–early 6th century A.D. ▪ Discovered in Tunisia ▪ Clay ▪ H. 1¼ in. (3.2 cm); Diam. 6⅞ in. (17.5 cm) ▪ Purchased in 1958 (INV. CA 6036) ▪ Restorer: C. Verwaerde, 2006

At the beginning of the imperial era, ceramics made in Gaul were exported throughout the empire. However, during the late first century A.D., African red slipware produced in North African workshops began to systematically penetrate the markets around the Mediterranean. These ceramics came from a uniform craftsmen's tradition: their characteristic features remained the same until the very end of the Roman era, as demonstrated by this plate decorated with a Christian symbol.

The plate is well-fired, with a durable, lustrous brick red slip typical of the ceramic type known as Terra Sigillata Africana D. The form, color, and ornamentation are typically simple, with a flat bottom mounted on a very narrow circular base. Exterior ornamentation consists of tongue-shaped elements, with a medallion of concentric indented rings framing a simplified monogram of Christ.[1] Alpha and omega symbols hang from the horizontal arms of the cross, emphasizing Christ's divine nature. Beginning in the fourth century A.D., African ceramics were decorated with both pagan iconography and Christian symbols like the lamb, dove, or fish, as well as with more explicit religious invocations that turned a simple utensil into a sign of the owner's religious affiliation. (N.M.)

NOTE
1 Hayes 1972, pp. 228, 273, 274, fig. 54; EAA, p. 131, no. 289, pl. LXI, no. 4.

BIBLIOGRAPHY
Unpublished

103 Dish

Late 4th–early 5th century A.D. ▪ Discovered in Utica (Tunisia) ▪ Clay ▪ H. 2 in. (5 cm); Diam. 13⅜ in. (34 cm) ▪ Daux gift, 1897 (INV. MNC 2254) ▪ Restorer: C. Verwaerde, 2006

This dish with curved and hollowed sides is bordered by a wide molded rim, framed by an indented ring. The design, characteristic of Terra Sigillata Africana D production, was very popular and widespread.[1] Such ceramics were more user-friendly than forms commonly used in the production of Gaul and Italy: their open form and either low or nonexistent base meant they could easily be stacked in kilns as well as for storage.

Typically, the bottom of the plate was stamped with a design of concentric circles alternating with palms arranged in a star shape. Part of the Louvre's collection, which was assembled in large part from the expedition of Maurice Hérisson[3] and was the gift of Paul Goetschy, this example from the late fourth or early fifth century A.D.[2] was found in Utica; but similar examples have been found throughout the empire, from the United Kingdom to Jordan, as well as in France, Italy, Portugal, and the former Yugoslavia. (N.M.)

NOTES
1 Hayes 1972, form 67, pp.112–16; EAA, pp. 88–89, pl. XXXVIII; Bonifay 2004, p. 171, fig. 92.
2 Style Aii: Hayes 1972, pp. 223, 229,231, 235, 236, figs. 38, 40; EAA, pp. 125–27, pl. LVI a-b, LVII b.
3 F. Barrate, "Une curieuse expédition archéologique en Tunisie: la mission Hérisson," *Revue du Louvre* 6 (Paris, 1971), pp. 335–46.

BIBLIOGRAPHY
Unpublished

104 Mortar

4th–5th century A.D. • Discovered in Ammaedera (present-day Haïdra, Tunisia) • Clay • H. 3 in. (7.5 cm); Diam. 10⅞ in. (27.5 cm) • Goetschy gift, 1927 (INV. CA 2826) • Restorer: C. Verwaerde, 2006

Roman cuisine was based on elaborate recipes with precise directions for the preparation of food. During the reign of Tiberius, the legendary gourmet Apicius compiled a collection of no less than 468 recipes.[1] Ceramic cooking utensils included a wide range of specially designed vessels, such as the bowls known as *mortaria* used to grind and mix ingredients—especially the herbs and spices used in the sauces that formed the main accompaniment for Roman meals.

Like this example, mortars could be crafted in terracotta and had an abrasive interior surface created by grit being mixed into the clay. Such mortars were widespread in the Greek world and were produced in large quantities in Italy during the first century A.D.[2] before being widely replaced with stone and marble versions.[3]

However, in the fourth and fifth centuries A.D., North African workshops resumed production of terracotta mortars that typically had the wide rim seen in this example.[4] (N.M.)

NOTES
1 *De re coquinaria*. The surviving manuscript actually dates from the end of the 4th century A.D.
2 They show an identical potter's mark to that found on tiles and bricks, probably produced in the same workshops. J.W. Hayes, *Handbook of Mediterranean Roman Pottery* (London, 1997), pp. 80–81.
3 Such as those published in *Domus, Viridaria*, Pompei, Casina dell'Aquila, July 5–September 12, 1992, pp. 122–23, nos. 47–48.
4 See also *Atlante delle forme ceramiche, I, Enciclopedia dell'arte antica classica e orientale*, XXX, I (Rome, 1981), p. 108, pl. CXXXV, no. 3; Bonifay 2004, pp. 249–60.

BIBLIOGRAPHY
Unpublished

105 Amphora

3rd century A.D. • Discovered in Adrumetum (present-day Sousse, Tunisia) • Clay • H. 9 in. (23 cm); W. 5⅞ in. (15 cm); Diam. 6⅞ in. (17.5 cm) • Goetschy gift, 1927 (INV. CA 2809) • Restorer: C. Verwaerde, 2006

In addition to luxurious serving pieces and cooking utensils, African ceramic workshops produced large quantities of ordinary serving pieces, most of them from central Tunisia. One group of such items, referred to as Terra Sigillata Africana A, appeared at the end of the first century A.D. They were articles with open forms, including trays, cups, and plates, based on models from Italy, Gaul, and Spain; closed forms were also developed. Among them one finds this amphora, with its ovoid body and slightly bulging cylindrical neck that terminates with small molding at the rim, is an example of the closed form. Two handles are attached with barbotine (thin slip) at the middle of the neck and the curved shoulders. The item's form suggests it should be dated to the third century A.D.[1] It was probably made in a Sousse workshop. Almost all examples of such vessels found intact have been discovered in cemeteries rather than in workshops or dwellings. They were interred with other ritual funerary offerings, including small objects such as coins and lamps. (N.M.)

NOTE
1 EAA 1981, pp. 76–77, pl. XXXI, nos. 16–17.

BIBLIOGRAPHY
Hayes 1972, pp. 191–92, form 165.

106 Small Vessel with Handle and Tubular Spout

5th century A.D. • Discovered in Adrumetum (present-day Sousse, Tunisia) • Clay • H. 5⅛ in. (13 cm); W. 3⅞ in. (10 cm); D. with spout 3⅞ in. (10 cm) • Goetschy gift, 1927 (INV. CA 2875) • Restorer: C. Verwaerde, 2006

This diminutive vessel has somewhat unusual features: a globular body, single handle, tall neck in the form of a truncated cone, and a tubular, side-mounted spout. The form of such jug-like containers is well known (Hayes 126), but the usage is uncertain. This example from Adrumetum is typical of items produced in North Africa, and like similar containers discovered in Sousse and Tipasa,[1] dating from the second century A.D. and known as Terra Sigillata Africana A. (Glass models of this type (Isings 99) found throughout the Roman world in the second and third centuries A.D. also have these distinctive features.[2] Such containers may be associated with various uses: the narrow tubular spout suggests use as a breast-pump or a baby bottle;[3] but the existence of a filter at the base of the neck may conflict with that interpretation. Or perhaps this filter was used to pour out the heavily spiced sauces that were so indispensable at Roman banquets. (N.M.)

NOTES
1 EAA, p. 51, pl. XXIII, nos. 10–11.
2 C. Isings, *Roman Glass* (1957), p. 118, form 99; Arveiller and Nenna 2005, p. 109, pl. 66, no. 883, or P. La Baume and J.W. Salomonson, *Römische Kleinkusnt*, Sammlung Löffler (1976), p. 57, no. 182.
5 N. Rouquet, "Les biberons, les tire-lait ou les tribulations d'une tubulure peu commune…," *Maternité et petite enfance dans l'antiquité romaine*; Bourges 2003, pp. 164–70.

BIBLIOGRAPHY
Hayes 1972, pp. 177–78, form 126.
Atlanta 1994, p. 109, no. 86.

107 Jug

5th century A.D. • Discovered in Adrumetum (present-day Sousse, Tunisia) • Clay • H. 9½ in. (24 cm); Diam. 6⅞ in. (17.5 cm) • Goetschy gift, 1927 (INV. CA 2809) • Restorer: C. Verwaerde, 2006

This undecorated vase has thick sides and an irregular glaze, but its overall shape and elaborately worked surface indicate attentive craftsmanship. A flat strip featuring regularly spaced thumb depressions divides its biconical body horizontally. The ribbed, high narrow neck widens at the mouth, and a large handle with three strips around it is attached to the neck.

We find the same type of divided bodies and similarly shaped necks in a series of jugs belonging to the Terra Sigillata africana A repertoire dated to the second century A.D.[1] It appears that this jug, which is very similar to a piece from Haidra in the Louvre's collection,[2] is representative of this shape's late evolution in the fifth century in North African red slipware (Terra Sigillata Africana D). (N.M.)

NOTES
1 Type Lamboglia 11: EAA, pp. 46–47, pl. XXI, nos. 7–11.
2 CA 2846; see Paris 1970, p. 176, no. 226.

BIBLIOGRAPHY
Unpublished

108 Anthropomorphic Vase with Double Head

Late 3rd–early 4th century A.D. • Provenance unknown • Clay • H. 8¼ in. (21 cm); W. 7⅞ in. (20 cm) • Purchased in 1978 (INV. CA 6701) • Restorer: C. Verwaerde, 2006

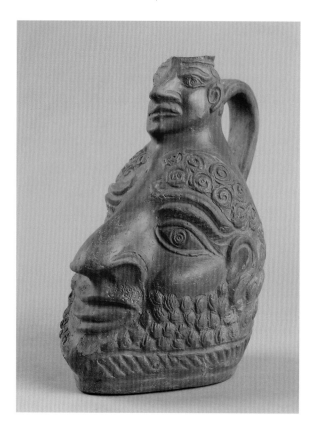

This single-handled vase was made in North African workshops in the late third or early fourth century A.D. The combination of two heads, each with peculiar facial features, gives the piece its originality. The molded body is in the shape of a male face— around the prominent nose are a large jaw, low forehead, and thick cross-hatched eyebrows above wide-open eyes with drilled pupils. Under the mustache rendered in small wavy lines, the tongue shows through the fleshy lips of the wide mouth. A thick beard frames the lower part of the face, and the top of the vase is covered with hair formed by curlicues rendered in a particularly graphic style. This rugged approach, characterized by deep incisions and pronounced contours, irregularity and asymmetry, exaggeration and simplification, is also visible in the smaller, hairless head that forms the base of the neck (missing).

The practice of making vases shaped like heads with grotesque features originated in Asia Minor. A fragment in the Louvre[1] demonstrates that the workshops of Smyrna, responsible for a significant production of grotesques, also made anthropomorphic vases in the shape of grimacing faces with hooked noses, furrowed brows, detached ears, and sneering mouths. Based on the provenance of another anthropomorphous vase in the Louvre,[2] it was determined that the superimposition of two heads, which reinforces the singularity and strangeness of the composition,[3] was invented in Asia Minor too. North African workshops adopted this style by adapting it to an unusual environment.

Indeed, in the case of this particular vase, comparable to a vase in the Bardo Museum[4] and very similar to the production of anthropomorphic vases from workshops in Navigius, Olitresis, Septus, and Gududio, the face's peculiarity is due more to ethnic specificities—particularly visible in the rendering of frizzy hair—than to exaggerated features. This morphological difference also modifies the meaning of the representation.

The heads on the earliest examples of this type of vase, whether simple or complex, were crowned with an ivy-and-corymb wreath, attesting to the link between these containers and Bacchus, the god of wine who presided over banquets. The deformation of the features could therefore be attributed to drunkenness; but Bacchus is also the god of theater, and seen in that light, the caricatural power of these representations may have another significance.[5] Indeed, some experts have suggested that the head is an evocation of Stupidus, a character from mime.[6] (N.M.)

NOTES
1 CA 4350 (Besques 1972, p. 249, pl. 323c, no. E 183). It can be related to an unpublished vase from Smyrna in the collections of the Geneva Museum of Art and History or to a vase from Asia Minor; see U. Mändel, *Kleinasiatische Reliefkeramik der Mittleren kaiserzeit* (1988), pp. 205, 229, pl. 21, no. P 187.
2 CA 1883 (Amisos), L. Ghali-Kahil, "Un lagynos au Musée du Caire," in *Monuments Piot*, 51 (1960), pp. 73-91, p. 78, fig. 5; I. Richter, *Das Kopfgefäss* (Cologne, 1967), p. 115, no. 126; EAA, p. 234, pl. CXIX, no. 2.
3 J. W. Salomonson, "Der Trunkenbold und die Trunkene Alte," *BABesch*, 5, 1 (1980), pp. 65–135.
4 Ibid., p. 117, no. 19. See also an identical model and a very similar one in the Cologne Museum: P. La Baume and J.W. Salomonson, *Römische Kleinkunst*, Sammlung Löffler (1976), pp. 172–73, pls. 67–68, nos. 631, 632.
5 M. Barbera, "Il tema della caricatura in alcune forme vascolari di eta imperiale," in *BABesch*, 67, (1992), pp. 169–82.
6 J.P. Cèbe, *La caricature et la parodie* (Paris, 1966), pp. 44–46.

BIBLIOGRAPHY
Pasquier 1998, p. 94.

109 Plate with Scalloped Handles

Late 1st century A.D. ▪ Provenance unknown
▪ Glass ▪ H. 1⅛ in. (2.7 cm); Diam. of edge 7⅞
in. (20 cm); Diam. of foot 6½ in. (16.5 cm) ▪
Longstanding part of the collection (MNE 386)
▪ Restorer: J. Dupin, 2006

This plate, in blown blue-tinted glass with a pontil mark, has a
rounded edge and flared inner walls. The bottom is flat with a pro-
tuberance at the center; the foot was shaped by folding back the
paraison. The two horizontal handles consist of an applied scal-
loped coil.

Found in the west, particularly in Liguria, in the necropolis of
Albenga[1] and in northern Italy,[2] and more sporadically in southern
France,[3] this type of plate was used in the second half of the first
century.[4] The decorative process used on shallow bowls was also
known in the eastern part of the empire. It is highly likely that such
dishes were produced in northern Italy, in the middle plain region
of the Po valley, but one cannot exclude other places of production,
in both the west and east. (V.A.)

NOTES
1 Genoa 1999, nos. 1–5.
2 Benedetti and Diani 2003.
3 Marseille 2001, pp. 131–34.
4 Roffia 1993, p. 93, n. 3; Arveiller-Dulong and Nenna 2005, no. 522–25.

BIBLIOGRAPHY
Arveiller-Dulong and Nenna 2005, no. 8.

110 Chalice

1st century A.D. ▪ Discovered in Italy (?) ▪
Glass ▪ H. 5¼ in. (13.4 cm); Diam. of edge 6
in. (15.2 cm); Diam. of body 4½ in. (11.5 cm);
Diam. of foot 2⅝ in. (6.6 cm) ▪ Purchased in
1825, formerly in the E. Durand collection (ED
1546; N 5099) ▪ Restorer: J. Dupin, 2006

This blown, blue-green glass chalice has a flared edge with a
rounded lip and is marked at the transition to the body by a roll
formed by folded glass. A conical foot has been added, cut along
the rim. In Pompeii, there are many pieces similar to this low-bod-
ied chalice.[1] Its origins are probably Italian or, more specifically,
Campanian. (V.A.)

NOTE
1 There are unpublished examples in the Museo archeologico nazionale in Naples
 (inv. 13551, 133297, 109426) in blue-green glass.

BIBLIOGRAPHY
Arveiller-Dulong and Nenna 2005, no. 33.

111 Cylindrical Bottle with Collar Rim

Late 1st–2nd century A.D. ▪ Provenance unknown ▪ Glass ▪ H. 7 in. (18 cm); Diam. of rim 2⅜ in. (5.9 cm); Diam. of body 3¾ in. (9.5 cm) ▪ Longstanding part of the collection (S 5997) ▪ Restorer: J. Dupin, 2006

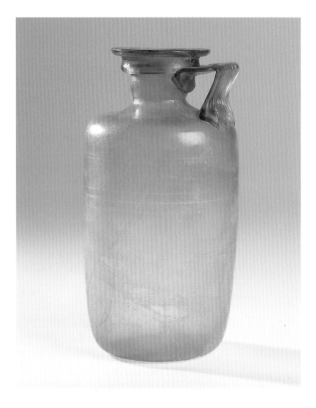

This greenish blown-glass bottle has a flared mouth with a rim folded downward, upward, and outward to form a collar with a flat lip. A small cylindrical neck tapers at the bottom. The bottom is concave. A broad sharply angled and ribbed (eight thin ribs) handle runs from the shoulder to the rim. The body is cylindrical and engraved with four groups of lines (from top to bottom, two, three, two, one).

This bottle belongs to a series of containers that were discovered for the most part in the eastern part of the Mediterranean basin and in the Black Sea.[1] Fabricated out of rather thick clear or greenish glass, they have flanged openings formed by double folds of the paraison; most have bodies decorated with engraved lines, sometimes with intersecting circles. Their sturdiness, particularly in the case of pitchers, may have made them suitable substitutes for the thick, blue-tinted glass prismatic bottles found in Western Europe. (V.A.).

NOTE
1 Saldern 1968, no. 3 (Crete); Hayes 1975, no. 147 (Cyprus); Dussart 1998, p. 159, no. BXI.12, pl. 47, 2 and 69 (Busra museum).

BIBLIOGRAPHY
Arveiller-Dulong and Nenna 2005, no. 559.

112 Pyxis with Lid

1st half of 1st century A.D. ▪ Discovered in Aintab, near Aleppo (Syria); produced in Tarse (?) ▪ Glazed clay with molded decoration ▪ H. 4 in. (10.3 cm); Diam. 5¼ in. (13.4 cm); L. 6¾ in. (17 cm) ▪ Purchased in 1931 (INV. CA 2926)

A *pyxis* was frequently used as part of a lady's toilette to hold cosmetics or jewelry. This one is very similar in form to a *skyphos*, or drinking vessel. The contours of its upper lip have been reduced and raised to adapt to a slightly conical lid, which is topped with a pointed central stud. The lid is decorated with a poplar leaf rosette around the central stud and a vine leaf frieze near the edge. A line of oak leaves adorns the top of the bowl. Both sides of the bowl feature the same decoration: framed by two flowers, a chariot is pulled by two galloping horses while a naked young man with a cloak draped over his back holds the reins in his left hand and a lit torch in his right hand. This motif, though previously interpreted as a representation of the god Helios or as a scene depicting a circus chariot race such as those found on Arezzo ceramic reliefs, is more likely to be an illustration of a torch race (a *lampadedromia*), a ceremony held in the Greek world in honor of the god Hephaistos.

Remarkable for its rare formal and decorative qualities and its exceptional state of conservation, this object is also interesting for its beautiful lead-glazed lid, which is green on the outside and yellow on the inside. This difficult lead glazing technique reached its brief apogee in certain cities in Asia Minor from 50 B.C. to 100 A.D: excavations in Smyrna and Tarsus have provided the most impressive examples. This *pyxis* may very well have been manufactured in a workshop in Tarsus, a city near Aleppo that was at its peak in the first half of the first century A.D. (M.H.)

BIBLIOGRAPHY
Merlin 1932, pp. 51–60, pl. V.
Gabelmann 1974, pp. 282, 283, no. 77.
Hochuli-Gysel 1977, p. 67, type 124, pl. 26, p. 171, no. T 228, pl. 10.
Paris 2005, p. 193, no. 515.

113 Small Cup

1st–2nd century A.D. • Discovered in Cyziqua (Turkey) • Glass • H. 1¾ in. (4.5 cm); Diam. of rim 4⅜ in. (11 cm); Diam. of base 2⅜ in. (6.1 cm) • Purchased, 1906 (MND 762)

This small bowl is made of dark blue glass; the rim is outsplayed with a lip cracked off; at bottom of the rim, a folded tubular flange. The body is flat-sided and conical; the base ring of the cup is splayed and concave underneath.

This example is one of a series of small receptacles with rectangular rims that resemble the pottery of the same period. This type of dish was found in Italy (at Pompeii), in the south of France, in Slovenia, and in the Middle East,[1] often made of violet, brown, or blue glass. The pieces varied according to their region of provenance but were most likely crafted in different workshops throughout the empire. (V.A.)

NOTE
1 Stern 2001, no. 25.

BIBLIOGRAPHY
Arveiller-Dulong and Nenna 2005, no. 815.

114 Spoon

1st–2nd century A.D. • Discovered in Italy (?) • Silver • L. 6⅝ in. (16.8 cm) • Purchased in 1825, formerly in the Durand collection (BJ 2356–INV. ED 4859)

Known as a *ligula,* the tapered, squared-off handle of this spoon ends with two superimposed baluster-shaped elements whose diameter tapers and then ends in an olive-shaped knob. The base of the handle takes the form of a wing feather and is attached by a volute to a very shallow oval bowl.

This type of spoon was developed at the same time as a smaller spoon (a *cochlearia*) designed for eating shellfish that had a circular bowl and pointed handle.[1] The spoons mark a change in the shape of the bowls and the means of attaching the handles. A partial spoon from the Boscoreale treasure is quite similar to this example.[2] It also has a baluster-type handle, but the handle extends directly from the spoon's bowl.

Another oval spoon from the same treasure has a deeper bowl that tapers to a point. The upper part of the bowl arches back to hold the handle in an elevated position.[3]

The existence of the volute and its attachment to the utensils deeper bowl suggests that that this piece should be dated to the end of the first or beginning of the second century A.D. In the third century, new types were developed, with the bowls taking on a rounder form, often attached to the volute in a more complex fashion.[4] (A.S.)

NOTES
1 Baratte 1986, p. 26 fig.
2 Musée du Louvre, Paris, Bj 2038 Héron de Villefosse 1899, p. 114, no. 62, pl. XXVIII, 3.
3 Musée du Louvre, Paris, Bj 2037; Baratte 1986, p. 26 fig.
4 Toledo 1977, p. 163, no. 108.

BIBLIOGRAPHY
Unpublished

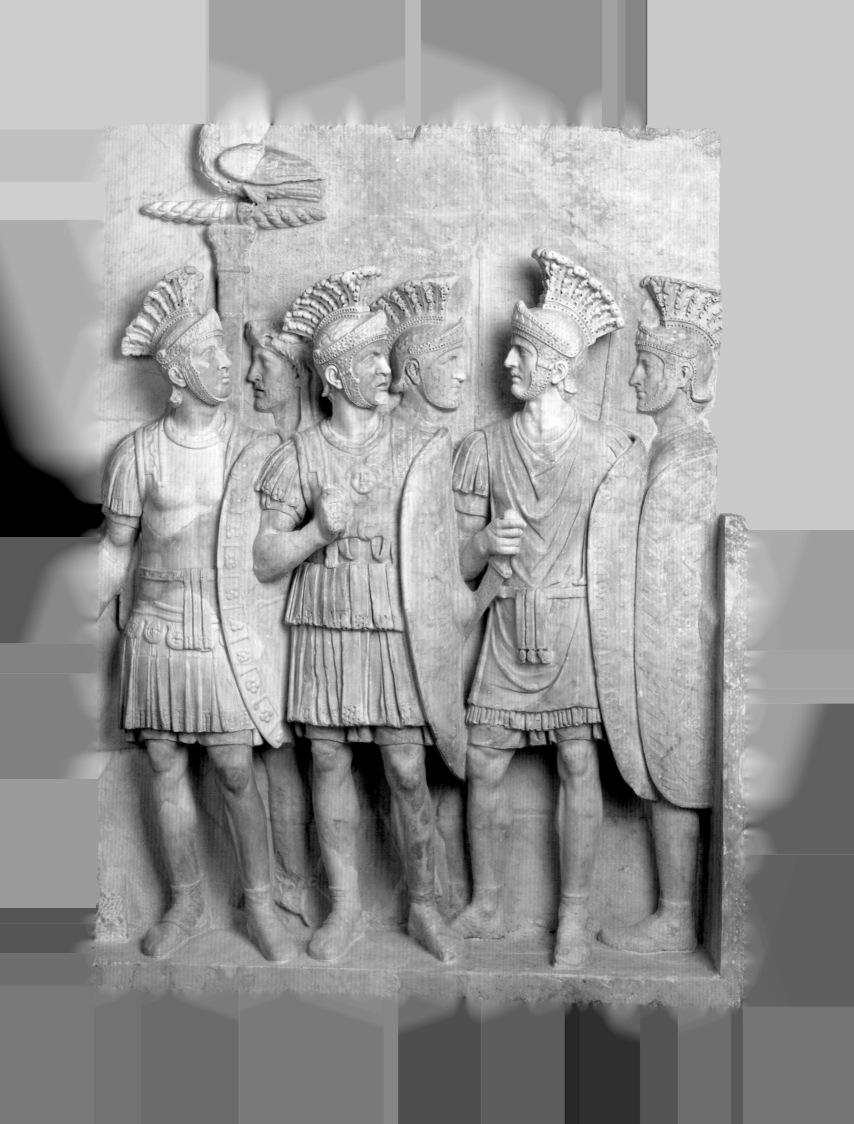

115 "The Praetorians Relief"

Ca. 51–52 A.D. ▪ Discovered in Rome ▪ Grey veined marble ▪ H. 63⅜ in. (161 cm); W. 48⅜ in. (123 cm) ▪ Purchased in 1824, formerly in the Mattei collection (MA 1079–INV. LL 398) ▪ Restorers: N. Imbert and A. Méthivier, 2006

This piece depicts three soldiers in high relief in the foreground and two others, accompanied by a standard bearer, in bas-relief behind. The plaque's original upright is preserved in the lower right; the upright on the left side is modern. As indicated by the leg of a seventh person appearing on the field of the relief, the scene once continued to the left. The soldiers wear helmets with high crests and carry shields ornamented with protruding bosses surrounded by various decorative motifs, including a winged thunderbolt and lightning, foliate designs, and meanders. In the foreground, the soldier on the left wears an anatomical cuirass (armor covering his torso) with a belt and a three-tiered *armiclausa*; the soldier next to him wears a cuirass decorated with a gorgon's head, a belt, and a two-tiered *armiclausa*. The third wears a sleeveless tunic over his cuirass, a belt and a three-tiered *armiclausa*. The bearded standard bearer wears a bearskin on his head and holds a pilaster-shaped pole crowned by an eagle with folded wings, poised on a thunderbolt.

This relief is mentioned as early as the sixteenth century. The head of the standard bearer is drawn in great detail in the *Album of Pierre Jacques de Reims*[1] on a page dated 1577 and executed in the Piazza Sciarra. Indeed, it was in that piazza that Flaminio Vacca mentioned that fragments of architectural sculpture coming from the Arch of Emperor Claudius (41–54 A.D.) were discovered during the reign of Pius IV.[2] This monument—consisting of an arch with one bay, framed by columns with Corinthian capitals—marked the passage of the Via Lata beneath the Aqua Virgo, an aqueduct restored by order of Claudius around 51 A.D.

Vacca specified that the reliefs were purchased by Giovanni Cesarino, whose collection was dispersed after his death in 1585. In 1615, Asdrubale Mattei acquired the relief from Pompeo Ferruci[3] along with a sacrificial scene (cat. no. 39). The two plaques were used as decorative pendants over the doors between the courtyard and the gardens of the Palazzo Mattei for almost two hundred years. During that period, "The Praetorians Relief" was mounted together with a plaque representing an imaginary version of the Capitoline Temple of Jupiter, so that it had the same width as the sacrificial scene.[4] Also at this time, the missing sections of the plaque were replaced, including the heads of the figures in high relief and a large part of the body of the far left figure, except for the middle part of his cuirass, as well as the right part of the eagle and thunderbolt. In the beginning of the nineteenth century, the two Mattei reliefs were acquired by Cardinal Fesch, the uncle of Napoleon I. The Louvre purchased the relief of the soldiers when the cardinal's collection was sold in 1824. In the beginning of the twentieth century, the more modern relief of Jupiter's temple that had been mounted beside the Roman plaque was removed and placed in storage.

That the relief is from the Arch of Claudius dates it to the middle of the first century. Its subject is tied to the triumph of the Roman armies in Brittany in 43 A.D. The dedication of the Arch (which was discovered in 1641 in the foundations of the palace of the Duke of Bassanello) did indeed celebrate the emperor's success in Brittany, specifying his titles as they stood in 51 A.D.: "The Senate and the Roman people, to Tiberius Claudius Caesar Augustus Germanicus, son of Drusus, *pontifex maximus*, during his eleventh Tribunicia Potestas, Consul five times, imperator twenty-two times."[5] The arch's construction, directly connected with the aqueduct, would logically have been undertaken at the same time as the aqueduct itself was restored in 51 A.D., with work continuing into the following year. By this time, Claudius had achieved additional success following the commemoration of his triumph, which was voted by the senate in 43 A.D.; in 50 A.D., he captured the Breton leader Caracatus.

The precise identification of the figures shown in this relief remains a topic of debate. They are not wearing the simple sandals *(caligae)* of ordinary soldiers, but rather the shoes known as *calcei* that were worn by high ranking dignitaries. The muscular cuirasses, particularly the one decorated with a gorgon and a belt with the two-tiered *armiclausa*, also suggest officers of high rank. The latter two ornamental elements probably distinguish the most eminent member of the group. The variety of their garb and shield ornamentation makes it difficult to identify the army corps to which these officers may have belonged. Serious doubts have also been expressed about the traditional interpretation that they are members of the Praetorian Guard; it has been suggested that they are actually officers of an unknown legion. G. Koeppel adheres to tradition, pointing out that the eagle with folded wings is not the emblem of the Roman legions, which is an eagle with outspread wings. On the other hand, the emblem shown in the Louvre's version appears in Claudian coins commemorating the reception of the emperor by the Praetorian Guard when he succeeded Caligula on the throne.[6] Finally, Tacitus recounts that when the captured Caracatus was exhibited in Rome, he was surrounded by Praetorian guardsmen in combat array,[7] although they customarily wore civilian garb within the city walls. It thus remains an open question whether these are officers of an unknown legion or members of the Praetorian Guard. (L.L.)

NOTES
1 Jacques 1577, *Album de dessins d'après l'antique exécutés à Rome*, pl. 62 on the copy at the Bibliothèque Nationale de France.
2 Vacca, Memoria 28, in Fea 1741 p. 228.
3 AM 41, IV, fol. 20, Panofsky-Sorgel 1967–68, p. 152, no. 154.
4 Venuti and Amaduzzi 1779, I pLI, III, pl. XXXIX.
5 Published by Barrett 1991, Musei Capitolini, CIL VI 920a, ILS 216 (1995).
6 Koeppel 1990, p. 107.
7 Tacitus, *Annals* 12, 36.

BIBLIOGRAPHY
Wace 1907, p. 246, n. 1.
Michon 1909, pp. 231–39, fig. 13.
Koeppel 1989, pp. 43, 44, no. 6, fig. 8 and p. 49.
Koeppel 1990, pp. 103–09, pl. 40–43.

116 Relief of the Dacians

1st quarter of 2nd century A.D. ▪ Discovered in Rome ▪ Marble ▪ H. 33½ in. (85 cm); W. 34⅝ in. (88 cm) ▪ Entered the Louvre before 1806 (MA 412–INV. MR 723) ▪ Restorer: A. Méthivier, 2006

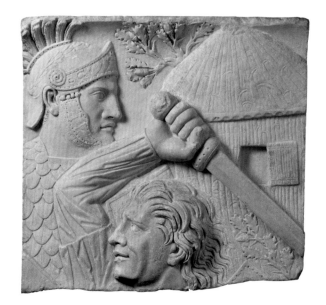

This bas-relief fragment, cut into a rectangular shape in modern times, depicts a battle scene. In the foreground, a frenzied barbarian, his face distorted with effort, hurls himself toward an unseen adversary. He wears a long-sleeved garment over a short sleeved tunic and brandishes a round pummeled sword above his head. The edge of his shield can be discerned behind the nape of his neck. In the background above him, a Roman soldier with a short beard heads in the opposite direction. He wears a *lorica squamata* (a scale armor cuirass) and a helmet in the Greco-Roman style and carries a shield that can be seen behind the barbarian's head. His helmet has distinctive ornamentation, with thunderbolts on the cheek plates, a frieze of arms on the visor, a laurel wreath on the crown, and a crest formed by a double row of feathers. His location in the composition and the design of his cuirass suggest that he could be a mounted knight. A third shield can be seen in the lower left of the relief, indicating the presence of a warrior in this section of the composition, perhaps the actual enemy of the barbarian. The right part of the relief depicts a log hut with an open window, with oak tree branches behind. The battle is raging in forested terrain inhabited by barbarians.

The provenance of this plaque is unknown. The Louvre guide published by Petit-Radel in 1806 mentions a "bas-relief from Trajan's Forum" without citing any supporting information from the archives. The large frieze from Trajan's Forum, which was built at the end of his reign (98–117 A.D.) and the beginning of Hadrian's (117–138 A.D.), is best known for the four panels that were re-used in Constantine's Arch in 314 A.D.),[1] the three fragments of the portal of the Villa Borghese, and a fourth panel inserted in the garden facade of the Villa Medici, which provide the best parallels for the representation of Roman soldiers and barbarians, as well as the oak branches. Relating the Louvre's barbarian to these fragments would identify it as Dacian, thus illustrating Trajan's most celebrated campaigns to conquer Dacia (modern Romania), carried out in 101–102 and 105–106 A.D. (L.L.)

NOTE
1 Despite several recent citations, the Louvre's plaque was never actually inserted into Constantine's Arch.

BIBLIOGRAPHY
Michon 1909, pp. 206–12, fig. 9.
Pallotino 1938, pp. 17–58.
Koeppel 1985, pp. 149 and 192–94, no. 16, fig. 25.
Martinez 2004a, p. 423.

117 Military Diploma

November 29, 221 A.D. ▪ Provenance
unknown ▪ Bronze ▪ H. 7⅜ in. (18.9 cm);
W. 5⅞ in. (14.9 cm) ▪ Purchased in 1993
(BR 4646–INV. MNE 984)

On each side of two rectangular tablets is an engraved inscription. Both tablets are the same size and pierced with two medial holes. One side of a tablet is chipped on the corner. The engraved inscriptions are still quite legible; on the two principal sides they are framed with two lines drawn by a pointed implement.

The word *diploma* is derived from the Greek word for a double object. These diplomas were copies of official documents, the original and complete texts of which were displayed in Rome on the Capitoline and, beginning in 90 A.D., in the Roman Forum. They were issued to soldiers from auxillary troops, who requested them when they had completed their lawful time of service and obtained a certificate of good conduct, awarded by the General of the Army. Thus veterans could obtain Roman citizenship for themselves and their children, as well as the right to legally marry. These two privileges, for foreign troops in the Roman army and sailors as well, were established under the reign of Claudius, undoubtedly in order to encourage recruitment. They gradually disappeared during the third century, when nearly all soldiers were citizens and had obtained the right to marry during their service.

There are numerous examples of military diplomas. Their material presentation always follows the same rules. The outer side of

the first page contains an excerpt of the imperial decision, which is engraved again, in more rapid fashion and in a horizontal direction, on the inner side of the two tablets. The outer side of the second page contains the inscribed names of seven witnesses, collected in order to proceed with the closing of the document. The tablets were then connected by a knotted metal thread, on which each of the witnesses affixed his seal. When necessary, the beneficiary of a diploma could have his civil status certified by a magistrate, who would smash the wax seals and unknot the thread in order to verify the similarity of the two texts.

According to custom, the legal text engraved on this diploma indicates the name and official title of the emperor, the troops in question, the period of service carried out, the privileges granted, and the date of the document. Its beneficiary was a sailor of Syrian origin, who had served twenty-eight years at the largest Roman naval base, located in Misenum, in the gulf of Naples. Both he and his wife, also of Syrian origin, and their five children were granted the right to marriage *(conubium)*, as well as citizenship. The document, which can be dated thanks to the reference to two consuls whose period of service is known, was issued by the emperors Elagabalus and Severus Alexander, who reigned together for seven months, prior to the assassination of Elagabalus in 222 A.D. (C.B.)

NOTE
1 For more on military diplomas, see H. Thèdenat, "Diploma," Daremberg Saglio, II, 2 (1892), pp. 266–68; and Absil and Le Bohec 1985, pp. 858–63.

BIBLIOGRAPHY
Baratte 1995, p. 19 s.
Eck 1995, p. 15 s.

118 Mars Wearing a Cuirass

Imperial Roman era • Provenance unknown • Bronze • H. 2⅛ in. (5.5 cm) • Purchased in 1825, formerly in the Durand collection (BR 669 —INV. ED 4880)

Here the god Mars wears a helmet surmounted by a tall crest that trails down over the nape of the neck, its helmet dome decorated with a rosette, its cheek-plates extending below the chin. Mars's cuirass is decorated with foliage, arranged on either side of a central motif, with a medallion on the chest. Such medallions were often decorated with a Medusa head, or *gorgoneion*. Shoulder pads and straps, known as *lambrequins*, form short sleeves. The lower portion of the cuirass, which ends at mid-thigh, is fringed with scallop-shaped *pteryges*.

The legs were once clad in metal leg-guards ornamented with foliage and fastened in back with leather straps. The hands once held attributes (now lost): a lance in the right hand, probably the strap of a shield in the left. The statue's left ankle and feet are broken off.

The figure is adapted from the statue of worship placed in the temple of Mars Ultor (Mars the Avenger) in Rome: the bearded god wore a cuirass and tall-crested helmet of the Corinthian type and leaned to the right on his lance, which was stuck into the ground. His left hand rested on the edge of a large shield (cat. no. 152). Inspired by the same format, the statuette shown here takes a far less idealized approach to the image of Mars: here he is depicted as a warrior, firmly holding a weapon in each hand. His beardless face, protected by his helmet's cheek-plates, resembles that of a Roman legionnaire. The tall crest that traditionally crowns the deity has been preserved, but the shape of the dome, absence of the nose-shield, and presence of the cheek-plates brings to mind officers and legionnaires sculpted on historical reliefs.

Under the empire, the richly embellished anatomical cuirass was reserved for high-ranking officers and emperors. Made of metal, it probably was worn over a leather garment that included lambrequins.[1] Representations of Mars wearing a cuirass were very popular in the Roman army. Soldiers may have carried small effigies like this one in their packs as a talisman to protect them during battle. (C.B.)

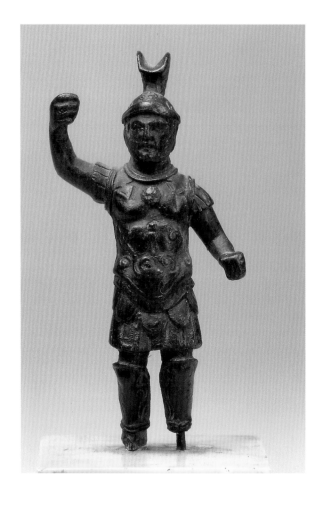

NOTE
1 Chew 2000, p. 231.

BIBLIOGRAPHY
De Ridder 1913, p. 93, no.669, pl. 47.
LIMC II, p. 517, no. 3, E. Simon, "Ares/Mars."

119 Medallion of Gordian III

Minted in Rome, 241–244 A.D. ▪ Provenance unknown ▪ Orichalcum, copper ▪ Diam. 1½ in. (3.7 cm); Weight 2 oz (55.7 g) ▪ On deposit from the Bibliothèque nationale de France, Département des Monnaies, Médailles et Antiques; G. Schlumberger bequest (Y 12703), 18 December 1929 (no. 100 in the registration list)

This medallion reads IMP GORDIANVS PIVS FELIX AVG (Emperor Gordian, Dutiful, Fortunate, and Great). Accompanying these words is the bust of Gordian III, turned to the right. He is crowned and dressed in armor. The reverse bears the words ADLOCVTIO (Augustus's speech to his troops.). The emperor is shown in military dress, standing erect on a podium and raising his right hand. Behind him is the Praetorian Prefect, and in front of the podium are four soldiers holding a spear, battle banner, insignia, and eagle, respectively. The two helmeted soldiers in the foreground are holding shields.

This medallion entered the Bibliotheque nationale de France as part of a major bequest from Gustave Schlumberger (d. May 9, 1929) that included 4,350 objects and coins, but only two Roman coins—this medallion and one of Theodosius. A note in a manuscript indicates that Schlumberger received this piece from Wilhelm Froehner, whose collection also entered the Bibliothèque nationale in 1929.

The term *medallion* is given to Roman coins made of bronze (or in bi-metallic cases such as this, orichalcum and copper), whose flans have a diameter and thickness far greater than that of the *sestertium*. Their average weight is 50 grams, which may have led to the belief that they were worth two *sesterces*. Medallions were distributed as gifts at the New Year or perhaps also at the time of the emperor's *dies imperii*, the anniversary date of the day he had been proclaimed emperor by the army. They were given to officers and high-ranking officials, which seems confirmed by the location of discovery sites of these medallions in the provinces. They were, in fact, discovered in towns that had established military quarters or were important centers for local or imperial administration.

Adlocutio, the act of addressing or haranguing, is a recurrent theme in the design of Roman currency, initially appearing with Caligula (37–41 A.D.). The first medallions bearing this theme were minted by Lucius Verus in 162–163 A.D. The Gordian III series is particularly remarkable because it links different types of depictions on one side of the medallion to the *adlocutio* topic on the reverse.[1] (M.A.)

NOTE
1 Gnecchi 1912, tav. 103, nos. 1–7.

BIBLIOGRAPHY
Gnecchi 1912, p. 87, Gordiano Pio 1

120 Urn of a Young Soldier

40–70 A.D. ▪ Discovered in Rome ▪ Marble ▪ H. 9½ in. (24 cm); L. 18½ in.(47 cm); D. 10⅞ in. (27.7 cm) ▪ Purchased in 1861, formerly in the Campana collection (MA 1510) ▪ Restorer: C. Knecht, 2006

The front of this rectangular urn is decorated with two friezes of hearts and darts. Smooth strips frame the decoration along the top and bottom rims and emphasize the container's shape. The central surface of such objects was inscribed. This example bears only a *tabula ansata* (cartouche with swallowtail motif), but the letters *D* and *M* are engraved in the background and extend beyond the tabula borders. Each swallowtail bears a palm leaf and is surrounded by two rosettes.

The cover—which is not relevant but assumes the same dating—completes the decoration on the front of the urn: a triangular pediment is bordered by ridges and grooves; two birds attack a lizard in the tympanum; on either side, half a palm leaf rests on a cylinder decorated with a central rose. This type of ornamentation is characteristic of the middle of the first century A.D. At this time, funeral urns, as well as funeral or commemorative altars, were produced in large numbers. Their iconography was drawn from a common repertoire. Made to hold the ashes of the deceased, they were usually placed in *columbaria* (niched walls), or in necropoli on the outskirts of cities. When placed in a wall niche, only the front surface of the urn was visible, which explains why so many urns are carved only on this side.

Epitaphs consisted of traditional formulas that were stereotypical and in an abbreviated form. This example is consecrated to D(iis) M(anibus), the deities then thought to represent the spirit of the deceased. The name of the deceased is also mentioned. Like most free men in Rome under the Julio-Claudians and the Flavians, he bears the *tria nomina* (name, family name, and surname): M(arcus) C(laudius) Feli(x). This inscription is followed by the soldier's age: 17 years, 8 months, and 21 days; such specificity was not unusual. The end of the epitaph indicates that Marcus Claudius Felix was a *mil(es)* (a soldier) for 1 year, 8 months, and 21 days. The term *miles* does not indicate rank: applied to simple soldiers and generals alike, it was a title kept for life. Marcus Claudius Felix thus began his military career at the precocious age of sixteen (epigraphical and literary sources generally put the age of military recruitment at eighteen to twenty-one years).[1] The inscription does not mention who ordered the urn and its epitaph—generally it would have been family members or close friends—nor does it specify if the death of the young soldier took place during the course of military activity. (C.P.)

NOTE
1 Le Bohec 2002, p. 76.

BIBLIOGRAPHY
CIL VI, 3582.
Ducroux 1975, p. 51, no. 152.
Sinn 1987, p. 167, no. 303, taf. 53 c.
Le Bohec 2002, p. 76.

121 Altar of a Veteran

2nd century A.D. • Discovered in Rome • Marble • H. 20½ in. (52 cm); L. 15⅜ in. (39 cm); D. 14⅜ in. (36.5 cm) • Purchased in 1802, formerly in the Albacini collection (MA 1655—INV. MR 937) • Restorer: H. Bluzat, 2005

This is a relatively small example of a widely used type of altar, consisting of a *cippus* (marker or stele) decorated with a sculpted motif with an inscription and resting on a molded rectangular base. Several decorative elements cover the front corners. Two rams' heads adorn the upper part, a popular theme in funerary design beginning in the time of Claudius (41–54 A.D.). This style is derivative of a *bucrane* (a sculpted ornament resembling an ox skull), which was a recurrent motif in Augustan art. Well-suited for decorating corners, the horns of the rams heads are ideal for draping a garland of plants, which was another popular motif at the time. The decoration of the *cippus* is completed by two eagles carved into the corners beneath the rams' heads and two lightning bolts stacked above the bow of the garland. Small bands are wrapped over the sides of the altar falling from the rams' horns and carved with liturgical items, including an *urceus* (pitcher) on the left and a *patera* on the right.

Although this composition is symmetrical with regard to decoration, the mixture of ornamental themes—sacrificial objects (small bands on sacrificed animals, garlands of leaves hanging above altars, *urceus*, and *patera*)—with allegorical (eagles) or symbolic (lightning bolts) motifs leaves an impression of arbitrary juxtaposition, without regard to scale. This was very common in objects produced by large workshops during the second half of the first century and during the second century A.D.

Surrounded by a molded frame, the inscription has poorly aligned letters of irregular sizes. That, and the scattered placement of the epigram, are telltale signs that this was executed by a mediocre stonecutter.

The altar is dedicated to the god Aesculapius: the cult of this Greek god of healing (Asclepios) took root in Rome in 293 B.C., during a plague. The temple of Aesculapius, which housed a hospital, stood on the Insula Tiberina (island on the Tiber), where the god had come in the form of a serpent. People solicited the healing powers of the divinity and thanked him with offerings such as votives and dedicated altars. The man who dedicated this altar, M(arcus) Aurelius Venustus, had a successful military career and thus carries the title of veteran of the IXth Praetorian cohort. This is mentioned in two places (on the base and left side). From the time of Augustus, nine cohorts constituted the Imperial Guard and played a significant political role. After the requisite sixteen-year term in this corps, a diploma was given to the veteran (cat. no. 117).

Although the iconography of this altar is drawn from the funerary repertoire, the dedication transforms it into a votive monument. Marble urns and altars were produced in large numbers during the first and second centuries A.D. Sculptors, working within an established repertoire of ornamentation, occasionally created a dichotomy between the funerary symbolism of an object and the meaning of its inscription. (C.P.)

BIBLIOGRAPHY
CIL VI, 2
Paris 1970, no. 171.
Ducroux 1975a, no. 1 p. 1.
Martinez 2004, no. 1155, p. 573.

122 Bust of a Young Gaul

Ca. 200 A.D. ▪ Discovered in Reims (France), 1929 ▪ Fine-grained marble ▪ H. 24¾ in. (63 cm) ▪ Purchased in 1932 (MA 3440 – INV. MND 1841) ▪ Restorer: Ph. Jallet, 2006

This portrait was discovered in Reims—called Durocorturum by the Romans—the capital of the Belgic tribe known as the Remi. It was found near the Gate of Mars, one of four ceremonial arches that marked the border of the ancient city center from the beginning of the third century A.D. The Gate of Mars was richly decorated with reliefs, including the legend of Rome's founding and various scenes of imperial triumph.

This sculpture was discovered in a cellar decorated with wall paintings and located on the side of a street parallel to the *cardo*, the main north-south highway. Extending over 1.9 square miles, Reims was one of the most extensive cities in the empire. The building was therefore most probably a *domus* (urban residence) or public building, rather than a country *villa* (farm). The various artifacts found were published by E. Michon and included ceramics of widely divergent periods, including pitchers from the Middle Ages. It seems probable that the structure inside of which the young *togatus* (Roman toga-clad citizen) was buried was a centuries-old junkyard.

This sculpture demonstrates the capacity of Roman artists to synthesize widely divergent influences and draw upon diverse styles. It shows that Roman art was capable of addressing very different concerns while still creating an impression of unity.

Executed by a provincial artist able to handle classical sculptural techniques with real flair, the bust depicts a young man with hair arranged in stiff, thick, and distinctively curving locks, except over the forehead. These features, including the discreet moustache—rare in Roman art—convey the stereotypically hirsute Gaul as he was shown in ancient art since in the Hellenistic period, most famously in the great altar in Pergamum. Whoever commissioned this work appropriated this convention, which would not have had any negative connotation for him; instead, the stereotype linked him to the classical culture he claimed as his own.

The bangs, which fall in a rather disorderly fashion over the forehead, have been worked with a drill. Together with the rather remote gaze and meditative expression, they give this bust a resemblance to representations of the youthful Marcus Aurelius, particularly the portraits made at the time of his adoption in 138 A.D. (such as the Louvre's Ma 1778 example, which depicts the future emperor at just seventeen years old). This allusion to the philosopher-emperor is an attempt to lay claim to the ideal of Stoic wisdom that was long associated with the character of Marcus Aurelius. In the second half of the third century A.D., the historian Dio Cassius attested to the widespread reverence for Marcus Aurelius even fifty years after his death. This commission by a citizen of Reims is both a political and personal tribute to the ideal Marcus Aurelius once embodied.

Here the young man wears a toga with *contabulatio*, a style that spread through the empire from Africa during the reign of Septimius Severus (193–211 A.D.). The toga was evidence of membership in Roman society, participation in civic activities, and political aspirations. The style also imitated the fashion adopted in the emperor's surroundings, demonstrating loyalty to the new dynasty. The *contabulatio* spots a date after which the bust was executed. The combination of respect for the character of Marcus Aurelius and loyalty to the Severan dynasty is not contradictory: Septimius Severus claimed the heritage and imitated the appearance of the philosopher-emperor (cat. no. 9). It is worth emphasizing that the wearing of a moustache and the treatment of the hair have much in common with the Type 2 portraits of Emperor Elagabalus (218–22 A.D.) in the National Gallery in Oslo and the Musei Capitolini (Imperatori 55).[1] Severus Alexander (222–35 A.D.) also appears with a light moustache in a number of portraits.

Rich in meaning and associations, the bust is a sensitive portrait of a distinguished man from the provinces, but also a philosophical manifesto and testimony of strong political commitments. Dense with symbols, literary references, mythological allusions, moral values, and elements drawn from history, Roman art embodies, in its finest masterpieces, a truly polysemic content. (D.R.)

NOTE
1 Fittschen and Zanker 1985, pp. 115–17.

BIBLIOGRAPHY
Michon 1934.
Kersauson (de) 1996, pp. 312–13

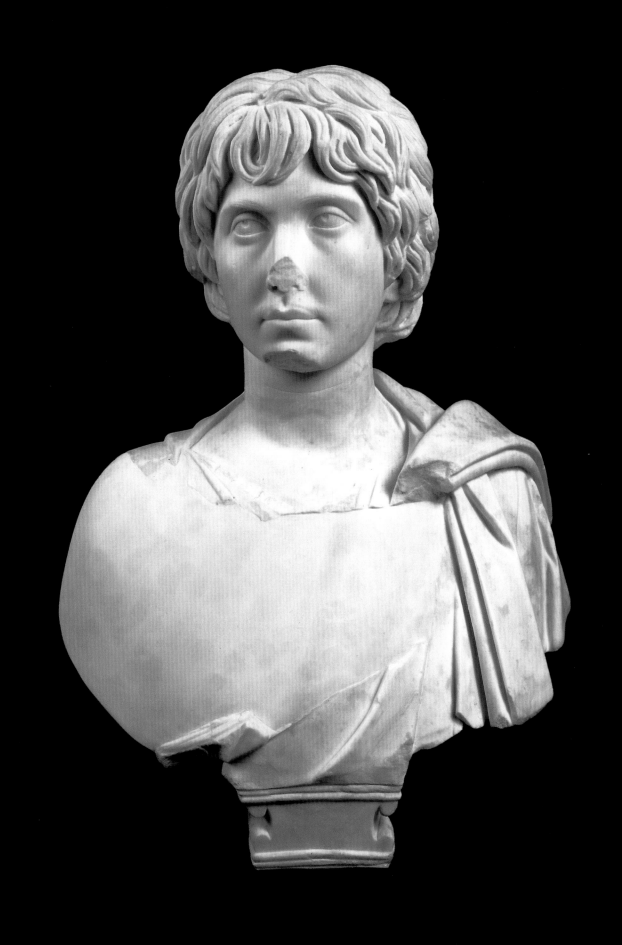

123 Barbarian Warrior

2nd century A.D. • Provenance unknown • Marble • H. 83⅛ in. (211 cm) • Purchased in 1807, formerly in the Borghese collection (MA 1019—INV. MR 357; N 673) • Restorer: B. Perdu, 2005

Images of barbarians, an essential element of triumphal ceremony in imperial Rome, were most often represented in a military context. They are found on the breastplates of *imperatores* (cat. no. 34) and on triumphal arches, such as the Gauls on the arches in Saint-Rémy-de-Provence and Orange, the Dacians on the arch of Benevento, and the Parthians on the arch of Septimius Severus at the foot of the Capitoline hill. The enormous prestige acquired through two successful campaigns against the Dacians (101–102 and 105–106 A.D. in present Rumania), and the military concept of power that Trajan personified, naturally led to a flourishing of artistic representations of Dacians conquered during his reign (98–117 A.D.). Between 6½ and 9 feet high (2.5 and 3 meters), such representations are omnipresent in Trajan's Forum, on the facade of the Ulpia Basilica, and along the bordering porticos. They perch above the columns in the attic, supporting an entablature. Like Telamones, they play an architectonic role.

Transformed into stone and wedged into a Roman edifice, a barbarian becomes a metaphor with an explicit message. The barbarians are shown over and over again in submissive postures: heads bowed, hands tied, disarmed of their weapons. This statue is an Asian, Dacian, or possibly a Parthian. The short belted tunic, the cloak pinned with a fibula on the right shoulder, and the trousers (*anaxyrides*) are typical; yet this statue is quite different from the Dacians in Trajan's Forum.

The restoration performed by the Louvre showed that the head was indeed ancient but did not correspond to the statue. Although it may well be that this is an archaizing head inspired by a Greek model—such as the head of the Στρατηγός (military and civil governor in the provinces of Hellenistic kingdoms) in the Louvre (Ma 278)—it is not inconsistent with statuary of barbarians. The Dacians on the metopes of the trophy of Trajan at Adamklissi (now in Romania) have unusual long, stiff beards; the ones on the Aurelian and Trajan columns also usually have beards. They are not wearing helmets, but on sarcophagi decorated with battle scenes, such as the one of Portonaccio in the Museo nazionale in Rome, the same barbarians are shown with helmets, which are down on the ground.

In the statue shown here, the right arm and shoulder, left arm, part of the cloak, and the feet are modern restorations from when the statue was part of the Borghese collection. This makes it impossible to know how the arms were originally positioned, but the sword on the left side indicates that this not a statue of a prisoner with bound hands. The fact that the reverse side of the statue was also sculpted, the relatively small size, and the way the body leans to one side, are all indications that this statue was not used as an architectural support.

This statue is thus a representation of a free barbarian. Communicating a political message was not its purpose. While one cannot exclude the possibility that this statue was once part of a private decorative scheme (there are no other examples of such), it is more likely that this statue and other analogous representations presented barbarians au naturel. This is somewhat in the manner of the provinces, the allegorical representations of young maidens that decorated the reliefs of the temple of divine Hadrian in Rome (Musei Capitolini). Under Hadrian's reign, the Roman Empire appeared to be consolidated, no further conquests were sought, and the image of a barbarian was no longer considered a threat in the midst of an era of peace and prosperity. This statue illustrates, rather, an imperial regime capable of allowing people from across the horizons to live in peace and harmony (D.R.)

BIBLIOGRAPHY
Martinez 2004a, p. 154.

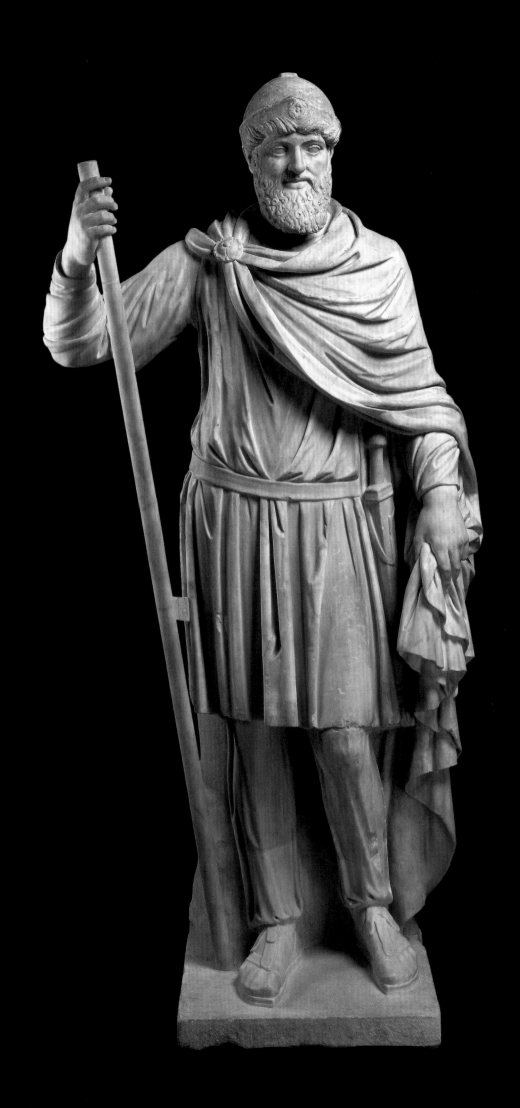

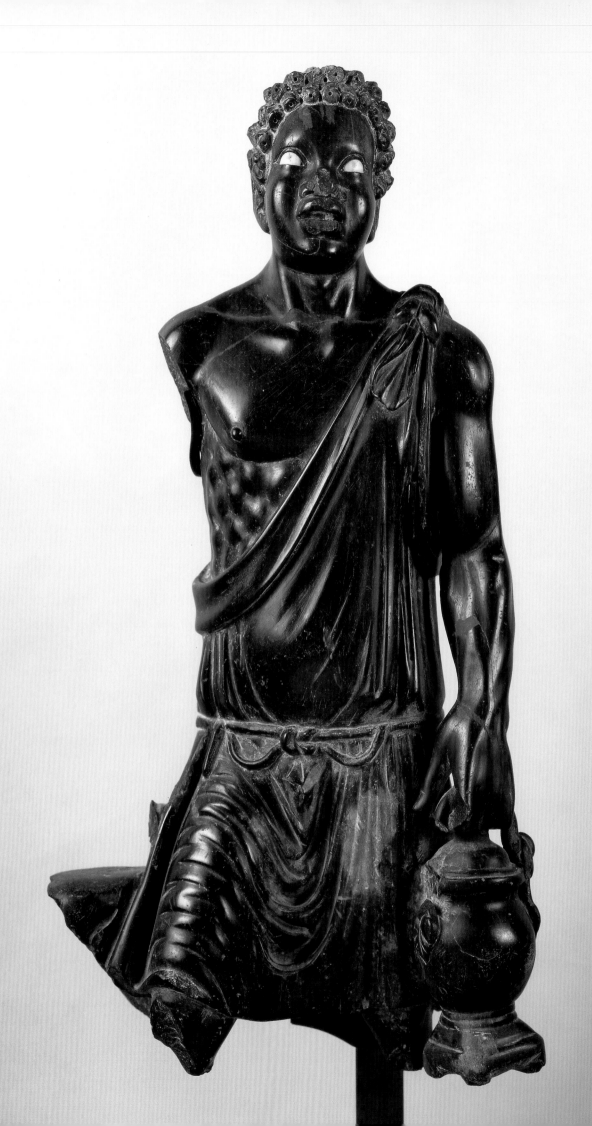

Foreigners, Slaves, and Freedmen at Work and at Leisure **Cécile Giroire** By basing itself on the study of ancient texts, historiography has equated the notion of citizenship with that of the Roman people, distinguishing only between citizens (who were free) and slaves (who were not). While certainly true in the early days of the republic, this clear-cut distinction became more complex with the conquest of Italy and completely obsolete with Rome's territorial expansion around the Mediterranean. In the latter period, the social dichotomy was between citizens and a non-citizen population that extended beyond slaves to foreigners. When the census of 47 A.D. recorded some six million citizens including women, children, and the elderly, that was out of a total population estimated at between 45 and 60 million inhabitants. In short, non-citizens made up the vast majority of the empire's tremendous population until the Antonine Constitution of 212 A.D. conferred citizenship upon anyone who was free.

In the most general sense, foreigners were defined in relation to Rome. Initially, they were free men and slaves who did not enjoy Roman citizenship. But Rome's imperialist policy soon extended this definition to include free men in conquered provinces *(perigrini)* who could very well have been citizens of their own cities. Roman law consequently classified foreigners into various categories, particularly in the case of Latins, Italians, and peregrines living outside the peninsula. During the imperial era, Roman citizenship could be granted to someone having served in the auxiliary corps or the naval fleet (beginning under Claudius) or by decision of the Prince, as evidenced by the spread of imperial *gens* (people who share a common ancestor), particularly under the Julio-Claudians.

The majority of slaves making up the laboring class at the heart of the Roman economy were of foreign origin. Though slaves had been rare in the early days of the republic, their numbers grew considerably with the wars of conquest and the resultant influx of prisoners—future slaves—to Rome. Of diverse ethnic and cultural backgrounds, these slaves now found themselves in an equally diverse range of situations. Indeed though Roman law provided a single, strict definition of the slave as thing *(res* or *mancipium)* or a commodity that belonged to a master who held the power of life and death, the realities of slavery were far more varied. One crucial distinction was whether a slave was owned by a public or private employer. In the former case, some slaves were assigned subordinate administrative tasks in service of magistrates or sanctuaries, while others worked in the extremely difficult conditions of public works, mines, and quarries. In the latter case, the situation differed according to whether a slave lived in a rural or urban setting. On farms (cat. no. 142), slaves were housed in shabby buildings *(ergastula)* and exposed to harsh conditions.

In the city, a slave generally led an easier existence and might be employed in any number of positions: servants for the master and his family (cat. no. 145); educators of the master's children or domestics for a single household (cat. nos. 146 and 147); doctors, architects, craftsmen, and or gladiators (cat. nos. 134–36); actors (cat. nos. 128–33); and charioteers (cat. nos. 138 and 139).

In fact, one of the most notable characteristics of Roman civilization, which was governed by laws favorable to social mobility, was that a slave could acquire his master's permission to escape his servile position. Through emancipation (manumissio), a slave could become a freedman or even a citizen. A freedman (libertus) retained certain obligations toward his ex-master, who was now considered his patron (patronus), but his descendants, who were born free, were liberated from these obligations (ingenuus). Despite being emancipated, a freedman was still likely to work in a profession largely staffed by slaves, as a professor, a doctor, an architect, or an actor. But he could also work in trade, crafts, and banking alongside other free men. Depending on the wealth of a freedman's patron and the gifts or testamentary arrangements that patron provided, that freedman could enjoy substantial wealth, particularly in land holdings. He could also become wealthy through his work, notably in trade (cat. no. 124). However, the extensive riches accumulated by a few illustrious freedmen (such as Trimalchio in Petronius's Satyricon) were exceptional for an otherwise modest segment of the Roman population.

Leisure and Work

Though they did not participate in the life of the city as political entities, foreigners, slaves, and freedmen were the primary forces within the cultural and economic life summed up by the otium/ negotium (leisure and work) dichotomy emblematic of Roman civilization.

The Latin version of the Greek, otium encompasses a far wider notion of leisure than our contemporary definitions. Taken in the positive sense, it refers to activities of the mind aimed at study, meditation, and intellectual fulfillment. Seneca (Letters to Lucilius) and Cicero (De Republica) celebrated otium as a virtue and a privilege. It was the characteristic virtue of the free man, the privilege of the citizen who can spend time cultivating his mind.

To understand the concept of free time in the Roman sense it is useful to delve into detail, for it was considered anything but unproductive. Initially, otium referred to a moment in which one paid tribute to the gods. In primitive Rome, these moments were organized into the feriae evoked by Augustan poets such as Virgil (Georgics) and Horace (Odes and Epistles). The calendar was punctuated with ludi, votive holidays for celebrating important gods: for instance, the ludi Romani were devoted to Jupiter in September; the ludi Megalenses were devoted to Cybele at the beginning of April; the ludi Florales were devoted to Flora at the end of April.

As decreed by Roman magistrates, these ludi were divided into two categories; ludi scaenici involved theatrical performances, as of the fourth century B.C. ludi circenses entailed circus games, reported as of the end of the seventh century B.C.

According to accounts by Titus Livy (VII, 2), ludi scaenici consisted of ritual spectacles that had a lasting impact on Roman theater by introducing the systematic use of song and flute. They combined Etruscan origins with the influence of the Greek theater of Magna Graecia and the Campagna. In 240 B.C., Livius Andronicus, who was of Greek origin, created the first dramatic

theater pieces in Latin. Soon, three major genres emerged: comedies—subdivided into fabulae palliatae (from pallium, a Greek coat) and fabulae togatae (from toga); tragedies—with variants such as the fabulae praetextae (from the toga praetexta worn by senators) inspired by Roman legends or historical subjects; and mimes—fictionalized scenes from daily life featuring prose dialogue. By the end of the republic, comedy and tragedy had been replaced by such mimes and pantomimes, which drove theatrical representation toward singing and dancing and were significantly developed during the imperial era.

The design of theaters evolved concurrently. The first were temporary wood structures erected before the temple of the divinity being honored. In 55 B.C., Pompey financed the construction of Rome's first stone theater, setting a precedent that would soon be followed in the cities of the peninsula and then throughout the empire (fig. 1). Semi-circular tiers (cavea) rose from the half-moon of the orchestra, which faced a platform on which actors performed (proscenium). The platform was enclosed by a stage building (scaena) with a back wall designed to look like a palace facade. The back wall had three or five doors through which actors could enter and exit. Beginning with the reign of Augustus, the public was seated according to a rigorous hierarchy: nobles sat in the orchestra section; knights (horsemen), citizens, the lower classes, and, finally, women were arranged behind them in rising tiers.

The actors, singers, and musicians (histrio or ludius) were slaves or freedmen, and their profession was considered so morally reprehensible that they were barred from becoming citizens and participating in political life. Yet certain performers—such as Roscius in the late second and early first centuries B.C.—developed tremendous popularity and accumulated large fortunes, thanks, in part, to the patronage of powerful individuals.

The other type of celebration, ludi circenses, often involved altars and sacred edifices—testament to their religious origins. Literary tradition (such as Titus Livy, I, 9) elevated these events to a key part of Rome's legendary history by promulgating the story that Romulus used the occasion of athletic games to order the abduction of the Sabine women, thus ensuring the perpetuation of his people. Athletic games largely consisted of harness races or horse races (cat. nos. 138 and 140) but also entailed footraces and wrestling (cat. no. 137). In Rome, the Circus Maximus, a massive ampitheater built in the valley separating the Palatine and the Aventine in the sixth century B.C., was known for its impressive size (1,902 × 259 ft.) and capacity (250,000 spectators, according to Pliny, XXXVI, 102). At the time, it was the largest building in the empire.

Munera gladiatorum, or gladiator fights (cat. nos. 134 and 135), which took place in amphitheaters (fig. 2), along with the venationes (wild beast hunts, cat. no. 136), were in stark contrast to the formal, public games of the ludi, but they were extremely popular, as evidenced from the abundant iconography devoted to them. Unlike the ludi, these were private endeavors, initially associated with funeral ceremonies. Eventually, the emperor organized them for political reasons, and magistrates who were eager to increase their popularity held them as well. The first gladiators were prisoners of war, such as the Samnites, Thraces, or Gauls. Later, slaves and condemned men were used. Watching them be executed, or attacked by wild animals, became the very crux of the spectacle

But the Roman economy hinged on work. As indicated by its etymology, negotium (nec otium) is the opposite of otium and

meant work, as well as political or commercial activity. The Roman economy was based on agriculture and cattle breeding, its primary sources of wealth in terms of both property owned and revenue earned. After a conquest, the city retained the land confiscated from the defeated *(ager publicus)* in order to rent it to farmers or use it for collective pastures. With the accession of Augustus, the emperor himself became the largest landowner in the empire. Large estates *(villae)* were also owned by the nobility, particularly on the Italian peninsula and in the more romanized Mediterranean provinces. These estates were worked by servile laborers charged with breeding cattle or cultivating and selling the fruits of extensive vineyards (cat. no. 142) or olive groves. Provinces such as Sicily, Spain, Africa, and Egypt provided the empire with wheat and other grains.

Beginning in the first century B.C., a rapid increase in consumption led to concurrent increase in the number of urban workshops (cat. no. 143). These workshops were grouped in neighborhoods according to specialization, and staffed by slaves or freedmen—as manual labor was held in a kind of contempt. Thriving industries developed and spread through certain regions, specializing in specific goods intended to be sold throughout the empire. One of the most famous examples of this type of industry is the sigillated ceramic industry that arose in Arezzo in the first century B.C. (cat. no. 101) and then in Gaul in the following century.

Roman imperialism led to an accumulation of wealth due to the production of conquered territories and the consequent increased trade. As the majority of the trade in such commodities as wheat, oil, and manufactured goods was sea-based, great ports sprang up all around the Mediterranean. As for luxury products, such as silk (cat. no. 124), perfumes, and spices—all of which were much appreciated in Rome—these were imported from Arabia, Central Asia, and the Far East. Their trade had an important and lasting impact on commercial exchanges outside the empire.

FIG. 1 *ORANGE THEATER*
Augustan period
Copyright Centre des monuments nationaux

FIG. 2 *ARLES AMPHITHEATER*
End of 1st century
Photo: Musée Réattu, Arles—Jean Bernard

124 Gabii Altar of Plutius Epaphroditus

2nd half of 2nd century A.D. ▪ Discovered in Gabii, near Rome ▪ Marble ▪ H. 27¾ in. (70.5 cm); L. 28 in. (71 cm); D. 21¼ in. (54 cm) ▪ Purchased in 1903, formerly in the Zola collection and the Borghese collection (MA 3721–INV: MND 595) ▪ Restorer: C. Knecht, 2005

This altar is in the common style of a rectangular marble *cippus*. The austere decoration appears only on the front and sides. A simple molding around the base and epigraphic area emphasize the altar's gravity. An *urceus* (pitcher) is carved in the center of the left side, and a *patera* (vase) is carved on the right. These two liturgical items were used in sacrificial ceremonies and are found on many altars. Traces of hand-tooling are still visible along the sides. The *patera* juts out from a part of the altar that was restored in the modern era; the *urceus* is smaller but more deeply outlined. The back of the altar was not carved. Most of the rear left corner is broken, and the right side was partially cut—most likely indicating an unfinished attempt to refashion the altar in the modern era. To facilitate transporting altars, it was a common practice at the time to trim the perimeters and cut down the thickness of pieces that were seen as too large. Only the inscriptions remained intact.

The inscription takes up the entirety of the front face. In structure and content, it is characteristic of an honorific inscription, not a funerary inscription as one might conclude from the ornamentation. As was noted regarding a veteran's altar (cat. no. 121), the dichotomy between the symbolic message of the ornamentation and the content of the inscription is explained by the mass production of this type of object during the imperial era: the person who commissioned the altar then had it engraved with the inscription of his choice.

This piece was commissioned by two *liberti* (freed slaves, i.e., freedmen) who wished to express homage to their patron A(ulus) Pluti(ius) Epaphrodit(us). The common expression *ob merita ejus* (he has earned it well) concludes the dedication. The patron was an *accens(us) velat(us)*. In imperial times, the *accensi velati* formed a collegium in charge of the maintenance of the streets and pavements at their own expense, though it is possible that, in municipalities outside of Rome, they played a larger part.

This man was also involved in large-scale commerce: he had the status of a *negotiator sericari(us)*, involved in the silk trade. The commercial route of the silk trade went all the way to China, as well as to Syria—where silk was sometimes spun and dyed. Plutius Epaphroditus was thus in contact with the caravanners, intermediaries who transported silk from the Orient. This trade, like all activities involving money, could not be carried out by families from the senatorial class. Men from well-to-do families therefore preferred political and military careers to commercial enterprise, but commercial professions were open to freedmen and allowed them to amass considerable wealth. Such may have been the case with A. Plutius Epaphroditus. This man, who used to own slaves, was likely a freedman himself. Freed by his previous master, a Roman citizen, he has acquired Roman citizenship and thus bears the *tria nomina*: Aulus, his first name, and Plutius, his family name, have been given by his previous master, and Epaphroditus, his surname from Greek origin, reveals he was formerly a slave. As a freedman, he was not allowed to achieve any curial office, but he fulfilled the charge of *accensus velatus*, probably the highest level of responsibility he could aspire to. Another inscription in the Louvre, also from Gabii, identifies the same man in a dedication he offered to Venus.[1] (C.P.)

NOTE

1 Louvre, Department of Greek, Etruscan, and Roman Antiquities, Ma 1562; CIL XIV, 2793.

BIBLIOGRAPHY
CIL XIV, 2812.
Dessau 1962, no. 7601.
Ducroux, 1975, p. 54, no. 160.

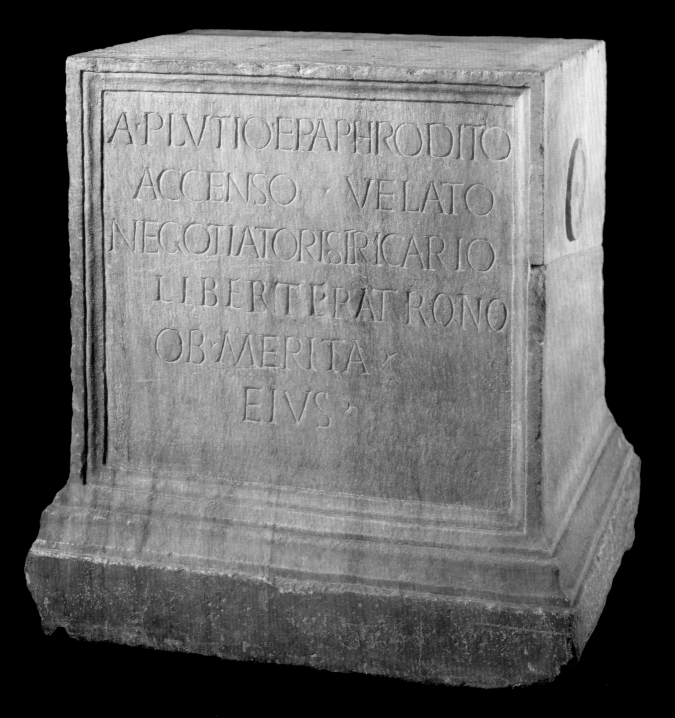

A·PLVTIO·EPAPHRODITO
ACCENSO · VELATO
NEGOTIATORI·SIRICARIO
LIBERT·EPATRONO
OB·MERITA·
EIVS·

125 Portrait of Herod Atticus

Ca. 160 ▪ Discovered by Fauvel in a tomb in Probalinthos (Attica, Greece), 1789 ▪ Marble ▪ H. 24¾ in. (63 cm) ▪ Purchased in 1865, formerly in the Choiseul collection and the Pourtalès collection (1814–65) (MA 1164–INV. NIII 2536) ▪ Restorers: P. Jallet and A. Liégey, 2006

At the time of its discovery near Marathon, this bust was tentatively identified as a portrait of the Greek philosopher and rhetor Herod Atticus, who resided and died in the Attic city. The identification was confirmed in 1919 with the discovery of the inscribed Hermes of Corinth, which features the same portrait.[1]

This effigy of the august man of letters was inspired by portraits of Greek philosophers from the fourth and third centuries B.C., but it remains true to the art of the Antonine portrait in its attempts to convey sensitivity and individuality. The deeply meditative, modest position of the head, which is slightly tilted and turned to the right, reproduces that of the Demosthenes that could be seen on the Athenian Agora in the second century A.D.[2]

The model wears a tunic glimpsed beneath the *himation* draped over his shoulders. Despite the broken nose and spall above the left eyebrow, the face has not lost any of its vivacity. Accentuated by prominent cheekbones and wrinkles etched across the forehead, the bust's pronounced features betray its sponsor's age. Elongated eyes look out from beneath the protruding arch of the eyebrows. The iris is simply engraved, while the pupil is hollowed with a drill and partially covered by the upper eyelid. The treatment of the hair and the beard along the jaw line combine naturalism with a light touch in the rendering of the wavy curls and is reminiscent of portraits of the classical era.

From this point of view, the portrait of Herod Atticus is significantly different from contemporary imperial models (cat. no. 7), including those of the same provenance attributed to the same sculptor.[3] This difference in style can easily be ascribed to the social status of the model, which would allow the sculptor more or less room for personal expression. In this case, the bust's formal qualities correspond to the grandeur of the man depicted.

Born in Marathon to a rich family, Herod Atticus (ca. 101–177 A.D.)[4] exercised his talents as a sophist in Athens. There, he quickly developed the reputation that led him to be hired by Antoninus Pius as private tutor for his two adopted sons, Marcus Aurelius and Lucius Verus. In 143 A.D. he was elevated to the rank of proconsul, responsible for a part of Asia and Greece. A great practitioner of evergetism (the practice of donating money and property to curry favor), Herod Atticus was responsible for the building of numerous public monuments in Greece and Italy,[5] some of which displayed ambitious decorative schemes. For instance, the exedra fountain he had built in Olympia featured two levels of niches containing statues of members of his family (on the upper level) and the imperial family (on the lower level), achieving a clever synthesis of the attachment to Greek culture and the adhesion to imperial political ideology.[6] This precedent leads us to suppose that Herod Atticus himself may have commissioned the Louvre bust and its imperial counterparts.[7] In other words, this portrait of a great patron, several examples of which have survived to the present day (given that eight other versions or copies of the same model are currently recorded[8]), displays the image Herod Atticus chose to exhibit to his contemporaries and to leave for posterity. (C.G.)

NOTES

1 A. Philadelpheus, "Un Hermès d'Hérode Atticus," *Bulletin de correspondance hellénique*, 44, 1920, pp.170–80.
2 Known through the Roman copy kept in the Vatican, Braccio Nuovo no. 62; see W. Amelung, *Die Skulpturen des Vaticanischen Museums* (Berlin: Georg Reimer, 1903), vol. I, no. 62, pp. 80–83 and pl. 11, fig. 62.
3 Louvre, Ma 1161; see Kersauson (de) 1996, no. 99, pp. 226–27, and Oxford, Ashmolean Museum, Albertson 1983.
4 W. Ameling, *Herodes Atticus*, Subsidia Epigraphica XI, Hildesheim (1983); and J. Tobin, *Herodes Attikos and the City of Athens: Patronage and Conflict under the Antonines* (Amsterdam: Gieben, 1997).
5 P. Graindor, *Un milliardaire antique: Hérode Atticus et sa famille* (Cairo impr. Misr, 1930, reprinted New York: Arno Press, 1979); and K. A. Neugebauer, "Herodes Atticus, ein antiker Kunstmäzen," *die Antike*, X (1934), pp. 92–121.
6 R. Bol, *Das Statuenprogramm des Herodes-Atticus Nymphäums* (Berlin: German Archaeological Institute, 1984); and Smith 1998, pp. 75–77.
7 Albertson 1983, p. 156.
8 Smith 1998, p. 78.

BIBLIOGRAPHY

Charbonneaux 1957, pp. 76–82.
Albertson 1983.
Kersauson (de) 1996, no. 132, pp. 290–92.
Smith 1998, pp. 78–79, pl. X, figs. 3 and 4.

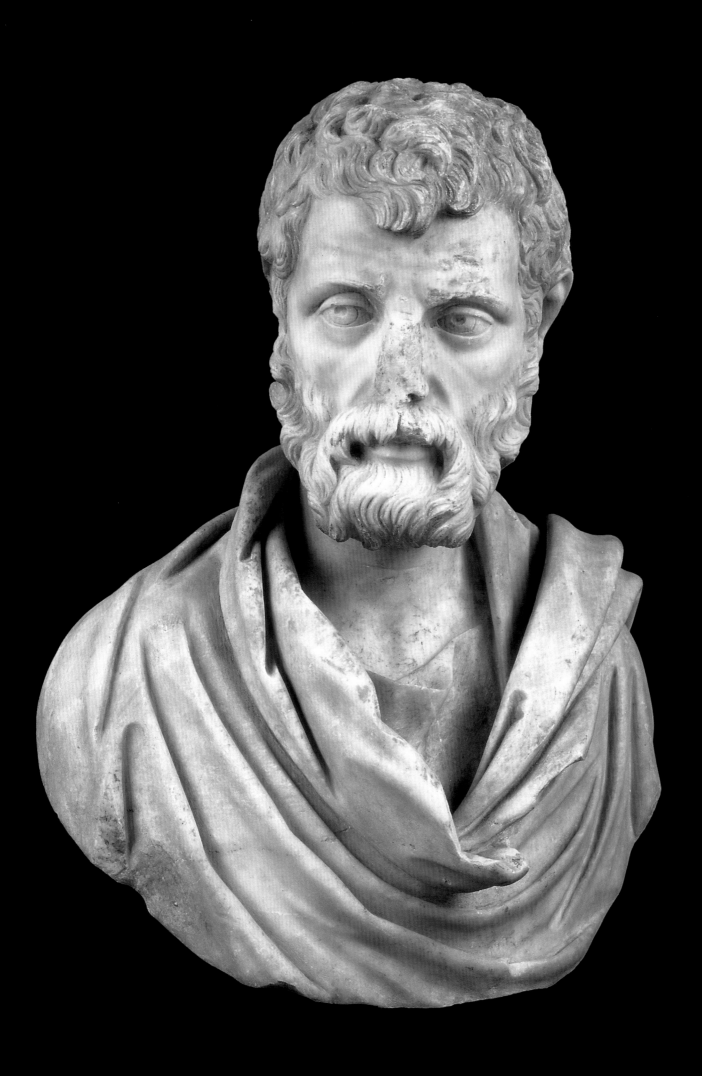

126 Diptych of the Muses

5th century A.D. ▪ Provenance unknown
(Gaul?) ▪ Elephant ivory ▪ H. 10 in. (25.5 cm);
L. 2⅞ in. (7.4 cm) ▪ Purchased in 1836,
formerly in the Durand collection (INV. LP 1267)
▪ Restorers: A. Cascio and J. Lévy, 2004

These ivory panels carved out of a single elephant tusk[1] feature figurative decoration carved in very high relief. Though no traces of gilding or polychromy remain, the figures' deeply carved irises indicate that the eyes may have been embellished with colored stones or glass. The panels have probably been recarved: the molding that rims both pieces has only been preserved on a few sides, and the lower edges of both pieces have been removed.[2] Other interventions, certainly subsequent to the making of the panels but difficult to date more specifically—the two holes drilled in the bottom of each of the panels and the matching holes in the panels' sides, some of which retain traces of the metallic studs used to assemble the panels—demonstrate an evolution in the method of fastening the pieces together. These elements have eradicated any trace or indication of how they were originally fastened.

The decor is structured on three levels, each depicting one male and one female figure. The figures are muses, some of which carry their attributes, and are represented in the company of the men of science or of letters whom they inspire. Not all of their identities are certain.

One hypothesis holds that the figures on the upper level of the left panel are Clio, the muse of history, holding a rolled manuscript in each hand and facing Herodotus, the Greek historian, whose gaze is turned toward her. Another hypothesis identifies the figures as Calliope, the muse of epic poetry, and Homer, the poet, whose blind eyes are allegedly suggested by the figure's deep, hollow eye sockets. There is no doubt as to the identity of the muse on the middle level: from the flute in her left hand she must be Euterpe, the muse of music. The description in an 1836 sales catalogue indicates that at the time, this muse held a second flute in her right hand.[3] The figure standing before her is the lyric poet Anacreon, or possibly Solon. On the lower level, Urania, muse of astronomy, holds a staff and what are probably measurement instruments. Seated before her, his head haloed as if by the evocation of the celestial globe, we find either Aristotle, or the Greek poet and astronomer Aratus of Soli.

On the second panel, the upper level shows a muse holding a lyre: possibly Terpsichore, the muse of dance, or Erato, the muse of lyric and erotic poetry. Both the poet Menander and Euripides are associated with Terpsichore, while Pindar is associated with Erato. The muse on the middle level wears a theatrical mask, and she has been identified as Melpomene, muse of tragedy, or Thalia, muse of comedy. In the former case, the poet would be the author of tragedies, Euripides; in the latter, either Euripides or Menander. The muse on the lower level has been identified as Terpsichore or Erato by the lyre she carries, but here she is inspiring the Latin poet Horace.

All of these figures, and particularly those of the muses, are depicted in lively positions, with dynamic gestures and light, flowing garments that follow the lines of their bodies and movements of their legs. The panels' iconography is extremely common; it speaks to the enduring attachment to Greek culture at this late stage of the empire.[4] The same iconography is in a variety of media: sarcophagi,[5] paintings, and mosaics,[6] and in precious materials such as ivory.[7]

But the fact that only six muses (out of the usual nine) are present on the Louvre diptych suggests there was a third panel. What were these panels used for? The height of the relief, the thinness of the panels, and the absence of a shallow bowl on the back of the panels excludes the possibility of a writing tablet, the most luxurious of which were made of ivory and often featured this type of iconography.[8] It may be more likely that these were used as facing on a coffer.

The panels' provenance is unknown. The hypothesis that they were produced in Gaul has often been put forward, as has a date during the fifth century A.D. (C.G.)

NOTES
1 Based on the observations of François Popelin, Museum d'Histoire naturelle, Paris.
2 On the left panel, the poet on the lower level has lost his right arm; the left foot of the muse facing him is lacunal.
3 *Catalogue de la vente E. Durand* (Paris: April 25, 1836)
4 G. Hanfmann, "The Continuity of Classical Art: Culture, Myth and, Faith." *Age of Spirituality: A Symposium* (New York, 1980), pp. 75–99.
5 L. Paduano Faedo, "I sarcofagi romani con muse, "*Aufstieg und Niedergang der Römischen Welt*, 1981, II, 12-2, pp. 65–155.
6 For occidental examples, see J. Lanche, *Mosaïque et culture dans l'Occident romain (Ier-IV. S.)* "Rome, L'Erma" di Bretschneider, 1997, pp. 318–24 and pl.; and Dunbabin 1978, pp. 130–36 and pl. LI–LII.
7 Bibliothèque de l'Arsenal, Paris, MS. 1169; see New York 1979, no. 241 p. 258.
8 Diptych with muse and poet, middle of the sixth century, treasury of the Cathedral of Monza; see R. Conti, *Il tesoro. Guida alla conoscenza del Tesoro del Duomo di Monza* (Monza, 1999), no. 12, pp. 29–31.

BIBLIOGRAPHY
New York 1979, no. 242, pp. 258–60.
Paris 1981, no. 37, p. 50.
Paris 2004, fig. p.108 and no. 118, p. 113.
Volbach 1952, no. 69, p. 44 and pl. 23.
Webster 1995a, fig. 59.
Webster 1995b, 6XI5 p. 511.

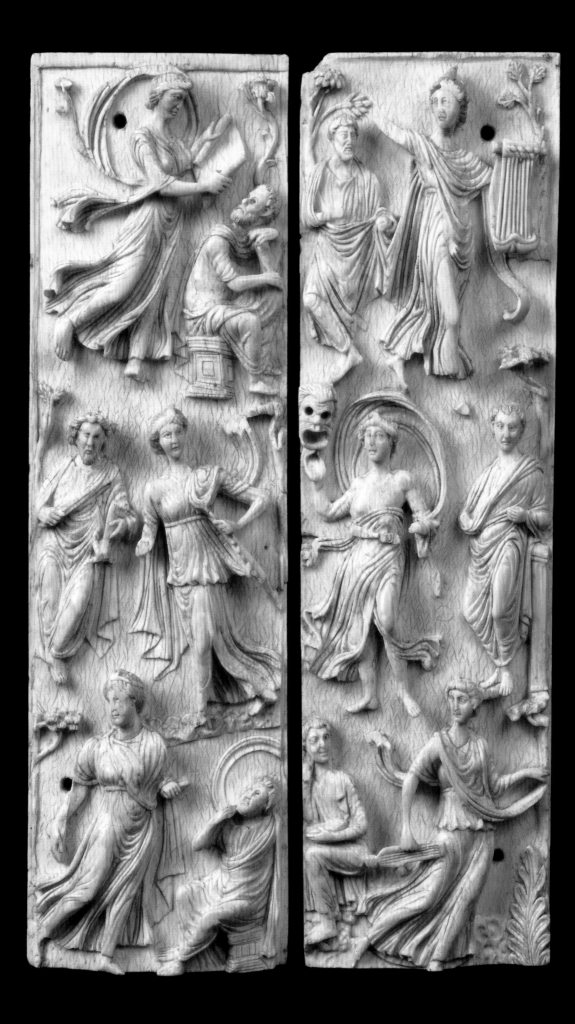

127 Fragment of a Sarcophagus with Muses and a Poet

Mid-3rd century A.D. ▪ Provenance unknown ▪ Marble ▪ H. 45¼ in. (115 cm); L. 31⅞ in. (81 cm) ▪ Purchased in 1807, formerly in the Borghese collection (MA 29–INV. MR 832, N 161) ▪ Restorer: P. Roumégoux, 2006

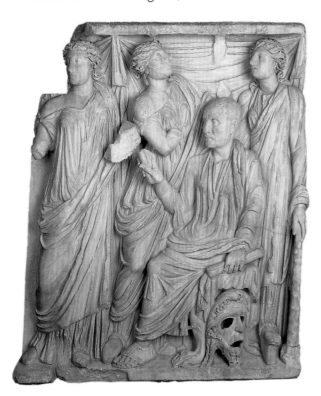

Formerly displayed embedded in a wall of the Villa Borghese in Rome, this relief was the right side of the front of a sarcophagus. The deceased is shown in the guise of a poet, seated in the foreground, with a *volumen* in his left hand and his right hand raised in a declamatory gesture. The figure's bald head and marked facial features give a picture of a rather old man. A theatrical mask rests beneath the chair whose legs end in lion's claws. On the second plane, three muses appear before a curtain: left to right are Clio—whose left hand holds tablets of which only a few fragments remain; Urania—with her eyes raised to the sky; and Melpomene—leaning on a club. The missing part of the front of the sarcophagus most likely represented the six other muses in the company of the deceased's wife, as can be observed on similar sarcophagi that have been preserved in their entirety.[1]

By studying representations of intellectual life on sarcophagi, H. I. Marrou has demonstrated how the ideal of the cultured man underpinned funerary art, particularly in the third century.[2] An abundance of examples associate the deceased's portrait with the iconography of the poet or teacher-philosopher, wearing the Greek cloak rather than the Roman toga. This iconographic type finds a logical parallel in epigraphs, when funerary epitaphs praise the deceased's intellectual qualities. Although not made to commemorate men of letters, these monuments demonstrate their sponsors' attachment to activities of the mind, as personified by the figures of the muses whose divine character and power ensure immortality. (C.G.)

NOTES
1 Sarcophagi of the cathedral of Palermo, of the basilica di San Paolo fuori-le-mura or the Vatican; see Wegner 1966, no. 68, pp. 33–34, no. 184, p. 72, and no. 138 pp. 57–58.
2 H. I. Marrou, *MOYCIKOC ANHP Etude sur les scènes de la vie intellectuelle figurant sur les monuments funéraires romains* (Grenoble, 1938; republished Rome, 1964).

BIBLIOGRAPHY
Wegner 1966, no.73, pp. 35–36, pl. 63b and 65a.
Baratte and Metzger 1985, no. 86, pp. 176–76.
Saragosse 2003, p. 95.

128 Fragments of a Sarcophagus with Theatrical Scenes

2nd quarter of 3rd century A.D. ▪ Provenance unknown ▪ Marble ▪ H. 24⅜ in. (62 cm); L. 27½ in. (70 cm) ▪ H. 25¼ in. (64 cm); L. 24⅜ in. (62 cm) ▪ Purchased in 1861, formerly in the Campana collection (MA 950–INV. CP 6557 and MA 3192–3193–INV. CP SUPPL 378) ▪ Restorer: V. Picur, 2003

surrounding the epitaph[3] or at the corners of the lid.[4] Scenes of theatrical performances are rare, though they seem to be appreciated and illustrated in other contexts.[5] Only a few fragments of lids, including those shown here—which are very similar stylistically to those in the Museo nazionale Romano[6]—bear some trace of theatrical performances. Another less fragmented example[7] also represents a comic actor in a tunic knotted at the waist over a vest with holes and features two occurrences of the same circular object seen in the Louvre's comic theater scene: in this case the object is topped with five discs and was understood to be a musical

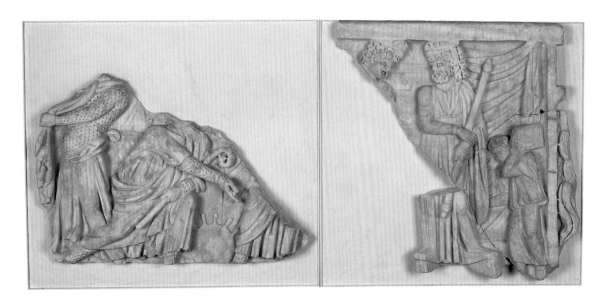

Fragmented on all sides, the first scene represents three characters from the comic theater, all three of which are now truncated. They stand against an openwork balustrade under hanging drapes, wearing the characteristic vest with holes worn under a tunic and a cloak. Turned to the left, his shoulders thrown far back, the first actor holds the drape of his cloak as if about to throw it back over his shoulder. The second actor is kneeling toward the third one, holding the *pedum* in his left hand, his right arm extended toward his fellow actor in a declamatory gesture. Placed on the ground between these two figures, a circular object with five vertical appendices is an element of scenic design intended to indicate the unfolding of the play.[1]

The same number of protagonists features in a second scene drawn from the tragic theater. At the center, a king, wearing a cloak and a long-sleeved tunic gathered at the waist, hides his face behind a bearded mask with long curly hair. He is holding a scepter in his arms. Turned to the left, toward a double door, he speaks to a figure of which only the face—also masked—has been preserved. To the right, on a smaller scale, a slave wearing a short-sleeved tunic nipped in at the waist is moving toward the king, head bent, carrying a heavy case on the back of his neck. A curtain is drawn across the upper part of the background. This second scene constitutes the upper right-hand corner of the lid of a sarcophagus, as can be determined from the listel running along two of its sides and the few remaining traces of the corner mask.

As F. Baratte has pointed out, while iconography relating to the theater can be found in funerary sculpture, it is not particularly abundant.[2] On sarcophagi, it is mostly found in the form of masks

instrument, such as a hydraulic organ or a percussive instrument.[8] Studying the relief of Flavius Valerianus kept in Rome, K. Dunbabin gives a new, convincing interpretation of the "disk with knobs." In her opinion, based on the different representations of this device, it deals with "a device to identify, for the audience assembled in the theater, the act structure of the play performed on stage."[9]

The presence of this theatrical iconography on funerary monuments is doubly justified. It should probably be related to the funeral games, *ludi funebres*, that took place during the funerals of high-ranking individuals, as well as to a certain conception of life based on the *minus vitae* theme that assimilates life to a piece of theater, which one must endeavor to play well.[10] (C.G.)

NOTES

1 Our understanding of this object, long identified as a hydraulic organ, for lack of any better hypothesis, is due to the research of K. Dunbabin. Dunbabin 2006, pp. 200–10.
2 See F. Baratte, "Le théâtre dans la sculpture funéraire," in Lattes 1989, pp. 99–100.
3 For example, an urn in the Louvre, Ma 2148; see Lattes 1999, no. 104, p. 218 and fig. p. 221.
4 Note that in the vast field of corner masks (represented here on sarcophagi cat. nos. 142 and 181), theatrical masks in the strict sense of the term, that is, those behind which the actor's face appears, are in the minority; see Baratte, op. cit.
5 Webster 1995a, pp. 72–73.
6 Inv. MNR 9059+9171; see Musso and Sapelli 1998, pp. 26–27 and fig. 3, pl. 10.
7 Kept in Rome, Vigna San Antonio according to Wegner 1966, no. 199, pp. 76–77, pl. 141 b.
8 Musso and Sapelli 1998, p. 27 and fig. 5, pl. 10.
9 Dunbabin 2006, pp. 200–10.
10 See Baratte, op. cit., p.100.

BIBLIOGRAPHY

Baratte and Metzger 1985, no. 9, pp. 38–40.
Lattes 1989, no. 105 and 106, p. 219, fig. p. 222.
Baratte 1993, p. 220, pl. 86, 2.
Webster 1995b, 6RS 2, p. 497.
Musso and Sapelli 1998, p. 27.
Saragosse 2003, p. 95.

129 Portrait of an Actor with a Mask

3rd century A.D. ▪ Carthage (Tunisia) ▪
Marble ▪ H. 12⅝ in. (32 cm); L. 10¼ in.
(26 cm) ▪ Purchased in 1890, formerly in the
Marchant collection (MA 1836—INV. MNC 1582) ▪
Restorer: C. Bréda, 2005

Despite its worn surface and truncated nose, this portrait of an
actor reveals the extent to which masks used in the theater in
ancient times covered the wearer's head, from the junction of the
chin and neck to the back of the head. In the case of this portrait,
the only features visible are the deeply incised, particularly expres-
sive eyes, the closed mouth, and a schematically rendered wavy
mass of hair hanging out of the back of the mask and down the
actor's neck. This is a heavy mask. Large cavities at eye level are
accentuated by incisions encircling them and by the bridge of the
nose, which rises to define quite prominent eyebrows. This combi-
nation of elements makes the mask strikingly expressive. A third
rimmed opening (for breathing and speaking) of similar propor-
tions surrounds the mouth. The mid-length hair is made dynamic
by highly stylized waves restrained by a narrow band high on the
forehead, which also holds in place the *onkos*, a hairpiece intended
to add vertical height to the hair and enhance the face.

Portraits of actors, whether participating in a scene or repre-
sented individually, were a mainstay of the theatrical iconography
found very frequently in Roman art. In the latter case, we have
abundant examples of small objects in terracotta, bronze, bone,
and ivory that depict men of the theater, from both the comic and
tragic repertoire, with a great freedom of expression.[1] Marble effi-
gies of actors are more rare[2] but do provide a good illustration of
one of the tendencies of this type of iconography that developed
in the third century. Emphasis was placed on the actor, whose ani-
mated eyes and mouth were glimpsed beneath the mask.[3]

Identifying this mask as one of the types—and therefore as one
of the characters—catalogued by Julius Pollux in his *Onomastikon*
is not an easy task; the *eikonikos* (mask 19), used in the sense of a
realist mask resembling a portrait, has been suggested but is rare.
It is drawn from comedy and represents a smooth-cheeked young
man of foreign origin wearing a handsome garment.[4]

Finally, the Carthaginian provenance of the Louvre's portrait of
an actor reminds us of the development of iconographic themes
related to theater in the empire's African provinces, particularly
during the Severian era.[5] Such themes led to some remarkable the-
atrical decors, including the very well-preserved one in Sabratha.
(C.G.)

NOTES
1 See Lattes 1989.
2 See the list established by Webster 1995-2, p. 474, to which we can add another
 portrait, a bust in the Vatican; see Bieber 1939, fig. 541, p. 411.
3 Webster 1995a, p. 75.
4 Ibid., p. 25.
5 Ibid., p. 74.

BIBLIOGRAPHY
Héron de Villefosse 1890, no. 5, p. 290, and fig. 26, p. 291.
Héron de Villefosse 1921, no. 179, p. 15 and pl. X, 4.
Bieber 1939, p. 409 and fig. 537, p. 410.
Atlanta 1994, no. 76, p. 170.
Webster 1995b, 6FS 5, p. 491.

130 Statuette of an Actor with a Mask

3rd century A.D. (?) ▪ Provenance unknown ▪ Bone ▪ H. 4⅝ in. (11.7 cm); L. 1¾ in. (4.5 cm); D. 1¾ in. (4.4 cm) ▪ Purchased in 1980 (INV. MNE 797) ▪ Restorers: A. Cascio and J. Lévy, 2006

This figurine carved from a bull's tibia[1] has been subjected to a modern restoration aimed to fill lacunae such as the missing left arm and hair. The figure of a slave is recognizable by the caricatured features and exaggerated posture: the slave, seated on an altar molded in the triangular section of the bone, has his legs apart with his double-belted chiton rolled up above the knees. With his bust turned to the right, the slave holds his hands together in front of his chin, bringing his speech to life with animated gestures. Framed by long hair falling to the figure's shoulders, the mask covering the face is characterized by a large gaping mouth with the lips pushed out (known as a "trumpet mouth"), a snub nose, arched brows, and three wrinkles across the forehead.

The character of the seated slave originated in the "New Comedy" that developed in Athens at the end of the fourth century B.C., the most illustrious representative of which was Menander (342–292 B.C.). Plots centered on matters of the heart and money and were acted by archetypes recognizable by their masks, costumes, and attributes. These characters and their identifying traits were catalogued in Julius Pollux's second-century *Onomastikon*. Among these, the figure of the slave—derived from the "Old Comedy"—plays an essential part.[3] Among the five variants of this figure,[4] that of the slave seated on an altar, attested in Delos in the second and first centuries B.C., is commonplace: guilty of something serious, the slave takes refuge on an altar to escape punishment.[5] The version shown here reminds us of the popular aspect of the theater in Rome, especially of comedy; material, iconography, workmanship, and style attest to a craftsmanship of a later manner. (C.G.)

NOTES
1 Based on the observations of François Popelin, Museum d'histoire naturelle, Paris.
2 F. Dupont, *L'acteur roi. Le théâtre dans la Rome antique* (new printing, Paris: Les Belles Lettres, 2003), pp. 233–48.
3 Bieber 1939, p. 189.
4 Lattes 1989, p. 106.
5 Among other examples, the bronze figurine at the museum of the Petit Palais in Paris (see Lattes 1989, no. 5, p. 126, fig. 5, p. 130), the terracotta figurine of the Borély Museum in Marseille (Lattes 1999, no. 13, p. 133, fig. 13, p. 134), the marble statuettes in the Vatican and the British Museum, the terracotta statuettes in the Athens Museum, a terracotta "Campana" plaque (see Bieber, op. cit., figs. 231 and 232, pp. 173, 271, pp. 195 and 425, p. 321).

BIBLIOGRAPHY
Revue du Louvre 1980, p. 262.
Webster 1995a, 6XI2, pl. 58.
Webster 1995b, 6XI2, p. 511.

131 Actor

1st century B.C. • Provenance unknown • Yellow-beige micaceous clay • H. 9 in. (23 cm); W. 3⅞ in. (9.8 cm) • Purchased in 1861, formerly in the Campana collection (INV. CP 4489)

This grotesque-featured character is an actor: bald, with a shaggy beard, he sports a fake, hooked nose dotted with warts. Thick eyebrows (reinforced by the wrinkles on his forehead) lend him a fierce expression. His large, thick-lipped mouth is twisted into a caustic grin. His costume—sandals with interwoven straps, a short tunic with a belt, and a cloak (chlamys) fastened with a large round fibula—only serves to reveal, not hide, a bulging stomach (probably due to padding). His pose—shoulders thrown back and left hand on hip—accentuates his obesity.

This figure, with his wrinkles, grooves, and cloak folds retouched by hand, is very eloquent. and may be related to a group of figurines in a similar style, possibly found in a single tomb near Vulci, and known as the Canino Group, but its provenance is far from certain. It may instead be from a site in Tarquinia. The expressiveness of such pieces, however, is certainly typical of the production of Campania.[1]

It was in Campania that the Atellan theater, in which this actor clearly participated, first appeared. The popular comic theater originated in the Oscan region, one imbued with Greek and Etruscan culture, and takes its name from Atella, a city between Capua and Naples.[2] Introduced in Rome in the third century B.C., Atellan theater featured plots improvised around a few archetypal characters immediately recognizable by their behavior, costumes, and masks: Maccus was a grotesque, debauched simpleton, the butt of relentless trickery; Bucco was an impertinent but clever parasite;

Dorsennus was a pedantic, immoral philosopher; and Manducus, or Pappus—the subject of this figurine—was a libidinous old miser. Obscenities, pranks, and beatings were the standard fare in these comical tales of daily life among the lower classes or the rural population.

Novius and L. Pomponius (famous authors of the first century B.C.) introduced mythological parodies to the genre, slipping in political allusions and denunciations, which led Tiberius to chase the Atellan actors out of Italy. The Atellan theater continued to decline until Hadrian's era, only enduring briefly in small towns. It has been considered the source of the Commedia dell' Arte, with Pantalone as descendant of Pappus, Pulcinella of Maccus, the Doctor of Dorsennus, and Harlequin a distant relative of Bucco. (N.M.)

NOTES
1 Webster 1995b, p. 243.
2 Frassinetti, *Fabula atellana, saggio sul teatro popolare latino* (1953); Frassinetti, *Atellanae Fabulae* (1967); J.-Ch. Dumont and M.-H Francois-Garelli, *Le théâtre à Rome* (1988), pp. 174–77.

BIBLIOGRAPHY
Campana 1851, pl. CXV.
Daremberg and Saglio, 1873–1919, pp. 513–15.
Besques 1986, IV-I, p. 75, pl. 67D, no. DE 3713.
Webster 1995b, III, pp. 243–44, no. 3RT1-4.
Grmek and Gourevitch 1998, p. 172, fig. 119.

132 Appliqué in the Form of a Comedy Mask

50 B.C.–50 A.D. • Provenance unknown • Bronze • H. 1⅝ in. (4.3 cm) • Purchased in 1825, formerly in the Durand collection (BR 830–INV. ED 3756) • Restorer: C. Pariselle, 2006

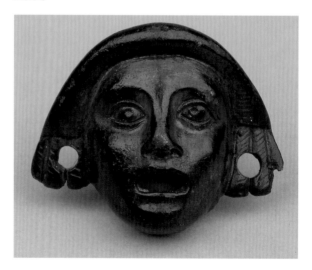

This youthful, full-featured face is framed on each side by three coiled locks of hair that fall along the cheeks. Rendered in incised hatching, the hairstyle forms a roll at the top of the forehead. The eyes, with hollowed pupils, are wide open. The eyebrows are delicately drawn. The nose is small and straight, and the gaping mouth is hollowed out. Two openings pierce the locks of hair on either side of the face, indicating that the object was originally attached to a support and perhaps decorated a piece of furniture. The back of the mask is hollow, and the top of the head is pierced by a small hole, which may have been made in modern times.

This mask of a young man represents a character from the New Comedy period that developed in Greece in the late fourth and early third centuries B.C. This theatrical genre attempted to describe the customs of the Athenian bourgeoisie, which was by then in full decline. Masks worn by actors allowed the public to immediately recognize each of the characters in a play. Forty-four comedy masks were listed by the grammarian Julius Pollux in the second century A.D., in a collection titled *Onomasticon*. Although later in date, these descriptions make it possible to identify the numerous masks depicted in Hellenistic and Roman art.

This mask is similar to Pollux's mask number 10, which corresponds to the type of a "perfect young man" (pánchrestos neanískos), with florid complexion and thick hair crowning his head. This type is well represented in Lipari, where many terracotta masks were discovered, dating to the first half of the third century B.C.[1] The Louvre bronze is a bland version of it: certain characteristic features that imbue the character with vigor, such as raised eyebrows (a symbol of youthful pride) and a slightly creased forehead (signifying contemplation), have disappeared. Only the candid look of the large, open eyes has been preserved. The result of a long iconographic tradition, this type of mask, which dates to the late republic and the early imperial era, probably was reproduced in series following a stereotypical formula. (C.B.)

NOTE
1 Bernabó Brea and Cavalier 2001, pp. 186–91, figs. 249–58.

BIBLIOGRAPHY
De Ridder 1913, p. 112, no. 830.
Webster 1995b, p. 335, no. 4XB 16 b.

133 Mask
End of 1st century B.C.–early 1st century A.D.
▪ Discovered in Boeotia (Greece) (?) ▪ Rosy beige clay ▪ H. 7⅛ in. (18 cm); W. 4⅞ in. (12.5 cm) ▪ Purchased in 1913 (INV. CA 1941) ▪ Restorer: C. Devos, 2005

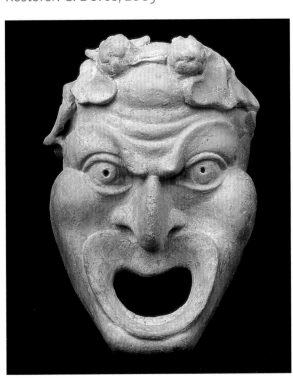

With marked features and an exaggerated expression, this mask consists of a face structured around prominent cheekbones, a hooked nose, and a gaping mouth shaped like a megaphone, through which the lower teeth appear. The contracted brow furrows the forehead and frames two eyes held wide open. A wreath of ivy and corymb sits atop the balding head. This was probably a Dionysian mask intended to represent a satyr.

In order to characterize their roles and make them immediately identifiable, actors used masks (which were made of perishable materials such as wood, wax, bark, and leather). Terracotta masks such as this one were intended to be dedicated in sanctuaries or left on tombs and were faithful reproductions of actors' masks. Thanks to the list established by Julius Pollux in the second century A.D. in his *Onomasticon*, we can connect this mask to those used for satyr dramas. Pollux described four characters: the "hoary or graying satyr" (satyros polios); the "bearded satyr" (satyros geneiôn) or "with a red beard"; the "beardless satyr" (satyros ageneios); and the "silene father" (seilènos pappos).

These characters formed the vigorous satyr chorus with which this theatrical genre, begun in the late sixth century B.C., confronted mythical heroes in an idyllic woodland and countryside setting. Satyr drama was a "tragedy that is fun"[1] that always ended happily and mixed the heroic and the comic, as can be seen in Euripides's *Cyclops* or Sophocles's *The Trackers*. Abandoned in the fourth century B.C., the genre experienced a resurgence in the third century B.C. and remained popular through the beginning of the imperial era,[2] both in Greece and Italy.

The rendering of the eyes, particularly of the bored pupils, allows us to date this mask to the end of the first century B.C. or to the beginning of the first century A.D. Its resemblance to a mask found on the Athenian Agora[3] suggests it may be an Attic piece. (N.M.)

NOTES
1 Demetrios, *On Style*, 169.
2 Horace describes it in his *Poetic Art* (v 220–250).
3 C. Grandjouan, *The Athenian Agora, Terracottas and Plastic Lamps of the Roman Period*, VI (1961), p. 60, pl. 14, no. 560. Rather than Amisos, see L. Summerer, *Hellenistiche Terrakotten aus Amisos* (1997), pp. 69–70, pl. 23–25.

BIBLIOGRAPHY
Webster 1969, p. 68, no. XT 23.
Ghiron-Bistagne 1970, 2, fig. 26, pp. 270–72.
Besques 1972, p. 73, pl. 100D, no. E6.
Webster 1995b, p. 458, no. 5XT 15.

134 Knife Handle in the Shape of a Thracian Gladiator

2nd half of 1st century A.D. • Provenance unknown • Bone • H. 3⅜ in. (8.5 cm) • Purchased in 1825, formerly in the Durand collection (s 2032) • Restorers: A. Cascio and J. Levy, 2006

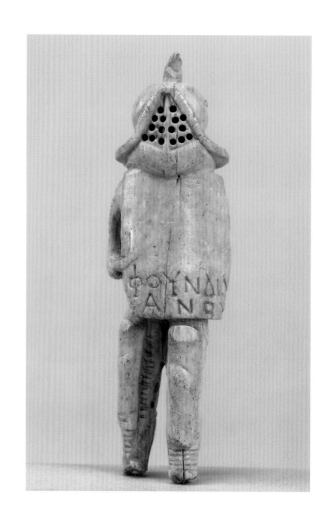

This handle for a knife with a folding blade is sculpted in the shape of a Thracian gladiator, recognizable by his dagger with a curved blade (known as a *sica*) and his heavy defensive armor. His legs, wrapped in puttees, are clad in tall leggings to which a rectangular shield is affixed, held up by the left arm. The right arm, armed with a dagger, is encircled by an armband made up of straps *(manica)*. The gladiator is dressed in a short loincloth held up at the waist by a wide belt, visible at the statuette's back. His head is covered by an impressive, broad-rimmed helmet, surmounted by a tall crest and fastened in front by a visor pierced by sixteen openings.

The statuette is broken off at the level of the ankles and the place where the blade attached. A section was pulled off at the back of the object, along the longitudinal crack meant to shelter the blade. The name Fundilanous, carved in Greek on the shield, probably belonged to the owner of the knife, or even to a gladiator.

The typical Thracian gladiator's helmet, which evolved over the course of the first century, makes it possible to date this statuette. After mid-century, the rim of the helmet expanded and the visor, formerly pierced by eyepieces, took the form of a grille that took up its entire upper portion. This visor was made up of numerous removable flaps, a fine example of which can be seen in the Louvre, discovered in Pompeii and dated to the third quarter of the first century.[1] Feathers were attached to the notches located on both sides of the dome, and the helmet was surmounted by a tall crest ending in a griffon's head, in this case broken off. This ornament evoked the animal favored by Nemesis, goddess of fate, to whom gladiators prayed before combat in chapels, consecrated to her, within amphitheaters.

Many similar knives sculpted in bone or ivory have been discovered in Italy and throughout the rest of the empire. They most frequently depict a single gladiator; more rarely, a pair of fighting gladiators.[2] Gladiatorial combats, greatly appreciated by the Romans, often were reproduced on utilitarian objects, as seen in the numerous oil lamps ornamented with subjects taken from the world of the arenas. (C.B.)

NOTES
1 Inv. Br 1108: De Ridder 1915, p. 3, no. 108, pl. 65; Junkelmann 2000, p. 167, no. 12.
2 These objects have been inventoried by Béal 1984, p. 101, B XII, n. 4.

BIBLIOGRAPHY
Longpérier 1851, p. 326, pl. 165.
Dain 1933, p. 189, no. 222.
Babelon 1943–45, p. 36.
Robert 1946, p. 128, n. 4.
Paris 1970, p. 180, no. 234.

135 Funerary Stele of a Thracian Gladiator

3rd century A.D. ▪ Discovered in Thyateira
(present-day Akhisar, Turkey) ▪ Marble ▪
H. 17⅜ in. (44 cm) ▪ Gaudin gift, 1904
(MA 4492–INV. MND 711)

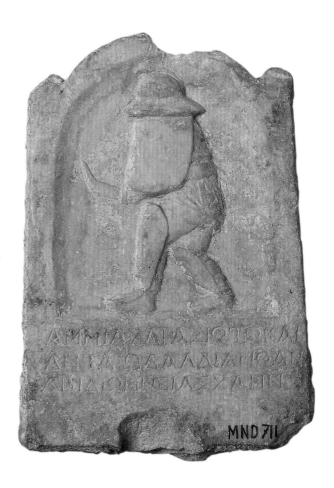

Arched at the top, this stele is embellished with a gladiator depicted
in profile, marching toward the left. He wears high leggings, a loin-
cloth held up at the waist by a belt, and a wide-rimmed, crested
helmet. His right hand, which extends out beyond the shield, is
armed with a *sica* (a dagger with a curved blade). The wide shield
held to his left side conceals his chest and face.

As can be indicated by the shape of his dagger, the gladiator is
a Thracian. The group was known for its heavy weapons. Depicted
in the midst of a fight, he holds out his weapon in his fist; stand-
ing in a half-crouch, he is protected by his defensive arms, which
form a sort of shell around him. His small shield, held between the
legging that rises to mid-thigh and the edge of the helmet, allows
him to appear entirely protected as he faces his adversary. A
Thracian sometimes fought a Hoplomachus, who was equipped
similarly and armed with a straight sword, but he was more tra-
ditionally opposed to a Mirmillo, who carried a large rectangular
shield (a *scutum*) and wore one low legging to protect his left leg.
Certain classes of gladiators took the names of regions conquered
by Rome: the many prisoners of war were then used as combat-
ants in the arena. This was especially the case for Thracia, located
northeast of Greece and conquered by the Romans beginning in
168 B.C.

Many similar reliefs, depicting a heavily armed gladiator in
combat, were discovered in Asia Minor. The epitaph carved in
Greek letters at the bottom of the stele bears the following text:
"Ammias, to Araxios, also known as Antaios, from Daldis, her hus-
band, in memory." As was often the case, the monument had been
erected by the gladiator's widow, whose single name, Ammias,
without a surname, reveals her humble rank. The inscription indi-
cates the name of the deceased, Araxios, followed by his nickname,
Antaios, the name of a giant in Greek mythology (evoking the idea
of strength), and finally his place of origin, Daldis, located in Lydia,
west of Turkey. Like athletes, gladiators chose colorful surnames,
sometimes borrowed from famous figures from ancient times,
which allowed them to be known in this way by the public. (C.B.)

BIBLIOGRAPHY
Buckler 1913, pp. 329–30, no. 21.
Dain 1933, p. 75, no. 62.
Robert 1971, pp. 220–21, no. 271.
Pfuhl and Möbius 1979, p. 301, no. 1240.
Golvin and Landes 1990, p. 169.
Junkelmann 2000, p. 28, fig. 31.

136 Lamp

Ca. 4th quarter of 2nd century–1st quarter of 3rd century A.D. ▪ Discovered and produced in Italy ▪ Clay ▪ L. 4⅝ in. (11.6 cm); Diam. 3⅜ in. (8.4 cm) ▪ Restorer: C. Knecht, 2006 ▪ Purchased in 1861, formerly in the Campana collection (INV. CP 4418)

The medallion in the center of this lamp portrays a scene from an amphitheater. Two gladiators, covered with protective armor yet armed only with lances, fight a thick-maned lion, which has knocked one of them to the ground. The second gladiator attempts to free the first from the animal's jaws. Beneath this scene, another lion rests dead on the ground. The bottom is stamped with an imprint of the artist's name, L. Caecilius Saecularis. The production of his wares was especially prolific in Italy under the Antonine and early Severan dynasties. (M.H.)

BIBLIOGRAPHY
CIL XV, 6350. 49.

137 Perfume Vase: Dwarf Wrestler

2nd century A.D. ▪ Provenance unknown ▪ Bronze ▪ H. 5 in. (12.8 cm) ▪ Purchased in 1882 (BR 2934–INV. MNC 219)

Completely naked, the dwarf stands with his left leg planted firmly behind him. Arms spread, fists closed, he raises his left hand to strike a blow against his adversary. He sports a short, curly beard and close-cropped hair. At the back of the head, one can identify the *cirrus*, a lock of hair characteristic of professional wrestlers. The forehead is creased by two small wrinkles, the eyebrows are knitted, and the pupils hollowed out. The musculature and creases in the torso and legs are hollowed out, as are the nipples, rendered by small concentric circles.

The dwarf wrestler is either practicing pancration wrestling, a violent form of combat carried out with bare hands, or boxing wearing leather straps to protect the hands. In fact, the ridges visible on the phalanges might be interpreted as leather straps wrapped

around the fingers. Athletes of Egyptian or Eastern origin faced off against each other on ground dampened with water or oil. Fights had no time limitation and lasted until one of the two protagonists was vanquished or admitted defeat. This took place at a gymnasium or a stadium, where competitions were organized.

This statuette, made in a hollow casting, was used as a vase. The trilobite mouth at the top of the figure's skull forms a sort of chignon. A small chain, one link of which survives, passed through two small handles on the neck. Vases formed from bronze, generally small in size, were made to contain perfumed oils. People took them when they went to places designated for bathing and physical exercise, namely baths and gymnasiums. The dwarf wrestler is depicted in a series of similar small vases.[1]

The theme of the dwarf appears within the repertoire of Alexandrian art, which had developed a particular taste for the grotesque during the Hellenistic era. Because of their menacing appearance, portrayals of dwarf boxers were supposed to ward off the evil eye.[2] (C.B.)

NOTES
1 Boucher 1976, p. 188, n. 80.
2 Nenova-Merdjanova 2000, p. 308, figs. 5–6.

BIBLIOGRAPHY
Perdrizet 1911, p. 62 (Br 2934, indicated as "unnumbered," is cited in comparison to no. 99 in the catalogue).
De Ridder 1915, pp. 128–29, no. 2934, pl. 103.

138 Race Scene

1st century A.D. ▪ Discovered in Italy ▪
Terracotta ▪ H. 11 in. (28 cm); W. 9½ in. (24 cm) ▪ Purchased in 1825, formerly in the E. Durand collection (INV. ED 1967) ▪ Restorer: C. Knecht, 2006

This terracotta plaque is broken on the left and right sides. There are several gaps in the upper part, and the lower edge is chipped in several places. The lower area of the plaque, three-quarters of the height, is taken up with a scene from the circus, bordered above and below by a flat surface. The elements in the background identify the circus as the scene of action: on the left, the steps, next, the column monument surmounted by dolphins (which served as the platform for counting the number of times the chariot went around the track), which was on the *spina* (the wall that divides the track in half, lengthwise), as well as the *meta* (the inner border of the track that the chariot turns around) on the right. In the foreground, a *biga* (a chariot drawn by two horses) rushes forward at a gallop, driven by a charioteer wearing a helmet, a short tunic, and a type of leather corset. The horse in the foreground is the only figure that is clearly depicted. The second horse is indicated only by the presence of his hind legs and the number of reins held by the charioteer. The top of the plaque is bordered by a frieze of closed palmettes with five leaves tightly bundled by a double strip, alternating with open palmettes of five leaves and hearts with pointed ends.

This terracotta plaque fragment belongs to the type commonly known as "Campana plaques," a reference to the great nineteenth-century Italian collector, the Marquis Campana, who first generated real interest in these objects. He even dedicated an entire room in his museum at Monte di Pietà in Rome to display them.

These plaques were used for architectural decoration, and most depicted mythological scenes and scenes of everyday life. They were made in casts; the detailed areas (e.g., the folds in the tunic, the detail on the palmettes, the helmet, the horse's mane and tail, the capitals on the columns) were then incised in the clay with tools before the plaque was put in the kiln. The letters L.S.ER., inscribed in a sort of cartouche under the horses' legs, are the initials of the artisan who made the plaque. Unfortunately, it is not known which artist these initials represent. (P.C.)

BIBLIOGRAPHY
Lattes 1990, no. 9, p. 221, fig. 9, p. 230.
Toulouse 1990, no. 69 and fig. 69, p. 112.

139 Inlaid Plaque

Late 4th–early 5th century A.D. ▪ Provenance
unknown ▪ Bronze inlaid with copper and
silver ▪ H. 6¾ in. (17 cm); W. 3⅜ in. (8.5 cm) ▪
Purchased in 1888, formerly in the Hoffmann
collection (BR 3447–INV. MNC 1012) ▪ Restorer:
F. Dall'Ava, 2005–06

Wearing a traditional driver's costume, a victorious charioteer
occupies the center of this rectangular plaque. He wears a helmet,
a long-sleeved tunic tightened at the chest by leather straps and
cinched at the waist with a wide belt, sandals, and tall leggings
wrapped in strips of cloth and reinforced with kneepads. He holds
a whip in his right hand and a palm leaf of victory in his left. To the
right, a small figure, helmeted and dressed in a tunic, runs and
brandishes a whip; this is perhaps an assistant in charge of rousing
the horses during races. To the left, three palms are stuck into a
modius, a dry measure of considerable capacity, which probably
was filled with coins. A valuable *modius* is depicted in mosaics of
circus scenes, and one example in bronze inlaid with silver was dis-
covered in Beja, Tunisia.[1]

As evidenced by the incomplete inscription, formed by the let-
ters N V S carved above the charioteer, and FICI, at the bottom of
the chipped plaque, the piece was part of a group. Because of its
shape and size, it has been compared to diptych leaves in ivory, but
in this case, this type of object would have been an exception. It is
more likely that the small plaque was part of a decoration for a box
or a piece of furniture.

The draftsmanship is somewhat clumsy: the charioteer's legs
are too long in relation to the rest of the body, and the head is very
small. Nevertheless, the disproportion between the two protago-
nists, which underscores the importance of the central figure, is
intentional, and the polychrome decoration, obtained with colored
metal inlays, is extremely refined. Sheets of copper and silver were
affixed by being hammered onto the ground, which was hollowed
out and streaked with furrows, still visible on the portions that
have lost their ornamentation. Set into the narrow grooves, silver
threads emphasize the contours of the objects and figures.

The silver facing preserved on the helmet implies that this char-
ioteer competed for the Whites, one of the circus's four stables.
Each faction was represented by a color—blue, green, red, and
white—that corresponded to a social class. Members of the pub-
lic, who placed bets on their stable of choice, were passionate
about the races and the drivers, who were extremely popular. From
poor origins, they began racing at a very young age and could
acquire wealth rapidly. In the fourth century, the factions in
Constantinople became true political parties, and the circus fre-
quently became the scene of scuffles between spectators. (C.B.)

NOTE
1 N. Duval, "Les Prix du cirque dans l'Antiquité tardive," in Lattes 1990, pp. 137–38,
 p. 145, fig. 13.

BIBLIOGRAPHY
De Ridder 1915, p. 175, no. 3447, pl. 116.
New York 1979, pp. 103–04, no. 94.
Rome 2000a, p. 448, no. 35.
Milan 2003, p. 383, no. 138.
Rimini 2005, pp. 206–07, no. 95.

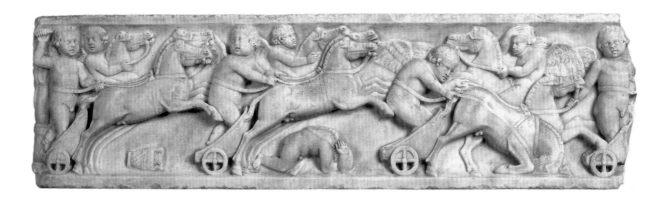

140 Front of a Sarcophagus with Erotes

Mid-2nd century A.D. • Provenance unknown
• White marble • H. 12¾ in. (32.5 cm); L. 44⅞
in. (114 cm) • Purchased in 1807, formerly in
the Borghese collection (MA 327—INV. MR 778) •
Restorer: C. Breda, 2006

This panel, which comes from a child's sarcophagus case, is sawed off cleanly on its extreme left and broken on the right side. Nonetheless, as a whole, this bas-relief piece executed with a chisel is in a rather good original state, with only a few restorations in Carrara marble.[1] The scene is undoubtedly set in the Circus Maximus where chariot races took place, yet the only evocation of the circus is through the *meta* (a marker decorated with a garland of flowers that served to define the edges and turnarounds of the course) on the extreme left. There must have once been an identical marker on the right of the panel. All of the characters here are represented as erotes, small winged nude children.

In the foreground is the two-wheeled chariot race, while on the second plane, galloping riders spur on the teams of horses. The young charioteers have slipped the reins around their waists. The first one holds a whip aloft in his right hand, while the second looks back. An assistant charged with wetting down the track has fallen under the second team and is huddled, head between his arms, in order to avoid being trampled. The wicker-covered jar he was holding has toppled over and rolled under the first team of horses. Meanwhile, the third charioteer has also had an accident *(naufragium)* and tries to control his horses as they fall or try to get back up. The fourth driver has succeeded in grabbing the reins of the horse on the left. His other hand probably once controlled his own horses, but these are no longer visible. In the background, a rider who has spun around to watch the scene holds his head as he witnesses the disaster unfolding.

This panel belongs to a series of about thirty children's sarcophagi representing erotes at the circus. The Louvre owns several others (Ma 1640, Ma 333, and Ma 1450). A small group of workshops seems to have produced all these sarcophagi between the middle of the second century A.D. and the first quarter of the third century A.D. This fragment is one of the most sober, with the architectonic representation of the circus reduced to its simplest state. Though its craftsmanship as a whole is of a good quality, the rendering of the figures is occasionally clumsy: the figures' heads and bodies are disproportionate, as are the charioteers and their chariots.

Marie Turcan-Deléani has studied this group of sarcophagi that present a constant motif, in particular the *naufragium*. She has suggested it represents the life of the child (symbolized by the chariot race) and its brutal interruption (the *naufragium* motif). (P.C.)

NOTE
1 Part of the reins for the first team of horses, the right forefoot of the horse pulling the second two-wheeled chariot, and the right forefoot of the horse on the left in the team pulling the third chariot.

BIBLIOGRAPHY
Turcan-Deléani 1964, p. 46.
Baratte and Metzger 1985, no. 91, pp. 181–82.
Huskinson 1996, nos. 6-21, p. 49.
Bastien 2003, pp. 14–15.

141 Fragment of Mosaic Paving

Ca. 300 A.D. • Zeugma-Seleucia on the
Euphrates (present-day Belkis, Turkey) •
Limestone, marble • H. 24⅜ in. (62 cm);
W. 22 in. (56 cm) • Gilbert-Martin gift, 1893
(MA 4129—INV. MNC 1686)

A large, lush acanthus leaf rolled in on itself forms a medallion against a black background. The medallion depicts a hunter cupid, a naked young boy whose left arm and shoulder are covered with a cloak that floats behind him. Looking away from the direction he is going, the child carries a stick aloft in his left hand and holds his

right arm out to a dog that leaps toward him.

Hunting, particularly popular in Rome beginning in the second century B.C., was practiced in two forms: as an athletic activity and a spectacle. The former activity, reserved for the elites, made a distinction between the bird hunt *(aucupium)* and the quadruped hunt *(venatio)* depicted here: the animal was startled, then driven by foot or on horseback into a net with the help of a dog.

This panel is part of a group of fragments originating in Belkis[1] but scattered among several public and private collections since the late nineteenth century.[2] Cupids in an acanthus scroll[3] allegedly constituted the central border motif of a composition probably representing Poseidon's chariot[4] surrounded by personifications of the provinces of the empire;[5] however, stylistic differences between the cupids in the acanthus scroll, which is dated around 300 A.D., and the personifications dating from the first half of the third century A.D., have led J. Balty to disconnect these two groups and describe them as fragments of two distinct pieces of mosaic paving.[6]

The lack of specific information regarding the discovery of this group allows us to establish such a hypothesis; moreover, the Belkis area yielded a great number of mosaics, particularly in the late nineteenth and early twentieth centuries. Since J. Wagner's research in the 1970s,[7] we know that the area corresponds to the site of Zeugma, the twin cities of Seleucia and Apamea on either side of the Euphrates. Located at the far edges of the empire between Syria and Mesopotamia, Seleucia was an important city in the Roman Orient; it was the seat of the five thousand-man Legion III Scythica in the first and second centuries. The filling of the Birecik Dam in 1998 submerged much of the area before any overall study of the site could take place.[8] (C.G.)

NOTES
1 J. Balty, "La mosaïque antique au Proche Orient. I. Des origines à la Tétrarchie," *Aufstieg und Niedergang der römischen Welt*, II, 12, 2 (1981), p. 384.
2 Ibid., n. 225, pp. 384–85.
3 The fragments in Museo Museo Nazionale Romano nelle Terme di Diocleziano in Rome are reproduced by W. Helbig, *Führer durch die öffentlichen Sammlungen klassischer Altertümer in Rom. III. Die Staatlichen Sammlungen* (Tübingen, 1969), p. 427; those in Berlin by L. Budde, *Antike Mosaiken in Kilikien*, I (Recklinghausen, 1967), pp. 81–82 and pl. 158–65.
4 In a private collection, reproduced by K. Parlasca, "Neues zu den Mosaiken von Edessa und Seleukia am Euphrat," *III Colloquio internazionale sul mosaico antico* (Ravenna, 1980–83), fig. 7, p. 232.
5 Fragments in Berlin reproduced by J. M. C. Toynbee, *The Hadrianic School* (Cambridge, 1934), pl. XXIV, 3, XXV, 3, XXVI, 2, and XXVIII, 2.
6 Balty, op. cit., pp. 385–86.
7 J. Wagner, *Seleukia am Euphrat, Zeugma* (Wiesbaden, 1976), pp. 52–56.
8 D. Kennedy, "Zeugma, une ville antique sur l'Euphrate," *Archeologia* (1994), 306, pp. 26–35. On the last digs, see D. Kennedy, *The Twin Towns of Zeugma on the Euphrates. Rescue Work and Historical Studies, Journal of Roman Archaeology*, Supplementary studies, 1998.

BIBLIOGRAPHY
Michon 1906a, pp. 380–84.
Baratte 1978, no. 54, pp. 131–32, fig. 139.
Rimini 2005, no. 154, pp. 301–02.

142 Strip Edging of a Sarcophagus Lid

Ca. 240 A.D. ▪ Discovered in Saint-Médard-d'Eyrans (Gironde, France) (?) ▪ Micaceous white marble with grey spots and large crystals ▪ H. 16⅞ in. (43 cm); L. 91¾ in. (233 cm) ▪ Formerly in the royal collections (?) (in the Louvre prior to 1820) (MA 284–INV. MR 859) ▪ Restorer: A. Méthivier, 2006

Sometime in the modern era, this strip from the lid of a sarcophagus was cut through the middle and at its edges. The chin of the mask on the left and the right arms of the basket-carriers are missing, and many details are modern additions.[1] The left two-thirds of the *tabula quadrata* have been redone in Carrara marble, while the right upper third has been redone in fine-grained marble. Both of the lid's far edges were decorated with the face of a young man with tangled hair.

Surrounding a *tabula quadrata* that was probably never given an epigraph are two tableaux depicting scenes from a grape harvest. On the left, two oxen pull a cart with disc wheels containing two baskets full of grapes. A herdsman wearing an *exomide* (a short, sleeveless tunic) goads on the team, while a man in the cart keeps the baskets upright with his right hand and holds his left arm forward. On the second plane, another man carrying a basket of grapes on his shoulder leans on a *pedum* (crook) as he moves toward a tree and a column topped with a sundial. In the scene on the right, a man on a ladder picks grapes from a vine arbor. Like the other figures in the scene, he wears a *perizoma* (loin cloth). A man in front of the grape-picker gathers the grapes into a basket on his shoulder and carries them to a vat to the right of the scene. The vat, with two spouts in the shape of lions' heads, sits before a columned building with a tile roof. The vat is filled with grapes which two men are busy pressing with their feet.

The popularity of rustic or bucolic scenes in funerary sculpture increased at the beginning of the third century A.D. Occasionally included in mythological representations, they were also used on their own as picturesque elements. The theme of the grapevine, often related to Dionysian representations, is evoked through the depiction of cupids, putti,[2] or, as in this case, more realistic peasants. The sequence of harvesting, transporting, and pressing the grapes is a common one; found, for instance, on a sarcophagus lid in the Palazzo dei Conservatori in Rome (inv. 2774). In the sarcophagus strip shown here, the cart scene on the left panel repeats the transport part of the sequence and also introduces a break in the sequence's narrative chronology, no doubt a decision based on aesthetics and the need to balance the composition as a whole.

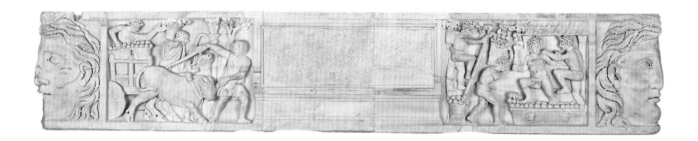

The quality of the craftsmanship; the use of a drill to render details such as the grapes, leaves, and hair; the figures clearly detached from the background; and the resemblance between the corner masks allowed researchers to establish a connection between this strip and the two lids found in Saint-Médard-d'Eyrans,[3] which may have come from the same workshop. (P.C.)

NOTES
1 Left to right: the right shoulder of the man on the cart, the ox in the foreground (except for the back legs), the left hand and torso of the herdsman, parts of the ladder and the vine stock, the basket-bearer's left leg, the first presser's right hand, and the second presser's left foot.
2 For instance, on the lid of Louvre sarcophagus Ma 1553.
3 Louvre Ma 1346 and Ma 1335.

BIBLIOGRAPHY
Charbonneaux 1963, no. 284, p. 243.
Turcan 1966.
Baratte and Metzger 1985, no. 7, pp. 35–37.
Bielefeld 1997, p. 113, no. 74, pls. 67, 2, 3.

143 Relief of a Workshop Scene ("The Forges of Vulcan")

1st century A.D. (?) ▪ Discovered in Italy (?) ▪ Marble ▪ H. 20½ in. (52 cm); L. 39⅜ in. (100 cm) ▪ Napoleonic seizure, 1806, formerly in the collection of the chateau of Berlin, purchased from Cardinal de Polignac, exchanged in 1815 for a relief from the Albani collection (MA 661–INV. MR 874) ▪ Restorer: C. Devos, 2005

character seems to be attaching the *porpax*, the shield's central handle. On the right, at the foot of a base supporting a breastplate and quiver, a small satyr sitting on the ground makes a greave.

The scene is difficult to interpret. It may be an illustration from Homer's *Iliad*, describing how, at Thetis's request, Hephaestus (the Roman Vulcan) forged new weapons for Achilles following Patroclus's death. On the other hand, those who identify the figure on the left as Cupid assert that the weapons are being forged for the Trojan Aeneas, who was Venus's protégé. Given that the central seated figure is not wearing the leather hat traditionally associated with the representations of Vulcan, it has also been suggested that this may depict the titan Prometheus.

Despite these theories, the scene's function and style remain entirely enigmatic. Though Roman sarcophagi were occasionally decorated with reliefs representing Vulcan forging Achilles's weapons,[1] this scene is significantly different. The cavities (dating from antiquity?) under the plinth are more likely to correspond to a votive relief set on a high base. The only precise parallel known to us, found in Catania, in Sicily,[2] displays a composition analogous with the lower-left corner of the Louvre relief, with a notable difference in the support, given that a tree trunk is distinguishable in the Catania piece.

Perhaps the picturesque context suits a first-century B.C. relief depicting a theatrical satyr drama. Sophocles wrote a satyr drama about Kedalion; a famous relief in Munich and a few examples in Rhenea and Rhodes prove that the genre existed. The Louvre relief seems to have retained traces of a technique of reproduction that utilized a compass: a hole was pierced through the center of

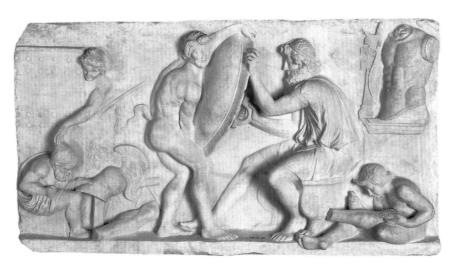

This strange relief, known as the Forges of Vulcan, depicts five figures at work. On the left, a figure appears behind a door; the lower part of his body is hidden by what appears to be either an animal skin or the smoke—possibly even flames—from the oven. Behind his arm are four motifs that resemble arrows. Some have suggested the figure is a cupid or a satyr. He touches the hat of a seated old man in a tunic who is making a helmet, near a greave (*knèmis*, Greek leg armor).

Compared to the other figures, the old man is the size of a dwarf. Some have seen him as Kedalion, considered Hephaestus's master, allegedly represented as a gnome. At the center, a tall satyr identifiable by his face and ponytail holds out a shield to a seated, bearded figure. Wearing an *exomis*, the artisan's tunic, this bearded

a small bulge to the right of Vulcan's head, and a hole was pierced behind the tall satyr holding the shield for Vulcan. We must at least dismiss doubts voiced since Froehner regarding the relief's authenticity:[3] the concretions revealed by the recent restoration confirm that the piece dates from antiquity. (J.-L.M.)

NOTES
1 Capitoline Museums, former della Valle collection.
2 See Libertine, 1937, fig. 1.
3 Froehner, 1869, pp. 136–38, no. 109.

BIBLIOGRAPHY
Hundsalz 1987, p. 167, no. K 53.
Dostat and Polignac 2001, p. 117.
Savoy 2003, no. 37, pp. 29–39.
Martinez 2004a, no. 1007, p. 499.

144 Scales

Imperial Roman era • Provenance unknown •
Bronze, lead • L. of beam 15⅞ in. (40.2 cm) •
Purchased in 1861, formerly in the Campana
collection (BR 3257–INV. CP 6955-6) • Restorer:
C. Pariselle, 2006

These scales consist of a beam, quadrangular in section, along which a weight—in the shape of a male head surmounted by a suspension ring—slides. Terminating in a round knob, the beam is marked with divisions of measurement on two sides. The vertical lines indicate units, the smaller lines indicate half-units, and the V's mark off units of five. The flat end of the beam, now broken off, probably had a ring from which a weighing tray was suspended. Two hooks, which can be placed in relation to each of the measurement marks, are attached by rings to the end of the beam. The scales were suspended from one or the other of these hooks, depending on the measurement gauge one wished to use.

Many examples of this type of scale were discovered in the cities buried by the eruption of Vesuvius in 79 A.D.[1] They are constructed on the principle of the lever: the weight of the load is determined by the measuring weight placed on the beam to balance it. The beam, polygonal in section, can have one to four different measurements, each one corresponding to a suspension hook attached at a distance, more or less removed, from the load to be weighed. The Romans also used scales with equal arms, already known to the Egyptians, and they used a duodecimal system of measure based on the pound (libra) as a unit, equal to approximately 327 grams.

Made from a hollow casting and filled with lead, the weight takes the form of a head of a young man wearing a skullcap from which some short locks of hair escape. He has bangs over his forehead.[2] The skullcap, with straps coming out from either side of the ears and tying under the chin, was probably made of leather. This type was worn by athletes, including gymnasts, as well as discus and javelin throwers, as we know from a Greek vase depicting the exercises practiced in a gymnasium.[3]

Numerous bronze weights have been found. They are often sculpted in the shape of heads or busts of deities, mythological heroes, and empresses, but sometimes they depict more modest figures, such as athletes and chariot drivers. (C.B.)

NOTES
1 Lista 1986, pp. 192–93, nos. 132–34.
2 A similar weight is now in the National Museum of Rome. See Corti 2001, p. 198, fig. 125 and p. 207.
3 Reinach 1899, "Galerus," Daremberg Saglio, IV, p. 1452, fig. 3478.

BIBLIOGRAPHY
De Ridder 1915, p. 160, no. 3257, pl. 114.
Paris 1959, p. 48, no. 84.

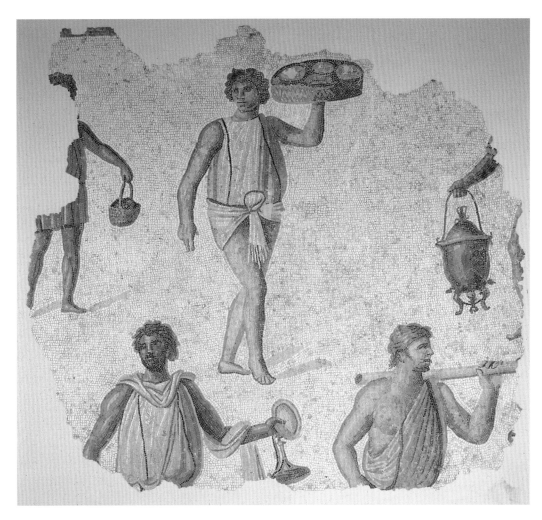

145 Mosaic Panel

Late 2nd century A.D. ▪ Discovered near
Carthage (Tunisia), 1875 ▪ Marble, limestone,
molten glass ▪ H. 88⅝ in. (225 cm); W. 94½ in.
(240 cm) ▪ Purchased in 1891 (MA 1796–INV.
MNC 1577) ▪ Restorer: Atelier de restauration
de mosaïques de Saint-Romain-en-Gal, under
the direction of E. Chantriaux, 2005–06

Staged against a neutral beige background, five young people
dressed in short tunics *(exomides)* are busy carrying table utensils
and food, making preparations for a banquet. They are young
triclinarii, slaves who acted as waiters. Only the figure at the center
is intact. His short tunic, ornamented with two blue stripes, covers
only the upper part of his body, while a sort of loincloth is knotted
around his hips. His raised right hand supports a flat wicker basket
of four breads or cakes. To the left, dressed in a red tunic with
vertical red stripes, a slave holds a small basket, probably of fruit.
All that remains of a third figure is the left arm holding a metal
kettle. In the lower section is a fourth young man, cut off at mid-
body, wearing a scarf with his short, red-striped tunic; he holds a
glass carafe, probably of wine, and a plate, in his left hand. The last
slave, whose tunic reveals one shoulder, holds a pole that must
have been used to carry a heavy load.

Notable for its high-quality workmanship, this floor fragment
can be dated to the late Antonine era, based on the treatment of

the volumes and the space—characterized by small shadows at the
figures' feet, the variety of poses combined to convey movement,
and the diversity of physical types and hairstyles. While interesting,
the iconography is not exceptional: banquet scenes were popular in
floor decorations in North Africa,[1] where they must have been one
of the chosen themes for the floors of *triclinia*, or dining rooms.
More broadly, they reflect the taste of wealthy proprietors for illus-
trating their way of life and surroundings, thus indicating their own
prosperity. Depictions of slaves, identifiable by their short tunics,
are common though they are not easily distinguishable from com-
moners. Only the scene in which they participate allows their
identification. Slaves are found in depictions of agricultural activi-
ties, hunting scenes, amphitheater games, and banquet scenes.[2] In
the latter category, highly skilled workers are most often depicted.
Indeed, as N. Blanc and A. Nercessian stress, "the luxury of a table
also includes the specialized slaves who serve the guests; they are
chosen from among the most beautiful and are dressed sumptu-
ously.... And just as all the guests, according to their rank, did not
have the choicest morsels, they were not all served by the same
slaves."[3] (C.G.)

NOTES
1 Dunbabin 1978, pp. 123–24; Blanchard-Lémée 1995, pp. 65–85.
2 Blásquez 1998.
3 Blanc and Nercessian 1992, p. 68.

BIBLIOGRAPHY
Baratte 1978, pp. 71–74.

146 Slave

Early 3rd century A.D. ▪ Discovered in the
thermal baths in Aphrodisias (Turkey) in 1904
(Paul Gaudin excavations) ▪ Black marble
known as Nero antico ▪ H. 22⅞ in. (58 cm) ▪
Donated in 1995, collection of the heirs of
P. Gaudin (MA 4926—INV. MNE 1009) ▪
Restorer: H. Susini, 1998–99

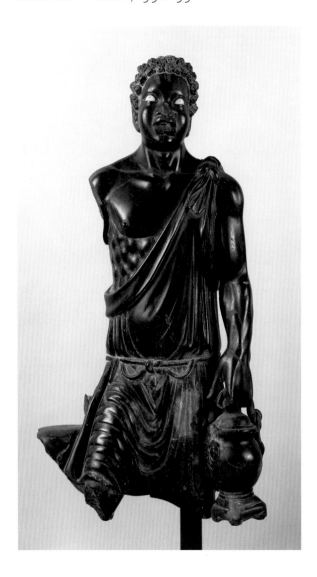

This young black slave, identifiable by his belted *exomis*, the tunic
of artisans and servants, carries a *situla* in his left hand. The globu-
lar container has a rounded lid and a square base and is carried
by a moveable handle that fits through rings attached with pal-
mette-shaped clips. Probably a bath boy at work, the young man
undoubtedly holds the vase with perfumed oil.

Ethiopian slaves employed in the thermal baths are referred
to by Cicero (*Rhetoric to Herennius* IV, 50, 6), while other repre-
sentations of black slaves carrying *situlae*[1] attest to the subject's
dissemination. The black marble, inlaid eyes, and the dynamism in
the boy's gait add to the realism of a statuette that once decorated
a niche in the thermal baths of the great city of Aphrodisias. This
prosperous city in Caria experienced spectacular urban develop-
ment during Augustus's reign, following the return of Zoilos, an
Aphrodisian who had been part of Caesar's entourage.

An athletic complex explored by Paul Gaudin from 1904 to 1906
lies in the city's shallow valley between the sanctuary in the north
and the Acropolis in the south. The statuette was found in the ther-
mal baths that had been built under Hadrian on the western part
of this monumental complex. The city's workshops specialized in
this type of sculpture, made of colored marble (black, red, or grey
veined) drawn from local mineral resources. In the imperial era, a
school of sculptors flourished in Aphrodisias, notably producing
the centaurs signed by Papias and Aristeas of Aphrodisias—two
red and black marble masterpieces discovered in Tivoli and now
in the Capitoline museums. The Aphrodisias school rose to promi-
nence under Hadrian and enjoyed a certain longevity. Its quarries
competed with imperially legislated Egyptian quarries that pro-
vided the porphyry, basalt, or green rock used by Roman sculptors
to depict exotic subjects, including Africans, Dacians, and Egyptian
divinities (cat. nos. 28 and 29).[2]

Based on the young slave's elongated proportions, the contrast
between the geometric arrangement of the folds of his tunic and
the exaggerated realism in the rendering of the indentations, and
the unfinished nature of the statuette's back, this piece may date to
the early third century A.D. (J.-L.M.)

NOTES
1 Athens, National Museum.
2 See Gregarek 1999, pp. 33–284.

BIBLIOGRAPHY
Erim 1967, p. 238, pl. 70, fig. 19.
Pasquier 1995.
Gregarek 1999, p. 207, no. G1.
Baratte 2001, figs. 1–4, 6–10, 13.

147 Slave

2nd–3rd century A.D. ▪ Provenance unknown ▪ Bronze ▪ H. 5⅞ in. (14.8 cm) ▪ Purchased in 1848 (BR 701—INV. MN 32)

This figure with Negroid features kneels and raises his right hand above his head. His hair forms large curls twisted around his forehead; his mouth is pierced by an opening. He wears a hooded cloak (*cucullus*) over a long-sleeved tunic, cinched at the waist. Hanging from his belt is a *bulla*, the protective amulet traditionally worn by children. He rests his hand on his left leg, which is folded and clad in an ankle boot. The bottom of the small statue, which consisted of the left foot and the right knee resting on the ground, is lost.

Both the figure's features and the clothing indicate that this is a slave. During the imperial era, there were many African slaves, particularly sought after because of their exotic nature. The hooded cloak was customarily worn by travelers and people of modest rank, slaves, and peasants. Young slaves, responsible for accompanying their masters when they went out at night, would wear this type of warm garment.

The theme of the *lanternarius*, or lantern-bearer, shows a young slave waiting on his master, dozing and huddled in his cloak, his lantern resting at his feet. This subject was reproduced during the Roman era, in both small statues and on small bronze vases, which probably contained perfumed oils.[1] Numerous such depictions were found in Gaul, including a perfume vase, now in the Louvre, dated to the second century A.D.[2] A remarkable silver pepper pot in the form of a *lanternarius* is in the British Museum; it belonged to the Chaourse treasure, found in northern France and dated 200–270 A.D.[3]

Inspired by this theme, the bronze described here represents a young slave, busy extinguishing his lantern. His cheeks puffed up, he leans his head forward to blow on the flame, which he protects with his raised hand. At the back, a handle (now broken) formed by the extension of the cloak and hood, indicates that the figure was part of a utensil. It most likely ornamented an *authepsa*, a large receptacle equipped with a compartment for embers, used for heating water. Such devices could be used with an *aeolipila* (a "ball of Aeolus" or steam turbine), invented in the first century by the Greek mathematician Heron of Alexandria. The small figure, placed on the lid of the *authepsa*, allowed the steam to escape from the opening visible between its lips. Thus it gave the impression that it was blowing on the embers.[4] (C.B.)

NOTES
1 Boucher 1976, p. 191, n. 112 and 114.
2 Br 2935: De Ridder 1915, p. 129, no. 2935, pl. 103.
3 Baratte 2001, p. 74, fig. 20.
4 The same function has been attributed to a very similar small statue in the Avenches museum, depicting a crouching Silenus. See Jucker 1961a, p. 49 s; Leibundgut 1976, pp. 37–38, no. 20, pl. 20–21.

BIBLIOGRAPHY
De Ridder 1913, p. 97, no. 701, pl. 49.
Jucker 1961a, p. 49, n. 3, pl. 23d, 24a.
Rolley 1967, p. 12, no. 120, pl. 40.
Amedick 1999, p. 191, pl. 62, 2.

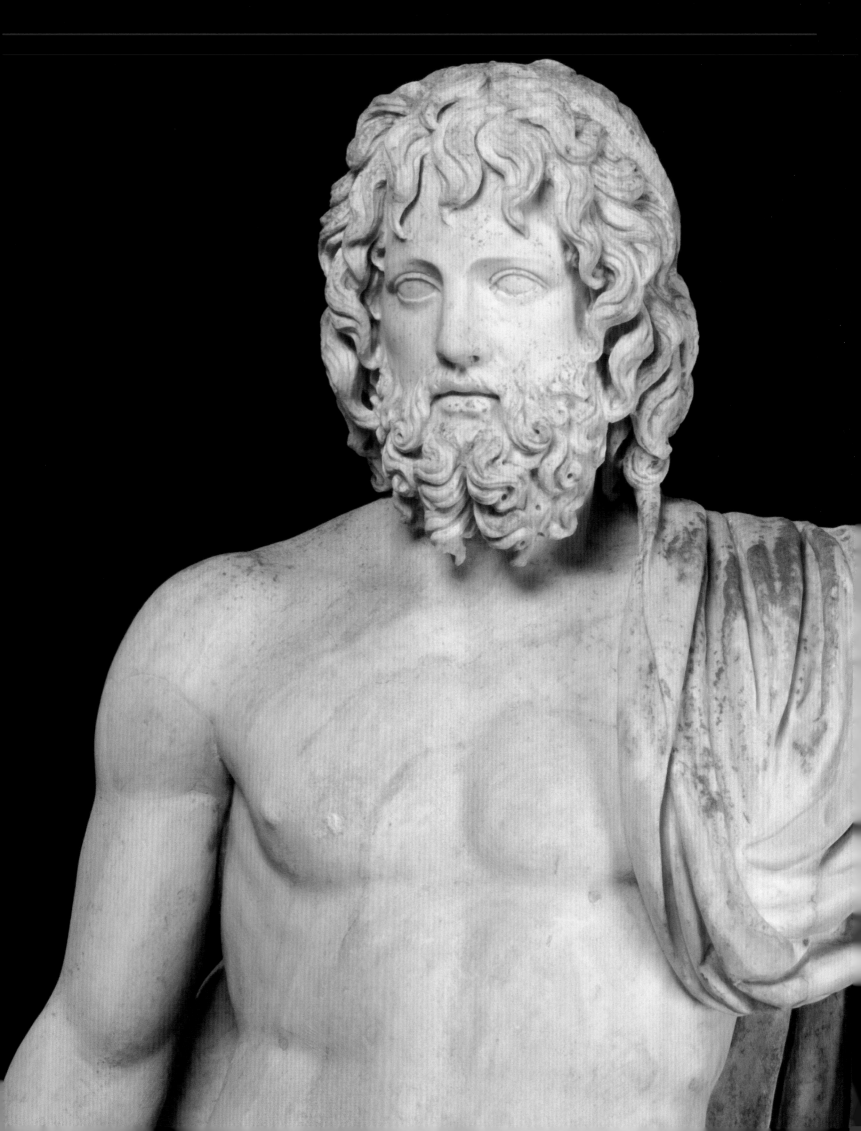

The Roman Religion Néguine Mathieux

If God is one, what happiness can he find in his solitude? —Cicero, *Hortensius*, fragment 47

The legacy of Latin is widely felt in the terms we use to refer to religious practices and attitudes, starting with the very word *religio*, that it seems possible to describe and evaluate the Romans' religion from the vantage point of our own presuppositions. Stuck between the richness of the Greek pantheon and the power of Christianity, without any specific faith or moral commandment, the Roman religion appears as a series of superstitions stamped with a rigid and cold administrative ritualism. Witness Cicero's definition of the term *religio* as a mere "pious cult of the Gods" (*The Nature of the Gods*, 1, 117), rather than a belief system establishing a direct, personal relationship to the divine. Yet this highly codified body of rites does manifest a comprehensive worldview, based on a rigorous division between men and gods.

The world described was, first and foremost, the world of a city, Rome, attempting to conquer a universe full of highly developed cultures in which Greek, Etruscan, and Oriental gods reigned supreme. Rome aimed not only to take control of entire territories, but also to grasp all the aspects of the divine and create unity out of the world's diversity. In the aftermath of its domination of territories and peoples, the conquering republic and rising empire sought to achieve this unity through a strict organization of space, competencies, and actions.

As the core component of the Roman world, the city was the natural context for religion, just as the individual was primarily defined as a member of a family and a social group. Romans began by adopting the gods of their community. Cicero's statement that, "each city has its religion, as we have ours" (*Pro Flacco*, 28, 69) is a clear indication that there were as many gods as there were cities.

Clearly, the Roman religion was polytheistic; yet this polytheism was also due to the omnipresence of gods who ruled over all fields of activity. Indeed, each of these countless gods, later railed against by Saint Augustine as "a noisy swarm of innumerable demons" (*City of God*, 4, 25, 177), had a particular purpose. A god's purpose could even be divided into various modes, providing the god with supplementary identities: *Mars* (cat. no. 152) could be Mars Pater, the god of war, or Mars Victor, a term that emphasized Mars's powers of victory and the actual effects of his military action. And the ultimate deification of Mars's victorious action was the goddess Victoria.

A god, then, was primarily an active force. The power of his action, known as *numen*, was regularly solicited for diverse reasons without subjecting his nature to fundamental changes. Mars could defend a territory against its enemies or assist an individual beleaguered by illness. How

ever, the selection of attributes characterizing the god's visual representation corresponded to his *epiclesis* (or how he was invoked)—*victor* or *ultor*, for instance.

Another way to unite and encompass the entire world was to bring several deities together. Thus, the Capitoline Triad of Jupiter, Juno, and Minerva could be addressed by the Capitoline Temple: one sanctuary, with rites for multiple gods. This approach to the divine explains the profoundly syncretic, open nature of Roman religion. Even artistic representations of the deities exhibit a wide variety of parallel visions. Though Roman tradition, according to Varro, eschewed the use of icons, the adoption of Greek and Etruscan gods imposed their representation. Statues were erected to represent major deities, including the twelve great gods of the Greek Pantheon (cat. nos. 148 and 151–57), as well as gods such as Janus (god of beginnings and endings) or Silvanus (god of forests and groves), both of whom had no equivalents across the Ionian Sea, and numerous minor deities such as Flora (who presided over all that blossoms).

Yet when Rome adopted foreign gods from its conquered territories, it did so both for religious reasons and diplomatic ones, as evidenced by the formal arrivals in Rome of Asclepius after 293 B.C. or of Cybele, the Mother-Goddess of Asia Minor, in 205–204 B.C. (cat. nos. 165 and 166). Following hardships and trials such as the plague or the Punic Wars, the help of a powerful deity was useful not only in guaranteeing good health, but in favoring relations with the Greeks or alliances with the kings of Asia Minor. The conquest of Egypt naturally—though, initially, through much conflict—introduced the cults of Isis (cat. nos. 163, 164, and 170) and Sarapis (cat. nos. 167 and 168) to the Roman cities, just as the empire's soldiers and merchants returned from Persia to spread the cult of Mithra (cat. no. 171). Certainly the political value of religious cults speaks to the very essence of religion, which is intimately linked with civic action.

This relationship allowed for the posthumous deification of the emperor (cat. no. 33) to exist alongside the cult devoted to his *genius*, or powers of creation and perpetuation (cat. no. 32). The posthumous cult drew equal inspiration from the Hellenistic tradition of the hero and from Roman funerary cults and victory ceremonies: the emperor was celebrated for the power of divine action that allowed him to be victorious. In this context, he represented the common interest, and his cult actively bolstered the empire.

The piety of the Roman people both ensured the power of the empire and was legitimized by its victories. According to Cicero, "Romulus, by ordering auspices, and Numa, by establishing sacrifices, laid down the foundations of Rome. Rome would probably not have risen to such greatness had it not used its cult to attract the favor of the Gods" (*De natura deorum*, 3, II, 5). In the absence of any revelation or dogma, piety was predominantly based on the correct execution of stipulated rites.

Such rites were executed in the name of the community by any public authority figure, from the head of the household to the magistrate or the emperor (cat. no. 30). As members of a strict organization (the colleges or the sodalities), priests (cat. nos. 172–74) were considered guardians and administrators of sacred law who celebrated certain specific rites. However, since priests lacked any distinctive training, they did not have an exclusive hold on the sacred. Nor did they wholly or eternally devote themselves to serving the divine.

Sacred rites thus enabled each citizen to develop a specific relationship with the gods. This was particularly true of the most important rite, the rite of sacrifice (cat. nos. 31, 38, and 39). The blood sacrifice consisted of offering an animal to a deity on the occasion of a banquet. To sacrifice meant to eat with gods. The animal was prepared, consecrated (*immolatio*), slaughtered, cut up, and divided; part of it burned on the altar (cat. no. 160) reserved for the deity and part was eaten by the attending worshippers. This division clearly expressed the respective positions of man and god—the mortality of man, the superiority of the gods. In another form of exchange, Romans offered personal objects— representations of themselves or anatomic *ex-votos*—as conciliations, signs of gratitude, or as tokens of requests that wishes be granted.

The balanced relationship between men and gods was rooted in every aspect of the city's activity. Romans used rites of divination not to question the gods about the future but to seek their approval of any decisions that had to be made. Divine approval was discerned by observing and interpreting natural signs (*auguria*) that were believed to convey the will of the gods, such as the flight of birds (*auspicia*) or the entrails of sacrificed animals (*extispicia*) (cat. no. 159).

This idea of peaceful collaboration nourished all relations with the gods, and the physical existence of each individual shared time and space with the immortals. In a notable example of this connection between man and god, magistrates setting up a new colony made establishing the calendar their first priority. Organized to synchronize with the community's various civic activities (agricultural work and military or political activities), the annual calendar was divided between *dies fasti* (days of the gods) and *dies nefasti* (days of the earthly realities). The year was highlighted by numerous festivals featuring sacrifices. These frequently culminated in theater or circus games that took place before the eyes of the deity, as represented by a statue brought in a procession to the site.

In the same manner, every part of a city and its territory were allocated either to man or to the gods. When a city was founded, certain places were orally attributed to human activity. If a space thus defined was approved by

the auspices during its inauguration, it became a *templum*. The many sacred edifices built in the *templum* came to be known as *templa*. The most important element of a place of worship was the sacrificial altar. However the temple, built according to a circular or rectangular layout was the actual residence of the deity, and sheltered the statue devoted to its worship (cat. no. 148 and fig. 1). Urban planning provided the temple with its full meaning by placing it among other public buildings, thereby connecting it to all of the city's activities. Yet the ultimate emplacement of the Roman religion was probably the forum, a space shared by the city and the gods. For instance, the reliefs may be decorating Trajan's Forum (cat. no. 159) depict a public setting in which religious space merges seamlessly with political space. They show the facades of temples as delimiting the forum where citizens, magistrates, priests, and the emperor gathered. This communal space allows for cohabitation with the benevolent, nearby gods working for the common good and the earthly success of the community.

This daily coexistence was established both in the context of the city and within the private sphere of the *domus* as well. Here too, the closely detailed and pragmatic nature of Roman religion implied specific space, practices, and gods. By placing offerings in a small stonework or wood chapel often situated in the atrium of his home, the head of the family honored gods such as the *genius* (cat. no. 32) of the *pater familias*, the *lares* (cat. no. 161), who were divine protectors of his family's home, and the *penates*, who guarded the household hearth. Aside from these deities, families freely selected those gods with whom they felt an intimate connection, or who they felt looked upon them with favor.

Indeed, so long as the cult and, therefore, public order were preserved, individuals were free to choose their religious beliefs and practices. However, since Roman religion was necessarily linked to the structure of the society and the State, private religion was more frequently considered a form of superstition. It follows that Romans specifically attributed it to slaves and women—in other words, to those who were not citizens. As such, superstition evolved on an independent, complementary plane to the civic religion: it did not primarily denote a false belief, but an improper approach to the divine that included an excessive desire for knowledge based on the premise that gods were malevolent and to be feared. From this point of view, dialogue with the gods was impossible—magic being the only means to mollify or contact them (cat. no. 162). The fair and balanced pact with the gods that cemented the Pax Romana was thus broken by a servile attitude in direct opposition to the Roman citizen's ideal of liberty.

During the period when the empire experienced crushing defeats and its world order began to falter, this conception of man's relationship with the gods spread beyond the private sphere and endangered the public order. At the same time, the idea of the individual came to take precedent over

FIG. 1 *MAISON CARRÉE DE NÎMES*
Beginning of 1st century
Copyright Centre des monuments nationaux

the individual's participation in the community. Even in the instance of death, the notion of the individual had long been meaningless in the Roman religion: funerals and the cult of the dead were intended to provide a codified place for the deceased within a group rather than to dwell on a personal memory, as was the case with the art of the portrait.

Funerary rites were always public, celebrated in the necropolises situated outside the city, most often along the roads (fig. 2). For a time, burial (cat. nos. 181 and 182) coexisted with incineration (cat. nos. 175–77); it became rare in the first century B.C. but prevailed in the second century A.D. Funeral rites introduced the deceased into the community of the Manes gods—in a sense, the underworld—and returned his kin to the society of the living. Similarly, the banquet that followed the funerary sacrifice divided the parts of the slaughtered animal in such a way that the status of each protagonist was redefined: the deceased now consumed his share of the animal in the fire. The Parentalia (feasts of the dead) consistently sanctioned this particular status.

The offerings that accompanied the deceased into the tomb (cat. nos. 178–80 and 183) primarily recalled earthly happiness and did not relate to the salvation of the individual; however, decorations on third-century sarcophaguses reveal that the fate of the soul after death had developed

into a persistent concern. Contrary to a common interpretation, the rise of mystery cults, such as the cults of Bacchus (cat. no. 158) or of Mithra (cat. no. 171), did not pave the way for Christianity or testify to a revival of spirituality. Rather, the initiations required by these cults reveal a search for personal intimacy with the gods.

These are merely isolated examples scattered throughout the richness of an open, multicultural polytheism that was believed to be working for the common good. The Roman religion was entirely worthy of the empire it arose from in that it was wholly centered on the notion of action: the gods were action *(numen);* belief was action (ritualism without an actual myth); the civil religion was action (the pantheon grew following the conquest of new territory, and piety was expressed through processions); and monuments consistently shaped citizens' urban activities (inaugurations, fora, streets). With action itself being invested with a religious significance, the entire field of spirituality was imbued with a practical perspective.

With Christianity, the city of men and its practices is disavowed. Instead, the city of God is found through faith. The worldview of a "civic contract" had already been weakened in the final centuries of the empire. This shift now marked a complete reversal of the Roman perspective.

FIG. 2 *THE NECROPOLIS OF PORTUS ROMAE
OR ISOLA SACRA IN OSTIA: THE RUINS OF THE
CHAMBER TOMBS.*
2nd–3rd century
Cimitero Isola Sacra, Ostia, Italy
Photo: Alinari / Art Resource, NY

148 Jupiter

2nd century A.D. (?) ▪ Discovered in Italy ▪
Marble from Paros ▪ H. 72⅞ in. (185 cm) ▪
Purchased in 1807, formerly in the Borghese
collection (MA 24–INV. MR 254; N 1240) ▪
Restorers: A Liégey, P. Jallet, and G. Delalande,
2005

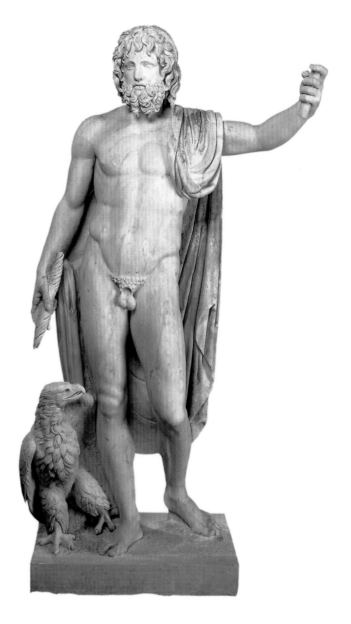

Here the god is shown standing, naked, a coat thrown over his left
shoulder. His left arm is raised and perhaps at one time leaned on
a long scepter. The thunderbolt in his right hand and the eagle at
his feet are other attributes of this lord of the heavens. Other signs
of his divinity, according to a schema established over time in
imperial-era Roman workshops, include his wavy hair escaping a
thick headband and falling over his forehead, and his full beard,
worked in trepan style. Traces of green on the central part of the
lightning bolt and red on his left eyelid and in the inner folds of the
drapery stir one to imagine the impact that this multicolored image
of serene majesty must have had.

Parts from modern restoration include the left arm, some folds
of drapery falling from the left shoulder, the hem of his coat held
under his right arm, his genitals, the ends of the lightning bolt, the
eagle (except for the left wing), the big toes, the front and back of
the base, and several fragments. The overall cleaning of the surface
by scraping out was also certainly done at various points after the
statue was placed in the Villa Borghese on the Pincio in Rome in
the eighteenth century.

The general appearance is in the style of Polyclitus, widely used
by Greek sculptors since the classical era, be it for representations
of Zeus at Sicyone by Lysippe, or of his avatar Sarapis by Bryaxis.
After the Hellenistic era, some Romans who sought to portray a
less idealized image were also inspired by this model, and sacrificed
their republican convictions to portray heroic nudity, as seen in the
work by Offelius Ferus in Délos, or Pompey in the statue currently
in the Palazzo Spada in Rome. Convincing despite its simplicity,
this style was extremely popular in the Roman world, as evidenced
by the innumerable replicas and adaptations that have been handed
down to us in many different materials and sizes. (C.P.-D.)

BIBLIOGRAPHY
Furtwaengler 1895, p. 212, n. 1.
Oehler 1961, no. 317, p. 71.
Picard 1936–66, vol. 4, 2, pp. 478, 878–96.
Martinez 2004a, no. 167, p. 108.

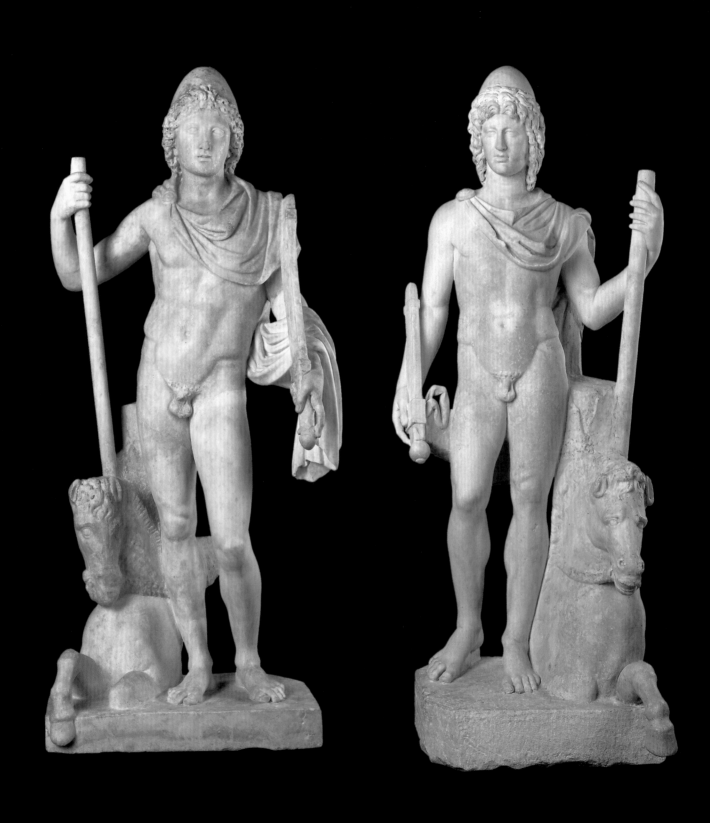

149 and 150 Dioscuri

2nd half of 2nd century A.D. • Discovered in
Italy • Marble • H. (MA 298) 66⅞ in. (170 cm)
• H. (MA 300) 65⅜ in. (166 cm) • Purchased
in 1861, formerly in the Campana collection
(MA 298 and 300—INV. CP 6509 and 6510) •
Restorer: D. Ibled, 2005

These two figures form a pair. Both are depicted nude, their long curly hair topped by a *pilos* (an egg-shaped, black felt skull cap), wearing a *chlamys* (coat) that is attached at the right shoulder with a round pin. Each holds an unsheathed sword and rests the weapon on a forearm. The other hand holds a stick, the bottom end of which is concealed in a tree trunk that supports the statue and a horse in harness, whose forequarters seem to emerge from a plinth. The front leg closest to the edge is propelled forward.

The statues are easily identifiable by their attributes: these are the Dioscuri, the twins Castor and Pollux, whose very birth guaranteed their unusual fate. Leda, after allowing her legitimate husband to pay her tribute, welcomed Zeus, who appeared in the form of a swan, to do likewise that same night. These love affairs bore fruit with the birth (from an egg) of Castor, Pollux, and their sister Helen, whose beauty would later prove fatal to the truce between the Greeks and Trojans, but only Pollux and Helen were made deities by the master of Olympus. Castor remained a mortal, like his father Tyndare. Having lived a life dedicated to the most heroic acts of warfare, Pollux shared his immortality with his beloved twin. A compassionate Zeus placed them among the stars, where both shine in the firmament in the constellation Gemini (cat. no. 160).

Another myth, of two brothers who broke relations with each other in warfare, thus partaking of human passion at the height of their powers, and who were finally deified, seems to have been lost over time and has been confounded with ancient indo-European astrological cults. The two brothers spend alternate periods as mortals and immortals, their joint immortality simply an allegorical expression of the natural progression of ashes and light. The adoption of the Greek cult of the Cabires by Italic peoples was widespread in cities in southern Italy and Sicily and met no opposition at the end of the fourth century B.C. and the next century. The Etruscans rapidly put up temples to them, most notably in Tusculum. When the Roman Aulus Postumius came into conflict with Tusculum, he took an oath that if the outcome of the Battle of Lake Regillus in 257 A.D. was in his favor, he would adopt the cult of these deities so venerated by his enemy. The Dioscuri emerged suddenly at the head of the Roman cavalry, thus assuring victory to the Romans. They then appeared at the Forum to announce the news to the inhabitants of Rome. A temple consecrated to them was built, beginning in 270 A.D., in the same spot.

The extension of the Roman Empire assured a wide diffusion of the cult of the Dioscuri. They were particularly venerated within the army but were also venerated by merchants, voyagers, and seamen. Beginning in the second century A.D., they became strictly associated with funerary rites, due to their Chthonian origins and luminous fate. (C.P.-D.)

BIBLIOGRAPHY
Froehner 1869, nos. 416 and 417, p. 384.
Caputo and Traversari 1976, p. 28.
LIMC III, no. 32, p. 615, pl. 491, "Dioskouroi-Castores."

151 Cameo with Jupiter

Imperial Roman era • Provenance unknown •
Double-layered sardonyx • H. 5¼ in. (13.5 cm);
L. 2¾ in. (7 cm) • Noted in 1816 registries
(BJ 1820—INV. MR 57)

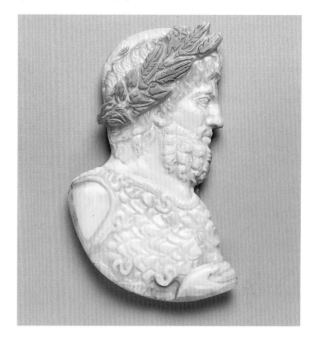

This bust features Jupiter in profile, looking to the right, wearing a crown of laurel leaves and ivy. His hair falls in undulating curls over his forehead, alongside his face and down his neck. The lower part of his right ear is exposed. His curly beard is divided into three distinct sections. The upper part of his torso is protected by the *aegis* (shield), covered with five snakes standing up to challenge the head of Medusa, who is visible in front of them. Jupiter grips a thunderbolt in his hand.

The cameo has several cracks: two start at the head of Medusa, one running toward the nape of Jupiter's neck, the other running through his beard. A third runs from the edge of the beard across the bottom of the cheek. A serpentine line on the face indicates repairs made to the lower forehead, eye, and nose. Fragments on the reverse side prove that the bust once rested on a support. The engraver worked deep into the material to attain the desired colors, leaving only the crown a darker hue.

It is not known why this great god in the Roman pantheon—god of the heavens, daylight, weather, thunder, and lightning—is rarely represented in gemstone and glass-paste cameos. Another surprising aspect to this piece is the crown: typically composed of oak leaves[1] or laurel leaves[2] and their fruit or berries, here it is composed of both. The *aegis*—made from the skin of the goat whose milk nourished Jupiter in Crete and on Mount Ida—serves as armor and is carefully detailed. An *aegis* is often depicted on a god or hero upon his departure from the empire. Augustus, who made a swift escape from a foray against the Cantabri tribe in Spain, relied on the gods to protect his safety: portraiture shows him wearing a crown, protected by the *aegis*.[3] The *aegis* thus became the attribute of sovereign power and covers the busts of his immediate successors.[4]

Certain iconographic details, such as the sectioned beard and curls covering the neck, are similar to those of a cameo in London from the middle of the first century A.D., which depicts Jupiter-Ammon facing Junon-Isis.[5] In that example, however, the workmanship of the engraving on the surface is quite different. (A.S.)

NOTES
1 Vollenweider 2003, text vol. pp. 78–80, no. 83; pl. vol. p. 11, fig. 83 (color); p. 65, fig. 83.
2 LIMC VIII, p. 435, no. 148, pl. 282, F. Canciani, "Zeus/Jupiter."
3 Richter 1971, pp. 99–100, no. 474, no. 477, figs. 474, 477.
4 Megow 1987, pp. 191–93, A70, pl. 23, 1.3.4.
5 Ibid., pp. 276–77, C13, pl. 17.

BIBLIOGRAPHY:
De Ridder 1924, p. 173, no. 1820.

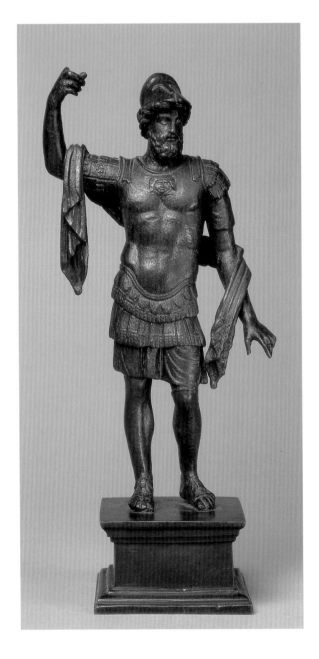

152 Mars Wearing a Breastplate

Early empire ▪ Provenance unknown ▪ Bronze ▪ H. 8⅛ in. (20.6 cm) ▪ Transfer from the Louvre's Department of Decorative Arts, 1897, formerly in the Lenoir collection (BR 667– INV. MNC 2189)

Mars, the god of war, wears a Corinthian-type helmet turned backward, the top of which probably had an attached crest. He has a dense beard and short, curly hair and is dressed in a short-sleeved tunic that stops above the knees. He wears a breastplate ornamented with a gorgoneion (Medusa head). A double row of fringed straps is attached to the armholes. The lower portion of the breastplate ends in *pteryges* (scalloped strips) and has two rows of rectangular protective panels with twisted fringe. A *paludamentum* (military cloak) in purple, the color reserved for generals and emperors, is thrown over his arms like a scarf. His feet are clad in sandals, his legs covered by metal leg-guards. Standing on his right leg, Mars once rested his left hand on a shield and held a lance in his right hand. The forefinger of the right hand is broken off. The base upon which the small statue rests is probably a modern addition.

Great care was given to this statue's execution. The close-fitting, anatomical breastplate is rendered quite realistically, as is the cloth of the garment, which falls in soft folds. The majestic pose and finely modeled face (including eyes inlaid with silver) convey the figure's nobility. The statuette was adapted from a statue in the Temple of Mars Ultor—Mars the Avenger, the god of war and symbol of the emperors' military power—erected in the Forum of Augustus in Rome and inaugurated in the year 2 A.D. Established by Augustus to avenge the death and honor the memory of his adoptive father Caesar, worship of Mars Ultor continued until the end of the empire.

The statue that adorned the Temple of Mars is known through marble copies, as well as numerous bronze adaptations of varying quality. The god is also represented on coins struck between the second and beginning of the fourth centuries A.D.[1] Numerous bronze statuettes have been found in Italy and throughout the Roman world. They were most likely destined for *lararia*—the altars placed in homes—but could also have been left as offerings to the god in military camp chapels. In fact, this type of bearded god wearing a breastplate was popular in the Roman army. (C.B.)

NOTE
1 LIMC II, p. 515, no. 24, pl. 384 (colossal statue found in the forum of Nerva in Rome), pp. 516–17, nos. 25–50, pls. 386–87 (bronze statuettes) and p. 530, nos. 231–35, pl. 399 (coins), E. Simon, "Ares/Mars."

BIBLIOGRAPHY
Furtwaengler 1897, pp. 62–63, fig. of the casting of the work.
De Ridder 1913, p. 93, no. 667, pl. 46.
Lebel 1962, p. 16, no. 6 (cited by way of comparison).
Boucher 1976, p. 376 (cited in the list of Mars figures wearing breastplates).
Simon, op. cit., p. 517, no. 43.

153 Aphrodite and Eros

Imperial Roman era ▪ Discovered in
Yakhmour (Syria) ▪ Bronze ▪ H. 9½ in.
(24 cm) ▪ Gift 1967, formerly in the Pérétié
collection and the Boisgelin-De Clercq
collection (BR 4427–INV. MNE 2) ▪ Restorer:
C. Pariselle, 2006

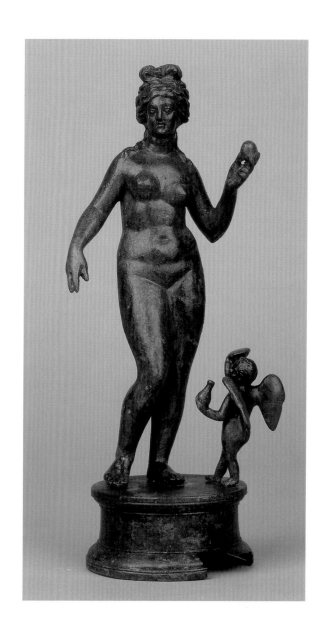

A naked Aphrodite stands with her weight on her left leg, her right
leg slightly bent. Her right hand, on which the two last fingers are
folded, probably held a butterfly, as does a similar small figure
found in Tartus.[1] The left arm is bent and the raised left hand holds
an apple, Aphrodite's characteristic attribute. The head, slightly
turned toward the right, is encircled by a small crown (*stephane*)
hidden by the hair, which separates into two coils on the forehead
and is pulled up into a chignon. Two locks fall to her shoulders. A
small Eros figure standing in front of her holds out an alabaster (a
small cylindrical flask for perfumed oil) in one hand and an open
box-style mirror in the other. The two small statues are attached to
a round, molded base that is broken off on the front.

Aphrodite's son, depicted as a naked and winged child, fre-
quently accompanies the goddess; he holds the objects for her
toilette.[2] The Eros, less carefully executed than the principal fig-
ure, is too small in proportion to Aphrodite. Fabricated locally, the
Aphrodite statue was probably inspired by numerous effigies of the
goddess created during the Hellenistic era, which frequently show
her at her toilette, taking her ritual bath.

The large number of bronze and terracotta statuettes of
Aphrodite discovered in Egypt and in the East demonstrate the
popularity of this deity, who had been assimilated with significant
indigenous goddesses, such as Isis-Hathor in Egypt, Atargatis in
Syria, and Astarte in Phoenicia (cat. no. 170). A symbol of love and
fertility, the goddess was associated with women throughout their
lives as wives and mothers, as well as in the afterlife, attested to
by figurines found in women's tombs. Some marriage contracts
from the Roman era, discovered in Egypt, mention a small statue
of Aphrodite, in bronze or silver, among the list of *parapherna*
(objects in a dowry), intended for the wife's personal use.[3]

This domestic worship is rooted in Roman traditions, which,
beginning in the second century B.C., had associated the Greek
goddess Aphrodite with Venus, a Latin divinity. In Rome, where she
was considered the ancestor of the Julii family, Caesar had erected
a temple dedicated to Venus Genitrix—Mother Venus—the city's
protectress. Inside houses, Venus-Aphrodite often had a place on
domestic altars and was the object of worship by the mistress of
the house, as seen on a sarcophagus from Arezzo, where a matron
addresses a gesture of greeting to a small statue of the goddess,
held out by a servant.[4] (C.B.)

NOTES

1 De Ridder 1905, pp. 87–88, no. 125, pl. 27, fig. 2.
2 The child sometimes holds an alabaster and a shell. See LIMC III, p. 877, no. 308, pl.
625, A. Hermary and H. Cassimatis, "Eros."
3 Burkhalter 1990, p. 515.
4 Veyne 1985, pp. 50–51.

BIBLIOGRAPHY

De Ridder 1905, p. 87, no. 124, pl. 27, fig. 1.
LIMC II, p. 161, no. 167, M. O. Jentel, "Aphrodite (in Peripheria Orientali)."

154 Minerva

2nd half of 1st or 2nd century A.D. ▪ Discovered in Italy (?) ▪ Marble ▪ H. 33⅜ in. (85.5 cm) ▪ Revolutionary seizure in 1798, formerly in the collection of the Duke of Modena (MA 674–INV. MR 288) ▪ Restorer: V. Picur, 2006

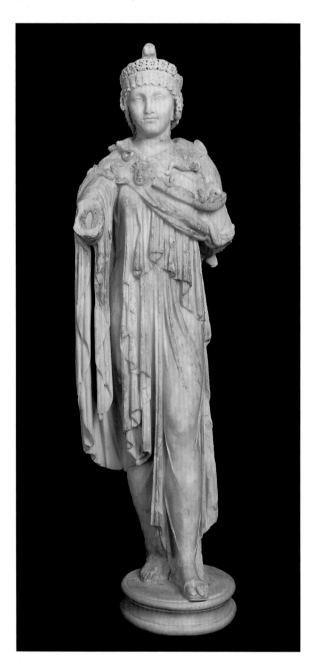

Here Minerva is represented standing, her left leg forward, her right arm in front of her, and her left arm probably alongside her body. The statue was once fitted with two modern arms carrying a scepter and a shield, which were removed in the twentieth century. The right foot and the plinth are modern.

The goddess can be identified by her helmet topped by a sphinx supporting the crest, and the *aegis*, the skin of the goat Amalthaea, which she wears across her chest. The helmet's style refers to Phidias's Athena Parthenos as it is known to us thanks to marble replicas, as well as the famous intaglio by Aspasios in the Roman National Museum and the medallion from Koul Olba in Saint Petersburg.

This classicizing model has, however, been completely modified with the addition of a floral wreath: Pindar and Athaenaeus's descriptions of a torch race in Corinth in honor of Minerva Hellotis, to whom myrtle wreaths were offered, have led to suggestions that these are myrtle flowers. The *aegis* worn transversally exemplifies other classical statues: this arrangement was invented by Phidias for the Athena Lemnia, then imitated on the eastern pediment of the Parthenon and, in the Agora, on the pediment of the Hephaisteion by the sculptor Locros of Paros. The gorgoneion (head of a gorgon) on the side seems to be reduced to a mere round fibula. The round-cheeked head contrasts with the austerity of the garments, which aim to evoke the archaic style. Indeed, Minerva is wearing a fine *chiton* and a transversal himation that cascade in same swallowtail folds as the Korai of the Acropolis and their imitations.

The statue is striking for such eclecticism of references. However, the composition of an Athena Promachos ("ready for combat") brandishing a spear and protecting herself with a shield likely dates back to a devotional statue created for the Tegea sanctuary by the sculptor Endeios in the sixth century B.C., the motif was widely disseminated in all forms and materials beginning in the archaic and classical eras (Acropolis bronze, Panathenaic amphora). Once the original ivory statue was taken to Rome by Augustus after the battle of Actium in 31 B.C., the motif became known throughout the Roman world. In archaizing Roman production of the imperial era, the subject became more complicated and developed several variants. A famous statue in Naples originating in Piso's Villa of the Papyri is a prominent example of a Severizing trend borrowing from the models elaborated in Paros: Minerva is seen in profile as she strides forward. Other examples (such as those in Poitiers, Palermo, Milan, and Chantilly), as well as the Louvre's statuette, depict a less animated Promachos, influenced by the rigid motif on the Palladion, the statue represented in scenes from the Ilioupersis (sacks of Troy). The exact date of pieces of this type remains uncertain: the arrangement of the locks of hair seems to emulate Julio-Claudian models, but the *aegis* could refer to the arrangement of the *paludamentum* in portraits from the Antonine era, a date that may also be confirmed by the use of the drill.

As sources of archaizing sculptures, the Temple of Isis in Pompeii, the Sanctuary of Eleusis in Greece, and Piso's Villa of the Papyri serve as reminders that the ancients attributed a certain nobility imbued with sacredness to the archaizing style: by using it, they aimed to evoke the ancient nature of a cult or a statue. In fact, the mere presence of a single archaizing statue in Pompeian paintings evokes parks and sanctuaries. (J.-L.M.)

BIBLIOGRAPHY
Zagdoun 1989, p. 49, p. 245, no. 324, pl. 1, fig. 5.
Fullerton 1990, pp. 55–56, p. 71, no. D1, fig. 23.
Paris 2000–01, p. 27, fig. 6.
Martinez 2004a, no. 197, p. 124.

155 Bacchus

Imperial Roman era · Provenance unknown · Bronze inlaid with silver · H. 7¼ in. (18.5 cm) · Delort de Gléon gift, 1921 (BR 4151—INV. MND 1357)

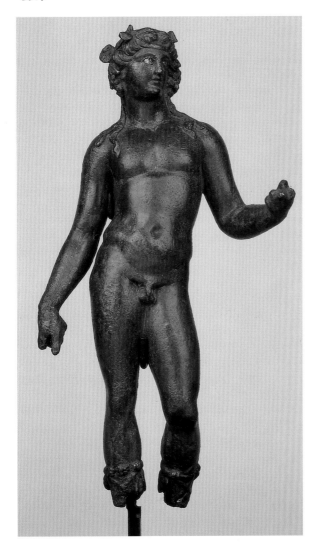

Bacchus, god of vine and wine, is here depicted nude, his weight on his right leg. He wears a crown of vine branches. Two bunches of grapes fall over his ears. His forehead is encircled by a headband known as a *mitra*. His youthful, full-featured face is turned toward the left, his glance directed upward. The eyes have hollowed-out pupils and are inlaid with silver. The hair is separated into two coils, pulled into a roll and knotted in a chignon at the nape of the neck. Two long, wavy locks fall to each shoulder. The right hand, the forefinger of which is broken off, is lowered and probably held a *cantharus*, a two-handled drinking cup. The left arm is bent and extended out from the chest; the hand, also missing fingers, once held an object (now lost). The legs, broken off below the calves, are clad in *embades*—the closed, laced-up boots that are characteristic of this god.

This very skillfully rendered figure has an S-curve stance. The marked contraposto, created by the body leaning on the right leg, is counterbalanced by the lifting of the left shoulder. This scheme, taken from the Greek sculptor Praxiteles, was often used by artists working in bronze during the Roman era for representations of youthful deities. The Bacchic repertoire, made up of images of the god and his retinue, was very common within the realm of the decorative arts, particularly for the ornamentation of furnishings and metal tableware; this statuette may have had a secular context.

Bacchus's posture, also inspired either by Praxiteles or his school, is shared by many Roman-era marble statues: the god, naked, leans his left arm on a pillar or vine stock. His head position and attributes may vary: most often, the lowered right hand holds a *cantharus*, and the left hand holds clusters of grapes.[1]

Two bronze statuettes of this type are known—one from Tunisia, the other from Egypt.[2] The latter is now in the Louvre (BR 347) and depicts Bacchus holding an attribute resembling a pomegranate[3] in his left hand. According to the origin of these statuettes, it seems that this iconography was more specifically valued in the southern Mediterranean basin. (C.B.)

NOTES
1 LIMC V, pp. 435–36, nos. 119–24, pls. 305–08, C. Gasparri, "Dionysos."
2 Manfrini-Aragno 1987, pp. 84–85, type BIIc, figs. 109–10.
3 De Ridder 1913, p. 55, no. 347.

BIBLIOGRAPHY
Unpublished

156 Mercury

2nd–3rd century A.D. · Provenance unknown · Bronze · H. 5⅝ in. (14.4 cm) · Purchased in 1825, formerly in the Durand collection (BR 530—INV. ED 4334)

A naked Mercury wears small wings over his short hair, which forms a crown of curls around his face and a roll at the nape of the neck. The head tilts toward the right. The god rests on his right leg, with the left leg slightly bent behind him. The thumb of the lowered right hand grips the long, narrow neck of a heavy purse in the shape of a goatskin, which is nestled in the hollow of his fist. Mercury's caduceus (a winged stick encircled by two snakes), now lost, was once held in his left hand and rested along his arm. The rendering of the anatomy and the beardless face, with hollowed-out pupils, is somewhat awkward.

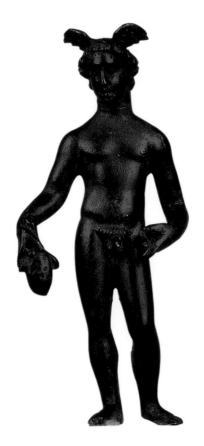

This statuette is related to an important series of bronzes of a standing Mercury. Portrayed in the Roman era with the features of an athletic young man, Mercury, identified with Hermes, was the Greek messenger of the gods and protector of travelers, merchants, and thieves. Many statuettes of him, of varying degrees of workmanship, were discovered in Italy, as well as in the western provinces of the Roman Empire, where the god was particularly popular. Made locally, they were fabricated in series, following a similar formula, whereby the god is depicted with identifying attributes: a merchant's purse and a caduceus. In many examples, Mercury wears a *chlamys* (a traveler's cloak), a *petasus* (a winged, broad-brimmed hat), and winged sandals.[1]

The purse is depicted in two different ways: held firmly by the neck or resting in the hollow of the hand, according to a model seen frequently in Gaul. This particular type may derive from the colossal bronze statue created by the Greek sculptor Zenodorus in 50–55 A.D. for the sanctuary of Arvernes in Puy-de-Dôme. This work in turn was inspired by a statue by Polyclitus, in the mid-fifth century B.C.[2]

The Louvre statuette, most likely Gallo-Roman, is similar to a figurine in the same style, dated to the late third century A.D. and now in the Mulhouse museum in eastern France.[3] (C.B.)

NOTES
1 LIMC VI, pp. 507–08, nos. 34 to 41, pl. 276, E. Simon, "Mercurius."
2 Boucher 1976, pp. 103–06.
3 Schnitzler 1995, p. 115, no. 137.

BIBLIOGRAPHY
De Ridder 1913, p. 78, no. 530, pl. 39.

157 Relief with Leto, Diana, and Apollo

End of 1st or beginning of 2nd century A.D. • Discovered in Italy (?) • Marble • H. 19⅛ in. (48.5 cm); L. 23¼ in. (59 cm) • Revolutionary seizure in 1798, former collection of Cardinal Albani (MA 519–INV. MR 870) • Restorer: A. Liégey and G. Delalande, 2005

The relief represents three characters in procession moving to the right toward a statue perched atop of a pillar. The statue depicts a naked young Apollo in the position of an archaic kouros, with his right leg forward and a *phialé* in his hand. The procession facing him is led by an Apollo wearing a *chiton* and *himation* and carrying a cithara. His hairstyle is particularly complex: long parotid locks are brushed back to the bust, while the hair at the back of the head is rolled and tied in an arrangement known as a *crobylos*.

Behind Apollo, his sister Artemis wears a diadem and *peplos*, brandishes a torch, and carries a bow. She walks ahead of her mother, Leto, who is lavishly decked out in a diadem, earrings, and a bracelet. She carries a scepter. Both the garments, falling in swallowtail folds, and the cult statue draw on the Roman style used in marble decorative furniture to refer to the archaic manner. Similar motifs are found on a monumental tripod base in Dresden and on the Louvre's Altar of the Twelve Gods (MA 666).

Certain physical postures allegedly date back to archaizing Greek reliefs, attested to as early as the fourth century B.C. by reliefs in Epidaurus (Athens National Museum) and in Samothrace; however, the design of this relief seems to be limited to a scaled-down copy of a more ambitious composition known through other reliefs. For instance, three other reliefs in the Louvre (MA 683, MA 964, and MA 965) represent one, two, or all three of the characters in this relief, while providing a more elaborate context to the scene: a temple is glimpsed behind a wall, before which stands the Apollonian triad, poised to serve a libation in the company of a Victory.

It has been suggested that the sanctuary represented here is the one in Delphi (given that the Omphalos, the stone symbol of the navel of the world, occasionally appears) or the Sanctuary of Zeus in Athens seen from the Sanctuary of Pythian Apollo, or—more likely yet—the Sanctuary of Apollo on the Palatine. Following this last hypothesis, the model for this composition would have been created under Augustus, who developed the sanctuary near his home following his victory at Actium in 31 B.C. Terracotta architectural plates, some of which were discovered on the Palatine, disseminated an iconography full of political symbolism, in which the victory over Antony and Cleopatra, who had placed themselves under Dionysus's protection, was attributed to Apollo, protector of Octavius, the future Augustus. (J.-L.M.)

BIBLIOGRAPHY
LIMC II, p. 413, no. 353, pl. 327 s.v.
Cain 1985, p. 100, n. 492.
Zagdoun 1989, p. 110, p. 246, no. 333, pl. 32, fig. 120.
Martinez 2004a, no. 994, p. 493.

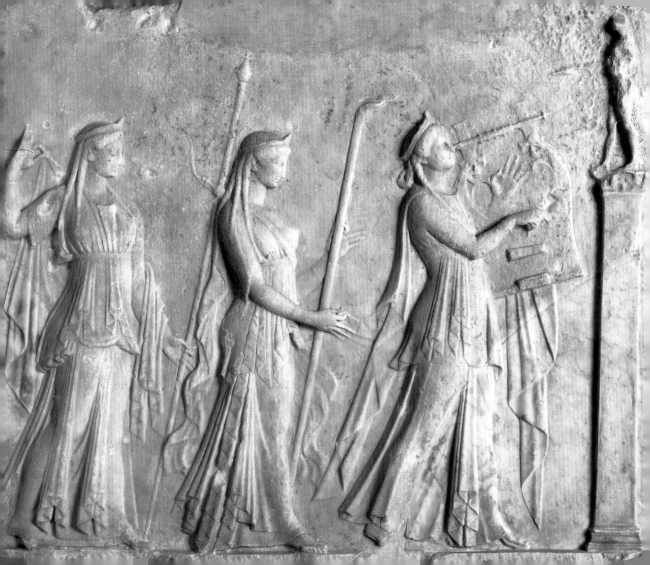

158 Dionysian Scenes

Ca. 60–80 A.D. ▪ Discovered in Herculaneum
(Italy) before 1775 ▪ Fresco-type wall painting
▪ Each, H. 9⅞ in. (25 cm); L. 23 in. (58.5 cm) ▪
Purchased in 1867, formerly in the Noël des
Vergers collection (P 27–INV. NIII 3073; P 28–INV.
NIII 3074) ▪ Restorer: D. Burlot, 2005

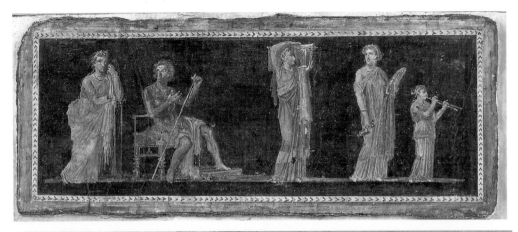

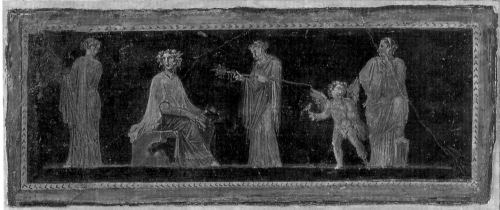

Discovered during the same period and in the same conditions as the trompe-l'oeil decor (cat. no. 80), these murals were part of a larger series that has been dispersed. After being mentioned in the *Catalogo degli antichi Monumenti* (1755), these *tabulae* (or *pinakes*) were first published in 1760, in volume two of the *Pitture antiche d'Ercolano*. Plates XIX to XXVII were devoted to a cohesive series of murals discovered in the same location, as was plate XII of the first volume of the books (1757). In all, ten panels are described, commented upon, and reproduced as engravings. The reproduction of panel XXVI shows that it was actually composed of two fragments from the same series but drawn from two separate panels. The site therefore yielded eleven separate panels, fragmentary or whole.

Aside from tabulae XXI and XXIII, which are in the Louvre, XXII is currently in Tokyo's Bridgestone Museum of Art; the sole surviving fragment of XX is in Munich, in the Archäologische Staatsammlung; XII, XIX, XXIV, and XXVII remain in the National Museum in Naples; XXV is in a private collection; and XXVI, which was composite and fragmentary, appears to be lost.

The restoration of the Louvre's tabulae has revealed that, contrary to a long-held belief, the chevron-decorated borders surrounding the scenes are not modern re-paintings. It follows

that these characters do not belong to a frieze but to a series of small, individual paintings, which could have been at the top of a wall, as if they were set on false cornices (as in the House of the Cryptoportico, Pompeii); or included in trompe-l'oeil backgrounds, like genuine small paintings hanging from candelabra (as in the House of M. L. Fronto, Pompeii); or perched on easels or hermes (as in the House of the Gold Bracelet, Pompeii); or, more improbably, at the center of vast red-brown panels (as in the House of Diomedes, Pompeii).

Renowned in the eighteenth century and notably copied on Capodimonte porcelain, these panels now represent about fifty realistic and mythological characters, all of whom are regularly spaced along a line on the ground. As the figures' identities, relationships, and the meaning of their gestures are completely unknown to us, the panels have been interpreted as having religious content of an initiatory nature. This theory is supported by many details related to religious worship. These small pictures have been compared to the megalographia in the Villa of the Mysteries in Pompeii, or to the Albobrandini Nuptials discovered on the Esquiline, which feature positions, activities, and garments similar to those of these panels.

In fact, the panels include two types of representations. XII, XIX, and possibly part of XXVI depict mythological episodes: respectively, Iphigenia recognizing Orestes and Pylades before her temple in Tauris, the agony of Marsyas, and a violent scene in which a man is lying on the ground. Though the other panels may be related to the cult of Dionysus (present in XXII), they do not represent specific events or even different stages of a religious ceremony. In fact, the attention to composition, pictorial balance, and symmetry seems to dominate the characters' spacing and expressions. The artist's hand was guided more by a desire to achieve certain effects than a narrative drive. Indeed, the painter succeeded in producing striking effect with limited means: the attitudes and poses depicted against a black background form a catalogue that puts us in mind of a series of studies primarily representing women. The faces and folds of the clothing are rendered through an impressionist technique in which parallel hatching successfully conveys volume and expression.

As indicated by this pictorial technique, the absence of spatial depth, and the simplicity of the characters represented, the painting is closely related to so-called "popular" art. However, the attention paid to composition and the elegance of shapes, along with the mythological and literary references, also relate it to "learned" Hellenistic painting.[1] (D.R.)

NOTE
1 Cerulli Irelli 1990.

BIBLIOGRAPHY
Roux 1862, pp. 1–29, pl. 1–9.
Tran Tam Tinh 1974, pp. 51–54.
Paris 1995, pp. 257–58, figs. 10–16.

159 Relief Showing the Reading of Auguries and Declaration of Sacred Vows

1st quarter of 2nd century A.D. ▪ Discovered in Rome, ca. 1540 ▪ Grey marble ▪ H. 64½ in. (164 cm); W. 90½ in. (230 cm) ▪ H. 79½ in. (202 cm); W. 66⅞ in. (170 cm) ▪ Purchased in 1807, formerly in the Borghese collection (MA 978—INV. MR 737; MA 1089—INV. MR 792) ▪ Restorer: D. Ibled, 2005

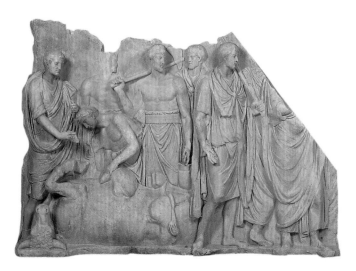

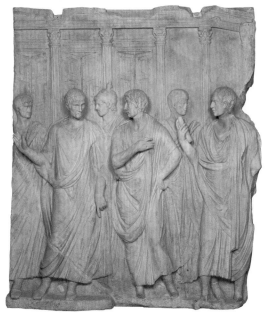

The scene unfolds on two panels sculpted in high relief, which today survive in fragments. On the left panel (159a) are a soothsayer and interpreter of entrails *(haruspex)* wearing a tunic and cloak, two sacrificial assistants, and a laurel-crowned *popa* (servant who slays the animal victims) wearing a ceremonial apron with a wide belt. They gather over a dead bull lying on its back. One of the two sacrificial assistants is standing, while the other leans over the newly slaughtered animal to examine its entrails. The *popa* carries a sacrificial ax over his right shoulder and a bucket in his left hand. On the animal's front left hoof, the sculptor has inscribed his name: M V[LPIUS] / ORE[S] / TES. Two lictors wearing a *sagum*, carry a bundle of fasces over their left shoulders: they provide a visual transition to the group presiding over the sacrifice: six toga-clad men, senators (among whom may be the consuls of that year), wearing *calcei* on their feet, all approach the emperor. At the emperor's left, in the background, a *flamen* (priest devoted to a single cult) appears, wearing a pointed headpiece. He is in fact the Flamen Dialis, Jupiter's priest in Rome, a figure who is rarely represented. The group is assembled in front of the facade of a hexastyla temple.

These reliefs, which have been heavily restored, have been known since the sixteenth century, well before they were incorporated into the façade of the Villa Borghese. A member of the school of Girolamo da Carpi (Gilli collection, Milan) drew them between 1540 and 1560, and they were also depicted by Pierre Jacques de Reims in the Capitol in 1576.[1] Evidence that the two panels do indeed belong together, these sources also give us various additional details of the scene: the pediment of the temple of Jupiter Capitoline and the heads of two toga-clad men, one of whom is

bearded, were in the large triangular section now missing from the right-hand panel; there was also a depiction of a Winged Victory carrying a banner *(vexillum)*. The pediment and male figures have not survived, but the Victory is in the Valentin de Courcel collection in Paris.

The Louvre's frieze depicts the religious ceremony, known as a *profectio,* that preceded the emperor's departure for a military campaign. This ritual was held on the Capitoline Hill, as indicated by the three symbolically opened doors of the temple of Jupiter Capitoline. Departures for campaigns, as well as victorious returns *(adventus)*, are frequently shown in reliefs. In the case of a *profectio*, the presentation of the bull at the altar or his actual sacrifice is the most commonly represented (cat. no. 39).

The precise moment depicted in these reliefs is exceptional: it shows the examination of the auspices *(haustia consultatoria)*, to assure that the requisite approval of the gods was secured before any departure on a warlike mission. The scene on the right shows the *extispicium*, the inspection of the bull's entrails by the priest in order to interpret the will of Jupiter. The Winged Victory in flight above gives incontrovertible proof of the god's opinion: the omens are favorable. The only other known depiction of this particular moment of the ritual appears in the frieze of Herôon on the sanctuary of Trysa in Lydia (now part of Turkey).

The related scene shown on the right panel depicts the emperor surrounded by the Flamen Dialis and senators; with his right arm raised, he is intoning the *nuncupatio votorum* (vows of victory). Once the omens are determined to be favorable, the sacrificial priest will place the entrails in the bucket held by the *popa*

for this purpose. The priests will then prepare the organs of the animal to be offered to the god, known as the *laeta exta*. The heart, liver, and lungs will be burned so that Jupiter can relish their scent. The emperor will soon don his cuirass and *paludamentum* (military cloak) to take command of the army, fortified by the favor of the gods.

The emperor's head, which has been restored, was originally turned to the left. His identification can therefore only be determined from the location where the reliefs were discovered, as mentioned by Antonio da Sangallo in his studies on architecture.[2]

The author also describes in detail the pediment of Jupiter's temple, which was drawn by Pierre Jacques among others. This reference, from about 1540, gives us the date and location where the reliefs were discovered. As it alludes to the eastern semicircular structure of the porticoes of Trajan's Forum, it must be this emperor who is shown here, about to depart on one of his many campaigns against the Dacians or the Parthians.

The Louvre's reliefs, which were signed by a Greek sculptor who had been freed by Trajan as indicated by his *nomen* and *praenomen*, can be compared to other panels on a comparable scale used in the Arch of Constantine. These were part of the large frieze that initially decorated Trajan's Forum, perhaps beneath the porticoes of the large courtyard in front of the *ulpia* basilica. The Louvre's reliefs are certainly unlike the spirited cavalry charges reused in the Arch of Constantine, and the subject matter is very different; but there are several similarities to comparable scenes shown on Trajan's Column and the Beneventum Arch, including the apron and belt worn by the *popa*, as well as the bucket he holds.[3]

The large frieze from Trajan's Forum has often been dated to the beginning of Hadrian's reign (117–138 A.D.), at least for its completion. The Louvre's panels also have a number of Hadrianic characteristics: the rather full togas are midway between the styles depicted in the Beneventum Arch (ca. 114–118 A.D.) and the reliefs of Hadrian distributing *alimenta* (alms) (ca. 136–138 A.D.), now in the Capitoline Museum. However, the togas of the men declaring the vows are not as full in this depiction. The Victory in the de Courcel collection may also be compared to the allegory of Eternity in the Sabine Apotheosis (ca. 136–138 A.D.), now in the Palazzo

dei Conservatori. In the opinion of I. Scott Ryberg, the drawing in the *Codex Vaticanus Latinus*, fol. 86c, depicting a bearded toga-clad man, may actually confirm the original presence of Hadrian himself in the missing triangular section of the left panel; however, this bearded head is very generic, and more recent excavations in Trajan's Forum since 1998 have generally diminished the extent of the construction performed during Hadrian's reign. It is difficult to determine whether a date late in Trajan's reign or during Hadrian's is correct for these reliefs; however, they represent a unique illustration of the Roman Empire's state religion at the beginning of the second century A.D. (L.L.)

NOTES
1 P. Jacques, Album de dessins d'après l'antique, executés à Rome (1577), pl. 29 and 38 on the copy at the Bibliothèque nationale de France. There are also drawings of the reliefs in the Berolinensis Codex (fol. 25r) and the Vaticanus Latinus (fol. 83).
2 Florence, Ufizzi Gallery, no. 1178.
3 The neo-Augustan hairstyles of the surviving heads are often used to support arguments for dating the reliefs to Trajan's era, but they were in fact reworked in more recent times; originally, they were bulkier.

BIBLIOGRAPHY
Michon 1909, pp. 217–23, fig. 11.
Scott-Ryberg 1955, pp. 128–30, figs. 69 a and b.
Koeppel 1969, pp. 146–48, fig. 5.
Zanker 1970, p. 516, fig. 25.
Koeppel 1985, pp. 154–57 and 204–12, figs. 35–40.
Leoncini 1988, pp. 29–32, figs. 1–3.
Turcan 1988, p. 34.
Goette 1990, p. 142, no. CA 21.
LIMC VIII, s. v. Victoria, p. 263, no. 321, pl. 287.
ThesCRA, I, p. 230, fig. 254.
Martinez 2004a, pp. 479–80, no. 969–70.

160 Altar Consecrated to Selene

2nd century A.D. • Discovered in Rome • Marble • H. 53⅛ in. (135 cm) • Purchased in 1807, formerly in the Borghese collection (MA 508—INV. MR 952; N 1096) • Restorers: D. Besnainou, 2000, and H. Bluzat, 2006

With a base and top edged by molding, this cylindrical altar depicts two profile images of the moon goddess Selene. Her bust is draped, and she rests on a crescent moon, the ends of which point toward eight-pointed stars. Two juvenile figures are placed between each representation of her, wrapped in short wool capes (chlamys). The ends of their capes float behind them. Their faces are turned toward one of the busts of Selene.

The busts of Selene surmount the representation of Titan Oceanos, identified by the dolphins in his beard and the crabs concealed in his hair. Beneath each youth is a torch: one youth, Phosphors, raises his gaze, and his torch stands upright; the other, Hesperos, gazes downward and watches as the flame of his torch is extinguished, as though it were plunging into the waves. This is clearly a figurative allegory of the waxing and waning lunar phases, and the moon is associated with the god Oceanos and the guardians of sailors sometimes seen as phosphorescent flames on the surface of waves or atop the masts of ships —St. Elmo's fire— (see cat. nos. 149 and 150).

This monumental base was probably dedicated by a navigator, by himself or with associates, to assure protection from the stars they relied upon for their very existence and for the success of long-distance expeditions. (C.P.-D.)

BIBLIOGRAPHY
Chapoutier 1935, pp. 277 and 278, fig. 50.
Dräger 1994, no. 41, pp. 213, and 214, fig. 62, 1.
Paris 2000, no. 30, p. 57.
Martinez 2004a, no. 1139, p. 563.

161 Dancing Lar

1st century B.C. • Provenance unknown • Bronze • H. 5⅞ in. (15 cm) • Purchased in 1825, formerly in the Durand collection (BR 683—INV. ED 4336) • Restorer: C. Pariselle, 2006

Executing a dance step, the household god lifts his right foot, while his left foot rests on a small bronze plaque. In his left hand he holds a patera; in his raised right hand he holds a drinking horn (rhyton) that terminates in the forequarters of a doe. His head is crowned by a garland trimmed with ribbons (lemnisci) that fall to the shoulders. His hair is separated by a center part, arranged in short locks, and headband encircles his forehead. The god wears a tunic with a studded surface, cinched at the waist with a cord; the left sleeve has slid off his shoulder and falls down along his arm. He wears ankle boots embellished with leaf-shaped cuffs.

Two figurines of lares—protectors of the home—flanked images of the deities placed in the lararium, the small domestic altar set up in the communal rooms of the home,[1] but this small statue, probably from a pair (with a similar figure striking the opposite pose), is different from traditional images of lares, which are customarily dressed in loose, flowing tunics. The coarse garment depicted here probably represents dog hide, which according to Plutarch, was sometimes worn by these deities.[2] The bare left shoulder and the right knee, bent and raised high, are also unusual features, making it possible to date the work to the pre-Augustan era, when the iconography of the dancing lar had probably not yet been clearly defined.

This figure most likely represented the lar compitalis (the lar of the crossroads), as opposed to the lar familiaris (the lar of the home), depicted with the features of an adolescent at rest. Lares of the crossroads protected agricultural lands located on either side of an intersection. Their worship, which was very ancient, was reorganized by Augustus between 14 and 7 B.C., when these figures were introduced throughout the various neighborhoods of Rome, in association with emperor worship. The image of the dancing lar, reproduced on monuments of official worship, became very popular and soon entered the private realm. In the frescoes that

embellish *lararia* in Pompeii, *lares* are shown in pairs on both sides of the *genius* of the master of the house. One hand pours wine from a drinking horn into a vessel held in the other hand, which is lowered. The stream traced by the liquid is sometimes depicted by fine red strokes, which form an arc above the young man's head.[3] (C.B.)

NOTES
1 Regarding the composition of *lararia*, see Adamo-Muscettola 1984, p. 9 s.
2 Plutarch, *Quaestiones Romanae*, 51.
3 Fröhlich 1991, pl. 1, pl. 10, 2, pl. 14, 2.

BIBLIOGRAPHY
De Ridder 1913, p. 95, no. 683, pl. 47.
Turcan 1988, p. 43–44, no. 115, pl. 45.
LIMC VI, p. 208, no. 53, pl. 100, Tran Tam Tinh, "Lar, Lares."
Boucher and Oggiano-Bitar 1995, pp. 234–35, fig. 3c.

162 Necklace with Intaglio

3rd–4th century A.D. (chain and intaglio); medieval period (rose-shaped ornament); modern era (setting) ▪ Discovered in the Middle East (?) ▪ Gold, colored glass, lapis lazuli ▪ L. of chain 15⅛ in. (38.5 cm); H. of medallion 1⅝ in. (4 cm) ▪ Gift 1967, formerly in the Péretié collection and the Boisgelin-De Clercq collection (BJ 2235–INV. MNE 78)

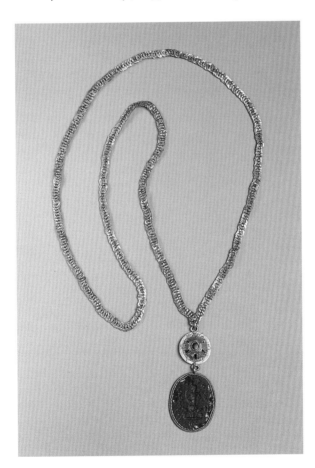

This necklace consists of two medallions. The first, suspended from a long chain braided in the loop-in-loop style, is round and convex, decorated with green glass fragments and encircled by six acanthus leaves. The second, an intaglio in lapis lazuli, is engraved on both front and back and set in gold.

The lower part of the intaglio is adorned with an *ouroboros* (a snake devouring its tail). In the center of the intaglio is a small boat carrying a child sitting on a lotus blossom. The child, nude and shown in profile, looks to his left, reaching to his mouth with his right hand holding a whip against his left arm.

He is surrounded by animals grouped in threes: clockwise from the lower left, the first group depicts crocodiles, falcons, and scarabs, followed by a group of caprides and rearing serpents. Carved on the reverse side are a lion on the ground looking to the left, beneath a half-nude female figure—an image of Aphrodite, looking to her left, clutching her hair, and standing with her hips draped. Above her head hovers a scarab with its front wings extended. Finally, an inscription—CABAΘIANANAΔ/IAIAWCABAWΘ—is engraved in a semi-circle along the edge, and inscribed in the background are two groups of letters: AI and WN.

The juxtaposition of these heterogeneous elements—and the way they are held together by modern gold chains—indicates that this necklace was recently redesigned.[1] Although it is unlikely that the floret ornament in the middle dates from antiquity, the chain and intaglio pendant may have always hung together as a necklace. Portraits painted on wood found in Egyptian necropolises depict similar necklaces. One example from the fourth century A.D., now in the Louvre,[2] has a long length of the chain—possibly incomplete—suggesting that the necklace was a large pendant suspended on a double chain that hung low on the chest. Such a necklace is also found in a portrait (now in Edinburgh) of an elegant Egyptian woman from Hawara, who died in the late second or early third century A.D.[3]

If the lapis-lazuli intaglio has indeed been worn as a pendant since antiquity (as it appears to have been), it was probably first worn as a talisman before being refashioned into a necklace. Stones were worn to protect against illnesses, to attract or keep hold of a revered but unpredictable being, or to indicate adherence to a set of beliefs. Several elements believed to have magical and protective powers—from natural elements such as plants and stones to certain incantations and inscriptions—would be combined to ensure the magic's success. After the stone's type and color were carefully selected, the amulet would be decorated with a subject appropriate to obtaining the desired outcome. Lastly, the reverse side was engraved with a magical formula. Here, in keeping with the style of amulets and other magical intaglios, the upper part was then pierced with a simple hole so it could be hung around its owner's neck.[4]

This pendant expresses a classical theme of Egyptian magical intaglios. The child sitting on the lotus is an interpretation of the origins of the sun according to the Hermopolitan creation myth.[5] The boat serves to symbolize the sun's daily and annual cycle. The animals that accompany the child in groups of three were purported to be ominous, and their presence on the amulet served to conjure nefarious powers. In general, only incantations in Greek were featured on the reverse side, most now indecipherable to us, but their presence enhanced the power of the images depicted. In this example, magical words accompany the goddess Aphrodite, whose appearance is similar to images of the goddesses depicted

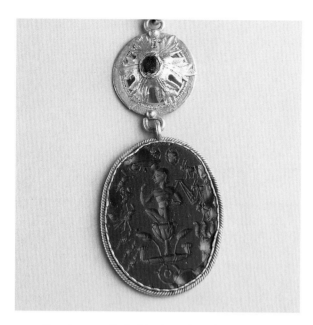

on an Egyptian gem, flanked by the gods Seth and Anubis.[6] And here Aphrodite holds her hair in the same manner as is seen in a series of intaglios thought to be talismans of love.[7] In those, the goddess is nude.

The decoration on this magical amulet, which places the goddess of beauty and love beside a typically Egyptian bestiary, and the use of a lapis lazuli found in the mountains of Egypt, suggest that this pendant is of Egyptian origin. It may have been engraved in Alexandria, a city renowned for its jewelry and glass-blowing studios, and whose wares were exported throughout the Mediterranean region in antiquity. (A.S.)

NOTES
1 Dominique Robcis, metal restorer at the Centre de Recherches de Restauration des Musées de France, examined this piece under a magnifying glass, and we are very grateful to him for sharing his conclusions with us.
2 Frankfort 1999, p. 18 fig. Louvre, Department of Egyptian Antiquities, inv. 1693, no. P. 202.
3 Pirzio Biroli Stefanelli 1992, p. 29, no. 29, p. 30, fig. Edinburgh, National Museum of Scotland, inv. 1951, 160.
4 Martin 2005, p. 187.
5 Delatte and Derchain 1964, pp. 106–09.
6 Zwierlein-Diehl 1991, p. 151, no. 2178, pl. 86, figs. 2178 a-b (dated from the second century A.D.).
7 Delatte and Derchain 1964, pp. 183–89.

BIBLIOGRAPHY
De Ridder 1911, pp. 191–92, no. 1169.

163 Head of Isis

Late 2nd or early 3rd century A.D. • Provenance unknown • Marble • H. 22⅞ in. (58 cm) • Purchased in 1817, formerly in the Marquis de Drée collection (MA 223–INV. LL 46) • Restorer: C. Devos, 2005

This head of Isis, turned to the right, with delicately parted lips, is almost entirely intact except for the ends of a few locks of hair and the left edge of her tiara. The neck stops at a recessed fitting, a tenon, indicating that the head must have been part of a statue. The Egyptian goddess is recognizable here by her coiled locks (known as Libyan curls) and by some of the decorative symbols on her tiara: the *uraeus* (cobra) and a feather on the left edge that evokes the quills of a falcon. This beneficent goddess had a large presence in the Egyptian pantheon, as seen in the cult that spread all the way to the west in the Roman era, particularly at the end of the first century B.C. (see cat. no. 164). The pomegranate and poppy also adorning the preserved edge of the tiara, the styling of cow horns as crescent moons that traditionally surround a *uraeus*, and the small horns surmounting the forehead are unique qualities in this representation. This version is a Greco-Roman syncretization: the pomegranate and poppy also allude to Demeter, while the crescent moon suggests Selene. The bovine appearance of the small horns may correspond to Isis and Hathor. The Greeks and Romans may also have interpreted this element as an allusion to Io, who was transformed into a cow by Hera.

The very skillful finish given to the skin, the almost abstract symmetry of the arch of the eyebrows, and the style of the pupils and hair—with sections of wavy locks separated by deep grooves—suggest that this work dates from the reign of Commodus (180–192 A.D.) or the Severan dynasty (193–235 A.D.). (L.L.)

BIBLIOGRAPHY
Freyer-Schauenburg 1983, p. 43, pl. 28-2.
LIMC V, p. 782, no. 268, pl. 518, "Isis."
Milan 1997, p. 114, III.33.
Hermann 1999, p. 79, no. 16, fig. 30.

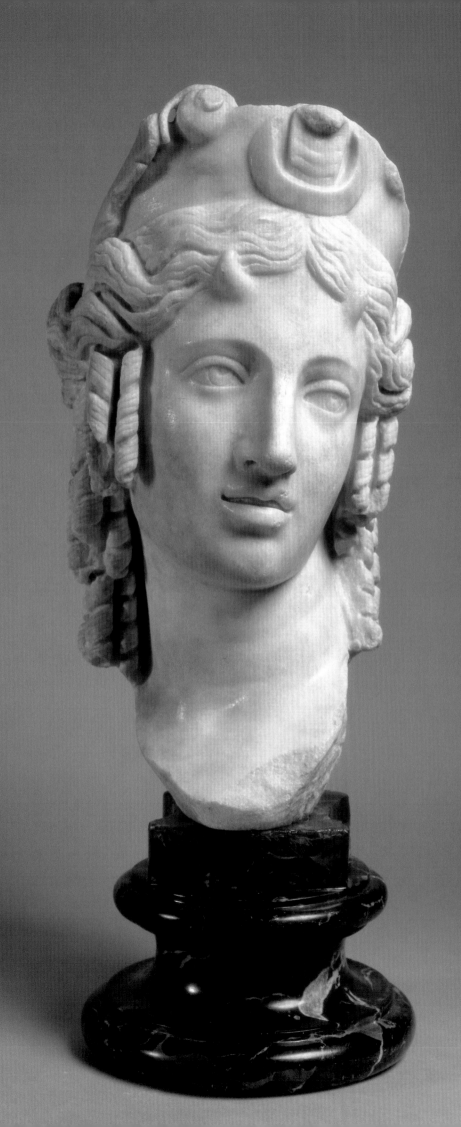

164 Statue of a Follower of the Cult of Isis

Imperial Roman era (?) ▪ Provenance unknown ▪ Marble ▪ H. 38⅝ in. (98 cm) ▪ Deposit 1959, Musée Guimet (MA 4726– INV. MND 2168) ▪ Restorer: H. Bluzat, 2005

With her hair separated in two sections of coiled locks, this figure is dressed in a long tunic, its folds slipping off to expose the right shoulder. A heavy fringed cloak hangs from the left shoulder and is wrapped around the body, under the right arm, and gathered in a knot at her chest. The fringed edge of the fabric drops in "napkin" folds from the center. The left arm emerges obliquely from this drapery just enough to expose the hand.

With fabric slung from one shoulder, like the vertical motif that echoes the front panel of Egyptian dress in antiquity, this style of dress is indicative of the cult of Isis. From Egypt, the Greek origins of the dynasty of Ptolemaic sovereigns accorded Isis a privileged place in the Alexandrian pantheon (see cat. no. 170). Her cult was widely disseminated throughout the Mediterranean region during the Hellenistic era, but some of its original aspects were changed. The faithful widow, who succeeded in saving the life of her spouse Osiris and whose devotion was rewarded with the birth of Horus, has been known ever since as a nourishing mother deity, a nature goddess who brings hope of renewal and fertility, similar to Demeter.

The Isis cult attracted primarily the lower classes: freed slaves viewed their new liberty in the guise of the goddess' role to free people from death. Her cult also attracted merchants and navigators, as it was via the wheat trade that the cult of Isis reached the Italian peninsula—not without influencing Platonic philosophy as it passed through the Greek islands.

It was thus by sea routes that the cult of Isis reached Campania in the second century B.C. It was introduced to the lower classes in Rome around 100 B.C. From that time on, the cult took root strictly in relation to the positions of Roman authorities. Periods of tolerance alternated with periods of crisis and the rejection of exogenous religions, despite the definitive annexation of Egypt in 30 B.C. The natural reticence of the Romans for eastern cults, however, gave way to the cult's rapid spread to the upper classes, demonstrating a genuine infatuation with the Egyptian goddess and an enthusiastic fascination for the strange rites and marvelous motives associated with her worship.

It is certainly convenient to view this small statue as a product of the Roman enthusiasm for Egyptian culture, but its origins are more Hellenistic than Egyptian. There are no attributes of antiquity: no *uraeus* (pitcher), Libyan curls, vulture, *sistrum* (rattle), or fibula to confirm an identification of the goddess. The coat is not even attached with the characteristic "knot of Isis." The absence of a headdress or of a rigid frontal view, as well as the care taken to preserve the goddess' modesty suggest that this is instead an image of a Roman devotee of the Isis cult. (C.P.-D.)

BIBLIOGRAPHY
Guimet 1896, p. 159, pl. 4.

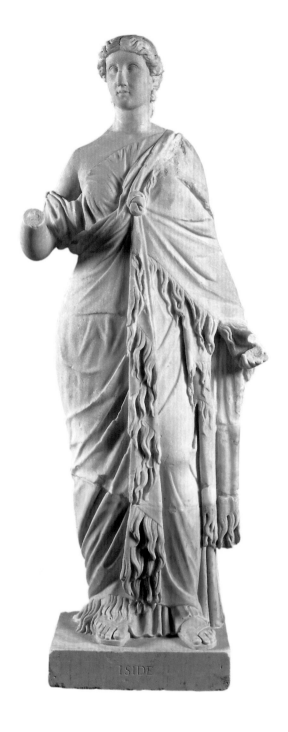

165 Stele Dedicated to Cybele Matyene

2nd century A.D. ▪ Discovered in Philadelphia (Turkey) ▪ Marble ▪ H. 30¾ in. (78 cm); W. 12⅛ in. (30.8 cm) ▪ Gaudin gift, 1898 (MA 3311– INV. MNC 2395) ▪ Restorer: R. Perréa, 2006

This lower part of this stele was cracked in two and has been repaired. It is topped with a triangular pediment decorated in low relief with a rosette and decorative elements *(acroteria),* featuring half-palmettes at the corners and a full palmette at the top. The stele is secured by a tenon that fits into its rectangular base. The sculptural field is framed by an arch resting on pilasters with inward-curving capitals. A dedicatory inscription appears on the plinth beneath the figure: a Roman citizen, Quintos Herrenios Geminos, dedicates the stele to Matyene.

The goddess Matyene is shown facing the viewer, her head turned slightly to the left, a leg bent toward the right. She wears a *chiton,* or tunic, beneath a *himation,* or cloak, which is rolled at the waist and draped like a veil over her head. Her right hand holds a shallow cup with an *omphalos.* Her left arm grasps a small animal, perhaps a sacrificial lamb, close to her body. She is flanked by two small lions, seated with their heads turned toward her, which allow us to identify her as Cybele, Mother of the Gods, who is known from the dedication in the stele by a special title, Matyene. In a local sanctuary, this invocation would have been used to summon her presence.

Interestingly, this stele does not depict Cybele as she had traditionally been shown since the sixth century B.C., seated, wearing a turreted crown, holding a drum, a lion resting on her lap or leaning against her legs. This different interpretation is based on Greek feminine types, used since the fourth century B.C. to represent divinities assuming mortal form. These sculptural formulas remained widespread in the art of Asia Minor during the Roman era. (L.L.)

BIBLIOGRAPHY
Michon 1906b, pp. 181–83, pl. 2.
Vermaseren 1987, p. 146, no. 487, pl. 108.

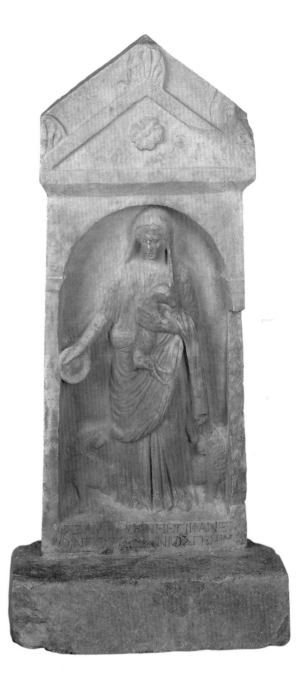

166 Lamp
4th quarter of 1st–1st quarter of 2nd century A.D. ▪ Discovered in Cyrene (Libya) and produced in Tunisia ▪ Clay ▪ H. 6⅛ in. (15.7 cm); W. 13¼ in. (33.6 cm); Diam. 5¼ in. (13.4 cm) ▪ Purchased in 1851, Vattier de Bourville excavation (INV. MN 852) ▪ Restorer: C. Knecht, 2006

167 Head of Serapis
End of 2nd or beginning of 3rd century A.D. ▪ Temple of Serapis in Carthage (Tunisia) ▪ Marble with traces of polychromy ▪ H. 24⅜ in. (62 cm) ▪ Gift 1889, formerly in the collection of Captain Marchant (MA 1830–INV. MNC 1129)

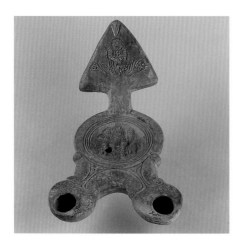

This lamp is exceptional due to its excellent condition and unusual size. The reflector is decorated with a half-length bust of an actor, standing on an acanthus-leaf base, hands joined, dressed in a robe and wearing a comic mask. There is no apparent connection with the ornamentation of the lamp's discus, which depicts the goddess Cybele and her companion Attis. The goddess was one of the most ancient divinities of Asia Minor, often referred to as the Great Mother or Mother of the Gods. She appears majestically enthroned, flanked by two seated lions, who symbolize her power over the forces of nature, and wearing a turreted crown while holding a *patera* (vessel for libations) and tambourine. A tall flaming torch stands at her left; at her right is the god Attis, wearing a Phrygian cap. As the story goes, Attis, in a fit of madness, castrated himself to become Cybele's servant. Her cult and its orgiastic rituals inspired a devoted following until the very end of the Roman Empire.

The maker's name is stamped on the lamp's base: Caius Junius Alexius, whose workshop was very active in Tunisia at the end of the first century through the first half of the second century A.D. (M.H.)

BIBLIOGRAPHY
Vermaseren 1966, p. 24, pl. 4.
Paris 2000, p. 107, no. 92.

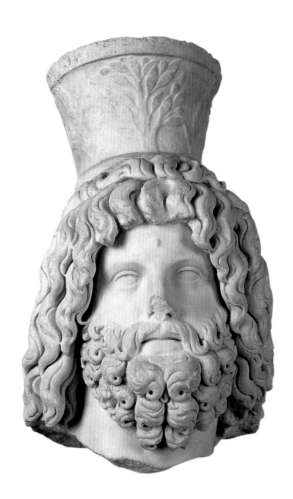

This head is a fragment of a colossal statue of the god Serapis, who is readily identifiable by his full beard and his long wavy hair. He is crowned by a *calathos*, a vessel used for agricultural measurement, decorated with blades of wheat and leafy boughs. Although the end of the nose and the locks of hair over the forehead have been damaged, the marble still retains some traces of red pigment on the beard and hair.

The cult of Serapis most likely originated during the reign of Ptolemy Soter I (322–382 B.C.), who established the Greek Lagus dynasty that ruled Egypt following its conquest by Alexander the Great in 331 B.C. Determined to place the capital of Alexandria under special divine protection, he resolved to establish a cult whose rituals could be shared by the indigenous population and its Greek conquerors. Ptolemy appropriated a popular divinity of Memphis, Osiris-Apis, whose name was initially rendered as Oserapis and later as Serapis by the Greek colonists. Depictions of Osiris had associated him with symbolism involving mummies and bulls, but this new god was stripped of these associations, which

did not correspond to the Hellenic notion of the divine; instead he would be depicted in a way that blended representations of Hades, Poseidon, Zeus, Asclepius, and Helios.

These divinities were all depicted with full beards and flowing hair; Serapis is represented with the addition of the *calathos*, which suggests his regenerative powers and thus supersedes his original association with the underworld. His position within the trinity of Isis was strongly supported by the Ptolemies and fully explains the immediate success of Serapis's cult, although it does not seem to have spread very widely beyond the territories dominated by the Lagus dynasty.

Romans, however, were intrigued by this Alexandrian god. He was considered to be the foremost divinity of Egypt, which Rome conquered in 30 B.C. His cult spread throughout the Mediterranean world, accompanied by its iconography, which reassured Roman sensibilities that were readily shocked by the exoticism of eastern cults. Modeled after the temples of Serapis in Alexandria, Canopus, and Memphis, colossal temples dedicated to Serapis proliferated throughout the empire, and various emperors became devoted followers of the divinity. Septimius Severus himself adopted the god's distinctive hairstyle in 204 A.D., and this head can be dated to his reign, based on the traces of chisel and trepan marks still discernible in the hair. (C.P.-D.)

BIBLIOGRAPHY
Héron de Villefosse 1921, no. 41, p. 6, pls. 10,1.
Atlanta 1994, no. 89, p. 172.

168 Sarapis

Imperial Roman era ▪ Provenance unknown ▪ Bronze inlaid with silver ▪ H. 13½ in. (34.3 cm) ▪ Purchased in 1885 (BR 511—INV. MNC 701)

Here Sarapis, dressed in a tunic with a *himation* draped over his hips and thrown over the left shoulder, stands with his weight resting on his right leg. He has a coiled beard and abundant, curly hair. Atop his head is a *calathos* embellished with an olive branch and a disk on the front, representing a star. His eyes, with hollowed-out pupils, are inlaid with silver. His left hand holds a poppy bough that ends with a cap encircled by three leaves, partially broken off. The forearm, made from a separate piece, is soldered to the drapery of the *himation*, which was cast with the torso. As indicated by the orientation of the shoulder, the right arm, now lost, was raised. The still-intact left foot is clad in a knotted boot known as a *calceus senatorius*, which was reserved for deities and important figures.

The god probably was making a gesture of greeting or benediction, as seen in a similar statuette in a museum in Florence.[1] The locks of hair, lifted and spread over the forehead, are characteristic of images of Sarapis from the Hellenistic period and appeared again during the Trajan era. Executed in a hollow casting and finely modeled, the figure belongs to one of the two major iconographic types known through Roman-era copies, which show the god standing or seated on a throne. Representations of the god enthroned, depicted with the features of Hades, god of the Underworld, were probably inspired by the statue of worship from the Sarapeum in Alexandria, built in the Egyptian quarter of Rhacotis, on a hill overlooking the city.

The origins of the worship of Sarapis remain uncertain (see cat. no. 167). A universal god, healer, and dispenser of earthly goods,

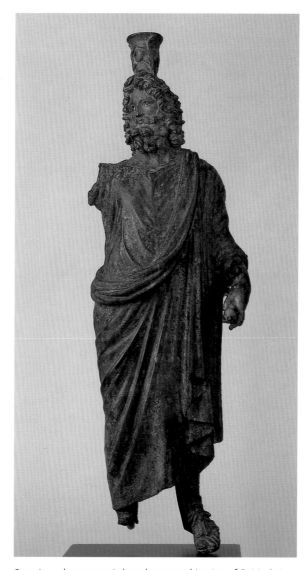

Sarapis—whose name is based on a combination of Osiris-Apis—was identified with the gods of the underworld, Osiris and Hades. Later he was assimilated with Zeus and Helios, the sun god. In the Roman era, he was customarily depicted as he is here, crowned with a measuring receptacle and holding a poppy in his left hand. The grain measure, like the olive branches that adorn his hair, symbolized agrarian fertility, while the poppy was both a funerary and a fertility symbol.

The worship of Sarapis, declining by the second and first centuries B.C., regained its status due to the popularity of Isis, with whom the god was associated. He became known (and worshipped) in the Roman world as the consort of Isis and occupied a place within the Isiac triad, alongside the goddess and her son, Harpocrates. Beginning with the reign of Commodus (180–192 A.D.) and the Severan dynasty (193–235 A.D.), he was also the protector of certain emperors, to whom he guaranteed prosperity and military success. (C.B.)

NOTE
1 Hornbostel 1973, pl. 198, fig. 327.

BIBLIOGRAPHY
De Ridder 1913, p. 76, no.11, pl. 38.
Jongkees 1948, p. 36.
Hornbostel 1973, pl. 199, fig. 328.
Kater-Sibbes 1973, p. 191, no. 997.
Besques 1978, p. 226–27, fig. 12.
LIMC VII, p. 674, no. 66, pl. 507, G. Clerc and J. Leclant, "Sarapis."

169 Sarapis Cameo

Imperial Roman era ▪ Provenance unknown ▪ White agate, iron ▪ H. 3¾ in. (9.5 cm) ▪ Purchased in 1861, formerly in the Campana collection (Bj1825) ▪ Restorer: D. Robcis, Centre de Recherches et de Restauration des Musées de France

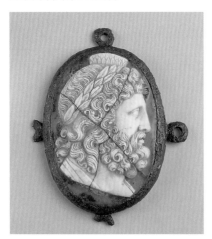

The oval iron setting of this cameo has four small rings attached at the edge, two of which are broken. The cameo has two overlapping cracks: the first from the top of the forehead to the middle of the base of the neck, the second from the nape of the neck to the chin.

Shown completely in profile, the face ends at the neckline. The flat *modius* (or *calathos*, cat. no. 167) with a double row of languets suggests a plant theme, symbolizing agrarian fertility; its placement on top of the head identifies this face as the god Sarapis. A crown of laurel leaves neatly separates the hair in two sections and tightly holds the long and sinuous locks in place along the back of the head. The thick curls in front tumble in two waves down to the edge of the drapery that covers the neck.

According to W. Hornbostel's studies, there are two distinct ways to depict this god's hair.[1] In the first, known as *anastole*, the hair is gathered above the forehead and falls down around both sides of the face. This style was mainly used during the Hellenistic era, inspired by images of gods from classical times, such as Zeus, Poseidon, and Asklepios. In the second style, known as *fransentypus*, the hair has evenly spaced locks covering the forehead; but in the example shown here, the layers of curls suggest it belongs to the first group, and should be dated from the early second century A.D., when the predominant themes in Greek art enjoyed a revival of interest and influence.[2]

The four rings on the perimeter of the piece were part of the original setting and suggest that the medallion may have been fastened to another object from the top or center. Many cameos were reconfigured during the medieval and modern eras to decorate liturgical objects such as crosses[3] and coffers.[4] (A.S.)

NOTES
1 Hornbostel 1973, p. 133, pp. 208–10.
2 LIMC VII, p. 690, G. Clerc and J. Leclant, "Sarapis."
3 Bourges 2004, pp. 207–08, no. 53. Nine small cameos from the cameo cross, one of which depicts Hades Serapis; Richter 1971, p. 111, fig. 539. A cameo is set in the back of a sixteenth-century cross.
4 Paris 1991, pp. 95–98, fig. Top of the "Escrain de Charlemagne," bust of Julia Titus.

BIBLIOGRAPHY
Clément 1862, p. 165, no. 737.
De Ridder 1924, p. 174, no. 1825, pl. XXI.

170 Isis-Aphrodite

2nd century A.D. ▪ Discovered in Lower Egypt ▪ Bronze inlaid with molten glass ▪ H. 22⅝ in. (57.5 cm) ▪ Purchased in 1852, formerly in the Clot-Bey collection (BR 12–INV. MN 1585) ▪ Restorer: M.E. Meyohas, 2006

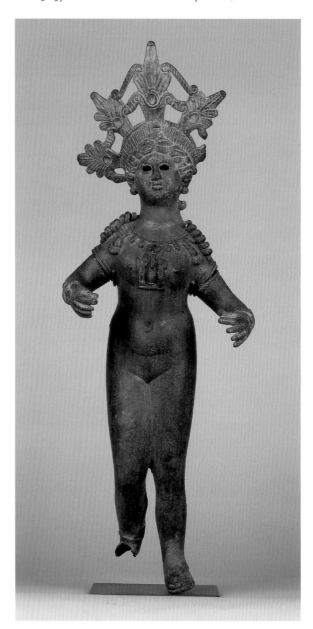

Wearing sandals and adorned with jewels, the goddess stands with her weight on her left leg, her arms outspread. Between the thumb and forefinger of her left hand she probably held the handle of a utensil, now lost. She wears a crown *(stephane)* surmounted by a diadem with five radiating palmettes, one of which is broken off. Her center-parted hair is arranged in a chignon at the nape of the neck, and two long corkscrew curls fall to her shoulders. Her adornments include sphere-shaped earrings, five bracelets worn in pairs on the upper arms and in a serpentine form on the wrists and right ankle, and an impressive ornamental breastplate, with heart and crescent-shaped pendants, from which hang three amulets: two small busts and a large pendant between them.

Made in a hollow casting, the statuette has heavy, schematically modeled forms. The waist is scarcely indicated, the hips broad, the legs separated only from the knees down. The arms were fabricated separately; the double bracelets concealing the joints beneath. Openwork metal lightens the heavy diadem, where each palmette was probably inlaid with a cabochon of stone or molten glass. A blue glass bead still adorns the crescent shape of the breastplate, and the hollowed-out eyes of the figure clearly contained inlays.

The statuette presents a synthesized image of Isis and Aphrodite that appeared in Alexandria beginning in the third century B.C. She was of a type and iconography probably created in Lower Egypt, which represents Aphrodite adorned with the emblems of Isis. At the front of the diadem is a representation of the *uraeus*—the cobra that adorned the crown of the pharaohs, while the radiating palmettes evoke the Phoenician goddess Astarte. The central palmette probably was inspired by the *basileion*, an Isiac symbol formed from the headdress of Hathor—a solar disc between two horns—surmounted by two feathers. The goddesses Hathor and Astarte, who, like Aphrodite, embodied love and marriage, had been assimilated with Isis before the arrival of the Greeks in Egypt.

On the necklace are two small busts depicting Isis and Sarapis, a deity combining the features of Zeus and Osiris (see cat. nos. 167–69). Three deities adorn the large pendant: at the center is Osiris Canope, a particular form of Osiris where the head rests on an ovoid jar, crowned with an emblem. To the right is Harpocrates, the infant Horus, son of Isis, who brings his forefinger to his mouth according to the traditional iconography. To the left is Aphrodite Anadyomene—Aphrodite emerging from the bath, drying her hair, and represented half-naked. This motif, particularly prized in Egypt, is sometimes associated with the goddess Isis.

First adopted by the Greeks, the worship of Isis had many adherents in Italy and in the Roman provinces during the first and second centuries A.D. In 69 A.D., Emperor Caligula officially consecrated a temple to her on the Capitoline hill. (C.B.)

BIBLIOGRAPHY
De Ridder 1913, p. 9, no. 12, pl. 3 (inventory number erroneous).
Paris 1970, pp. 145–46, no. 175.
Jentel 1981, pp. 152–53, pl. II, 1.
LIMC II, p. 158, no. 85, pl. 162, M.-O. Jentel, "Aphrodite (in peripheria orientali)."
LIMC VII, p. 126, no. 75, G. Clerc, and J. Leclant, "Osiris Kanopos."
Sannibale 1995, p. 16, n. 6, and appendice pp. 32–35.
LIMC V, p. 779, no. 249b. (with comparisons), Tran Tam Tinh, "Isis."
Williams 1979, pp. 95–96, no. 11, pl. 10 a.

171 Mithraic Relief

Late 2nd century or 389 A.D. ▪ Discovered in Sidon (present-day Saida, Lebanon), 1881 or 1882 ▪ Marble ▪ H. 17½ in. (44.5 cm); L. 30⅜ in. (77 cm); D. 3¾ in. (9.5 cm) ▪ Gift 1967, formerly in the Pérétié collection and the Boisgelin-De Clercq collection (DEPARTMENT OF EASTERN ANTIQUITIES, INV. AO 22255) ▪ Restorer: M.-E. Meyohas, 2001

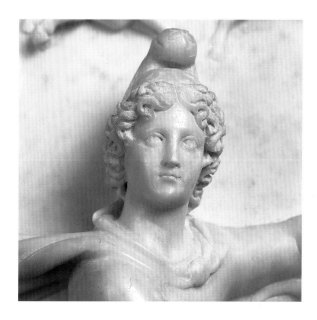

This relief depicts a tauroctony, a scene in which the god Mithra sacrifices a bull. In this scene, which represents the most important aspect of the pagan cult of Mithra, the god, having subdued the bull by blocking it with his left knee and gripping it by the nostrils, drives his dagger into its throat. A dog, a snake, and a scorpion attack the wounded animal and feast on its blood. Mithra wears a long-sleeved tunic, a Phrygian cap, and laced boots. His *chlamys* (cape), decorated with stars and fastened at the chest with a fibula, dances in the wind.

The central scene is surrounded by symbolic motifs: on either side of Mithra's head are busts of Helios and Luna, in each corner are busts of the Seasons, and around the edges are the twelve signs of the zodiac. The two crows may represent the messengers of the sun, who have come to give the god the order to kill the bull. It should be noted that the grotto in which the sacrifice supposedly took take place does not appear in the panel.

This sacrificial act symbolizes the struggle between the sun and darkness, good and evil. Sacrificing the bull ensures the fecundity and salvation of the world. The cult of Mithra, a god of Iranian origin, enjoyed great popularity toward the end of antiquity. Initiates were categorized according to seven levels.

This small-scale relief was discovered at Saïda at the end of the nineteenth century along with eight sculptures in the round, including another tauroctony; Mithra carrying the bull; the god's two torch-bearing acolytes—Cautes and Cautopates; two characters carrying a double axe; a monstrous creature with a lion's head—probably Aion-Kronos; and a triple Hecate. The series was part of the decor of a vast underground building. The building's

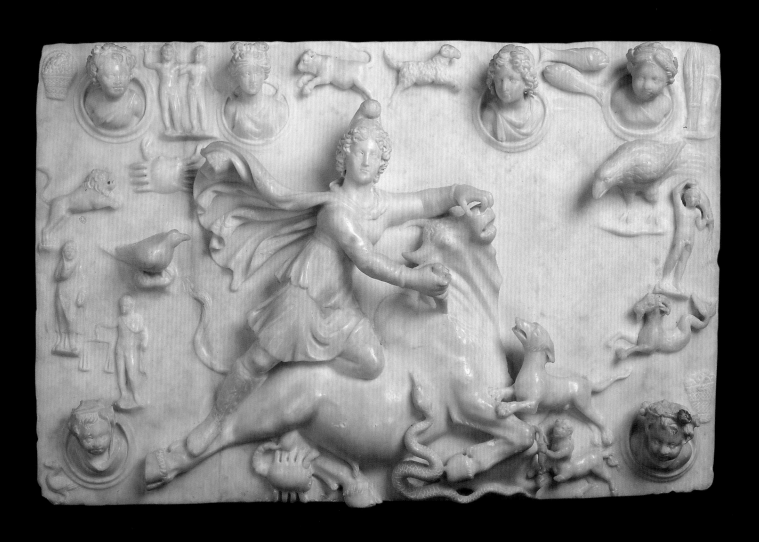

discoverers, Alphonse and Edmond Durighello, provided a highly colorful description[1] but never revealed its exact location.

Three of the statues have Greek inscriptions at their bases, indicating that they were dedicated by a certain Fl. Gerontios, a high dignitary of the Mithraic cult, in the year 500. Determined according to the Seleucid era, this date would be equivalent to 188 A.D., the date established by A. de Ridder in the first published reference to the piece. Yet as E. Will has demonstrated, calculating the date from the era of Sidon brings us to 389 A.D., a date more compatible with the style of the piece. This relatively late date proves that the Mithraic cult was still in full bloom in the Orient shortly before pagan cults were banned from the empire. Still, this hypothesis should be qualified by the fact that the sculptures from the *mithraeum* in Sidon are not homogeneous. The craftsmanship of the relief is much more refined than that of the sculptures in the round; therefore, one could plausibly date this piece to the second century A.D. (E.F.)

NOTE
1 E. Durighello, in *Le Bosphore égyptien* (August 19, 1887), quoted by S. Reinach in *Revue Archéologique*, new series 11 (January–June 1888).

BIBLIOGRAPHY
De Ridder 1906.
Will 1950, pp. 261–69.
Caubet, Fontan, and Gubel 2002, pp. 87–97.

172 Portrait of a Priest of Serapis

Ca. 130 A.D.–140 A.D. ▪ Memphis (present-day Saqqara, Egypt) ▪ Marble with large crystals and traces of polychromy ▪ H. 13 in. (33 cm) ▪ Purchased in 1901 (MA 3169–INV. MND 417) ▪ Restorer: H. Susini, 1999

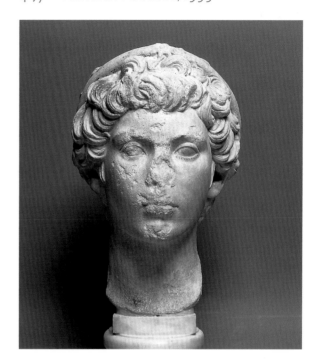

This portrait shows a young man, his head crowned by a broad bandeau, or ribbon, with a star over the forehead. The existence of a cylindrical base shows that this head was to be mounted on a statue. Such sculptures were produced in quantity in ancient workshops and could be individualized to varying degrees depending on the requirements. The irises are incised and retain traces of brownish red pigment as on the locks. The nose is destroyed, and there is considerable damage to the chin, lips, cheek, right eye, and left eyebrow.

The ribbon—which can be identified as a royal bandeau—once[1] led to the head being identified as that of young King Ptolemy III of the Lagus dynasty; however, the star means that this is in fact a portrait of a young priest of Serapis, an identification supported by the work's provenance, the Temple of Serapis in Memphis. This building was the site of the necropolis of bulls sacred to Apis in Pharaonic times. During the Hellenistic and Roman eras, it became a primary center of the cult of Serapis, together with the city of Alexandria.

Dating this portrait is a complex matter. It could be dated to the first century B.C.,[2] but comparison with similar portraits made later suggests that it was sculpted in the Antonine period. This hypothesis is supported by the distinctive gravity of the representation. (C.P.-D.)

NOTES
1 Poulsen, 1947.
2 Charbonneaux 1963.

BIBLIOGRAPHY
Charbonneaux 1963, p. 54.
Goette 1989, no. 3 p. 174, pl. 15.
Fittschen 1999, no. 6, p. 81.
Poulsen 1947, pp. 133 and 134, figs. 10 and 11.

173 Portrait of a Priest

1st century B.C. ▪ Discovered in Egypt ▪ Wadi Hammamat graywacke with a plate of whitish quartz on the upper right portion of the face ▪ H. 8⅝ in. (22 cm) ▪ Purchased in 1952, formerly in the Nahman collection (MA 3530—INV. MND 2053)

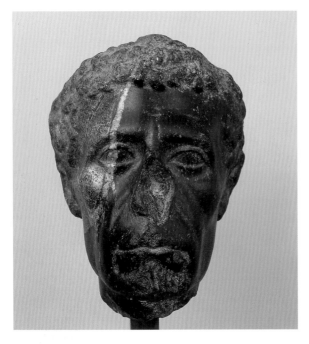

This austere head portrays an elderly man, his prominent cheekbones accentuated by deep wrinkles and the entire lower part of the face sagging into folds around the mouth and chin. This rather fluid, sensitive, aesthetic treatment contrasts with the hardness of the material revealed by the head's barely polished hair.

The man wears a semi-circular wreath visible from the sides and the back but interrupted at the center by a broken ornament that may have been a lotus flower. This may be the "wreath of justification" found on Roman-era mummies, as referred to in book 19 of the *Book of the Dead*. But experts have also found it reminiscent of the wreath made of palms found on those initiated to the cults of Osiris. In this case, the portrait could be of a priest rather than simply one of the initiated. The material (used to reproduce the Negroid features?) and the presence of the vertical dorsal pillar behind the head are reminiscent of the techniques of Egyptian sculpture. Indeed, the Louvre head belongs to a group of portraits from Roman Egypt (in Brooklyn, Athens, and Trieste) that combine the realism of Hellenistic and Roman art with the hieratic quality of the Egyptian tradition. (J.-L.M.)

BIBLIOGRAPHY
Charbonneaux 1966, pp. 414–20.
Adriani 1970, pp. 79–80, pl. 38, 41, 1.
Kersauson 1986, pp. 22–23, no. 6 bis.

174 Portrait of Melitina

163–164 A.D. ▪ Discovered in the Metroon of Piraeus (Greece), 1855 ▪ Marble ▪ H. 27½ in. (70 cm) ▪ Purchased at auction in 1914, formerly in the Vassoigne collection (MA 3068—INV. MND 1014) ▪ Restorer: A. Courcelle, 2006

Remarkable for its excellent condition, this portrait bust shows a middle-aged woman whose hair is parted in the middle, arranged neatly in waves and gathered at the nape of her neck into a braided chignon, a style made popular by Faustina the Younger (cat. no. 54). Beneath her draped mantle she wears a finely pleated tunic. A wreath of acanthus leaves connects the bust and its base, which bears the following inscription in Greek: "Melitina, daughter of Primos of Peania, has dedicated this bust during the Archonate of Philstides, having been a priestess, Philemon, son of Praxiteles of Phyla, was then a priest."

Based on the dedication of this portrait of a woman who had been a priestess of Cybele from 154 to 155 A.D., these details allow us to date the bust to 163–164 A.D. The acanthus leaves, often associated with death, suggest a funerary portrait, but we cannot be sure whether the bust was made posthumously or ordered by Melitina herself and sculpted from life.

The Metroon of Piraeus, where the bust was found, was not a state shrine. Consecrated to the Mother of the Gods and to Attis, it belonged to an association that appointed a priestess annually. The priestess was assisted by a college of priests. Holding this enviable office explains Melitina's desire to perpetuate her memory by placing her image in the sanctuary where she had served.

The sculptor has clearly conveyed the aura and authority of her position. Although her garments are treated in a somewhat simplified manner in the provincial style, her features are rendered with objective realism; her face shows the marks of age, and her severe gaze—emphasized by the eyes' hollowed pupils and the engraved irises—gives testimony to an earnest, resolute character. (C.P.-D.)

BIBLIOGRAPHY
Froehner 1864, no. 110, p. 211.
Jucker 1961b, pp. 97 and 98, no. ST 45, pl. 38.
Charbonneaux 1963, pp. 171 and 172.
Kersauson (de) 1996, no. 139, pp. 308 and 309.

175 Urn with Foliate Ornamentation

Late 1st–early 2nd century A.D. ▪ Provenance unknown ▪ Marble ▪ H. 17⅜ in. (44 cm) ▪ Documented in the Louvre's collections in 1817 (MA 94—INV. MR 903) ▪ Restorer: H. Bluzat, 2006

This tall, chalice-shaped vase or urn has a lid with a pinecon shaped handle. On the body, slightly protruding handles are decorated with nets that seem to link the tails of two dolphins separated by a shell. Foliate ivy vines spring from the dolphin's mouths. The surfaces of both lid and urn are covered with leaves and branches.

Such ornamentation has Bacchic symbolism: ivy and dolphins are attributes of Dionysus. The dolphins recall the events of his voyage to Naxos, when the pirate crew decided to kidnap the young god and sell him into slavery. Dionysus immobilized the boat by covering it with climbing ivy and transforming the ship's ropes into

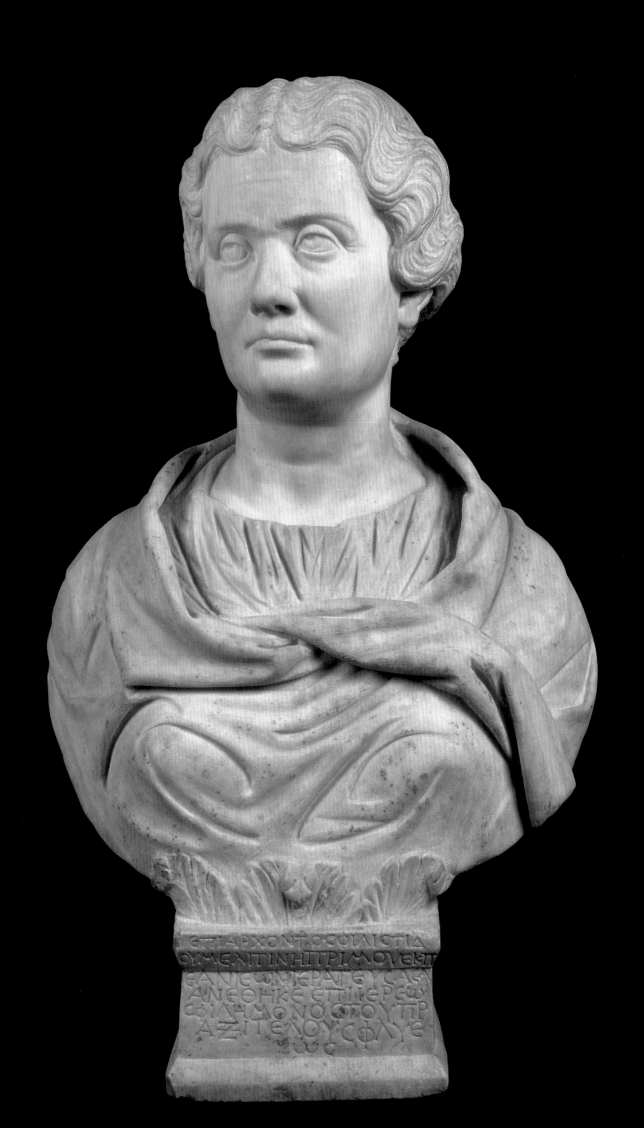

ΕΠΙΑΡΧΟΝΤΟΣΦΟΛΑΙΣΤΙΔ
ΟΥΜΕΝΤΙΝΗΤΤΡΙΜΟΥΕΝΤ
ΘΑΝΙΕΩΝΜΕΡΑΙΕΥΣΑΙ
ΑΝΕΘΗΚΕ ΕΠΙ ΙΕΡΕΩ
ΣΟΙΔΗΜΟΝΟΣΤΟΥΠΡ
ΑΖΙΤΕΛΟΥΣΦΛΥΕ
ΩΣ

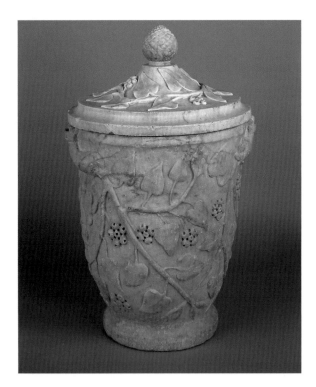

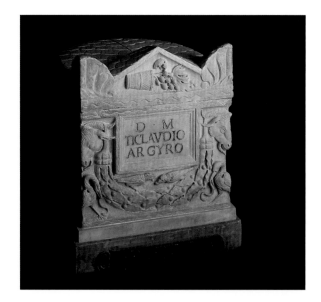

serpents. The terrified pirates hurled themselves overboard, where they were transformed into dolphins. An additional layer of symbolism pertains to funerary traditions: after the musician Arion escaped from pirates by throwing himself into the sea, a dolphin kept him from drowning. Dolphins were also thought to accompany the soul after death, and evergreen ivy is a symbol of rebirth. Perhaps, then, this urn had a funerary purpose, but without an inscription, the assumption cannot be confirmed. It is certainly possible that the urn was placed in a *columbarium* in a niche inscribed with the name of the deceased, but it may also be a simply decorative object. (C.P.-D.)

BIBLIOGRAPHY
Martinez 2004a, no. 1078 p. 534.

176 Cinerary Urn of Tiberius Claudius Argyrus

Mid-1st century A.D (?) • Provenance unknown • H. 16⅞ in. (43 cm) • Marble (the red pigment is modern) • Formerly in the Malatesta collection (?), documented in the Louvre's collections in 1810 (MA 2165–INV. MR 888) • Restorer: C. Bredat, 2005

This urn is based on a small-scale model of a semicircular building. Regular incisions on the curved rear facade mimic a stone wall. The sixth and final course of stones is part of the cover, whose upper surface is decorated with lozenge shapes modeled in very low relief, representing roof tiles. Two half-palmettes on the facade frame the corners of a triangular pediment whose tympanum bears a carving of a tipped-over basket spilling fruit, including grapes and perhaps a pomegranate—clearly an allusion to death.

Two bands incised with a wavy lines link the urn's lid to its facade. Goats' heads adorn the corners. Hanging from the goats' horns are laurel garlands, on which two birds perch, eating ber-

ries. Under each goat head, a stork consumes a serpent: the motif appears so frequently on funerary monuments that it must be symbolic of the purification of the deceased. The stork was considered a propitious bird for feeding on reptiles and insects and was revered by the Romans as it cleansed dwellings and cemeteries from these objectionable creatures—which were associated with malign powers. Storks were also symbolic of filial piety: according to a folk legend, they provided food to their parents when the parents were too old to hunt for themselves.

The urn's ornamentation is organized around a rectangular frame. A simple inscription within the frame dedicates the monument to the *manes* (divinities comparable to our concept of the soul) of Tiberius Claudius Argyrus. He may have been a former slave of the Claudia family who assumed its patronymic upon his manumission, as was customary. He may have served one of the emperors of this family known by the given name of Tiberius—such as Tiberius, Claudius, or Nero. In that case, this unknown man would have lived during the middle of the first century A.D. (C.P.-D.)

BIBLIOGRAPHY
Martinez 2004a, no. 1054, pp. 523 and 524.

177 Urn with Broad and Sharply Angled Handles

Late 1st–early 2nd century A.D. • Discovered in Guéret (Creuse, France) • Glass • H. 8 in. (20.2 cm); Diam. of mouth 4⅛ in. (10.5 cm); Diam. of body 7½ in. (19 cm) • Purchased in 1825, formerly in the E. Durand collection (ED 1528; N 5229) • Restorer: J. Dupin, 2006

This urn of greenish blown glass has a wide mouth with the lip folded inward, a short, cylindrical neck, and a spherical body. The bottom is concave. Two large handles, broad and finely ribbed, attach at the shoulder and turn in against the neck and below the mouth.

Made from rather thick glass, this type of spherical urn is found for the most part in the west, probably from Gaul or the Rhineland. It was produced in northern,[1] central, and western[2] Gaul. Some pieces are known in the south[3] and southwest[4] as well, and in Germany[5] and the Netherlands,[6] but a piece was also found as far

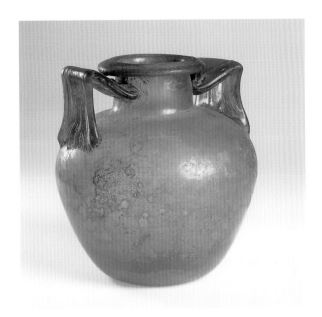

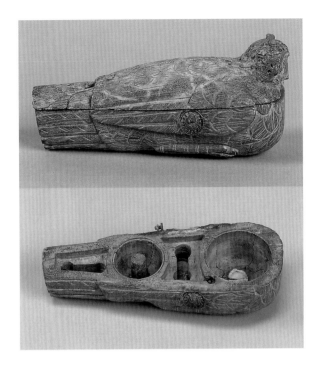

away as Padua, perhaps fabricated in Gaul or in the Rhineland in the late first or early second century.

These urns were probably meant to contain or transport foodstuffs (liquids or solids) but are found most often in a funerary context, where they were used to contain the cremated remains of the deceased. (V.A.)

NOTES
1 Guiry-en-Vexin 1993, no. 235 (Amiens, Somme).
2 Simon-Hiernard and Dubreuil 2000, no. 48 (with other references).
3 Marseille 2001, no. 379 and p. 202, n. 44.
4 Slitine 2005, p. 142.
5 Fremersdorf 1958, pl. 107; Tr 148.
6 Isings 1971, p. 38, no. 123.
7 Zampieri 1998, no. 294.

BIBLIOGRAPHY
Arveiller-Dulong and Nenna 2005, no. 467.

178 Jewel Box

End of 1st or beginning of 2nd century A.D. •
Discovered in Le Pouzin (Ardèche, France) •
Ivory • H. 2⅛ in. (5.5 cm); W. 5⅞ in. (15 cm) •
Purchased in 1913 (MND 984) • Restorer:
J. Lévy, 2006

Around 1850, the eminent Dr. Lamotte discovered a cinerary urn containing a ring (cat. no. 65) near Pouzin in the Ardèche. Some fifteen years later, additional exploratory excavations in the area revealed a second funerary collection.[1] A small Gallo-Roman town, still unnamed and unmapped, once stood nearby between the right bank of the Rhône and the road linking Vienne to Nîmes.

Near the northern side of the 12.3 by 9.8 foot cemetery was a cube-shaped sandstone coffer, discovered with its cover still sealed shut. Among the ashes inside was a glass bottle (cat. no. 179), resting in a small amount of water, which had helped to protect it over the centuries. Its neck rested in an onyx cup (cat. no. 180), and this jewelry box in the shape of a bird identified the deceased as a woman. She was buried in this small country necropolis, which may have been a private burial ground.

Sculpted in the round, the box represents a chicken (identifiable by the little crest on top of the head). It looks to the right,

toward the front of the box, and seems, with its feet tucked under its body, to be sitting on its nest. Details of its plumage are rendered realistically with delicate carving. The upper and lower parts of the object are crafted from the same piece of ivory, an elephant tusk, whose shape required the artist to adapt the bird's pose (the head is pulled in so that the neck is not visible, for example). Still, the functional requirements of the object are well served. The base and top were connected by a hinge attached with bronze fasteners, and the box was closed with a device, but these have been lost. The bird's front wing, however, still has the silver roundel that once controlled the clasp.

The cover is partly hollowed out in two areas, which correspond approximately to the cavities in the body of the sculpture. The two circular areas with a separator in the middle (the one nearest the head is broken) were designed for rings. The two longitudinal areas shaped like a double keyhole were intended to hold rings set with stones.

This piece has general similarities with comparable objects from Egypt, Mycenaean Greece, and Italy in the third and second century B.C. and is therefore evidence of the diversity and scope of cultural exchanges throughout the Roman world, which flowed around the Mediterranean and followed the extensive trade routes connecting the empire. (C.P.-D.)

NOTE
1 The manuscript account "Discovery of two Gallo-Roman tombs near Le Pouzin: a memoir presented to the Science Society of the l'Ardèche by Dr. Lamotte" was acquired with the associated objects by the Louvre (documentation in the Department of Greek, Etruscan and Roman antiquities).

BIBLIOGRAPHY
Michon 1915, pp. 77–82, fig. 3, pl. 8.
Blanc 1975, no. 79, p.66. (There are errors pertaining to the date and location of the discovery of the objects.)
Béal 2000, pp. 104–07, pls. 4–5.
Dupraz and Fraisse 2001, pp. 310–11, figs. 388–89.

179 "Mercury Bottle"

2nd century, A.D. ▪ Discovered in Le Pouzin (Ardèche, France), ▪ Italian or Rhineland production ▪ Clear glass, blown in a mold ▪ H. 10¼ in. (26 cm); W. (side) 2⅜ in. (6.2 cm); Diam. (mouth) 2⅜ in. (6 cm) ▪ Purchased in 1913 (MND 986) ▪ Restorer: J. Dupin, 2006

This bottle with a disc-shaped lip—formed by turning it inward—has a long, cylindrical neck and a square body with smooth sides. Along the bottom's perimeter are four illegible letters: an H and an I at the corners—separated by two dots in relief—and a circle containing a crown of dots with a composition of four dots in its center.

Produced from the late first until the third century A.D., bottles of this type were known as "Mercury bottles" because they frequently included a depiction of that god (or some other figure) in the center of the bottom. Generally made of thick, clear glass, they were decorated with various motifs, such as a palm design on the walls or three lines of an inscription marking the bottom. Other marks on the bottom might include a letter at each of the four corners, two letters flanking a palmette, or dots, circles, and the age-old motif of the swastika. Their distribution in Italy (Rome and the Po region), the Rhineland, and France[1] suggests regional fabrication. Their scant capacity indicates that they held precious contents: probably balm, perfumed oil, or a pharmaceutical or medicinal product.[2] (V.A.)

NOTES
1 Stern 1977, pp. 64–72; Facchini, 1998.
2 De Tommaso 1990, pp. 27–28.

BIBLIOGRAPHY
Michon 1915, pp. 74–76, fig. 2.
Isings 1957, p. 100.
Arveiller-Dulong and Nenna 2005, no. 432.

180 Skyphos (Two-Handled Cup)

1st century A.D. ▪ Discovered in Le Pouzin (Ardèche, France) ▪ Red and white veined onyx ▪ H. 1¾ in. (4.6 cm); Diam. 4 in. (10.3 cm) ▪ Purchased in 1913 (INV. MND 985)

Carved from a single piece of onyx, this cup was found together with an ivory jewel box (cat. no. 178) and a glass bottle (cat. no. 179) in the same funerary urn, discovered in Pouzin around 1865. The cup is remarkably well-preserved, despite the fact that the onyx is extremely thin to maximize its translucency, and the handles are carved with extraordinary delicacy—only a small end piece of one needed to be reattached.

This cup has what is known as a "thumbhold" form (the upper part of each handles is flattened and enlarged to make it easier to grasp with the thumb). It is set on a circular base and similar to numerous silver vases of the first century A.D. found in the Boscoreale (cat. no. 4) and Alésia treasures; however, the richness of this material and the perfection of its carving make this an object of extreme ostentation; particularly striking since the calcinated remains of a second cup were also found among the ashes, according to Dr. Lamotte's account. It is indeed extraordinary to find such luxury in an otherwise fairly unremarkable funerary setting. Certainly such riches would not be expected far from any town or significant country residence. With the other objects found in the same tomb, this discovery is evidence of the elegance and refinement to which at least some landed proprietors of Roman Gaul could aspire. (C.P.-D.)

BIBLIOGRAPHY
Michon 1915, pp. 76–77, pl. 7.
Blanc 1975, no. 79, p. 66. (There are errors pertaining to the date and location of the discovery of the objects.)
Béal 2000, pp. 105–06, pl. 5.
Dupraz and Fraisse 2001, pp. 310–11, fig. 387.

181 Sarcophagus Showing the Myth of Actaeon

Ca. 125–130 A.D. (?) ▪ Discovered in 1738 on the Via Labicana in the area of Torre Nuova, now known as Casilina, in the environs of Rome ▪ Marble ▪ H. 49⅝ in. (126 cm); W. 92⅞ in. (236 cm) ▪ Purchased in 1807, formerly in the Borghese collection (MA 459– INV. MR 878; N 1010) ▪ Restorers: D. Besnainou, 1994, and A. Courcelle, 2006

This sarcophagus has three carved sides, with ornamental garlands draped beneath scenes from the myth of Actaeon. The story begins on the left lateral side, where a griffon holds a laurel garland in its beak. Two shepherds are shown with three dogs in a rocky landscape. This peaceful scene is followed by one depicting the tragic events of the tale of Actaeon on the front of the sarcophagus. The episodes are split into two scenes, from right to left chronologically. Each tableau occupies a space above two weighty garlands of fruits and flowers attached to acanthus-leaf bases, and carried by three feminine figures dressed in *chitons*. These must be depictions of the Charites or Hours.

Artemis, at right, is surprised by the hunter Actaeon as she is bathing in the forest. She kneels in water flowing from an urn held

by a deity of the spring. A putto pours water from an amphora over the goddess's back, and a second putto collects the water she wrings from her hair in a shell. Startled, the chaste goddess turns toward Actaeon, whose upper body appears behind some rocks, his right hand raised in a gesture of amazement.

The dreadful punishment of the luckless intruder is shown on the next side. Condemned by the pitiless huntress, Actaeon is transformed into a stag; his head already bears the animal's antlers and, brandishing his *pedum* (rod), he struggles vainly to defend himself from his attacking dogs. The unfortunate hunter will be devoured by the pack under the indifferent gaze of a river god.

The composition on the next panel shows the burial of Actaeon by two women, his mother and his sister—or perhaps his lover, whose unbound hair attests to her grief.

The cover has four corner ornaments: at the rear are two palmettes and in the front are two masks showing the faces of satyrs or perhaps spirits of the seasons, crowned with ears. Each short side of the sarcophagus lid displays a mascaron of an old man with long hair, surmounted with acanthus leaves from which dolphins emerge. Perhaps these heads belong to water gods, given that the front panel shows a procession of fantastical maritime beings.

This exceptionally well-preserved sarcophagus is one of the finest examples of a stylistically coherent series produced by Roman workshops during Hadrian's reign. These works combine Greco-Asiatic elements with traditionally Roman design features of the first half of the second century A.D.: the use of mythological episodes set above garlands; the juxtaposition of pastoral scenes inspired by the neo-Alexandrian aesthetic with rococo landscapes; the neo-Greek style of the sea creatures' procession; and the classicizing style of the figures bearing the garlands. The elegant formality of this work and the extremely high technical quality of its execution are typical of the art of Hadrian's era. In works of this period, the subtle yet abundant use of mystical allusions to ritual practices sometimes fails to convey genuine religious feeling, which was often subsumed in the aestheticism of the time. (C.P.-D.)

BIBLIOGRAPHY
Baratte and Metzger 1985, no. 15, pp. 49–55.
Herdejurgen 1996, no. 26, pp. 93–95, pls. 28–31.
Grassinger 1999, no. 71 p. 225, pls. 72, 2, 4, 6 and 73, 1–2.
Paris 2000–01, no. 16, pp. 161 and 162.
Martinez 2004a, no 1039, p. 515.

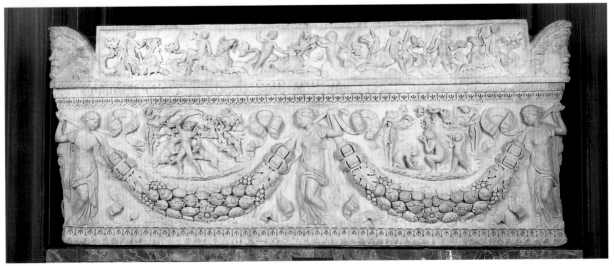

182 Lead Sarcophagus

1st–3rd century A.D. ▪ Discovered in Tyre (Lebanon) (?) ▪ Lead ▪ H. 23⅜ in. (59 cm); L. 72⅜ in. (184 cm); W. 17⅜ in. (44 cm) ▪ (Department of Eastern Antiquities AO 17268) ▪ Restorer: L. Rossett, Laboratoire Arc'Antique (Nantes)

In ancient Syria, sarcophagi, which were decorated on all sides as well as the cover, were frequently made of lead. Lead sarcophagi found outside Syria are seldom ornamented.

A large number of decorated lead sarcophagi were found during nineteenth-century excavations in Tyre and Sidon. Their sizes vary according to the height of the deceased, but their ornamentation was executed using molds of clay or sand, in which the imprint was made with a harder stamp, which explains why standard, identical designs could be found on various sarcophagi (though compositions varied). The production of the coffins often seems to have been carelessly executed, with designs juxtaposed unevenly and incorrectly distributed over the decorated surface.

Four major centers of production have been identified: Tyre, Sidon, Beirut, and Jerusalem. There were also secondary workshops in this eastern Mediterranean area. The largest production was in Tyre, where this sarcophagus was made. Ornamentation known to be from Tyre is characterized by its architectonic structure: the container is treated as a sort of temple, with columns punctuating its length. Between the columns one might find different depictions for different sarcophagi, of lions, sphinxes, heads of Medusa, Dionysus, Victories, or ornamentation with designs in laurel, ivy, vine leaf foliation, and wine vessels. All of these motifs are from the Greco-Roman decorative repertoire; none appear to be directly tied to any concept of the afterlife, and neither subject nor style allow these sarcophagi to be dated with certainty, although all of them belong to the era of the Roman empire. Various texts tell us that such sarcophagi were still being made in this area in the Byzantine era, as described in an account of the burial of Saint Simon Stylites. (S.C.)

BIBLIOGRAPHY
Bertin 1974.
Duval 1975.

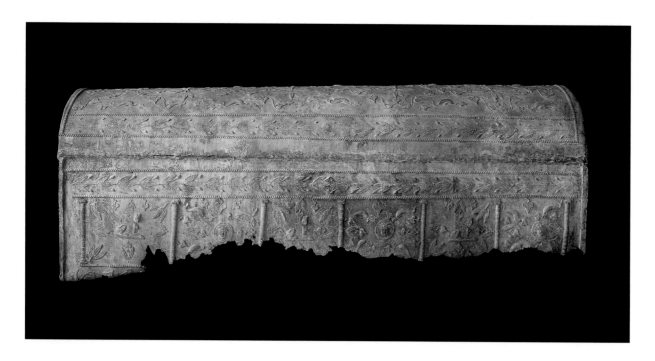

183 Funeral Wreath

3rd century A.D. ▪ Provenance unknown ▪
Gold ▪ L. 21¼ in. (54 cm); H. of medallion
1¾ in. (4.4 cm); L. of medallion 1½ in. (3.8 cm) ▪
Gift 1967, formerly in the Pérétié collection and
the Boisgelin-De Clercq collection (BJ 2236
—INV. MNE 79)

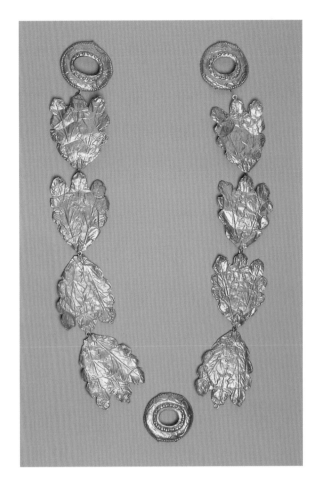

Numerous funeral portraits found in Egypt[1] suggest that the combination of elements seen in this gold wreath were meant to imitate wreaths made of real plants, in which leaves, usually attached to a necklace,[2] converged toward the center of the face. Here the addition of medallions makes this wreath similar to real wreaths worn by the Emperor Severus and his family, as depicted on a painted wood panel from the early third century A.D.[3]

The wreath is composed of eight sets of three oak leaves (one on top of the other) rendered with great detail in thin gold leaf. The leaf-stalks hook into a ring at the end of each center leaf. There are also convex, oval medallions with beaded edges, decorated with a thin garland in a plant design. The wreath is divided into two lengths. The first is formed by a medallion and four leaves: two of the leaves face each other, the others point in opposite directions. The second consists of four leaves: three leaves point in one direction, the last points the other way. The two end medallions show signs that there were once four small clasps.

The evolution of the decorative elements of this wreath is unknown. The two single medallions must have been attached to other elements at one time since on the back, halfway around their circumference, were two clasps. The center of the medallions was probably empty, as indicated by the flexibility of the gold leaf, the absence of scratches, and the fact that there is no backing for the placement of a semi-precious stone or piece of colored glass. The edges of the decorative elements were never pierced, and the piece has never been sewn onto a fabric backing. (A.S.)

NOTES
1 New York 2000, pp. 109–10, no. 68, fig.
2 Tongres 2002, pp. 189–90, no. 125, fig.
3 Heilmeyer 1988, pp. 372–73, no. 7, fig.

BIBLIOGRAPHY
De Ridder 1911, pp. 11–12, no. 1.

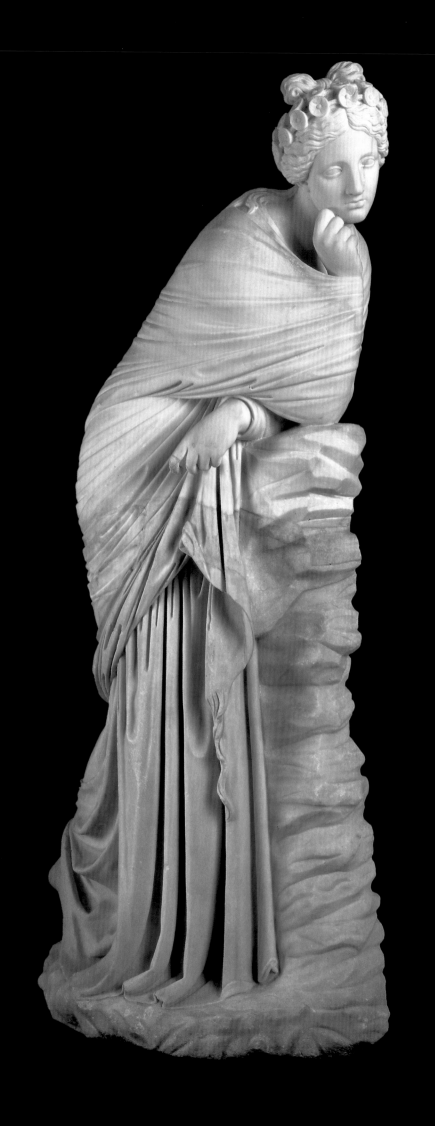

184 Polymnia

Fragment from 1st or 2nd century A.D.
completed by Agostino Penna (1780–84) ▪
Discovered in Italy (?) ▪ Greek marble (lower
part), Carrara marble (upper part) ▪ H. 73¼
in. (186 cm) ▪ Purchased in 1807, formerly in
the Borghese collection (MA 472–INV. MR 325)
▪ Restorer: H. Susini and D. Braunstein, 1999–
2000

Just as modern as it is ancient, the former Borghese collection's Polymnia is characteristic of the practices of eighteenth-century restorers and the relationship European culture maintained with the art of the ancients. Though the lower part of the statue, including the plinth and the bottom of the draped legs, dates from antiquity, the entire upper part from the thighs up is a skillful restoration-creation by sculptor Agostino Penna (1728–1800).

Prince Marcantonio IV Borghese commissioned architect-decorator Antonio Asprucci to follow a new approach during the refitting of the Pincio villa from 1780 to 1784. By drawing on the neoclassical taste then in fashion, the strategy affected not only the interior of the villa and its furniture, but also its collection of antiquities. Asprucci imagined a lavish grouping to set off the Borghese Gladiator, including four antique statues of athletes completed for the occasion, colored statues of animals, heads and portraits, reliefs inlaid in the bases (including four medallions Penna designed for the Gladiator's base), and, in facing niches, Polymnia perched on Actaeon's sarcophagus (cat. no. 181) and the monumental Ceres framed by two horns of plenty. This grouping of more than twenty sculptures was combined with the paintings of Jean-Baptiste Tierce (1737–1794), recently rediscovered, to evoke the heroism and the world of the hunt.[1]

The grouping reflects a popular debate of the time concerning the art of the ancients and how it should be related to that of the moderns. Admired for more than twenty years, this exemplary arrangement of neoclassical Roman taste was also characteristic of a historical turning point in archaeological studies, with Penna's muse as a perfect example. The restoration of the Borghese antiquities was carried out under the guidance of the scholar Ennius Quirinus Visconti, future curator of the Louvre, following a new principle of iconographic consistency based on comparisons with better-preserved archaeological material. These draped legs only became a Polymnia leaning on her right arm through imitation of a famous relief by Archelaos of Priene, then on display at the Colonna Palace in Rome (now in the British Museum). The motif, known through other replicas,[2] must be reproduced from a Greek original of the Hellenistic period. The original might be one of the muses from the famous group by Philiscos of Rhodes mentioned by Pliny (*Natural History* XXXVI, 34), and particularly appreciated by the Romans, who could admire it on the Portico of Octavia. A Greek original, transported and then copied by the Romans; a Roman replica completed by an Italian neoclassical sculptor for the decor of a princely villa; the purchase by Napoleon for the Louvre—a perfect example of the fate of antiquity in European culture. (J.-L.M.)

NOTES
1 See Rome 2004.
2 In Berlin or the Vatican, for instance.

BIBLIOGRAPHY
Paris 2000–01, p. 162, no. 17.
Martinez 2004a, no. 223, p. 137.
Martinez 2004b, p. 125, fig. 127.
Rome 2005, pp. 169–70, no. 54.

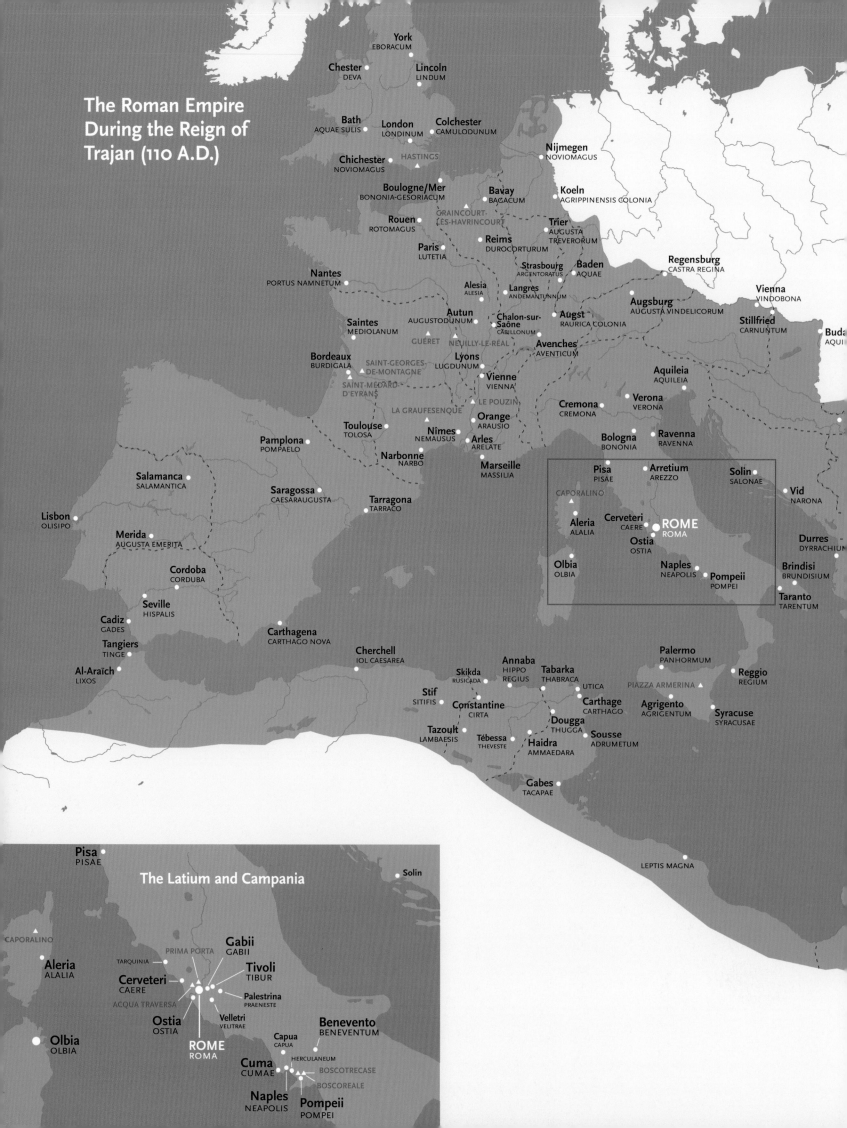

The Roman Empire During the Reign of Trajan (110 A.D.)

York EBORACUM
Chester DEVA
Lincoln LINDUM
Bath AQUAE SULIS
London LONDINUM
Colchester CAMULODUNUM
Chichester NOVIOMAGUS
HASTINGS
Nijmegen NOVIOMAGUS
Boulogne/Mer BONONIA-GESORIACUM
Bavay BAGACUM
Koeln AGRIPPINENSIS COLONIA
GRAINCOURT-LES-HAVRINCOURT
Rouen ROTOMAGUS
Trier AUGUSTA TREVERORUM
Reims DUROCORTURUM
Paris LUTETIA
Strasbourg ARGENTORATUS
Baden AQUAE
Regensburg CASTRA REGINA
Nantes PORTUS NAMNETUM
Alesia ALESIA
Langres ANDEMANTUNNUM
Augsburg AUGUSTA VINDELICORUM
Vienna VINDOBONA
Saintes MEDIOLANUM
Autun AUGUSTODUNUM
Chalon-sur-Saône CABILLONUM
Augst RAURICA COLONIA
Stillfried CARNUNTUM
GUÉRET
NEUILLY-LE-RÉAL
Avenches AVENTICUM
Buda AQUI
Bordeaux BURDIGALA
SAINT-GEORGES-DE-MONTAGNE
Lyons LUGDUNUM
Aquileia AQUILEIA
SAINT-MÉDARD-D'EYRANS
Vienne VIENNA
Verona VERONA
LE POUZIN
Cremona CREMONA
Ravenna RAVENNA
LA GRAUFESENQUE
Orange ARAUSIO
Bologna BONONIA
Toulouse TOLOSA
Nîmes NEMAUSUS
Arles ARELATE
Pamplona POMPAELO
Narbonne NARBO
Marseille MASSILIA
Pisa PISAE
Arretium AREZZO
Solin SALONAE
Salamanca SALAMANTICA
Saragossa CAESARAUGUSTA
CAPORALINO
Vid NARONA
Tarragona TARRACO
Aleria ALALIA
Cerveteri CAERE
ROME ROMA
Lisbon OLISIPO
Ostia OSTIA
Durres DYRRACHIUM
Merida AUGUSTA EMERITA
Olbia OLBIA
Naples NEAPOLIS
Pompeii POMPEI
Brindisi BRUNDISIUM
Cordoba CORDUBA
Taranto TARENTUM
Seville HISPALIS
Cadiz GADES
Carthagena CARTHAGO NOVA
Palermo PANHORMUM
Tangiers TINGE
Cherchell IOL CAESAREA
Annaba HIPPO REGIUS
Tabarka THABRACA
PIAZZA ARMERINA
Reggio REGIUM
Al-Araïch LIXOS
Skikda RUSICADA
UTICA
Stif SITIFIS
Carthage CARTHAGO
Agrigento AGRIGENTUM
Syracuse SYRACUSAE
Constantine CIRTA
Tazoult LAMBAESIS
Dougga THUGGA
Sousse ADRUMETUM
Tébessa THEVESTE
Haidra AMMAEDARA
Gabes TACAPAE
LEPTIS MAGNA

The Latium and Campania

Pisa PISAE
Solin
CAPORALINO
PRIMA PORTA
Gabii GABII
Aleria ALALIA
TARQUINIA
Tivoli TIBUR
Cerveteri CAERE
Palestrina PRAENESTE
ACQUA TRAVERSA
Velletri VELITRAE
Ostia OSTIA
Benevento BENEVENTUM
ROME ROMA
Capua CAPUA
Olbia OLBIA
Cuma CUMAE
HERCULANEUM
BOSCOTRECASE
BOSCOREALE
Naples NEAPOLIS
Pompeii POMPEI

OLBIA

Turda
POTAISSA

Tiraspol
TYRAS

Kertch
PANTICAPAION

Sebastopol
CHERSONESUS

Sinop
SINOPE

Trabzon
TRAPEZUS

Artashat
ARTAXATA

Nitrovica

Adamclisi
TROPAEUM
TRAJANI

Constantza
TOMIS

Nis
NAISSUS

Plovdiv
PHILIPPOPOLIS

Sozopol
APOLLONIA PONTICA

Samsun
AMISUS

Amasya
AMASIA

Istanbul
BYZANTIUM

Izmit
NICOMEDIA

Ankara
ANCYRA

Kayseri
CAESAREA MAZACA

Sanliurfa
EDESSA

saloniki
SALONICE

CYZICUS

Iznik
NICAEA

Balikesir
HADRIANOUTHERAI

Bergama
PERGAMUM

Rengini
NARYKA

Akhissar THYATEIRA

Sart
SARDIS

Tarsus
TARSUS

Balqis
ZEUGMA

Eleusis
ELEUSIS

Izmir
SMYRNA

Amman PHILADELPHIA

elphi
DELPHI

PROBALINTHOS

Aydin
TRALLES

Antalya
ATTALIA

Balkis
ASPENDOS

Antakya
ANTIOCHA

Halab
BEROEA

Corinth
ORINTHUS

Athens
ATHENAE

MAGNESIA

Geyre
APHRODISIAS

Side
SIDA

DAPHNE

Afimia
APAMEA

Epidaurus
EPIDAURUS

Piraeus
PIRAEUS

YAKHMOUR

Homs
EMESA

Herakleion
HERAKLEION

Paphos
PAPHOS

Beirut
BERYTUS

Baalbek
HELIOPOLIS

Gortyne
GORTYN

Cnossos
GNOSSUS

Saïda
SIDON

Damascus
DAMASCUS

Tyre
TYRUS

Busra
BOSTRA

Jerusalem
HIEROSOLYMA

DURA EUROPOS

Shahhat
CYRENE

Gaza
GAZA

Alexandria
ALEXANDREA

Saqqara
MEMPHIS

Aqaba
AELANA

Fayum
ARSINOE

Sheikh'Ibade
ANTINOOPOLIS

El Ashmunein
HERMOPOLIS

- - - - Boundaries of Provinces
○ **Towns**
△ ARCHAEOLOGICAL SITES

0 60 km 300 km 600 km

Timeline of Imperial Rome

55 B.C. First stone theater built in Rome

End of the Republic

Julio-Claudian Dynasty

27 B.C. Beginning of the Roman Empire

Octavian becomes Augustus

Beginning of the Principate (Early Empire)

14 A.D. Reign of Tiberius

37 A.D. Reign of Caligula

41 A.D. Reign of Claudius

54 A.D. Reign of Nero

9 B.C. Dedication of the Altar of Peace (Ara Pacis in Rome)

Beginning of the Third Pompeian Style (wall painting)

Expansion of the House of the Faun in Pompeii (end of first century B.C.)

Flavian Dynasty

69 A.D. Reign of Vespasian

79 A.D. Reign of Titus

81 A.D. Reign of Domitian

64–68 A.D. Construction of the Domus Aurea in Rome

70–80 A.D. Construction of the Coliseum in Rome

Beginning of the Fourth Pompeian Style

Antonine Dynasty

96 A.D. Reign of Nerva

98 A.D. Reign of Trajan

117 A.D. Reign of Hadrian

138 A.D. Reign of Antoninus Pius

161 A.D. Reign of Marcus Aurelius and Lucius Verus

180 A.D. Reign of Commodus

112–113 A.D. Trajan's Forum and Trajan's Column in Rome

117 A.D. Reconstruction of the Pantheon in Rome

128 A.D. Construction of Hadrian's Villa in Tivoli

Severan Dynasty

192 A.D. Reign of Septimius Severus

211 A.D. Reign of Caracalla

217 A.D. Reign of Elagabalus

222 A.D. Reign of Severus Alexander

203 A.D. Arch of Septimius Severus in Rome

216 A.D. Baths of Caracalla in Rome

58 B.C. Caesar begins conquest of Gaul (ends in 51 B.C.)

44 B.C. Assassination of Caesar

31 B.C. Octavian's victory over Antony and Cleopatra at Actium

30 B.C. Egypt becomes a Roman province

Birth of Christ

43 A.D. Beginning of the conquest of Britany (present-day Great Britain)

69 A.D. Year of four emperors: Galba, Otho, Vitellius, finally Vespasian

79 A.D. Eruption of Vesuvius (destruction of Pompei, Herculaneum, and Boscoreale)

107 A.D. Annexation of Dacia (campaigns in 101 and 107 A.D.)

130 A.D. Death of Antinous, favorite of Hadrian

166 A.D. Victory of Lucius Verus over the Parthian Empire

195–198 A.D. Victorious campaign against the Parthians

212 A.D. Antonine Constitution (granting citizenship to all free men of the empire)

306–312 A.D. Basilica of Constantine and Maxentius in Rome

315 A.D. Arch of Constantine in Rome

450 A.D. Mausoleum of Galla Placidia in Ravenna

Period of Military Anarchy

Beginning 235 A.D. Successive reigns of the "emperor-soldiers"

Tetrarchy

284 A.D. Reign of Diocletian, Maximian, Constantius, and Galerius (Late Empire)

Constantine Dynasty

307 A.D. Reign of Constantine

337 A.D. Reigns of the sons of Constantine (Constantine II, Constans, Constantius II)

361 A.D. Reign of Julian the Apostate

Valentinian Dynasty

364 A.D. Reigns of Valentinian I, Valentinian II, Valens

367 A.D. Reign of Gratian

Theodosian Dynasty—End of the Western Roman Empire

379 A.D. Reign of Theodosius

395 A.D. Reign of Honorius

425 A.D. Reign of Valentinian III

455 A.D. Reign of Avitus

457 A.D. Reign of Majorian

461 A.D. Reign of Libius Severus

467 A.D. Reign of Anthemius

472 A.D. Reign of Olybrius

476 A.D. Reign of Romulus Augustulus

284 A.D. Diocletian creates the Tetrarchy: Diocletian and Maximian are Augustus (having decision-making powers), and Constantius and Galerius are Caesars (having executive powers)

The empire is divided into the Western and the Eastern part

307 A.D. Constantine, the first Christian emperor, reunifies the empire

313 A.D. Edict of Milan (freedom of religion)

330 A.D. Constantinople becomes the capital of the empire

361 A.D. Julian the Apostate restores paganism

379 A.D. Theodosius prohibits pagan worship

395 A.D. The empire is definitively split between East and West

410 A.D. Sack of Rome by Alaric, king of the Goths

476 A.D. Sack of the Roman Empire by Odoacer, king of Heruli

Odoacer sends back to Constantinople the insignia of imperial power

End of the Western Roman Empire

Bibliography

Absil, M., and Y. Le Bohec. 1985. "La libération des soldats romains sous le Haut-Empire." *Latomus*, 44, 2, pp. 85–870.

Adamo-Muscettola, S. 1984. "Osservazioni sulla composizione dei larari con statuette in bronzo di Pompei ed Ercolano." In *Toreutik und figürliche Bronzen römischer Zeit, Akten der 6. Tagung über antike Bronzen*. Proceedings of a symposium held in Berlin, 13–17 May 1980. Berlin: Staatliche Museen Preussischer Kulturbesitz, pp. 9–26.

Adriani, A. 1970. "Ritratti dell'Egitto grecoromano." *Mitteilungen des deutschen archäologischen Instituts, Römische Abteilung*, 77, pp. 72–109.

Albertson, F . C. 1983. "A Bust of Lucius Verus in the Ashmolean Museum, Oxford, and Its Artist." *American Journal of Archaeology*, 87, pp. 153–63, pl. 18–20.

Albertson, F. 2004. "The Creation and Dissemination of Roman Imperial Portrait Types: The Case of Marcus Aurelius Type IV." *Jahrbuch des Deutschen Archäologischen Instituts*, 119, pp. 259–306.

D'Alconzo, P. 2002. *Picturae excisae: conservazione e restauro dei dipinti ercolanesi e pompeiani tra XVIII e XIX secolo*. Rome: "L'Erma" di Bretschneider.

Alföldi-Rosenbaum, E. 1960. *A Catalogue of Cyrenaican Portrait Sculpture*. London: Oxford University Press.

Amad, G. 1988. *Recherches sur le mythe du Phénix dans la mosaïque antique*. Montevideo.

Ambrosio (d'), A. 1994. *Gli ori di Oplontis*. Naples: Bibliopolis.

Ambrosio (d'), and E. De Carolis, 1997. *I monili dall'area vesuviana*. Rome: "L'Erma" di Bretschneider.

Amedick, R. 1999. "Die Gruppe der Schweinsbrüher." In *Gedenkschrift für Andreas Linfert: hellenistische Gruppen*. Mainz: Philipp von Zabern, pp. 187–98.

Amelung, W. 1908. *Die sculpturen des Vaticanischen Museums*. II Berlin: G. Reimer.

Anti, C. 1928. "Un Nuovo Ritratto di Agrippina Maggiore." *Africa Italiana*, vol. 2, year 7, pp. 3–16.

Arveiller-Dulong, V., and M. D. Nenna 2005. *Les verres antiques du musée du Louvre. II. Vaisselle et contenants du Ier siècle au début du VIIe siècle après J.-C.* Paris: Musée du Louvre and Somogy.

Atlanta 1994. *From Hannibal to Saint Augustine. Ancient Art of North Africa from the Musée du Louvre*. Michael C. Carlos Museum, February 16–May 29.

Aubert, E. 1874. "Séance du 11 février. Travaux." *Bulletin de la Société d'Archéologie Française*, pp. 59–67.

Aubin, G., F. Baratte, J.-P. Lascoux, and C. Metzger 1999. *Le Trésor de Vaise à Lyon (Rhône)*. Lyon: Ministère de la Culture et de la Communication. Direction régionale des Affaires culturelles. Service régional de l'Archéologie.

Autun 1985. *Autun Augustodunum, capitale des Eduens*. Hôtel de ville, March 16–October 27. Autun: Musée Rolin.

Babelon, J. 1943–45. "Trois figurines d'ivoire représentant des gladiateurs." *Bulletin archéologique du Comité des travaux historiques et scientifiques*, pp. 34–39.

Bailey, D. M. 1996. *A Catalogue of the Lamps in the British Museum. IV, Lamps of Metal and Stone, and Lampstands*. London: The Trustees of the British Museum.

Baldini Lippolis, I. 1999. *L'oreficeria nell' Imperio da Constantinopoli tra IV e VI secolo*. Bari: Edipuglia.

Balmelle, C. 2001. "Les demeures aristocratiques d'Aquitaine. Société et culture de l'Antiquité tardive dans le Sud-Ouest de la Gaule." *Aquitania*, supp. 10.

Balty, J.-C. 1963. "Notes d'iconographie julio-claudienne, I." *Monuments et mémoires—Fondation Eugène Piot*, 53, pp. 95–134.

Balty, J. 1980. "Trébonien Galle et Volusien." In *Eikones. Studien zum griechischen und römischen Bildnis. Hans Jucker zum sechzigsten Geburtstag gewidmet*. Bâle–Berne: Francke Verlag, pp. 49–56.

Balty, J. 1981. "La mosaïque antique au Proche-Orient I. Des origines à la Tétrarchie." *Aufstieg und Niedergang der römischen Welt*, 2.12.2, pp. 347–429.

Balty, J. Ch. 1982. "Portrait et société au Ier siècle avant notre ère." In *Römisches Porträt: Wege zur Erforschung eines gesellschaftlichen Phänomens*. Proceedings of a symposium held at Humbold-Universität, Berlin, May 12–15, 1981. Berlin: Wissenschaftliche Zeitschrift der Humboldt-Universität zu Berlin, pp. 139–42.

Balty, J. Ch. 1993. *Porträt und Gesellschaft in der römischen Welt*. Mainz: Philipp von Zabern.

Balty, J. Ch. 2000. "Sculptures antiques retrouvées." *Bulletin des Musées royaux d'art et d'histoire*, 71, pp. 53–86.

Baratte, F. 1978. *Catalogue des mosaïques romaines et paléochrétiennes du musée du Louvre*. Paris: Réunion des musées nationaux.

Baratte, F. 1986. *Le trésor d'orfèvrerie romaine de Boscoreale, Musée du Louvre*. Paris: Réunion des musées nationaux.

Baratte, F. 1991. "Un plato galloromano de Plata en el museo Lazaro Galdiano." *Goya. Revista de Arte*, 222, pp. 322–30.

Baratte, F. 1993. "Quelques fragments de sarcophages inédits dans les collections du Louvre." In *Grabekunst der Römischen Kaiserzeit*. Edited by G. Koch. Mainz: Philipp von Zabern, pp. 219–22, pl. 86 and 87.

Baratte, F. 1995. "Un 'diplôme militaire' pour un vétéran de la flotte romaine." *Revue du Louvre et des musées de France*, 1, pp. 19–25.

Baratte, F. 2001. "Exotisme et décor à Aphrodisias: la statue de jeune Noir de l'ancienne collection Gaudin." *Monuments et mémoires—Fondation Eugène Piot*, 80, pp. 57–80.

Baratte, F., and C. Metzger 1985. *Catalogue des sarcophages en pierre d'époques romaine et paléochrétienne, Musée du Louvre*. Paris: Réunion des musées nationaux.

Barrett, A. A. 1991. "Claudius' British Victory Arch in Rome." *Britannia*, 22, pp. 1–19.

Bartman, E. 1999. *Portraits of Livia: Imaging the Imperial Woman in Augustan Rome*. Cambridge: University Press.

Bastien, C. 2003. *La Vie quotidienne à l'époque romaine*. Paris: Musée du Louvre.

Baugier, E. 1721. *Mémoires historiques de la province de Champagne*. Châlons: C. Bouchard.

Béal, J.-C. 1984. *Les objets de tabletterie antique du musée archéologique de Nîmes*. Nîmes: musée archéologique de Nîmes.

Béal, J.-C. 2000. "Objets d'ivoire, valeur des objets, lieux de production: l'exemple de la Gaule romaine." In *Des Ivoires et des Cornes dans les mondes anciens (Orient-Occident)*. Lyon: Institut d'archéologie et d'histoire de l'Antiquité, Université Lumière-Lyon 2, pp. 101–17, 6 pls.

Becatti, G. 1962. *L'arte romana*. Milan: Garzanti.

Becker, L., and C. Kondoleon 2005. *The Arts of Antioch: Art Historical and Scientific Approaches to Roman Mosaics and a Catalogue of the Worcester Art Museum Antioch Collection*. Worcester: Worcester Art Museum.

Belli Pasqua, R. 1995. *Sculture di età Romana in "basalto."* Rome: "L'Erma" di Bretschneider.

Bénazeth, D. 1992. *L'art du métal au début de l'ère chrétienne. Musée du Louvre. Catalogue du département des antiquités égyptiennes*. Paris: Réunion des musées nationaux.

Benedetti, D., and M. G. Diani 2003. "Contributo alla conoscenza della diffusione di una forma vitrea di età romana." In *Il vetro in Italia meridionale ed insulare*. Edited by C. Piccioli and F. Sogliani. Proceedings of a symposium held by the Comitato nazionale Italiano dell'Association Internationale pour l'Histoire du Verre, in Naples, March 5–7, 1998. Naples: Di Frede, pp. 241–51.

Bergmann, M. 1978. *Marc Aurel*. Frankfurt: Liebieghaus.

Berlin 1980. *Bilder vom Menschen in der Kunst des Abendlandes*. Nationalgalerie, July 5–September 28. Berlin: Gebr. Mann.

Berlin 2002. *Die griechische Klassik. Idee oder Wirklichkeit*. Martin Gropius Bau, March 1–June 2. Mainz: Philipp von Zabern.

Bernabó Brea, L., and M. Cavalier 2001. *Maschere e personaggi del teatro greco nelle terracotte liparesi*. Rome: "L'Erma" di Bretschneider.

Bernouilli, J.-J. 1882. *Die Bildnisse berühmter Römer, mit Ausschluss der Kaiser und ihrer Angehörigen*. Stuttgart: W. Spemann.

Bertin, A.-M. 1974. "Les sarcophages en plomb syriens au musée au Louvre." *Revue archéologique*, pp. 43–82.

Bertrand, A. 1868–69. "Les bustes en bronze d'Auguste et de Livie trouvés à Neuilly-le-Réal en 1816." *Bulletin de la Société d'Emulation du Département de l'Allier*, t. XI, pp. 255–58.

Besques, S. 1947. "Scène de coiffure, groupe en terre cuite." *Bulletin des musées de France*, 9, pp. 3–8.

Besques S. 1972. *Catalogue raisonné des figurines et reliefs en terre-cuite grecs étrusques et romains, 3, Epoques hellénistique et romaine, Grèce et Asie Mineure*. Paris: Réunion des musées nationaux.

Besques, S. 1978. "Trois têtes de Sarapis." *Revue du Louvre et des musées de France*, 4, pp. 223–29.

Besques S. 1986. *Catalogue raisonné des figurines et reliefs en terre cuite grecs, étrusques et romains, 4–1. Époques hellénistique et romaine, Italie méridionale, Sicile, Sardaigne*. Paris: Réunion des musées nationaux.

Besques, S. 1991. "Trois nouvelles acquisitions de figurines en terre cuite grecques et romaines." *Revue du Louvre et des musées de France*, 4, pp. 17–25.

Besques, S. 1992. *Catalogue raisonné des figurines et reliefs en terre cuite, époques hellénistique et romaine, 4–2. Epoques hellénistique et romaine, Cyrénaïque, Egypte ptolémaïque, Afrique du Nord et Proche-Orient*. Paris: Réunion des musées nationaux.

Besson, C. 2003. *Pendants d'oreille romains du Musée du Louvre*. Saint-Amand-Montrond: Musée de Saint-Vic.

Bianchi Bandinelli, R. 1953. "Continuità ellenistica nella pittura di età medio e tardoromana." *Rivista dell'Istituto Nazionale di Archeologia e Storia dell'Arte*, new series, 2, pp. 77–161.

Bianchi Bandinelli, R. 1960. "Römische Kunst, zwei Generationen nach Wickhoff." *Klio*, 38, pp. 267–83.

Bianchi Bandinelli, R. 1961. *Archeologia e cultura*. Milan–Naples: Riccardo Ricciardi.

Bianchi Bandinelli, R. 1969. *Rome: Le centre du pouvoir*. Paris: Gallimard.

Bianchi Bandinelli, R. 1970. *Rome: La fin de l'art antique*. Paris: Gallimard.

Bianchi Bandinelli, R. 1973. *Storicità dell'arte classica*. Bari: De Donato, 3rd ed.

Bieber, M. 1939. *The History of the Greek and Roman Theater*. Princeton: University Press.

Bieber, M. 1977. *Ancient Copies*. New York: University Press.

Bielefeld, D. 1997. *Stadtrömische Eroten-Sarkophage. Faszikel 2 – Weinlese-und Ernteszenen*. Berlin: Gebr. Mann.

Bienkowski, P. 1895. "Deux sculptures de l'école de Praxitèle." *Revue archéologique*, 1, pp. 281–85.

Bins de St-Victor, J. B. M. 1821. *Musée des Antiques, dessiné et gravé par P. Bouillon...* Paris: Didot l'Aîné.

Biscontin, J. 2000. "Dessins et Antiques: deux monuments de la collection 'Maffei' de Vérone au Louvre." *Revue du Louvre et des musées de France*, 4, pp. 38–53, figs. 11–17 and 19–21.

Blanc, A. 1975. *Carte archéologique de la Gaule, L'Ardèche*, XV. Paris: Centre National de la Recherche scientifique.

Blanc, N., and A. Nercessian 1992. *La cuisine romaine*. Grenoble : Glénat. Dijon: Faton.

Blanchard-Lemée, M. 1995. *Sols de l'Afrique romaine: mosaiques de Tunisie*. Paris: Imprimerie nationale.

Blas de Roblès, J.-M. 1999. *Libye grecque, romaine et byzantine*. Aix-en-Provence: Edisud.

Blázquez, J. M. 1998. "Representaciones de esclavos en mosaicos africanos." In *L'Africa romana*. Edited by M. Khanoussi, P. Ruggeri, and C. Vismara. Proceedings of a symposium held at Olbia, (Italy), December 12–15, 1996. Sassari: Ed. democratica Sarda.

Bol, P. C., and E. Kotera. 1986. *Bildewerke Aus Terrakotta Aus Mykenischer bis Römischer Zeit*. Frankfurt: Melsungen Gutenberg.

Bonadonna Russo, M. T. 1983. "Archeologia a Velletri nel XVIII secolo e la scoperta della Pallade." In *Il Lazio nell'antichità romana*. Rome, pp. 365–84.

Bonifay, M. 2004. *Etudes sur la céramique romaine tardive d'Afrique*. Oxford: Archaeopress.

Bonn 1973. *Antiken aus rheinischem Privatbesitz.*, Bonn, Rheinischen Landesmuseum, November 9, 1973–January 13, 1974. Cologne: Rheinland-Verlag; Bonn: R. Habelt.

Borda, M. 1953. *La scuola di Pasiteles*. Bari: Adriatica.

Borg, B. 1996. *Mumienporträts. Chronologie und kultureller Kontext*. Mainz: Philipp von Zabern.

Boschung, D. 1989. *Die Bildnisse des Caligula*. Berlin: Gebr. Mann.

Boschung, D. 1993a. "Die Bildnistypen der julisch-claudischen Kaiserfamilie." *Journal of Roman Archaeology*, 6, pp. 39–79.

Boschung, D. 1993b. *Die Bildnisse des Augustus*. Berlin: Gebr. Mann.

Boube-Piccot, Ch. 1975. *Les bronzes antiques du Maroc. II. Le mobilier*. Rabat: Musée des Antiquités.

Boucher, S. 1976. *Recherches sur les bronzes figurés de Gaule pré-romaine et romaine*. Rome: Ecole française de Rome.

Boucher, S., and H. Oggiano-Bitar 1995. "Les Lares des Provinces romaines: essai de datation." In *Acta of the 12th International Congress on Ancient Bronzes*. Proceedings of a symposium held in Nijmegen, 1992. Nijmegen: Provinciaal Museum G.M. Kam, pp. 231–40.

Bourges 2004. *La Sainte Chapelle de Bourges: une fondation disparue de Jean de France, duc de Berry*. Musée du Berry, June 27–October 31. Paris: Somogy.

Brandi, C. 1963. *Teoria del restauro*. Rome: Ed. di Storia e letteratura.

Brendel, O. 1931. *Ikonographie des Kaisers Augustus*. Nuremberg: E. Kreller.

Brendel, O. J. 1936. "Gli studi sul rilievo storico romano in Germania." *Gli studi romani nel mondo*, 3, pp. 129–44.

Brendel, O. J. 1953. "Prolegomena to a Book on Roman Art." *Memoirs of the American Academy in Rome*, 21, pp. 7–73.

Brendel, O. J. 1979. *Prologomena to the Study of Roman Art*. New Haven–London: Yale University Press.

Brenot, C., and C. Metzger 1992. "Trouvailles de bijoux monétaires dans l'Occident romain." In *L'or monnayé III. Trouvailles de monnaies d'or dans l'Occident romain*. Paris: Centre national de la recherche scientifique, pp. 313–71.

Bruhn, J.-A. 1993. *Coins and Costume in Late Antiquity*. Washington, D.C.: Dumbarton Oaks.

Bruneau, Ph. 1982. "Le portrait." *Revue d'archéologie moderne et d'archéologie générale*, 1, pp. 71–93.

Brussels 1993. *Splendeur des Sassanides*. Musées royaux d'art et d'histoire, February 12–April 25. Brussels: Crédit communal, Musées royaux d'art et d'histoire.

Buckler, W. H. 1913. "Monuments de Thyatire." *Revue philologique de littérature et d'histoire anciennes*, 37, p. 289 s.

Burkhalter, F. 1990. "Les statuettes en bronze d'Aphrodite en Egypte romaine d'après les documents papyrologiques." *Revue archéologique*, 1, pp. 51–60.

Burlot, D. 2005. "Contrefaçon de peinture murale antique: *la scène égyptisante du Louvre et autres exemples*." *Revue du Louvre et des musées de France*, 5, pp. 54–61.

Cain, H.-U. 1985. *Römische Marmorkandelaber*. Mainz: Philipp von Zabern.

Calza, R. 1964. *Scavi di Ostia V, I ritratti. Parte I*. Rome: Istituto Poligrafico dello Stato.

Calza, R. 1972. *Iconografia romana imperiale: da Carausio a Giuliano*. Rome: "L'Erma" di Bretschneider.

Campana, G. P. 1851. *Antiche Opere in Plastica*. Rome. 2nd ed.

Campbell, S. 1988. *The Mosaics of Antioch*. Toronto: Pontifical Institute of Mediaeval Studies.

Caprino, C. and M. Üblacker 1985. *Das Teatro Marittimo in der Villa Hadriana*. Mainz: Philipp von Zabern.

Caputo, G., and G. Traversari. 1976. Sculture del teatro di Leptis Magna. Rome: "L'Erma" di Bretschneider.

Caubet, A., E. Fontan, and E. Gubel 2002. *Art phénicien. La sculpture de tradition phénicienne*. Paris: Réunion des Musées nationaux.

Cavaceppi, B. 1768–72. *Raccolta d'antiche statue, busti, teste cognite ed altre sculture antiche*. 3 vols. Rome: P. Manno.

Cèbe, J.-P. 1966. *La caricature et la parodie*. Paris: De Boccard.

Cerulli Irelli, M. G., et al. 1990. *La Pittura di Pompei*. Milan: Jaca Books.

Chabouillet, A. 1861. *Description du Cabinet de M. Fould*. Paris.

Chadour-Sampson, B. 1997. *Antike Fingerringe/Ancient FingerRings: Die Sammlung Alain Ollivier/The Alain Ollivier Collection*. Munich: Prähistorische Staatssammlung München, Museum für Vor-und Frühgeschichte.

Chamoux, F. 1958. "Agrippa Postumus." *Revue des Arts*, 8ᵉ année, IV, pp. 154–60.

Chapoutier, F. 1935. *Les Dioscures au service d'une déesse, étude d'iconographie religieuse*. Paris: De Boccard.

Charbonneaux, J. 1957. "Portraits du temps des Antonins." *Monuments et mémoires – Fondation Eugène Piot*, 49, pp. 67–82.

Charbonneaux, J. 1961. "Portraits romains." *L'Œil*, 73, pp. 31–37 and 87.

Charbonneaux, J. 1963. *La sculpture grecque et romaine au musée du Louvre, Guide du visiteur*. Paris: Editions des musées nationaux.

Charbonneaux, J. 1966. "Prêtres égyptiens." In *Mélanges A. Piganiol*, 1. Paris: S.E.V.P.E.N. pp. 414–20.

Chausson, F. 2003. "Domitia Longina: reconsidération d'un destin impérial." *Journal des Savants*, 1, pp. 101–29.

Chew, H. 2000. "A propos d'un fragment de statue cuirassée en bronze. La trouvaille de Saint-Nizier-le-Bouchoux (Ain)." *Antiquités nationales*, 32, pp. 219–41.

Ciampoltrini, G. 1987. "Il sarcofago di Q. Petronius Melior (CIL XI, 1595): un contributo ed un'ipotesi." *Prospettiva*, 50, pp. 42–44.

CIL. *Corpus Inscriptionum Latinarum*.

Cimok, F. 2000. *Antioch Mosaics*. Istanbul: A Turizm Yayinlari.

Clarac, V. 1851. *Musée de sculpture antique et moderne*. Paris.

Clément, C. 1862. *Catalogue des bijoux du Musée Napoléon III*. Paris: Firmin Didot Frères.

Coche de la Ferté, E. 1952. *Les portraits romano-égyptiens du Louvre. Contribution à l'étude de la peinture dans l'antiquité*. Paris: Editions des musées nationaux.

Coche de La Ferté, E. 1961. *Bijoux du Haut Moyen Age*. Lausanne: Payot.

Conticello De' Spagnolis, M., and E. De Carolis 1986. *Le lucerne di bronzo*. Vatican: Biblioteca apostolica vaticana.

Conticello De' Spagnolis, M., and E. De Carolis 1988. *Le lucerne di bronzo di Ercolano e Pompei*. Rome: "L'Erma" di Bretschneider.

Corti, C. 2001. "Pesi e contrappesi." In *Pondera. Pesi e misure nell'Antichità*. Edited by C. Corti and N. Giordani. Modena: Libra 93, pp. 191–212.

Crema, L. 1959. *L'architettura romana*. Vol. 1. Turin–Geneva–Milan: Società editrice internazionale.

Croisille, J.-M. 1965. *Les natures mortes campaniennes. Répertoire descriptif des peintures de nature morte du Musée National de Naples, de Pompéi, Herculanum et Stabies*. Brussels: Latomus.

Cumont, F. 1896. *Textes et monuments relatifs au culte de Mithra*. Vol. 2. Brussels: H. Lamertin.

Dacos, N. 1961. "Le Pâris d'Euphranor." *Bulletin de Correspondance Hellénique*, 85, pp. 371–99.

Dain, A. 1933. *Inscriptions grecques du Musée du Louvre: les textes inédits*. Paris: Les belles lettres.

Daltrop, G., U. Hausmann, and M. Wegner 1966. *Die Flavier*. Berlin: Gebr. Mann.

Daremberg, Ch., and E. Saglio 1873–1919. *Dictionnaire des antiquités grecques et romaines*. Paris: Hachette.

De Caro, S. 2001. *La natura morta nelle pitture e nei mosaici delle città vesuviane.* Naples: Electa.

Delatte, A., and P. Derchain 1964. *Les intailles magiques gréco-égyptiennes.* Paris: Bibliothèque nationale.

Delmaire, R. 1993. *Carte archéologique de la Gaule. Le Pas-de-Calais 62/2.* Paris: Académie des Inscriptions et Belles Lettres.

Deppert-Lippitz, B. 1993. "L'*opus interrasile* des orfèvres romains." In *Outils et ateliers d'orfèvres des temps anciens.* Edited by C. Eluère.Proceedings of a symposium held by the Société des amis du Musée des antiquités nationales et du Château de Saint-Germain-en-Laye in the Musée des Antiquités Nationales, Saint-Germain-en-Laye, January 17–19, 1991. Saint-Germain-en-Laye: Société des amis du Musée des antiquités nationales et du château de Saint-Germain-en-Laye, pp. 69–72.

Deppert-Lippitz, B. 1996a. *Ancient Gold Jewelry at the Dallas Museum of Art.* Dallas: Dallas Museum of Art.

Deppert-Lippitz, B. 1996b. "Late Roman Splendor: Jewelry from the Age of Constantine." *Cleveland Studies in History of Art,* 1, 1996, pp. 30–71.

De Ridder, A. 1905. *Collection de Clercq. III: Les Bronzes.* Paris: E. Leroux.

De Ridder, A. 1906. *Collection de Clercq. I: Les marbres, les vases peints et les ivoires.* Paris: E. Leroux.

De Ridder, A. 1911. *Collection de Clercq. VII: Les bijoux et les pierres gravées.* Paris: E. Leroux.

De Ridder, A. 1913. *Les bronzes antiques du Louvre. I: Les figurines.* Paris: E. Leroux.

De Ridder, A. 1915. *Les bronzes antiques du musée du Louvre. II: Les instruments.* Paris: E. Leroux.

De Ridder, A. 1924. *Catalogue sommaire des Bijoux Antiques.* Paris: Editions des musées nationaux.

Dessau, H. 1962. *Inscriptiones latinae selectae.* Berlin: Weidmann.

De Tommaso, G. 1990. *Ampullae vitreae: Contenitori in vetro di unguenti e sostanze aromatiche dell'Italia Romana (I sec. a. C. -III sec. d. C.).* Rome: "L'Erma" di Bretschneider.

De Tommaso, G. 1993. "Roman Glass Unguentaria in Greece." In *Annales du 12ᵉ congrès de l'Association internationale pour l'Histoire du Verre.* Proceedings of a symposium held in Vienne (France), August 26–30, 1991. Lochem: Association internationale pour l'Histoire du Verre, pp. 53–58.

Dhénin, M., and X. Loriot. 1985. "Deux monnaies d'or du haut empire découvertes à Fleurines (Oise)." *Bulletin de la société française de numismatique,* 40, pp. 673–75.

Dostert, A., and Fr. de Polignac. 2001. "La 'description historique' des antiques du cardinal de Polignac par Moreau de Mautour: une collection 'romaine' sous le regard de l'érudition française." *Journal des Savants,* 1, pp. 93–151.

Doxiadis, E. 1995. *Portraits du Fayoum. Visages de l'Egypte ancienne.* Paris: Gallimard.

Dragendorff, H., and C. Watzinger 1948. *Aretinische ReliefKeramik mit Beschreibung der Sammlung in Tübingen.* Reutlingen: Gryphius.

Dräger, O. 1994. *Religionem Significare. Studien zu reich verzierten römischen Altären und Basen aus Marmor.* Mainz: Philipp von Zabern.

Ducroux, S. 1975. *Catalogue analytique des inscriptions latines sur pierre conservées au musée du Louvre.* Unpublished.

Dunbabin, K. M. D. 1978. *The Mosaics of Roman North Africa.* Oxford: Clarendon Press.

Dunbabin, K. M. D. 1999. *Mosaics of the Greek and Roman World.* Cambridge: University Press.

Dunbabin, K. M. D. 2006. "A Theatrical Device of the Late Roman Stage: The Relief of Flavius Valerianus." *Journal of Roman Archaeology,* 19, pp. 191–212.

Dupraz, J., and C. Fraisse 2001. *Carte archéologique de la Gaule. L'Ardèche 07.* Paris: Académie des Inscriptions et Belles-Lettres.

Dussart, O. 1998. *Les verres de Jordanie et de Syrie du Sud.* Beirut: Institut Français d'Archéologie Proche-Orientale.

Dussaud, R. 1920. "Jupiter héliopolitain. Bronze de la collection Charles Sursock." *Syria,* I, pp. 3–15, pl. 1.

Duval, N. 1973. "Un grand médaillon monétaire du IVe siècle." *Revue du Louvre et des musées de France,* 6, pp. 367–74.

Duval, A. 1975. "Les sarcophages en plomb romains du Musée du Louvre." *Revue du Louvre et des musées de France,* 1975, 1, pp. 1–6.

EAA. *Enciclopedia dell'arte antica classica e orientale,* 30, 1. *Atlante delle forme ceramice,* 1, 1981. Rome: Instituto della enciclopedia italiana fondata da Giovanni Treccani.

Eck, W. 1995. "Ein neues Militärdiplom für die misenische Flotte und Severus Alexanders Rechtsstellung im Jahre 221/222." *Zeitschrift für Papyrologie und Epigraphik,* 108, pp. 15–34.

Eggers, H. J. 1951. *Der römische Import im freien Germanien.* 2 vols. Hamburg: Hamburgisches Museum für Völkerkunde und Vorgeschichte.

Elderkin, G. W. (ed.). 1934. *Antioch on-the-Orontes. I. The Excavations of 1932.* Princeton: University Press.

Ennabli, A. 1990. "Découverte d'une nouvelle tête en marbre à Carthage." In *L'Afrique dans l'Occident romain (Ier siècle av. J.-C.– IVe siècle ap. J.-C.),* Proceedings of a symposium held at the Ecole française de Rome, December 3–5, 1987. Paris: De Boccard.

Ensoli Vittozzi, S. 1990. *Musei Capitolini. La Collezione Egizia.* Rome: Silvana.

Erim, K. T. 1967. "De Aphrodisiade." *American Journal of Archaeology,* 71, pp. 233–43.

Escamps (d'), H. 1855. *Description des marbres antiques du Musée Campana à Rome: Sculpture grecque et romaine.* Paris: W. Remquet.

Fabbrini, L. 1980. "Marco Vipsiano Agrippa: concordanze e discordanze iconografice – nuovi contributi." In *Eikones.* Bern: Frankke Verlag, pp. 96–107.

Facchini, G. M. 1999. *Vetri antichi del Museo archeologico al Teatro Romano di Verona e di altre collezioni veronesi. Corpus delle collezioni archeologiche del vetro nel Veneto 5.* Venice: Comitato Nazionale Italiano dell'Association Internationale pour l'Histoire du Verre.

Fauduet, I. 1999. *Fibules préromaines, romaines et mérovingiennes du musée du Louvre.* Paris: Presses de l'Ecole Normale Supérieure.

Fea, C. 1790. *Miscellanea filologica, critica e antiquaria.* Rome.

Ferrare 1996. *Pompei: abitare sotto il Vesuvio.* Ferrara, Palazzo dei Diamanti, September 29, 1996–January 19, 1997. Ferrara: Ferrara Arte.

Feugère, M. 1985. *Les fibules en Gaule méridionale de la conquête à la fin du Ve siècle après J.-C.* Paris: Centre National de la Recherche Scientifique.

Fittschen, K. 1982. *Die Bildnistypen der Faustina minor und die Fecunditas Augustae.* Göttingen: Vandenhoeck & Ruprecht.

Fittschen, K., and P. Zanker 1983. *Katalog der römischen Porträts in den Capitolinischen Museen und den anderen Kommunalen Sammlungen der Stadt Rom.* Vol. III. Mainz: Philipp von Zabern.

Fittschen, K., and P. Zanker 1985. *Katalog der römischen Porträts in den Capitolinischen Museen und den anderen Kommunalen Sammlungen der Stadt Rom.* Vol. I, Text. Mainz: Philipp von Zabern.

Fittschen, K. 1987. "I Ritratti di Germanico". In *Germanico: la persona, la personalità, il personaggio: nel bimillenario dalla nascita.* Edited by G. Bonamente and M.-P. Segoloni. Proceedings of a symposium held in Macerata–Perugia, May 9–11, 1986. Rome: G. Bretschneider, pp. 205–18.

Fittschen, K. 1999. *Prinzenbildnisse antoninischer Zeit.* Mainz: Philipp von Zabern.

Frankfurt 1999. *Augenblicke. Mumienporträts und ägyptische Grabkunst aus römischer Zeit.* Schirn Kunsthalle, January 30–April 11. Munich: Klinkhardt & Biermann.

Frankfurt 2005. *Ägypten Griechenland Rom, Abwehr und Berührung.* Liebighaus, November 26, 2005–February 26, 2006. Frankfurt am Main: Liebighaus, Museum alter Plaskik.

Fremersdorf, F. 1958. *Das naturfarbene sogenannte blaugrüne Glas in Köln. Die Denkmäler des römischen Köln, IV.* Cologne: Verlag der Löwe.

Fremersdorf, F. 1962. *Die römischen Gläser mit aufgelegten Nuppen. Die Denkmäler des römischen Köln, VII.* Cologne: Verlag der Löwe.

Frey-Asche, L. 1996. "Aphrodite in Mainz." *Istanbuler Mitteilungen,* 46, pp. 277–86.

Freyer-Schauenburg, B. 1983. "Io in Alexandria." *Mitteilungen des deutschen archäologischen Instituts, Römische Abteilung,* 90, pp. 23–29.

Froehner, W. 1864. *Inscriptions grecques du Louvre.* Paris.

Froehner, W. 1869. *Notice de la sculpture antique du musée impérial du Louvre.* Paris: Charles de Mourgues.

Fröhlich, Th. 1991. *Lararien und Fassadenbilder in der Vesuvstädten.* Mainz: Philipp von Zabern.

Frova, A. 1961. *L'arte di Roma e del mondo romano.* Turin: Unione Tipografico-Editrice Torinese.

Fuchs, M. 1992. *Glyptothek München. Katalog der Skulpturen. VI. Römische Idealplastik.* Munich: Beck.

Fuchs, M. 1999. *In hoc etiam genere Graeciae nihil cedamus: Studien zur Romanisierung der späthellenistischen Kunst im 1. Jh. V. Chr.* Mainz: Philipp von Zabern.

Fullerton, M. D. 1990. *The Archaic Style in Roman Statuary.* Leiden: E. J. Brill.

Furtwaengler, A. 1895. *Masterpieces of Greek Sculpture: A Series of Essays on the History of Art.* London: W. Heinemann.

Furtwaengler, A. 1897. *Collection Somzée. Monuments d'art antique.* Munich: F. Bruckmann.

Fuseli, H. 1830. *Lectures on Painting,* 2nd series. London.

Gabelmann, H. 1974. "Zur hellenistisch-römischen Bleiglasurkeramik in Kleinasien." *Jahrbuch des Deutschen archäologischen Instituts,* 89, pp. 282–83.

Gabori-Chopin, D. 2003. *Ivoires médiévaux, Ve-XVe siècle.* Paris: Réunion des Musées nationaux.

Gargiulo, P. 1999. "Reperti di vetro dagli scavi di Liternum." In *Il vetro in Italia meridionale e insulare.* Edited by C. Piccioli and F. Sogliani. Proceedings of a symposium held by the Comitato nazionale Italiano dell'Associazione Internationale pour l'Histoire du Verre, in Naples, March 5–7, 1998. Naples: Di Frede, pp. 161–70.

Gassinger, D. 1991. *Römische Marmorkratere.* Mainz: Philipp von Zabern.

Gauckler, P. 1909. "Le couple héliopolitain et la triade solaire dans le sanctuaire syrien du Lucus Furrinae à Rome." *Mélanges d'Archéologie et d'Histoire de l'Ecole Française de Rome,* 29, pp. 239–68.

Gauckler, P. 1912. *Le sanctuaire syrien du Janicule.* Paris: A. Picard.

Gazda, E. 1981. "A Marble Group of Ganymede and the Eagle from the Age of Augustine." In *Excavations at Carthage 1977.* Edited by J. H. Humphrey. Vol. VI. Ann Arbor: Kelsey Museum, University of Michigan, pp. 125–67.

Genoa 1999. *Magiche trasparenze. I vetri dell'antica Albingaunum,* Genoa, Palazzo Ducale, 1999. Milan: Mazzotta.

Ghiron-Bistagne, P. 1970. "Les demi-masques." *Revue archéologique,* 2, pp. 253–82.

Giuliano, A. 1957. *Catalogo dei ritratti romani del Museo profano lateranense.* Vatican: Tipografia Poliglotta Vaticana.

Giuliano, A. 1979. *Museo Nazionale Romano. Le Sculture. I,* 1. Rome: De Luca.

Gnecchi, F. 1912. *I Medaglioni romani, descritti ed illustrati. II, Bronzo.* Milan: U. Hoepli.

Goette, H. R. 1989. "Kaiserzeitliche Bidnisse von Sarapis-Priestern." *Mitteilungen des Deutschen Archäologischen Instituts, Abteilung Kairo,* 45, pp.173–86.

Goette, H. R. 1990. *Studien zu römischen Togadarstellungen.* Mainz: Philipp von Zabern.

Golda, Th. M. 1997. *Puteale und Verwandte Monumente.* Mainz: Philipp von Zabern.

Golvin, J.-C., and C. Landes 1990. *Amphithéâtres et gladiateurs.* Paris: Centre National de la Recherche Scientifique.

Gori, A. F. 1743. *Inscriptionum antiquarum graecarum et romanarum quae exstant in Etruriae urbibus pars III.* Florence.

Gori, A. F. 1759. *Thesaurus veterum diptychorum consularium et ecclesiasticorum.* Florence: J. B. Passeri.

Grassinger, D. 1999. *Die Mythologischen Sarkophage, 1.* Berlin: Gebr. Mann.

Gregarek, H. 1999. "Untersuchungen zur kaiserzeitlichen Idealplastik aus Buntmarmor." *Kölner Jahrbuch,* 32, pp. 33–284.

Grenier, J. 1952. "Les Portraits du Fayoum." *Verve,* 7, pp. 115–16.

Grenier, J. 1989. "La décoration statuaire du Serapeum du Canope de la Villa Hadriana." *Melanges de l'école française du Rome, Antiquité,* pp. 925–1019.

Grivaud de la Vincelle 1817. *Recueil de monumens antiques, la plupart inédits, et découverts dans l'ancienne Gaule: ouvrage enrichi de cartes et planches en taille-douce, qui peut faire suite aux Recueils du Comte de Caylus, et de la Sauvagère.* Paris: Treuttel et Wurtz.

Grmek, M. D., and D. Gourevitch 1998. *Les maladies dans l'art antique.* Paris: Fayard.

Gros, P. 1995. "Le Culte impérial dans la basilique judiciaire de Carthage." *Karthago,* 23, pp. 45–56.

Gros, P. 1996. *L'architecture romaine du début du IIIe siècle av. J.-C. à la fin du Haut-Empire. 1. Les monuments publics.* Paris: Picard.

Gros, P. 2001. *L'architecture romaine du début du IIIe siècle av. J.-C. à la fin du Haut-Empire. 2. Maisons, palais, villas et tombeaux.* Paris: Picard.

Grossman, J. B., J. Podany, and M. True (eds.) 2003. *History of the Restoration of Ancient Stone Sculptures.* Proceedings of a symposium held at the J. Paul Getty Museum, October 25–27, 2001. Los Angeles: J. Paul Getty Museum.

Guerrini, L. 1972. "Sculture di Palazzo Mattei. Brevi note su alcuni rilievi." *Studi Miscellanei,* 20, pp. 65–71.

Guimet, E. 1896. "L'Isis romaine." *Comptes rendus des séances de l'Académie des Inscriptions et Belles-Lettres,* 24, pp. 155–60 and pls. 1–18.

Guiraud, M. 1988. *Intailles et camées de l'époque romaine en Gaule.* Paris: Centre National de Recherche Scientifique.

Guiry-en-Vexin 1993. *Verres et Merveilles Mille ans de verre dans le nord-ouest de la Gaule.* Musée archéologique départemental du Val d'Oise, October 17, 1993–January 31, 1994. Guiry-en-Vexin: Musée archéologique départemental du Val d'Oise.

Hafner, G. 1954. *Späthellenistische Bildnis-plastik versuch einer Landschaftlichen Gliederung*. Berlin: Gebr. Mann.

Hamberg, P. G. 1945. *Studies in Roman Imperial Art: The State Reliefs of the Second Century*. Copenhagen: Munksgaard.

Hanfmann, G. M. A. 1964. *Roman Art*. New York: New York Graphic Society.

Hannerstad, N. 2002. "Das Ende der antiken Idealstatue." *Antike Welt*, 33, pp. 635–49.

Haskell, F., and N. Penny 1981. *Taste and the Antique*. London: Yale University Press.

Hayes, J. W. 1972. *Late Roman Pottery*. London: The British School at Rome.

Hayes, J. W. 1975. *Roman and Pre-Roman Glass in the Royal Ontario Museum*. Toronto: Royal Ontario Museum.

Heilmeyer, W.-D. 1988. *Antikenmuseum Berlin: die ausgestellten Werke*. Berlin: Staatliche Museen Preussischer Kulturbesitz.

Herdejürgen, H. 1996. *Stadtrömische und italische Girlandensarkophage, Sarkophage des ersten und zweiten Jahrhunderts*. Berlin: Gebr. Mann.

Herdejürgen, H. 1997. "Kleinasiatische Terrakotten und stadtruömische Sarkophage, Marginalie zur Typenüberlieferung in der kaiserzeitlichen Kunst." *Antike Kunst*, 40, pp. 40–63.

Hermann, J. 1991. "Rearranged Hair: A Portrait of a Roman Woman in Boston and Some Recarved Portraits of Earlier Imperial Times." *Journal of the Museum of Fine Arts, Boston*, 3, pp. 34–50.

Hermann, J. 1999. "Demeter-Isis or the Egyptian Demeter?" *Jahrbuch des Deutschen archäologischen Instituts*, 114, pp. 75–102.

Héron de Villefosse, A. 1888. "Séance du 8 février." *Bulletin de la Société Nationale des Antiquaires de France*, pp. 129–31.

Héron de Villefosse, A. 1890. "I. Mouvements des Musées. Direction des musées nationaux. Musée du Louvre. Département des antiquités grecques et romaines." *Bulletin des musées*, pp. 285–92.

Héron de Villefosse, A. 1899. "Le trésor de Boscoreale." *Monuments et Mémoires—Fondation Eugène Piot*, 5.

Héron de Villefosse, A. 1910. *Bulletin de la Société Nationale des Antiquaires de France*, pp. 192–94.

Héron de Villefosse, A. 1921. [Le] *musée africain du Louvre*. Paris: E. Leroux.

Hiesinger, U. W. 1975. "The Portraits of Nero." *American Journal of Archaeology*, 79, pp. 113–24.

Hochuli-Gysel, A. 1977. *Kleinesietische glasierte Reliefkeramik*. Bern: Stämpfli.

Hochuli-Gysel, A. 2003. "L'Aquitaine: importations et productions au Ier siècle av. J.-C. et au Ier siècle ap. J.-C." In *Echanges et commerce du verre dans le monde antique*. Proceedings of a symposium held by the Association Françaisee pour l'Archéologie du verre, in Aix-en-Provence and Marseille, June 7–9, 2001. Montagnac: Monique Mergoil, pp. 177–93.

Hoffmann, H. 1961. *Kunst des Altertums in Hamburg*. Mainz: Philipp von Zabern.

Hölscher, T. 1987. *Römische Bildsprache als semantisches System*. Heidelberg: Carl Winter Universitätsverlag.

Hölscher, T. 2004. *The Language of Images in Roman Art*. Cambridge: Cambridge University Press.

Holtzmann, B. 1993. "Un Dionysos ivre, dispersé, et mal entendu." *Revue des Etudes anciennes*, pp. 247–56.

Hope, Ch., and A. Nova 1983. *The Autobiography of Benvenuto Cellini*. Oxford: Phaidon.

Hornbostel, W. 1973. *Sarapis. Studien zur Überlieferungsgeschichte, den Erscheinungsformen und Wandlungen der Gestalt eines Gottes*. Leiden: E. J. Brill.

Hundsalz 1987. *Das Dionysische Schmuckrelief*. Munich: Tuduv-Verlag.

Huskinson, J. 1996. *Roman Children's Sarcophagi: Their Decoration and Its Social Significance*. Oxford: Clarendon Press.

Inan, J., and E. Alfoldi-Rosenbaum 1979. *Römische und Frühbyzantinische Porträtplastik aus der Türkei: neue Funde*. Mainz: Philipp von Zabern.

Isings, C. 1971. *Roman Glass in Limburg, Archeologica Traiectina IX*. Groningen: Wolters-Noordhoff.

Jentel, M.-O. 1981. "Quelques aspects d'Aphrodite en Egypte et en Syrie à l'époque hell nistique et romaine." In *Mythologie gréco-romaine, mythologies périphériques: études d'iconographie*. Edited by L. Kahil and C. Augé. Proceedings of a symposium held in Paris, May 17, 1979. Paris: Centre National de Recherche scientifique, pp. 151–55.

Johansen, F. S. 1971. "Ritratti marmorei e bronzei di Marco Vipsanio Agrippa." *Analecta Romana Instituti Danici*, 6, pp. 17–48.

Johns, C. 1996. The Jewellery of Roman Britain. Celtic and Classical Traditions. London: UCL Press.

Jones, H. S. 1912. *A Catalogue of Ancient Sculptures Preserved in the Municipal Collections of Rome*. Oxford: Clarendon Press.

Jones, C. P. 2006. "A Letter of Hadrian to Naryka (Eastern Locris)." *Journal of Roman Archaeology* 19, pp. 151–62.

Jongkees, J. H. 1948. "New Statues by Bryaxis." *The Journal of Hellenic Studies*, 48, pp. 29–39.

Jucker, I. 1961a. "Der Feueranbläser von Aventicum." *Zeitschrift für schweizerische Archäologie und Kunstgeschichte*, 21, pp. 49–56, pl. 23–26.

Jucker, H. 1961b. *Die Bildnisse im Blätterkelch*. Lausanne–Fribourg: Urs Graf.

Jucker, H. 1968. "Eine neue Geschichte der römischen Kunst." [Review of Kraus 1967], *Schweitzer Monatshefte*, 48, pp. 750–55.

Junkelmann, M. 2000. *Das Spiel mit dem Tod. So kämpften Roms Gladiatoren*. Mainz: Philipp von Zabern.

Kabus-Jahn, R. 1963. *Studien zur Frauenfiguren des 4. Jhs v. Christus*. Darmstadt: Echo.

Kähler, H. 1958. *Rom und seine Welt: Bilder zur Geschichte und Kultur*. Munich: Bayerischer Schulbuch-Verlag.

Kähler, H. 1962. *Rom und sein Imperium*. Baden-Baden: Holle Verlag.

Kalveram, K. 1995. *Die Antikensammlung des Kardinals Scipione Borghese*. Worms am Rhein: Wernersche Verlagsgesellschaft.

Kaschnitz-Weinberg, G. 1961. *Das Schöpferische in der römischen Kunst*. Reinbek bei Hamburg: Rowohlt Taschenbuch Verlag.

Kaschnitz-Weinberg, G. 1961–63. *Römische Kunst*. 4 vols. Reinbek bei Hamburg: Rowohlt Taschenbuch Verlag.

Kater-Sibbes, G.J.F. 1973. *Preliminary Catalogue of Sarapis Monuments*. Leiden: E. J. Brill.

Kaufmann-Heinimann, A. 2004. "Götter im Keller, im Schiff und auf dem Berg. Alte und neue Statuettenfunde aus dem Imperium Romanum." In *The Antique Bronzes: Typology, Chronology, Authenticity*. Proceedings of a symposium held in Bucharest, May 26–31, 2003. Bucharest: Editura Cetatea De Scaun, pp. 249–63.

Kent, J. P. C., B. Overbeck, and A.U. Stylow. 1973. *Die Römische Münze*. Munich: Hirmer Verlag.

Kersauson (de), K. 1986. *Catalogue des portraits romains, t. I, Portraits de la République et d'époque julio-claudienne, Musée du Louvre*. Paris: Réunion des musées nationaux.

Kersauson (de), K. 1990. "Portrait d'un prince julio-claudien au Louvre." *Revue du Louvre et des musées de France*, 2, pp. 113–18.

Kersauson (de), K. 1996. *Catalogue des portraits romains, t. II, De l'année de la guerre civile (68–69 ap. J.-C.) à la fin de l'empire, Musée du Louvre*. Paris: Réunion des musées nationaux.

King, C. W. 1872. *Antique Gems and Rings*. London: Bell and Daldy.

Kiss, Z. S. 1975. *Iconographie des princes julioclaudiens au temps d'Auguste et de Tibère*. Varsovie: PWN – Editions scientifiques de Pologne.

Kleiner, D. E. E. 1992. *Roman Sculpture*. New Haven–London: Yale University Press.

Koeppel, G. M. 1969. "*Profectio und Adventus*." *Bonner Jahrbuch*, 115, pp. 130–94.

Koeppel, G. M. 1983a. "Die historischen Reliefs der römischen Kaiserzeit I." *Bonner Jahrbuch*, 183, pp. 84–141.

Koeppel, G. M. 1983b. "Two Reliefs from the Arch of Claudius in Rome." *Mitteilungen des Deutschen archaeologischen Instituts, Römische Abteilung*, 90, pp. 103–09.

Koeppel, G. M. 1985. "Die historischen Reliefs der römischen Kaiserzeit III." *Bonner Jahrbuch*, 185, pp. 143–213.

Koeppel, G. M. 1986. "Die historischen Reliefs der römischen Kaiserzeit IV." *Bonner Jahrbuch*, 186, pp. 1–90.

Koeppel, G. M. 1989. "Die historischen Reliefs der römischen Kaiserzeit, VI." *Bonner Jahrbuch*, 189, pp. 17–71.

Koeppel, G. M. 1990. "Die historischen Reliefs der römischen Kaiserzeit, VII." *Bonner Jahrbuch*, 190, pp. 1–64.

Kraus, Th. 1967. *Das römische Weltreich*. Berlin: Propyläen.

Kreilinger, U. 1996. *Römische Bronzeapplik-en. Historische Reliefs im Kleinformat*. Heidelberg: Verlag Archäologie und Geschichte.

Kunckel, H. 1974. *Der römische Genius*. Heidelberg: Kerle.

Kunow, J. 1983. *Der römische Import in der Germania Libera bis zu den Markomannenkriegen*. Neumünster: K. Wachholtz.

Lahusen, G., and E. Formigli 2001. *Römische Bildnisse aus Bronze: Kunst und Technik*. Munich: Hirmer.

Lamberti, L. 1796. *Sculture del palazzo della villa Borghese detta Pinciana*. Rome.

Lanciani, R. 1992. *Storia degli scavi di Roma, 4*. Rome: Quasar.

Lanciani, R. 2000. *Storia degli scavi di Roma e notizie intorno le collezioni romane di Antichità, 6*. Rome: Quasar.

Landwehr, Ch. 1998. "Konzeptfiguren—Ein neuer Zugang zur römischen Idealplastik."*Jahrbuch des Deutschen Archäologischen Instituts*, 113, pp. 139–94.

La Regina, A. 1998. *Palazzo Massimo alle Terme*. Milan: Electa.

Laronde, A., and G. Degeorge 2005. *Leptis Magna. La splendeur et l'oubli*. Paris: Hermann.

Laschke, B. 1993. *Fra Giovanni Angelico Montorsoli: Ein Florentiner Bildhaur des 16. Jahrhunderts*. Berlin: Gebr. Mann.

Lassus, J. 1938. "La mosaïque du Phénix provenant des fouilles d'Antioche." *Monuments et Mémoires—Fondation Eugène Piot*, 36, pp. 81–122, pl. V.

Laterre, Ch. 1987. *Les candélabres en bronze des villes du Vésuve (Pompéi, Herculanum et Boscoreale)*. Mémoire de Licence en archéologie et histoire de l'art, Université catholique de Louvain, Faculté de Philosophie et Lettres, Louvain-La-Neuve (unpublished).

Lattes 1989. *Le goût du théâtre à Rome et en Gaule romaine*. Musée archéologique Henri Prades, January 20–April 30. Lattes: Ed. Imago-Musée archéologique de Lattes.

Lattes 1990. *Le cirque et les courses de chars: Rome–Byzance*. Musée archéologique Henri Prades. Lattes: Ed. Imago.

Lebel, P. 1962. *Catalogue des collections archéologiques de Montbéliard. III. Les bronzes figurés*. Paris: Les Belles Lettres.

Le Bohec, Y. 2002. *L'armée romaine sous le Haut-Empire*. Paris: Picard.

Leibundgut, A. 1976. *Die römischen Bronzen der Schweiz. II. Avenches*. Mainz: Philipp von Zabern.

Leoncini, L. 1988. "Due nuovi disegni dell'extispicium del Louvre." *Xenia* 15, pp. 29–32.

Levi, D. 1947. *Antioch Mosaic Pavements*. 2 vols. Princeton: University Press.

Libertine, G. 1937. "Sculture siciliane inedite." *Mitteilungen des deutschen archäologischen Instituts, Römische Abteilung*, 52, pp. 67–73.

LIMC, *Lexicon iconographicum mythologiae classicae*. Zürich–Munich: Artemis, 1981–.

Linfert, A. 1976. *Kunstzentren hellenistischer Zeit*. Wiesbaden: F. Steiner.

Liou, B. 1969. *Praetores Etruriae XV populorum*. Brussels: Latomus.

Lista, M. 1986. "Gli oggetti di uso quotidiano." In *Le collezioni del Museo Nazionale di Napoli*. Rome: De Luca, pp. 174–201.

Liverani, L. 2003. "Restauro e allestimenti storici nei Musei Vaticani." In *Le sculture antiche. Problematiche legate all'esposizione di marmi antichi nelle collezioni storiche*. Edited by A. Romualdi. Proceedings of a meeting held at the galleria degli Uffizi in Florence, April 10, 2002. Florence: Polistampa, pp. 27–48.

Locarno 1988. *Vetri Romani del Cantone Ticino*. Locarno: Museo civico e archeologico.

Loffreda, S. 1984. "Vasi in vetro e in argila trovati a Cafarnao nel 1984." *Liber Annus*, 34, pp. 385–408.

Lollio Barberi, O. 1995. *Le antichità egiziane di Roma imperiale*. Rome: Istituto poligrafico e zecca dello Stato, Libreria dello Stato.

Longpérier (de), A. 1851. "Note sur les armes de gladiateurs." *Revue archéologique*, pp. 323–27.

Longpérier (de), A. 1862. "Le trésor de Tarse." *Revue numismatique*, 13, pp. 309–36.

Longpérier (de), A. 1883. "Vase d'argent antique appartenant à M. le Baron R. Seillière." *Gazette archéologique*, pp. 1–7.

L'Orange, H.-P. 1933. *Studien zur Geschichte des spätantiken Porträts*. Harvard: University Press.

Loriot, X., and S. Scheers 1985. *Corpus des trésors monétaires antiques de la France. 4. Haute-Normandie*. Paris: Société française de numismatique.

Lozinski, J. B. 1995. "The Phoenix Mosaic from Antioch: A New Interpretation." In *Fifth International Colloquium on Ancient Mosaics, Journal of Roman Archaeology*, suppl. series no. 9, pp. 135–42.

Lyon 1978. *Le Louvre présente au Muséum de Lyon les animaux dans l'Egypte ancienne*. Muséum de Lyon, November 6, 1977–January 31, 1978. Lyon: Muséum de Lyon.

Machaira, V. 1993. *Les groupes statuaires d'Aphrodite et d'Eros*. Athens: Université nationale et capodistriaque d'Athènes.

Maiuri, A. 1933. *La casa del Menandro e il suo tesoro di argenteria*. 2 vols. Rome: Libreria dello Stato.

Manfrini-Aragno, I. 1987. *Bacchus dans les bronzes hellénistiques et romains: les artisans et leur répertoire*. Lausanne: Université de Lausanne, Faculté des Lettres.

Mansuelli, G. A. 1961. *Galleria degli Uffizi —le sculture—Parte II*. Rome: Istituto poligrafico dello Stato-Libreria dello Stato.

Marseille 2001. *Tout feu, tout sable: mille ans de verre antique dans le Midi de la France.* Musée d'histoire, June 8–December 31. Marseille: musées de Marseille–Aix-en-Provence, Edisud.

Martin, M. 2005. *Magie et magiciens dans le monde gréco-romain.* Paris: Errance.

Martinez, J.-L. 2004a. *Les antiques du musée Napoléon, édition illustrée et commentée des volumes V et VI de l'inventaire du Louvre de 1810.* Paris: Réunion des musées nationaux.

Martinez, J.-L. 2004b. *Les Antiques du Louvre, une histoire du goût de Henri IV à Napoléon Ier.* Paris: Fayard and Musée du Louvre.

Marx, K. 1968. *Fondements de la critique de l'économie politique (Grundriss der Kritik der politischen Ökonomie): ébauche de 1857–1858.* Translated by R. Dangeville. Paris: Anthropos.

Massner, A. K. 1994. "Zum Stilwandel im Kaiserporträt claudischer Zeit." In *Die Regierungszeit des Kaisers Claudius (41–54 n. Ch.): Umbruch oder Episode?* Proceedings of a symposium held at the University of Freibourg Im Breisgau, February 16–18, 1991. Mainz: Philipp von Zabern.

Mastrodonato, V. 2000. "Una Residenza imperiale nel suburbio di Roma: La Villa di Lucio Vero in località Acqua Traversa." *Archeologia Classica,* 51, pp. 157-235.

Matzulewitsch, L. 1929. *Byzantinische Antike: Studien auf Grund der Silbergefäße der Eremitage.* Berlin–Leipzig: Walter de Gruyter.

Megow, W.-R. 1987. *Antike Münzen und geschnittene Steine.* Vol. XI. *Kameen von Augustus bis Alexander Severus.* Berlin: Walter de Gruyter.

McCann, A. M. 1968. *The Portraits of Septimius Severus (A. D. 193–211).* Rome: American Academy.

Megow, W.-R. 1999. "Beobachtungen zum Bildnis-Typus des sog. Postumius Albinus." In *Antike Porträts, Zum Gedächtnis von Helga Heintze.* Edited by H. von Steuben. Mannheim: Bibliopolis, pp. 113–22, Taf. 26–30.

Meischner, J. 1964. *Das Frauenporträt der Severzeit.* Berlin: E. Reuter.

Meneghini, R. 2001. "Il foro di Traiano. Ricostruzione architettonica e analisi strutturale." *Mitteilungen des Deutschen Archäologischen Instituts, Römische Abteilung,* 108, pp. 127–48.

Merlin, A. 1932. "Pyxide grecque à glaçure plombifère." *Monuments et mémoires – Fondation Eugène Piot,* 54, pp. 51–60.

Metzger, C. 1980. "Les bijoux monétaires de l'Antiquité tardive." *Dossiers de l'archéologie,* 40, pp. 82–90.

Metzger, C. 1991. *Revue du Louvre et des musées de France,* 2, p. 73.

Meyer, H. 1991. *Antinoos.* Munich: W. Fink.

Michaelis, A. 1889. *Catalogue of Ancient Marbles of Lansdowne House.* London.

Michaelis, A. 1908. *A Century of Archaeological Discoveries.* London: J. Murray.

Michon, E. 1906a. *Bulletin de la société des Antiquaires de France,* pp. 380–84.

Michon, E. 1906b. "Bas-reliefs d'Asie Mineure." *Revue des Etudes anciennes,* pp. 181–90.

Michon, E. 1909. "Les bas-reliefs historiques romains du Musée du Louvre." *Monuments et Mémoires—Fondation Eugène Piot,* 17, pp. 139–253.

Michon, E. 1914. *Monuments et Mémoires—Fondation Eugène Piot,* 21, p. 168.

Michon, E. 1915. "Le trésor gallo-romain de Pouzin (Ardèche)." *Bulletin archéologique du Comité des travaux historiques et scientifiques,* pp. 71–82.

Michon, E. 1934. "Buste d'homme trouvé à Reims." *Monuments et mémoires—Fondation Eugène Piot,* 34, pp. 75–96.

Mikocki, T. 1995. *Sub Specie Deae, les impératrices et princesses romaines assimilées à des déesses.* Rome: G. Bretschneider.

Milan 1997. *Iside. Il mito, il mistero, la magia.* Palazzo Reale, 22 February–1 June. Milan: Electa.

Milan 1999. *Magiche trasparenze. I vetri dell'antica Albingaunum.* Palazzo Ducale, December 17, 1999–March 15, 2000. Milan: Mazzotta.

Milan 2003. *387 d.c.: Ambrogio e Agostino; le sorgenti dell'Europa.* Museo Diocesano, Chiostri di Sant'Eustorgio, December 8, 2003–May 2, 2004. Milan: Olivares.

Mora, P., and P. Philippot 1977. *La Conservation des peintures murales.* Bologna: Compositori.

Moreno, P., and A. Viacava 2003. *I marmi antichi della Galleria Borghese.* Rome: De Luca.

Musso, L., and M. Spaelli 1998. "Sarcofagi di vita humana nel Museo Nazionale Romano." In *125 Jahre Sarkophag-Corpus.* Proceedings of a symposium held in Marburg, 1995. Mainz: Philipp von Zabern, pp. 25–27, pl. 10.

Mutz, A. 1972. *Die Kunst des Metalldreher bei den Römern. Interpretationen antiker Arbeitsverfahren auf Grund von Werkspuren.* Basel–Stuttgart: Birkhäuser.

Nadalini, G. 1992. "Les collections du musée Campana: origine et formation des collections, l'organisation du musée et les problèmes de restauration." In *L'Anticomanie. La collection d'antiquités aux 18e et 19e siècles.* Edited by A. F. Laurens and K. Pomian. Proceedings of a colloquium held at Montpellier-Lattes, June 9–11, 1988. Paris: Ecole des hautes études en sciences sociales, pp. 111–22.

Naples 1999. *Homo Faber: natur, scienza e tecnica nell' antica Pompei.* Museo Archeologico Nazionale, 27 March–18 July. Milan: Electa.

Naples 2003. *Storie da un' eruzione. Pompei, Ercolano, Oplontis.* Museo Archeologico Nazionale, March 31–August 31. Milano: Electa.

Nenova-Merdjanova, R. 2000. "Images of Bronze Against the Evil Eye (Beyond the Typological and Functional Interpretation of the Roman Bronze Vessels for Oil)." *Kölner Jahrbuch,* 33, pp. 303–12.

Neverov, O. J. 1971. *Antique Cameos in the Hermitage.* Saint Petersburg: Aurora Art Publisher.

New York 1978. *The Royal Hunter: Art of the Sassanian Empire.* Asia House Gallery, Winter 1978. New York: The Asia Society.

New York 1979. *Age of Spirituality: Late Antique and Early Christian Art, Third to Seventh Century.* The Metropolitan Museum of Art, November 19, 1977–February 12, 1978. New York: Metropolitan Museum of Art; Princeton: Princeton University Press.

New York 2000. *Ancient Faces. Mummy Portraits from Roman Egypt.* Metropolitan Museum of Art, February 15–May 7. New York: The Metropolitan Museum of Art–Routledge.

Notices 1808. *Notices des statues, bustes et bas-reliefs de la galerie des Antiques du Musée Napoléon.* Paris.

Nuber, H. U. 1972. *Kanne und Griffschale. Ihr Gebrauch im täglichen Leben und die Beigabe in Gräbern der römischen Kaiserzeit.* Berlin: Walter de Gruyter.

Oehler, H. 1961. *Untersuchungen zu den Mannlichen Römischen Mantelstatuen.* Berlin: Gebr. Mann.

Oettel, A. 1991. *Bronzen aus Boscoreale in Berlin: Antikenmuseum.* Berlin: Staatliche Museen zu Berlin, Preussischer Kulturbesitz.

Oppermann, M. 1985. *Römische Kaiserreliefs.* Leipzig: E.A. Seemann Verlag.

Painter, K. S. 2001. *The Insula of the Menander at Pompeii. IV: The Silver Treasure.* Oxford: University Press.

Palagia, O. 1980. *Euphranor.* Leiden: E. J. Brill.

Pallottino, M. 1938. "Il grande fregio di Traiano." *Bullettino della Commissione Archeologica Comunale,* 66, pp. 17–58.

Panofsky-Sorgel. 1967–68. "Zur Geschichte des Palazzo Máttei di giove." *Römisches Jahrbuch für Kunstgeschichte,* XI, pp. 111–88.

Pape, M. 1975. *Griechische Kunstwerke aus Kriegsbeute und ihre öffentliche Aufstellung in Rom: Von der Eroberung von Syrakus bis in augusteische Zeit...* Diss., Hamburg.

Paris 1959. *La vie privée en Grèce et à Rome.* Musée du Louvre, July 1–December 31.

Paris 1963. *L'art dans l'Occident romain: Trésors d'argenterie. Sculptures de bronze et de pierre.* Musée du Louvre, July–October.

Paris 1970. *L'art de Rome et des provinces dans les collections parisiennes,* travelling exhibition. Paris: service des expositions d'action éducative et culturelle.

Paris 1981. *A l'aube de la France.* Musée du Luxembourg, February 26–May 3. Paris: Réunion des musées nationaux.

Paris 1987. *Le trésor de Garonne.* Musée de la monnaie. Nantes: musées départementaux de Loire-Atlantique.

Paris 1989a. *Les donateurs du Louvre.* Musée du Louvre, April 4–August 21. Paris: Réunion des musées nationaux.

Paris 1989b. *Trésors d'orfèvrerie gallo-romains.* Musée du Luxembourg, February 8–April 23. Paris: Réunion des musées nationaux.

Paris 1991. *Le trésor de Saint-Denis.* Musée du Louvre, March 12–June 17. Paris: Réunion des musées nationaux.

Paris 1992. *Byzance: l'art byzantin dans les collections publiques françaises.* Musée du Louvre, November 3, 1992–February 1, 1993. Paris: Réunion des musées nationaux.

Paris 1994. *Egyptomania: l'Egypte dans l'art occidental.* Musée du Louvre, January 20–April 18. Paris: Réunion des musées nationaux.

Paris 1995. *Jeunesse de la Beauté. La Peinture romaine antique.* Mairie du Vᵉ arrondissement, April. Paris: Ars Latina.

Paris 1998. *Liban. L'autre rive.* Institut du monde arabe, 27 October 1998–2 May 1999. Paris : Flammarion and Institut du monde arabe.

Paris 1999. *Hadrien: trésors d'une villa impériale.* Mairie du Vᵉ arrondissement. September 22–December 19. Exhib. cat. Milan: Electa.

Paris 2000a. *L'empire du Temps. Mythes et créations.* Musée du Louvre, April 10–July 10. Paris: Réunion des musées nationaux.

Paris 2000b. *D'après l'Antique.* Musée du Louvre, October 16, 2000–January 15, 2001. Paris: Réunion des musées nationaux.

Paris 2004. *Ivoires. De l'Orient ancien aux Temps modernes.* Musée du Louvre, June 23– August 30. Paris: Réunion des musées nationaux.

Paris 2005. *Faïences de l'Antiquité de l'Egypte à l'Iran.* Musée du Louvre. June 10– September 12. Paris: 5 continents-musée du Louvre Éditions.

Paris 2005–06. *Trésor antiques, bijoux de la collection Campana.* Musée du Louvre, October 21, 2005–January 16, 2006. Paris: 5 continents-musée du Louvre éditions.

Parlasca, K. 1980. *Ritratti di mummie. Repertorio dell'Egitto greco-romano.* Series B, vol. 3. Rome: "L'Erma" di Bretschneider.

Parlasca, K., and H. G. Frenz 2003. *Ritratti di mummie. Repertorio dell'Egitto greco-romano.* Series B, vol. 4. Rome: "L'Erma" di Bretschneider.

Pasquier, A. 1995. *Revue du Louvre et des musées de France,* 5–6, p. 109, no. 7.

Pasquier, A. 1998. *Le Louvre, Les antiquités grecques, étrusques et romaines.* Paris: Scala and Réunion des musées nationaux.

Pavesi, G., and E. Gagetti 2001. *Arte e materia. Studi su oggetti di ornamento di età romana.* Milan: Cisalpino.

Perdrizet, P. 1911. *Bronzes grecs d'Egypte de la collection Fouquet.* Paris.

Pernice, E. 1925. *Die hellenistische Kunst in Pompeji, 4, Gefässe und Geräte aus Bronze.* Berlin–Leipzig: Walter De Gruyter and Co.

Petit-Radel, L. 1806. *Les Monuments antiques du musée Napoléon, III.* Paris: F. et P. Piranese frères.

Pfuhl, E., and H. Möbius 1979. *Die Ostgriechischen Grabreliefs, 2.* Mainz: Philipp von Zabern.

Piazza, G. 1797. *Descrizione della Minerva veliterna.* Velletri.

Picard, C. 1936–66. *Manuel d'archéologie grecque, la sculpture.* Paris: A. Picard.

Picard, G.-Ch. 1962. *L'art romain.* Paris: Presses Universitaires de France.

Piganiol de la Force, J.-A. 1742. *Nouvelle Description des châteaux et parcs de Versailles et de Marly, contenant une explication historique de toutes les peintures, tableaux, statues, vases et ornements qui s'y voient, leurs dimensions, et les noms des peintres et des sculpteurs qui les ont faits ; avec les plans de ces deux maisons royales...* Paris: T. Legras.

Pirzio Biroli Stefanelli, L. 1990. *Il Bronzo dei Romani: arredo e suppelletile.* Rome: "L'Erma" di Bretschneider.

Pirzio Biroli Stefanelli, L. 1991. *L'argento dei Romani: Vasellame da tavola e d'apparato.* Rome: "L'Erma" di Bretschneider.

Pirzio Biroli Stefanelli, L. 1992. *L'oro dei Romani: Gioeilli di età imperiale.* Rome: "L'Erma" di Bretschneider.

Plantzos, D. 1999. *Hellenistic Engraved Gems.* Oxford: Clarendon Press.

Pochmarski, E. 1990. *Dionysische Gruppen.* Vienna: Selbstverlag des Österreichischen Archäologischen Instituts.

Pottier, E. 1926. *Le dessin chez les Grecs d'après les vases peints.* Paris: Les Belles Lettres.

Potts, A. 1998. "The Impossible Ideal: Romantic Conceptions of the Parthenon Sculptures in Early Nineteenth-Century Britain and Germany." In *Art in Bourgeois Society, 1790–1850.* Edited by A. Hemingway and W. Vaughan. Cambridge: University Press, pp. 101–22.

Poulsen, F. 1947. "Caton et le jeune prince." *Acta Archaeologica,* 18, pp. 117–39.

Poulsen, E. 1977. "Probleme der Werkstattbestimmung gegossener römischer Figuralbronzen." *Acta Archaeologica,* 48, pp. 1–60.

Poulsen, E. 1991. "Römische Bronzeeimer: Typologie der Henkelattachen mit Frauenmaske, Palmette und Tierprotomen." *Acta Archaeologica,* 62, pp. 209–30.

Price, S. R. F. 1984. *Rituals and Power: The Roman Imperial Cult in Asia Minor.* Cambridge: University Press.

Princeton 1990. *The Coroplast's Art: Greek Terracottas of the Hellenistic World.* Exhib. cat. New Rochelle, N.Y.: A.D. Caratzas.

Raeder, J. 1983. *Die Statuarische Ausstattung der Villa Hadriana bei Tivoli.* Frankfurt–Bern: Peter Lang.

Rayet, O., and M. Colligon 1888. *Histoire de la céramique grecque.* Paris: G. Decaux.

Rebaudo, L. 1999. "I restauri del Laocoonte." In *Laocoonte—Fama e stile.* Edited by S. Settis. Rome: Donzelli.

Rebourg, A. 1994. *Carte archéologique de la Gaule. La Saône-et-Loire 71/3*. Paris: Académie des Inscriptions et Belles Lettres.

Reinach, S. 1897–1930. *Répertoire de la statuaire antique*. Paris: E. Leroux.

Reinberg, C. 1995. "Senatorensarkophage." *Mitteilungen des deutschen archaeologischen Instituts. Römische Abteilung*, 102, pp. 353–70.

Revue du Louvre et des musées de France 1980. "Les récentes acquisitions des musées nationaux," p. 262.

Richter, G. M. A. 1971. *The Engraved Gems of the Greeks, Etruscans and Romans. II. Engraved Gems of the Romans: A Supplement to the History of Roman Art*. London: Phaidon.

Rimini 2005. *Costantino il Grande, la Civiltà al bivio tra Occidente e Oriente*. Castel Sismondo, March 13–September 4. Milan: Silvana.

Robert, L. 1946. "Monuments de gladiateurs dans l'Orient grec." *Hellenica*, 3, pp. 112–50.

Robert, L. 1971. *Les gladiateurs dans l'Orient grec*. Amsterdam: Adolf M. Hakkert.

Roddaz, J.-M. 1984. *Marcus Agrippa*. Rome: Ecole française de Rome.

Rodenwaldt, G. 1927. *Hellas und Rom*. Berlin: Propyläen Verlag.

Rodenwaldt, G. 1935. *Über der Stilwandel in antoninischen Kunst*. Berlin: Walter De Gruyter.

Rodenwaldt, G. 1940. "Römische Reliefs: Vorstufen zur Spätantike." *Jahrbuch des Deutschen Archäologischen Instituts*, 55, pp. 12–43.

Roffia, E. 1993. *I vetri antichi delle civiche raccolte archeologiche di Milano*. Milan: Comune di Milano, Sottore cultura e sjettacolo, civiche raccolte archeologiche.

Rolley, C. 1967. *Monumenta graeca et romana. V. Les arts mineurs grecs. 1. Les bronzes*. Leiden: E. J. Brill.

Rome 1992. *La Collezione Boncompagni Ludovisi Algardi, Bernini e la fortuna dell'antico*. Fondazione Memmo, Palazzo Ruspoli, December 5, 1992–April 30, 1993. Venice: Marsilio.

Rome 2000a. *Aurea Roma: dalla città pagana alla città cristiana*. Palazzo delle Esposizioni, December 22, 2000–April 20, 2001. Rome: "L'Erma" di Bretschneider.

Rome 2000b. *L'Idea del bello, Viaggio per Roma nel Seicento con Giovan Pietro Bellori*. Palazzo delle Esposizioni, March 29–June 26. Rome: De Luca.

Rome 2003. *Villa Borghese: i principi, le arti, la città dal Settecento all' Ottocento*. Villa Poniatowski, December 5, 2003–March 21, 2004. Milan: Skira.

Rome 2004. *La Stanza del Gladiatore ricostituita: il capolavoro della committenza Borghese del Settecento*, Galleria Borghese, December 12, 2003–May 16, 2004. Milan: Skira.

Rome 2005. *Settecento a Roma*. Palazzo Venezia, November 10, 2005–February 26, 2006. Milan: Silvana.

Ronke, J. 1987. *Magistratische Repräsentation im römischen Relief: Studien zu standes- und statusbezeichnenden Szenen*. Oxford: B.A.R.

Rossi Pinelli, O. 1991. "Il frontone di Aegina e la cultura del restauro dell'Antico a Roma interno al 1816." In *Thorvaldsen, l'ambiente, l'influsso, il mito*. Edited by P. Kragelund. Rome: "L'Erma" di Bretschneider, pp. 123–29.

Rouen 2000. *Miroirs. Jeux et reflets depuis l'Antiquité*. Musée départemental des Antiquités, October 21, 2000–February 26, 2001. Paris: Somogy.

Roullet 1972. *The Egyptian and Egyptianizing Monuments of Imperial Rome*. Leiden: E. J. Brill.

Roux, H. 1862. *Herculanum et Pompéi. Recueil général des peintures, bronzes, mosaïques, etc*. Paris: Firmin Didot.

Rupprecht Goette, H. 1990. *Studien zu römischen Togadarstellungen*. Mainz: Philipp von Zabern.

Saldern (von), A. 1968. *Ancient Glass in the Museum of Fine Arts, Boston*. Boston: Museum of Fine Arts.

Sannibale, M. 1995. "Qualche osservazione su una statuetta di Venere orientale del Museo Gregoriano Egizio." *Bollettino —Monumenti musei e gallerie pontificie*, 15, pp. 15–35.

Saragosse 2003. *El teatro romano*. Saragossa, La Lonja, April–June. Saragossa: Ayuntamiento.

Sarnataro, T. 1997. *Per un catalogo del vasellame bronzeo da Pompei ed Ercolano nel museo nazionale di Napoli: le patere*. Tesi di Laurea in antichità pompeiane ed ercolanesi, Naples, Università Federico II. Unpublished.

Sarti, S. 2001. *Giovanni Pietro Campana, 1808–1880: The Man and His Collection*. Oxford: Archeopress.

Savoy, B. 2003. *Patrimoine annexé. Les biens culturels saisis par la France en Allemagne autour de 1800*. Paris: Maison des Sciences de l'Homme.

Schneider, C. 1999. *Die Musengruppe Von Milet*. Mainz: Phillipp von Zabern.

Schnitzler, B. 1995. *Bronzes antiques d'Alsace*. Paris: Réunion des musées nationaux.

Schröder, St. F. 2004. *Katalog der antiken Skulpturen des Museo del Prado in Madrid. II. Idealplastik*. Mainz: Philipp von Zabern.

Schurmann, W. 1989. *Katalog der antiken Terrakotten im badischen Landesmuseum Karlsruhe*. Göteborg: Paul Áströms Förlag.

Scott, D. A., and J. Podany 1990. "Ancient Copper Alloys: Some Metallurgical and Technological Studies of Greek and Roman Bronzes." In *Small Bronze Sculpture from the Ancient World*. Proceedings of a symposium held at the J. Paul Getty Museum, Malibu, March 16–19, 1989. Malibu: J. Paul Getty Museum, pp. 31–60.

Scott Ryberg, I. 1955. *Rites of the State Religion in Roman Art*. Rome: American Academy in Rome.

Settis, S. 1982. "Ineguaglianze e continuità, un immagine dell'arte romana." In *Introduzione all'arte romana*. Edited by O. J. Brendel. Turin: Giulio Einaudi, pp. 159–200.

Shelton, K. J. 1981. *The Esquiline Treasure*. London: The British Museum.

Simon-Hiernard, D. and F. Dubreuil 2000. *Verres d'époque romaine Collection des musées de Poitiers*. Poitiers: Musées de Poitiers.

Sinn, F. 1987. *Stadtrömische Marmorurnen*. Mainz: Philipp von Zabern.

Slitine, F. 2005. *Histoire du verre: l'Antiquité*. Paris: Massin.

Smith, R. R. R. 1998. "Cultural Choice and Political Identity in Honorific Portrait Statues in the Greek East in the Second Century A.D." *The Journal of Roman Studies*, 88, pp. 56–93.

Soechting, D. 1972. *Die Porträts des Septimus Severus*. Bonn: Rudolf Habelt.

Sparti, D. L. 1998. "Tecnica e teoria del restauro sculptureo a Roma nel Seicento, con verifica sulla collezione di Flavio Chigi." *Storia dell'Arte*, 92, pp. 90–118.

Stemmer, K. 1978. *Untersuchungen zur Typologie, Chronologie und Ikonographie der Panzerstatuen*. Berlin: Gebr. Mann.

Stern, E. M. 1977. *Ancient Glass at the Fondation Custodia*. Groningen: Wolters-Noordhoff.

Stern, E. M. 2001. *Roman, Byzantine and Early Medieval Glass 10 BCE–700 CE, Ernesto Wolf Collection*. Ostfildern: Hatje Cantz.

Stillwell, R. 1938. *Antioch on-the-Orontes II. The Excavations, 1933–1936*. Princeton: University Press.

Stilp, F. 2001. *Mariage et Suovetaurilia: Etude sur le soi-disant "Autel de Domitius Ahenobarbus."* Rome: G. Bretschneider.

Stirling, L. 1996. "Divinities and Heroes in the Age of Ausonius: A Late-Antique Villa at Saint-George-de-Montagne (Gironde)." *Revue Archéologique*, 1, pp. 103–43.

Stirling, L. 2005. *The Learned Collector: Mythological Statuettes and Classical Taste in Late Antique Gaul*. Ann Arbor: The University of Michigan Press.

Stuart, M. 1938. *The Portraiture of Claudius: Preliminary Studies*. New York: Columbia University.

Summerer, L. 1996. "Karikaturen und Grotesken." In *Hauch des Prometheus, Meisterwerke in Ton*. Munich: Staatliche Antikensammlung und Glyptothek, pp. 171–77.

Szabó, K. 1995. "Situles de Pannonie." In *Acta of the 12th International Congress on Ancient Bronzes*. Proceedings of a symposium held in Nijmegen, 1992. Nijmegen: Provinciaal Museum G. M. Kam, pp. 77–85.

Tansini, R. 1995. *I Ritratti di Agrippina Maggiore*. Rome: G. Bretschneider.

Tassinari, S. 1993. *Il vasellame bronzeo di Pompei*. 2 vols. Rome: "L'Erma" di Bretschneider.

Tassinari, S. 1995a. "Recherches sur la datation et l'origine de la vaisselle de Pompéi." In *Acta of the 12th International Congress on Ancient Bronzes*. Proceedings of a symposium held in Nijmegen, 1992. Nijmegen: Provinciaal Museum G. M. Kam, pp. 87–96.

Tassinari, S. 1995b. *Vaisselle antique de bronze: collections du musée départemental des antiquités de Rouen*. Rouen: Conseil général.

ThesCRA. *Thesaurus Cultus et Rituum Antiquorum*. Los Angeles: The J. Paul Getty Museum, 2004–.

Toledo 1977. *Silver for the Gods: 800 Years of Greek and Roman Silver*. The Toledo Museum of Art, October 8–November 20. Toledo: Toledo Museum of Art.

Tomei, M. A. 1999. *Scavi Francesi sul Palatino*. Rome: Ecole française-Soprintendenza archeologica di Roma.

Tongres 2002. *Schone Schijn. Romeinse juweelkunst in West-Europa. Brillance et prestige. La joaillerie romaine en Europe occidentale*. Musée provincial gallo-romain, October 26, 2002–March 16, 2003. Louvain: Peeters.

Torelli, M. 1982. *Typology and Structure of Roman Historical Reliefs*. Ann Arbor: The University of Michigan Press.

Tortorella, S. 1992. "I rilievi del Louvre con suovetaurile: un documento del culto imperiale." *Ostraka*, 1, pp. 81–104.

Toulouse 1990. *Le cirque romain*. Musée Saint-Raymond. Toulouse: Musée Saint-Raymond.

Tran Tam Tinh, V. 1974. *Catalogue des peintures romaines (Latium et Campanie) du musée du Louvre*. Paris: Editions des musées nationaux.

Traversari, G. 1960. *Statue iconiche femminili cirenaiche*. Rome: "L'Erma" di Bretschneider.

Treister, M. J. 1994. "Italic and Provincial-Roman Mirrors in Eastern Europe." In *Akten der 10. Internationalen Tagung über antike Bronzen*. Proceedings of a symposium held at the University of Freiburg Im Breisgau, July 18–22, 1988. Stuttgart: Thesis, pp. 417–27.

Tulsa 1981. *Roman Portraits in the Getty Museum*, Philbrook Art Center, April 26–July 12. Tulsa: Philbrook Art Center.

Turcan, R. 1966. *Les sarcophages romains à représentation dionysiaque*. Paris: de Boccard.

Turcan, R. 1988. *Religion romaine. 1. Les dieux. 2. Le Culte*. Leiden: E. J. Brill.

Turcan, R. 1999. *Messages d'outre-tombe: l'iconographie des sarcophages romains*. Paris: de Boccard.

Turcan-Deléani, M. 1964. "Contribution à l'étude des amours dans l'art funéraire romain: les sarcophages à courses de chars." *Mélanges d'archéologie et d'histoire de l'Ecole Française de Rome*, 76, pp. 43–49.

Tyskiewicz, M. 1895. "Notes et souvenirs d'un vieux collectionneur." *Revue archéologique*, 2, pp. 272–85.

Valenciennes 1997. *Trésors archéologiques du Nord de la France*. Musée des Beaux-Arts, May 16–October 19. Valenciennes: Musée des beaux-arts de Valenciennes.

Valenza, N. 1977. "Le lucerne di bronzo del Museo di Napoli." In *L'instrumentum domesticum di Ercolano e Pompei nella prima età imperiale*. Proceedings of a symposium held in Naples, May 30–June 3, 1973. Rome: "L'Erma" di Bretschneider, pp. 155–61.

Van der Poel, H. B. 2001. *Pompei. I tesori di Boscoreale (Lettere e documenti)*. Rome: H. Van der Poel.

Venuti, R., and G. C. Amaduzzi 1779. *Vetera monumenta quae in hortis Caelimontani et in aedibus Matthaeiorum adservantur*. Rome: Venantis Monaldini.

Vermaseren, M. J. 1966. *The Legend of Attis in Greek and Roman Art*. Leiden: E. J. Brill.

Vermaseren, M. J. 1987. *Corpus Cultus Cybelae Attidisque*. Leiden: E. J. Brill.

Vermeule, C. C. 1960. *The Dal Pozzo-Albani Drawings of Classical Antiquities in the British Museum*. Philadelphia: American Philosophical Society.

Veyne, P. 1985. "Les saluts aux dieux, le voyage de cette vie et la 'réception' en iconographie." *Revue archéologique*, 1, pp. 47–61.

Virgili, P. 1989. *Acconciature e maquillage*. Museo della civiltà romana, 7. Rome: Quasar.

Visconti, E. Q. 1784. *Il Museo Pio-Clementino*. Rome: L. Mirri.

Visconti, E. Q. 1797. *Monumenti gabini della villa Pinciana*. Rome: A. Fulgoni.

Vogel, L. 1969. "Circus Race Scenes in the Early Roman Empire." *Art Bulletin*, 51, pp. 155–60.

Volbach, W. 1952. *Elfenbeinarbeiten der spätantike und des frühen Mittelalters*. Mainz: Verlag des römisch-germanischen Zentralmuseums.

Vollenweider, M.-L. 1972. *Die Porträtgemmen der römischen Republik*. Mainz: Philipp von Zabern.

Vollenweider, M.-L. 1984. *Deliciae Leonis. Antike geschnittene Steine und Ringe aus einer Privatsammlung*. Mainz: Philipp von Zabern.

Vollenweider, M.-L., and M. Avisseau-Broustet 2003. *Camées et intailles*. Vol. 2, II *Les Portraits romains du Cabinet des Médailles*. Paris: Bibliothèque nationale de France.

Von Blanckenhagen, P.H. 1942. "Elemente der römischen Kunst am Beispiel des flavischen Stils." In *Das neue Bild der Antike. 2. Rom*. Edited by H. Berve. Leipzig: Koehler and Amelang, p. 310s.

Wace, A. J. B. 1907. *Studies in Roman Historical Reliefs*. London.

Walker, S. 2000. *Ancient Faces: Mummy Portraits in Roman Egypt*. New York: The Metropolitan Museum of Art – Routledge.

Walker, S., and M. Bierbrier 1997. *Ancient Faces: Mummy Portraits from Roman Egypt*. London: British Museum Press.

Weber, T. 1999. *Baal der Quelle: zur geographischen Lage und historischen Bedeutung von Baalbek-Heliopolis*. Mainz: Philip von Zabern.

Webster, T. B. L. 1969. *Monuments illustrating New Comedy*. London: University, Institute of Classical Studies. 2nd ed.

Webster, T. B. L. 1995a. *Monuments Illustrating New Comedy*. London: University, Institute of Classical Studies, vol. 1, 3rd ed.

Webster, T. B. L. 1995b. *Monuments Illustrating New Comedy*. London: University, Institute of Classical Studies, vol. 2, 3rd ed.

Wegner, M. 1939. *Herrscherbildnisse in antoninischer Zeit*. Berlin: Gebr. Mann.

Wegner, M. 1966. *Die Musensarkophage, Die antiken Sarkophagenreliefs*, 5, 3. Berlin: Gebr. Mann.

Weitzmann, K. 1971. *Studies in Classical and Byzantine Manuscript Illumination*. Chicago–London: The University of Chicago Press.

West, R. 1933. *Römische Porträt-Plastik*. Munich: F. Bruckmann A.G.

Wheeler, M. 1964. *Roman Art and Architecture*. London: Thames and Hudson.

Wickhoff, Fr. 1900. *Roman Art: Some of Its Principles and Their Application to Early Christian Painting*. London: William Heinemann.

Will, E. 1950. "La date du mithréum de Sidon." *Syria*, 27, pp. 261–69.

Williams, E. R. 1979. "A Bronze Statuette of Isis-Aphrodite." *Journal of the American Research Center in Egypt*, 16, pp. 93–101.

Winckelmann, J.-J. 1784. *Storia delle arti del disegno presso gli antichi*. Rome.

Winkes, R. 1995. *Livia, Octavia, Julia, Porträts und Darstellungen*. Louvain-la-Neuve: Art and Archaeology Publications.

Worcester 2001. *Antioch: The Lost Ancient City*. Worcester Art Museum, October 7, 2000–February 4, 2001. Princeton: Princeton University Press in association with the Worcester Art Museum.

Wood, S. 1988. "*Memoriae Agrippinae*: Agrippina the Elder in Julio-Claudian Art and Propaganda." *American Journal of Archaeology*, 92, 3, pp. 412–13.

Wrede, H. 2001. *Senatorische Sarkophage Roms: der Beitrag des Senatorenstandes zur römischen Kunst der hohen und späten Kaiserzeit*. Mainz: Philipp von Zabern.

Wünsche, R. 1972. "Der Jüngling vom Helenenberg." In *Festschrift Luitpold Dussler. 28 Studien zur Archäologie und Kunstgeschichte*. Munich: Deutscher Kunstverlag, pp. 45–80.

Yeroulanou, A. 1999. *Diatrita. Gold Pierced-Work Jewellery from the 3rd to the 7th Century*. Athens: Benaki Museum.

Yourcenar, M. 1951. *Mémoires d'Hadrien*. Paris: Librairie Plon.

Zagdoun, M. 1989. *La sculpture archaïsante*. Rome: Ecole française de Rome.

Zahlhaas, G. 1975. *Römische Reliefspiegel*. Kallmünz: M. Lassleben.

Zampieri, G. 1998. *Vetri antichi del Museo Civico Archeologico di Padova. Corpus delle collezioni archeologiche del vetro nel Veneto, 3*. Venice: Comitato Nazionale Italiano dell'Association Internationale pour l'Histoire du Verre.

Zanker, P. 1970. "Das Trajansforum in Rom." *Archäologische Anzeiger*, 85, pp. 499–544.

Zanker, P. 1974. *Klassizistische Statuen: Studien zur Veränderung des Kunstgeschmacks in der römischen Kaiserzeit*. Mainz: Philipp von Zabern.

Zanker, P. 1976. "Zur Rezeption des hellenistischen Individualporträts in Rom und in den italischen Städten." In *Hellenismus in Mittelitalien*. Edited by P. Zanker. Proceedings of a symposium held in Göttingen, June 5–9, 1974. Göttingen: Vandenhoeck and Ruprecht, pp. 581–619.

Zanker, P. 1982. "Herrscherbild und Zeitgesicht." In *Römisches Porträt: Wege zur Erforschung eines gesellschaftlichen Phänomens*. Proceedings of a symposium held at Humbold-Universität, Berlin, May 12–15, 1981. Berlin: Wissenschaftliche Zeitschrift der Humboldt-Universität zu Berlin, pp. 307–12.

Zanker, P. 1997. "Individuum und Typus: Zur Bedeutung des realistischen Individualporträts der späten Republik." In *Roman Portraits, Artistic and Literary*. Edited by J. Bouzek and I. Ondrejova. Proceedings of a symposium held in Prague, September 25–29, 1989. Mainz: Philipp von Zabern.

Zwierlein-Diehl, E. 1991. *Die antiken Gemmen des Kunsthistorischen Museums in Wien. Band 3, zweiter Teil, Die Gemmen der späteren römischen Kaiserzeit*. Munich: Prestel.

Index

Page numbers in *italics* refer to illustrations.